ART,
PERFORMANCE,
MEDIA

ART, 31 INTERVIEWS
PERFORMANCE,
MEDIA

NICHOLAS ZURBRUGG, EDITOR

University of Minnesota Press
Minneapolis • London

Every effort has been made to obtain permission to print the interviews and reproduce the illustrations in this book. If any proper acknowledgment has not been noted, we encourage copyright holders to contact the publisher.

Published by the University of Minnesota Press
111 Third Avenue South, Suite 290
Minneapolis, MN 55401-2520
http://www.upress.umn.edu

Library of Congress Cataloging-in-Publication Data

Art, performance, media : 31 interviews / Nicholas Zurbrugg, editor.
 p. cm.
 ISBN 0-8166-3832-2 (hc : alk. paper) — ISBN 0-8166-3833-0 (pb : alk. paper)
 1. Arts, Modern—20th century. 2. Avant-garde (Aesthetics)—History—20th century. 3. Multimedia (Art). 4. Artists—Interviews. 5. Authors—Interviews.
 6. Musicians—Interviews. I. Zurbrugg, Nicholas.
 NX456.A684 2004
 700'.92'2—dc22

 2004001827

Printed in the United States of America on acid-free paper

The University of Minnesota is an equal-opportunity educator and employer.

12 11 10 09 08 07 06 05 04 10 9 8 7 6 5 4 3 2 1

CONTENTS

PREFACE

NICHOLAS ZURBRUGG COMPLETED THE MANUSCRIPT FOR THIS BOOK shortly before his sudden and untimely death in Leicester, England, in October 2001. He would have wished to thank all the writers, artists, editors, and publishers who contributed to and facilitated this project with advice, artwork, discussion, encouragement, photographs, permissions, editing, and proofreading.

Nicholas was an avid collector of books and art, and much of the material from this book, including tapes of interviews, will be deposited in an archive. For further information, contact tz@merlinpress.co.uk.

Anthony Zurbrugg
London, England
May 2004

INTRODUCTION

In 1949 it was all very vague—nobody knew what Dada was, and nobody knew very much about Italian Futurism or Russian Futurism. I had to visit the artists themselves before I finally discovered the true art of the twentieth century.

—Henri Chopin

SHARING THE FRENCH SOUND POET HENRI CHOPIN'S SENSE that the best way to discover the "true art" of any era is to "visit the artists themselves," this book attempts to document the surprisingly positive agendas of the mid-to-late-twentieth century's chronologically post-modern multimedia avant-garde in a series of interviews with the cut-up and collage novelists Kathy Acker and William S. Burroughs; the visual and sound poets John Giorno, Brion Gysin, Dick Higgins, Robert Lax, Jackson Mac Low, Larry Wendt, Emmett Williams, and Ellen Zweig; the language artist Jenny Holzer; the multimedia theater directors Richard Foreman and Robert Wilson; the performance artists Laurie Anderson, Diamanda Galás, Meredith Monk, and Rachel Rosenthal; the composers Charles Amirkhanian, Robert Ashley, Warren Burt, John Cage, Kenneth Gaburo, Philip Glass, and Steve Reich; the filmmakers Beth B, Mike Kuchar, Yvonne Rainer, and Nick Zedd; and the video artists David Blair, Nam June Paik, and Bill Viola.

What makes all of these artists so distinctive, perhaps, is their compulsion to work between, across, and beyond all the categories just listed. While certainly writing novels, both Acker and Burroughs have also worked individually or collaboratively in almost all the other arts listed here, alongside many of these other artists. Acker, for example, discusses her contributions to multimedia operas by Foreman, her CD collaborations with the punk rockers the Mekons, her time with Monk, and her first publishing support from conceptual artist Sol LeWitt; she also turns out to be both a contributor to LPs published by Giorno Poetry Systems and the dedicatee of Burt's first epic textual composition, *Nighthawk*. In turn, Burroughs discusses his taped and cut-up collaborations with Gysin, his filmic collaborations with Antony Balch, his multimedia collaborations with Wilson, and his final experiments as a painter.

Many of the artists listed here might well find the categories of poet, composer, performance artist, or filmmaker to be equally applicable to their work, or might prefer such alternative categorizations as dancer, choreographer, storyteller, public artist, or installation

artist. Not surprisingly, perhaps, the concrete poet—or sound poet? or Fluxus artist? or painter? or composer? or typographer? or publisher? or theoretician?—Dick Higgins typically observes: "Actually, I became ill over the matter when I was very young . . . I kept asking myself, Dick, you can't possibly be serious? When are you going to be just a composer, or just a poet, or just a visual artist? . . . I realized that it just was not my way. I cannot stop working in all these different media."

But as Higgins also points out, academia seldom welcomes "new work that doesn't readily fall into classifiability." Observing how "our art life is largely controlled by people in the university," and regretting the way most academics "teach whatever it is they can teach" and "ignore those things which they can't," Higgins persuasively argues that things are unlikely to improve "until we have departments of the arts in which the visual artist or professor is seated side by side with the poetry professor." Here Higgins identifies the key dilemma confronting truly innovative creativity—what Roland Barthes's essay "Michelet's Modernity" describes as academia's tendency "to throw out the baby with the bathwater, rather than get . . . wet" (1986: 211). Yet as Barthes's essay "Writing the Event" (1968) suggests, knowledge can only advance if critics look beyond old explanations in order to begin new investigations.

Somewhat as Cage commends Eric Satie's maxim, "Show me something new, I'll begin all over again!," Barthes's "Writing the Event" insists that those trained by the "old system" of "interpretation," according to which "one assigns to a set of confused or even contradictory appearances a unitary structure," should "gradually give way to a new discourse" in order to identify those "multiple structures," subject to "still unknown rules," which collectively "constitute the object of a new theory" (1986: 154).

But what exactly are the new discourses of the multimedia avant-garde? And what kind of new theory best articulates the complex interplay of the multimedia avant-garde's multiple structures? Confronted by such questions one suddenly feels considerable sympathy for Thomas Gradgrind's conviction in Charles Dickens's *Hard Times* that "in this life, we want nothing but Facts, sir; nothing but Facts." What, one asks oneself, are the most relevant facts making up the "multiple" adventures of the postmodern multimedia avant-garde? And where can one locate them?

The interviews in this book attempt to map the complex interplay between the different practices making up the careers of the thirty-one multimedia artists represented here. Recorded here, there, and everywhere—Brisbane, Melbourne, Sydney; London, Paris, Geneva, Berlin, Patmos; San Jose, San Francisco, Minneapolis, Vermont, New York—these conversations reflect a highly personal pilgrimage through the multimedia arts by a more or less English academic, initially working in Australia, then back in England, but in earlier sun-drenched days annually circling the globe whenever the going got too hot and humid during Brisbane's subtropical summers.

Usually undertaken face-to-face, occasionally by phone, and once or twice by letter, and generally commemorating the coincidences of intersecting paths spanning two decades and three continents, these self-consciously partial portraits of the multimedia avant-garde are at least partially *poetically correct*, as a record of the fascinating complexities, contradictions, and intergenerational continuities animating the contemporary avant-garde. Questioning mainstream academia's frequent misrepresentation of postmodern media culture in terms of its weakest populist practices, these pages perhaps offer more challenging food for thought.

Throughout these interviews I asked artists how their work developed across the media in terms of three general contextual questions. First, what do we really mean by the "avant-garde"? Second, to what extent does this concept still make sense in today's culture? And third, how seriously can we take hyperbolic diagnoses of mass-media trash culture? Is it really the case that we are all "agnostics" (1993: 22), "condemned to indifference" (1993: 18) in a culture of "total confusion" (1993: 10) characterized by La Cicciolina's "pornographic innocence" and Madonna's "artificial nitroglycerine" (1993: 21), as Jean Baudrillard's *The Transparency of Evil* suggests?

At first glance, such claims offer amusing reading, and, in Giorno's terms, typify the way in which delusion can be both "fascinating" and "entertaining." Significantly, though, Giorno also tellingly qualifies this claim with the suggestion that "you can only write words like 'Life Is a Killer' when you have great joy in your heart!" He argues that far from negating communication, such insights form the essence of successful performance "when the hearts of the collective audience get connected to yours in some moment of absolute recognition of wisdom that they hadn't recognized before, but already knew." For Giorno, "That's when you're successful as a poet. You're only a poet when something actually happens, miraculously."

To some extent Baudrillard's *The Perfect Crime* (1996) endorses Giorno's commitment to the miracles of art, particularly when condemning the ominous "They" trying to "wipe out" all the "magic" and "supernatural reflexes of thought" (1996: 18) in the name of the "autonomized, inhuman" empire of "Artificial Intelligence" (1996: 34). Yet while *The Perfect Crime* passionately defends the "felicity of language" and the "poetic singularity" of theoretical "analysis" (1996: 103), it rather halfheartedly concludes, "As for art . . . There must be some mystery to it . . . but we can't see what it is" (1996: 129).

Can't see, or *won't* see? one might ask. If contemporary cultural theorists refuse to acknowledge or to examine the most compelling mysteries and manifestations of contemporary multimedia art, then as performance artist Laurie Anderson observes, this is partially because "they're looking for it in the wrong place." More specifically, as video artist Nam June Paik comments, academia's technomyopia seems both very much the consequence of its traditional technophobia and very unlikely to go away unless "we intellectuals . . . give up certain parts of intellectual vanity, and look at the good parts of so-called high-tech research."

Given this miracle's improbability, it makes most immediate sense to seek illumination from visionary multimedia practitioners like John Cage rather than misanthropic theorists like Fredric Jameson. Responding to the question "Is the avant-garde dead?," Cage typically observes: "People ask what the avant-garde is and whether it's finished. It isn't. There will always be one. The avant-garde is flexibility of mind. And it follows like day the night from not falling prey to government and education. Without the avant-garde nothing would get invented" (1987: 238).

Rather differently dismissing the postmodern condition as an era when "there are no more masterpieces, no more great books," and certainly "no video masterpieces" (1987: 208), Jameson typecasts media culture as a limbo of "mechanical depersonalization" in which "auteurs themselves are dissolved along with the spectator" (1987: 205), warning that the impulse to discuss a "single video text" as the work of a "named artist or 'auteur'" fatally "opens the way for the return of all those features of an older modernist aesthetic which it was in the revolutionary nature of the newer medium to have precisely effaced and dispelled" (1987: 209).

As the practitioners interviewed in this book repeatedly indicate, Jameson's theoretical speculations could not be more misleading. Far from compulsively effacing or dispelling the modernist avant-garde's "older aesthetic," the creative aspirations and achievements of the postmodern multimedia avant-garde are most accurately defined in terms of the wide-ranging ways in which they both technologically deconstruct and technologically reconstruct, reassert, and generally rerevolutionize the complex values making up the "older modernist aesthetic."

Considered more metaphorically, the postmodern multimedia avant-garde's innovative practices might be said to offer the same kind of ill-defined performative profile as Françoise Janicot's 1983 photograph of John Giorno, as they pause at the "emergency exits" of mainstream culture, before entering unprecedentedly multimediated futures. Or, defined in terms of Roland Barthes's exemplary discussion of prophetic technocreativity in "The Third Meaning," such practices may be said to be "born technologically, occasionally even aesthetically," long before receiving academia's eventual baptismal blessing when finally "born theoretically" (1977: 67).

What innovative multimedia art dispels and effaces, Barthes lucidly suggests, are not so much the modernist avant-garde's utopian aesthetic aspirations as mainstream academia's predictably anachronistic orthodoxies. As Barthes observes, new forms of multimedia creativity, such as the "filmic," always begin "where language and metalanguage end" (1977: 64), offering what he defines as the miracle of a "new—rare—practice affirmed against a majority practice," and as such, "a luxury, an expenditure with no exchange" that "does not yet belong to today's politics but nevertheless *already* to tomorrow's" (1977: 62–63).

Intermingling theoretical, material, economic, and political references, Barthes incisively evokes the paradoxical ways in which the most significant avant-garde artworks confusingly affirm new values *against* past majority practices, *against* past systems of exchange, and *against* past systems of theoretical metalanguage. As such, avant-garde art still awaits legitimation from "today's politics" insofar as it is "still to be born theoretically." But at the same time—as something already born technologically and aesthetically—avant-garde art also already offers the technological and aesthetic substance for *tomorrow's* theory, for *tomorrow's* metalanguage, for *tomorrow's* politics, and, in time, for *the decade after tomorrow's* majority practices.

While mainstream academia all too often deflects the challenges of unfamiliar creativity by denying its existence with such sweeping claims as Jameson's assertion that it is "quite out of the question . . . to look at a single 'video work' all by itself" (1987: 208) and Jürgen Habermas's still more chilling hypothesis that "anyone who considers himself avant-garde can read his own death warrant" (1981: 6), most veterans of the modernist avant-gardes warmly welcomed their postmodern successors' finest innovations.

For example, while acknowledging the chronological and formal discontinuities between his generation's work and Robert Wilson's Paris production of *Deafman Glance* (1971), which he notes "is not surrealism at all, however easy it is for people to call it that," the surrealist poet Louis Aragon applauds Wilson's multimedia practice as "an extraordinary freedom machine" and unambiguously emphasizes the evolutionary continuities between Wilson's and surrealism's visions, hailing *Deafman Glance* as "what we others, who fathered surrealism, what we dreamed it might become after us, beyond us" (1987). Likewise, writing in a letter of August 1, 1979, the Dadaist artist Marcel Janco acknowledges the ways in which the tape-recorded sound poetry of poets such as Henri Chopin projected Dada's

"new expression of life" into still more revolutionary realms of "fantastic mechanical and technological progress" (1982: 75).

Chopin's accounts of his precursors' initial reactions to the first public presentation of his early *audio-poème* titled *Espace et Gestes* at the Galerie Mesure in Paris, in 1961, equally revealingly exemplify the fascinating solidarity between the modernist and postmodern avant-gardes. "An artist who had been listening to the tape gave me his address and said 'Come to my studio and I'll give you a painting, because you've achieved with sound something which we could never have done.' So I went to visit him. It was Marcel Duchamp!" (1992: 43).

Predictably emphasizing the technological discontinuities between successive avant-garde generations, Chopin reasons that while the modernist avant-garde's pioneering experiments represent "a beginning," somewhat like the "first motorized flights" of Blériot, the innovations of the postmodern avant-garde reflect a culture animated by "supersonic planes like the Concorde" (1982: 74). But at the same time, Chopin equally intransigently traces the aesthetic continuities between these generations, noting how "the first half of the twentieth century seems to manifest a kind of artistic desire which only becomes fulfilled in the second half of the century" (1992: 43–44).

In turn, the pioneering research of the midcentury avant-garde poets of Chopin's generation inspired subsequent innovations that only later became fully realized in the work of younger text-sound poets, composers, and performance artists such as Charles Amirkhanian, Laurie Anderson, Warren Burt, Diamanda Galás, and Larry Wendt. Both celebrating Chopin's mastery of the "early types of tape recorders" and deploring his "horrendous" strategies—"you know, sticking matches into it!"—Wendt typifies the way in

Participants in the One World Festival, Amsterdam, October 1981. Photograph by Françoise Janicot.

which his generation similarly dissociates itself from—and associates itself with—earlier attempts to "use technology artistically."

As Janicot's photograph of the poets at the 1981 One World Festival in Amsterdam suggests, recent avant-garde gatherings not only cultivate the remarkable international solidarity between different generations of artists using various technologies "artistically," but also tend to unite both predominantly multimedia artists like Mac Low, Chopin, Heidsieck, Burroughs, and Giorno (standing, first and third to sixth from left), and more conventional declamatory poets such as Michael McClure (standing, second from left), Diane Di Prima (standing, fourth from right), and Linton Kwesi Johnson (kneeling, first from left). Not surprisingly, New York poet John Giorno remarks how the contemporary avant-garde embraces "a myriad" of increasingly populist publishing possibilities:

> The albums are played in the living room, but are heard also on the radio. Then what's on the album gets made into a video that's then on television or home video. The point of communication is the many possibilities. During all of this, the poet gets involved in the production and the process. If it's on a record, the poet is performing it. Or the poet is making a video and is developing video skills.

Emphasizing how multimedia creativity invariably leads artists to develop new contemporary "skills" peculiar to new contemporary media, Giorno also notes how his texts for the page break out into all kinds of extratextual registers:

> Somehow, letting go of the page, not having the page there, releases some incredible energy . . . you develop these melodic qualities and phrases, which take off on your breath! Well, that's singing—but not in the traditional sense! I don't know how to sing! I never learned how to sing. Which is great for me, because I'm not saddled with all of those rules of songwriting and singing! I'm a poet, and I perform my work, so I can do anything I want!

New media, Giorno suggests—such as Robert Moog's first synthesizers—are usually inseparable from such initial phases of avant-garde experimentation as his technological distillation of a kind of "musical score . . . inherent in the words," in order to reveal what he calls "something that is slightly fuller and *more* than just if it were straight." Over and over again, it is precisely this quest for something "slightly fuller and *more*" that most obviously characterizes the experiments of the postmodern avant-garde.

But as the musicologist Michel Chion points out—when fascinatingly analyzing the evolution of electroacoustic music in terms of cinematic paradigms—the "austere" innovation prompted by the avant-garde's initial "purist" desire to transform a particular technology into "a specific art, with its own language," usually grows into more open-ended "hybrid" creativity combining old and new materials. At this point, Chion concludes, "the puritan impulse relaxes," as later phases of new multimedia art reflect a "confusion of genres and references." But as Chion crucially specifies, "This confusion in no way signifies a return to zero, since it is based upon experience, upon its own tradition" (1972: 27).

Giorno's work reflects precisely this kind of evolution. At first exploring highly multimediated tape montages refining the "musical score" inherent in his texts, Giorno's later work with his rock band and as an actor in the La MaMa Experimental Theatre's video production of Beckett's *Eh Joe* projects his early "skills" into fascinatingly new hybrid directions. Having established what Chion terms "its own tradition," Giorno's mature work exchanges the austere surprises of its "purist" phases for more diverse explorations of such

more or less mainstream forms of performance as rock music and Beckettian theater, according to his earlier work's "tradition."

Significantly, most multimedia artists' seemingly negative rejections of mainstream orthodoxies invariably lead to subsequent self-identification with both new and older "traditions." Thus while Chopin defends new multimediated languages, "which have nothing to do with Dickens and Balzac" (1992: 50), he also aligns himself with the "artisans of the past," arguing that "it's necessary to create a kind of synthesis—to go towards the future, while at the same time remaining aware of everything that has been written" (1992: 51).

At one extreme, artists like Bill Viola and David Blair attempt to attain this kind of creative synthesis with new technologies. Others, like the poet Robert Lax, usually "compose" language in predominantly unmultimediated experiments. Still others, such as Meredith Monk, explain: "We all use technology for what it can do. I certainly sing in front of a microphone and I use lights, although I also feel that I'd be very comfortable singing with one candle—and that's it!"

Viola, for example, remarks how "this thing called the camera—the video camera—and the screen, the monitor, are tools that can . . . give you new points of view and new insights in a very simple way," by permitting such innovations as the decelerated "microacting" in his installation *The Greeting*. For Viola, technological art simultaneously builds futuristic bridges leading away from the limitations of dominant contemporary cultural conventions and retrospective, transhistorical bridges "going back to what was rejected, to the academy, the classical, the neoclassical." As works like *The Greeting* indicate, the most interesting multimedia creativity fulfills each of these agendas, by both technologically refining "tip of the wave" innovation and subsequently—or simultaneously—identifying "new words, new semantics, a new grammar" commensurate with the challenge of retranslating the ahistorical certainties of art's "great themes." Likening this process to "transposing music, changing keys," Viola equates "video tools" with unprecedentedly "physical . . . physiological and palpable visceral experience of these ideas."

In much the same way, New York video artist David Blair relates how emergent nonlinear editing technologies allowed him to complete his cyberpunk film *WaX; or, The Discovery of Television among the Bees* (1991) with similarly preverbal "visceral" immediacy:

> I discovered that there was a nonlinear editing system in New York that had been made available for artists' use, but no one wanted to use it, because the other artists had no idea what the hell they could use it for . . . Editing became so fast, it really was just like composition . . . Well, when the whole thing is available, all two thousand shots all at once, you can work almost preverbally. So the narrative was verbally created, but emerged preverbally, through the pictures. . . . I guess it relates in a lot of ways to experimental music—video-image processing derives directly from analogically controlled experimental music and musique concrète.

Working with a kind of multimedia compositional logic, rather than with the technologies explored by Viola and Blair, Robert Lax similarly recounts how his contemplative poems attempt to capture the elementary patterns that he perceives in nature or in music—as opposed to poetry:

> One day it rains, one day it's sunny, and so on. Clouds come, and clouds go. And if we get used to looking at permutations in our poetry, we have a chance of beginning to—not understand, but to get a way of watching the permutations that take place in nature, and in

the more microscopic life . . . And I think in a way, music gets close to the way those things in nature work. But poetry—up to now—has been riding on the fringes of it . . .

And perhaps this is some way of getting back to—aspiring to the condition of—music and getting back to the sort of scale or color wheel that musicians can work with, and painters can work with, and which we have a harder time working with, as writers.

As Emmett Williams observes, Lax's poems culminate in partially visual, partially sonic, partially abstract compositions, most notable for "all that profound simplicity, echoes of classicism in a new form. A piety that rings true, and provokes laughter." Exploring somewhat similar paradoxes, Cage describes the "touching," "pathetic," and strangely "beautiful" experience of simultaneously hearing twelve 78s in *Europa 3* (1989); Wendt commends the challenge of attempting to "barbecue a chicken with an acetylene torch" and of making "a microphone that will fit into a chicken that you can burn, without burning up the microphone"; and Warren Burt defends a performance with an "amplified parsnip" on the grounds that "I do pieces which are completely off the wall and silly, and I also do very serious pieces, and I maintain my right to do both." Just as the modernist avant-garde encompasses such conflicting priorities as George Grosz's and Wieland Herzfelde's wish to "give up 'pure art'" (1971: 85) and Kurt Schwitters's assertion that "Merz aims only at art, because no man can serve two masters" (1967: 60), the postmodern multimedia avant-garde continually reflects equally disparate agendas.

The dancer, choreographer, and filmmaker Yvonne Rainer observes: "I don't make films for posterity. One can't do that. You have to make them for where you stand right now, and not second-guess the future, or second-guess an audience even." At the same time, however, Rainer points out that even her most rigorously minimalist dances offered a certain "surrealist cast," admits that her early polemic was "totally overstated," and remarks how her more recent films radiate a curiously neglected "sly kind of humor."

Discussing her performances' slightly more mythological attempts to evoke ecological crises, and simultaneously differentiating the autobiographical register of her vision from both the "very hidden and couched" sensibility of Cage's circle and the comparatively "shortsighted and tunnel-visioned" explicitness of politically correct militancy, Rachel Rosenthal rather similarly explains, "I need to get the ideas across . . . they can be pretty surreal, but people have to get them."

Leaning still further toward the surreal—or toward what Aragon (1987) defines as realms "after" and "beyond" the surreal; sharing Nick Zedd's refusal "to make propaganda"; and generally deploring the way naturalistic performance presents "one-liners" asking, "Do you get it, audience?," Robert Wilson explains: "One invents a language and then once this language becomes discernible, we can destroy it and start again. I think that's what Mozart did when he was composing—you know, the theme and the variation." Not surprisingly Wilson acclaims the "density" of East German writer Heiner Müller's texts on the grounds that "their volume of contradictions . . . makes interpretation impossible," leaving them to "read in many different ways, like all great literature."

Whether questioning the concept of "great" art like Rainer's or whether sharing Rosenthal's enthusiasm for the way in which great artworks "just sit there over the eons and look gorgeous!," and whether focusing upon what Jenny Holzer calls the "hellish parts of modern life" or upon the "moments of eternity" evoked by Bill Viola, all of these artists

clearly share Viola's sense that far from neutralizing individual and collective communication, new multimedia afford a remarkably effective "commerce of images."

Contemplating the more forceful works of the contemporary multimedia avant-garde one often has the curious sense of confronting work that is both quintessentially of its time, in terms of its immediate themes or in terms of its mastery of available technologies, and yet "out of time" or "back in time," in terms of its quintessential purity and originality; a paradox to which Robert Lax refers when he wonders, "How you can talk about timelessness and progress at the same time?"

Perhaps the answer to this enigma is that progressive art attains purity and timelessness by extricating itself from obsolete cultural orthodoxies obscuring the creative potential of the present. But as Gertrude Stein's *Picasso* suggests, this is a rare achievement, since however contemporary their habitats may be, when considered in terms of their aesthetic sensibility and "everything that does not contribute to their immediate comfort," most people "live in the preceding generation" (1939: 31).

As Richard Foreman and Meredith Monk suggest, when affirming their admiration for early modernists like Jean Cocteau, and as Dick Higgins intimates when recalling his meetings with Dadaists such as Richard Huelsenbeck, Raoul Hausmann, and Hannah Höch, the most adventurous artists of preceding generations also obviously offer valued kindred spirits. What makes the avant-garde "avant-garde," in other words, is its distinctively contemporaneous vitality when compared with the nostalgic orthodoxy of those sections of mainstream society and academia modeled on the most conservative traditions of previous decades.

Somewhat as Baudrillard's "The Precession of Simulacra" posits that Disneyland is "presented as imaginary" in order to conceal the fact that "it is the 'real' country, all of 'real' America, which *is* Disneyland" (1983: 25), mainstream academia frequently both typecasts and outcasts authentically contemporary creativity as futuristically and dangerously "avant-garde" in order to conceal its reluctance to confront the challenges of the present, and in order to maintain the myth of its own exemplary contemporaneity.

Arguing with the insight of a visionary contemporary artist, Henri Chopin rather more accurately suggests that "if one carefully follows the creativity of the past quarter century, it becomes quite apparent that far from being experimental, we're simply living . . . with the twentieth century" (1982: 74). Likewise, reasoning that "it's important, since we live in an age where there are so many technological marvels and horrors, to use technology when appropriate," Jenny Holzer probably speaks for most of the artists interviewed in this book when she concludes, "If high tech gets the message across, it would be stupid to turn your back on it."

Yet as the writings of Peter Bürger, Walter Benjamin, Richard Schechner, Achille Bonito Oliva, and Hal Foster variously indicate, many theorists and critics all too often found it all too easy to invoke ideological reasons for turning their backs on the authentically contemporary creativity of the avant-garde's high-tech messages, particularly when such messages lack the left-wing and the "anti-art" demands they equate with the "historical" avant-garde.

Contending that the fact that the "historical" avant-garde's works are now in museums demonstrates the clear "failure" of its "protest . . . against art as institution" (1984: 53), Bürger's *Theory of the Avant-Garde,* for example, concludes that "Neo-avant-garde" anti-art, such as Warhol's "Campbell soup cans," becomes even more "void of sense" (61) in the

"changed context" of the 1960s, since its "resumption of avant-gardiste intentions" no longer has "even . . . the limited effectiveness the historical avant-gardes achieved" (58).

But as Renato Poggioli suggests, the "activist," "antagonist," "nihilist," and "agonist" (1968: 25–26) impulses constituting the avant-garde's "*anti*-creation" gestures often consist of little more than a kind of immature self-publicizing posturing preceding subsequent transition—via intermediary moments of "*ante*-creation" (1968: 137)—into the kind of "positive" creativity that Dadaist Marcel Janco contrasts with the avant-garde's initial "negative speed" (1971: 37).

Briefly, whereas Bürger and his followers argue that mid-to-late-twentieth-century media culture accelerates the "death" of the avant-garde, the "changed context" of the 1960s is surely more accurately defined in terms of the ways in which its new technologies allow the postmodern multimedia avant-garde to realize and revitalize the modernist avant-garde's most positive multimedia aspirations with exemplary flair.

While acknowledging that the "spiritual violence" and "negative speed" of Dada's "first phase" often "remains in the same state, not having found soil fertile enough to expand into the positive," Janco insists that Dada's contribution to twentieth-century art becomes clear only when the "two Dadas, negative and positive" are examined "as objectively as possible in all stages and all moods." Only in such circumstances, Janco concludes, can one "estimate at their true value the negative . . . side with the prophetic work of positive Dada," which "opened to art a new road, upon which, to say the least, artistic creativity has remained dependent through the present day" (1971: 37–38).

In turn, the "true value" of postmodern avant-garde can be estimated accurately only when judged in terms of both its positive and negative agendas. Astonishingly, many critics complacently equate postmodern media culture with its weakest mass-mediated manifestations, rather than making any serious attempt to evaluate its more affirmative creative achievements. As Dick Higgins remarks, once such critics declared the avant-garde art to be "dead," this "put the spotlight on them," since they "didn't have to keep themselves informed about what mere artists were doing because criticism was the art." But how persuasive are such negative critical generalizations? Four key questions come to mind:

1. Does "mechanical reproduction" always bring about the "decay" of creative "aura," as Walter Benjamin suggests (1979: 225)?
2. Is it really the case that "the current avant-garde offers no surprises" and is "simply a menu of options drained of the fervor of their original impulses," as Richard Schechner argues (1993: 8)?
3. Has the "historical optimism of the avant-garde—the idea of progress inherent in its experimentation with new techniques and new materials" utterly succumbed to what Achille Bonito Oliva defines as a state of irremediable "collapse" (1982: 8)?
4. Does the alleged poverty of recent art fully justify Hal Foster's assertion that he need no longer "address art directly," and can now use theoretical texts "as both objects and instruments of my history" (1996: 208)?

Succinctly challenging all of these claims, Jean Baudrillard's most recent writings suggest that far from permanently ending, stalemating, or collapsing auratic creativity, and far from leading him to forsake art for a diet of more and more theoretical texts, his artistic practice as a photographer not only persuades him that he has experienced "my greatest

sense of pleasure—and indeed, my strongest sense of passion—in the realm of images, rather than in the realm of texts" (1997: 37), but now also convinces him that "photography has recovered the aura it had lost with the coming of the cinema" (1999: 134).

Equally tellingly questioning his earlier analyses of technology as "a medium of alienation and depersonalization," Baudrillard also now admits that he is "more interested in seeing technology as an instrument of magic" (1997: 38). Not before time, Baudrillard's critical writings finally address many of the most positive agendas of the multimedia avant-garde.

If Baudrillard's belated recognitions of multimediated "aura" and "magic" come as a welcome surprise following his constant equivocation before media culture, one returns with even more admiration to the still more active "aesthetic idealism" that Philip Glass associates with those artists who never doubted their art's "magic" potential, even when denied access to existing contemporary technologies and forced into what Robert Ashley calls "the position . . . of being the visionary—of advocating something that is outside of my experience" while knowing that "it's possible." As Dick Higgins suggests, such artists are among the few of their generation who have "kept their nerve, kept the vision, and kept the energy together" in an era of widespread creative and theoretical delusion.

Like the figures in Paul Gauguin's *D'Où venons-nous? Que sommes-nous? Où allons-nous?* (1897), we might well ask: Where are we from? What are we? Where are we going? These questions may seem unanswerable, but as visionary creators like Cage suggest, the finest avant-garde art often increases the confidence with which we approach the future. Somewhat as filmmaker Mike Kuchar suggests that "creative expression through visionary arts is spiritually contagious," Cage remarks that other artists' discoveries "don't give you a sense of the loss of the ability to discover, but rather, an intensification of that."

Generally predicting the way in which most postmodern multimedia avant-garde creativity culminates in innovative performance demanding the attention of all the senses, Cage's 1955 article "Experimental Music" concludes: "Where do we go from here? Towards theater. That art more than music resembles nature. We have eyes as well as ears and it is our business while we are alive to use them" (1970: 12).

To be sure, this ideal is not exactly new. But as Henri Chopin suggests when identifying the "Fabulous Independents" of his century with "a kind of theater which has nothing to do with conventional theater" (1999: 114), multimediated performance surely attains unparalleled precision in avant-garde experiments such as the composer Kenneth Gaburo's explorations of the principles of "compositional linguistics."

As Gaburo explains, he uses this term to denote the extralinguistic interaction of text, image, lighting, gesture, vocal sound, and music in multimedia performances in which "no particular discipline . . . is sufficient in and of itself to express that which is necessary to express." Inspired by the composer Harry Partch's concern for kinds of "assimilation-integration, such that the parts become inseparable," this kind of performance assumes that "those things which one recognizes as discrete elements elsewhere—like light, movement, dance, acting, music" become integrated as "systems of dependencies." Accordingly, having observed this kind of performance, "one couldn't say, 'Well, I sure liked the music, but the dancing was lousy,'" since "there'd be no way in that situation to make such a partition."

Initially refining a rigorously intermedia aesthetic treating "music as language, language as music," and then increasingly incorporating "active involvement with computer, video, film, optical, laser, and electroacoustic technology," performed by a multiskilled group "regarded as a kind of generative, and transformational grammar," Gaburo's experiments

culminate in what one might think of as hybrid realms of multimediated intermedia—or of intermediated multimedia.

Compositional linguistics differs from conventional linguistics, Gaburo suggests, in terms of its wager that such group-generated and group-composed intermediated and multimediated discourse can create what in *The Music in Samuel Beckett's* "Play" he defines as "another language," generating its own "language-sensibility" and requiring its audience to develop an equally innovative sensibility in order to perceive its newly composed meanings in their own "light," beyond conventional semantic communication.

Best quoted in full, Gaburo's conclusion to his carefully argued analysis of *Play* as performance, in performance, "in its time," observes:

> Its conditions won't give an observer, nor performer, time to dwell (reflect) on meaning (think). One either gives in and becomes physically caught up in the whole transmission, . . . in PLAY's time; . . . bombarded by WORDS, sound, spot, motion, WORD-densities, literal/ actual continuous WORD-sound drones (with traces of sensibility) at rates where WORDS lose their intelligibility, and act as carriers of an acoustic, . . . OR: becomes lost. PLAY either performs as a composition performs, . . . with fluid motion, and without indulgence, caprice, para-sentiments, OR: does nothing. If one pauses, even for an instant, to meditate on a transmitted expression, a very large number of others will have passed by unnoticed. It is in the kind of attempt to fix meaning, or fix on meaning, . . . as PLAY unfolds, which will cause it to forever be unintelligible (incomprehensible). But, if one lets go, PLAY is abundantly rich in sonority, and alive with human expression and circumstance. If we take meaning (in its narrow, usual semantic sense) out of WORD/PLAY, . . . so difficult because we seem unable to dismiss the notion that WORDS are present, and WORDS presumably have definitions, . . . that they mean something other than what they are, where and how they are, then PLAY generates *another* language. In this language meaning may be found. PLAY generates its own language-sensibility because it is composed. Comprehension, on any level, has to obtain in its light. (1976: 10)

Written following "a six month rehearsal and subsequent performance" (1976: 11), Gaburo's empirically grounded conclusions fascinatingly complement Barthes's more speculative parallel accounts of the ways in which new multimediated languages, such as the "filmic," soar beyond conventional semantic meaning into realms of "third meaning." Arguing that such third meanings simultaneously exist both "within interlocution" and "outside (articulated) language" (1977: 61), Barthes incisively concludes:

> The filmic, then, lies precisely here, in that region where articulated language is no longer more than approximative and where another language begins (whose science, therefore, cannot be linguistics, soon discarded like a booster rocket). The third meaning—theoretically locatable, but not describable—can now be seen as the passage from language to significance and the founding act of the filmic itself. (1977: 65)

Like Chion's interdisciplinary analyses of the evolutionary phases of avant-garde film and electroacoustic music, Barthes's and Gaburo's interdisciplinary discussions of "founding acts" annunciating new multimediated creativity impressively gravitate toward the same kind of flexible critical and creative sensibility that Gaburo cultivated in his work with "bodies, tactilities, text-sound poetry, sound-music, talk-music, speech-music, sound-movement, improvisation, gesture, and . . . an extraordinary range of multiphonic techniques."

Here, within Eisenstein's and Beckett's "multiple structures," Barthes and Gaburo identify precisely the kind of "object of a new theory," subject to "still unknown rules" (Barthes, 1986: 154) that any authentically contemporary arts course should surely begin to highlight, elucidate, and generally get to know in terms of the most recent innovations of the postmodern multimedia avant-garde.

While the enthusiasm for "overarching ideas between all the art forms" of younger composers such as Warren Burt suggests that Gaburo's creative experiments and theoretical insights have already inspired a significant creative legacy, by the late 1980s Larry Wendt rather more discomfortingly reported how the next generation of "electroacoustic students" seemed both "unaware of the whole history of electroacoustic music and experimental art" and indifferent toward any skills without "commercial applicability." In turn, by the early 1990s, Burroughs similarly disparaged mainstream culture as a state "almost bordering on the far side of idiocy," warning that future years presented "a pretty bleak picture."

Yet all is perhaps not yet wholly lost. Remarking how he attributes "most significance to that which is separate, a quality which I associate with particular insight into the quality of our times, as opposed to artistic schools, which seem little more than history's punctuation marks," and commending the insights of such "one-man movements" as "the Pole Tadeusz Kantor, the Czech Jiří Kolár, the Frenchman Jean Genet, the Swiss Paul Zumthor, and the Americans William Burroughs, John Cage, and Robert Lax," Henri Chopin movingly concludes:

> Were one only to conceive of large groups on the one hand, and written traditions on the other, it would become virtually impossible to classify these curious individuals, and yet when all is said and done, it is they who have inaugurated those momentous forms of spoken or sonic theater which offer the finest syntheses of our continually astonishing century. (1999: 114–15)

In much the same way, Burroughs's 1991 interview celebrates meetings with such eminent contemporaries as Samuel Beckett, Paul Bowles, Jean Genet, and Brion Gysin, recalling, "It was extraordinary—you could just see right away this is somebody extraordinary, just as if they had a halo—which they probably do."

As the following pages perhaps suggest, the same might well be said of many of the artists interviewed in this book.

Works Cited

Aragon, Louis. 1987. Open Letter to André Breton (June 2, 1971). Translated by Linda Moses. In program for Robert Wilson's *Hamletmachine*. London: Almeida Theatre.

Barthes, Roland. 1977. *Image Music Text*. Translated by Stephen Heath. Glasgow: Collins.

———. 1986. *The Rustle of Language*. Translated by Richard Howard. New York: Hill and Wang.

Baudrillard, Jean. 1983. *Simulations*. Translated by Paul Foss, Paul Patton, and Philip Beitchman. New York: Semiotext(e).

———. 1993. *The Transparency of Evil* (1990). Translated by James Benedict. London: Verso.

———. 1996. *The Perfect Crime* (1995). Translated by Chris Turner. London: Verso.

———. 1997. The Ecstasy of Photography (1993). Interview with and translated by Nicholas Zurbrugg. In Nicholas Zurbrugg (ed.), *Jean Baudrillard: Art and Artefact*. London: Sage.

————. 1999. "For Illusion Isn't the Opposite of Reality . . ." Translated by Chris Turner. In *Photographies 1985–1998*. Ostfildern-Ruit: Hatje Cantz; Graz: Neue Galerie.

Benjamin, Walter. 1979. The Work of Art in the Age of Mechanical Reproduction (1936). In *Illuminations*. Translated by Harry Zohn. Glasgow: Collins.

Bonito Oliva, Achille. 1982. *Trans-avantgarde International*. Translated by Dwight Gast and Gwen Jones. Milan: Giancarlo Politi.

Bürger, Peter. 1984. *Theory of the Avant-Garde* (1974). Translated by Michael Shaw. Minneapolis: University of Minnesota Press.

Cage, John. 1970. *Silence*. Cambridge, Mass.: MIT Press.

————. 1987. Interview with Stephen Montagu (1982). In Richard Kostelanetz (ed.), *Conversing with Cage*. New York: Limelight.

Chion, Michel. 1972. Vingt années de musique électroacoustique ou une quête d'identité. Translated by Nicholas Zurbrugg. *Musique en jeu*, no. 8.

Chopin, Henri. 1982. Letter of July 17, 1979. Translated by Nicholas Zurbrugg. *Stereo Headphones*, no. 8–10.

————. 1992. Interview with Nicholas Zurbrugg. In Nicholas Zurbrugg and Marlene Hall (eds.), *Henri Chopin*. Brisbane: Queensland College of Art Gallery.

————. 1999. Fabulous Independents. Translated by Nicholas Zurbrugg. In David Miller and Nicholas Zurbrugg (eds.), *The ABCs of Robert Lax*. Exeter: Stride.

Foster, Hal. 1996. *The Return of the Real: The Avant-Garde at the End of the Century*. Cambridge, Mass.: MIT Press.

Gaburo, Kenneth. 1976. *The Music in Samuel Beckett's "Play."* Ramona, Calif.: Lingua.

Grosz, George, and Wieland Herzfelde. 1971. Art Is in Danger. Translated by Gabriele Bennett. In Lucy R. Lippard (ed.), *Dadas on Art*. Englewood Cliffs, N.J.: Prentice-Hall.

Habermas, Jürgen. 1981. Modernity versus Post-Modernity. Translated by Seyla Ben-Habib. *New German Critique*, no. 22.

Jameson, Fredric. 1987. Reading without Interpretation: Postmodernism and the Video-text. In Nigel Fabb et al. (eds.), *The Linguistics of Writing*. Manchester: Manchester University Press.

Janco, Marcel. 1971. Dada at Two Speeds (1966). Translated by Margaret Lippard. In Lucy R. Lippard (ed.), *Dadas on Art*. Englewood Cliffs, N.J.: Prentice-Hall.

————. 1982. Letter of August 1, 1979. Translated by Nicholas Zurbrugg. *Stereo Headphones*, no. 8–10.

Poggioli, Renato. 1968. *The Theory of the Avant-Garde*. Translated by Gerald Fitzgerald. Cambridge, Mass.: Harvard University Press.

Schechner, Richard. 1993. *The Future of Ritual*. London: Routledge.

Schwitters, Kurt. 1967. Merz (1920). Translated by Ralph Manheim. In Robert Motherwell (ed.), *The Dada Painters and Poets*. New York: George Wittenborn.

Stein, Gertrude. 1939. *Picasso*. London: B. T. Batsford.

Kathy Acker. Photograph by Della Grace.

KATHY
ACKER

I FIRST HEARD KATHY ACKER'S VOICE on the Giorno Poetry Systems LP *Sugar, Alcohol, & Meat: The Dial-A-Poem Poets* (1980). Its cover notes specify: "*I Was Walking Down The Street,* one of the fairytales the whores of Montmartre tell each other to put each other to sleep after a hard night's work in '*The Adult Life of Toulouse Lautrec.*'" Recorded live at C.B.G.B.'s in New York, this is quintessential Acker: richly intoned bedtime narrative echoing high culture and low life, innocence and experience, parody and poetry.

A decade or so later—back in those still-sonorous, pre-e days—I phoned Acker from Brisbane one morning, leaving on her answering machine a request for a meeting in San Francisco. By the time I got to work at Griffith University, she'd confirmed our meeting on my office's answering machine. We met in June 1991, the day I arrived in San Francisco, and her accounts of her adventures among the postmodern avant-garde's multimedia arts proved every bit as fascinating as I'd anticipated.

Far from simply offering the literary autobiography of a writer "trained as a classicist," Acker's multimedia reminiscences evoke her encounters with the New York underground filmmakers, such as Jack Smith; subsequent days in San Diego with artist Eleanor Antin, poet David Antin, and composers Robert Ashley, Warren Burt, and Peter Gordon; her move back to New York's postconceptualist performance scene, where she took tickets at the Kitchen, worked with dancer Meredith Monk, and collaborated with Ontological-Hysterical Theater director Richard Foreman, composer Peter Gordon, and artist David Salle; and more recently, the *High Risk* milieu of Karen Finley and David Wojnarowicz and the postpunk world of the Mekons.

Subsequently outlining her sense of the demise of the art world "as a funding body," her enthusiasm for bad girl rock band Tribe 8, and her increasingly cosmopolitan identity, our second interview was taped during a pause in Acker's 1995 Australian tour with Ellen Zweig, as we sipped wine in Brisbane on the Heritage Hotel's sunlit terrace, the Story Bridge

arching to infinity on our left, my old Kangaroo Point pad nestling across the sparkling river—that old Mexican-looking house there—on the right.

Over the next two years we crossed paths at a Diamanda Galas concert in London and then at the Festival de la Bâtie in Geneva, where her reading from *Pussy, King of the Pirates* ended as she half-lisped, half-danced—a kind of victory jig along with the Mekons' recording of "Antigone's Running Wild." We discussed a UK gig, and she was scheduled to read in Leicester on November 3, 1997. But by then, as phone calls indicated, she was fighting cancer, not long to go.

San Francisco—June 8, 1991

When did you first start thinking of yourself as a writer?

The feeling that I could be a writer, I think, came when I was roughly fourteen or fifteen. I started sneaking out of school and hanging out with artists who were orientated around the New York Film-Makers' Cooperative, which was an experimental center, not only for filmmakers such as Stan Brakhage, but for poets such as Robert Kelly and Jackson Mac Low. It was the first time in my life that I felt I was around people with whom I was comfortable.

I remember the day that Kennedy died—I think I was in eleventh grade—and my whole school was weeping, and honestly, I didn't feel anything. So I went down to the co-op, and it turned out that Jean Cocteau had suicided the same day—and his suicide, so the rumor went, had something to do with Edith Piaf's death. This I related to instantaneously, and all the poets and filmmakers and whatnot were mourning Jean Cocteau's death. He'd been very close to the people at the Film-Makers' Co-op. And I thought, This is how I want to live—these are my values. And I thought, I have to do something—it's not enough to be a pretty girl of fourteen or fifteen years old—I have to do something in the world, so I can live with these people. So that was very, very, very influential.

What sort of things appealed to you most?

What I remember most was that I had a boyfriend who got me into all this, named P. Adams Sitney—who's teaching film now, I think, at Princeton. He was running the film anthology archives for a number of years, and he was trying to teach me about the work of Charles Olson and the other Black Mountain poets. And I remember not understanding, being very confused. And that, surprisingly—that's what attracted me the most! It was the mysteriousness—it was something I had to learn.

And the other thing that attracted me the most was that Jack Smith was part of this group. I was just amazed by him. For whatever reasons, he would have coffee with me now and then, and he would talk about all his dreams, and I remember he told me about one dream in which he wanted to go somewhere in North Africa and build a huge dome. And he wanted whoever came into that dome to tell him their dreams or their desires, and he would instantaneously make a film of these dreams or desires, and films would show twenty-four hours a day. I loved that!

I liked dreams a lot. I like working with dreams—I like working with the imagination. Myth fascinated me—when I was a kid, my fairy tales were the Greek myths. And Maya

Deren's films absolutely fascinated me. She made some wonderful films on voodoo dances—which is amazing because the Haitians at that time certainly didn't want a white woman recording their dances—and became a voodoo priestess, a mythic figure among those film-makers. That fascinated me—that they were working with myth—the strangeness. It all had to do with a quality of life—a quality of really living in the imagination.

Where did that lead?

They took me seriously for some reason, and said, "We want you to edit *Film Culture*"—the magazine P. Adams did—because he was gone for a month or two. And I thought, God, I'm fifteen years old, I don't understand any of this, I can't do this. I'd been brought up in a certain class, in a certain society, and I was a female, and it was very hard for me. This was a secret part of my life—my public life was to wear a nice school uniform and do what my parents told me and go on to college and marry a nice rich boy and live out that life. And it took me a long time to make this secret life into my real life. I didn't have the guts to do it at age fifteen. I was scared of starving, I was scared of the world out there—I saw that there was a lot of junk, people were very, very poor, and I was frightened!

So there was this hiatus when I did what I was supposed to do. My parents wanted me to go to a university named Smith, very WASP, and I ended up going to Brandeis, which was the place where all the radicals were hanging out. Angela Davis was there, Abbie Hoffman had just left, the Weathermen were hanging around. But it was still a university—I hadn't just gone off into the art world. It took awhile to figure out how to live my life the way I wanted to live it, without ending up starving to death or in trouble.

So I went to university, went through all the programs, kept on writing. The man who was my first husband was Herbert Marcuse's student, so when Marcuse was offered a nice teaching position at the University of California, we all followed to San Diego. In those days it was left wing, and the schools had lots and lots of money, so they thought, Oh, we'll get those flaming radicals down here!

And then a man came down to San Diego named David Antin, and when I met David it was love at first sight. Not sexual at all—I just followed him around. He hadn't started the long talking poems yet—he was doing what I'd guess you'd call conceptual poetry, before he got into the talk pieces.

And suddenly, I saw how I could live the life I wanted to. So I just followed him around for two years. Eventually he said, "What are you doing in a university? You know, you obviously want to write, this is no place for you," and pretty much sent me back to New York, where I lived over Jerome Rothenberg's apartment with a boyfriend. So I then sort of followed Jerome Rothenberg around for a year. He was still involved with the second generation of Black Mountain School—Diane Wakoski, George Economou, and Rochelle Owens.

Did you try to write in the manner of Black Mountain?

No, I wasn't trying to write in the manner of Black Mountain. At that time I had two lives. My parents had disinherited me and I was living off university grants, and the minute I left university I found myself with no money. I happened to have an illness at that time where I needed very good doctors, so for money I started working in a sex show, on Forty-second Street, and making porn films. And strangely enough that connected me to the early Andy Warhol people, because they were all doing the same thing—we were all working in sex

shows to make money. In fact, I worked with a gay man—we couldn't even kiss—he would giggle if he had to kiss me. We did little plays, and we tried to get the audience to laugh—it was total appropriation. In a way it was a very funny art form.

Of course, the social setting was not so funny! So I didn't want to write poetry, I wanted to write prose. I looked around for a model, and really, the only people were Kerouac and Burroughs at that time, so I just started imitating Burroughs. And because I was in a sex show I had a different attitude towards—and view of—what was going on in New York City and in the world. So I think my content matter was rather different. I was more political, I was more street, because I was living a very rough life in a way, and I couldn't keep the life out of my writing.

The people like Jerry and the Black Mountain people were very friendly to me, and very supportive of my writing. But the writers my age, the St. Mark's group of people—Anne Waldman and Bernadette Mayer and Harris Schiff and Larry Fagin and lots of people like that—were not supportive of my work. Bernadette and I were good friends, but I think they thought that my work was very, very strange. Ted Berrigan was pretty supportive, but the others thought, Oh, she's a sex freak! What's going on here?—because they were sort of happy hippies. They didn't see the street, black side of things at all, so that there was a lot of disagreement there. So that was that time in New York.

And after that?

I ran back to San Diego because I couldn't keep doing the sex industry for money any more, and I met a guy who became my second husband in San Diego—Peter Gordon—so I came back to live with him. He was going to UCSD with Warren Burt in the New Music department.

Didn't he play with Robert Ashley's ensembles?

Yes, we were friendly with Robert Ashley at that time.

Were there overlaps between your ideas and those of Ashley? Did they have any impact on you?

Yes, very much, but later on. The first impact was David and Eleanor Antin.

What was most interesting to you in their work?

I think their relations to conceptualism. That was a time when a lot of artists were doing mail work, and Eleanor had just started her boot series—she sent out postcards with a little story about boots—and she also started her ballerina work. She decided that she'd become a balle-rina. A lot of the women were doing transformational work, where they'd become somebody else. I think those were my first big influences when I started writing my first published work, *The Childlike Life of the Black Tarantula*. I don't think I was influenced by music at all at that point—more by what people were doing in performance art, and by the mail artists.

We spent two years down in San Diego, and then Peter went to Mills College. So we moved up to San Francisco. Up there the musicians and the performance artists overlapped—people like Phil Harmonic are still around here. We all took on different names. It was very campy up here, very androgynous. Peter was studying under Robert Ashley, and I was writing *Great Expectations*. I was thinking of a novel that didn't have a centralized plot or centralized char-acters, but was more like a Robert Ashley piece of music—decentralized environmental.

There was a strong conceptual element in your early writing?

Oh, absolutely—totally! When I did *Tarantula,* I was very interested in finding a model for identity that wasn't based on a single centralized symbol or myth, and I was reading a lot of work on schizophrenia. Since I was working through language, I was trying to figure out what the "I" is in language. So I wrote down regular autobiography: "Today I went to the bathroom, when I ate a sausage."

Next to it, I tried to figure out who I wasn't, and thought, Well, as far as I know anything, I know that I've never murdered anybody. So I went to the library, and I got these biographies of murderesses, simply took the text and changed the text from third person to first person, and put this fake autobiography next to the real autobiography to see what would happen. And, of course, there was no difference between the fake and the real.

It was a different idea of the I—it was the idea that the I is made and is multiple. The idea that when you write fiction you don't express something that's already happened, you actually *make* something. Part of the influence of the conceptual artists on me is that I didn't care if I wrote well. I'd taken a number of how-to-write-poetry courses, and it was all about "here's the correct word" in English, as opposed to the American kind of writing. And I really didn't like that at all. I made up laws for myself, such as, "It doesn't matter how you write, all that matters is the concept." I wanted to try to find out how the I worked in language. Is it a single thing? What's the difference between fact and fiction? I wasn't interested in producing a piece of literature—I wasn't interested if something worked or not—all I was interested in was what would happen to the word *I* if I did this.

Were you publishing at this stage?

Yes. I did this sort of experiment with the word *I* for three years and I did a booklet a month, for six months, every year, and sent these out by myself—it was self-publishing. People were sending things through the mail, so that's how I did it. If a novel was six chapters, I'd have a novel a year. So it was all published.

So things began as a fusion of fiction, conceptual art, and mail art?

Yes. Then, about two years later, two people in New York who I didn't know at the time—Ted Castle and Leandro Katz—said, "We want to republish this as a book." So I said, "Fine!" and came to New York. They sort of introduced my work to the art world, and introduced me to many artists—mainly the artists around Joseph Kosuth. The books that they published— *The Childlike Life of the Black Tarantula* and the last of this series, *The Adult Life of Toulouse Lautrec*—were republished by Sol LeWitt and Printed Matter, who became my publisher for many years.

That's very interesting. From one point of view your work was a kind of conceptual process. But in those early pieces, were you also writing a lot about sex or what might be construed as pornographic matter?

Well, you know, I don't know really if I was or not. If you look at common novels of the time—best-sellers by Sidney Sheldon, Irving Wallace—I wouldn't think that there's any more sex in my novels than in their novels. Obviously the media have picked my work up as sex work, so that sort of remained with me. And I think because that point of view that

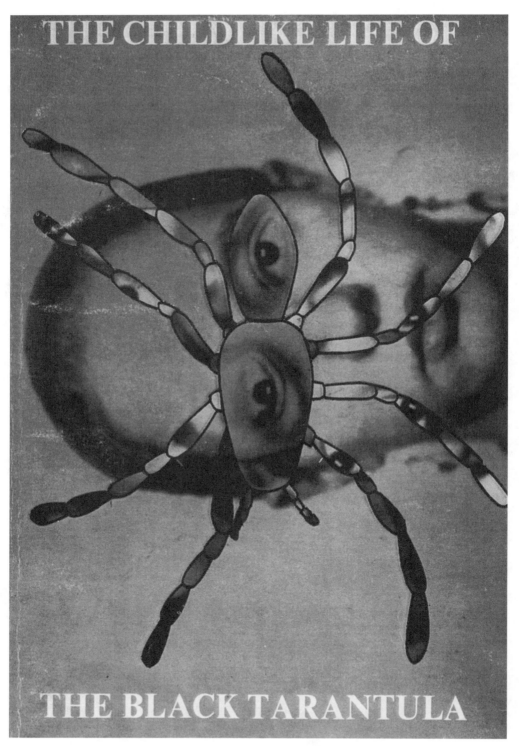

Cover and title page of *The Childlike Life of the Black Tarantula,* by Kathy Acker, published by Viper's Tongue Books, 1975.

came from a politicalization that happened to me while I was working in the sex show, that definitely, my point of view was colored by sexuality—by a sexual viewpoint. So that's always clung to me.

But there are all sorts of things in them. I liked using low genres—one of the things that made me giggle was to use low genres. I didn't use science fiction much in those days, I used mystery stories, and mixed a lot of pornography in with high literature. That seemed lots of fun to do.

But I was not writing pornography. Rather, my politics were sexual because I had realized, from my sex show experiences, that, for a female in this society, politics is always sexual; that is, this society is patriarchal and sexist. In other words, I did not and do not write pornography—rather, I live in a deeply pornographic society. I live in a society in which females are not allowed to decide on their own fun.

What happened after that?

Printed Matter did those two books and then *Research* magazine and I collaborated on producing *Great Expectations*. And then Grove Press and Picador bought up my books, so that was that.

Were you disappointed to move into a more commercial context?

Well, most of all, of course, I was pleased, because it was very frustrating to have people constantly writing you, saying, "We'd love to get your books, but we can't find them anywhere." It's nice to earn a living. But there was a great deal of disappointment too, in that I really knew my audience before, when I was publishing on the small scale. People would write to me all the time.

What sort of people read your books? Did they tend to be writers or artists?

In those days, poets and artists—not novelists, so far as I know.

*Another of your early texts—*Hello, I'm Erica Jong—*reminded me of the partially graphic and partially typographic poetry pamphlets from the '70s. Its cover describes it as a "Prose/Poem." Did you feel more of a poet than a novelist?*

Well, I thought of myself as a novelist, except that I'd come out of the poetry world. I think that's still true—most of my friends now are novelists who've come out of the poetry world. I don't think we write poems per se, but we go to poetry readings and the life is much more that of poets.

Did your style of reading change over time?

I think they've always been the same—although after a while I wanted to work with my friends because everyone else was working with their friends. So the readings became rather theatrical—I'd do a reading, and someone would play music or do something else.

Presumably this prepared the way for your collaborations with Richard Foreman?

Right—we've done an opera and a play together.

How did those go?

Well, the play went well. I think the way it works best with Richard is he just does whatever he likes with my texts. I mean, I think Richard's just smashing! His work's fabulous.

He understands my work very well, and I think he's very good at taking what he wants and knowing how to put it together for his purposes. Because his sort of theater is so particular he needs his kind of rhythms, and he really does a very exquisite vaudeville.

The Birth of the Poet was the opera. I don't know if you'd apply "successful" or "not successful" to it. In one sense it was a huge fat failure. What Richard wanted to do was to work with three different artists. Basically, each artist would work as much as possible independently, but no one person would be telling the other what to do.

However, the whole thing became a bit of a mess. First of all, there was competition about who would have the greatest showing in this opera. In a way I was out of it—once I'd done the script, I had nothing to do, so I wasn't part of the ongoing process. I think Peter Gordon, to whom I was no longer married, decided that it would be an opera rather than a play. I had envisioned it as a funky play, the way Richard would do his Ontological-Hysterical theater—but I think Peter had grander ideas and suddenly decided to put everything to music.

And then we asked David Salle to do sets, and David had huge elaborate sets. So suddenly the thing was on the scale of a monstrous opera that demanded lots and lots of money to put on, and it just got out of hand. Kate Mannheim was supposed to do the main role—and I think she and Richard had split up at the time—so we suddenly needed a new actress, and that was a huge problem, because the piece had been written for Kate.

But the opening night at the Brooklyn Academy of Music was probably a success if you want to talk about it in that way, because the thing provided a scandal—a huge scandal! Part of the audience started . . . *booing* would be a very mild word, and the other half of the audience started saying it was a work of genius and fighting the first half! It almost dissolved into a riot, so I guess that makes it a success. I don't know. It was an experiment and it was interesting to do.

Did this put you off collaborations?

Oh, no, no, no. I loved it. And when Richard did a play in Paris based on my work—*My Life, My Death by Pier Paolo Pasolini*—that was fabulous!

How did you come to work with Richard Foreman?

Peter Gordon called me up and said, "I know someone who wants to see a bit of your work—will you send it to him?" And I said, "Well, what's the mystery? Why? Who?" He was very dodgy and just wouldn't tell me who it was, and said, "Just send it to me and I'll give it to him." So finally Richard called me up and said, "Well, I want you to do this," and I was just overwhelmed.

Did he specify what sort of work he wanted from you?

He told me, "Whatever you want to do!," and I said, "I've never written a play in my life—I don't know how to do this." And he said, "I don't want a play—I hate plays." In fact, he told me the only problem was that what I sent him was too much like a play. And I was really influenced by his work—I tried to do something I thought he would want.

Were you also influenced by other artists' collaborations? Did Robert Wilson's work have an impact on you?

Was I influenced by other collaborations? Well, when I lived in New York I was the ticket taker for the Kitchen for about three years, which means I saw about everything that passed through New York for about three years. Lord knows what I was influenced by—I can't remember just one thing, I saw so much. What I've seen of Robert Wilson was a bit tame. But what I'd heard of Wilson's earliest work—the two early theater pieces that went on for hours and hours—sounded fabulous. I was told that one play or spectacle began by a piece of glass coming down and shattering. And because Wilson had been trained as an architect, he had calculated exactly how the glass would shatter so that nobody in the audience would be hurt. Things like that totally moved my imagination—I like entering strange worlds. Anything that's just like, "wow!"—I like that.

I had also taken a lot of dance classes when I lived in New York in my early twenties, and worked with Meredith Monk and was friends with her. And I think her spectacles influenced me, or moved me a lot. I like dance a lot. I like Trisha Brown, I like Simone Forti's work. Simone did a lot of work with being an animal—how animals move, what dancing thinking is, body thinking as opposed to rational thinking. And I thought about that a lot.

Did you manage to transfer that sort of interior logic to your own writing?

With that sort of thing, yes. Thinking in the body as opposed to rational, logical thought, and the question of what causal or sequential language might be, that would be from another part of the mind rather than from the Aristotelian cause and effect—things like that come out of Simone's work.

I also remember an early Joan Jonas piece where her dancers had huge sheets of glass that were often between them. You'd have this absolutely huge sheet of glass, and you'd have one dancer facing the other on each side, so that they'd be mirror images of each other, and they'd roll around on the floor—it was actually quite dangerous—and that I loved! I liked things that were on the edge of being dangerous—for whatever reason—not just physically dangerous.

Did you ever get bored with these kinds of performances?

No, I was never bored with that. But I think that most of the work—for reasons of money— became much tamer. I think Wilson's work became tamer, though I saw his version of *Hamletmachine* and I thought it was just fabulous! But then it had a Müller text behind it, and Müller is one of my favorite writers. If I could work on that scale—if I had people to work with—I'd love to do it. But I'm not greatly one that goes out and starts projects. I really am a little lazy and do what comes to me.

Do you think the page can generate the same kind of energy as the staged Hamletmachine*?*

It's a different kind of energy from that of a book. A book's a different kind of energy—it's something you live with, something you read a little, go away from, come back to, dream about. But I think books penetrate—maybe because of the time element that you live with— in ways that the theater doesn't.

You know, you need so much money to do theater and film—and there's something about books that always comes out of the proletariat. Anybody can do a book—it doesn't

work the same way that theater or film does. To my mind, books always come out of the underground, finally—where some force says, "I've just got to do this, and there's no money, there's nothing." And that'll always be that way.

In your ICA interview in London you said you consider yourself a mainstream rather than an underground writer. Do you still feel this way?

Well, I'm in a different culture now, and it's hard to see the large picture. England's a tiny place in a way—everybody knows everybody else, and everybody's put in little boxes, and you're told who you are. The media decide, "Here's the flavor of the month," and everybody talks about it. America's not like that at all. The only things that are well known here are McDonald's hamburgers. I don't see one culture in America—I don't know what being "mainstream" is. In my little culture I'm very well known, but I'm certainly not mainstream here—I'm not on TV.

I remember that in an interview you did with Melvyn Bragg for English television your reverent reference to Keats really took me by surprise, given that your image seemed the epitome of punk irreverence. Do you think your punk image confuses the issue a little bit?

Yes, I think my image confuses the issues quite a bit. In England, the publishing world manufactured an image of me and, you know, it was bad and good. I mean, frankly, it made me a living.

I think Grove did the same thing.

Grove tried! They didn't succeed.

Great Expectations, *an* Evergreen Review *ad suggested, was still more outrageous than* Burroughs.

No, the work is different—it has nothing to do with the image, and why it is has nothing to do with punk. First of all I'm a woman, and it's very different for a woman to do what I do than for Burroughs to do what he does, though both of us play with images, if you like, of sexual perversity.

Do you feel close to other women in this field, such as Karen Finley?

I love Karen Finley's work—I think she's fabulous.

What do you like best about her work?

I like the way both she and David Wojnarowicz tread this kind of crossover between politics and the personal, being experimental and also not being elitist about experimentalism, so that you can have both high and low culture. It's very open. It's not minimal at all, it allows everything to come in—it's a little like voodoo—and I like that very much.

That sounds like your sort of project.

Yes. I feel very close to Karen and David. I don't know if all writers feel this way, but I feel very much I exist in a lineage—the *poète maudite* lineage—that I think in one way began

with Rimbaud. It's writers who posit themselves as being *against* the ongoing society and culture.

It's certainly not social realist—it's not the lineage of Zola. The reaction against the culture has to do with language, and the language is formed by this *againstness.* The kind of language that develops has a lot to do with parody—it has a lot to do with invention.

In other words it's more experiential than theoretical? It's not just an academic, deconstructionist project?

I think interesting work emerges when theory is multiplied by political reality. For instance, for me, the most interesting deconstructionists were certainly not straight. You know, Foucault not only was gay, but I was told that he was into dressing up as an old woman. I mean, I think what's called "sexual perversity"—in a lot of quotation marks—has a lot to do with this lineage, and this againstness has something to do with sexual nature. Because when you look at this lineage, you could hardly find—again, we're using these social definitions— what's called "sexual," what's called "straight." It's very much an antitradition.

Have you been influenced by French theory?

Oh, absolutely, I'm very interested in certain theorists. I'm very much a deconstructionist writer. I think that in some of my middle novels—from *Great Expectations* to *Don Quixote*—I was very directly doing deconstruction.

The theorists who have influenced me the most are all theorists who seem to have been dealing with the different parts of their lives in the same way as Karen's and David's work— there's never this refusal to recognize all the different aspects of life. So that theory has to do with the living of life, it has to do with sexuality, it has to do with politics. Some of the Anglo-Saxon versions of postmodernism have nothing to do with politics—but I certainly regard *Anti-Oedipus* and Foucault's work as coming deeply out of sexual concerns and political concerns. And that moves me—I've been influenced by that a lot.

Was Roland Barthes an influence?

Yes, Roland Barthes deeply influenced me, especially his analysis of the bourgeois novel in *Writing Degree Zero.* What happened is that I started reading this sort of theory in about 1976 when I first met Sylvère Lotringer, who does *Semiotext(e)*—Sylvère really introduced me to a lot of this theory. And what it did was to give me a way to understand why I was writing the way I was. Because, you know, I could say, "Robert Ashley does this in music, therefore I'll try to do it in words," or "Some of the Metro Picture painters are painting this way." But I didn't really understand why I didn't have a centralized plot, why my characters kept changing sexual gender. And reading the theory gave me not only a way of understanding why I was impelled to do this but also a way of being a bit more rational about what I was doing, so that I could go further. So it meant a lot to me.

What about Baudrillard?

No, Baudrillard's not someone I'm terribly influenced by. I have trouble with Baudrillard's work. I haven't read his work since *America,* and I must say that I didn't read *America* very well. When he writes that "there's no more value, there's only this black hole," I find this denial almost a celebration of—if you want to call it that—the disappearance of value. I find

this celebration very problematic because the way it's been interiorized in this culture, it becomes a celebration of consumerism and of the kind of culture we've got. And this I dislike greatly.

I mean, I don't think that to say that we want to get rid of the centralized phallus as the main structure around which we all turn, or that we want to get rid of the Oedipal myth as the main structure of this society, is a way of saying that we want no values. I don't think that when Deleuze and Guattari talk about nomadism, they're talking about the destruction of all value. I mean, I've met Félix a few times, and to say that the man has no values is ridiculous. When I met him he was very politically concerned. Both of them have been bothered by the police for their political stances. You know—Baudrillard's work makes me angry for this reason.

Would you say that you're trying to postulate alternative values?

Well, it sounds very pretentious to say yes, but certainly in my life I'm interested in alternative values.

Do you think that art can become top-heavy with social or political concerns?

No. I think we have a very funny idea of art, because art's basically been marginalized to be either a minimal part of our society, or really not part of the society at all, so that we wonder whether it's worth being in art because it's so marginal. My idea of art is that it should run the society. I mean, I think Burroughs is right—that a society without dreams, without art, the actuality of dreams, is a dead society. It's the artists who make the possibilities, and people go on and make the possibilities actual. So artists should be the magicians who work with the politicians!

Do you have much hope of politicians working with your work?

I don't have much hope of politicians in this country working with anything! I don't think there's any answer. I mean, we live in a very destructive postcapitalist society, and we do the best we can. When I have to do business, I do business in the literary world—and the realities of the situation in this country are that the publishing world has gone more and more towards money values. All but Norton are now multinational companies and no longer interested in what I mean by literature.

Do you think that there's a return to underground publishing?

Yes, I think that's what's happening. You know, you should pick up the *High Risk* anthology—it's really important! David's in it—all the people that I'm close to are in it.

What do you think makes High Risk *particularly important?*

I think there's suddenly an interest in writing that's more out of the poetry world, that's more hot, rather than cool. It's not minimal. It's not stuff that PEN is going to like or that's going to win any awards. It's really more dangerous writing. I don't mean it's just about sex, but it disobeys the old rules—it deals with topics that are not to be dealt with. It's not going to earn as much money. It's maybe even going to be offensive to a lot of people—the majority of these writers come very clearly out of the gay world. Well, that's not going to be a big seller!

Isn't it a bit strange to subtitle High Risk *a collection of "forbidden writings"—like those "forbidden classics" advertised in early* Evergreen Reviews*—when few of its contents have been published or forbidden?*

Well, it's not forbidden, but it's because of the sexuality issue. It's because people who are gay, or of different colors, don't get published very easily, if at all.

Do you ever see yourself writing not so much in antagonistic response to something, as writing for writing's sake?

No, I don't do writing for writing's sake. But I'm not as antagonistic now as I used to be, and certainly with the new book that I'm working on—though I'm sure some people would see it as antagonistic. Maybe I'm just getting older, but I feel now that there are a number of people who are working the way I am—they're a community—and that we can work positively. Certainly, until recently, I did work negatively, because everything was against. But now I feel there are a number of people who are exploring various issues like sexuality, and we don't have to fight against all the time—but we can fight *for.*

For instance, I have to do something at Temple University next year, and they said to me, "Oh, will you also be on this panel about pornography?" And I said, "Well, what do you want?" and they said, "Oh, this woman has just written this book, and I gather it's feminist antipornography." And I said, "No, it's really boring. I'm sick of that argument. What am I to do? Sit on the panel and say, 'I like pornography, thank you very much'?"

I said, "Why don't we talk about something positive? I don't care anymore about people who are arguing against pornography. They're boring—I've been through the arguments five million times. Let's talk about something a lot of women in San Francisco who are in different fields are working on very positively—female sexuality, what the female body is, images of female sexuality, what women really desire. Why don't we have a panel about that?" And I really feel there is a community here that's working on that, and it's totally interesting work, because the woman's body on the whole is not known. And this guy I was talking to was amazed—"Oh, we couldn't talk about that!"

Finally, we've cleared enough air that we can do something like this. A lot of women now are working with horror films and images of horror, but not negatively. Maybe women like this—what's involved with the body that has to do with blood? what's women's relation to blood? Of course, a lot of people are going to be very askance. But you know, I see this as being positive. For years women have not been allowed to explore what their self-images are, what could be possible self-images, or what images of desire are. And it's fascinating to me!

Brisbane—July 27, 1995

Do you feel the art world has changed much over the last five years?

Well, the last five years I've really been out of the art world insofar as the art world in America is not located in San Francisco. By the art world, I mean a certain part of a kind of funded world—basically gallery-funded stuff—and I feel most of the interesting work is happening outside that world. On the whole, the exciting work for me isn't coming up from specified funded areas. It's crossing genres.

You've discussed the rock band Tribe 8 as an example of this. What do you like best about them?

They're sort of the spearhead of the scene in San Francisco, which is very different from the feminism that I grew up in. It's a feminism that is not based on victimization or really very concerned with the relations between men and women, but one where women are finding their own power and feeling they have the freedom to act with all the space and breadth and width that they've seen men act with—and there's no longer that kind of fear of men that governed the early feminist movement. It's like you take care of your business, we're taking care of our business.

The strongest change—and the most nonviolent change—I've seen in communities, and I'm not talking about technological change now, is the feminist revolution. Things have just altered totally since I was five or six years old and the world I began to grow up in. I think we're seeing certain reconfigurations of society—and perhaps the end of patriarchy. Humanism is over with. Everyone's fairly aware of that.

What do you mean by "humanism is over"?

I mean the idea that the human is the center of the world and that, being the center of the world, we have models of identity such as psychological ones. I think one reason why a writer like William Burroughs is so important is that his models, his characters, the uses he makes of identity, are not based on psychology. He's more concerned with models of possession than he is with inner turmoil, and that's a very radical position given that we all were baby-fed Freud.

As a global traveler you also seem to be repudiating national identity.

Well, most of my friends certainly are not in San Francisco. I have as many friends in London as I have in New York and Berlin, so when I go to certain places now, I don't feel like I'm going anywhere foreign.

Presumably this kind of process led to your present collaboration with the English punk rock band the Mekons? How did this came about?

Yes—we have mutual friends in London, but I first met them through a friend in San Francisco about two years ago, and about six months ago they said, "Let's do a record together." So I said, "Well, I'm finishing this book. Why don't I write you some songs based on the book?" And they said, "Great." On the record, they're singing the songs and I'm doing the narrative voice-over, so the record will be a bit like a movie track.

Did the AK Press book Pussycat Fever *follow a similar genesis?*

Yes, a friend of mine in London who runs Compendium Bookstore said, "You must meet AK's Ramsay when you go back to San Francisco." As you know, I started by doing little books and sending them out myself, and I was thinking, Gee, I'd like to do that again. It's such a long process to do a book, and I'd love to get a bit of it out before the real book comes and we have all the fighting over the artwork and the typesetting.

So I said to Ramsay, "I'll give you something. The deal is, you don't pay me but I get to do exactly what I want with the artwork." I was also hanging around with the filmmaker

Jennie Livingston, who did *Paris Is Burning,* and she introduced me to Diane DiMassa, who's the comic strip artist for *Hothead Paisan,* which in the States is very big. I wanted to use Diane, and she agreed and then Ramsay invited Freddie Baer, who's probably the premier designer-artist for the science fiction world. So it became a collaboration between Freddy, Diane, and me.

This sounds pretty positive. Why, then, do you diagnose the "death of art" in America?

Well, by the death of art I mean the death of the art world as a funding body. The problem isn't doing art—doing art is not going to die—there's a great desire to do art. The problem is how people can support themselves while they're doing art. How they can pay for their food, their board, the materials that are needed, and how they can distribute their work.

So it's fortunate live performance allows writers to earn something?

Well, people have to support themselves. When you're young, you can start by doing stuff for free and you can happily live on twenty dollars a week or whatever people do, but by the time people hit thirty—and some people want babies and medical problems increase—people have to support themselves. And it's very hard in the United States to support yourself doing any writing except for commercial writing. So you have to have family money behind you or you have to have a lover who'll support it or you have to be incredibly lucky. I was very lucky.

Charles Amirkhanian (standing, far left), Rome, July 1990. Others shown include (standing, left to right) Armand Schwerner, Benn Posset, Antonio Servente, Jackson Mac Low, Allen Ginsberg; (sitting, far left) Simon Vinkenoog; (sitting, second from right) Jean-Jacques Lebel. Photograph by Françoise Janicot.

CHARLES
AMIRKHANIAN

I MADE CONTACT WITH THE CALIFORNIA TEXT-SOUND COMPOSER CHARLES AMIRKHANIAN in the late 1960s, when he subscribed to my experimental poetry magazine, *Stereo Headphones*. He sent me details of his work, and I published two of his poems in issue five, in 1972. Sometime later, after I'd started working in Australia, he organized a lecture for me in Chicago during my first trip to America in 1981, followed by a party where someone played an advance copy of Laurie Anderson's "O Superman." Art rock had been born!

A percussionist by training, and director of KPFA Radio's highly influential *Ode to Gravity* program, Amirkhanian also edited a number of 1750 Arch Records' pioneering LP anthologies, such as *10 + 2: 12 American Text-Sound Pieces* (1975), which gathered the work of poets like John Giorno and Brion Gysin, composers like John Cage and Robert Ashley, and younger multimedia text-sound composers such as Amirkhanian himself.

This was followed by *New Music for Electronic and Recorded Media* (1977), an equally pioneering LP anthology of avant-garde women composers, featuring Johanna M. Beyer, Annea Lockwood, Pauline Oliveros, Laurie Spiegel, Megan Roberts, Ruth Anderson, and Laurie Anderson. As his cover notes observe, these "more listenable" compositions typify the post-1960s avant-garde's increasing explorations of a "more personalized art."

Writing in a letter of 1971, Amirkhanian explains how his own early texts were essentially studio-composed works, "first read by me in a control room and then altered in various ways," before final poststudio notation and subsequent partially taped, partially live performance. Of these, his 1970s classic is surely *Dutiful Ducks* (as he explains, a partially autobiographical fantasy), a work recorded in wonderful live version on Larry Wendt's cassette anthology *Variety Theater* (1977) and in a crisper studio rendition on Amirkhanian's first LP, *Lexical Music* (1979).

I finally interviewed Amirkhanian—and his collaborator and partner, the visual artist Carol Law—in 1983 in Minneapolis, where he was performing at Walker Art Center as part of a multimedia program also featuring William Burroughs. I'd wanted to ask him more about

the evolution of his work and was fascinated to hear about the formative impact of Viennese composer Ernst Toch and the subsequent phases of his collaborations with Carol Law.

Revising and updating this interview seven years later, Amirkhanian and Law suggest how the whimsically autobiographical register of the 1970s avant-garde developed a more general satirical agenda in the 1980s and 1990s, as it turned its attention to "political doublespeak."

Charles Amirkhanian and Carol Law
Minneapolis—October 9, 1983, and El Cerrito–Brisbane—August 7, 1990

How did you first begin to work with text-sound composition?

CA: I think it came to me through my work as a percussionist. I had been interested in extending the palette of composition for ensemble pieces by means of using "nonmusical" objects, very much in the manner of John Cage and Lou Harrison, who collected automobile parts from junkyards in the late 1930s.

In the process, I came across the idea of using nonpitched vocal sounds or speech—because percussionists use many so-called non-pitch-specific instruments such as the bass drum. I had also been particularly attracted to Ernst Toch's *Geographical Fugue* and Virgil Thomson's *Capital, Capitals,* a setting for four male voices and piano of a text by Gertrude Stein. And I think that at church during my childhood we probably did an occasional speech choir presentation.

At any rate, I began composing in 1961—exclusively for percussion ensembles because I didn't have any formal composition lessons in harmony, or counterpoint, other than the vaguest theory instruction as a private piano student—and my first piece incorporating speech was made in 1965 when I was twenty.

The work is called *Genesis 28 Four Speakers.* In it, four male voices speak and intone a text roughly based on the biblical story of Jacob's ladder, punctuating their entrances and selected words by striking a metal plate with a xylophone mallet. The plates were round irrigation lid covers taken from my grandfather's ranch. They were about nine inches in circumference with a three-inch-long bolt attached in the center by which the performer could hold the instrument, and their sound was a kind of Chinese cymbal timbre.

After this I produced a number of other such pieces with various combinations of ensembles. The musical materials consisted largely of patterns formed by phrase and sentence structures, sometimes used in arranged sequences and simple canons. It wasn't until I heard Steve Reich's *Come Out* from a commercial LP that I began to use the repetitive phrase structure of the first-generation minimalists.

In July 1969 I began to work at KPFA Radio and had access to professional reel-to-reel tape equipment for the first time, which gave me the chance to do far more sophisticated tape pieces than my previous efforts with home equipment.

My first tape loop piece was a longish compilation of various Clark Coolidge–influenced poems collaged together over the course of a fifty-seven-minute tape piece— *Words*—made in 1969. Then I did a quadraphonic tape piece in Esperanto with the voice of composer Lou Harrison speaking the text I wrote in that language: *Oratora Konkurso Rezulto: Autoro de la Jaro* (1970).

If in Is, a piece manipulating just three words—*Inini, bullpup,* and *banjo*—was composed and played at the Fylkingen Festival in Stockholm, in 1971. The idea of the piece was to speak rapidly and without apparently taking any breaths. What you hear is a series of improvisations, with pauses after each line equal to one word:

Inini
Inini Inini
Inini Inini Inini
Inini
Inini Inini
Inini Inini Inini
Banjo Inini
Banjo Inini
Banjo Inini Banjo Inini Banjo
Banjo Banjo

These are recorded in overlapping and later multilayered levels, which are dervishlike in their apparent exhaustion of the performer.

Did this lead to further contributions to the Fylkingen Festivals?

Yes. In 1972 I was invited to the Fifth Annual Fylkingen Text-Sound Festival and ended up making five short pieces including *Just,* a quadraphonic work—which has become one of my better-known pieces—based on the four words *rainbow, chug, bandit,* and *bomb.* And it works well, because I had the services of a very professional staff in recording the original voice tape and mixing it. I had the time necessary to iron out most of the imperfections apparent in previous pieces made by myself at KPFA. And I had the experience of making several pieces in this style. Finally, I had my own idea of creating a more "restless" minimalism—jumping from one loop to another more quickly than was being done by the first-generation people at that time.

It was then that I learned how important it was to have a professional engineer in charge of the technical details of making the piece while I kept a close eye on creating the work without having to be distracted. This is a procedure I've followed almost exclusively ever since.

Around 1974, there came a point at which I found myself playing tapes in darkened halls and needed to find a way to bring in a visual and theatrical element. I began working with Carol Law, after we had been rather assiduously avoiding collaborating for the previous six years of marriage. As it turned out, the results were very pleasing to both of us. Carol's use of scale and bizarre juxtapositions—taking advertising photos of women and making grotesque comments on them visually—was very much akin to my miking a voice, or ambient sound close-up, and juxtaposing what might be in real life a very quiet sound at the same volume with a sound which might be very loud in reality.

Were these your first multimedia collaborations?

No. I had always been very interested in the visual arts and around 1966 had begun to work in Fresno with a painter named Ted Greer on Happening-like musical performance work. We used visual scores consisting of two series of drawings done in parallel above one another. I "played" his drawing and he "played" mine, interpreting both abstract and

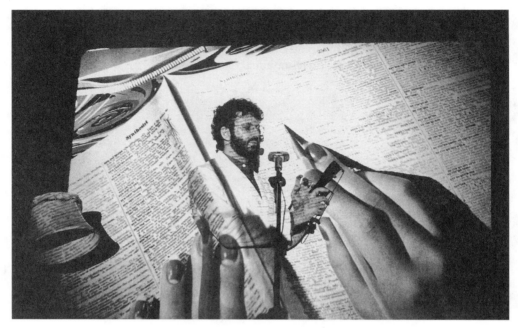

Charles Amirkhanian, "Hypothetical Moments." Courtesy of the artist.

representational drawings in a subjective fashion. The instruments we used ranged from a license plate marimba to Indonesian bamboo *angklung* rattles, to household objects and a bathtub filled with red Jell-O. All this time I was taking lessons in photography and print-making and coorganizing a number of Happenings influenced by reading Allan Kaprow and Dick Higgins's Something Else Press publications.

When I moved to San Francisco in 1967 I did a performance of one of my collaborative pieces with Ted Greer and other pieces incorporating live electronics and multiple 8mm film projections, and this attracted the attention of Ann Halprin of the Dancers Workshop Company. I then became the main composer-collaborator in her piece *A Ceremony of Us,* which was a marvelous and prophetic multicultural dance collaboration between young Marin County dancers—all white—and young dancers from Watts in southern California—all African American. After this I was hired at KPFA at the age of twenty-four and had no time for the endless rehearsals and logistical planning for Happening-like events, and I turned to tape music as a means of expression.

Then in 1971 or so, I met the Swedish text-sound composer Lars-Gunnar Bodin and began investigating all the European sound poets. In 1972 Carol and I spent three months in Europe after the Fylkingen Festival, and I interviewed for KPFA nearly all the living sound poets imaginable and really got caught up on the field. I have to admit that I was often disappointed in the quality of recorded work from a sonic and musical standpoint, but the spirit of linguistic experiment was of enormous interest to me.

I've always found Dutiful Ducks *one of your strongest works. How was that made?*

Well, part of it refers to a conference on noncommercial broadcasting that I'd been to at Airlie House in Virginia—a place where the CIA has think tanks and corporation heads

discuss their business strategies. A lot of the speeches were quite boring, and so I took a walk around the grounds of this place, and there were ducks leaving their droppings everywhere and this image somehow became *Dutiful Ducks.* At the same time, my mother had been in an automobile accident and had been in a coma for several days. When she was coming out of the coma I brought her colored pens from the gift shop, and she would try to write her name, Eleanor. She would write "ELEA," and then the writing would trail off in a series of loops, as her mind just wandered. At one point she writing with two at once, and thought it quite normal, and that's the image of "double Elly" in the piece. It's a very disjointed narrative—a lot of words are used more for their sound. On the other hand, some residue of meaning gives life to the experience of hearing the piece.

Dutiful Ducks *builds up to quite an impressive crescendo at the end.*

It employs a musical device of accumulation. There's more clapping, more intense rhythmic activity, without rest—it's intentionally made that way. I remember practicing a long time to figure out how many "dutiful, du-dutiful, du-du-dutiful, du-du-du-dutifuls" I could do and not get lost. And five seemed to be the right number, and yet still gave you the sense of, "My God, that sounds impossible!"

Your work seems very disciplined, but there's also a surprising sense of almost involuntary comedy in Dutiful Ducks *that seems less self-conscious perhaps than the distorted voices Laurie Anderson uses.*

CA: But the way she modulates the voice is sometimes very effective, because she doesn't overplay it—she knows just when to turn it on and off. So for me, it works all right.

CL: Do you know that piece by Laurie Anderson called *From the Air,* in which she lowers her voice, talks about being in the plane, and speaks as if she's the pilot? The most important part of that was the visual impact of seeing her onstage, and knowing that she couldn't have such a low voice. Just listening to the tape, I don't think the impact is as great. Seeing her actually standing there with the microphone, and hearing the voice coming out, you become incredulous. You see this slight woman standing there and you hear this low *wrrr.* That's the way it's made—to be seen. Hearing the recording is not the same as a visual experience of this work.

CA: That ability to change the pitch without changing the speed was only possible previously by taking a tape and running it through another machine that has a revolving tape head which would sample parts of the sound and yet you'd be playing the tape at a different speed. But now with digital equipment, you can do it in real time, so that I can be talking to you at this speed and my voice can be as high as a woman's or as low as somebody with a much deeper voice.

 I took, for instance, *Church Car,* which is only possible to do up to a certain speed, and played it back much faster on a tape recorder by changing the electrical voltage going into the machine. I controlled the voltage to alter the way the machine ran, so that if you give it more juice it can run faster. So the tape machine runs slightly faster, let's say twenty percent faster than it should be, but at the same time, I'm running the sound through an Eventide Harmonizer, which drops the pitch. You know, when you speed up a tape, the voice goes up naturally. But this drops the voice back down to the normal level.

So you manage to speak quicker but at the natural voice pitch?

CA: Incredibly quick. "Church-car-box-car"—I can't do it! But you see how fast it can go. And then I made another recording of *Church Car* where I picked up this speed, and sped it up again, forty percent faster. And the effect is almost unintelligible. I can imagine going even faster and it would just be like drumbeats. And did you know that Ernst Toch—when he wrote *Geographical Fugue* in 1930—specified that the piece should be almost inhumanly fast. He wrote for four voices in counterpoint, and all of the verbal material consists of geo-graphical place-names. *Trinidad and the Big Mississippi*. It's a fantastic piece—it was this piece that got me going, in a way.

Could Church Car *be done completely live?*

CA: It could be, but not in the sped-up version—not yet. That's the problem. You can change the pitch in real time, but you can't speed up and slow down in real time. That would be impossible at this point.

Have you done more explicit narratives or stories?

CA: I have done a number of pieces that are more like straight poetry that are read along with ambient sound recording and background sound, where I would tape the background sounds and just do a reading with the microphone. With *Mahogany Ballpark* we went out and built the whole narrative.

With tapes and slides?

CL: Yes—Charles is not onstage, but in the projected slides as a narrative character. So it's a kind of dual portrait. Visually, we created an outdoor set where Charles is dressed up in a baseball suit, painting a very minimal, geometric grid on a canvas stretched between two trees. This relates to art moving from realism into very minimal, abstract expression and the confusion of game and process, and continues to a collage image created from an old photograph of baseball players from the '40s, trying to deal with a baseball that's become a massive wad of paper. At the same time, Charles sort of seesaws back and forward between ambient sound and verbal material in a circular pattern.

CA: I recorded just the words first, in the zoo in and under the subway station in San Francisco. There was also a recording in Paris with the widow of the composer George Antheil and knocking at the door of Man Ray's apartment, and attempting to get in as the concierge says he's not there. In other words, the reading takes place in several locales simultaneously. What I did was take all these mono recordings and place them in space in a stereo spectrum, after multitracking them on an eight-track machine at the 1750 Arch studio. So that there were sometimes as many as three or four or five tracks going at once in the final mix when I could select the left-to-right placement of each track. The emphases of the words were in some way the score for the way Carol handled the visuals.

CL: *Spoilt Music*—our largest piece—is similar. It's a narrative of a man in his living room facing the fires of his experience.

CA: It's a forty-minute-long performance with lines from a turgid romantic novel from the 1920s by Ruby M. Ayres—*Spoilt Music*. Carol created a 16mm black-and-white film of a

fireplace, and all you see is the image of the fire and the fireplace as I'm trying to write a love letter and throw it at the screen so that it looks like it's being consumed in the fire.

CL: It's very difficult to put on. It's a full evening, with lots of props. It's hard to travel with, and we haven't done it that much.

Have you produced any other such narrative pieces?

CA: Yes, in 1986, we produced *Veto,* a piece with texts for a politician and another for a newscaster—both played by myself—commissioned by the Newport Harbor Art Museum in Orange County, the heart of conservative Republican political thought. We were fascinated by the way Reagan and his crowd had reinvented the political doublespeak predicted by Orwell's *1984.* Performing with a political lectern to the left and a television newscaster's desk in the center, I speak and read with a backdrop of projections by Carol on two large screens.

The politician performs in a stentorian manner at the lectern, reading the piece *Dumbek Bookache,* which is very much like *Dutiful Ducks* and *Church Car*—with a live voice and a prerecorded one. Then I slip into an obnoxious olive green sports coat to become a news telecaster and read various texts taken from a book on political charisma and how it operates. Juxtaposed in alternation to me are recorded statements by Saul Landau—a left political commentator—and by Reagan, defending his policy of funding the "freedom fighters" in Nicaragua. All this was produced shortly before the Iran-contra scandal broke into the establishment media. KPFA, being a left-oriented station in general, had been revealing some of the violations when we premiered the work on November 8, 1986, and when we did the second performance the following spring in Miami, much of the message of *Veto* seemed prophetic in specific relation to the Nicaragua situation.

CL: All the while, there are large slide projections and live video camera shots viewed on a television monitor by the audience. I photographed some San Francisco skyscrapers from the bottom up to convey an image of overwhelming corporate power, along with a section in which I made double-image slides of pictures of the presidents' wives superimposed with dried decaying funeral wreaths shot at a compost heap in a cemetery. For me this symbolizes the casualties of the patriarchal power system in the U.S.

Laurie Anderson, 1990. Photograph by Ebet Roberts.

LAURIE
ANDERSON

LISTENING TO EARLY LP ANTHOLOGIES OF AVANT-GARDE PERFORMANCE—such as One Ten Records' *Airwaves: Two Record Anthology of Artists' Aural Work and Music* (1977) and 1750 Arch Records' *New Music for Electronic and Recorded Media* (1977)—it seemed obvious that Laurie Anderson's multimedia performances offered remarkable syntheses of the experimental and the popular, the simulacral and the profound.

And later, watching Anderson from both stage-side and back-row seats in the Sydney Opera House in 1986, I was intrigued by her ability to project her persona across this vast auditorium, juggling with enough gadgets to keep two or three lesser mortals busy, while usually conveying "something that's very intimate."

I'd arranged to interview Anderson in New York in December 1990, but on arriving at her door heard her explain that she had to rush off that day to Europe, and so . . . she hoped I'd understand. My mind whirled—I mentioned I was spending Christmas in England myself—and we finally met up at her London hotel, in January 1991.

Asked to what extent she felt her work with new media was "avant-garde," Anderson disarmingly replied that she didn't really consider herself avant-garde and that she doubted whether there really could now be a New York avant-garde in a city where "downtown art images are comped-up into ads" in a mere weekend, and where the life span of an artist could be "eighteen months."

Nevertheless, acknowledging "a few exceptions," and arguing that "until we're all dead, creativity isn't dead" (a point Rachel Rosenthal also makes, when observing, "Art is the only thing that will remain as long as there's one person alive"), Anderson memorably warns, "For anyone to say that creativity is dead just says that this particular person is creatively dead."

Anderson's concluding remarks equally movingly discredit the myth that postmodern multimedia culture courts incomprehension: "I always just wanted to make things that other people could understand. That's my only reason to be here. My only reason."

London—January 30, 1991

Would you describe yourself as a multimedia artist?

I don't think of that first. I mean, I've used a lot of tools, and I think it's kind of strange to describe yourself by tools, although I suppose painters do—they use a paintbrush. But that hardly says anything about them. Although it might say more than "multimedia" says about someone, because who doesn't work with multimedia? Often it gets a little bit blurry, especially in watching the Gulf War develop. A lot of artists talk about multimedia the way generals talk about F-16 bombers—you know, how efficient they are—it could be the same description as an artist describing tools. So I describe myself as a storyteller. That seems to work well enough.

Don't other storytellers tell stories in a more conventional way?

Yes, but it doesn't matter to me. People have told stories in a million kinds of ways. First it was sitting around a fire, with no tape recorders. But fire's magic, and so is technology. You just hover around something that has to do with light or circuitry, and that brings out stories, I think.

Does new circuitry inspire new kinds of storytelling?

It helps. It's an atmosphere. But it's not ever the point of the story. And I've been realizing that more and more, the last few things that I've done have really just been talking. I've been using maybe one slide, and some electronics, but not very much. Maybe it's a reaction to doing a lot of very big projects that involved two huge truckloads of stuff. And I thought, Well, this is an awful lot of equipment, just to tell these stories—why don't I just tell the stories instead? So, I started to do that.

This seems like a return to the register of your early performances at places like the Ear Inn, before relatively intimate audiences.

Well, it's just for a change. I'm not good at predicting what I'll do next year. I'm not saying that one thing's better than the other. It's just what I happen to be doing at the moment as a reaction to another thing. Which is often the way a lot of artists work. They work on a big monument, and then they decide, How about a nice little pencil sketch? And they can both be extremely beautiful.

Can you remember your first performance as a storyteller?

I can remember my first performance as a liar.

As a child?

Yes, sure. I'd just make up things for other kids. And these sort of had to do with the Bible. I'm from the Bible Belt, where everyone believed in the most amazing miracles. There were people who were just mowing their lawns and doing the most mundane things that you can imagine, and they believed that the oceans parted, and that snakes suddenly appeared on the earth. And they would talk about this quite matter-of-factly.

Was that a sort of local surrealism?

No, no, that was local truth. Surrealism is an art term. We were not artists.

How did you move from Bible Belt storytelling? When did you go through the art barrier?

I haven't. I try to tell the truth as I see it. I'm just telling the same mixture of midwestern Bible stories that I always have. They're a mixture of the most mundane things with a fabulous twist on them. It's only what I learned in Bible school. How Bible school related to public school is what I'm interested in. Always have been.

Didn't New York offer other opportunities for presenting things?

Yes, but they were still the same stories. In an art context they may have seemed a little odd. But some of the first performances I did were really about things that had happened to me as a child, and what I thought about them. And I kind of branched out and included politics. And in including politics you have to include media, because media is politics, and vice versa. Just invert the "M" of "Music Television" and you get "War Television." It's still entertainment of the same order, complete with logos, soundtracks. "*War* in the Gulf—War *in* the Gulf—*da da da da da, da da da da da*"—and it immediately turns into a song.

The Gulf War has become a media war. People watch television and have the illusion that they're watching history. And for a day or so that was actually true. When the war first started, I was in Zurich, and I was transfixed by the way this story was being told. Firsthand, first person—you knew it was the beginning of the story, but you had no idea what the end would be. It was riveting. I watched them put their microphones out of the window and go, "What do you hear? What's that sound?" And it was the first bomb that fell on Baghdad. You turn the dial, and for the first time in history you see someone putting on a mask because they think there's going to be a nerve gas attack.

After two days there was a blackout on that kind of reporting. Absolutely nothing after that. And you saw these huge objects moving into place—you saw the ways things functioned. You saw who wanted you to see what, who wanted you to hear what about this story, watching that network organizing itself. In other words—particularly in the United States—you can see quite easily how a story becomes propaganda, and becomes what people want to hear. On the other hand, I'm interested in what people want to hear, because so many people base their lives on what they want to hear, or on some future where everything will be perfect.

So telling stories is for me a futuristic experience. Not in the sense of Marinetti, who said war is the highest form of modern art. And his colleague in amateur art, Mussolini, happened to agree, as did the would-be painter Hitler, as do the would-be media stars George Bush and Hussein. You'd be hard pressed to say on a basic level how these groups differ from artists in what they want. They want their name in lights, they want to be in history.

I mean, I know that art is a supremely egotistical act, at one level. But another—the one I hope to get to—is one where my own sense of "I," which is telling the story, becomes very unimportant. And the listener can identify enough with this to recognize that I'm not just talking about myself. Even if I don't use "you," it becomes an experience in which the listener kind of goes, "Did that happen to me or did that happen to you? Who did that happen to? It happened to someone—I can relate to it."

What I'm really trying to do is find ordinary situations which people can understand in an immediate way. I have an ax, and there are huge frozen oceans inside everybody, and I just chip away at this, and look at it slightly differently from another angle. But it's not surrealistic. It's an incredibly ordinary old chunk of ice. And I know it works when people say, "I know what you're talking about."

All the same, you're orchestrating many contemporary technologies that other people don't bother to use.

I consider that unimportant. I use technology as just a way of amplifying or changing things. I use technology to change my voice. Storytellers have always assumed other voices. It's just a slightly different way of doing it. No better and no worse—it's really just a tool. And a lot of people focus on it as if it were something important. It's the least important thing about what I do, by far.

Why do you think people focus upon technology?

Maybe it resonates a little bit with their life, because so many parts of our lives come through speakers and circuitry, and we deal with that all the time. And so is this something everyday, like I hear in the subway? Or is this art? I thought art was supposed to be mute, and was supposed to be hanging somewhere in a museum—I thought art was supposed to have an aura. I think art has an aura, too—an aura that means that things resonate in the mind and the heart of the person who's receiving them. Real contact is very mysterious.

Do you think that your high-tech performances work as well as some of the earlier ones? I found your early pieces—like Time to Go—*very moving. Later, when I saw you in 1986, from the back of the Sydney Opera House, it seemed quite a job to project yourself to an enormous audience. I wondered if this involved any loss of immediacy and intimacy. Was this something you thought about very much?*

Well, I do. And that was the nature of that piece—it was not very intimate. The latest thing I did was extremely intimate, and at the same time had this huge amount of high-tech stuff. It was a solo thing. Seventeen people came along on tour for this so-called solo thing.

But I felt myself that it was by far the most intimate thing I've ever done. So it's not a question of size at all. It's a question of how you address people and what you say. Two people can sit at a table, and one can lecture the other in the most formal, remote kind of way you can imagine. And on the other hand, before an audience of ten thousand one can say something very intimate, in a way that's very intimate, and it will be received that way. There's a whole lot of things that are just not that simple.

You've remarked how the direct reporting of war becomes a certain sort of fiction. Does it worry you that use of the mass media might modify your work in that way?

Of course it modifies it. It does a lot of things to it. That's why I try to use several different ways of speaking. It's ventriloquism, what I'm doing. And so I can switch from something that is more authoritative to something that's very personal, to something that's conversational, to something that's anecdotal. And I'm very, very conscious of those voices and how I try to use them.

Do you find that certain voices become autonomous, so that their impact wanes a little bit?

It depends on a lot of things. I think you can use a confessional form of address for three hours, depending on what you're saying.

What kind of things do you find yourself wanting to say?

The last thing that I did, called *Empty Places,* was very, very political. It became almost poster-like in parts, because what I wanted to say, at times, didn't mean sixteen different things—it only meant one thing. This for me was the riskiest kind of talking, because I was vulnerable.

In what ways was it political?

Well, there's a long section about the relationship of songs to political tirades. That starts out with Hitler as a drummer—with the persuasive way that he spoke to get people excited by his drumming and marching to his drumming. Mussolini as an opera singer was another example. He sang to people, operatically. And then an American example was Reagan, who was basically a crooner singing pretty corny "When You Wish upon a Star" kinds of Disney numbers. This is the kind of singing that pushes American buttons. So you find, stylistically, there are many, many ways of saying words. I'm interested in the way they relate to music.

Another sense in which this was political—at least for me—was that it became a lot about women as well. I'd been taking singing lessons, and I suddenly realized I was a so-prano, and that I had some different things to say with the soprano singing voice, than I had with a more neutral "art voice." So I used that voice to say things I probably would have said in my own voice. But the voice that we have—what is it? For me, it's a kind of mixture of my father's and my mother's voices. My father's voice—he learned English from Jimmy Cagney and Bob Hope and—way back—Abe Lincoln. And my mother's more of an academic voice, a Church of England voice. And I've mixed those up and found my own voice.

Of course, that's not to say I've *one.* Everyone has at least twenty—at the bottom line, at least twenty. They have their hail-a-cab voice, they have their interview voice, they have their confessional voice, their telephone voice, and their most intimate voice talking to their dearest loved ones, to name just a few.

What about our other faculties?

Well, our other faculties seem severely limited. The ears don't perk. They hang there. The eyes can't zoom, pan, or dolly very well. For example, you walk into a restaurant and you see a very jerky pan as you look for a place to sit and things go in and out of focus. If you looked at the rushes at the end of this day, you'd fire the cameraman. It's terrible stuff. The point is, you think back on it, and it looks pretty good. You see a bird's-eye view of the restaurant. You see a two-shot of you and the person sitting next to you. It's pretty well lit, it's fairly well cut. Your mind has fixed it up for you. What we see is actually very chaotic. This is the important point about memory and projections—our memories make things smooth, very smooth.

Would you say that all artistic memories become coherent?

I don't think art is necessarily coherent. Some writers and some painters try to duplicate this chaotic experience that we have with our vision, and some avant-garde films become

December PERFORMANCES

15 at 12pm: Ron Littke
16 at 12pm: Beethoven's Re-Birthday w/Phil Harmonic
17 at 3pm: Laurie Anderson, $2
31 at 3pm: Ned Sublette/Warren Burt

the Ear Inn

326 Spring St.
New York City 10013

serving lunch Mon.-Fri.
dinner Tues.-Sun.

"We are here..."

for information, reservations: 226·9060

January

5,6 at 12pm: Saheb Sarbib
7 at 3pm: Peter Van Riper
12 at 12pm: The Claremonts
13 at 12pm: Performance Workshop Cabaret
14 at 3pm: Keven Hayes and New Life Resolution
19 at ? : Lydia Davis & Billy Stephen
20 at 12pm: Cabaret
21 at 3pm: Leonard Horowitz—Soundworks
27 at 12pm: Cabaret
28 at 3pm: Jon Gibson

Advertisement for *Ear Inn* performances, December 1978.

almost unviewable—we see this stuff all day, so why see it at the movies? But art fixes it up, too. And when art fixes it up, it goes even another step past memory. It idealizes it. It gives it a certain meaning and a purpose.

How useful do you find the term avant-garde? *Do you see yourself as an avant-garde artist?*

I'd be pretty hard-pressed to find the avant-garde now. The existence of the avant-garde depends upon its ability to hide. In many places it's quite hard to hide—and the reason, in my view, is speed. The media is voracious for something—it's running out of topics—and has to go to downtown New York to find something new-new-new. If it's not new-new-new, it's nothing.

And so, for example, the lag time between up- and downtown New York is two days now. Your young painter, let's say, may have delusions about the life of an artist. Green plants, big lofts, parties, a little work, a little suffering, followed by your picture in a Gap ad, followed by media stardom. But, times are hard, so you can't afford this loft. To get a job in an ad agency, every Saturday, you go to the galleries to see what's way cool. On Monday morning these downtown art images are comped-up into ads, for shoes, for cars, whatever. Two days' lag time.

It's hard for an artist who's so-called avant-garde to develop and nurture art. Because the avant-garde is eighteen, and he's selling his new hot stuff for five hundred thousand dollars a painting, because he's a media star. And his career is eighteen months long, because our attention span is twelve minutes long. So by the time the media finally picks up on it, he's dead of a drug overdose. Jean-Michel Basquiat. The lifetime of an artist is getting more like a lifetime of a pop star—a year, eighteen months.

What about somebody like John Cage, who seems to go on forever, experimenting with new possibilities, which might not immediately prove user-friendly or commercially adaptable?

Well, Cage is one of the few artists who actually appeals to the senses, and not to the idea of what should be important this year, and what idea you're going to process and then discard, like any other commodity. He's not at all an intellectual artist—he's somebody who uses his ears, and that's such a shock to people when they're reminded of it, they can't believe it. Change is built into his work. He says, "Listen to the way things constantly change." So he's a definite exception to what I'm talking about. And fortunately, there are a few exceptions. But a general rule is that the art world, like any other consumer subculture, is interested in consuming and buying. I mean, salesmanship is not exclusively an American skill, although Americans are extremely good at it.

Do you feel very pressurized by this?

My father was a salesman—I know a lot about salesmanship. And of course, much of art is so specialized that you carve out your little territory and defend it. And when the army moves on, you're left defending your little patch of corn, and nobody cares, except that you fit into somebody's preconceived ideas of what history and the avant-garde are.

Or maybe nobody fits in? According to critics like Fredric Jameson, significant avant-garde art can no longer emerge in the "postmodern" era, insofar as the media have allegedly neutralized

creativity. According to this hypothesis, contemporary creativity can't possibly compete with that of the early twentieth century.

Well, you can imagine why he'd say some of those things because of the appropriation aspect of art of the last ten years. Sherrie Levine copies things. Rap artists appropriate phrases from music. But I think he's missing the point in a big way, because it's a very object-oriented way of thinking of things—you know, that they ought to present a new product, rather than a new way of seeing the product or seeing the thing. And Sherrie Levine, for example, asks some very interesting questions about that, and makes people think about it in a certain way. And it's an act of bravery and grace, to do that. And a very astute comment on the consumer aspect of art.

For anyone to say that creativity is dead just says that this particular person is creatively dead. Until we're all dead, creativity isn't dead. It changes, and I think a lot of people can't identify what it means, because they're looking for it in the wrong place.

Yes. Shakespeare appropriated left, right, and center, and nobody complains. All the same, I've always been a little confused by the appropriation of William Burroughs's phrase "language is a virus" in your film Home of the Brave. *I felt this phrase had sort of walked out of Burroughs's domain—and even beyond your domain—into a general anthem, rather than offering your particular version of it. How did you feel about this?*

I was glad that "virus" didn't *rhyme* with anything, at least! I appreciate slogans like that because they can be repeated—they're not clichés, and each time you hear it, it sings itself a little bit differently. And sloganeering is something that not just one person does—it's contagious, like a virus. But the real reason I presented it like this was because I liked it as song, and I liked the harmony. And many things that I try to do on a very basic level of—I like the way they look, or I like the way they sound, I don't know what they mean. And I have to wait to see what they mean. I have to trust that they mean something, because I like them. That's why I'm not a pamphleteer—I'm an artist. I like color and sound. It makes me respond to something in a particular way.

If I was just interested in what things meant, if I was just some kind of French philosopher, I would really just write it down and Xerox it and hand it out. I would not bother to go to all this trouble of turning these words into colors, and colors back into words and notes, and finding the right tone of voice to say things in. You can say the same sentence in a hundred different tones of voice and it will mean a hundred different things. So I don't trust words enough to just read something on a piece of paper and expect to know what it means. If I can see and hear the person saying it, or if they have a really large context to put it in, then maybe I can guess at what they mean. But generally it's a cipher to me. It could mean anything.

Is that where the slides and the other things come in—as a way of establishing a more immediate set of contexts?

Yes, as a sensual field for these things, and as a way to become less judgmental and to make associations that you wouldn't necessarily make—like we're trying to make over this table. And to appreciate the craziness of life—that a lot of it doesn't make a lot of sense, and that you're always being pushed by the way things feel, and not just what they mean.

Do you find it frustrating to select a final version of a piece on record or video?

It depends on the piece. Some things go onto records very well, and some things just keep jumping off them and don't want to stick. When I try to force them to stick, sometimes they lose their life, and sometimes they have another, different life that I hadn't expected. So I always try and experiment with how things can stick, and see what the best way to do it is. Sometimes it's just the spoken word, and that's enough.

How important do you find collaborative experimentation?

A real collaboration to me is two people sit down and go, "What shall we do?" I've only done that with one person—Peter Gabriel—and it was hard for me to do that. I'm a control freak, you know. I have to try to follow an idea through, and see if it works. In terms of my work, I don't feel control is a problem, because I don't collaborate. I feel very privileged in that way, but it's also a privilege that I took. It's a privilege that anyone can have.

Anyone could do their own work and sign their name to it, and that's that. And most people don't realize they are free to do this. They think they have to work their whole life to get to a point where they can do what they want, when they're sixty-five, instead of thinking, Well, maybe I don't need three cars, a dishwasher, four cats, and three kids. You know, it depends on your priorities. I always just wanted to make things that other people could understand. That's my only reason to be here. My only reason. Do you see what I mean?

Robert Ashley, 1989. Photograph by Jack Mitchell and Performing Artservices.

ROBERT
ASHLEY

BROWSING THROUGH A RECORD STALL sometime after my arrival in Brisbane in 1979, I found a copy of Robert Ashley's strangely titled LP, *In Sara, Mencken, Christ and Beethoven There Were Men and Women* (1973), and immediately bought it, intrigued by its cover and encouraged by the thought that it was on Cramps Records, the daredevil publishers of the Italian poet Arrigo Lora-Totino's heroic seven-LP sound poetry anthology, *Futura Poesia Sonora* (1978).

I was fascinated and confused by this extraordinary monologue, like nothing I'd ever heard before, and two or three years later, guided by Performing Artservices, met Ashley at his New York apartment and asked him if he had always worked with texts. Yes, he had chosen to work with "natural speech" and "vocal sound" rather than "instrumental sound," "trying to make pieces that would allow the performers to speak naturally."

Beginning with "totally improvised" question-and-answer pieces with the ONCE Group, Ashley experimented with "a new kind of music theater"—the haunting *Perfect Lives*, which David Byrne might well have performed had Talking Heads not gone "into orbit" before this could occur. In the event, Ashley explains, "I couldn't find anybody else who could do it . . . So I did it myself."

And he "did it" quite exceptionally. Cage, for example, wrote: "What about the Bible? And the Koran? It doesn't matter. We have *Perfect Lives*." And Spalding Gray recounts: "Last winter after performing *Swimming to Cambodia* I would lie on the floor and listen to *Perfect Lives* over and over. It floats in my head like a memorable, ever-changing dream."

Commissioned in New York by the Kitchen in 1978, toured live for two and a half years, and then premiered on television by Britain's Channel Four in 1984, *Perfect Lives* still awaits Ashley's ideal realization as a series of seven episodes, each made up of "seven tapes" to be freely intercut, "like the seven replay tapes of a sporting event."

Regretting the conservatism of public broadcasting policy, Ashley valiantly concludes: "I'm still in the position, unfortunately, of being the visionary—of advocating something that is outside of my experience. But I know that it's possible."

New York—August 31, 1982

Have you always composed with the kind of textual materials used in your opera Perfect Lives*?*

Yes, I've always used texts and it seems to me that most of the important work in American music since 1960 has been vocal work. But the mystery of how you make a piece of music with a text, and what comes first, is something that we barely understand—if we understand it at all!

How did your work in this area evolve?

The first opera I did, in 1963—*In Memoriam . . . Kit Carson*—was open to either vocal words or instruments. But it took me quite a few years to realize that every time I produced it I always made it vocal, and that it would be too abstract if it were done just as an instrumental piece.

Then, I think the main influence on me was the opportunity to work—between about 1954 and 1959—with eight people called the ONCE Group. Most of them were not musicians, but were trained as artists, architects, or whatever. And by virtue of what they developed as a style, they gave me a totally unusual, rare, and perfect opportunity to work with vocal forms. I made about five major pieces for them, most of which did not involve my own voice.

I was principally interested in other people's voices, and put an enormous amount of energy into trying to make pieces that would allow the performers to speak naturally. It's an extremely difficult thing. As soon as you put a person onstage, it's almost impossible to be casual. So most of those pieces were built to make it possible for speakers to lose their self-consciousness and speak normally when they knew you were observing them. A typical one was a piece I did in 1968 called *The Trial of Anne Opie Wehrer and Unknown Accomplices for Crimes against Humanity,* in which Mrs. Wehrer—a brilliant speaker—simply answered a hundred questions about her life that I put to her.

In the staging of the piece she was free to answer the questions that I gave at any length. And they were fairly "philosophical" questions—questions that could elicit a lot of detail—and she had an amazing memory for detail. A simple question could result in a twenty-minute answer, so she might get through five or six questions in an evening. We performed this piece about fifteen times, and I don't think we ever got to the last question.

So it was very improvisatory?

Totally, for her. She knew what the questions were, but her answers were totally improvised. In addition, there were two men onstage with her, who at any point could cross-examine her by asking her specific questions about her story, and two women who could answer as proxies for her, but in their person, so that the answers got to be very complex.

If Mr. A. asked Anne a specific question, then one of her "proxies" could answer that question in the first person, from her own point of view. And as soon as she had made the first statement of fact, then Anne was free to interpolate a "revision" into that proxy statement. So there were two cross-examiners, and two proxies, and Anne could tell the story of her life and interpolate material from those proxies into her answers. I liked it a lot—it was very effective. The five people were all brilliant talkers. They were all amplified at the same time too, but the recordings of the stage version are not very good—when it's reduced to a couple of channels, it's just talk on top of talk.

After the work with the ONCE Group, I went to California to work at Mills College,

and started the Center for Contemporary Music as a public-access place with synthesizer studios, film studios, recording studios, and that kind of stuff. Then after about five years, I decided that I wanted to be involved in television—that television was the most interesting theater for my music.

So the first project I did for television was an opera called *Music with Its Roots in Ether*. It's a set of seven portraits of composers and their music. And in each of those two-hour portraits, the composer's speaking style and speaking presence are played off against his or her instrumental music. And of course, their music sounds just like the way they talk.

Then I started on *Perfect Lives*—an opera in seven half-hour episodes, narrated by the principal character and by "Buddy, the World's Greatest Piano Player," who tell the story in a vocal style and an instrumental style. The other two principal characters are male and female voices who represent all of the characters of the opera. Each of the episodes is about one or two of the characters from the story.

We're just starting to work on the production for television now. We've worked on the stage performance of the piece for about two and a half years, and we've performed it a lot—sort of in preparation for doing it on television, in the sense that each of us had to develop our character from this vocal material.

Why television?

Well, for me, television has the most interesting language, as a possible style of opera. I mean, in the situation we're in now—economically or technologically or whatever—the possibility of doing opera onstage is not very interesting. The language is not strong enough for what we're trying to do—the language is too sort of antiquated. I used to be enormously interested in motion pictures as a vehicle for opera, but in the last ten years all of my interest has gone toward television. It's such an amazing medium for the kind of music that I do.

In the ideal situation, television is the most live of all the media. It's more live than live onstage, because the live onstage limitation is too great. I mean, things look dull when you see them onstage. And the very best work I've seen onstage—as interesting as it can be—would look still more alive if it were given full television possibilities, and treated as a live event by television. I believe that's going to be the most important thing of the next decade or so—for television to recognize that as its potential. I think there'll be a whole new kind of music theater.

By "live" television, do you mean something broadcast as it's happening?

Well, you'd do it all live—but the television would be live, too. What I'm trying to do with my video collaborator is to make a sort of studio television—with the economic limitations of having to do studio television—that's an imitation of live television. In the best sense it looks like "first decision."

Some people can get very close, even to the extent of making first decision, and just recording the material. What I'm talking about is the spirit of first decision—the spirit of actually making the decision live, in the same sense that music is based on making it live.

You're envisaging very close collaboration between performers, composer, and camera?

Yes—very, very—it's totally intimate, in the best sense. Well, it's done now, of course, in the most expensive television, in sports. And, in a more humorous sense, and a much

more limited sense—it's done in news, on television. The news cutting on television is first-decision cutting, but the setting is so fixed that it appears to be like drawing-room comedy. But it still has that quality of first decision, and that's the way you feel, when you watch it. In that way, I guess it's related to music in that very abstract way of the energy of the thing coming from rhythm and texture.

What persuaded you to use your own voice in Perfect Lives?

Well, what persuaded me was that I couldn't find anybody else who could do it. I had wanted to use David Byrne of Talking Heads, and he said yes, but before we got around to actually doing it Talking Heads went into orbit, and he said he was too busy to do it. So I did it myself for the practical reason that I had nobody else to do it. I'm going to do the first performances of the satellite to *Perfect Lives—Atalanta (Acts of God)*—myself, too. But I'm hoping I can get somebody else before we go to television so that I can stand out of the piece in some way.

You don't see the tone of your voice as being very intimately linked—or irreplaceably linked—with the performance of the piece?

Not irreplaceably, no. There's an ancient idea in music that other people play the music better than the composer—and add something else to it that the composer would never think of. So if I had somebody else do it, by directing the score I could be assured that they were going to use all the aspects of it that I use, but they would add a lot of other things, too. And I'm positive that having invented it with my voice—and having then performed it all these years—I've learned habits that I would be better without. I think I could even do it much more freely, more extravagantly, than I do it, if I hadn't done it so many times.

Some of the sound poets insist that their texts have to be performed with the sonic qualities peculiar to their voices.

Well, the idea of performing your own music—in the United States at least—is a fairly new idea. Before the late '50s, it was always in the European tradition—you write it, and somebody else plays it. But I think that in the '60s and early '70s the main work was done by people who did their own music—at least for practical reasons—because there was nothing else that they could do. So they developed these extraordinary individual voices. And I'm totally fascinated with that idea. That's what *Music with Its Roots in Ether* is all about. At that time I was in the same situation of performing it myself, but I was never interested in being a solo pianist, and I've never been interested in being a solo poet or solo singer.

My imagination has always gone toward more ensemble-type pieces, and so it's not really possible for me to think just in terms of my voice. I'm perfectly willing to use my voice, I'm perfectly willing to play in the ensemble—but I always think of it as being a huge ensemble. So I'm excited about playing in my own music, but I would be just as happy to have somebody else doing it—if I could ever find somebody who could do it!

Twenty years ago, it was impossible for me to think of somebody else who could do my music apart from the ONCE Group, which was an extension of myself. Every person seemed totally isolated in his dream, in his sound. But that's changed. Especially among the younger musicians now, I could find a lot of people who could do my work very well.

How important for you is recording technology? Are you moving away from the studio, toward the studio, or using both studio and live techniques?

Oh, both! I have to! The best of all worlds would be to make the live thing more like the studio thing. These days you can't conceive of going onstage without every possible piece of equipment you can get your hands on. That's what makes stage performances interesting. The more sound equipment you have, the more interesting the performance is.

New York—January 12, 1991

Shortly after we last spoke, I saw your London performance of Perfect Lives *at the Almeida Theatre. What projects have you been working on since then?*

I guess that was 1982, and that was the last public performance of *Perfect Lives.* While we were in London we negotiated a premiere contract for the television version with Channel Four. We delivered that in seven half-hour episodes, in September 1983, and it was first broadcast in April 1984.

Immediately after that performance of *Perfect Lives,* I gave the first sketch performance here in New York of a new piece that I had been working on, called *Atalanta (Acts of God).* We performed that piece from 1982 till the last performance in London, two years ago, when I felt it was fully developed.

In the meantime, I had begun the third group of pieces in this trilogy. It's a kind of chronology of the way people living in North America who came from Europe have developed a sense of who they are, where they came from, and what they are. The first of those, *Atalanta,* comes from the European Atalanta myth. The middle group is *Perfect Lives,* and the last, *Now Eleanor's Idea,* is a sort of futuristic group.

Over five years, I think we made fifty performances of the *Atalanta* material in various combinations. Each performance would focus on a different character or a different set of arias. We had about nine hours of stage music, and when we stopped performing it, I edited that material down to four and a half hours for television, which came out to be three eighty-eight-minute pieces. When we stopped performing *Atalanta* a couple of years ago, I felt the wisest thing for me to do was to go immediately into recording my next pieces because they're so much involved with the media technique.

Perfect Lives and *Atalanta* had been developed as performance pieces—we would take a unit of the piece and work on it in a rehearsal, perform it a couple of times, and go to another unit. It was the only economical and practical way to develop that music. But the next group of operas is so specifically in a format—in a template—that I felt it would take much too long to try to develop them in performance. So I actually haven't yet performed any versions of these four operas, except part *eL/Aficionado,* because it's a monologue opera. The other operas are too complicated vocally, and it's just not practical.

Does that mean they exist primarily as recordings?

Right now they exist primarily as scores and sound tracks. In other words, I have *Improvement* as sixteen tracks of vocal music and an orchestral score—a score for an orchestra

that is based on MIDI format—Musical Instrument Digital Interface, the electronic cuing format. So now I'm trying to build the orchestra for *Improvement* from that. Each of the last four operas uses a different form of studio technique, but they're all essentially studio technique pieces. As I said, it didn't seem very practical—I mean, at my age and in the circumstances of the American avant-garde—to try and develop them in performance, because it would take too long.

Presumably it's also very expensive.

It's very expensive from the producer's point of view—it means you have to get a lot of people who help you develop the piece. But it's also expensive from the performer's time-participation point of view. It requires that people be sort of devoted to the piece for like five years. And in the situation I'm in now I just can't afford to keep a big ensemble together.

Did any particular problems or changes occur while making the television versions of Perfect Lives *and* Atalanta?

Well, I haven't made the television version of *Atalanta* yet. It's scored, and I'm trying right now to find someone who will produce it. What has happened as a result of working on this idea for television in the last ten years is that I can now speak about the music as though it were a television series.

I have thirty-nine or forty half-hour episodes. It really breaks down very much like a television series. So after this ten years of very hard work, I have it now, and my next problem is to find how to produce this as a television piece.

With *Perfect Lives,* I think I was very lucky, because we had been performing it without any specific format for the production in mind. But it was scored for these half-hour episodes. So when we made this agreement with Channel Four in England, it simply meant that we had to go into the studio and do the work—one thing after the other.

I had hoped that we could build these as a television director's piece—a performance piece for a television director. I had in mind the idea that we would make seven tapes that ran synchronously for each episode, and that the patterns of what was on the seven various tapes in synchronization with the music would allow the different television directors to perform the piece, like a conductor.

I was not able to sell anybody that idea, but what happened—which was very, very lucky for me—was that through Carlota Schoolman, the producer at the Kitchen, I met a young television and video artist, John Sanborn, who took on the role as the director of the piece. And he had been working very closely with another young engineer here in town, named Dean Winkler, who's a brilliant design engineer and television engineer.

Dean had just finished designing the most beautiful television production facility in New York, and he asked for and got a three-month leave of absence to work on the piece. Dean took total responsibility for the technical production, and John went through the script with me and designed the kind of processing of the video image that would be possible in the most visionary live situation—he designed a sort of fake live television program, which we then made.

That's the way pop music is made, for instance, and he did a brilliant, brilliant job. So the long answer to your question is that I had to change my vision of the technique of the piece, for practical reasons. But the result was something that was just as wonderful, because I worked with these two brilliant men.

| a fact | of course | as one | agreed | no doubt | true enough | allowed | *

 | in accord | so right | I'd say | well said | *

|a fact | * |* |* |* |* |* |*

 |* |* |* |* |*

|* *| a fact |** |* |* |* |* |*

 |* |* |* |* |*

|* |* *| a fact |* He takes | himself | seriously.|* |*

 | Motel rooms |* |* have lost their | punch for him.|*

|* The | feeling is |* *| a fact |** | expressed | in bags.|*

 | There are two | and inside | those two | there are | two more.

| It's not |* an easy | situa|tion, | *a fact* |* but there is | something like |*

 | abandon in | the air. |* |* |*

|* There is | something like the | feeling of the | idea | of | *a fact* |* |*

 | silk scarves | in the air.|* |* |*

|* | There is | a kind |* of | madness | to it. | *a fact* |*

 | The kind we | read about in | magazines. |* |*

Robert Ashley, page 1 of "The Park," episode one of *Perfect Lives*.

This seems a considerable—if not total—step toward your ideal of more radically real-time television.

It was! With *Perfect Lives,* I was not idealistic or visionary or dumb enough to imagine that at any moment, at any television station, we could bring in all the performers and costume them—I mean, even I was not that stupid!

But I had imagined a performance piece for television made up of seven videotapes. We

would make, for instance, a tape of Blue Gene playing the piano in the costume and the design of the piece. We would make another tape of the chorus—David and Jill; we would make another tape of me—the narrator; and we would make tapes of the background material and tapes of the landscape material.

And we would run those seven tapes at the same time as though there were on-camera situations. So if you were a television director, I would give you these seven tapes, and you would lock them together in sync and just make a piece, as if you were looking at seven cameras. The director could cut into Blue Gene playing, or he could cut away from Blue Gene playing—like the replay tapes of a sporting event. They're all running, and you can look at them, and say, "OK, cut—cut to camera five," or whatever.

But from talking to people I realized that the technique was real but was unavailable. In other words, you really could do all this synchronization thing, because you could see it on the most expensive sporting events—fourteen cameras, six replays, five graphic inputs, and this sort of stuff. So naturally, that's what you dream about.

It was not visionary from a technical point of view, but it was visionary from a financial point of view, because I thought that that technique would jet into local broadcasting quicker. I didn't realize that there might be such a financial barrier or aesthetic barrier or barrier of the imagination. And I discovered that almost no television stations in the United States had that equipment available. They didn't think of it that way. It was so special that it only occurred in special situations.

Did you have more positive responses from overseas television?

No. Nobody had it—it was only in America. The Europeans weren't even interested at that time. I'm not sure they're interested now. It was only in America, and I discovered—unfortunately—that it was only associated with the most expensive, big public events.

Did you then think of using this almost modular perception of the piece—which could be reedited at will—onstage? Has there been feedback from this television conception into live performance?

Yes. In all the live performances of *Perfect Lives* and *Atalanta,* we put as many orchestra tracks as the situation could afford. When we started performing, I bit off more than I could afford. I started with eight tracks, and it turned out that it was more practical with four tracks. So we would take four things of the orchestra, all playing at the same time on the tape, but not heard.

That meant that the sound designer—in the beginning Peter Gordon, and later in *Perfect Lives* and *Atalanta,* Paul Shorr—could pick those orchestras and process them any way he wanted to. It was something that was very wonderful, because it meant the performers onstage, even though they knew the tempo and the key, and what the cues were and everything like that, never heard the same music twice. So you never got bored.

Is this the equivalent of using sampling, or at least, of using a number of prerecorded samples— or options—live?

Yes, exactly. Sampling is certainly the most obvious answer to the problem of using very good electronics in your performance without having to do the same thing every time. It

was a wonderful technique and a wonderful way to perform, and everybody enjoyed it because you never heard exactly the same version of the same piece every time.

How does this relate to your present practice of prerecording voice and orchestra tracks?

Well, finally you have to make a decision. If you're going to make a version, a record, a CD, a television program—whatever—finally you have to make a decision. In the early '70s, everybody was saying, "Well, you don't have to make a decision—you know, we're going to have interactive television and all that kind of stuff." And possibly that will happen someday—maybe not in my lifetime, but it probably will happen.

But right now, what we've discovered is that that is impractical. So what you have to do is to convert the optimum performance situation—which is to have variety when you're performing night after night or week after week—into something that you're satisfied with when you finally make the television program, or the CD or whatever.

How do you conceive of this?

I feel that you want to have another level of consideration. I don't think it should sound just like another performance. I can't even define this quality, but I feel it has to have sort of another layer of wisdom. It's like when you're a writer, you can maybe write ten versions of the same paragraph, but one of them is better, and then you reedit it and you make it even better. In other words, you leave behind the ones that you like, that were part of you. Finally, you have to make one of them work.

That's the quality. The two things have to exist side by side. You have to do something onstage that's an optimum condition for being onstage—which is having fun. Then, when you get into the situation where you have to make the final decision, there's another thing that comes into play.

This is quite reassuring, given the general claim that the last twenty-five years witnessed the fragmentation and dissolution of performance, reality, and so on. And yet it seems inevitable that artists should work towards some kind of synthesis, following these experiments.

Well, I'm not an expert on theoretical language. I respect it and I read it whenever I can. When you read literary criticism they suggest that there's no underlying narrative for any particular civilization now, and that you can't say, "Well, you know, I'm British," or "I'm American," or "I'm avant-garde"—everything is all mixed up. But if your experience is that on a daily basis, then it seems to me all the more reason why you wouldn't want to replicate that experience in one of your documents. In other words, why would I want to make a piece that is just another version of that? Because I've already got it—I have it all day.

I suppose John Cage would say that life is full of the kind of interesting coincidences and fragments that art should reflect.

I know what John Cage says—I think John Cage is wonderful—but I just don't believe that. And if life is all coincidence and things are happening at the same time, everybody experiences it! You don't have to be an artist to experience it—the kid on the street experiences it. So I was thinking that as long as you're at it, you might make something that's a kind of another part of that experience. Not a replica of that experience, but an ingredient in that

experience! I want it to be like something they won't experience anyplace else—I don't want to be like their experience.

Has your recent work placed more emphasis on modes of coherence as opposed to fragmentation?

I don't know how to answer that, because I've never thought of my work as being anything less than coherent or orderly. I mean, I'm terrible about that. But what I've experienced, and what I think every composer today is experiencing—especially American composers of my generation—is that we don't have a cultural network that supports this kind of thinking, and as a result, most of your plans, most of your musical dreams, go unrealized.

So if there appears to be a lack of coherence in my work, it's not my fault. It's because it's not possible to do what you really think you should do with the material. To use the old analogy of cooking: it's possible to imagine things that you would cook that are more complicated, technically, than you can do in your situation. But if you're not in a situation where that's possible, you can imagine great meals and still have to eat hamburgers.

What is your equivalent of that? Is it having access to television and recording studios?

Yes, it's access to the technique, but it's also access to the people who can do it. For a long time, there were very few people in America who could actually play it—people weren't trained to do it—and that's why composers played their own work. Thirty years ago, you couldn't get an engineer to help you with an electronics circuit, because he didn't understand what you wanted. He would say, "Well, you can't do that," and you'd say, "Yes, you can," and finally you'd just have to make it yourself. But I think we've seen a very positive advance. We really have more people now who can play the music and understand the ideas, and a lot of the technical ideas of 1960 are now all available in a very, very practical way as consumer products.

But one also often now sees ensembles performing independently, with the composer offstage.

Well, as you get older there's always a limit on performance. Music is very physical and it's very hard. It's very rare in professional sports to find an old man playing—old men are coaches. There is a time when it's just too big for you—you can't play that fast. So at a certain point you want somebody else to play your music, otherwise it doesn't get played. So that's the reason I'm trying to write myself out of my pieces—that's the reason everybody's trying to write themselves out of their pieces—because they're getting too old. It's not just a matter of, like, the hotel rooms are uncomfortable or the traveling is uncomfortable—it's that you actually get too old to be a virtuoso.

How are younger musicians responding to your work? Have you come across much resistance from them?

No. I hope I'm not flattering myself, but I think young musicians are more and more interested in the things I've always been interested in. Because the things I'm interested in—along with many of the composers of my age—are not eccentric or crazy ideas, but the language of music today.

This leads to another question—the problem of what the term avant-garde *might mean today. If what you're doing is clarifying the language of music today, this implies that what so-called*

avant-garde artists do is not so much endlessly innovative and experimental, as something that becomes progressively normal, in the sense of gradually refining and defining the most dynamic language of the day.

Well, the problem we have in America is that the country is so huge, and the cultural development within this country is so recent, that we haven't been able to knit together the idea of what it means to be a composer. I can't emphasize how bizarre it is to go from what's currently possible in America, to what was happening when I was a kid. If you didn't get a few performances in the city, you were out—the rest of the country was like primitive, primitive! So up to today, the work has been done mainly by the composers, and there is not a coherent and intelligent and workable intellectual community behind us, so there is effectively no criticism—there's nobody who sees the whole thing.

Not even in New York?

Where would you look for it? Most critics and writers are involved in the arts as bureaucrats, feeding off the arts. And they get discouraged, so you read a lot in the newspapers about how music is dead.

Where do you see the multimedia arts going in the '90s?

Well, I personally feel very encouraged by the response to the idea of marketing popular music through television. It became so powerful that it's inevitable that it will have to be expanded, and might even conceivably in my lifetime include me, as people begin to get the idea that music is as interesting on television as sport.

Have your videotapes successfully attracted attention?

Yes—it's the most successful thing that could have happened to me. Everybody sells CDs, and everybody sells records, but what I'm happy about—and what I predicted—is that people really want the videotapes. They're published by Lovely Music and are distributed by independent distributors rather than the big stores, which are still dominated by the first attempts at mass-market saturation.

Would you like to make video versions of all of the operas?

I'd like to make television. Video, so far, is a by-product of television. My interest is in making television, and I'd like to make live real-time music on TV, as opposed to pop music video. I hope I'll be able to finish this large project that I've set out for myself, because I'd like to be able to see it myself. In other words, I'm still in the position, unfortunately, of being the visionary—of advocating something that is outside of my experience. But I know it's possible.

Beth B. Photograph by Mike Lavine.

BETH
B

I FIRST CAME ACROSS THE WORK OF BETH B when I saw her film *Thanatopsis* (1991), starring Lydia Lunch, at the Tenth World Wide Video Festival in The Hague in 1992, and then read more about her work in Jack Sargeant's book *Deathtripping: The Cinema of Transgression* (1995).

Like David Blair and Nick Zedd, B belongs to a younger generation of experimental New York filmmakers engaging with, emerging from—and initially screening, performing, and exhibiting their work within—the predominantly populist milieu of 1980s punk rock club culture, before partially infiltrating mainstream and upmarket subcultures to differing degrees.

Subsequently talking to Nicola Kearton, the editor of the London art magazine *Art and Design,* who was planning an issue on art and film, I learned that Beth B was going to be in London for the opening of her installation *Trophies,* at the Laurent Delaye Gallery in February 1996, so I phoned to see if we could record an interview.

We met up a few days before the private view, and having looked over B's installation—a series of sculptural meditations upon the ways in which different cultures contort the female body—we discussed the evolution of her work, from her 1980s activities as a print-maker and a rock-club-based, Super 8 "serial" filmmaker, to her 1990s activities as a multimedia installation artist and as the director of such feature films as *Two Small Bodies* (1993), funded by ZDF Television (Germany) and Arte Television (France).

Reversing Jean Baudrillard's suggestion in *The Perfect Crime* (1996) that video is a "deferred-responsibility" technology generally "deadening desire," Beth B suggests how the most vital contemporary multimedia artists evince both the responsibility and the capacity "to create and provoke thought and dialogue between people."

London—February 5, 1996

Perhaps I could begin by asking you how you prefer to be described as an artist, and whether your sense of identity has changed over the years?

I don't really want to be perceived as any one thing, because I think that puts such a limitation on what I can do. What excites me the most is change—I've discarded certain parts of myself and then found twenty years later that I've come back to them. When I got out of art school in the late '70s I was very disillusioned—executing art seemed rather secondary to the whole concept of art. During that time there was a backlash against the gallery system in New York, and a large group of artists got together with the idea of finding alternatives— alternatives to the alternatives!

What so-called alternatives were you rejecting?

The Franklin Furnace, the Kitchen—even in places like that it felt like the whole curatorial system was working against artists. A lot of the work that people in our group were interested in doing was more politically based than conceptually based, and I really wanted my work to get beyond the museums and the galleries to the guy in the street. I started doing some postering and some stenciling, and then started to shoot some Super 8 films as a reaction against art.

Were you inspired by any other filmmakers?

I hated all the films I saw at that time! It was all that structuralist and minimal film—it was treating a concept, executing a concept—but ultimately it was completely boring. I related much more to the concept of B movies and also to Jack Smith, whose work was more about confrontation and disturbing the safe place that we hold within ourselves. Kenneth Anger was also an inspiration.

What was most exciting at that time were the rock clubs—venues where you could show films, and where you could smoke and drink and really react to the material, rather than the gallery situation where everyone was very comfortably sitting on their hands, not reacting, being very polite. We started doing a kind of soap series—like a serial, every week shooting and showing a new portion to club audiences. It was more about spectacle—and realizing that in a rock and roll club you really have to grab people's attention.

Did you ever find your work's relationship with club audiences too fast and furious?

No, I think those films still hold up in museum situations and in cinemas. They're narratives, they tell stories, but it's done in a confrontational way. But I think they still do have the depth and the contemplative qualities that are essential for any kind of work. That's what I feel is the beauty of cinema—you not only have characters, you not only have stories, you also have psychology and a whole visual and aural sensation to explore, and then people walk away and think about it.

I think any work, whether it's cinema, sculpture, or painting, whatever, is like an onion, and you just keep peeling away, peeling away layers, and hopefully each time you see it or think about it you will have found something else that is hidden below. It's that element of mystery that intrigues me. I don't like to give people answers or solutions. I don't like to reveal everything.

Did club audiences respond favorably to your films?

Yes, it was very exciting—and when we did a week-to-week serial the audiences got bigger and bigger and bigger.

So it was very interactive in a way?

Yes, very interactive. It was the first time that I realized how important the media are, how much power television has. In many ways through the years my work has reacted against that, at the same time that it has also been able to use it. When it's broadcast on television the audiences are so much larger than those for any ordinary work of art.

What sort of responses did your work receive from the more mainstream art world?

Well, just by its format we got a reaction of negativity, because cinemas don't show Super 8, and most galleries and museums don't show Super 8. But it was fascinating because Karen Cooper from the Film Forum—which is a great cinema in New York—came to see *The Offenders* in Super 8. She'd vowed that she'd never show Super 8, but when she saw the film she said, "I've got to show the film—I'll rent a projector and we'll show it."

It must have been pretty exciting to see a marginalized medium suddenly becoming legitimated like that.

Yes, but the medium is not the issue—it's the content. And so much of the time people are stopped by the medium. I myself used to say, "If it's a painting I don't even want to see it!" And through the years I've learned that it's not the medium that counts—it's what I am able to say and convey and explore through different media, and what is most appropriate in that medium.

So I think I always try to push out, beyond film or sculpture or whatever. That's why I don't call my video works videos—I call them film tapes, because people have an aversion to video. With each thing I do I really try to emphasize that it doesn't matter whether it's sculpture or film or painting or multimedia or whatever—hopefully, we can look beyond that.

We have the same problem when we refer to human beings, whether as a man or a woman or a homosexual or a black person—we're so used to society judging a person or a thing based on form. I mean, the news media are giving you the news with a preinterpretation attached to it, so you have to work to read between the lines, in order to understand what's really being said. It's entertainment—the media have become entertainment, whether it's O. J. Simpson's trial, the war in Bosnia, or the Persian Gulf War—it entertains the masses.

Does your work try to resist becoming this kind of entertainment?

No. To me the point is not about resistance, it's about indulgence. I need to indulge myself in entertaining people, informing people, creating a mystery, provoking people. To me, provocation is the most important element because I think that is what ultimately gets people thinking. A lot of my work is very confrontational, but people need to be seduced—you have to seduce them in some way.

Was your strategy of using B movies a way of addressing what you describe as "the poor white trash culture that I always felt in life with?" That reminded me of the way Joyce's stories in Dubliners *are extremely moving while being about ordinary people making a muck of ordinary lives. Could you tell me a bit more about your early use of B movie materials?*

Well, you seemed to sum it up very well just now! It's very much about the outcast—the person who is not so visible in society and in our culture. And I think that only by giving

voice to—and really seeing—those things that we don't want to hear or see can we start to deal with certain issues that generally are disguised or that we are in denial about.

And that's something my movies have a lot to do with—with struggling to go beyond what we are taught to accept in life. A lot of my films have to do with self-exploration and discovery and the roles we are taught to bind ourselves with, and breaking loose of those and discovering what other ways we can travel through life.

Whereas the Burroughs generation went outside America in order to critique its conventions, I get the feeling that a younger generation of film and video artists like Nick Zedd or David Blair are kicking against their own suburbs from within their own suburbs. To what extent is your work reacting against—and informed by—the status quo in America, and to what extent is it informed by ideas from outside America such as European cinema?

I'm much more related to European cinema than American cinema, but I think it's critical for me to stay in America and give voice to issues within my own country. I mean, Americans don't see cinema as art—there is no art cinema in America anymore. Even a lot of independent filmmakers nowadays are gearing their films towards Hollywood.

Which European filmmakers do you find particularly interesting?

Well, the films of Liliana Cavani, who did *The Night Porter,* or Joseph Losey and Fassbinder.

If The Night Porter *looked at midcentury war guilt, could one say your films are looking more at contemporary "cultural guilt"?*

Well, I think American culture is a culture of forgetfulness, and a lot of my sculptures and installations—such as *Trophies*—are reminding us about history. Today it's facial surgery, breast implants, and anorexia. But in years past it's been Chinese foot binding, corseting, and a multitude of other things that women have agreed to have done to them or have had imposed upon them. And now what's really sad is that it's happening to men in American culture. We are so much into treating ourselves as objects that we're becoming a society of objectification, and the disposable nature of America just seems to promote that even more. I think my work definitely has to do with a historical perspective—maybe a psychological perspective.

You've said your work tries to avoid offering explicit solutions, but also observe that at the end of your film Two Small Bodies *the female protagonist turns the tables in the power game and reaches a certain sort of self-realization. Is this a form of tentative affirmation?*

Yes, I think that whether you watch someone onscreen taking a journey, or whether you walk through an exhibition and you feel that you're taking a journey, it gives you a certain kind of insight. I don't think it's a solution because the term *solution* implies that there's an end to a problem, and even though you may have a momentary solution for something, you inevitably encounter more problems. Which is what really makes life fascinating. It's like a big puzzle, and you move one piece here and that changes the whole picture.

That's what Proust says about reading. He says that rather than just reading great writers, you have to work out their significance for yourself, and take responsibility for your own creativity.

The concept of responsibility remains one of the most important aspects of what I hope to inspire. In my installation *Under Lock and Key,* which is about the prison system in America—and the way it does not work—I tried to create a triangular dialogue between the imprisoned, the imprisoner, and the victim. I wanted to suggest that we can't keep pushing the prison problem away and that even as the victims of crime we're still responsible for the way the prison system is designed. The installation is asking where each of us individually fits into this system and where our responsibility is.

In other words, you're looking beyond accounts of cultural stasis, and beyond the punk slogan No Future?

There are times in my life when I have felt things were in a state of stasis, but I feel it is my responsibility today to try to create and provoke thought and dialogue between people, because I think communication is where it all stems from.

Has television facilitated this kind of communication?

Well, *Stigmata,* a kind of art film documentary about drug abuse and recovery—about people who have gone very deeply, darkly, into that area and come out on the other side and stopped using drugs—has been broadcast a number of times on television.

The response was tremendous, and millions of people saw it. To me, it's the most successful piece I've done, because of the exposure it got beyond "the converted." I want to be able to reach as many people as possible. Another thing that happened was that after *Trophies* was shown at the P.P.O.W. Gallery in New York, they got a call from *Ms.* magazine, which

Beth B, *Under Lock and Key,* sculpture, video, and audio installation, 1993. Photograph by Beth B.

was doing a feature on breast implants, and wanted to use one of the images from the exhibition. It was great to be able to show my work in another context.

Did your work on Two Small Bodies *in collaboration with German and French television employ more conventional narrative?*

Yes, *Two Small Bodies* is more of a traditional narrative, though the early films were as well. My work's taken a circular route in a way, because I started with the fine arts and went into experimental film, then narrative cinema. Then in 1989 I went back to the fine arts—to my origins in posters and painting—and realized that I can do all of these things simultaneously.

How did you combine different media in installation work such as Under Lock and Key *and* Out of Sight/Out of Mind*?*

Under Lock and Key is physically a sculpture made of steel, fashioned in four very small confinement cells for absolute isolation. When you go into the cell, there's a voice reading from Jack Henry Abbott's book *In the Belly of the Beast,* which recounts his experiences of being isolated—so you hear this voice that's both very distant and yet very close, very emotional. And then when you come out of the cell there are two video projections on the wall. One shows people reading letters to persons who abused or attacked them, and on the other screen I had an actor read interviews with Ted Bundy, the mass murderer. So the audience is able to interact with these different voices and actually feel what it is like to be inside this cold isolation cell.

Reviews suggested this confessional footage veered towards talk show sensationalism. Was this a fair comment?

I think that if you see them you know it's not. The video projections are very large—it's just the head of the person, so that in a sense they're addressing you. You become the person who has assaulted them, and this direct address creates a dialogue, whether you want to be in the dialogue or not.

Did you want Out of Sight/Out of Mind *to confront the viewer with a similarly intimate intensity?*

Yes. This installation once again combined sculpture, audio, and video and seemed extremely successful in that it forced people to make a decision about participating in the piece. First you encounter a rotating machine that was used in the 1800s for people who were diagnosed as being mad. They were spun around at a hundred revolutions per minute to cure them of madness! I had one of these devices constructed so that when you enter the installation you can actually sit down in this chair and get spun around.

Then behind that you have a wall of four padded cells, and each has a little spy hole so that you can look into the cell. You make a decision whether you want to go in the cell or not. So you open the door, enter the cell, where you hear the voices of different people who were deemed to have been mad or who committed suicide—you're sitting with them in this padded cell, so to speak.

And then you see another door with a window in it, through which you see a video projection. So you make a decision whether you want to continue further into the madness, or you can leave through another door.

Beth B, *Out of Sight/Out of Mind,* video installation detail (padded cell and video projection), 1995. Photograph by Beth B.

If you go through this door you see a very powerful tape based upon the true story of a thirteen-year-old boy in New York who brutally murdered a four-year-old boy. He was put on trial, was refused an insanity plea, and tried and convicted as an adult—a thirteen-year-old boy! And ultimately that sort of says it all, in terms of how insane our society has become. Who is to judge sanity or insanity, and by what means?

Are there many American artists that you presently judge to be of interest?

I don't really keep that close a track on American art or art in general. There are certain people that I think of as really inspiring artists, like Nan Goldin, Robert Mapplethorpe, or Ida Appelbroog, Hans Haacke. I like to see their work and feel quite inspired by it, because I think they're going beyond the medium.

I think for me that is the key—to go beyond just visual quality—or the visual expression of the medium. I very rarely get moved by a work of art that is just about the medium. I need something more, content or emotion, complexity or disturbance.

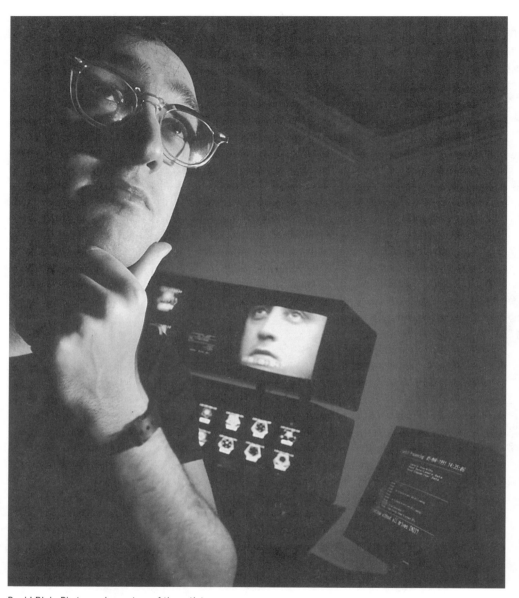

David Blair. Photograph courtesy of the artist.

DAVID
BLAIR

THE AMERICAN FILMMAKER DAVID BLAIR'S *Wax; or, The Discovery of Television among the Bees* (1991) was one of the most startling contributions at the Third International Symposium on Electronic Art in Sydney, November 1992. Following a screening of this film, I introduced myself to Blair, chatted for a while, and arranged to meet to record an interview over lunch the next day.

What were the origins of Blair's innovative, multilayered aesthetic? Was it performance based? To my surprise, Blair traced his practice back to his enthusiasm for science fiction novels and films, Thomas Pynchon, and the radio productions of the Firesign Theatre, explaining how he left Boston to elaborate the first phase of his work—his *Monkey Monk* performances—against costumes and stage sets inspired by the subway graphics of Keith Haring.

Characterizing his generation as "guerrilla art show" activists, following the more established generation of Laurie Anderson, Blair fascinatingly recounts his discovery—and immediate application—of nonlinear editing systems as a new means of orchestrating the "punning machine" of his relatively scriptless filmic narrative, working "so fast," it was really just like composition. With such editing systems, Blair suggests, one's working "almost preverbally," with "pictures suggesting story" rather than following the verbal convention of "story suggesting pictures."

Turning to the reception of *Wax*, Blair relates how it seems to have been shunned for its superficially incorrect thematics by video curators; how it was unexpectedly applauded by New York tabloid film critics; welcomed as a milestone in cinematic cyberculture by literary academics; acclaimed as "a treat for the eyeballs" and as "almost like a new kind of sex" by pop cultural gurus Timothy Leary and David Byrne; and finally legitimated by the *New York Times* business section's headline "Cult Film Is First on the Internet."

Costarring William Burroughs, and in many respects projecting Burroughs's theories of text and manipulation into realms of electronic hypernarrative, unrolling like "three-dimensional chess," Blair's *Wax*, as cyberpunk novelist William Gibson observes, is in almost every respect "winningly strange."

Sydney—November 14, 1992

Your film Wax *has been hailed as one of the most original early cyberpunk films. What sorts of experiences and experiments preceded its creation?*

Well, I'm a suburban person from outside of Boston. My first narrative reading accomplishment was fantasy, like the trilogy of Tolkien, but I think the first really experimental fiction—the first really experimental anything that I ever dealt with—outside of the science fiction shows on television, which have all sorts of dislocation of time, space, and identity, were the short stories of Harlan Ellison, such as "Repent, Harlequin!"

I guess the first movement-sized collision between science fiction and mainstream literature was the British new wave in the late '60s, and Ellison was pretty much the American voice of it, bringing modernist experiment into science fiction forms in a kind of cinematic fiction. That's why it was really enjoyable—it would chop up and move around and have a lot of the same sorts of transformations and dislocations that you would only get once in a television show, or twice in a television show. The first real science fiction story I wrote was an assignment they gave us—to imitate one particular part of *Catch-22* where time was backwards.

The first sort of cinematic experience that I can remember having was going over to someone's house, where they played a film of somebody diving off a board forwards and backwards, and as they played it backwards, I somehow made the connection that you could actually have your hands on the image of the cinema.

But it wasn't for another seven or eight years that I saw that my next-door neighbors had a film camera and grabbed it from them, bought some film, shot it, and chopped it up. I went to this Fourth of July parade where there were lots of people, lots of costumes, and I pixelized it. It was already cut up, and then I cut it up some more and projected it. And of course, it's just incredibly fun—you have your hands on the pictures—on the movie pictures.

Had you come across Burroughs's theories of the cut-ups?

No, never. I never actually have read any of his theories. I managed to buy a camera almost immediately afterwards and started doing science fiction movies. Nobody else was doing it—there was absolutely no context for it at all. By the later part of high school I started going to art movies, but in 1972 and 1973 in Boston, I was pretty much in isolation.

Then a friend passed on to me the Firesign Theatre albums—a radio comedy group who did a sort of surreal science fiction audio with a lot of sudden transformations—the first cybernetic fiction that I came across with characters that were disembodied. It was grotesque—with the pressing sense of impending danger and dislocation of the self.

Then, traveling into Cambridge, I discovered a magazine called the *Harvard Lampoon*, which later spun off the *National Lampoon*. Just at that moment I also found *Gravity's Rainbow,* by Pynchon, which had just come out. The *Lampoon* was the first lesson, however. They were best at parody, a great training tool. Parody teaches you to reread—first it rereads genre for you and trains you how to change things around. Then later you can generalize it, treating your life and environment as genre, so that when you talk to people and tell them stories, you make these stories by rereading everything happening around you, in your environment.

WAX OR THE DISCOVERY OF TELEVISION AMONG THE BEES

limited edition

NO.

157 of 500

A WORK OF INDEPENDENT ELECTRONIC SCIENCE FICTION CINEMA

BY DAVID BLAIR

84 MINUTES

COPYRIGHT 1991

ALL RIGHTS RESERVED

NOT FOR RENTAL OR EXHIBITION

WAX OR THE DISCOVERY OF TELEVISION AMONG THE BEES

A work of independent electronic science fiction cinema by

DAVID BLAIR

"Wax or the discovery of television among the bees" (85:00, 1991) by David Blair
Graphic and editing assistant: Florence Ormezzano; Camera: Mark Kaplan;
Music and Sound Design: Beo Morales and Brooks Williams at Harmonic Ranch, NYC;
With: David Blair, Meg Savlov, William Burroughs, Florence Ormezzano
Funding: National Endowment for the Arts, New York State Council for the Arts,
American Film Institute, Jerome Foundation, Checkerboard Foundation
Made in co-production with ZDF, German Public Television
Supervsing Producer, ZDF: Carl Ludwig Rettinger
Special thanks to:
Film/Video Arts; Microtime; Montage; Experimental TV Center; Lev Manovich

David Blair, cover of *Wax* videotape, 1991.

The best pleasure this direction finally led me to was when I would get a little stoned with a friend and sit and talk about a very bad science fiction movie and turn it inside out from moment to moment. It was as if the momentary appearance of part of the story was what we'd nowadays call an algorithm—or the TV screen itself was the algorithm—that could unfold many different stories, dependent upon what story-picture was passing at that moment.

One of the best moments was an afternoon when we saw two movies with the same script—*It Conquered the World* and *Zontar, the Thing from Venus*. We got this incredibly ineffable sense of the same thing being repeated twice with different actors—something "really Pynchonian."

What was it that drew you to Pynchon's fiction?

Gravity's Rainbow was for me the superlative text in that it was mysterious. The things he's talking about could easily be approached by a sixteen-year-old—World War Two and all that pop culture stuff—but pretty soon it gets quite a bit weirder and connected to everything else. There are many, many layers, and that's why you spend a long time reading it and that's what ended up helping me the most, more than anything else. In college, in the later '70s, I tried to write a thesis about *Gravity's Rainbow,* and spent about a year and a half trying to figure out all sorts of things that would hopefully illuminate it in the context of the grotesque.

Exactly at the moment when I felt I couldn't finish this thesis, I decided I'd go to New York and become a film director. I got an industrial job in film and then left it because I wanted to go into video. I had a little bit of money—enough to buy lunch and pay rent, and for two months I went to the research library every day, trying to read about video. But of course in 1981 there was nothing to read about video, so what I ended up doing essentially was guided random reading, inspired by Pynchon's method of "working it up." A lot of the stuff I read randomly over that two-month period turned into *Wax* a couple of years later. I was also deliberately seeing video art—things like *Sunstone* by Ed Emshwiller and *Suite 212* by Nam June Paik.

Right after that I started to do a thing called *Monkey Monk* after reading a Russian Orthodox pamphlet called *The Way of the Pilgrim*—which actually got folded into *Wax* at a later point. I'd seen Keith Haring chalking white drawings on black paper in the subway—so I imitated that. I made a narrative drawing of two-and-a-half-by-three-foot black panels, stacked three high by about fifteen long, in total about seven and a half feet tall, about forty-five feet long.

The idea of the drawing was that it was like my few experiences with acid—you could go down to small, or you could go up to large. It was filled with little things like a quarter of an inch tall, and also large figures that were seven feet tall, and it was heaven, earth, and underworld.

The main narrative thrust was on earth, in the middle section, where the Monkey Monk was, sort of squeezed between the top and bottom—the unborn dead were planning to implant something in his gut that he was going to give birth to—it was a whole, very complicated sort of sexual, mythological story. Then I made a costume, some complex molded black masks with white paint, and painted white emblems on a black karate uniform—pretty much the same as those three-D bodies of the dead in *Wax*—which came out of automatic writing, and performed in front of the drawing, in the costumes.

Was this in preparation for a film?

Well, first it was supposed to be for performance, but the real ambition was that it was supposed to be for black-and-white TV, which was also the cheapest way I could make TV. But the principal task, of drawing, was practically interrupted by my first access to video.

I had this terrible video-dubbing job where I did film transfer, and I realized the transfer machine could be a video camera. So I started to do all that experimental film stuff I had never had the chance to do, such as stripping stock footage with Clorox and drawing on it, or making scribbles or collages on acetate sheets and placing them in the registration slot. They also had one of the first Sony Series 5 Umatic editing systems, where you could just punch in and out of insert while the tapes were running.

My source material came from the transfer machine or stolen stock footage from the dub work we did. There was no way I could get my hands on a camera. I had heard a little bit about cut-ups, but was really thinking more in terms of surrealist automatism. I did multiple passes on those tapes to get proper rhythms, and then would black out stuff, to try and get a bit of space. Finally, I quit that job and went to work at a media center in New York, where I could get my hands on a camera and real editing, and tried to turn these fifteen-minute-long experiments into finished works.

The first one I cut down to three minutes was *Note in the Box*—and it was very multi-layered. The main narrative was in the naming of images flying by, through a voice-over that unified the whole thing. But there were several other stories going on at the same time, through picture and intertitle.

Then I turned to another of these fifteen-minute pieces, called *Wax*, which was about flesh and the Nazis and sadness and long black spaces interrupted by very mysterious, private language stuff. I tried to cut it down, but found that in the process of cutting it down, you have to add new material to name material that you already have.

So I looked in the library and thought, OK, I'll do something about bees with this—what are they?—they're different things!, and tried to find out what people had written about where they come from. One book under "Bees" that caught my attention was called *Blazing the Trail: Reminiscences of A. Z. Abushady, Poet, Beemaster, Humanist.* So I got it out and found it had never been called for before.

It was a book published in Alexandria in 1939, but written in Sussex by a crippled World War One vet, secretary to Abushady during his crusade to reform British beekeeping. The imprint and authorship were strange, but what really clinched it was the frontispiece painting by Abushady—a painting of the beekeepers of the world at a circular table. England and America are talking to one another, and all the other honey-producing nations are listening in and there's a globe on the table with Esperanto on it. The second frontispiece showed a guy holding up honeycomb to a big box. The picture was labeled "The World's First Television Broadcast of Beekeeping, 1939."

So there it was—bees, television, and artificial language! It's an unbelievable book, with characters such as a fellow called J. C. Beemason—this very stern fellow who's completely bald—who's this pioneer of bee cinematology! So that turned into a sort of Pynchonian story to anchor all the completely absurd science fiction extrapolations that I started to write about. I tried to concretize these sci-fi ideas in the same sort of way, literalizing metaphysical ideas as concretely as the Esperanto globe on the cartoon table.

So the film version of Wax *more or less grew out of your video animations of drawings for your multimedia* Monkey Monk *performance?*

Yes, I planned *Monkey Monk* as a performance with slides of the drawings, and myself live in front of the slides, and hoped to turn it into a video piece and an artist's book. Each was to provide a different way of understanding the work.

When did the performance version take place?

Well, around 1982 and '83. From the late '70s into the '80s, there were a lot of performance art venues in clubs in New York City. There was so much activity I could participate in it.

Was this in places like the Mudd Club?

No, that was after the Mudd Club—the Mudd Club period was people who are very famous now, like Eric Bogosian, Laurie Anderson, and all those people. This was the second or third wave. During this time there were a lot of guerrilla art shows, peaking with the Times Square Show. I came in about two years later, with the Terminal Show—a show with about four hundred artists in an abandoned building in Brooklyn, the world's largest concrete structure.

That was my entry into New York, after living there for five years. I realized I could take all the stuff I was doing in isolation, and perform it in front of people, and started to perform the finished first third of *Monkey Monk* in clubs. There would be a slide at the top, in the middle, and at the bottom, and I would perform in poses in front of it while a prerecorded voice would read the story in the background. The backdrop was meant to be cinematic with the very close shots which were part of the story—close-ups, medium, and large shots.

Were these contrasts a conscious alternative to the minimalist aesthetic?

Well, it's minimal, but in many ways it's also maximal. With this kind of minimal art you start with one very strong thing which starts a chain of punning perhaps, and that becomes maximal very quickly.

My ideas of symmetry and structure and staging were really determined by the grotesque. The architectonics of the grotesque are all about distorted rigid symmetries indicating an immanent, uncontrolled expansion into some sort of hyperbolic space. One thing always refers to another in this sort of narrative.

How did you begin to make Wax*?*

The process of making *Wax* was pretty much one of collecting things intuitively, just the same way as going to a library and copying something down from a book—going out and collecting pictures, or taking pictures and processing them. I was trying to cut down a fifteen-minute piece that was already very, very open, to a three-minute piece and in order to do that, I had to add new material, partially derived from the book, partially real, partially fantastic, using whatever was available for images.

Did you have a clear narrative in mind?

Well, one of the first things I did was start writing a story to hang the three-minute narrative on. This organized in a fairly approachable way all those loosely connected ideas that

punned with each other, and made up the impulsive heart of the narrative. Of course, the whole thing grew further and further apart as I started to collect more and more material, so I had to invent more and more connections to pull them all back together again.

In a way, those original ideas weren't even the base of the story. At the center, inside the heart, was some sort of gnostic negative space. Unsayable, unknowable things, around which the entire structure concretized. You don't know what it is you're talking about, but a lot of things are similar to it, and you use those things to talk about it. It's like the idea of a punning machine.

When Kathy Acker discussed *Wax* she saw it as a huge articulated punning structure, with puns between word and image, puns in just an image, puns between narrative and text, puns between narrative and picture—just all the different types of puns that you could have—multimedia punning.

That negative space is the actual punning machine, some kind of algorithm spinning out the puns. But the articulation of all those puns in space and time—their structure—is the closest you'll ever get to seeing the algorithm, so you end up saying that the movie, or whatever it is you made, is the punning machine. That's the sort of story *Wax* is—everything is associational, in a punning sort of way. It's something like what you learn from parody. You beome a punner in space. Punning is like a way of trying to find a link between you and your descriptions of where you are. It's all about the tension between knowing where you are and not having the faintest idea.

I tried—maniacally—to take really detailed logs of every shot. Then I realized that didn't work, so I bought a thermal video and printed out every shot—after a period of time we had twenty or thirty thousand stills. But of course that was too cumbersome.

Then, fortunately, I discovered that there was a nonlinear editing system in New York that had been made available for artists' use, but no one wanted to use it, because the other artists had no idea what the hell they could use it for. I went up to see it, and realized that this was exactly what I was trying to do.

You could have two thousand pairs of digitized frames available, each pair representing the first and last frames of a shot. These were all lined up, and by pushing buttons, you could rearrange their order, like rearranging a collage on paper. Then you could order the machine to play the shots represented by these virtual stills, in the order they were arranged. Editing became so fast, it was just like composition. And I could try out every possible combination before I chose the sequence that I really wanted.

I was a bit limited because all I had was cut and dissolve, but I used it to the maximum—there are twenty-one or twenty-two hundred shots in *Wax,* and about nineteen hundred dissolves. Which is pretty unheard of for a video piece. In several other ways, the formal characteristics of this film really fit in very well with all the ways I was trying to work, and it was because of that I was able to finish the tape.

How did you match the image track to the text track?

Well, when the whole thing is available, all two thousand shots all at once, you can work almost preverbally. So the narrative was verbally created, but emerged preverbally, through the pictures. That was part of the production process—the pictures suggesting the story—whereas in ordinary scripts the story suggests the pictures.

Now, of course, I did work on the script intensely over the six years, separately from the

picture. But at the very last moment, when I had the final cut, I fitted the script to the picture and added some new things. A lot of the very light poetic things were done very quickly, but of course they relied on a lot of earlier work.

Did this process have anything in common with the way in which John Cage worked with Merce Cunningham, where he did the music, and Cunningham did the dance, and they put them randomly together?

Probably, but it's more direct, because it's one person. And it wasn't a chance operation. The big thing is that words were often naming the pictures—in a funny way—by dislocating the pictures.

Were there other editing effects—or compositional effects—that you wished you'd been able to have access to in Wax*?*

Well, some of my peers work directly upon the final cut, doing the rough cut and final cut at the same time on the switcher, as that is the only intuitive way for them to get the level of image complexity they strive for. They have access to a lot of keying, multilayering sort of capacity, that I would have liked to have, because it adds a lot of richness to the images.

One of the big things of electronic cinema would be to have the nonlinear editing and the compositing together—to have image synthesis and image processing right there in the nonlinear editing device, available for you while you do your cutting, so that you could work on your image while you were cutting. I guess it relates in a lot of ways to experimental music—video-image processing derives directly from analogically controlled experimental music and musique concrète.

Have you been tempted to go back to performance having done this?

With actors, yes. The next thing will have actors. I wouldn't be in it again—I can't do it twice. I'm not Woody Allen or Spike Lee.

You wouldn't want to do another monologue like your narrative in Wax*?*

No, I'm not a monologuist. In *Wax* I was working alone in isolation, I couldn't have any actors, and it was the proper thing to do because it was coming out of performance. Maybe the most strategic thing to do next would be to direct a variety of monologues.

All the same, part of the impact of Wax *seemed to come from the rather self-effacing quality of your performance and monologue, and while William Burroughs had a role, he just pottered about and didn't speak. Perhaps the general flatness of all that allowed multiple dimensions of all the other things to work all the more forcefully? The monologue is central, but there seems to be considerable attention to the other elements.*

Yes, it's a parallel thread, it's not the dominant thread, like in a movie where you could just zoom in on the lips of the two people, crosscutting, and everything else is incidental to that. The flat acting is a specific way of working—it makes a lot of interpretation available.

Presumably the slow pace of Wax *also gives the audience time to think.*

The funny thing is, I always felt that it was fast. I've made it as fast as I possibly could. All the shots are about two or three seconds—you couldn't cut much faster than that and really keep people's attention. So it's somehow a very interesting contradiction. Part of it may be my pacing. The fact that it's so regular—which came out of the limitations of my editing—gives it a sense of slowness.

How did you feel about the general response to your work?

I was quite surprised that it was really disproportionately unpopular in video art circles, considering that it was a big long work that was polished and, I thought, articulate. It was impossible to get anybody to show it in the United States, and at video art festivals it was not really interesting to people.

All the things I did, I guess, were all the things people don't trust. It was popular science fiction narrative, and in the context of the current critical idea of multiculturalism, it looks terrible from the outside. Things like a man in a white suit, a man talking all the time, dealing with bees as if they were some sort of reified femininity, and speaking from the very heart of patriarchal culture—Missile-Land—as if this was a myth to live by, as if I was promulgating all the things that people thought were evil. I think a lot of people reacted that way, and I think that's why it was unpopular in the States.

On the other hand, I transferred it to film so that I could show it around a bit, just to prove that I helped with the rhetoric of electronic cinema, and I got a week at the Joseph Papp Public Theater and then we got reviews in every single paper in New York City. I got a big review in the *New York Times*—which was just completely amazing—and a rave review in the *New York Post*, which is a tabloid, and then I got this backhanded review in the *Village Voice*.

But the cyberpunk literary establishment seems to have come to the rescue. How did this come about?

That's where St. Mark's Bookshop came in. One day I went to St. Mark's and was sort of thinking, Well, science fiction—maybe the next one I'll make will be more science fictional, and got a science fiction magazine—*Sci-Fi Eye*—out of the rack there, and wrote everybody on the masthead. Steve Brown, the editor, really liked it and said, "Let me print a review about it, let me tell you about this guy in California, Richard Kadrey."

Then Kadrey wrote about it in *Mondo* and gave me the names of people, and I went out and bought Larry McCaffery's book *Storming the Reality Studio,* and wrote everybody in Larry's book and talked to him about it. Larry absolutely flipped out about it—he's seen the movie about thirty-five times—and started making copies and sending it out to all those literary people. Maybe it seems very literary, with all these relations to metafiction, magic realism, and encyclopedic fiction. Many literary people say it's the first time they've seen a movie that in eighty-five minutes has everything that happens in a novel—Kadrey referred it to J. G. Ballard's "condensed fictions" in *The Atrocity Exhibition*. For some people it's like a talking book, like a hypermedia book.

Looking back, would you like to make any major changes to Wax?

Carl-Ludwig Rettinger, a dramaturge from ZDF Television who helped me shape the story, pointed to places where we could have cut out something to make it go a little bit faster. But

it plays so different every time I watch it that I couldn't imagine going back and reworking it. That's why for the next one, I'd really like to do a multimedia piece—not a multimedia stage piece, but a hyperversion, like parallel movies in a way.

It would be like driving a time machine—you could swing the wheel and go somewhere else, or stop, get out, dig a hole in the ground, and see just how much texture there was in the imaginary world. You know, like the eight million stories they claimed were in the "Naked City." Except that you'd have access to more than one, and might also get an access to an imitation of what is going on at the cellular level.

New York–Brisbane—November 19, 1993

How have Wax's *fortunes progressed?*

I'd thought while making *Wax* that I would be able to make back my expenses on it through television sales and that some heartwarming enthusiasm would come in through video art distribution, but it has been a bit of a counterintuitive trek. I found soon that television really wasn't interested in it, and that the video art circuit—at least in the U.S.—was either so uninterested or so moribund that even finding a few places to play was nearly impossible, though it certainly did run through the Euro festival circuit.

Strangely enough for a video-originated piece, its true home turned out to be the art film circuit. After that rather amazing New York opening—for me, with such a small film that wasn't a film—it became possible to book it. The trouble was I still couldn't find a distributor, so I ended up getting some help picking the theaters to approach and, through a huge number of phone calls, eventually managed to place and play it in almost every major market in the country.

The other area where counterintuition ruled was in cassette sales, which really kept me afloat and finally helped put me over the edge. Starting with a suggestion by Steve Brown of *Sci-Fi Eye* that I sell cassettes, I managed to get word out on a limited edition of five hundred signed and numbered copies, which I finally sold out recently. That over, I've given the cassette to a commercial distributor, and video store copies will be out in the next months here in the U.S. Not quite the fate I expected.

A good part of my work getting the word out on the film has involved use of the Internet. Through regular posts on Usenet, the bulletin board of the Internet, I was able to bring the film's play dates in front of a core audience, and assist, in a low-key way, the cassette sales. E-mail made it possible to talk personally to people on most of the continents. A good bit of the film's "cult" identity came from this presence on the 'net.

Through good luck, I have managed to get the film into the international marketplace, and can pretty well claim now that it is the first piece of independent electronic cinema to achieve successful international distribution. The film was picked up in Japan by Uplink and given a Japanese sound track. One of the film's strengths is that with that single voice, it is easily carried into other languages. The film was a success, with a relatively huge press for a small film—*Nikkei* journal called it maybe the best foreign film of the year, which I thought a bit strange. The book and cassette are out, and there are supposed to be a diskette book and CD-ROM.

Wax carried well not only into other languages but also into altered frame rates and, I hope, alternate media. Partly as a result of giving the film a presence on the 'net, I ended up sending it across at about six frames—black and white, with most of the audio—in May 1993, which the *New York Times* gave the business section headline of "Cult Film Is First on the Internet," slightly twisting the point of the event to the five hundred channels rhetoric.

At present, I am working on a hypertext version of the script, with the collaboration of about twenty-five hypertext writers. We're using the crude groupware functionality of the hypertext software, and remaining connected through a variety of Internet tools, as the writers are scattered around the world. This is meant to be one of the front ends to the film—digital—on a CD-ROM. We're not at the point yet where a CD gives full video and easy authoring, but I'm not too worried, as it still looks great at six frames per second. These two projects are test runs for my next feature, which I want to release as hypertext and CD soon after the film. This is not commercial marketing but multimedia, in the old sense.

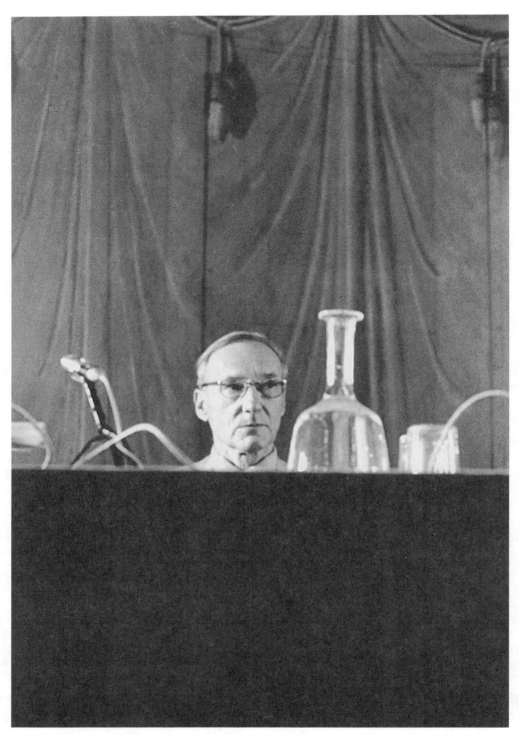

William S. Burroughs, Colloque de Tanger, Geneva, 1975. Photograph by Françoise Janicot.

WILLIAM S. BURROUGHS

WHEN DID I DISCOVER WILLIAM BURROUGHS'S WORK? At school perhaps, in England, reading a local library's copy of *Junky*.

Later, as a student in Norwich in the late 1960s, I'd sometimes hear a local poet—Tim Sillence—imitating Burroughs's inimitable nasal drawl. We all heard it again when Henri Chopin screened Burroughs's *Towers Open Fire* and *The Cut-Ups* for the university's poetry society, and soon after, having hitchhiked to Henri Chopin's First Days of Ingatestone Festival—on June 13, 1970—I found myself sitting opposite Burroughs at a kitchen table and nervously asked, "Could you pass the salt, please?"

I subsequently discovered a copy of the LP *Call Me Burroughs* in a Rouen bookshop while studying in France, and a decade or so later briefly greeted Burroughs during the 1982 Final Academy events in London, when his assistant, James Grauerholz, astonished me by announcing that he could—and would—answer the list of questions that I'd prepared to put to Burroughs. Grauerholz's answers were certainly illuminating, but it was with some relief that I first interviewed Burroughs in Minneapolis in 1983.

Burroughs's answers were uncompromisingly abrupt. His texts were to be taken "quite literally." Words like *mystical* didn't mean "anything." And he didn't really think of himself as the master of fragmented imagery that I'd always taken him to be. "That's a little vague," he insisted, given that "images always cohere" through "a sort of magnetism."

Visiting Burroughs in Lawrence, Kansas, a month later, as twister sirens signaled disaster, we retreated to his cellar, where he introduced his collection of guns: "That's the Winchester, that's the rifle that won the West." Did he like teaching? No, it was like pouring everything into a "bottomless pit." Which authors did he use as examples? An unexpectedly comprehensive reading list followed.

Meeting again in St. Louis in 1989, we discussed his new career as a painter exploring "Space-Art," and meeting for the last time in Lawrence in 1991, Burroughs emphasized his ecological concerns, his interest in UFO sightings, his investigation of shamanistic culture,

his conviction that America was becoming "stupider and stupider," and his enduring admiration for Beckett, Bowles, Genet, and Gysin: "It was extraordinary—you could just see right away this is somebody extraordinary, just as if they had a halo—which they probably do." As Emmett Williams's notes for *Call Me Burroughs* suggest, Burroughs's utterance is also "terrifyingly convincing."

Minneapolis—October 6, 1983

What interests me in your writing is the way your treatment of images seems to reverse that of modernist writers like Proust or the symbolist poets. Like them, you seem to be looking at small fragmented images. But whereas Proust—more often than not—brings these images together in a very harmonious fusion, wouldn't you agree that your work often seems to explore images which don't cohere?

Well, I think that's a little vague, because images always cohere. By nature, there's a sort of magnetism. If you have an image over here, it's going to attract—or attach itself to—similar images. That's simply a matter of the way the words work. There seems to be a sort of magnetism.

But doesn't Electronic Revolution *remark that if you tape-record and then replay certain sorts of images in public, you can cause chaos to some extent?*

Very definitely. That's what happens all the time in newspapers—the whole theory of propaganda and the Big Lie and so on—all uses of words and images and phrases produce a certain effect.

I suppose I was thinking of a more subversive use of images and words than newspaper propaganda. Do you think it's possible to create an antidote to mass propaganda and to insulate oneself against it?

It's possible, certainly, for individuals. A newspaper is looking for statistical effects—it's not expecting to get every individual. If they get something like thirty or twenty percent they're doing well.

Do you have any effect in mind when you're writing that you want to have on your readers?

No. No, you don't think in those terms. You think in terms of what you're doing. It's like—whatever your job is, you're doing the best job you can. But you're not necessarily thinking of the effect.

All the same, some of your experiments in Paris with Brion Gysin and Ian Somerville seem to have explored the general perceptual effects of montages, cut-ups, and so on with the electronic media that were emerging in the '60s.

Well, I haven't done any of those in years, but they were interesting. They explored the whole matter of synchronicity. You can record in the street, and you can take something that you've recorded and play it back in the street, and you observe all sorts of synchronicities. It just makes you aware of certain things going on all the time anyway.

Your collaborative films with Antony Balch and Brion Gysin, such as Towers Open Fire *and* The Cut-Ups, *are also very impressive—they still seem to have considerable impact and authority. Are you still quite pleased with those films?*

Oh yes, I still think they're very definitely milestones. They were experiments that were very definitely worth doing.

What do you think the role of the experiment is in a writer's work? Do you think it's really just a preliminary thing? Or would you say that you're still experimenting?

Well, any writing is experimental. To some extent, you're always trying to do something new in writing. Otherwise it becomes very stereotyped.

You also suggest in The Job *that there's a danger in pushing experiments too far, because you get too isolated.*

Oh, absolutely. You end up like Joyce, writing the great book for twenty years that nobody can read. Oh yes, there's definitely a danger of getting tied up in experiments—experimental fiction which is not very accessible to the reader—and you get sidetracked.

Could your present work be seen as something of a synthesis and a slightly more moderate direction than the earlier writing?

Well, I would say so. It's certainly accessible. Anyone can understand it—or understand part of it anyway. I don't think many readers realize that I mean what I say.

Do you mean that your work is to be taken literally?

Absolutely, absolutely.

This applies, too, to the notion of our destiny in space?

Absolutely—I mean it quite literally.

How do you see this transition?

Well, I see it as definite a transition, and as drastic a transition from time into space, as from water to land—something that will require biological alterations. Of course, they've gone into space in an aqualung. Now this is valuable. It's one governmental expense that I don't grudge. But as I say, it's been done in an aqualung. It's like taking some fish and putting them in an aquarium and putting them up onto the land. Well, you haven't made any biological transition there.

Are there any examples of effective biological transition?

Well, apparently, we're in a state of arrested evolution now. I say that we're not supposed to remain, or not designed to remain, in our present state, any more than a tadpole is designed to remain a tadpole. But that's evolutional change, you see. I mean, evolution did not come to a reverential halt with *Homo sapiens.* And if you accept that fact, then there are bound to be changes—biological changes—sooner or later.

Do you think that this will be speeded up by anything in particular?

Well, it could be speeded up by research directed towards making the human artifact more suitable for space conditions. But of course, this isn't being done, and it's not very likely that it will be done.

In some of your recent writings you also discuss the attainment of immortality. Is that to be taken literally?

Yes, absolutely. You get out of time—that's the point. Most people can only see immortality as time. When someone says they want to live forever, they're talking nonsense—*forever* is a time word. Time is that which ends. Time is limited time. So I'm talking about getting out of time and into space. That is the only immortality that we can attain.

Have you had experience of that sort of thing, or any intimations of it?

Well, everyone has. You're out of your body all the time, and particularly in dreams. It's part of human experience—an integral part of human experience. Dreams are an intimation of what space is like—of what space conditions are. And of course, they've recently discovered that dreams are a biological necessity. So that means, to my way of thinking, that they're a link to the biological and spiritual destiny in space. Dreams are a link to that. And if you cut off that link, you're finished.

I postulate, of course, that man is an artifact designed for a purpose—namely, designed for space conditions and space travel. A society, like the individuals that compose it, is an artifact designed for a purpose. Without the purpose, there's no point.

When you say "space travel," you mean travel beyond time?

Yes—out of time.

Does this put these views in a sort of mystical context, would you say?

Well, *mystical* doesn't mean anything to me. I mean, I'm talking in factual terms, about actual space travel, not about mysticism or some of those words like *romanticism* that really don't mean anything.

Lawrence—November 22, 1983

You've recently been teaching in New York and at Colorado. Could you tell me what sort of things you addressed in your lectures?

Oh well, I started giving a course on creative writing at New York City College, examining the fact of just whether there is a technology of writing, and I don't think there is a technology of writing. Really, I don't think writing can be taught. You can give a few dos and don'ts, which won't necessarily apply. What may be a useful technology for one writer is quite worthless or even detrimental to another. So there is no technology, no hard-and-fast technology that can be taught, the way you can teach someone to fly a plane or engineering

or something like that. So then at Colorado, I've been trying to teach creative reading—to teach people how to read—how to spot whether the writer's playing fair with the reader.

My general proposition is that the purpose of art is to teach people what they know, to show people what they know and don't know that they know. You can't tell anybody anything that he doesn't know already, on some level. And I've been trying to show how some writers do this and some don't. Well, I had plenty, plenty of materials and examples—such as, say, Hemingway—of how a writer got trapped in his style. Hemingway's supposed to be a master of dialogue, but nobody ever talked like people in Hemingway's novels except people in Hemingway's novels. He certainly was a victim of his style. And so on.

Did you find many other writers useful as examples?

Oh well, lots of them. I had several—well, nearly a hundred people on a list. I've got it here somewhere.

Did you find it quite fun teaching?

No. I don't like teaching at all. I don't like classes, I don't like teaching, period. I enjoy performing, at a reading—that's a very different thing. But teaching, you're putting a lot out and getting nothing back. You put things out and they're not going anywhere. It's like pouring it into a bottomless pit. No, I would never teach if I could possibly avoid it. I always cut it down as far as possible. Even if I do teach I keep it more in the form of lectures, so that I can get up and talk, give a lecture, and that's it.

I suppose you spent a lot of time preparing stuff?

A terrible job, a terrible job. I hate teaching. Here's that list! I discussed a number of neglected writers. A writer that I said quite a lot about, a writer by whom I am more influenced than any other, is Denton Welch. He died in 1948. A lot of his books are out of print. He's coming back in slowly. He's certainly the writer who's had more influence than any other one has.

In what respect?

Well, Kim Carsons, the hero of my latest novels, is Denton Welch.

So it's a sort of homage?

No, not a homage, not a homage. He is Denton Welch. He's derived from Denton Welch as revealed in the books. He's the character of Denton Welch. Audrey and Kim Carsons, who are the same person—they literally are Denton Welch. You've not read Denton Welch?

No.

Well, if you really knew his work, you'd see it immediately.

So you might actually be quoting from his work?

No, it isn't quoting. It's just like his voice—it's his style. He had a motorcycle accident at the age of twenty from which he never recovered, and he died ten years later as a result of the injuries. So he only wrote for ten years. I think I've got everything that he wrote.

I see from your list that you also put on some best-sellers like Jaws. *Is that to discuss how they're written or what their characteristics might be?*

Well, there are several reasons. They're to show what the best-seller formula is. There are two. First, "Something you know something about, and something that you want to know more about." Well, that would be *The Godfather,* the Mafia. And second, "the Menace"—the crisis brought about by the menace and then the removal of the menace—*Jaws.* Now the menace can be an epidemic, it can be an animal, whatever. Like the cats, the rats, the birds, whatever. So those are the two main best-seller formulas.

Just because a book is a best-seller doesn't mean that it is a bad book. *The Godfather,* I think, is quite a good book in that it says some very important things about power, some very relevant and profound things about power and the exercise of power. Here's my list of readings. This is much more detailed. I'm always adding to it—it just keeps growing.

Your mention of epidemics reminds me of the outbreak of "Virus B-2" in Cities of the Red Night. *But I think what emerges in your work is not just the threat of an epidemic but a whole dimension of comic intensity, irony, phrasing, and rhythm that is in all your writing—something far more complex than the commercial, monodimensional crisis story. So I suppose there might be problems in being a multidimensional writer, in the sense that your work might be both richer but less commercial than its popular counterparts?*

Yes, well, I talk about that—the devil's bargain as applied to writers. How Hemingway sold out for a safari, and let them make a terrible movie out of "The Snows of Kilimanjaro," with a happy ending. A book about—a story about—death, with a happy ending! And it's that what killed him. And of course, Maugham as an example of the devil's bargain. Now he knew that he had made the devil's bargain.

Have you been tempted to make a devil's bargain?

No. It's impossible. You're never paid to shut up about what you know. You're paid not to find it out. Once you find it out, no one's going to pay you. That's some of the essay material, and I also used that in the class. All those dumb kids, they don't know what a devil's bargain is. They said, "Well, the story still remains 'The Snows of Kilimanjaro.'" I said, "Yes, the story remains. But that's not the point. The point is what happens to the writer."

Another big influence is Conrad—Joseph Conrad. Paul Bowles is also something of an influence. He's written some very good books. Have you read *The Sheltering Sky*? Of course, Jane—Jane Bowles—is the better writer. Have you read her work? She didn't write much, she had terrible writer's block, so her whole complete works could be contained in one book. She was a very great writer. Somewhat related, somewhat similar, to Denton Welch. Nothing special happens, but she manages to make it very interesting.

Did you read *Nightwood,* by Djuna Barnes? Here's another very good female writer, Carson McCullers. A good writer who's been very much neglected is Julien Green. He did some very good stuff in the supernatural genre, which is one of the more difficult of all genres. Let's see—I like some of Graham Greene, but when you've read one you've read them all. What about *Under the Volcano,* by Malcolm Lowry? *Chéri* and *Fin de Chérie*—all the Colette books are very good, I think, short stories.

All Frederick Forsyth books, as well as being best-sellers, are also interesting as the final

antitheses of the psychological novel. In *The Day of the Jackal,* the killer is always seen from the outside. You never ever find out what he's thinking, what motivates him. You're getting as far as you can from *Crime and Punishment.* You just see the outside. And science fiction—this is a very difficult genre in which to achieve any plausibility at all—that it ever could have happened anywhere. And nonfiction books, of course. Very basic to my thinking is Alfred Korzybski's *General Semantics.* He points out that the either/or dichotomy is one of the flaws of Western thought—that something is true or false, instinct or emotion.

Every action is both instinctive and intellectual. So this has set up a false dichotomy, and also all generalities. The journalists start asking me questions about "the American people," and I say, "Who did what, where, and when? Who are you talking about? Book-of-the-Month Club ladies? Are you talking about people who live in ghettos?" I mean, there is no such entity as the American people, as society, as the English people, as the consensus of opinion, or any of those things.

You can't generalize. The whole notion of generality is something of the past. Also, any abstract words like *justice, civilization, communism, fascism, democracy*—you have as many definitions as you have people who use the words. So they're just really meaningless.

Could you tell me a bit more about your idea of creative reading?

I have a lot of exercises I give my students like, well, take any novel that you like and think about making a film out of that novel. Or, say in one sentence what this book is about. Get it down in one sentence. What is this book about? What is *Lord Jim* about?

Is it about loyalties, or making decisions?

No, no, no. Two sentences. "Honor lost. Honor regained." Exactly the same as—have you read "The Short Happy Life of Francis Macomber" by Hemingway? Well, that's a short story. It's "Bravery lost. Bravery regained." It's an old, old formula. Of course, some novels won't break down like that.

And just because you can get a novel into one sentence doesn't at all mean you can make a film out of it. You can get *The Great Gatsby* into a couple of sentences, but you can't make a film out of it. What is this about? "Poor boy loses girl. Poor boy tries to get girl back, which results in tragedy." "Poor boy loses girl to rich man, and tries to get her back. Does get her back for a brief interlude, and then there is a tragic denouement, because he's trying something that isn't going to work—he's trying to put back the clock." And so on. But this isn't film material, because it's all in the prose, in Fitzgerald's prose. That's where Gatsby exists. They resorted to the very awkward device of the voice-over, which has been used repeatedly in films, but is just not a viable device.

At the other extreme, films like Bill and Tony, *where you and Antony Balch exploit super-imposed image and sound, couldn't exist nearly so effectively on the printed page.*

Oh no—no, there's no way you could put that on the printed page. That's the way it is. Some things are much better on film, and sometimes one picture—one short film sequence—is better than fifty pages of text. And then there is prose that you just can't get into film, like the end of *The Great Gatsby.* You have read *The Great Gatsby,* haven't you?

I have read The Great Gatsby.

Good. Well, you remember the end of the *The Great Gatsby*—that's one of the famous scenes in English prose, like the end of "The Dead," by James Joyce, the famous "snow falling faintly—like the descent of their last end, upon all the living and the dead." There's no way that you can put that effectively into film. I mean, you can show snow, but what does that mean? It doesn't mean anything. And the same way with the end of *The Great Gatsby*. And all they could do was a voice-over. Sometimes one works, sometimes another doesn't. But in no sense has the film medium superseded the written word.

Well, at the beginning of The Job, *you speculate that literature must try to produce the same impact as photographs and films.*

Well, yes, the impact, certainly, but they just aren't the same medium. It's not the same medium. When someone says, "Well, the film didn't do justice to the book," or vice versa, they're talking about things which aren't the same medium. You don't even refer to the book. The film must stand on its own as a separate piece of work, quite apart from the book.

Though in many cases, I found it to be a rule, one of those very rough-and-ready rules, that films made from quite mediocre books make the best films. Like *The Treasure of the Sierra Madre*. I saw the film, and it was a great film, but the book was, I thought, quite mediocre. Whereas if Hollywood gets hold of something that's a classic, a classic, then the results are usually terrible. Like, everything of Hemingway's that they've put on screen is just awful. Occasionally they're done Conrad with very poor results. They did *Lord Jim*, come to think of it.

And Apocalypse Now *is a travesty of* Heart of Darkness.

Well, I enjoyed it. I thought the latter scenes, when they got up to this really fake-looking outpost, sort of went downhill. But some of the scenes were good—the battle scenes. But, if you have a film that has, oh, say, ten good minutes in it, that's a pretty good film. A very good film, actually. You can't expect much more.

Do you think any of your works will be made into films?

It depends entirely on a director being interested. But just because something in a novel is visual doesn't mean that it is film material, at all, at all, at all. I think it would be very difficult to make a film of *Naked Lunch*. If you did, you'd just have to take one aspect— well, you do anyway, you just have to simplify. Even when a novel is written for film, like *Jaws,* even there they had to cut out all the subplots because there just wasn't time. So if you have a complex novel—sometimes they really just buy the title and do anything they want.

Well, I seem to remember that you once acted as Judge Hoffman in London, in a dramatization of the Chicago Seven conspiracy trial. Perhaps one solution would be for you to play one of your own characters?

There are some characters I could play, and some I can't. If anything, it would be a bit part, but not one of the main characters.

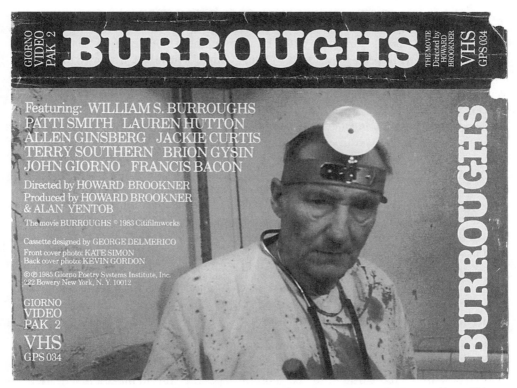

Video cover for Howard Brookner's *Burroughs: The Movie* (1983), with Burroughs as Dr. Benway Giorno. Video Pak 2, 1985.

I believe you and Brion Gysin also did performances with slide projections of images and calligraphics back in the '60s, in Paris.

Yes, Brion did. He and Ian Somerville did a very brilliant performance at the American Center, but I didn't see it. It used the same technique as *Bill and Tony*. You project someone's face onto someone else, and it looks like the face of the person that's projected. So Brion did this thing of projecting a nude photo of himself on himself, and then snapping it off, and there he is in a white robe. And people didn't realize this was done with projections—they thought it was all a film. Well, it wasn't at all.

You've got another experiment—a cut-up reading called Valentine Day Reading—about the last days of "A great American—Dutch Schultz"—on one of Henri Chopin's OU LPs. Were you pleased with the way this worked out?

Well, there were some cut-ups in it, yes. There was nothing very brilliant. Using the last words of Dutch Schultz, I made a lot of rearrangements. I think it had a certain interest, yes.

Did you cut up tapes to make this work, or was it just a live reading?

No, I didn't cut up tapes, just the text. If you cut up tapes it's really very laborious unless you have large tapes. Now you can cut up movie tape much better.

Have you done this?

A very little bit, because it just turns out to be an awful lot of trouble, an awful lot of work, unless you have a really professional facility. I did a couple of little bits. It seemed to be working rather well, and then this thing fell to pieces, and I've never done any more with that. We were working with very simple equipment—just a couple of tape recorders.

Of course, Brion Gysin's poem "I am that I am" was done at the BBC with a lot of technology at his disposal, and shows what the human voice can do when you start playing around with it. I thought it was remarkable.

Do you wish ever you'd had time in radio studios to do that sort of thing?

Not anymore. I mean, I don't have time to be doing that sort of thing now. And a lot has been done anyway. I'd much rather just suggest something, and have someone else do it, and see the results. I don't even own a tape recorder any longer. I never found them any use at all in writing.

Well, would you say that they were useful, then, for taping if not for writing? Because there's that LP of your tape experiments that Genesis P. Orridge issued called Nothing Here But the Recordings.

Oh yes. Well, that was just a little bit from a lot of old tapes I'd made. Those were experimental tapes. But what I mean is that I've never found it at all useful in the composition of writing, because it's more trouble to take it off the tapes than it is to make a first draft. So I really have very little use for a tape recorder now. Because I'm not into any experiments.

I've one last question. In an early article about your work, entitled "Anyone Who Can Pick Up a Frying Pan Owns Death," Alan Ansen quotes from a letter in which you write that you are "tired of sitting behind the lines . . . receiving inaccurate bulletins," and suggest that writing should be "at the front." Do you still hold these views?

Well, yes—this is many years ago, and what I was really talking about are as I've come to see, very basic limitations of the media. And there's just no way you can get around words on a printed page and have a product. The same thing is true of painters—you can have a Happening, or make a brick wall, or all kinds of things like that. But what do they get? What are they selling? They don't have an object. Now you can have writing Happenings, just the same as painting Happenings, but you wind up—you've got no book or canvas to sell, so that's a dead end really.

Where would you say "the front" is now?

I don't think there is any such thing as a "front" so far as writing or painting goes. Some things obviously have been done, and there's not much point in doing them again—even well. There's not much point, for example, in doing landscape paintings such as Cézanne did at this point, or even Monet, because you can do it with photography.

Photography really hit painting very hard, whereas there's no comparable invention that had the effect on writing that photography had on painting. They had to turn away from representational painting, because they spent years painting a cow or a peach or something,

and a camera can come along and do it in a fraction of a second. So that got them moving. But there's nothing comparable in writing.

I suppose some people watch a soap opera like Dallas *rather than reading a book. Television, then, might have replaced book reading.*

Well, no, I don't really think so, because in the first place you've just got a certain amount of very low class material there on the screen. It hasn't replaced book reading. And God knows how many people buy books! You buy a book about something that you're interested in, whereas soap opera—that only reaches a certain audience. It may be large, but it's not—sort of—even below lowbrow.

Are you relieved that your novels are coming out quite easily now? In the '60s and so on a lot of your work was being published in dozens of little magazines.

Oh well, I never had much trouble. Remember that censorship trouble was minimal with my books, so that really wasn't a problem, although at that time I was doing a lot more with little magazines than I do now. I couldn't sell things to *Vanity Fair* and magazines of that caliber at that time, which I can now. Oh yes, of course, it's a much better situation so far as I'm concerned.

St. Louis—April 27, 1989

Would you say that your painting represents a substantially new activity?

Well, yes, but it dates back. I've been working with montages for many years since the '60s, with the whole concept of image, illustrated image, image to illustrate writing. So it's not a new idea. But painting as a separate career from writing is. That is, I had my first show little more than a year ago, at the Tony Shafrazi Gallery in New York, in December 1987. Yes, the idea of actually painting on paper without photographs, montages, or collages is new.

Your earlier scrapbooks have always used graphics and images and photos and typed and hand-written words and so forth.

They do, yes. Well, there's some of that in the painting. I have a photographer who takes close-ups of the paintings. I'll say, I want this part and that part. Then I'll use those in other paintings. Or I might blow one up and make it the center of a painting and paint around it.

So you're actually recycling elements?

Yes, taking a piece of a painting here, and putting it over in another painting. The cut-up method, the montage method, moving bits and pieces around.

Are you exploring abstraction rather than recognizable images?

No—that's what I'm looking for, a recognizable image. There are a lot of secondary images. In a lot of paintings there'll be a portrait. If you look around there'll be a lamp, a curtain,

or a wall, or a cloud or faces—quite definitely recognizable images. I like to concentrate on those.

Do these things emerge more by chance than by deliberation?

Well, I don't believe that anything is random. But they certainly do not emerge by conscious manipulation. You won't get anything that way—it's not the way it happens. It happens with the hands, or whatever. These images are quite clear, anyone can see them. It's not subjective—they're there, quite clearly. Then I use a lot of silhouettes.

I may make a painting using random techniques like shotgun blasts of paint across the surface, and then impose random order by putting in quite recognizable silhouettes of faces, of trees or cars or whatever—the silhouette of a bottle, anything—so the viewer can see something clearly.

Towards the end of your essay "Entrance to the Museum of Lost Species," you say that you are interested in "unforeseeable, unpredictable images and patterns."

Well, a lot of them are ambiguous. But *Long Radio Silence over Portland Place* (1988) is an image of Portland Place—a place right here, in St. Louis. It's one of the private sectors, so they have big posts, with a chain across it.

So it's a picture of a particular environment?

Yes, sure. It's like snow, snow on everything, the gates, the windows.

Did you want to do a painting of Portland Place, or did Portland Place emerge?

Portland Place emerged. I name them afterwards. After the picture is finished I see what it is.

This process seems reminiscent of some of the references to Paul Klee's writings that James Grauerholz quotes from your journals. Is Klee a painter you particularly like?

Well, I like his painting, but I also like what he has to say about painting. It's more interesting than anything I've ever heard from any other painter. He says that the painter—and the writer, too—is trying to create something that has an existence apart from the painter and the writer, which can in fact even put him in danger—which would be the clearest proof of it being separate. And he said, "Art does not render nature, it renders visible." That is, the artist sees something that others don't see, by seeing it in painting. Painting it renders it visible.

What new things do you feel you've been able to explore in painting, as opposed to verbal media?

Well, there's the obvious difference that painting can convey simultaneous images and events that you can't do in writing. In writing you have to move from here to here to here. There's another thing—you can't help but know what you're writing, just by the thoughts and process of writing it. But with painting you don't know—you see with your hands.

In another of your famous statements, you quote Brion Gysin's assertion that "writing is fifty years behind painting." Does your painting allow you to catch up with the present?

Well, I attempt to. But you see, there are differences in the medium. In writing you've got a book, you've got a page, which must be read in a certain way, and you can't get away from that. In painting you have a medium—you have a frame. So there are these given limitations.

But in painting you have a more immediate juxtaposition of images?

Certainly, because in writing you have to translate. You've got the words there, and the reader has to translate those into images. Whereas in painting you have the images there. You don't need to go through the process of translation.

Has there been any feedback from your painting into your writing?

Oh yes, I find that very often. I was writing this book called *Ghost of Chance* when I was very heavily into painting. And I found very often that my paintings were illustrative of passages in the book.

Which one seemed to come first? Did you find that you were writing something that you'd already painted, or that you were painting something that you were writing?

Both. I may paint something that I will write later, or write something that I will paint later, and so on. There's no necessary sequence.

I like your comments on the paintings—in fact, the paintings seem to be very good subject matter for your writing. In your text "Entrance to the Museum of Lost Species" you were saying that in one work, "Winston Churchill comes into focus, cigar and all," adding, "So what is the mission of this dim grey agent, looking at the chewed butt of Churchill's cigar? No one will ever know." The paintings seem to have that pleasant air of mystery which seems to suit your writing.

Yes, they should have a certain uncertainty or ambiguity. Not should have, but they do have, a degree of ambiguity. This one, *Curse of the Red Seal* (1987), is a mixture of all kinds of things. There are shotgun blasts there, there are photographs here. There's a photograph up here of one of the paintings, reduced in size. So there's quite a number of different elements—brushwork, silhouettes, montages.

This seems to be in the tradition of some of the collages in The Third Mind, *where you and Brion Gysin juxtaposed texts, reduced images, and handwritten commentaries.*

That's right, yes. That one, *Heart of Darkness* (1987), has got a lot of shotgun blasts in it; there's no collage there, no photographs.

Do you have any preference for using photographs or not?

No. It depends upon the picture—entirely upon the picture.

I think I prefer the ones with the photographs. Maybe because I like some specific images.

Well, sometimes I only do one with spray paint, and I take one look at it, and I say, "No, don't add anything, no brushwork." Then I do something with brushwork, and I say, "I'm not going to have any spray paint or anything else—just leave it as it is." The most important

thing for a painter—certainly, I find this to be true—is to know when a painting is finished, and nothing's to be added. If you make too much of a mistake, and then you try to rectify it, it gets worse. In some cases, where I've made a mistake, I will just put a photograph over it.

So, photographs to the rescue!

Photographs to the rescue, absolutely. Sometimes it may work very well—just what it needs. But there are no hard-and-fast rules.

Has your painting changed much since you began?

It keeps changing all the time—I don't like to keep on doing the same thing. I began by shooting at plywood. Where the blasts came out you get all these striations of wood—some of which were very interesting, and some of which were not. Then I started using tubes of paint, and I began putting brushwork on first, and brushwork on afterwards. So it soon progressed.

Are some of these works painted from different directions like Brion Gysin's calligraphies?

A good many of them are painted up and down and crossward. So then there's the question of which way the painting goes. Well, I think of these as being Space-Art, and there is no up and down in space. So it's not always easy to say. It can go one way, or it can go another. It can probably go four ways, or in any number of ways. I've been meaning to do other shapes like circles—it's a question of getting plywood cut in different shapes.

When we spoke last time, some years ago, you were quite enthusiastic about popular fiction like The Godfather *and* Jaws. *Does popular imagery of that sort enter your paintings?*

Not much. It certainly is not pop art in any sense. I'm pretty far, should we say, from Warhol and David Hockney.

Your work often seems more primitive, ritualistic, or magical perhaps. The Milky Way, *for example, looks rather like some kind of cave painting.*

It's supposed to be, yes. It's supposed to have an element of magical invocation. Then there's a whole series called *The Land of the Dead*—a number of paintings illustrating the land of the dead in *The Western Lands* and *The Place of Dead Roads*.

Have you begun any more sustained fiction since The Western Lands*?*

Well, I've just finished one—*Ghost of Chance*—which is about the lemurs on Madagascar, and Captain Mission's pirate settlement there, and also about Jesus Christ. It's a short novel, and it's also illustrated by about fifteen of my paintings. Also, I've been working on a libretto for an opera that Robert Wilson is doing called *The Black Rider*. It's an old German folk thing about selling out to the devil—the devil's bargain, which is always a fool's bargain.

What's The Black Rider *about?*

Well, this man, he wants to be a forester, because he's in love with the forester's daughter, and the forester must have a hunter as his son-in-law. But he can't hit anything. So he meets

someone peg-legged, an old soldier, who is the devil, who gives him these magic bullets—they always find the mark. Then he has to go to the crossroads to make more, with all sorts of spells and invocations. Sixty of them are his, and three belong to the devil.

The windup is, having used his sixty, and with two misses, he's got one left, belonging to the devil. So he's shooting at a dove, on a branch over here, and his betrothed is over here with some other people. So when he fires, she falls to the ground, and they think she's fainted, and they turn her over, and the bullet has hit her in the forehead and killed her. So the last scene, he's in an asylum. Now it's not my story, but I've made a number of notes on it. I suppose he will use them—I don't know. This is in Hamburg, in September, so I suppose I'll have to be there for a couple of weeks.

Do you have any other projects on the boil?

Well, in two weeks, I go to Basel, where there's a show, and Rome, where there's a show. These are very crucial—Rome is very important. Keith Haring told me: "Listen, after the first six or seven, you don't have to go. But you have to do it at first."

So, this is the spadework?

This is the spadework, yes. I went to all of them. There was the October Gallery in London, there was an art fair in Amsterdam where I had some paintings, there was Vancouver, Seattle, and Santa Fe. And then I'm just back from Montreal and Toronto. All of those, I've been to.

And are you stoically tolerating it, or are you enjoying it?

Oh, I enjoy it. If you're going to do something, you have to do it, and if you have to do it, you enjoy it.

William S. Burroughs, *The Milky Way,* 1988. Paint on black matte board.

Lawrence—June 10, 1991

The last time we spoke I think you were writing the libretto for The Black Rider, *your collaborative opera with Robert Wilson and Tom Waits.*

Yes, I spent eleven days in Hamburg, went to rehearsals at seven-thirty, got out of there at two-thirty, then I'd write for the next day. Udo Breger and James Grauerholz were also there, at the same hotel, and then they would translate it—so we had the German text the next day. It took ten days of very intensive work. Now that was in September 1989—the opening was scheduled for March 31, 1990. Then, two or three weeks before the opening, they met again, sending faxes back and forth, saying they wanted this changed and that changed, so I did a lot more work at that time. Then I went to the Thalia Theater for the opening.

I don't know if you know it, but it was a tremendous success. There were fifteen curtain calls, which is almost unheard of. And someone timed twenty-three minutes' standing ovation. I was very gratified of course. When I wrote the libretto, I was emphasizing the similarity between heroin addiction and depending on the magic bullets. The more he depends upon the magic bullets, the less he can hit without them. So finally he can't do anything without the magic bullets. And as I say, he's "hooked, heavy as lead."

What did you like best about Wilson's work?

Oh, it's terrifically effective pictorially—he's a genius when it comes to putting on an effective scene adaptation.

Did the collaboration lead you to things that you hadn't done before?

Well yes, it was all something that I hadn't done before—I'd never done any theater. But it hasn't led to anything further—to any further work in the way of theater.

Would you like to do more theater?

Well, I might, yes. I had an idea that I sent to him—I don't know if anything will become of it—of an opera based on *Paradise Lost,* where Lucifer and the fallen angels have been the victims of an atomic attack and they're picking themselves up out of the ruins of Hiroshima. Well, that's the general idea. I wrote a few pages on the possibilities.

I was just looking at one of the drafts of your new novel, Ghost of Chance. *What would you say were your main concerns here?*

Well, just what's in there. The whole matter of lemurs, Madagascar, and also Christ. Who was Christ? Did he actually perform the miracles attributed to him? Yes, I think he did. As you know, the Buddhists are very, very dubious of miracles. They say, "If you can, don't." Because you're disturbing the natural order, with incalculable long-range results. So there's a lot to be said for that.

Is this symptomatic of a sort of ecological impulse in your writing?

Good heavens, yes! The destruction of the rain forests is one of my principal concerns. Overpopulation—it comes down to overpopulation—they should put contraceptives into

the water supply! Not only do you have a proliferation, but it's a proliferation of a third-rate product.

I think Ghost of Chance *talks about this—about species wearing out?*

Yes—well, it seems we're getting an increasingly flawed human product. It's incredible. In a recent poll, something like half of high school graduates could not locate Vietnam on a map and didn't know we'd fought a war there, much less that we'd lost a war there. And when it comes to World War Two—no idea who Churchill was, or Stalin—"Stalin, don't know about him!" Now these are high school graduates! It's appalling! Then there was a sex poll, and half of those polled thought that homosexual intercourse could cause AIDS, even though neither party was infected with the virus. Good heavens, what is this—the immaculate conception? It's appalling. People are getting stupider and stupider and stupider! There's no doubt about it.

Is this enough to drive you back to teaching, to try to remedy it?

No. No, no, no, it's past that! It's past remedy—it's hopeless. There's nothing you can do with something like that.

Except, I suppose, satirize it?

Well, this is going to have almost no effect. There's a very minute percentage of people who come in contact with anything that I do.

All the same, you've recently contributed some thoughts on drug hysteria to High Risk.

Well, I said what I had to say about the whole preposterous war against drugs. It's a very calculated move to increase police power—that is, to use this hysteria in order to increase police power and concentrate power in the bureaucracy, in Washington, D.C.

Looking back over your career, are there any other things that you feel you still have to explore, or would still like to do?

Not much. I'm not doing any traveling nowadays, so there's not too much left to do. I'm very interested in Indian shamanism now. Shamans can really call up the spirits, and there's one who will be here in a couple of days, and I hope he can demonstrate. Most of the shamans come from Dakota. A friend of mine called Bill Lyon, an anthropologist who specializes in shamanism, has spent twelve years with Wallace Black Elk, and he wrote a book—*Black Elk: The Sacred Ways of a Lakota*. He tells how Black Elk calls up spirits—animal spirits of all kinds. He's done it in front of physicists.

And what happens when he does this?

The spirits come up. It seems that they want to answer questions.

Do you have questions for them?

Lots of them—sure! There's also a healing ceremony. They've had rather good luck with AIDS patients—I know of two rather remarkable remissions they've got from healing

ceremonies. Well, anyway, you can pick up a copy of that in the bookstore here; it's out now in paperback.

I'm also very interested in all of these space aliens—their flying saucers and all that. I went to see Whitley Strieber, who's the author of a book called *Communion,* about experiences with "the visitors," as he calls them. I visited him for a weekend in upstate New York, but I didn't see anything—they're really sporadic. But I'm convinced that he's telling the truth, no doubt about it. All the people living around him all say, yes, they have seen these things, but they don't want to talk about it. He puts out a *Communion Newsletter* with thousands and thousands of accounts. So I'm convinced that it's a real phenomenon. I'd just like to see some myself, that's all. As a matter of fact, there've been sightings in Kansas, and some out at the lake—where I have my house on the lake—but I have not been favored.

To put things very simply, your writings and your years have both always been explorations of new things?

Yes—sure—always, always.

Do these explorations culminate in any sort of overall message to your readers?

No, I don't have any overall message. I'm not an enthusiast for overall messages!

Who do you think are the most illuminating people that you've come across?

Brion Gysin more than anyone else—the only man that I've ever respected. Then there are a number of others, Jean Genet, certainly. Beckett I never knew well enough—I only met him on two occasions. And Paul Bowles, whom I know quite well.

What is it that you find most remarkable in these writers? Is it possible to say?

Oh well, they're special people—insight, talent. Jean Genet had an immediate impact. I don't speak French at all well, and he spoke almost no English, but there was never any trouble communicating. It was extraordinary—you could just see right away this is somebody extraordinary, just as if they had a halo—which they probably do.

Were you all exploring any particular common problems or terrain?

Well, they're all different—they're individual artists. Paul Bowles wrote a very great novel, *The Sheltering Sky.* Also, *Let It Come Down* and some of his short stories will stand up. Brion, I think, was a very great painter who was never appreciated. And Genet was sort of classical French prose—I'm surprised he didn't end up in the French Academy. And Beckett of course is Beckett—something very extraordinary and special—there's only one Beckett.

Genet says some extraordinary things about writing. He says that "the writer undertakes the responsibility for the characters he creates," which he regards as real—as real beings, which I do, too. As Klee says, "Any serious artist is trying to create something with a life of its own, apart from the creator, and apart from the canvas"—the canvas and the words are very much the same thing. Genet, of course, didn't do very much writing in the last years of his life. Although there's one book, *The Prisoner of Love,* which I've just finished reading, about his two years in Palestine with the Palestinian guerrillas. That's quite a fascinating

book. It's quite different from anything else—there's no sex at all. And it skips around a lot. It will just be a bit of this and a bit of that, but it manages to hold one's interest. It's very much like what I've been doing lately—here, in *The Book of Dreams*. There are essays, there are little bits of short stories—all kinds of things are interwoven.

The most interesting dreams for me are those that contain absolutely no relation to any waking experience. I notice a change in my dreams, say, in the past three or four years. I used to be much more aware of dreaming, when I was dreaming. In many dreams now, I'm not aware that I'm dreaming at all. It's completely real, and completely different from anything before in my waking experience. Many, many dreams about the land of the dead, in which I can never get breakfast—always looking for breakfast.

And if I can't get breakfast, and everyone I see is dead—people that I know are dead—then I know it's the land of the dead. Here is one of these examples of meetings with strange creatures: "Dream flashes a creature nearly three feet in length. He had clear, enormous pink eyes which then turned red. I touched his head and found that he was burning with a fever."

Do you think technological advances offer much hope for the future?

Well, we have all this technology and ways of disseminating information, but you have this appalling ignorance. So you have all this technology, but what's it doing? Are people becoming more aware, or are they availing themselves of all this available information? Apparently, not at all.

So maybe that's the challenge—to work out what the potential is?

I don't think there is any. It's sort of strange, but we're just getting stupider and stupider. I think one thing that characterizes the present day are these separations between, say, people who have any awareness and the mainstream, which is just sinking into a complete state almost bordering on the far side of idiocy. There are going to be more and more stratifications, separations and gaps between people, and there's no cultural cohesion at all.

Is this maybe why you're interested in things like shamanism, because it's a return to something fundamental and substantial?

Well, it's not necessarily a return, but going on—going on to some sort of basic change, biologic change, mutations. That's why I'm interested in this whole space alien concept. Apparently, they're way ahead of us, and they're not very impressed with the contact. Because it seems to me, that speaking of the mainstream—it's going nowhere—it's going nowhere rather fast. It's appalling.

No politicians, of course, can address the issues—such as the destruction of the rain forests—or take the measures that would be necessary, in time. They will not do anything until it's too late. The only thing that gets homo-sap up off his dead ass is a foot up it! And that foot usually comes too late. They won't do anything about it till it's much too late. Till they've destroyed the ozone layer, or destroyed whatever it is that's being destroyed. They're destroying the rain forests—the lungs of the world—until something drastic happens. We'll suddenly say, "My God, I can't breathe!"—and then it will be way too late.

Do you have any other predictions for the next decades?

All bad, all bad. More and more overpopulation and pollution. So it just looks bad all around. There are people doing what they can, doing admirable work—environmental organizations and institutes and animal conservation—but they're pretty much a very small number.

I'm doing paintings on the seven deadly sins, and also writing on each one, showing the ravages of, well, avarice, for example. That's at the back of all this destruction of the environment. Companies—they don't care what happens to the rain forests or anything, so long as they can made a good show in front of their stockholders.

And so on, and so on, right down the line. Sloth, that's the whole bureaucracy. "Take the easy way! Go by the book! Don't stick your neck out!" And then, anger, of course—pride and anger. The war against drugs as an example of stupid, undisciplined anger—hysteria manipulated by interested parties. And it's a pretty bleak picture.

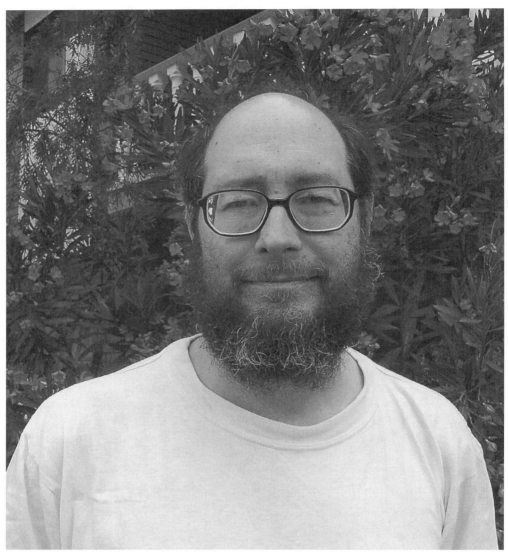

Warren Burt. Photograph by Catherine Schieve. Copyright 2003. Courtesy of the artist.

WARREN
BURT

AS I LISTED THE NAMES OF THIS BOOK'S OTHER CONTRIBUTORS for Diamanda Galás when we initially talked in 1996, and advanced from "Acker" to "Burt," Galás delightedly exclaimed: "Warren Burt! The first genius I ever met!"

I met Burt, an expatriate American, long resident in Melbourne, at one of his performances in Brisbane, and since then we've regularly gotten together, to exchange news, views, and ideas as we've traveled to and fro. On first interviewing Burt in Melbourne in 1989 I was particularly intrigued by his collaborations with another great mutual friend, the Melbourne, and now New York, poet Chris Mann, with whom Burt has spent several decades elaborating successive performances fired by Kenneth Gaburo's concept of compositional linguistics.

As Burt explains, his career really accelerated in the high-energy early 1970s in San Diego, where he met Gaburo, David Antin, Galás, Kathy Acker—to whom he dedicated his first text-sound epic, *Nighthawk* (1977)—and Chris Mann, "in his early days when he came through." Subsequently moving to Melbourne, Burt rapidly established himself as one of the major catalysts of 1980s and '90s Australian multimedia collaborations interweaving music, poetry, performance, video, radio art, and more. Burt's "intermedial" aesthetic is as multifaceted as its cultural contexts: "There seem to be as many different collaboration procedures as there are collaborations that I've worked on. I don't think there's any one way of doing it, even with the same person."

Reading through these interviews, I notice how both Burt and his San Jose contemporary Larry Wendt typify the way in which the younger veterans of the high-tech avant-garde cheerfully alternate between the highbrow and the farcical, maintaining their "right to do both." Yet as David Blair remarks, "What you never see talked about in postmodern critical theory is how absolutely crucial comedy is."

One of the most perceptive innovators within the international multimedia avant-garde, Burt was the ideal person to write the afterword to my essays in *Critical Voices: Myths of Postmodern Theory*. He incisively concludes:

It becomes clear that the work of many contemporary critical theorists is as irrelevant to our artistic concerns as our work is to theirs. Surely we, as artists, and as intelligent perceivers of the richness of the contemporary environment, have the right to demand interesting, lively, broad-minded, and informed responses from, and dialogues with, our critics and cultural theorists. And if they fail to measure up to these criteria, surely we have the right to be as contemptuously dismissive toward them, and their works, as they have been toward ours.

Melbourne—July 13, 1989

Can you recall how you began your career as a composer and a multimedia artist?

Well, the years of my undergraduate education—1967 to 1971—were a very wonderful time when, for a while, people thought that there were no boundaries between the various art forms. Although I was studying music at the State University of New York at Albany, we had this wonderful course that looked at visual art, music, and literature as a continuum of stylistically related things.

So it never occurred to me that these were individual disciplines. Rather, I saw overarching ideas among all the art forms. It was quite natural for me, even as an undergraduate, to hang out with sound poets and with video artists and so on, although I didn't actually make my first sound poetry performance or video art until I went to California.

From 1971 to 1975 I worked at the University of California in San Diego, which was everything that Albany had been, squared—there was even more interaction between the various art forms. I was working with people like Kenneth Gaburo and had contact with David Antin, whose talking poems were well known then, and I was the head of the analog electronic music and video studio at the Center for Music Experiment from '73 to '75. Also, there was a lot of voice work in the air—it wasn't just sound poetry. For two years I was a paid member of the Extended Vocal Techniques Ensemble, which had a grant from the Rockefeller Foundation to research the limits of the human voice. We researched many different vocal techniques like Mongolian harmonic chanting and Tibetan chant and many other techniques—ingressive sounds, vocal fry, and all sorts of ululations.

Speaking of name-dropping, there was this young undergraduate student, a friend of mine named Diamanda Galás, who came to us saying, "This stuff looks fascinating." And she certainly picked up on that voice work and took it to some amazing places. I also was very much influenced by Kathy Acker, who at this time was a graduate student and a friend of mine at San Diego. I liked the way she was cutting up texts at that point. All this led to my first large-scale sound poetry thing, which was called *Nighthawk*.

When was this?

This was in 1973. *Nighthawk* has three huge sections. One is a sound poem which is an hour long. It's a collage text, and all the punctuation is performed by hand gestures. Any scratch-outs in the handwritten text are realized with inhaled vocal sounds.

The first two of the forty paragraphs are collages from a number of sources—Burroughs, Le Corbusier, socialist realist fiction, and so on. The texts of the first two paragraphs form the material for the next two paragraphs, which then form the material for the next two

paragraphs, and so on. It's all done with random Fibonacci numbers determining where you begin and how many words you take, cutting things up. By the end of it, with the decay of information, it becomes a mantra on two or three or four words.

The second part is a composition for four-channel tape and slides of the text, because what's happening to the text on the four-channel tape is so elaborate, you almost need a road map to follow it through. The third part is an eighty-minute-long video piece, with colorization and text and musique concrète.

The main source for the text of part three is Australian newspaper hoardings. I started the piece in '73 in California and finished it in late '76 in Australia. I performed the first section of *Nighthawk*—the reading section—about forty or fifty times, in a number of locations. The entire thing, a three-and-a-half-hour monster, was performed on a tour in 1976. There have been two or three performances in Australia, in Melbourne and Sydney, and fourteen performances in the U.S. Sections of it have also been done in Europe.

Since 1980, my work as a sound poet has involved me in a number of collaborations. I've worked with Chris Mann extensively, I've worked with Amanda Stewart extensively, and I did the sound for Barry Hill's radio piece, *Ghosting William Buckley,* which was nominated as Australia's entry for the Prix Italia. I also worked with Chris Mann, Walter Billeter, Les Gilbert, and Kris Hemensley on the radio piece *Words and Sounds in the Australian Landscape,* and produced a whole show of Jackson Mac Low's work for the Australian Broadcasting Company's *The Listening Room.* Upcoming with Kris Hemensley is a piece called *The Mysterious Baths,* which we'll do for ABC radio.

Although it may sound immodest, I'm probably to radical Australian experimental poetry and sound poetry what Schubert was to the poetry scene in Vienna in the early 1800s—in that as he worked with many of the hot poets in Vienna, I've done the same with the sound poets in Australia.

Would you agree that this kind of multimedia is largely characteristic of West Coast aesthetics in the '70s and the '80s?

Oh, very much! At that point in the '70s we all quite naively thought that now that all the world's cultures were available, it behooved us to learn them, and to see what other cultures were doing, for the revivification of our own culture. There really was a sense that we were trying to rebuild American/European/Western culture from the ground up. That's what minimalism was about in the first place—back to square one, back to one note, and on from there.

How cerebral was this rebuilding impulse, as opposed to being expressive or subjective? How important was content or theme, as opposed to the identification of new aesthetic possibilities?

Like all the people I worked with—people like Kenneth Gaburo, Ned Sublette, David Dunn, even Chris Mann in his early days when he came through—I never actually made that distinction. For all of us there was no distinction between what you were saying, and the way you were trying to say it. I've never, I think, done a structuralist exploration just for its own sake. At the same time, I don't think I've ever written a piece that was purely an expression of emotion or content. Everything is tied together.

I mean, *Nighthawk* can be seen as random numbers on some selected texts. And the texts themselves were selected at random. But I took these texts from my favorite books—here's

where taste comes in. But then, random numbers picked things out of them. But then again, by the time I was performing it, it was full of meaning—whatever that means—with all these delightful threads that are followed through, often very funny things. So it's like a lot of mathematical games—you have a few very simple rules, but they generate enormously rich things.

The structure used in the reading of *Nighthawk,* part one, relates a lot to work that I've done up to the present. I'm very much involved in both random number systems and recursive systems—systems that generate themselves. A lot of my instrumental and electronic music for the last few years had investigated the idea of self-generating systems even more vigorously.

I've used, for example, *The Game of Life,* which is a computer game with very simple rules, to generate a score—*Voices, Tuning Forks and Accordion*—which was performed by the Astra Choir a few years ago, with forty singing voices, each one also playing a different tuning fork and a retuned accordion. And at the moment I'm investigating the potential of Strange Attractors—which is a part of Chaos theory—for generating computer pieces.

Would you want to argue, like Cage, that such systems can place us within a more profound harmony?

No, not really. As Ron Robboy said in the film *Der Yiddisher Cowboy,* which I made with him in 1979, "The thing about Warren is that he can take any thin thread of trashy material and make a piece out of it."

For many years, as a source of random numbers, I was enamored of dream books, which are gambling charts formerly used by the black American population. You have a dream about, say, a turtle, and you look up "turtle" and it says "379," so you bet that number in the lottery next day. My take on that was that John Cage's use of the I Ching—a form of random numbers that had been evolved by the Chinese nobility—was very Apollonian. And as a young postmodernist punk, I wanted to have something that was more Dionysian and gritty—with the people. So I used random numbers which were based on the numbers racket. Cage had used Chinese nobility—I used the Mafia. The idea was "any thin thread of trashy material."

This seems to fit in with Nighthawk's *use of playful noises and sounds in the place of traditional instrumentation and language.*

Yes. The second part of *Nighthawk*—the piece for four-channel tape and slides—is subtitled *Three Poems of Substitution and Reassemblage.* In this piece I recorded the text and then substituted the sounds of toys for certain words. A word circled in green would mean one sort of toy, whereas other colors indicated other sorts of toy instruments. These texts were then projected on the wall, so that the audience could follow it through. It's a very busy text.

Were you also using very much technological manipulation of language and sound in the Nighthawk *period?*

No. This was on tape, but the only technological manipulation was recording and mixing. Although I had done pieces with electronic modification of the voice before this, in *Nighthawk* the sounds and the text were rich enough. You didn't have to technologically modify them. But just after this piece, Chris Mann and I began a whole series of pieces where we electronically modified the voice. However, *Nighthawk* did involve a certain amount of image modification. In the final section, the newspaper hoardings were first recorded as sound, on tape loops, about one minute long.

I was at La Trobe University at the time, and we had tape loops that ran the whole length of a hallway. Two tape loops would fade against each other. When they first went through they would actually combine quite nicely, but after the first time through they were out of phase, and so you'd have a collage of newspaper things. I also tried to use the headlines in a way that had a strong visual impact. You know those wonderful corny things in old movies, where a newspaper headline spins towards you, and then comes into focus? Each of these headlines also did a thing like that on two loops of Super 8 film.

I remember spending the better part of two weeks in my flat with a Super 8 camera, doing single-frame animation, getting all these film loops happening, and then videoing them, and juxtaposing that video with a tracking shot that we had done out of a train window, and so on. It was quite a complex piece. Then the whole thing was colorized with a really sickly pink, which obscured a lot of the detail. The piece is so intense and so monomaniacal for so long—eighty minutes—that not too many people have been able to stand it. I haven't actually looked at it in a decade myself, but I have a feeling it's now going to seem quite mellow and quite melodic.

Did you explore similar effects in your recent Collaboration *pieces with Amanda Stewart?*

Yes. In one section of *Collaboration* which we've performed as an independent thing in New York and in Australia, I play fragments of her voice back to her. First of all, she improvised nonverbal sounds, and when I heard a sound I liked, I pressed the record button on the sampler. Having recorded seventeen of these little sounds, I then set them up across my keyboard. I reversed some of the sounds—she's so musical that it actually forms a melody—and made loops out of others. In performance, I will be playing on the keyboard, and Amanda will be improvising. We'll toss motifs back and forth, so that if I make a particular sound, she'll make a sound that in some way reflects it, which forces me to something else. There's a real give-and-take.

How liberating do you find such collaborations? Do they offer valuable alternatives to the aims of your solo performances?

Oh, absolutely. The reason you work in a collaborative way is to do things you wouldn't normally do. I wouldn't have explored these problems as intensely or in such depth without working with Amanda.

The other collaboration, which is quite remarkable as far as I'm concerned, is the one between Chris Mann and me, which has now been going on since 1974. We have done a lot of work over those fifteen years now, where there is real give-and-take. He'll make a suggestion and I'll panic, and I'll say, "No, that's not possible." And three days later, I'll phone him up rather sheep-faced and say, "Oh yes, we can do that rather easily—here's how we do it—and by the way, if we do that, then this thing also becomes possible." And he'll say, "OK, that's fine, but what about *da da da da da*?" And I'll say, "Oh no, that's not possible." And three days later, I'll phone him up and say, "Oh yes, it is possible."

So it's this sort of back-and-forth. With the things that I come up with, he says, "Yes, that's a good way to do it," or "No, that's not." Some of his ideas have proved completely impossible, or have involved much more labor than I've been able to put in, at which point he then is quite happy to change his idea. Chris is an eminently practical performer, so the work we do is pushing the technology that we have to the limit, within a limited time.

New York—January 14, 1991

Warren, now that you're in New York for three days rather than in Melbourne, are you tempted to think of yourself more as an American composer?

In Australia I'm considered an Australian composer—in America they consider me an expatriate. Basically, I think the idea of nations is a dumb idea. In terms of influences, my early influences were all American artists. The people I work with now are almost all Australian.

Do you find yourself bringing something American to Australia?

Yes, to my great embarrassment, I have to. In the '70s I was accused by a number of Marxists of being an agent of American cultural imperialism. And I'd have to say, "In essence, yes— but I hope that the American culture that I'm being an imperialist for is, in fact, the alternative traditions of American culture, which is the tradition that actually opposes a lot of the crap the U.S. stands for."

Musically speaking, what is this tradition?

Musically, the tradition stems from people like Charles Ives and Harry Partch, John Cage and Henry Cowell. It's a tradition of experiment, it's a tradition of open-mindedness, it's a tradition of tolerance and embracing things. It's a tradition of trying to find out how things work, why things work, and not being afraid to go beyond accepted limits. In terms of social functioning, these are composers who all started out writing fairly traditionally, and all went beyond the traditional sociologies of music. They all tried to change the sociology of where they were playing. They didn't work with the accepted chamber ensembles anymore, but made their own ensembles and their own groups.

Would it be fair to say that these changes either go forward, with high technology, or go backward by reexploring past traditions?

Well, no. They neither go forward nor backward. It's a parallel stream. The accessing of high technology is one thing, the accessing of world musics is another, and in someone like Cage— or like Partch—you can see them absolutely hand in hand, in radically different ways.

The criticism of the accessing of high technology is that you're simply using the castoffs of what Allen Ginsberg calls the "suck-ghoul-strangle-death culture." The criticism of the accessing of world musics is that you're raping the Third World for your own petty gain. This is a criticism that's also leveled at Australian composers who use Asian music.

The reply to the technology question is that since this technology exists, it's up to artists to show that it should be used, that it can be used, and that it must be used for peaceful purposes and the expansion of the human spirit. And the reply to the world musics question is that we *are* all in one world now—one planet. And if we choose to be interested in the musics of our neighbors, it is to be hoped that those musics are used cooperatively, with sensitivity and with a political consciousness that respects their point of origin.

How have these questions influenced your practice?

Well, I think I've been very careful—for example, I can quote a piece that Sylvia Staehli and I collaborated on in 1989, entitled *Free Trade Zones,* which was a dance piece using Simon

Veitch's video system, 3DIS. Here, the audience has a text about the exploitation of women in the Third World by the electronics industry, which is taken from firsthand reports by workers in the field, like Aiwa Ong, and Sister Mary Soledad Perpiñan, who's a nun and social activist in the Philippines. So we have a text from these two women in the program notes that the audience reads. Then, while this is happening, Sylvia is walking around the space. It's a very pedestrian dance—we consciously said, "Let's go back to early post-modernist pedestrian dance forms here."

She's wearing a peasant skirt, and as she walks around, and as the audience is reading about the exploitation of women by technology, she hits these areas in space which have the potential to turn on various fragments of Third World music. It doesn't always happen—there's a random element—but when it comes on, she makes a little dance with that music, for a few seconds. When the music turns off, she keeps wandering, trying to find another place. Her dark skin and dark peasant dress trigger the 3DIS system as it detects changes in light levels at eight successive places along a figure eight. She doesn't trigger the system to turn on a sound, but triggers the system to make a decision whether or not it will turn on a sound.

How does that work?

Through a simple little sequence that I wrote in, which has something like five parts silence to two parts sound. Whenever she hits one of the eight spaces, she advances their sequence a certain number of steps. The number of steps it advances depends on how long she's in the space. So in that piece, I'm using a whole gamut of Third World music—African tribal rituals, Chinese music, a whole bunch of things—Laotian mouth organs, South American harp music. But I would hope that anyone who saw the piece realized that those musics were not just a symbol of the oppressed. They actually sound beautiful together—they're very carefully chosen. The reason we're using that music is to problematize our whole exoticizing, Orientalizing relationship to the Third World, and the ways we, as Western artists, use Third World culture.

Which technological developments have you found most consequential in the '80s, and which seem likely to be most consequential in the '90s?

For me, the most useful development in the '80s, generally speaking, was the development of the MIDI standard—the Musical Instrument Digital Interface. It's a common standard language that all synthesizers now use to talk to each other. What this meant was that the industry standardized, prices plummeted, and very interesting equipment like the digital sampler became available. The whole explosion of cheap computer music in the '80s was for me the most significant thing in terms of technology.

I think in the '90s, what we're seeing right now—which is making a big explosion—are the systems for direct recording to digital hard disc, where you don't record on tape, but you record on a big computer disc. You can then look at any part of the sound waveform, mix and edit it, and so on. That, for the next two years, is going to be the big buzzword. For me, the other big thing that will happen in the '90s—I hope—will be that video synthesis systems will also plummet in price, and video, like sound, will become cheap and available, so that I can actually resume my career as a video artist with a minimum of financial pain.

How would you like to bring these arts together?

So far, all the work I've done over the past eighteen years, bringing images and sound together, has been to explore the many possible relationships between sound and image. Sometimes it's been a direct, one-to-one relationship, sometimes no relation at all. Actually, a relationship I like is an analogical relationship, where there's some structural reason for the sound to be there, and for the image to be there, but it's not immediately apparent.

This year, for example, I collaborated with Chris Mann on a piece called *Thirty Eight: Thirty Seven—A Machine for Making Sense*, where I did a silent videotape of abstract imagery while Chris read a text. There were only three notes in the whole piece. So here you have two ostensible composers, collaborating on a multimedia piece, using materials which have nothing to do with music.

There seem to be as many different collaborative procedures as there are collaborations that I've worked on. I don't think there's any one way of doing it, even with the same person. *Thirty Eight: Thirty Seven* was the third big collaboration that Chris Mann and I have done in as many years, and the way that we've worked on each one has been different.

Are there any new collaborative approaches you're exploring?

Well, I'm starting to work a lot more with Al Wunder, who's formerly an American choreographer and now works in Melbourne. He used to work with Alwin Nikolais, and he's a composer himself, and a very good improviser, and makes musical instruments. So we both have American accents, black beards, sort of bald, move sort of funkily, and both can do music and both can do verbal things. In one of the pieces we did together last year, he did a vocal improvisation while I played an amplified parsnip.

An amplified parsnip?

Yes, a parsnip with a guitar pickup in it. I mostly stroked and scraped it, and eventually ate it. We both also danced in this performance. He dances very beautifully, although his age is just starting to restrict his movement slightly. I dance terribly. But I don't mind. I like it. There's an intermedial sensibility—we both have a varied background and we're both not afraid to make total fools of ourselves.

How would you characterize this intermedial sensibility?

What it involves as far as I'm concerned is generally a problems first, and media second, way of thinking about art. If I have this particular thing I want to do, then I ask myself, Of all the media that I know and that I'm comfortable with, which is the best way for it to go?

At times, of course, it evolves out of the situation. *Thirty Eight: Thirty Seven* evolved out of Chris and me talking about how we wanted to make a piece that was easy to do. It had to involve video—that was one of the givens. It had to involve text. How did we actually want to proceed? We decided eventually to throw away music. And the reason for that was not any big aesthetic decision. It was because *Anyway, You Can Always Put Language Down to Experience,* our piece of the previous year, had necessitated hauling loads of gear around both Europe and Australia. And frankly, our backs were a little sore.

So you wanted something lighter?

Yes. It's a lighter piece in terms of being more happy, but it's also lighter in terms of suitcases.

Chris Mann and Warren Burt, Queensland Art Gallery, February 1994. Photograph courtesy of Ray Fulton and Queensland Art Gallery.

Is this relatively open-ended, problem-based aesthetic ever complemented by work where you know exactly what you want to do, right from the beginning, and just have to do it?

Occasionally there's a piece like that. The piece with the parsnip, for example, came about from me thinking, What is the weirdest thing that I can do? I was intentionally trying to be avant-garde, provocative—the whole thing—everything that one could criticize.

Was this just a display of witty showmanship? Or do you think it worked as music?

I think it was a display of witty showmanship. I was very delighted when it actually turned out to work well as music. I had no illusions that musically it was going to be anything. The work with Al had been getting more and more comedy oriented—more and more slapstick oriented—the avant-garde's version of the Three Stooges, except there were only two of us.

Isn't there a danger that such self-styled avant-garde art—or avant-garde provocation art— might turn out more playful than purposeful?

No. It depends on the individual artist and the individual piece. There are artists who are nothing but gimmickry. There are artists who are so serious, that that's "all they do." And there are artists who play around with both. I do pieces which are completely off the wall and silly, and I also do very serious pieces, and I maintain my right to do both.

John Cage. Photograph by James Klosty. Courtesy of The John Cage Trust.

JOHN
CAGE

WHEN I FIRST VISITED JOHN CAGE AT WEST EIGHTEENTH STREET, he greeted me as I stepped out of his building's elevator, asked what I was doing in New York, and before I could finish explaining, exclaimed, "Isn't that amazing?"

To my favorite questions regarding postmodern crisis theories, Cage first replied, "Well, I'm in disagreement," peered out of his window—through glass and at glass—and continued, "I think a great deal of our experience comes from the long use of glass in our architecture, so that our experience is one of reflection and collage and transparency."

Did he find the concept of "mechanized chance" somewhat paradoxical? "No, I like it very much!"

Having discussed his "reading through" a statement by Jasper Johns, Cage agreed to contribute a "sculptural" reading through Samuel Beckett's poem "they come / different and the same" to the guest-edited Beckett issue of the *Review of Contemporary Fiction* that I was preparing at the time, adding that I should ask Beckett's permission, as "it occurs to me that he might not accept my using his text in this way."

A month or two later I showed Cage's text to Beckett in Paris, and he inscribed it "Permission granted," despite his sense that it offered so many "hieroglyphics"—partial testimony at least to the at least partial compatibility between two great admirers of Joyce innovatively exploring what Beckett called "a form that accommodates the mess" and what Cage described as "a kind of amorphous, shapeless kind of mystery."

During our last interview in September 1990, when he was invited by Vincent Barras to read in French at the Festival de la Bâtie's Sound Poetry program, along with such old friends as French poet Henri Chopin, Australian poet Chris Mann, and American poet Ellen Zweig, Cage movingly summarized his aesthetic as a response to—and one should add, as a source of—the kind of "renewed sense of joy" intensifying the wish "to discover" that he'd found before the white monochrome paintings of Robert Ryman.

I last glimpsed John Cage in 1992 in St. Mark's Church, as he and Merce Cunningham

carefully made their way into the cramped audience to see Meredith Monk's *Facing North*. As Monk observes, "to stand a few minutes" with Cage was probably "more inspiring than almost anything that I can think of."

New York—January 27, 1987

Perhaps I could begin by asking you what projects you are presently working upon?

I'm working on *Europera*, an opera without a libretto. There's no plot. It's a collage of all the theatrical elements, and nothing is related intentionally to anything else. The lighting does not light the activities, but is independent of them. The singers will be singing arias of their choice. The instruments will be playing bits and pieces of actual, say, flute and oboe parts from the literature. So that the instrumental music will be at the same time as the arias, but will not accompany them. It comes from submitting an unabridged dictionary to chance operations. So that I would read a page of the dictionary until one of the words on the page suggested some kind of action. And just yesterday we were able to get through all the actions of the ten singers in *Europera 1*, which is an hour and a half long. And I think what happens, both in succession and simultaneously, can be said to be surprising and unexpected. It's actually in a form of theater with which I'm unfamiliar. I look forward to experiencing it.

Does this relate to Robert Wilson's theater?

Well, Robert Wilson's work takes a long time and very, very little happens. It's also an interesting form of theater. But it's almost at the other extreme of what I'm doing, because here, every four minutes a wealth of material is changing. It's very complex.

You're most interested, in other words, in the complex connections arising between these materials?

Well, the connections are multiple. And since there's no intention, the multiplicity of possible interpenetrations is very great. It's like the puns in *Finnegans Wake*—things go in almost any direction.

It's often argued that the "postmodern" age lacks all connections, all meaning, and so on. But what you're describing seems far more affirmative.

I hope so. I'm a member of the American Academy and Institute of Arts and Letters, and I was asked to be on a committee giving awards to composers. And I had to listen to sixty pieces of music. And most of it was what is now called neoromantic material. It was as though we were living in the nineteenth century! It was unbelievable. There seems to be nothing learned from the twentieth-century experience by many people. Maybe it's peculiar to music? What do you think?

Well, in painting there's a widespread return to neoexpressionism, and it's often argued that there's no technological advance possible, and that all one can do is synthesize the past in a fairly unadventurous manner.

Well, I'm in disagreement.

This is a vast question, but is it possible to say what the most important lessons of the twentieth-century experience might be?

I think a great deal of our experience comes from the large use of glass in our architecture, so that our experience is one of reflection and collage and transparency. And I think those elements are very important and very different from a life that had less glass in it!

You wouldn't agree, then, with the argument that we're living in a culture of surfaces, without depth and without significance?

No, we see several things at once!

So it's a rich simultaneity?

It's very rich. Instead of seeing one thing, it's as though we lived constantly in Rome where you see many centuries interpenetrating. It's like transparency. I remember once when I was giving a performance with David Tudor—of what we called "live" electronic music. There was one machine that was under my control which was not plugged in. But it worked anyway.

How did it work?

It worked as though it were plugged in. And I said, "Isn't that strange?" to David. And he said, "No—it's because it's so close to the others that are plugged in." So it was vibrating sympathetically! Isn't that amazing? But that's like transparency and reflection. I don't think we know all the words yet that describe the effect on the other senses.

I mean to say, we could accept the word *collage* in music. *Transparency* becomes a little more difficult, and *reflection*. Collage, I think, is of the essence of work in the arts in the twentieth century. And for someone who is neoromantic, collage is impossible. They simply don't accept it. They think you should carry one thing through to the end—like a stone wall!

But even reading a "linear" novel, it's possible to jump about and to consider the text out of line.

Yes. I'm able with my mesostics to put a source text in the computer, and then, following the rule of the mesostics, which is to not commence the second letter of a string until the second line, and so on, or not to permit either letter between two letters of a string, I'm able to analyze such a text with the computer, so that I have a list of all the words throughout the source that satisfy the mesostic rules, and then, through the use of chance operations, to write a text which comes first from here and then from there.

And I find it very fascinating. I did it recently for a longish text from an interview with Jasper Johns about ways of making a painting. It goes on and on, and it interested me because although it comes from ideas, it produces other ideas. There comes a kind of fertilization of ideas.

Do you ever find the idea of working with a computer at all contradictory? The idea of "mechanized chance" seems a little paradoxical, doesn't it?

No, I like it very much!

```
                    as it Were

               anotHer world

                    A whole or
                    The best one can of it

          suddenlY
                    sOmething

                                   move
               miniatUrized

                              or
                    Something
                    A whole or that
                    You
                    Add things is correct

     that a whole can Be
                    hOw does one
                    occUpy
                    a siTuation in which it is
                    soMething and then
                    mY
                    funcTion as
                    anothEr
               whole caN
                    aDd
                    onE
                    iNto it

               a whole Can be
                    onlY a part

                    aT the same time

                    Or does one
               function As
          another worlD

                    Do
                    Time
               and tHen proceed to
                    dIvide it

                    oNe
          a paintinG
```

John Cage, *fifty percent mesostic* (1986), from text by Jasper Johns (1979). Courtesy of The John Cage Trust.

New York—February 7, 1990

I wonder if you could tell me a bit more about your work in those areas where music, performance, and language overlap?

We had such a program like that last night at the Paula Cooper Gallery. It was called "Spoken Music," and it was the work of Dick Higgins, Emmett Williams, Jackson Mac Low, and Anne Tardos. I think what music invites poetry to do is to repeat words in a way that they couldn't be repeated in poetry.

Because music is—or was, according to Schoenberg—a question of repetition. I myself have been involved from time to time in repetition, but I'm more interested, as you know, in a continuity which is unpredictable. And there's nothing more predictable than repetition!

Your work is to do with unpredictable conjunctions of meaning and sound?

Well, my work is to do with nonintention, and the enjoyment of the life we're living. And the life we're living is characterized by nonrepetition. I mean the traffic sound never bothers to repeat itself!

Did your interest in unpredictable language evolve at the same time as your work with unpredictability in music?

No, no. We are persuaded from the beginning that words mean something. And so we use language generally in order to say what we mean. But then we aren't meaning anything, and we come to nonintention, that's rather far along. Whereas with music, it's easier to come to that view earlier.

How did people respond to your work at the "Spoken Music" concert last night?

The public seemed to be very friendly. And it was an interesting audience that came from different parts of the world. There was a man from Hungary who was quite interested. And now we have—almost as a part of any audience—a mixture of Orient and Occident.

And this is something that you find very gratifying?

I like it very much. At least in terms of the culture, I think we've become a world.

Have you ever used Oriental language materials in your work?

Yes, I have some sometimes. I write mesostics all the time, and I've tried to apply chance operations to Japanese characters. I've done it, of course, without knowing what the effect of the result was, except that the people who asked me to do it were pleased! Otherwise, I know nothing! I've now written in many different languages, none of which I understand—like German, Spanish, and, of course, French. I write French in a way that French is not written.

And how do the French respond to that?

They're getting more and more interested!

Do you have any particular preference for working just with language, as opposed to language combined with sounds of various sorts? For example, in Europera *you use language with sounds and music.*

Well, I work according to what it is I have to do. And it's interesting to do anything if one can, and if it's practical. And the greatest interest, of course, takes place in theater, which is a use of many materials together, rather than just a single body of material.

Back in the '50s, you wrote: "Where do we go from here? Towards theater."

It's time! But what comes after theater is what we have to begin with, and that's daily life!

Where does that leave us?

It leaves us at the point when our work is unnecessary. So that we do it even though there's no reason to do it. We do it out of our energy and joy, and to celebrate the fact that we're still here, don't you think? And no one wants us to do it! We do it of our own desire!

At this point two different ideals seem to come to mind. When we last met you described the way you were using a Jasper Johns text to generate other texts. But you said just now that at the end of theater, we come back to our daily lives. Isn't the process of generating texts more engrossing than daily life? Posting a letter may not be the most exciting thing that one could do?

You never know what will happen!

But isn't the creative urge an attempt to do more than just everyday things and to explore unfamiliar frontiers?

Schoenberg put this very beautifully years ago. He asked one of his students who did very little work—he asked her how many hours there were in the day. And she looked at him as though he were an idiot, and said, "Twenty-four hours." And he said: "Nonsense—there are as many hours in the day as you put in it!"

Well, I think you were saying last time that Europera *would be a form of theater that you were not familiar with, and that you were looking forward to discovering. That sounds more like finding new letterboxes, as it were.*

Yes, something that you don't know.

Is there something that you don't know that you are looking towards at the moment?

I'm not sure that I can verbalize it, though. I have the feeling that it's a kind of amorphous, shapeless kind of mystery. And I think that's what we're getting closer to. And I see it coming in different ways from different people. For instance, I heard a piece by Alfred Schnittke, the Soviet composer, and starting with Russian church music, which was diatonic, he was carrying it both one way and another into chromaticism.

In other words, whole steps were becoming half steps and all the places in between, so that the steps became more and more shapeless, and you couldn't tell what the steps were.

This absolute inability to make precise the shape of something is more and more what we're involved in, I think. It's preparing us for our future.

Is this some sort of transcendental experience or direction?

I think it's—as I said before—it's to give us the culture by means of which we can enjoy our lives, which are changing in ways over which there are some controls, and some lack of control, too—both. But I think the thing that we're getting prepared for, more and more, is the absence of control.

I think the attitude that I admire the most in daily life is the attitude of the tourist. In other words, the person who is living in a situation with which he is completely unfamiliar. And therefore everything is interesting. And that's the case for Losa the cat. Even though he has sniffed everywhere, he repeats that process almost every day!

Does work with language permit as felicitous explorations as work with sound?

Oh, I think so. The work Jackson Mac Low is doing with language now is quite amazing. And he's doing it with computers, so the things that happen to words with the program he's using are absolutely astonishing. And because he begins with English, in a sense, he ends with English, even though it's completely transformed. It sounds like—it has the dignity of—Chaucerian English. And yet it's something unheard of, that we've never seen.

Do you have any other verbal projects at the moment?

No, at the moment my activity is in music. I want to finish the *Freeman Etudes* and several new commissions that I must do soon in music. On top of which, my graphic work is more in demand, so that I have to set aside periods for doing that. So there are many things for me to do. I'm getting more and more like a university than like a college! People say, "How does it feel to be so institutionalized?"

How does it feel?

Well, I wanted to feel the same as it did for Thoreau, but the other side of the coin. He was very little known in the time of his life. And I'm too well known. But otherwise, I'd like to have it be the same. Which is, I would like to do what it is that I have to do, rather than—rather than not.

Geneva—September 12, 1990

What questions are you asking in your present work?

At the moment I'm finishing the *Freeman Etudes*—so those are questions I began asking twelve years ago. And I had forgotten what they were. So I employed the musicologist James Pritchett to study my manuscripts, to tell me what questions I had been asking! As a result, I've been able to write from seventeen through twenty-three. These are very complex works, and the questions are very detailed, because it's the solo violin playing.

The questions I'm asking in my new work are not yet clear to me. One has to do with a piece for me to perform which will be called *One 7,* because it will be the seventh that I've written for a single performer. And this will be a way of using my voice, between speaking and vocalizing, which won't have a text, but will call upon me—or someone else—to use his voice in a variety of ways within flexible time brackets. That's about as clear as I can be.

I may think of the voice as being a number of instruments—for instance, it could be an instrument for the production of vowels, it could be an instrument for the production of aspirants, or consonants. How many different things I might discover—or recognize, rather—I just can't specify. And these time brackets will be overlapping. There might be six different uses of the voice, all overlapping, having different time zones. Whether I could perform them, I will have to discover.

Would that involve using tapes?

No, no tapes. I've written a piano piece, which is *One 6,* for Ellsworth Snyder, who lives in Wisconsin. It gives him two things to do at once, in different time brackets. I'm considering increasing that procedure towards six. And whether one's capable of performing in that complex time situation I don't know.

Is it a process of improvising?

Yes—to improvise within complex time brackets and overlapping time brackets. The time brackets can be longish, or they can be shortish. The shortest one will probably be an overlap of five seconds, and the next an overlap of ten seconds, up to, say, thirty.

How would you remember these overlaps?

I'd have a reference to the time, and a reference to the uses of the voice, overlapping. Now the marvelous thing about this—if I can do it—is that they will never be twice the same! But it wouldn't be easy to do. However, I can always have recourse to doing nothing, within the time brackets.

Kenneth Gaburo similarly observes that having worked with groups, he's now asking individual musicians to play, dance, and move in a number of different ways.

I'm not going to ask myself to dance, but I might ask myself to do something else than dance!

And would you be using words?

Well, using words would of course be one of the ways one can use the voice. On the other hand, if I decided not to use words, it would be more musical. With the voice, we can move from language to music, and the field is really rather extensive between the two.

And how long would the whole performance be?

I think it would be at least thirty minutes. The reason for that is that the first performance will be at Hofstra College, on Long Island. They're having a series of readings and performances called "Bamboo and Oak," which means the East and the West, and I gave them

a choice of reading *Empty Words,* which I can do and everyone knows I can do, and this, which no one knows but me—and they chose that, of course!

Have you done any other performances of this nature?

No, it will be the first time.

And have you come across any other people who seem to be exploring this sort of solo performance?

Well, you spoke of Kenneth Gaburo. We spoke recently together over the phone. At the present time I've written a mesostic to introduce his book of Chris Mann's writings—he's asked several people to do that. In other words, there are ideas in the air.

Does that interest you, to try to locate ideas that are in the air?

Oh yes, of course. I can imagine that each one will respond to this air message—so to speak—in his own way. So it won't be lacking in originality, which I might want to have, because of my love of invention. But I like also that corroboration, that truly is in the air, because—don't we know that several people invented the electric light at the same time, and only one of them got to the post office!

Are there any other things in the air that interest you?

Well, this morning and yesterday I was trying to find out how to approach the sho, which is a Japanese mouth-pipe instrument, with seventeen pipes, like a bundle of pipes. It's a question of the fingers of the right hand and the fingers of the left hand. I thought I was at the point of understanding what the playing of it is. But going over my notes and so forth, I find it's still part of the mysterious East. I don't know what's going to happen there, or what—as you would put it before—what questions will seem to me to be interesting.

Perhaps this confirms the theory that artists are often defining questions, rather than always answering them? One's work is to identify them.

To find out what they are, and what's reasonable to ask. Or what will be productive of interesting answers!

Are some of the questions you're asking the consequence of work with technology, or collaborative work in particular?

I don't think technology is of any particular consequence, except that it changes the specific nature of the question. Otherwise, I think the same attitude that one develops say, towards one set of possibilities can be used in relation to more familiar things, which are also interesting. So that the difference, say, between the clarinet and the computer is not as great as one thinks on the surface.

So that we're not necessarily falling off the edge of the known world, as we go into technology?

No. In fact, my tendency now is to go backward, technologically, but stimulated by the technology.

Would that apply to Europera*?*

Well, that was another circumstance. One of my first questions when I worked on *Europeras 1* and *2* was, can the singers not vibrate? And I was told immediately that that's what they do—they vibrate. So there was no possibility of asking them not to. What one had to do was to accept the fact that they do what they do, which is vibrate. So I went farther and said that they can sing whatever they like—choose what arias they wish from the past, providing it's free, in the public domain. And that holds for *Europeras 3* and *4,* as it did for *1* and *2.*

The other thing which was perhaps superficially interesting is that instead of using musical instruments, as I did in *1* and *2*—or decor and costumes and so forth—there are no costumes or sets in *3* and *4,* and there are no musical instruments, except two pianos. The two pianos are played on chance-determined excerpts from the Liszt *Opern Phantasien* in flexible time brackets, so that there's an overlapping of this brilliant pianism in bits and pieces scattered through a situation of chosen arias by the singers.

And beyond that, there are only electric Victrolas—that means machines from the period from 1950 to 1960—the technology we no longer have, except as antiques. All those records that have scratches and only last—oh, at the most—four minutes, but prefer to last two and a half, to three or four minutes! And it's not easy to play.

They're 78s?

Yes, 78s. There are arms in connection with the machines, and a stack of records can be put on, and the machine itself will pick them up and put them away! But it's not easy to play—one has to practice. And in *Europera 3* there are twelve such machines for six players, so each player plays two machines, and has a stack of records to play. In *Europera 4* there's only one player, and his machine is not electric. It's simply manual—the kind that you see with the big horn and the dog, and you have to wind it up. That also requires a certain virtuosity!

I imagine this is very humorous.

Well, it's not so much funny as it is touching. It tends not to make you laugh, but brings tears to your eyes.

Because you remember?

Because you remember, and the sound is so pathetic! It's really sad, rather than funny.

Is this something that interests you, capturing or referring to elements of the past?

Well, it wasn't part of my intention, but it's certainly the effect of having made that choice.

What led you to do it?

Well, I was thinking about what kind of sound should go with the singers. And I had moved away from percussion and instruments, particularly the winds, brass, and strings. And when I had just the pianos and the voice effects, I found that I wasn't really expressing the nature of the opera, which is so rich. And then it occurred to me that a recording of opera would do the trick.

These are recordings of operas?

They're recordings of operas, so that you get the orchestral accompaniment without the instruments. Then I realized that the CD recording would not represent opera as it was in the nineteenth century. And then it seemed to me that the machine should be an earlier machine, and that was how things arose.

Usually you say that you don't like listening to records.

No, I don't. But I enjoy listening to 78s, and particularly when you have twelve going at once! I can't tell you how beautiful it is!

And I suppose that's not really a familiar nostalgic experience. I wonder how many people ever listened to twelve 78s at once?

Well, it's very beautiful. The scratches—everything, everything is just beautiful.

Have you also been tempted to work with video or with film?

I've done recently some film using a fixed camera, rather than a mobile camera, in relation to the playing of a game of chess. So that the camera could be, say, on the ceiling, and focused directly on the chessboard. And then all the various things that can be changed with the camera can be effected by means of a person operating it from a ladder.

And what interested me in film, I think, more than anything else, is making it economical. I don't like the wasting of film that is so popular among filmmakers, and I don't like the wasting of film on the part of photographers. I think if they click, they should click at the right time! I don't know what they do, but they make something like a hundred clicks in order to get one photograph. I think that's reprehensible. In view of the complexity of the material, there should be greater economy. So, I use every frame.

Does that mean it only takes as long to make the film as the film's duration?

No, it takes longer, because I edited the frames with chance operations.

Was this accompanied by music or by sound?

No, I used the sound of the board and of the conversation of the people. But that also was fragmented. The result is very interesting, and you don't need further sound to have any instrumental music. You can have just the ambient sound.

The other thing I like is the case of video. I think it must be video rather than film, though I'm not certain. But I have an interest in making—and I have a little experience now in making—either one or the other with shadows. I begin with a studio, with an empty studio with lights in it. I noticed this in a television studio in the Boston area where I was asked to do something. When I went into the empty studio there were all these lights—and they were on, and they of course not only produce light, but they produced shadows, of themselves. And these were fascinating. And I contemplate making a film, a long film, to project that material and shadows.

I imagine multiple shadows and their overlaps would interest you.

Oh yes, very much. And that can have music, or not. I think instrumental music would come back to my use—I mean not just ambient sound. At least, I've been asked by the West German Radio that if I make such a film to make also a piece of music of the same length so that it could be with the film, or independent of the film.

Have you ever collaborated with video artists like Nam June Paik?

I've only worked at Nam June's request to make a film some years ago. The interesting part of it was that we played this silent piece having recourse to this map of Manhattan, choosing three different places to go, to listen to the ambient sound. One was on the Upper East Side, the second on the Upper West Side, and the third was near the United Nations building, which we reached at the evening as it was getting dark.

Do you find any correspondences between his work and the work you are doing? I saw a recent video piece he did called Living with the Living Theater, *and it seemed to be a relatively biographical piece.*

I find Nam June's work, as you say, often biographical, or close to his changing likes and dislikes. I saw a beautiful exhibition at La Jolla of sculptures outside and inside the building. Quite a number of other people, too, seem to enjoy putting sculptures in unlikely spots, where there is rubble and other things. This was a selection of Buddhas as far as I recall! Sometimes there's a kind of violence in Nam June's work. You find the same kind of violence in Zen—of the monk picking up a cat and a knife in one hand, saying, "Quick! A word of truth, or I slit the cat's throat."

And this you don't sympathize with?

No, it frightens me.

I think you said once, when we were talking generally about Burroughs's work, that you found Burroughs tended to be more critical than affirmative so far as you were concerned.

Something like that. Though I find his painting now quite lovely. I enjoy it.

Are you surprised that you are doing more graphic work?

I'm doing more work—yes—in that field. I might have been surprised sometime ago, but I've been doing it for so long I'm no longer surprised!

 I've reached the point of using smoke and watercolor, and that still fascinates me. The paper on which I make watercolors is smoked, and what I enjoy now is the ambiguity between smoke and watercolor. I like to make a surface where you can't tell whether I did it, or whether the smoke did it.

Do you smoke the paper yourself?

No, I have other people do it. When I work with the people in San Francisco, in relation to etching, they smoke the paper in their different ways. And the people who help me in Virginia

smoke enormous amounts of paper with big fires. They wet the paper first, and they smoke it over a fire, and then they put out the fire, which increases the smoke. It goes from small to large, and when it gets too large, it's quite an undertaking—the water involves hoses, and the fire involves six people.

Does this mean that you are making very big graphic works?

I made one that was thirty-four feet long. You know that I draw around rocks. The rocks for some of them are very large—as large as this small coffee table—and had to be lifted by other people. When I do these things, like the smoking of paper and the lifting of heavy rocks, it requires a great deal of help. I would be unable to do it alone, and in recent years, my use of the computer is such that I couldn't do it alone.

And now I have the desire—when I finish the *Freeman Etudes*—to become my own assistant. I want to learn to work in such a way that I don't need help to do it. Formerly, before the technology changed, I was able to be my own assistant. And it's only in recent years, and because of the computer and so forth, and these other things like film and video, that I have had assistants.

Now my tendency is to want again to work alone, but in a new technology. I want to get to the point where I use my head about what I'm doing, rather than other people's. Because inevitably the work changes if there's someone else.

Another thing I've been doing lately is making what's called new "edible drawings." And those come out of an awareness that everything is "C," "H," and "O," and that paper could be edible. So I made the first series of edible drawings—we don't eat them, we look at them. Because it's paper, they're dried out. So, I suppose, as we do with beans or rice, we could take my paper if we were hungry, and we could soak it and then eat it.

Are there drawings on the paper?

No, I don't do anything about that. In the papermaking process it becomes something interesting. The paper is made of the ingredients, which follow a recipe, which is chance determined! The ingredients are either fibers, such that they effectively make paper which will hold together, or they're what we call additives, like saffron, which simply add color. It does something similar in food—in food recipes. I've made two editions—one of food that can be found in a store, and which is more or less macrobiotic, and food which is wild and growing in the country.

What led you to make them?

What led me to do this is the remark I made in my *Diary: How to Improve the World (You Will Only Make Matters Worse)*. I wrote that diary by chance-determined numbers of words. I had numbers of words that I could compose, and say I had something with five words, then I had to wait until such an idea occurred to me, and then I would put it where the five words belonged. Anyway, in that frame of mind, I made a remark to the effect that it would be good to have edible paper so that instead of throwing away our junk mail, we could eat it for lunch.

And that came from the awareness that the very poor people in Chile collect thrown-away newspaper, soak it during the night, and eat it for breakfast. It seems a waste of C, H,

and O—if everything is that, which it is—it seems a waste of material, if all we do is throw it away. We should be able to eat it with pleasure. I don't mean with poverty—with pleasure! And the inks we use on our junk mail should be tasty!

So books might say, "Printed on edible paper, with gastronomic ink."

Yes—that's the general raison d'être!

You've mentioned conditions in Chile. Do you find European or South American cultures radically different from American culture?

I think people who live in the United States, who have been to Europe, and who then go what we call "south of the Border"—to Mexico, Colombia, Venezuela, Brazil, Argentina—have a feeling of going to something that is related to Europe more than it's related to us, even though our economic relation to South America is reprehensible. I remember going in Rio de Janeiro with a Brazilian, and when we passed by the United States embassy, he said, "There is the capital of Brazil." Which is a shame.

When I was a child in high school I wrote a lecture called "Other People Think"—it's about our relation to South America. My idea was that if we could stop our factories and stop ourselves from talking for a while, we might be able to hear what South Americans thought of us, and then we might change our ways.

So you commend the possibility of understanding other cultures?

Yes. I wish the United States as a whole were more silent in regard to the rest of the world. But particularly now, in what's called the Gulf crisis, we seem to be just jumping into a police situation thinking of ourselves as powerful police, even though our dollar has sunk in value. We're poor police.

You've no wish to be a cultural police inspector?

Oh, I hope not.

Does it disturb you that people might be unduly influenced by your ideas?

Well, I've warned them—"Get out of whatever cage you find yourself in." But then, as we said earlier, we're in an air situation—we're responding to connections that are in the air, that set us going. And any optimism that we have comes not from the United States or South America but rather from the awareness that we live on the same globe. And our optimism comes largely from the diminution of the differences, maybe keeping the differences, but eliminating the power differences.

I think the big difference we must get rid of as soon as possible, besides getting rid of the nation, is getting rid of the richness and poverty. And we must have some kind of credit system so that everybody has what he needs. In the present situation, you might hesitate to give everybody what he needs, because you think they're all so greedy. But they won't be greedy if they have at least an approach to what they need. Now people don't have an approach to what they need, if in Chile they have to gather up wastepaper in order to survive.

Possibly a final general question might be that of the function of the avant-garde. In one of your interviews you comment that we need the avant-garde, because without it we wouldn't have invention.

Yes, I said that, and I more or less concur with it! I am, after all, the son of an inventor, so I continue that way. It's not as easy for me to get around as it has been in the past, but I'm still kicking, and I try to make a discovery if I can.

Many cultural critics claim that there can no longer be an avant-garde, because innovation is immediately taken up by the mass media

Well, we can always make a discovery, or at least, we think we can. I remain more alive when I make some kind of discovery than if I am doing the same thing over and over. It's harder for me to write the *Freeman Etudes*—it's more tedious than it is to write the piece which I haven't yet written. I breathe better, doing something I don't know how to do.

You find the Freeman Etudes *a little too familiar?*

Oh yes! I have to make a schedule, to force myself.

What is the relation, do you think, between invention and tradition—between doing things one doesn't know and the whole domain of the past?

It's a question of placing your attention, either on the making of something that you don't know, or occupying yourself with something that is known.

The two realms may be antithetical at one point, but do you see them as being compatible?

I don't know quite how to answer that except with reference to an experience I had here in Switzerland, in Schaffhausen, a town near Zurich, where there's a factory which is turned into a museum, just as churches are turned into nightclubs! And the top floor of the one in Schaffhausen is devoted largely to the work of Robert Ryman. Some of the top floor is also for Sol LeWitt.

The work of Ryman I was not familiar with, until I saw this retrospective show. And it was amazing to see what had happened to his dedication to white. I loved formerly the white painting—it was called "white writing"—of Mark Tobey, who also died here in Switzerland. But the development—or his life with white—that Robert Ryman made, is amazing.

The different materials on which he puts white, and the different ways in which he does it, are just extraordinary. And I came away from that exhibition with a renewed sense of joy, and even a joy close to a change of mind.

So in a sense, his labor in a new area becomes a source of renewed sustenance.

And the discoveries don't give you a sense of the loss of the ability to discover, but rather, an intensification of that. So that the work, rather than contemplating itself, contemplates what hasn't yet been done. So that it's not just a process of something becoming known, or of increasing the known—it increases the unknown at the same time!

Your readings through Joyce's texts similarly seem to generate new writings and create a bridge with the past. Are you most interested in the next domain—the domain of the new?

Well, I like them both—I'm delighted with *Finnegans Wake*.

Is there anything else that you'd like to add?

I don't know. The only other idea I've had recently is with regard to the drawing around stones, or the painting around stones. I'm now in recent works making another idea about that, so that one doesn't draw completely around the stones, but is restrained because this other idea is superimposed on the stones, and forbids going all the way around, resulting in a kind of fragmentation.

Does this interest in superimposing entire or almost entire forms, and fragmentary forms, lead to a general sense of fragmentation or confusion? Or does this lead to a renewed sense of assimilation, or to something else?

I don't know. In my case, it's leading to this ambiguity between smoke and watercolor. So that rather than having any strength in the affirmation of something, your action becomes invisible, or not clearly visible, through the fragmentation.

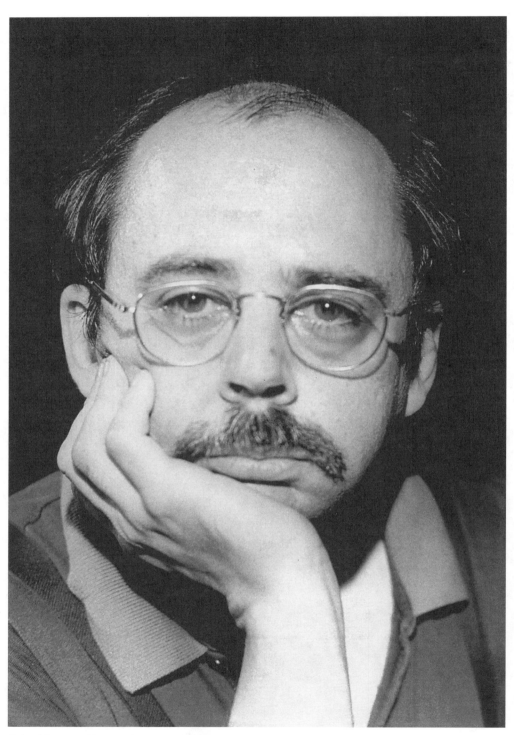
Richard Foreman. Photograph courtesy of the artist.

RICHARD
FOREMAN

I FIRST ENCOUNTERED RICHARD FOREMAN'S WORK when I saw *I've Got the Shakes* with Ellen Zweig at St. Mark's Church in the early 1990s, while passing through New York. Kathy Acker had mentioned that Foreman had directed her *The Birth of the Poet,* and when I belatedly found that *Permanent Brain Damage* was programmed as part of Laurie Anderson's 1997 Meltdown Festival at London's Royal Festival Hall, I moved heaven and earth to arrange an interview. All contact seemed unlikely until late one afternoon, when I returned from a nightmare staffing meeting to a phone message advising me that Foreman could see me next morning at the Bonnington Hotel. Substitute teaching arranged, I raced to catch the train for that night's final performance.

Perched on the armrest of an empty back-row seat, I looked over audience heads and under an overhead network of string partitions, into the claustrophobic density of the little wooden windmills, optician's eye charts, and Rouault reproductions making up Foreman's set, where an onstage figure grinned at entering spectators with all the pantomime gusto of a kind of New York deli Sweeney Todd.

I've Got the Shakes had struck me—perhaps rather unfairly—as a kind of art school pandemonium. But *Permanent Brain Damage*'s succession of abruptly glimpsed images and scenes seemed more of a multimedia quartet, bombarding the senses with accelerated or decelerated surprises like a fast-forward Fellini or *Mad* magazine narrative, as characters froze, fell, sneaked on or danced off the stage, to looped lilts of nostalgic 1920s European harmonies, and Foreman's commentary solemnly explained his hero's search for truth in a realm of "magic" beyond magic and reality beyond words. Kafka on speed, I thought, as I delightedly absorbed as much of this volatile performative fresco as rapid note taking allowed.

Entering the Bonnington next day, and seeing a figure in a lobby chair sketching a slightly familiar set, I introduced myself, and as our discussion advanced, Foreman fascinatingly outlined his commitment to a curiously American sense of "paradise" in spectacles resisting all logical order, but seeking transfiguration perhaps through some alternative sense of grace.

London—June 27, 1997

As I watched Permanent Brain Damage *last night, your recorded monologue seemed a little like a radio play with live actions onstage, or like the mix of actions and voice-over narrative in* Last Year at Marienbad.

Well, maybe more so in this play than in earlier works, but in most of my plays the actors are talking. Nowadays—even in my small theater in New York, which only seats ninety people—we use radio mikes so that people can speak very quietly, because I don't like the theatrical sound of the projected voice. A radio play? Perhaps? Radio's been a powerful image to me, because just as the radio transmits voices from other places, I think of human beings as essentially transmitting everything they've been subjected to and programmed by and so forth, so I do think we're radios broadcasting to each other.

Presumably this kind of broadcasting is more personal than political? Permanent Brain Damage *seemed to offer a dreamlike evocation of the confusions of a central character rather than an analysis of the social forces conditioning this character's consciousness.*

Yes, yes. But of course, my take on that has always been that I don't believe political theater works, for reasons I could give. I have to admit that political science interests me less than metaphysics and psychoanalysis, so what can I say? The socialized life we lead is such a contingent construct. Obviously we need it, obviously it feeds us, but I'm interested in another level—I'm interested in the level below that, and always have been since I was a small child.

Throughout the monologue that you read in Permanent Brain Damage, *you refer to levels of "aliveness" and the desirability of more intense experience. Are these your ideals?*

Yes. Of course I have to emphasize that since I think we all are radios, including myself, I am trying to make a hovercraft that is all of the things that have passed through me—all of the things I've read, all of the things that attract me. So what is said are interesting reminders in an aphoristic way, but the intent is not necessarily to take them for the gospel truth, because a lot of them contradict each other, and the idea is to make this thing that hovers in the realm of the potential, rather than providing a committed specific position.

Although presumably when you've completed the production you've selected a certain set, certain music, and a certain configuration of contradictions?

Yes, yes, but the problem for me in directing the play is always to avoid the play going too clearly in one direction—in one emotional direction. Now that has nothing to do with making it muddy. I'm interested in clarity—in the clarity of this kind of thing, be it a mystical state, or be it Derrida, or whatever it is—in total clarity about all these contradictions and all these things that are both different and the same.

 It always amazes me that so many theater critics who are not experienced in other realms refer to these plays as if what is being said is total nonsense and so forth. What is being said, so far as I'm concerned, represents the mainstream of current philosophical thought and echoes everything that's happening in contemporary poetry, so, you know, I think I'm almost reactionary in my interests in particular strains of negative theology and so on!

ONTOLOGICAL AT SAINT MARK'S THEATER
Richard Foreman, Artistic Director; Paul Berman, Administrative Director
Sophie Haviland, Administrator

An Ontological–Hysteric Theater Production

I'VE GOT THE SHAKES

Written, Directed and Designed by Richard Foreman

A play of nuances, in which Madeline X knows she teaches -- but cannot know for herself what it is that she teaches. She simply makes herself available -- and life uses and misuses her, in order to allow its paradoxical nature to shine through every little catastrophe.

The paradox is that life has no form except the momentary form projected upon it by each moment as it is lived. Life itself is ready to upset every apple cart, to turn every received idea upside down, to reverse every perspective. And the mental dance of Madeline X is the dance of that paradox. Meaning is destroyed, but the hunger for meaning is thereby rendered even more intense, more poignant.

(Sweet ice cream turns sour. Mountains of achievement are superseded by their representations -- so if one climbs, one has no destination except dizziness. Reality itself is a drug to which one becomes addicted. A hall of mirrors. No way out except -- just totally stop doing anything. That's the choice -- the catastrophe of the world (where everything deceives us by pretending to be its opposite) -- or the paradise of losing everything and holding onto nothing! What a choice. No wonder somebody has the shakes!)

Richard Foreman, flyer for *I've Got the Shakes.*

That's very interesting—I was starting to wonder if your way of putting things together might be a precursor to L=A=N=G=U=A=G=E poetry, where there are different phrases and words evolving in a nonsyntactic way.

Yes, I'm friendly with the L=A=N=G=U=A=G=E poets. About ten years ago I came back to New York after doing a play in Paris, and I saw this strange magazine, L=A=N=G=U=A=G=E, in a bookstore, and I picked it up and I opened it—and there was an article by me! And I had never given them anything—they took it from my program! So I called them up and said, "Hey, I'm not upset, but who are you? What are you doing?" Actually I'm very friendly with Charles Bernstein, Bruce Andrews, and some of the other L=A=N=G=U=A=G=E poets.

What about John Cage and Jackson Mac Low—are they textual allies?

I know Jackson. Of course, Jackson comes directly from John, and John I knew—I think he's a genius and I like him very much. But no, John Cage was not very influential on me at all. First of all, at the time when I got out of college and he could have been a seminal influence, I was totally immersed in the American underground cinema movement. I have to say that while I respect John tremendously, his events and his music never really reached me. The randomness that John was interested in, to me, very soon acquires a predictable quality, and it just never spoke to me.

But you wouldn't be offended if someone commented that your own work has a certain predictable quality?

No, of course not, because I realize that we're all trapped by what we are! If you look into my plays, there are a lot of recycled elements, just as when you go to Kabuki theater, it's always the same! But of course, if you're familiar with that tradition, then within that tradition you start enjoying the differences. Or if you take Francis Bacon, it's always the same thing—smudged faces! But it's the subtle variations worked within an obsession—within a stylistic obsession—that to me are the interesting things about art.

How did you become interested in the underground film tradition?

Well, I graduated from Yale Drama School in 1962, and I had always been interested in what I thought was vigorous, intellectually vicious European art, and just after my last year at Yale I happened to see a very early showing of some underground films that was taking place at the Living Theatre, which Jonas Mekas was organizing. And I just found it totally revelatory!

I thought it was very beautiful—the use of music in those sorts of films was very evocative. I saw young contemporary Americans like myself making art out of everything that I hated about America, as opposed to my lust for European intellectualism, and out of everything that I had tried to reject in myself—because as a young playwright at Yale I was trying to imitate Brecht, Giraudoux, or whoever you can think of. I saw these young postadolescent Americans—and all Americans are adolescents, myself included—making art out of their crummy friends and their crummy apartments, and it was very inspiring.

And then I became involved, and my wife became involved, with Jonas Mekas. They were having court cases with *Flaming Creatures,* and we didn't know them, but we called them up and said, "Can we do anything to help?" and my wife started working there, and I a few years later worked for Jonas Mekas trying to raise money for the filmmakers. And every night of the week I would go and see these films and just find them amazing! I never really wanted to make films, but there was something terribly freeing about their aesthetic that allowed me to accept a little bit more who I was.

Well, I found Permanent Brain Damage *ebulliently and very amusingly American. I couldn't imagine Osborne, Beckett, or the French getting anywhere near it.*

I tell you, when I first went to France, I came with the reputation of being this American intellectual, and I thought that was true. But when a critic at that time for *Le Monde*—Colette Godard—interviewed me, she said, "You know why your work interests me so much? It's so raw and primitive." And I thought, Primitive, me? And then, of course, I realized that she was right. So yes, I think it could only be the work of an American—but who knows?

I hate America, but I realize that I'm an American. I wanted to move to France, I did eight plays in France, and then I realized why I had to return. I had never in my whole life understood why Henry Miller towards the end of his life came back to America, which he hated—but now I understand. You have to! That's where I belong, that's where I have to fight my battles! And I am an American, and I'm not a vicious French intellectual.

Again, some of the characters in Permanent Brain Damage *had a distinctly cartoonlike air about them, not unlike figures in early* Mad *magazine parodies.*

Oh yes! My dream has always been to render my feelings about the most esoteric material—be it Bachelard, Bataille, or whatever—but in terms of kind of low-down American shtick.

But I don't think that's a disreputable ambition, if it means one's honoring the local materials of one's culture.

It's honoring what I am. Through my whole life I felt myself to be this awkward person who's shy and embarrassed whenever he has to go to a party, which I hate doing. In the theater I stage big dances and so forth for some of my plays, but I'm the kind of person who never got up and danced socially—I was too shy. So that's me.

Permanent Brain Damage *also uses very evocative early-twentieth-century popular music. Were those German songs?*

No, the singing was Czech. For a very long time I have sampled all kinds of music and made loops which are continually in the background of my plays. And very often when I'm staging the play, I'm thinking as much of the music as I am of the text.

Do you build the set first and then add sound tracks and actions?

No, what comes first is the text, and the text is made in a sort of collage fashion and then rewritten. And then I start working on a set model and at the same time I start thinking about what kind of music I want to use. I have a collection of hundreds of loops, but usually for each show I have some idea of something I've heard recently that I think might be a source of some new music. These days I also generally have a vague idea that often involves a prop, with about two prop ideas for each page of text. I look at my script, and say, "Maybe if we had a big disc when they're saying that." And when, on the first day of rehearsal, we start playing some of the music—and this is all changing, of course, because we're rehearsing—I just start telling the actors where to go and what to do, and they do that for ten weeks!

And are you rigorous in rehearsal, or do you encourage improvisation?

I'm very rigorous, and the actors rarely improvise. I try to sit back and watch, and very often when I'm talking to another actor, the actor will do something totally unrelated to the play and it's wonderful. I'll say, "Wait a minute, let's do that!" But they don't improvise. I tried at various times having the actors improvise and bring in material, but it really never worked because it wasn't my improvisation, and I've always tried to make a play—like making a painting—in which you had the experience of what the world was like for one head, which in this case was my head. And the actors' heads were in different places, so it didn't work.

Are you trying to achieve a distancing quality preventing empathy with characters, or alternatively, inviting empathy with a more general vision?

I don't think about that. All I'm trying to do is make something that for every moment makes me notice—gives me something to notice—with an intensity that energizes me. I tend to be a very lazy person, so I try to make things that keep me energized.

You're not tempted by a slower, more contemplative pace?

Often I start out thinking, This year, I'm going to make this play more contemplative, and after a while I just get bored, and I feel, This is too much like Bob Wilson, or something.

Have you shared Wilson's tendency to collaborate with composers?

Well, I did a whole series of operas with a composer in New York—Stanley Silverman. I directed Phil Glass's opera *The Fall of the House of Usher,* and I'd like to do an opera with Glenn Branca, but it's hard finding the money. There's also a New York composer who I just discovered whom I'm ravished by, Michael Gordon, who organizes the Bang on a Can Festival in New York—he's sort of out of Phil's work, but he's much more aggressive.

You've also worked with Kathy Acker's texts.

Yes, we did two pieces. In *The Birth of the Poet,* which was an opera, the rules were that nobody interfered with anybody else. I didn't tell the composer, Peter Gordon, what to do. David Salle painted the scenery, and the rule was that he did whatever he wanted, and that aspect of the collaboration was the most interesting to me. David gave sets that had nothing—on the surface—to do with what the play demanded, and sometimes it worked wonderfully—it was just inspired—and other times it was awfully difficult to figure out what to do in this crazy environment. That piece caused a big scandal because of Kathy's words. We premiered it in Rotterdam, and then we took it to New York and there was a big scandal—the audience was screaming back at the stage all through the show. I think Kathy was very shaken by it. She didn't expect that to happen.

Which other artists do you now find most interesting?

Well, as I said, I've just discovered this composer, Michael Gordon, whom I'm really interested in. A lot of people don't like them, but I find David Salle's paintings give me ideas. I find his juxtaposition of images very suggestive and powerful—though not for any symbolic reading, obviously, which is not what he is interested in. David is very smart, and I think it shows through in his particular choices and organization of ideas.

To what extent do you now feel you've established a new kind of theater?

Well, I realize that it's not so unfamiliar anymore—for me. I mean, I'm trapped by my style. Every year I think, Now I've got to do something different, and every year it drifts back to what gives me a thrill. You see, I really do things on a totally intuitive level. After the fact, I'm intelligent, and I can look and I can see where it's all coming from and what the implications are, but I don't think about that at all when I'm making it. I just want a kick—an unbelievable kick!

Do you consider yourself an avant-garde writer, insofar as you're looking for a new aesthetic kick challenging past conceptions?

Obviously there are very few people who if asked, "Do you consider yourself an avant-garde writer?," would say yes these days. The chic thing is to say no, of course, and I would say no, too. You see, I think at this point I'm closer to Molière. I think I'm a moralist, really,

like Molière—a comic writer like Molière. I've just turned sixty a couple of days ago, and I just think, as I've always felt, How can I be avant-garde? I'm working in the mainstream of Western contemporary art. I'm making art like René Char, and that seems pretty old-fashioned, I guess, and I'm just doing what everybody else making serious art does.

But maybe your art is more serious? There must be other mainstreams which are slightly more tepid or stagnant.

Yes, quite. But I think of the mainstream as being the so-called avant-garde tradition, but it is a tradition.

Well, the French sound poet Henri Chopin, who uses tape montages of predominantly abstract sound, argues that he is not so much avant-garde as "living with the present," confronting the contemporary creative obligations of the here and now.

Sometimes I think I identify a lot with contemporary necessities and what everybody else is doing. Sometimes I think, Oh, wow! These days the Wooster Group is popular because they do all this high-tech stuff that everybody's into—maybe I should do something like that! But I can't! In a way, what I do is old-fashioned, I refer to the music of the thirties, the feeling of the bric-a-brac of a different era.

Perhaps it's a kind of Douanier Rousseau preference in a way, creating your own magic vision without feeling threatened by—or overly respectful towards—present fashions?

Yes, I feel that way—I've often felt attracted to that aesthetic. I always assumed that the most magical, mysterious epoch for everybody is the period just around the time they were born or a little bit before. I've always been fascinated by all these books about scientific devices of the turn of the century.

Meredith Monk similarly emphasizes her work's continuity with that of early-twentieth-century artists like Jean Cocteau.

Yes. When I was a young person I saw Cocteau's movies, and they were very influential. I think I've been influenced by everything—a lot of things have influenced me. In my dreams and my reveries I'm a modernist—the spiritual yearning that's manifested in modernism is still what drives me. I can't really be a totally cynical, surface postmodernist.

Perhaps Permanent Brain Damage *echoes the way Huysmans's* Against Nature *evokes both mental turmoil and yearning after spiritual truth?*

Yes, absolutely.

Are you also interested in contemporary cultural theory?

Oh, absolutely. Again, it does not inform my day-to-day work of creating art, but to relax I read everything, especially poststructuralist theory, especially French. The person who I have read the most over the years is Lacan. For two months I'll be obsessed by Bataille, and for two months I'll be obsessed by Adorno, and two months later a more obscure figure, but I have to admit that Lacan is the person I've been returning to the most.

The other book that was the most influential on me—an overwhelming book—was Anton Ehrenzweig's *The Psychoanalysis of Artistic Vision and Hearing,* which was published, I think, in 1953. There's also a second book published posthumously in the early '70s by the University of California, called *The Hidden Order of Art,* in which the intensity is a little less. I return again and again to those two books.

Presumably underground film was equally influential?

Yes, there were many things that moved me deeply, but I can't translate that too well into theory. I never really wanted to be a filmmaker, but it was my world, the world in which I existed. Those people gave me my first opportunity to make theater, so of course it had a profound influence. But I don't find it that sympathetic today. I go back and look at some of the films that I was just ravished by in those days and I find them a little disappointing, I must admit.

Presumably filmic work is more influenced by this underground tradition. I'm thinking, for example, of the ways in which the Kuchar brothers' parodies of Hollywood kitsch influenced or encouraged John Waters and so on.

I enjoyed the Kuchar films tremendously. But when I think back to those days, the people whose films really interested me most were Jack Smith, Ken Jacobs, Michael Snow, Ernie Gehr, Harry Smith. They were a little different from the Kuchars—Harry Smith was more influenced by all kinds of magic and the occult tradition.

Where do you see theater going next? Have you seen many impressively new tendencies?

The only new thing that I saw in America that filled me with delight was just one piece I saw before he died by Reza Abdoh, a young guy who did very aggressive, pornographic events with lots of people and lots of music and energy which I thought of as the first new energy that I'd seen. He died of AIDS a couple of years ago, so his career was cut very short. But no, I don't see anything new. I don't go to the theater very much, but I'm surrounded by young people who are very interested to do theater, and nobody talks about anything new that has excited them, so I suspect that at the moment it's not happening in America.

What about cyberculture?

Well, yes, I imagine in twenty years, or ten years, maybe there'll be something fantastic. But I'm very old-fashioned. And it doesn't bother me too much anymore that I'm old-fashioned. Coming to Europe, and buying a couple of books on European scenic design, and things like that which I haven't paid too much attention to for a long time, it strikes me even more strongly than it did in the past that in comparison with the kind of sleekness and grandeur of official European theater, I represent something totally different—sort of a homemade, ready-to-break-down, clunky whatever. To me, all the great European directors have the same kind of slick deadness as going to church.

The San Jose sound poet Larry Wendt distinguishes high and low tech from "handy tech"—a concept that probably suits the quirkily handmade quality of some of the details of your set?

Absolutely. The painter today that I'm most inspired by is Sigmar Polke, whose work also has this handmade quality. It's all just like this crazy guy working alone—a sloppy alchemist!

Is that what you'd quite like to be?

Yes. As a matter of fact, when I started making this kind of theater, one of the things that inspired me a lot was reading about the alchemists and thinking, I'm just reworking this material, and some grace will descend if I just keep reworking this material, not anticipating what one might do or say. But I've spent so much time in Europe, especially in France, that I fully understand that Americans are *all* adolescents. There's something about our character structure, I think, that's very childish, and that's me, I realize!

I wouldn't say that entirely. I think both European and American art evince very interesting levels of innovation and sophistication.

But, you see, I think that the American inventiveness *is* the inventiveness of the brilliant adolescent, who's doing all these things but who lacks maturity and understanding of the manipulations of the world at political, sexual, or intersocial levels.

Maybe that's a precondition of a certain sort of freedom—if understanding such manipulations implies their acceptance?

Yes, but I'm saying that I still would define it as a kind of adolescence—that maybe that's wonderful and I've come to terms with it. For many years I rejected it totally in myself, and hated it in this society, but I see that there are tremendous advantages as well as disadvantages.

How would you respond to those critics who claim that for all its startling effects, the "theater of images" usually lacks the thematic advantages of a politically or socially coherent vision?

First of all, I don't think I'm part of the theater of images. One of the reasons the sets are so complex, and they have that string, and they have all the other stuff, is that in a sense I wanted to become unseeable. I wanted to be so fragmented, so dense in fragmentation, that you stopped trying to see and instead you listen, and you sort of relate to the rhythm of the piece.

As the years go by, I have increasing difficulty imagining, inventing, what the physical environment of the play could be. Because when I write the plays, and when I read the plays, and they seem good to me before I go in to rehearsal, somehow what I invariably sense is that the room I'm in when I am reading does not crystallize into an image that is there before you on an imaginary stage, because I'm not paying attention to it. It's all a kind of peripheral blur. And I *wish* that I could find a way to capture that onstage, and I'm always dissatisfied.

The other day we were sitting here before going to the theater, and some of my actors were around, and I said, "OK, I have a task for you—I can't figure out what color to make things anymore. Invent a new color." How can I color my sets? I always have problems—how can I color it so that it doesn't become about that color? I need a new color that doesn't exist! So I don't think I'm part of the theater of images anymore. And even in the days when people were saying that I was, it was always a dialectical interplay between the scene and the set.

Maybe the idea of the theater of images reflected an initial critical fixation on certain very strong images, whereas you seem to be suggesting an almost musical intent and a kind of holistic intensity. Maybe that's what one likes? Observing a beautiful sunset one doesn't say, "The sun is nice" or "The trees are nice," but "I want to photograph this because it's all there."

But I'm not interested in the beauty of the sunset. I'm interested in paradise. My art is therapeutic, and I'm interested in paradise. But to me, to do what somebody like Wilson does, is to present you—whether you think it's seriously beautiful or a little slick—with a beautiful image. Now, paradise of a certain sort can be evoked by a beautiful image.

But for me the task is to make paradise out of all the crap that you have to deal with in your life—to change the rhythm of your perception, the rhythm of your being, amidst all the scary, frightening, aggressive stuff, so that indeed, in a kind of Keatsian process of negative capability, you are in paradise, in terms of the very stuff you want to reject.

Maybe it's a little like Kurt Schwitters's aesthetic, in the sense that whereas Eliot's Wasteland *juxtaposed slices of low-life London dialogue with selected sacred fragments such as "Shantih, shantih, shantih," Schwitters stuck to everyday available materials.*

But I also feel very close to Eliot. I feel that we have similar personalities, in terms of all of Eliot's repressed guilt and spiritual longing. I feel pretty close to T. S. Eliot these days.

Does this mean that in a sense, yours is a very autobiographical form of performance, albeit by way of distant textual fragments?

Yes, I think so, and I think that's all any artist really has. However, it's not subjective. It's using the autobiographical materials of my life, just as, I think, everybody else does. But it's an attempt to speak to them on that level that Mallarmé is talking about when he says, "My language is extremely objective." I'm a scientist.

But the quality of your reading of the narrative tape in Permanent Brain Damage *is very personal. The tape's description is scientific, but distinctive subjective presence and persona inform the gravitas of your voice.*

Yes, but it's not always the case in my plays, of course. In this play I decided, "Can I make a play out of me just speaking from my heart?" And this was a very specific choice for this play, so I think that's a little different. Now it's true that my language is always me talking to myself, but I think that me talking to myself on that level is me reflecting everything that has bled through me, radio that I am.

The poet Robert Lax similarly discusses the attempt to refine a highly personal language which is not so much superficially anecdotal, as compatible with implicit biography, while remaining commensurate with the more general rhythms of what you call the level of the heart.

But I only refer to this play—and one can even have different opinions as to what level the heart we're speaking of is located.

That's still rather a cheering distinction, if it implies that this level of language can inform a variety of discourses, as opposed to the critical claim that authentic communication or performance is somehow obsolete.

But I think that in general—and certainly in America—theater critics come from a different world. Theater critics don't spend their time immersed in the particular kind of art, the particular kind of thinking, that to me is everything. So they're viewing all of that from a very particular perspective.

Today in one of the London newspapers there was a little review of *Permanent Brain Damage,* and it wasn't too happy. And right next to it was a review of a production of Genet's *The Maids* that starts out talking about the way in which the critics treated *The Maids* for the first time in the '50s. And it's exactly the same for me in the '90s! At times I look at my plays and I don't like them. But I'm amazed—it seems to me that there are so many things that are self-evident, and so unexceptional, and so easily acceptable in terms of the intellectual tradition of the West at this point, that theater critics never pick up on.

Maybe critics can't keep up with the ways creative energy mutates? As Laurie Anderson puts it, those who find art to be dead are probably looking for it in the wrong place.

Sometimes I think art is dead too, but it's irrelevant because I've got to do another play next year, and so you do it. And I still find some art in other areas that interests me—occasionally something gives the same challenge and the same breathless thrill that I had thirty years ago.

Why do you think this kind of thrill seems so elusive in today's culture?

There's a whole theory that the West started going wrong when we overrelied on a kind of focused vision, as opposed to a peripheral vision. With all the so-called great art of the West, people seem amazed that the artist could take this world and focus it in tableaux, narratives, whatever. And the reason that people can't see that art that is just as important is being done today, is because most of the art that is interesting today is not so much trying to do that, saying, "Here it is," but is saying, "Here's something you know. Now let it sort of slowly expand, let the field widen your field of vision, let it widen its field of vision."

So you sort of can't see *it* anymore. But the energy points in it are here, here, and here, tweaking you behind the ear. But where is it? Where is the center? Where is the thing that I used to look for in classical Western art? Well, artists are interested today in blurring the focus and discovering how what used to be here is now reflected in that little light up there. It really is a sort of atomic dispersion of the focused energies that art used to evoke.

Maybe it falls back in a more complex way? In other words, it might not be words conveniently falling back together, but it might be that you've got words, actions, and tapes and quirky music, funny actions, and certain caricatural figures in a general constellation which somehow coheres. It's not a disintegrating constellation, but there again it's not a stable constellation.

Well, I think that's true, and critics in general of the theater, for instance, seem to be incapable of understanding that your discourse is not only the words of the play.

As the string in your set might suggest, it perhaps evinces what one might think of as a "net-cultural" logic—a kind of cat's cradle of internetted components and mobile tensions. One could probably say that's what Hamlet *is too, when you get down to it, but I would think your work is working more self-consciously with this kind of problem.*

Yes, I think it is. I used to spend my youth going to the theater and thinking, Well, all right, the delineation of this character's relationship with this other character is OK. But when he says to the other character "I hate you," there's no thought being given to what section of the wall you are seeing him against. And that window that is there in the wall, it's not placed right for that moment, to reinforce or comment on that moment.

So in a sense, your work takes theater back towards installation art, to something very, very complex. It's not just installation art as installation, but installation with animation.

Yes, exactly, exactly.

Kenneth Gaburo. Photograph courtesy of Kirk Gaburo.

KENNETH
GABURO

I BECAME ACQUAINTED WITH THE AMERICAN COMPOSER KENNETH GABURO'S CONCEPT of "compositional linguistics" in Australia in the late 1970s, in discussions with Warren Burt and Chris Mann, but it was not until 1983 that I first met Gaburo, at video artist Hans Breder's multimedia workshops in Iowa City. As Gaburo rapidly indicated—and who spoke faster than Kenneth?—his concept of compositional linguistics advocated work "so composite and so integrated" that it was impossible to say, "Aha! that's a piece of music, Aha! that's a text, Aha! that's a piece of poetry, Aha! that's a piece of dancing."

Gaburo most succinctly outlines this aesthetic in his article "The Music in Samuel Beckett's *Play*" (reprinted in the summer 1987 "Samuel Beckett" issue of the *Review of Contemporary Fiction*). Here, he successively discusses Beckett's *Play* "as Music," "as Theater," and "as Language," before finally attributing its performative originality—as multidimensional multimedia performance—to the way in which it both "generates *another* language" and requires analysis in terms of "its own language-sensibility."

For Gaburo, the originality of multimedia performance derives from its fidelity to a multidimensional compositional logic, far surpassing the monodimensionality of text-based linguistics predicated upon the conventional "language-sensibility." In much the same way, Gaburo's contemporary, the veteran French sound poet Henri Chopin, defines the multimedia arts as "new languages, which have nothing to do with Dickens or Balzac," while younger artists such as David Blair discuss nonlinear editing technologies as a mode of "composition," functioning "almost preverbally." Gaburo's concept of compositional linguistics offers the perfect definition for those variously preverbal or postlinguistic multicompositional principles informing the postmodern avant-garde's most accomplished orchestrations of wholly or partially technologically mediated sound, text, gesture, and image.

Significantly, when Gaburo discusses *Few* (1985), an electroacoustic collaboration with Chopin in Iowa City (published on CD in the French review *Licences,* 8 rue de Nesle, 75006 Paris), he does so in terms of a distinctively *postlinguistic* mode of composition requiring

133

very little verbal exchange. Writing in 1992, Gaburo explained: "While here we met and made a work. His sounds came from multi-phonics using a mike imbedded in his throat, and mine came from a synthesized patch . . . No rules; only quiet, interactive, concentrated celerity: a tape made in a moment. During the entire event few words were spoken."

As Gaburo's second interview indicates, his final *Testimony* project typifies the way in which the 1960s and '70s avant-garde's multimedia experiments often attempted to incorporate more subjectively and more verbally defined utterance in response to the anxieties of the 1980s and '90s.

Iowa City—September 9, 1983

Perhaps I could begin by asking you how your work with music and the voice and with ensembles all began?

My very first class in the first grade was a music class. The teacher began by playing the piano and talking about Stephen Foster's songs, and she referred to him as a composer. At some point she asked if anyone in the class wanted to play duets with her, and I went up there and banged around the upper part of the piano while she played in the lower register. When I came home that day my mother asked me how it went. I told her about the music class and intuitively said I want to be a composer, and she arranged for me to study the piano and to learn about composition from a local teacher who happened to be a graduate from the Eastman School of Music.

From about age twelve to the end of high school I was encouraged to go to New York on weekends with friends. Somehow, I think, also quite instinctively, we enjoyed going to three diverse events—on Friday it was jazz; on Saturday, theater; and on Sunday, the New York Philharmonic or some new music event. At the time, I had no idea how these areas would become the central integrating components of my work, and how they opened up—sometimes by mere chance—other avenues of inquiry.

For instance, I have always been involved in jazz, and put myself through college arranging for big bands. One night in 1959 I got a gig as pianist with a band in Champaign-Urbana and learned that the bandleader was a linguist, doing special studies in phonetic analysis and phonetic transcription. I was fascinated by this, and all of a sudden the whole matter of music, the voice, and language began to vibrate in me.

Shortly thereafter, sometime between 1961 and 1962, I formulated the expression "compositional linguistics." It has gone through a number of transformations, but at the time it signified music as language, and language as music to me. By this expression, I did not—and do not—intend casual, informal, or expressionistic metaphors such as "the music of architecture." And so, at the core of my work reside continually evolving concepts of language and linguistics, and the notion that no particular discipline—music in this case—was or is sufficient in and of itself to express that which is necessary to express.

To be sure, there are reasons why one can make a distinction between visual art and music, or sculpture, or poetry. They are somehow, in their basic nature, distinctly different from each other. But at the same time I am aware that no particular "discipline" is an

entity without connections or links to other phenomena, and so it makes sense to me to be involved in as many domains as possible, and to find a way of connecting them.

I cannot say that I realized the full implication of such pursuits at the time. But the voice and language, relationships and interactions were becoming connecting links to specific works and to working with groups; the voice as primitive, basic, rich—extraordinarily potent as expression. The "voice" evolved into a metaphor for humanness and diversity, as a crying out to be heard, and in a sociopolitical sense as antagonist to the increasing noise in the world and the violence done to all living matter.

You wanted to do everything yourself?

Yes. But how else? For me these matters are needs, not wants. It seemed necessary to my growth to be involved in what I consider to be interactive states, with the actual acts of making. And these makings necessarily required working with other people in diverse ways.

When did you form your first ensemble?

My first group was formed during the period 1950 to 1954, when I had my first job, teaching in a small obscure town. In that context the only thing that made sense was for the few people who were there to make music together. So I started a choral group [the New Music Choral Ensemble], and we began to do experimental work with the voice. What began there was the idea that a group could actually develop diverse language, in a certain anonymous sense, and clearly not to map onto performed works a predetermined choral style.

The second group was at the University of Illinois from 1962 to 1967. NMCE2 performed work not written for the group, work written for the group, and work written by members of the group. We began to experiment with multiphonics, movement, theater, and interactions with electroacoustic sound. Most composers who composed both choral and instrumental music put forth a different "style" for each—it was assumed that voices could not do the complex things that instruments could. So we turned that around. The conceptual barriers of whether work was inclusive or exclusive began to break down.

By profoundly regarding each work as unique, it became clear that each required a different "voice." In a presentation of, say, eight works, one could easily imagine that eight different groups—one for each work—had been onstage. It was also the case that the various members came from different disciplines and groups—composers, a librarian, trained singers, and some who had no vocal training at all. Opera singers were never flexible enough.

NMCE3 was formed when I began teaching at UCSD. We threw away the music stand and mostly worked on a large gym mat in my garage or at the beach. We worked with our bodies, tactility, text-sound poetry, sound-music, talk-music, speech-music, sound-movement, improvisation, gesture, and developed an extraordinary range of multiphonic techniques. We toured only when each member of the group felt ready. There was a lot of talk about talking and much introspective thinking, for instance, What is a group? We created many works—for instance, *The Quality of Soft Is Not Straining,* and work made by others, such as Brun's computer graphics *Mutatis Mutandis,* Kagel's *Pas de Cinq,* and the first two parts of my *Lingua One: Poems and Other Theatres* and *Maldretto (for Seven Virtuoso Speakers).*

During 1972 to 1975 NMCE4 was a resident group within the UCSD Center for Music Experiment under a three-year grant from the Rockefeller Foundation. In the first year, a

stretched heterogeneous group was formed, consisting of three singers, a mime, a virtuoso speaker, an actor, an acrobat, a cellist, a dancer—the most idiosyncratic group to date. Because of its makeup, its major task was to explore avenues by which its diverse membership could be connected as an interactive whole.

One approach was to pursue the notion that the group could be regarded as a kind of generative and transformational grammar, in the Chomskyan sense, in terms of rigorous research performances along physiological, acoustical, and structural-linguistic lines. My earlier postulate of compositional linguistics—of music as language, language as music—became transformed into a more profound notion of "composing by language," actively incorporating computer, video, film, optical, laser, and electroacoustic technologies.

How did you deal with these different approaches?

By the transference of talents. The mime began to learn from the virtuoso speaker, the virtuoso speaker began to learn from the mime, and the singers began learning from both mime and virtuoso speaker, who would teach them vocal techniques. So by the end of the year, everyone was quite facile with each other's particular talent. The elasticity was not merely a function of numbers, but the degree to which each member could perform multiple tasks—as many as possible at the same time. In this sense, it became extremely difficult to reduce our work to music or theater or text or whatever! It became free of classification.

The second grant year provided for four performers who devoted themselves to such matters as fine-tuning, multiphonics, video composition, translation, noninterpretive states, focus, awareness, attention, and sound as a means for generating movement. After that, the third grant year provided for five dancer-acrobats who embodied elements from all previous groups and viewed movement as a means for generating sound.

As we speak, NMCE5 is currently developing here at the University of Iowa, where I am currently director of the Experimental Music Studio. The classes are beginning to become a group, an ensemble. Individual work is made, group work is made, and each member is encouraged to find their own voice as we investigate psychoacoustic perception, hearing-listening, and interactive states of live performance with technology.

What sort of performances did this lead to?

Well, NMCE4, the dancer-acrobat group, was sitting on the mat one day, quietly meditating and paying attention to each other's breathing, and someone said, "Let's fall," just, "Let's start falling." So we began to fall—we always worked on the mat—and pretty soon, two things happened. First, we were hurting each other badly, and second, we realized as a group that we didn't have the foggiest notion of what falling was all about. So we felt we needed to do research on historical reports and testimonies that had to do with falling, including psychological inquiry as regards falling in dream states. At the same time, we tried to find a process by which we could actually fall, and finally discovered that in terms of what we had in mind, nobody knew anything about falling. So we proposed, "Let's imagine that falling down is falling up, and falling up is falling down." Immediately, the movement became a continuing cycle, where direction of fall became a mere illusion.

This ended up nine months later as a work called *My, My, What a Wonderful Fall*. It included five dancer-acrobats falling in such a magnificent way by this time—on this mat, fifteen by fifteen—such that never once did they hurt each other. They could fall in any

direction without losing the trajectory of the gesture. There were no longer any collisions—they were able to fall over each other, inside and around each other. Each stage of the work was questioned in the light of what else was needed, as we pushed the work—in terms of endurance—to about twenty-five minutes.

Somewhere during the falling process, someone made an utterance, and the utterance felt good, and out of that, poems began to be generated. Not just abstract sounds, but sounds which never could be made by people other than when they were in states of falling. Out of this also came a four-channel-speaker acoustic output that consisted of falling sounds picked up by contact mikes under the mat which are played back in performance against the sounds being made as they fall. And out of the utterance texts they generated, I found texts in the sixteenth and seventeenth canti of Dante's *Inferno* which roughly corresponded to the acoustics of the falling sounds, and the general contextual metaphor, and these interlocking subtexts are read during the performance.

Next, an optical engineer involved as an observer began to imagine what the lighting might be like on the basis of how someone who is falling needed to be lit, and generated huge shadow-reflections in the entire space of the motions the performers were making. Everything became intrinsic and organic. When it was done it couldn't merely be called dance, it couldn't merely be called text sound—the work included these properties, but couldn't be reduced to them. Rather it was our collective testimony to "falling." And this is what fascinates me—to take some word as "text" and to actually translate and vivify that word by participating in making "sense" of it by actually doing—or perhaps "becoming"—it.

And for you, this is best achieved by group work?

Yes. It's the integrating, interactive sense of developing a whole, such that the multidimensional parts cannot be separated from each other. And this includes endless questioning, research, and change—a transformation from that which was into a new circumstance not yet experienced.

How would you distinguish multimedia work from multidimensionality?

My perception is that multimedia generally involves a collection of elements, technical and otherwise, which occupy the same space and generally create a kind of aura of belonging there.

But this is often a deception, particularly when these elements exist as parallel structures. By definition, parallel structures don't talk to each other—although there is a kind of mechanistic mixing going on. Multidimensional structures, in my sense, are intrinsically linked. The elements are indispensable to each other, talk to each other, and exhibit properties of each other—and have a certain conceptual resonance with the work of Harry Partch.

How exactly?

Well, he went so far as to ponder, Okay, I've got this musical idea, but there are no instruments to play the idea, so he made instruments. So, after having made instruments, he argued, I need people to play the instruments—what kind of musicians shall I have? Well, I want musicians to be onstage, and not in the pit. Once onstage are they really there only

to play music, or must they also move? Well, of course, they've got to move. Well, if they move, are they just going to move as any instrumentalist would move? No, they can't just do that—performing the music while moving is not the same as movement—so they must also be dancers, they must also be acrobats, they must also be actors, they must use their voices. Why? Because I want them to be as full of life as possible.

So Partch's concern was for assimilation-integration, such that the parts become insepa-rable. Those things which one recognizes as discrete elements elsewhere—like light, move-ment, dance, acting, music—are not discrete in his work. If you take any one of the parts out, the work becomes insufficient. All the needed elements depend on each other. And Partch's stage works are absolutely magnificent—they are systems of dependencies. They were integrated in such a way that having observed a stage work one couldn't say, "Well, I sure liked the music, but the dancing was lousy." If an observer and performers were really involved, there'd be no way in that situation to make such a partition.

Many avant-garde poets now seem to be trying to use language musically, and many avant-garde composers seem to be trying to use language in a way that isn't explicitly musical. But I sense that your work points to another kind of practice, distinct from these points of departure?

That's what I hope for. That crossovers are taking place is only possible by acquiring new language integrated with what *was* a particular discipline's language. What I abhor is to be referred to as a musician, or a composer, as if that's *it* in some academic sense.

Because the terms are too restrictive?

Yes—it's too separatist, which is not possible anyway. No work is that context-bound or that "area-specific." These kinds of evaluations do not hold up under scrutiny. One of the things poets do is to create language which didn't really exist before they created it. That's what all genuinely creative endeavors do—search for sense that didn't exist before. Profound creative acts create new language—going beyond the boundaries of their own specialty, so to speak.

And this is precisely your agenda?

Yes, I've been doing that for a long time, because I found the so-called language of music insufficient. If I were a poet, I would find the language of poetry insufficient. So what does one do? I'm disenchanted with the conventional notion of finding a style, a technique, a concept, which satisfies. I'm interested in growth—in exploring the unknown, and perhaps unthought of, domains. So I continue to deconstruct a previous work made in order to construct new steps. I like very much the notion of beginning a work with *no* idea as if it is a first work each time.

You've emphasized the power of the voice. Have you also found technology to be a creative catalyst?

That's a very interesting one! In terms of music in the mid-'50s to early '60s, composers who were not merely interested in writing acoustical music made a big jump and went into electronic music. I made my first "solo" tape work in 1959. But I also found that there were

things about the acoustical side of music—not merely the electronic side—that were still very compelling. So it seemed a natural thing to say, "Why not try to use the two?"

When people who brought studio technology, and the necessity of thinking about music differently, went back to the human performer, the performer was asked to do things they could not have done before. And correspondingly I began to do studio work as if it was a human performer on tape. My *Antiphonies*—integrations between technological outputs and human performer interaction—are instances of this fusion. My first *Antiphony* was made in 1958—a work for three string groups and tape. Interestingly enough, it's called *Voices*.

In that respect, changes in the new arts seem to be both technological and conceptual—in the sense that people now think of producing things in a new way. You've suggested how studio technology can lead to new attitudes towards real-time performance, but presumably group experiments prompt the same kind of shift. So maybe one can distinguish between solo experiments with studio work, live work, and mixtures of the two, and their collective counterparts in your kind of ensemble?

Of course! But the interactive work done with technology and groups, as in the *Antiphonies*, easily mapped into the question, "Could I ask the solo performer to be a group?"—and considerable groundwork for this had been done with the experimental groups during the UCSD period. For example, in *Mouth Piece: Sextet for One Solo Trumpet Player*, of 1970, for Jack Logan, the performer has to execute six discrete but integrated functions, including covering the entire range of the piano—a task beyond the ordinary range of the trumpet.

Early on, if I'd worked that composition for an ensemble, I'd probably have passed out those functions to six people. But here, Logan had to manage the extraordinary demands of the frequency range of the instrument and do a multiphonic "dance," articulate a poem through the trumpet, make specific gestures with his body, breathe ingressively, and move in the space of the score—which consisted of a set of slides projected onto a ten-by-six-foot surface.

Likewise, in *Cantelina III*, for soprano-violin, of 1967, each performer has six nonintersecting functions to execute. And *Inside*—a quartet for one double bass player of 1969, for Bert Turetzky—requires some forty different kinds of articulations—also to sing, to use the bass as a drum, and to move in the space with his instrument with certain given gestures. And in *Subito*, a theater work for four performers with viola, double bass, voice, and trumpet, of 1977, each performer has eight discrete parts—all nonintersecting—to articulate. This work involves theories of complexity to the nth degree!

So all your work has led towards modes of integral performance addressing the concurrent potential of lots of possibilities?

Yes. That's what interests me. But it's not only potential, though, it's actual. It's the case! I think I'd be bored to death if I condemned myself to a life of just writing notes or words or whatever. There's always another level hidden from view. Of course this means taking chances—putting forth change in a world of making, which, at the same time, is drawing more and more from historical precedent. It's making it as it goes, it's questioning as one goes, it's becoming as one goes—and it's kicking ass a little bit, here and there as it goes.

Brisbane–Iowa City—November 5, 1990

Your recent works, particularly Testimony, *seem to focus much more explicitly on social and political issues than those we discussed seven years ago. How did this project come about?*

Well, first, as an artist who continually puts forth the desire for change, I'm continually going against the status quo of what is imagined to be what an audience wants. That makes it sociopolitical. That is, I make the work *I* want—I frankly don't know what an audience is, so I can't possibly imagine writing for one.

Second, when quite young, I held the notion that I was a composer who was in the world. During my living-in-the-desert years, a radical shift took place, and I now regard myself as someone in the world who happens to compose. It has been clear for sometime that there is no way to escape the increasing level of violence, corruption, and noise all around us. And so, from topics of interest such as *My, My, What a Wonderful Fall*—which, by the way, was a metaphor for the "fall of the university," written at the time I resigned from UCSD in 1975—I've moved on to topics which address states of affairs in the world. My *Scratch Project,* begun in 1982, is one such.

How did this project come into being?

It began during a weeklong seminar with students in the theater department at Union College in Schenectady, New York. We were working on some "Sensing Instruction Compositions," which had been formulated with and by the NMCE group at UCSD, beginning with *Countdown.* This work's instructions were to lie down on a gym mat, in some "scattered" array, get into a state of deep, quiescent breathing, and then focus on some profound experience in your life. When your image is focused clearly, you begin a countdown from one hundred to zero, at your own rate. Gradually, as you approach zero, you begin to imbue your countdowns with the quality of your image such that reciting numbers becomes an *expressive* act. Once zero had been reached, each member was to remain in a quiescent mode, continuing their deep breathing until the last person sounded "zero," and then rise to a sitting position.

I remember I was struck by the anguish and tension in their expressive transmissions. It was the time of the cold war and the arms race, and their parents were engaged in factory work which entailed assembling components of nuclear warheads. They were doubly distressed— not only about the possibility of nuclear war but because their parents were involved. Most of them had simply concluded that they were powerless to do anything about it.

And so I began to talk about the "voice"—the power of it, and the necessity to have their voices *heard.* They were not interested in creating an acting project, as I had originally planned. Instead, a video project was discussed—a kind of oral history on the topic of nuclear war—to be presented publicly, as our production, on the last night of my residency. Together we formulated the following question: "In the event of a nuclear war, humans would be sacrificed. This sacrifice could not take place unless human life was thought to be expendable. In this, your life is included. How do you feel about being expendable?" This became the beginning of the *Testimony* project.

How did it develop?

The project asks individuals, one at a time, to respond as they please to this question before a fixed video camera, monitor, and VCR. The testifier is asked to look directly into the

camera, placed about two feet away, and the question is always read audibly off-camera, usually by the person who has just completed a testimony. I found that the expressive quality of the reading is almost always different from the manner in which the testimony was given. So, in this sense, there are two "takes." It also turns out that most men misread the word *feel* and talk about how they *think* about the issue. Women, almost invariably talk about how they feel. On tours, I often have a camcorder with me and have gotten many testimonies this way.

I should also mention that *Testimony* forms part of a much larger work called the *Scratch Project*—a massive four-act theater based on the subjects of war making, male sexuality, violence, and the social nature of argument. Initially it is to be presented in the form of an installation and, subsequently, as a two-hour broadcast-quality videotape. These acts are entitled *Testimony, Antiphony VIII, Pentagon/Y,* and *De/Bate.*

Act one, *Testimony: How It Is,* is its centerpiece. The initial installation will consist of at least five hundred unedited, uncensored, individual testimonies from as many areas of the world, and from as many different people as is possible, and will be distributed among thirty one-hour cassettes, each with roughly sixteen testimonies. Each cassette will have its own video playback system, placed around the perimeter of the installation space, in such a manner as to allow for discrete viewing. All systems will transmit at the same time—thereby encircling all viewers—and the tapes will recycle continuously except for scheduled times during which the other three acts are to be presented.

Act two, *Antiphony VIII: (Revolution),* for one percussionist, four-channel audiotape, and stage lighting, is a kind of theater in which a percussionist functions as a performer, acrobat-dancer, and actor. A complex score is played from memory on forty percussion instruments made of steel and skin. Steel and skin represent death and life, respectively. The performer is asked to experience five changes of being—indifference, distraction, denial, fire-with-fire, uncertainty—which reflect certain current societal attitudes towards nuclear war.

Act three, *Pentagon/Y,* concerns guns and cockfighting for solo reader, and consists of ten writings in literary-poetic form, which explore the substantial interconnections between traditional concepts of manliness and male sexuality, and those of power, force, violence, and war making. In these writings, one can "hear" the result of extensive historical research, complexly interwoven with the author's raw—and often painful—self-examination.

Finally, act four, *De/Bate (Conversations between Or, Da, and Ip),* for two actors, one mime, two video cameras, monitors, and VCRs, is a stage work based on a nuclear disarmament confrontation between a Philadelphia lawyer and a spokesman for the Pentagon that I witnessed in 1983. Ultimately, the issues canceled each other out due to the elegance of argument on both sides.

Do you know when it will be presented?

There are no set dates yet—perhaps in a year or two. The main task will be to find a good space for the premiere, and, of course, seek funding. In any event, a booth will be set up on-site to continue to gather testimony, so that this part of the project may never end.

You've got a distinctive historical and confessional agenda.

Yes. The *Scratch Project* focuses intensely on history and biography.

Have you continued to write virtuoso pieces for solo performance?

Well, I've made certain sketches. But as I've suggested, there have been other preoccupations. At some point this approach will return, hopefully, with a new twist. Meanwhile, *Subito,* a kind of theater for four instruments, has not yet been possible to perform. Perhaps I reached the limit there. I may not have mentioned that the desire in this work was not only to increase levels of complexity but, in fact, to free myself from any particular instrumental built-in constraints, such as instrumental range. So I wrote a composition I heard in free space, so to speak. For instance, the voice part—either male or female—extends to the entire range of the piano. To perform this "part" would require taking in, at the high end, extraordinary feats of falsetto, ingressive multiphonics, and at the low end, Tibetan chant techniques and so on. Philip Larson can almost do it.

Meanwhile, I have composed *Enough,* for forty voices and solo percussionist. Some forty different kinds of articulation are required—the whole group forms eight subgroups of five each, and the piece requires distinct articulations from each group. As well, each member was asked to make a small, "tinkly" percussion instrument which they use here and there, and also make gestures with. The text comes from a speech Benjamin Franklin made to the constituency prior to the signing of our constitution. In this work it could be said that there is a kind of polyphony between individual groups performing multiple tasks. The sounds are fantastic!

Have you any further thoughts on the functions of computer technologies and video?

Well, I continue to do works for tape only, such as an ongoing series which explores "muted" voices generated either by analog or computer techniques, or combinations of both. *Re-Run, Of Metal,* and *Tapestry* are three such. Currently, I prefer working with "knobs"— or analog systems—rather than with "terminals" or computer systems. Perhaps one day I will be able to buy, or construct, a touch-sensitive device which will drive the computers. While I need to continue my work with both technological and human interactions, I still feel a friction between them. Sometimes that is good, sometimes not.

I have no problem with a beautiful video work, as an *observer.* But I have had great difficulty with performers *interacting* with video. Perhaps it's because of the "frame" of the video itself— so far, there seems to be a void which cannot be breached. Video is a kind of visual radio—it doesn't know who is listening, looking, or present. To attempt two-way interaction becomes a pseudo interaction with a nonother! And much computer music still sounds like a demonstration of the machine—not the other way around. So that's where I am at the moment.

What about multimedia collaborative work?

I've recently completed a collaboration with video artist Hans Breder entitled *La Cora.* In our next collaboration we propose to exchange roles. And somewhere in 1985, Henri Chopin and I did a neat work which he named *Few.* In process is *Antiphony XI (You!)* for guitarist, alto flutist, and the dancer Patricia Hruby—we are collaborators—based on a text by Lizbeth Rhymland. Most of the *Antiphonies* have been collaborations at every level of work.

Do you have any other multimedia projects?

Well, there is a group in Santa Fe—where I expect to take up residence very soon—including video artists and composers Steina and Woody Vasulka, environmentalist-composer-

philosopher David Dunn, and David Muller, computer designer and programmer extraordinaire, who are working on the creation of a multidimensional theater based on concepts of actual-virtual space. Technology will include computer-controlled robotic cameras implementing transmissions via complex arrays of video systems and audio, including ambisonic techniques.

These technologies will require interaction with a number of live performers who may be involved with other technologies as well, and I hope to be actively involved. There has been some discussion of "stagecraft"—texts, movement, and other theatrical matters. Hopefully, an illusion can be created—for me, anyway, it could become a work which addresses the nature of multimedia and that of multidimensionality at the same time.

Further collaborations!

Yes, I've said a lot about interactions, collaborations, and so on—including the integration of people with people and work. But the elements of successive works, such as the *Lingua I* series, are not necessarily *intra*connected. But more recently, I've been thinking about differences between an individual as such—that is, as "unique, distinct, and complete"—and the extent to which these properties give way to another *kind* of uniqueness when one—or a work—becomes a member of a group. Each part of this kind of "ecocluster" is complete and can stand on its own and at the same time—in one complex fashion or another—holds membership in the group. Resonances abound between the one state and the other.

From a conceptual point of view, my work began in the domain of relationships, then became transformed into domains of interactions, then into domains of interconnectedness, and—more recently—into what I call ecoclusters. From an aesthetic and philosophical point of view, my growth has consisted of a motion from relativistic modes of thinking to phenomenal ones. I suspect I shall continue to reside in the latter domain.

Diamanda Galás. Photograph by Tom Caravaglia.

DIAMANDA
GALÁS

ONE OF MY INITIAL VISIONS of the high-tech, high-volume performance diva Diamanda Galás was a menacingly gothic photograph in the San Francisco art magazine *Art Com* (no. 22, 1983), overlooking the marvelous assertion: "There is a stupid concept that electronics have us evolving to this unfeeling inhuman state . . . I *dominate* my electronics." I subsequently saw footage of Galás in performance on John Giorno's Video Pak 3, *It's Clean, It Just Looks Dirty* (1987)—"Just recordings of poets and artists," I assured Australian customs at Brisbane airport—and discovered more about her early work across the media when a student gave me a photocopy of her classic interview in the rock 'zine *Forced Exposure*.

Then at last, flying out from the UK for the occasion—and unexpectedly accompanied by fellow New York visitor Rachel Rosenthal, who regally chided lurking punk bouncers for smoking near a performance space—I finally saw Galás perform *Schrei X* at the Knitting Factory in February 1996.

When I met up with Galás the next day, I was keen to ask her about the origins of her work in San Diego, and the nature of this virtuoso performance with sound engineer Blaise Dupuy—which immediately reminded me of Warren Burt's similar real-time fusions of live and electroedited text, song, scream, and sound in his performances with Australian poets Chris Mann and Amanda Stewart. To my surprise, we initially spoke not so much of Galás's San Diego days with Burt, as of their mutual mentor, the composer Kenneth Gaburo, with whom she had also worked, talked, agreed, and disagreed. Once again, another missing link between different postmodern avant-garde generations zoomed into focus.

As Galás suggests, her multimedia practice seems most distinctive in terms of its fusion of live, amplified utterance and Dupuy's battery of "vocal samples and . . . electronic manipulations"; its integration of sources ranging from the Book of Job and the writings of John of Patmos, to such relatively recent "blood brothers" as the French poets Baudelaire and Corbière; and its elaboration of harrowing "antiliturgies" in solidarity with those "isolated or kept aside by their mainstream society."

Hearing Galás in concert in London, later that year, I was struck all the more by her capacity to project the highbrow, the lowbrow, and the popbrow into a vitriolic vocal wasteland, where even a seemingly innocuous Motown hit like "My World Is Empty without You, Babe" attained demonic finality. Here, the "black mass" intensity of Galás's diction transmuted the more abstract energies of *Schrei X* into a stunningly collective "mass" avant-garde discourse, as compellingly accessible as it was chillingly disorienting.

New York—February 24, 1996

How do you best like to be described as an artist? Critics often refer to the unusual quality of your voice and to its virtuoso range across gospel, rock, avant-garde music, and extended voice techniques.

Whereas I think it's accurate to describe me as a "virtuoso"—or in such relatively neutral terms as a "composer-virtuoso," I find references to myself as "a virtuoso singer with a three-and-a-half-octave range" absolutely mindless, because if one octave isn't interesting, who the hell cares about the next two and a half? I mean, Carmen McRae used primarily one octave, and she sang more than most people sing in their whole life—in one octave—so that isn't really a relevant issue.

As Kenneth Gaburo said to me a long time ago, "The most important thing in composing is being able to fulfill in that exploration what it is that you intended to do." And if someone can say that he or she does not agree with what you intend to do, and finds it tasteless, uninteresting, boring, or whatever, that really is just a personal, unimportant observation at the end of the day.

What I, personally, have intended to do demands a very large technical ability on the part of the voice, because it involves precomposition work and improvisational work with an artillery of timbre, of vocal range, of vocal-signal processing elements, including the spatial manipulation of the voice, and uses works in different languages by my blood brothers—Baudelaire, Corbière, Nerval, Pasolini, and so on—to say most articulately what I wish to say about the world.

I took two private lessons from Gaburo, and the second time I was in my car afterwards and practically had a car accident because he got me so angry. We had this discussion about my work, and he mentioned something that was quite true—having to do with wanting the largest palette available to you as a painter of sound. What he said was, "You've chosen this one direction in the use of the voice, but are you aware that that certain direction is repetitive in a certain way?"

And I immediately thought, Son of a bitch! I'm never going to see him again!, and almost crashed into the car in front of me. But of course he was completely right, and at that point, more than ever, I realized that as a composer you really have to understand what it is to be a good craftsman, in order to do the work you really want to do, rather than a lesser work which may be limited by your technical ability to say what you wish. If you do not *hear* anything else, then there is no problem, but if you do, you must become a virtuoso of sorts in order to compose honestly—and manage to stay awake while you are performing.

What are the most difficult challenges you've encountered within your chosen area of multimedia performance?

Well, another project that I've been working on is *Insekta,* which has only been performed four or five times in New York. It's a piece that's performed in a large metal cage. It was built very soon before the shows, so there was little time to rehearse. *Insekta* refers to things invisible to the naked eye, something unseen, unknown, anonymous, something that is available for biochemical, biological research—the kind carried out on prison populations after their families have signed that they are available for experimentation.

It's very difficult because it involves solo voice, and a lot of text that I've written, texts from the Book of Job, and a lot of texts from the Apocalypse in Greek and Latin, written by John of Patmos. The most interesting thing about it is the tape work that Blaise Dupuy and I did with a combination of a lot of my vocal samples and with electronic manipulations of that—it's a very large, difficult piece.

I haven't used the word *multimedia* in my work because I've never known exactly what it means, or whether it refers to an earlier tradition of performance, or whatever. But if you think of avant-garde theater or even avant-garde opera, it is by definition multimedia, and in this case it's very visible. I have two microphones strapped on a breastplate, so there's freedom to move really quickly through the space making vocal sounds.

It's a really rough piece, and I discuss it now because I have not had the opportunity to really work on it because it's expensive, it's dangerous. In one of the performances the cage almost ripped apart—and it's one of those things that you have to really rehearse, or it becomes your last show! After this project I want to work on something dealing with the Salem witch trials, so I'll be using more of these texts from *Apocalyptic Revelations.*

I continue to work on *Job*—that's one of the most interesting texts because it's an obscene paradigm, an untenable paradigm. When you talk to people who are religious and terminally ill, the story of Job appears as an eyeball in hell. *Job*—the card game between God and Satan, which determines how well God's servant Job will respond when everything but his life is taken from him—is a paradigm of torture, because if you kill the animal, he is no longer available for torture—the basic *Sadeian* principle. My declaration of the text and the work that appears to be nonverbal are not two separate things—they're very, very much linked through the text, and that's something that I'm doing more and more that I find very interesting.

Is it a mixture of live work and prerecorded materials?

Insekta is. The piece you saw last night, *Schrei X,* is all live.

That's a kind of one-person quartet in a way, isn't it? You're jumping around in microphonic space, using the four different microphones to project sound from different directions in different registers.

That's exactly right.

It's very dense and condensed.

It's very dense—and it's as spatial choreography that I always think of it. Blaise Dupuy, the sound engineer for *Schrei X,* is working with live signal processing, with ring modulation, sound distortions, and different delay times—we work very carefully together changing the

Diamanda Galás, *Insekta*. Photograph by Catherine McGann.

Diamanda Galás, *Schrei X,* CD cover.

processing for each section of the piece. Often very subtle changes are made, and it's often difficult because of the way that I sing for people to distinguish the vocal sounds from the processed vocal work, because of the subtlety of the processing and of the way Blaise works as an accompanist, using electronics to shape an interface between my voice and his processing.

He's shaping it in real time, modifying your live voice?

Precisely—so that's quite different. In *Schrei X* he doesn't use any samples, but those are used in *Insekta.*

Presumably, it's a very close collaboration?

Yes. The people I work with are always great musicians—it's not just a person who's an engineer and is just sitting there and doing some sort of abstract technical work that has nothing

to do with the music, and occasionally there's an interface. But most people don't know that—it's an extremely musical process, and I appreciate it because I've been working with these people for twenty years, so I know. And you always know if somebody isn't good!

Well, Warren Burt, who you knew in San Diego, has done many collaborative performances with Chris Mann and other poets in Australia, sampling or modifying their work in real time. Chris will read something, Warren will instantly sample it and start playing it, and Chris will then improvise against that. There seems to be a parallel here to your work with Blaise Dupuy.

There is—you're right. There is a mutual improvisation that takes place, especially in rehearsals, and then both parties decide upon a fixed setting—"This works and this works and this works." It's the way choreographers work with dancers—"This works, try this, that works, try that." But then, in the case of somebody like Blaise, who is so familiar with technology, he'll try something as I'm improvising, and then I'll stop and say, "That works, and that works and that works." But with *Schrei X,* I wanted to do extensive work with ring modulation and distortion, because I wanted it to be an interface between the voice and the electric chair—the voice and this type of electronics. Do you know the story of Leon Theremin, the scientist who invented the theremin—the instrument used for the very high sounds in a lot of horror films? He was a Russian, working in this country constructing the first electronic manually played instrument, and he was kidnapped and brought back to Russia to work in factories because they said, "This research that you're doing, it's most important for the execution of traitors to the government—don't waste your time on silliness like electronic music." There's something very interesting about the interface of an absolute technology to kill man, and then the vulnerability of the voice—I see it as the charring of flesh, in a way. And that's what I wanted to work with.

In each piece, I experimented with a different range of vocabulary, not just with the signal processing, but also working with whoever was doing the light. I wanted to do this piece in darkness—it was very important to do this piece in darkness—but it's not complete darkness, because I still need to see the text. At some point maybe, if I'm capable of memorizing it, which I may not be, then we won't have any light at all. The reason why I want to be in complete darkness is first of all, because then I'm as alone as possible, and I'm just a medium for the work, which is about me, but is not about me. And so it's a sort of sensory deprivation which I enjoy, although I have heard otherwise from certain audience members, vocally, during the show.

But as someone doing electronic music, I also enjoy the idea that the audience has nothing to look at, because I think audiences have been getting away with having things to look at for quite some time now, and should learn to use their ears. The visual element (often ridiculous concert lighting) detracts from the severe concentration which is needed to attend to such work. Obviously Varèse and Xenakis thought a great deal about this.

Could you tell me a little bit more about how you got started?

Well, in the 1970s I was working at the Center for Music Experiment in San Diego, working with my friend Richard Zvonar, who's another composer, a wonderful composer. We were working in quadraphonic space—working then as now with the four or five microphones, but at that time only working with incremental changes in reverberation, with very simple electronics.

I then began to work with prerecorded voices on tape, because of the orchestral possi-

bilities of unorthodox vocal timbres, dry or processed. For example, I would take vocal timbres and lay them so thickly that it would just be like rock formations. You wouldn't ever even think of it as being vocal sound, and that's very interesting. Certainly much of this can be done live as well, especially with the superior digital technology we have access to, but it is different, a different way of thinking, and therefore a different result.

I started my performances in the '70s with no amplification, with my back to the audience, wearing all black just to be as invisible as possible. This was in a lot of different places. The Living Theatre suggested I perform in mental hospitals where they were performing, and took me to a few mental hospitals, and then I went and performed in a couple of art spaces. But the art world did not like me in the '70s at all—not at all—because they were more interested in cold, conceptual stagings.

And that wasn't your thing?

Hardly! They'd say, "Oh my God, that woman's screaming!" Eleanor Antin, I have to say, was one of the only people in visual arts who was extremely supportive of my own work, and then later her husband was—David Antin—as well. So I just started to do solo performances, after working on the torture piece—the opera *Un Jour Comme un Autre* by the Yugoslavian composer, Vinko Globokar, at the Festival d'Avignon in 1979. The extraordinary musician and later my friend, the vocalist Carol Plantamura, sent my work to Vinko, and he asked me to come to Paris to work on the piece.

René Gonzalez of the Théâtre Gérard Philippe Saint-Denis then asked me if I had solo work I wanted to perform, and in 1980 I performed in the basement cabaret of his theater, which was outside Paris. There was a Henry James play upstairs, and people came downstairs afterwards, thinking they were going to have an evening of French cabaret music, and instead I would do *Wild Women with Steak Knives*. At that time there were between three and twenty people in the audience, and the people writing about it were mainly for publications like *Liberation,* but not the main papers.

All this was after your San Diego time?

Oh yes, after my San Diego time. I went back and forth to San Diego because my parents lived there and because my teacher, Frank Kelley, lived there—I worked very hard with him and he gave me free lessons for ten years. He was a wonderful teacher, extremely dedicated to his work and to his students. Back in Paris, I also met Iannis Xenakis and performed his work. I had been initially accepted in the music department as a pianist in the master's program, and then I switched to experimental vocal performance.

That was quite a shock for everyone, but I just felt that what I wanted to do in vocal performance was going a distance further than what I heard myself doing on the piano. The music and visual art departments were diametric in their interests—one in film, the visual arts in general, and this performance art stuff; and the other in contemporary music, avant-garde music, computer music, with a focus on experimental performance and composition.

It sounds like a rich crossroads of interests.

I think so. There were a lot of very, very sharp people at San Diego. Warren Burt was there, Chris Mann visited, Dick Moore worked in the computer department. Will Ogden and

Beverly Ogden, Tom Nee, Jean-Charles François, Carol Plantamura, Bert Turetzky, Damian Bursill-Hall—I had many interesting instructors there. I was seen as a sort of renegade who was not really excelling in the music program, but having a few interesting ideas. I would say I was treated with much kindness, especially when one considers my tendency to do everything but what was assigned to me.

Your contacts with Xenakis, with the Yugoslavian composer Globokar, and with the Living Theatre all seem to have offered lots of different stimulants—in the best sense.

In the best sense—it's true. I worked with these people, because people would say, "With your voice, this is what these composers are looking for," and so I thought, Iannis Xenakis is a hero of the Greek people, and so I'm going to work with him. And Globokar pushed music to the limits, he pushed the limits of the instruments, and I thought, That's a challenge!, because his pieces had ruined two or three singers before me, so I heard, and I was up for the challenge. I later decided that if I were going to take the voice as far as I was taking it, then I

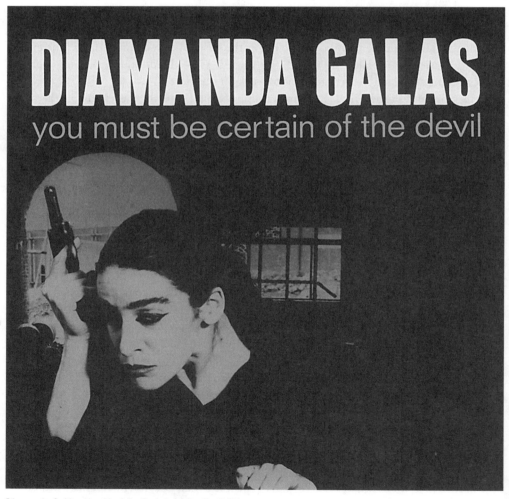

Diamanda Galás, *You Must Be Certain of the Devil*, CD cover.

should do it for myself, in my own compositions, because of course that is always the most interesting direction.

I played all the piano stuff, whatever the avant-garde piano stuff was, but I failed all the dictation classes—I couldn't do any of the traditional stuff. I was really miserable, and even when I did a class of extended vocal techniques, I did poorly because I could not get interested in writing about such things, more in performing them. Let's face it: I was a terrible student, more of a visitor on the sidelines, learning what I wanted. I am not promoting this; it was simply the case.

Was there also a rock music and jazz influence as well?

Well, that comes through my father, who directed a gospel choir when I was younger. He had a black gospel choir that did all those things—"Swing Low, Sweet Chariot"—and I would always hear this and play piano with them sometimes, and then play piano in his New Orleans band. And that led to listening very carefully to stride pianists, at first studying stride with Barbara Du Bois in San Diego when I was about nine years old, later with Ilana Mysior on the concert repertoire when I was thirteen. Later I studied with some very great bebop pianists and other musicians in San Diego, Pasadena, and Los Angeles—I worked on bebop for a while. Butch Lacey and Jimmy Donahue, a little work with Walter Davis in Los Angeles and later Bobby Bradford. I remember Butch telling me once, "You don't play passive-aggressive piano: you play aggressive-aggressive piano." That made me laugh. In those days I wore big overcoats when I played, so people would not look at me.

So I think that my influences are quite numerous. But you know Gaburo—I keep talking about Gaburo—one of the last times I saw him, he did a jazz gig at the university cafeteria. He was playing stride piano and Erroll Garner kind of stuff! It was very good! It was very good!

What about New York influences? Did you find another ball game here?

Well, I'll tell you, the biggest New York influence is walking down the streets in New York City every day, especially at five p.m. yesterday, when I'm trying to get home before the show, and I can't get home, and I'm walking in Chinatown with crowds everywhere—just the sound and the noise and the speaking and the crashing into people—you can build up this real frenzy! I'm not afraid in New York—I get annoyed, not afraid! I was afraid in San Diego; I would be afraid of isolated spaces and of being on the streets by myself there. This place doesn't make me afraid. It's a kind of celebratory atmosphere, but it's a very loud and frenetic one, as if the phone lines are always taken up! So it has a different swing to it and a different language.

Have you come across any other performance work that you particularly like which seems to engage with this kind of momentum?

Well, there's the dancer Elizabeth Streb, who's wanted to defy certain gravitational principles. She believes dancers can fly; she has people doing things that are very, very dangerous. I find her very kindred in spirit.

Well, the impression I get from your work is that it's taking risks with energy and urgency, in order to break through the limits of your immediate gravity.

Yes—and that's what she does with her dancers. It's physically very dangerous, her work, and I really like that. I also get a lot of inspiration from . . . from certain sports where certain levels of vigor are demanded in order to execute the idea.

To be at one with the idea—that's interesting to me, because it really, really means that you have to take whatever the concept is and put it into a physical reality, which is very hard. It's something that, unfortunately, Artaud was not able to do, not enough, and that's what drove him crazy, among other things. He was not able to extrovert that energy and put it in a physical realm, in a physical space, and so he had all these magnificent ideas, and he was writing them down, but he couldn't breathe, he was asphyxiated by these claustrophobic spaces. This is a very dangerous thing—there are beautiful things to be learned from him, and then there are things to be sharp-eyed about as well.

Does your work frighten you sometimes? Do you feel you're pushing yourself into dangerous spaces?

If I'm doing my work, then I feel happier than anyone could possibly be—than I could possibly be. If I'm not hot, then it's kind of a bad thing. Because what happens to me is that when you get that adrenaline, that unnatural surge of adrenaline—for any reason whatsoever, usually fear—it's a big motivator, it's very exciting, but then when you come down from it, it's quite depressing, and things look very, very bleak.

So I have to keep performing, so that I can keep a sense—a clear sense—of how things are. If we were in this room two days from now and I wasn't doing a show for three days, I couldn't be in this room with all these people—I'd just go fucking crazy. I'd just go crazy, because my spirit, metaphorically speaking, would be very much inside the body and I'd feel encroached upon by all these people. But because I did this thing last night I don't feel encroached upon.

Well, it's interesting that you're emphasizing the physical articulation of this thing, and yet you're doing it—and I don't think it's at all paradoxical—via technology. As you said in your early interview in Art Com, *you "dominate" your technology in order to make things happen.*

That's right!

Whereas a lot of cultural theorists look at mass technologies and say that our culture is neutralized by their impact.

If you're not strong enough to interface with the technology, then it'll come out in the wash, and everyone will hear it. I mean, a lot of sound groups that I know on the road who work for Motorhead and bands like that, they say the following: "Shit in! Shit out!" It'll give you what you put into it. That's it, you know. That's it. And I'm not an electronic genius. As I say, I have to work with people. I mean, I know what I want, but I still have to work with people who are masters—sound engineers who are masters of the work.

That leads to something else that I find very, very interesting. You're working with virtuosos—or fellow virtuosos—of high tech, but you're also working with contemplative writers from other centuries, even back to the Old Testament. So there are historical continuities and contemporary continuities across your work, and I think that interface probably leads to a rich potential of adventure and creativity.

I agree. I am most probably writing electroacoustic liturgies/masses for the dispossessed—guerrilla liturgies, or masses in the sense that the work is written *from* the margin *for* the margin, the *living* margin, not only the dead. These dispossessed persons were the original inheritors of masses—the people who have been isolated or kept aside by the larger part of society. Masses for the Invisible.

John Giorno, Centre Pompidou, June 1983. Photograph by Françoise Janicot. Courtesy of the artist.

JOHN
GIORNO

APPREHENSIVELY APPROACHING NUMBER 222 FOR THE FIRST TIME IN 1982, and recalling John Giorno's suggestion that the Bowery's air of "pain and suffering and death" could be "very refreshing," I wondered if the group of figures clustered in his doorway would request my wallet. They didn't.

I buzzed Giorno's apartment and was soon looking around an archive of boxed reel-to-reel tapes recording the best minds of his generation. Did he consider himself a sound poet? Not really—just a poet working with "the sound of words and with performance" and with those practices making audiences "*surrender* themselves to you."

But surely audiences often got things wrong? Hadn't Larry Wendt written that San Francisco punks had laughed at all the wrong places? "No, they were laughing at all the *right* places! . . . Even if they hate it, at least it's hot, and it works, just by the fact that it's connected."

Subsequently crossing paths across two decades in London, Quebec, Brisbane, Sydney, Lyon, and Paris, our successive discussions trace Giorno's explorations of performance as a means of transforming "one thousand percent" subjectivity into collective "objectivity" recognized by "everyone in the audience," be this by solo work with multitrack tapes, by vocals with the John Giorno Band, by computer-designed poem prints, by award-winning video clips, or by the curiously detached, offstage gestures of his monumental presence as "Joe"—"tears three feet wide"—in the La MaMa Theatre's audiotape and live video production of Beckett's television play *Eh Joe.*

Discrediting the myth that postmodern performance snoozed to death in Warhol's film *Sleep*—in which he slept—and nurturing "ten different projects a day," including the production of CDs and videos, the organization of his AIDS Treatment Project, and New York lectures by visiting Tibetan Buddhists, Giorno justifiably celebrates the "very unusual fortune" allowing him "just to survive for thirty years and to work on whatever I want," irrespective of the indifference of the art and literary establishments.

New York—August 25, 1982

Perhaps I could begin by asking you how you would describe your kind of performance? Would you call yourself a sound poet?

No, I just think of myself as a poet, and I work with words. I work with the sounds of the words and with how they're performed and recorded, and I think those are just the jobs of a poet, as opposed to calling it something special like "sound poetry."

When did you first start using tape recorders?

Well, I met Brion Gysin in 1964, and he introduced me to the use of the tape recorder in poetry, and the making of sound pieces. He and William Burroughs had just come back to New York for the first time in many years. At the time I had already started the found poems and then the sound pieces were just the using of the found words—*Subway Poem* actually being the first sound poem I did.

What did you find most interesting in Brion's use of sound and recording?

The idea of using the tape recorder and the possibility of layers of sound—for example, using prerecorded subway sound and the reading of the poem. Brion and William left in the middle of 1965, and I just went on experimenting, and in that same year I met Bob Moog, who had just invented the Moog Synthesizer. I used to go up to his factory, and we fed the words through the synthesizer and changed their modulation in terms of oscillations, and then put down various layers of the straight voice and then under that, the layers of modified voice. I used sound, experiments in sound, to create a sound piece, to create a musical score, so to speak, that is inherent in the words, that creates something that is slightly fuller and *more* than just if it were straight.

At the very beginning, shortly after 1965, it was all on tape, and I even used other people's voices as found voices to read the poems, and then permutated those, or modified those, with the synthesizer and various electronics. And then the whole performance thing, like everything else, over the years, opened up and changed.

Have your performances always mixed live and prerecorded utterance?

No, that's what I've been doing for the last few years. There's a highly constructed, composed, performance tape, and it's played through house speakers, and I follow it, as a musical score, reading live with the tape, and using it as one would use music. And now, I've begun to work with music. The new record, *Who You Staring At?,* has Glenn Branca, who's a composer-musician on one side and me on the other with David Van Tieghem on drums, and Pat Irwin of the Raybeats on guitar, keyboards, or whatever.

Do you have any general sense of the differences between American and European sound poetry and related performances?

Not really, because they are all friends of mine, and so I tend to like their work as regards their friendship, which has nothing to do with good or bad—I've known them for so many years. Bernard Heidsieck and Brion Gysin, myself and Burroughs and people like that—we

all go to Amsterdam, or we all go to the festival in Rome, or we all go to Brussels or wherever we are. So every year we spend a bit of time together, in sort of a way that's accidental and coincidental of performing together, which continues the friendship, which is focused on sound poetry or whatever you want to call it. So it becomes this natural sort of support. I love these festivals because they're truly community affairs, like family affairs.

Do you find yourself falling out with the family?

Well, it depends. The one great thing about the festivals is that they're never that long, you're only there for three days—just enough! All of those fucking sound poets have had so much to say about me all over the years, and I have just done what I wanted to do and now I'm doing music. So I don't care what they think!

When I saw Brion Gysin in Paris, he said that he felt things were grinding to a standstill, and everybody was doing the same works at each festival.

Well, I think that's true. It's one of the reasons I've stopped those overlays—that type of composition that I've been doing for all these years.

In order to work with musicians?

Right. It's replacing the performance with instruments. I've gone about it very carefully, because I don't know very much about music and I don't know how to sing, and I don't want to make a rock and roll song. So what one's done is working with these friends that I have in a twenty-four-track studio, laying down the drum tracks and then laying down scratch vocals. Because I perform so much, I have this sort of rhythm or beat, and it's connecting it to the drums, and then calling in Pat Irwin and having him lay down various guitar and keyboard things, that accentuates the work. I've just been doing it for the last two months, and it's worked well, fortunately.

Is America more receptive to these experiments than Europe?

It doesn't really matter, actually. The audiences one tends to be performing to are these young audiences in rock and roll clubs. Last year we did a lot of small regional tours in the Midwest, William Burroughs and myself—and in these places like Bloomington, Indiana, there'd be these punk clubs, and they'd be packed and they would have come for no good reason at all. I mean they had heard the name William Burroughs. But they had never read any of his books and they had no idea of what he was about, and they had never heard my name, nor knew my work or anything, and they had come, and paid all this money, and they were totally hot, and they loved everything.

There was this immediate audience reaction, laughing and cheering and applauding and clapping and screaming and whatever and that kind of wonderful dynamics that you get in clubs. Because when you perform with that kind of energy, it just sort of feeds inside—it pumps the performance up and that pumps the audience up and it becomes wonderful.

And those audiences, in a strange way, I found they were like the best audiences, as opposed to San Francisco or New York, where everyone knows my work, and when they come, they come to see how it's changed, what it's done, is it this, is it that, and they have all those concepts, because they've known my work for years.

One friend wrote that when he saw you and Burroughs perform in San Francisco the punk audience seemed to be laughing at all the wrong places.

No, they were laughing at all the *right* places! It doesn't matter where they laugh, as long as there's some feeling generated and there's some connection with what's happening. Even if they hate it, at least it's hot, and it works, just by the fact that it's connected.

How does all this relate to the printed page?

Well, the way I make these poems is that they're written down on a page. They're very carefully thought out, and they change constantly, until they're fixed according to how they sound, and how the rhythm is, and where the beat falls, and what the intent is, and what the content is. And then, when they're fixed, they're written down, and then I perform them. And then it takes all those other steps into developing a performance of a particular poem, and then bringing it on to the electronics and the musicians, and making the piece for the LP record, or the live performance, or this or that. But their origin is on a printed page.

Back in the '60s, you were already well known as the star of Andy Warhol's film Sleep. *Did pop art have any distinctive effects on your work?*

Yes, Andy and Bob Rauschenberg strongly influenced me in terms of the way they chose found images and then transformed them through silk screen onto canvas. I worked, or tried to work, in written words with found images from magazines.

My preoccupation was with the way images were used. And instead of using them in terms of silk screen on canvas and collaging them in that fashion like Rauschenberg—or in the way in which Andy did *not* collage them—my concern was with how those images were taken and seen as verbal images. Because you translate images verbally. I mean you think about an image, whether you see it in front of you or you read the words. And it was dealing with those concepts that I worked on for all those many years.

They were different from the way all the other poets were working. Frank O'Hara, John Ashbery, and Kenneth Koch had poetic considerations, which have all sorts of historical bases. Henri Chopin and all the Europeans were thinking about sound poetry, what a poem is, or what images are used or not used. The concrete poets had an idea about the page and about the alphabet taken apart and presented in some fashion. Whereas I was concerned with what came into one's mind: what was the thought, the metaphor, that one was thinking when one read the word?

Are you still influenced by painters?

Painting is dead! Whatever took place in the whole of the passing of all these twenty years, I don't know where it went, but it's not happening now—it's not a medium that's really interesting me now, the way that painters have in the past. Nothing has been interesting in painting, so far as I'm concerned, for the last ten to fifteen years.

Do you have more confidence in different sorts of performance?

Well, when I talk about performance, I don't really mean that thing that's commonly called performance art, which I think was a phenomenon of the late 1960s and is not an essential

working form at the moment. When I talk of performance, I really mean entertainment. You know, you realize that it's the entertainment business. And I find that fascinating! Because one discovered, actually, that when you make people feel good, they *surrender* themselves to you. And then you're in this shameless position, which is wonderful!

Is there a clash between audience-directed work and more personal work?

My work is completely personal, absolutely one hundred percent subjective, or one thousand percent subjective! And when it works, it's like the subjectivity becomes the objectivity. It becomes the subjectivity of the audience, so it's what the audience wants to hear. And it's inside that space that one works. There's the idea that poets write about themselves, and that it's very personal, therefore it doesn't interest an audience. I write *completely* about myself, but I'm no different from anybody else in the audience. So it's not subjective in the sense that it's *just* me—but it's everyone in the audience, and it becomes completely *objective*. And then one works with the subtlety of what one's intention is with the poem, and what clues one wants to give the audience.

Do you try to have a particular effect on your audience? Given that your poems evoke emotions and images which mirror your subjectivity, are you aiming for a state of collective hysteria, tranquillity, or something like that?

No. None of those things. It just has to do with, like, whatever the nature of the phenomenon that arises is—that it's empty and deluded.

I beg your pardon?

Deluded! It's all illusion! All that arises in one's mind is illusion. Wherever one is, no matter what context. And it's entertaining! Delusion is fascinating!

New York—February 7, 1990

How did you start working with the John Giorno Band?

Well, the first band with David Van Teighem and Pat Irwin of the Raybeats was one configuration. A year or so later, it became Lenny Kaye and a bunch of other musicians. Then I got together with the present band, which has been together for the last five years. Charlie Roth is my band leader with his brother Adam on guitar, Mike Osborn on drums, and David Conrad on bass, who is Adrienne Rich's son.

These days I do two things—one is the band, and the other is solo performance. The band involves a lot of equipment and synthesizers, and we need two roadies with us when we go on the road, and it costs a bit of money. When that happens, it's wonderful, and when it doesn't happen I do a lot of solo performances. I just go by myself, and since all of my poems are memorized, I don't even have to bring a piece of paper. Occasionally, with "Scum and Slime," I'll use a tape of the instrumental mix to end my set.

How do you prepare these works?

Well, I write a poem and I develop the musical qualities inherent in the phrases. I can only really do that—since I'm not a musician—by rehearsing, which I do in the Bunker. When I rehearse something, suddenly a musical quality in a phrase—almost like a melody—will appear. And then by rehearsing it more the melody becomes more fully developed. I'm working on a new poem called "Hi Risque," and I performed it for the first time at a benefit we did on Monday night with Kathy Acker and all those people.

The next step is making it into a song. This time I've asked Chris Stein to do the music. We've talked about what kind of music we want, funk, hard-core rock and roll, or whatever, and then we take it from there. I think Debbie Harry will do backup vocals. Chris is going to write the music and produce it, and my band will play it in his recording studio with him on guitar.

Do your poems change when performed with your band in the studio?

No, because whoever I've worked with, I've always said, "Listen, tell me what words are horrible—what words you hate—and I'll take them out!" They all get this horrified look, and say, "No, no, no, leave it exactly the way it is!" Once it gets up to the stage of being finished and rehearsed, the music in it never changes, because it's like a song—it becomes fixed.

I do a lot of solo performances with memorized poems, which is quite different from reading. I've noticed that when a poet has a book in his hand, he is reading—he can't let go of the page. Somehow, letting go of the page, not having the page there, releases some incredible energy—you're talking to someone. Just not having this piece of paper, you develop these melodic qualities and phrases, which take off on your breath. Well, that's singing—but not in the traditional sense. I don't know how to sing! I never learned how to sing. Which is great for me, because I'm not saddled with all of those rules of songwriting and singing. I'm a poet, and I perform my work, so I can do anything I want.

Have there been any other developments?

It's hard to tell. I've been writing this book of prose for the last year. It's sort of a memoir—it's called *Obscene Pornographic Moments.* I started working on it when Andy Warhol died. I was asked to write a piece about him. I've got what you'd call perfect recall—I can actually go back to the moment, I can see the room and remember the conversations. I didn't stop writing poetry, but I have been preoccupied with various prose pieces—with William Burroughs in 1965 and Brion Gysin in Tangier, Bob Rauschenberg in 1966, Jasper Johns in '68 and '69, and so on. I've written about 150 book pages of this memoir thing.

You haven't performed it?

No, no. I would never dream of reading from it, because I don't like reading. Reading words, in front of an audience, is not what I do.

But Kathy Acker and William Burroughs both read parts of their prose.

That's different, though, and both of them are interesting examples. They're naturally, basically, prose writers. William Burroughs—and Kathy, too—when they first started reading,

they didn't know how to do it. William came back to New York in '73, and in '74 he and I performed at St. Mark's Church—the first major reading that he had ever given in his life. William has always had this great way of phrasing, but if you listen to those tapes, it's like a naive boy reading his own work. Then we went on to all these endless tours, all over America and Europe, and by the late '70s he was this masterful performer.

The same thing is true with Kathy. When she first performed she was incredibly boring, because she was reading her prose, the way you read prose to yourself sitting in a chair. And now, she's become a brilliant performer. She's figured out what she can do within her range. She takes in a deep breath, and she releases great phrases or sentences—slowly with great power. She actually reads it almost in meter, in a beat, with pauses because she realizes that sound travels across a large hall and comes back—and people can't hear if you go too fast.

When you're performing in front of an audience, they read your body language and your breath, and you feel what they feel when they hear the words. And then it's really interesting to reflect upon the feeling that you got from each word. With a new poem, like the one I'm working on now, it's less than half there, and I'm terrified that it doesn't work and that it was a complete mistake to have done it at all. If I'm lucky, when I perform it, I get a really good reaction—just people's breath going "Ohhh!"—or laughing and screaming—and I say to myself, It worked!

Is there a problem deciding how long a piece should be?

Actually, what really decides things is that when the poem eventually gets made into a song, into a video, and all the rest, it can't be anything more than three or four minutes. Nobody wants to hear a song for more than three minutes. And that means that it can't be more than two and a half minutes reading it solo, because that gets stretched to three and a half minutes with the guitar solos, the bass solos, and so on. But that's not necessarily such a short poem, because the way I read it, two and a half minutes is a three-page poem, single spaced.

Do you feel limited by this scale of creativity?

No! I really adore that quality of people's short attention span. A poem is absolute wisdom, you know, so it doesn't matter. I love working with those short phrases. It's a joy! The night before last, when I finished reading, I went and sat next to Kathy Acker, and she said, "Oh, I love your work, I love those phrases, I love those words." And she remembered one of them; it was "Nothing recedes like success."

That's what short attention span is! It's the ability of people to hear something and re-member it. In this context, "Nothing recedes like success" was in the middle of a poem with lots of words going on, but the breath and phrasing set it off—by itself—from the words that came before. Another thing I've been doing is making silk screen prints of these phrases.

You mean texts like "I want to be filthy and anonymous—scum and slime"?

Yes, and some are longer. The thing that's wrong with a lot of visual poetry is that it's just duplicating what's on the printed page of a book onto a canvas, somehow thinking that it's art. What I'm trying to do is take it into a whole new realm of its own. There's no reason why there can't be twelve lines or eighteen lines, done in a way that's visually fascinating.

When did you begin these works?

I began doing poem prints in the late '60s, and they were shown in the Museum of Modern Art in 1970. In the series I'm doing now, I pick lines from various poems that work—short lines. When we design them, the maquette is only twelve inches square, and then they can get blown up to four and a half feet square. I type these lines into the computer. Some of them I think don't work that well—and I show them to someone I'm working with—and they say, "This is the great one!"

So when you're writing, you might be thinking, This piece will work with a rock band, or This piece will be good for solo, or This will be good for video?

No! Each should be good for everything! The poem has to be good for solo, then should be good for the band—and by its nature it works for whatever video we make of it, and then as far as the paintings go, they're only three-line images. With great design any line can work. It should work in all venues, but I don't necessarily make every poem in every venue.

Is this what you meant last time by poetry as "entertainment"?

Poetry is so boring that any entertaining qualities are a triumph! When I said "entertainment," I meant it in its most profound sense, which is play—the play of all phenomena, the display of all the realms—that's entertainment. Poetry is somehow very bound by tradition, and it's only in the last twenty-five years—and mostly in America—that there's been a breaking of this bondage. Some of it's bad, some of it's good.

Aren't certain performers such as Karen Finley using crude shock techniques in order to develop a kind of "porn modernism"? Is it fair to say that there's an element of playing to the gallery in her work?

Karen Finley's really a great woman and a brilliant writer. There are elements of porn in her work, just as there are elements of porn in my work, and they transcend! I mean, the way she uses porn is really very extraordinary. She's very political, and she uses pornography to make many great political statements. And she's a consummate performer! Accusing her of playing to the gallery is just cheap.

I think in this day and age, anyone who uses pornography in their work is heroic. If any poetry center in the United States invites you, and they are funded by the National Endowment for the Arts—which they all are—and you are, like myself, homoerotic, or like Karen, S and M erotic, or just sexually explicit, they can have their money taken away from them, after the fact. It is really catastrophic for the arts here, because it means poetry has to be safe—safe poetry! For myself and Karen it's a really big problem. So instead of being a cheap trick, it is a heroic action.

In addition to Kathy Acker and Karen Finley, which other writers are publishing on your LPs?

Nick Cave is a great writer—there's a reading from his novel *And the Ass Saw the Angel* on my LP *Smack My Crack*. On all the records I do, there's a lot of rock and roll, but they're all poets. Somebody like Nick Cave is a poet who also is a totally great musician. Tom Waits was a poet before he was a singer. The Butthole Surfers—they're all poets. That's why they're on these records, even though they seem like they're just rock and rollers.

IT'S CLEAN, IT JUST LOOKS DIRTY

CABARET VOLTAIRE
Trust In The Lord, 5:55

HÜSKER DU
Girl Who Lives On Heaven Hill, Powerline,
5:00

DIAMANDA GALAS
Live in London, 2 excerpts from *Eyes Without Blood*, 4:28

EINSTURZENDE NEUBAUTEN
Sand, 4:00

ROBERT FRANK/RUDY WURLITZER/GARY HILL
Energy And How To Get It, (Edited) 14:20
featuring William Burroughs and Doctor John

Video cassette, color,
running time 59:45 minutes
GPS 037, VHS or Beta $39.95
¾ inch $100

JOHN GIORNO BAND
Scum & Slime, 4:04

DAVID JOHANSEN
Heard The News, 4:18

**ROBERT WILSON
and the CIVIL warS**
Directed by Howard Brookner, excerpts,
9:35
Music By Shubert, David Byrne, and Philip
Glass

SWANS
A Screw, 3:30

PSYCHIC TV
Unclean, 3:30

JOHN WATERS
No Smoking In This Theater, 40 secs

Flyer for GiornoVideo Pak 3, *It's Clean, It Just Looks Dirty*. Photograph by Giorno Poetry Systems.

What about your Video Pak publications?

One great phenomenon of home video is pornography, particularly now in the 1990s, with this epidemic of AIDS. We're in this sexless world, the phenomenon of promiscuity is completely ended, so I was saying to myself about six months ago, it would be really great to have some fabulous pornography on the next Video Pak. And it was all just mindless and stupid, except this great young poet named Nick Zedd, who did this totally great pornographic video called *Whoregasm*. It was perfect! We do whatever we want to do at Giorno Poetry Systems. Nobody's going to tell me, "Don't put any pornography on your video."

Couldn't it be observed that having put rock and roll on your poetry records and videos to make poetry sell, you're now adding pornography and selling out to the fastest market?

It could—but I adore both of those media! I adore rock and roll and I adore pornography. One of the things they always said was that I performed my poems with energy similar to rock and roll—in the 1970s the *Village Voice* called me "the Bruce Springsteen of poetry." And my first record, released in 1967, was called *Pornographic Poem*! This poem also appeared in the *Random House Anthology of New York Poets* in 1967.

I had twelve people read the poem on the record. The poem is a page long and takes each of them about one and a half or two minutes to read. The intention is everyone reveals all of their own personal sexual hang-ups and preferences in the sound of their voice! So there's Patti Oldenberg, Claes Oldenberg's wife—she was just totally cool, a totally hip woman—but she was very uptight, like she was being strangled! And there was Nina Thurman, she'd just divorced Timothy Leary—and she's also this great Swedish aristocrat—and read all these obscenities with a wonderful resonating voice!

Bob Rauschenberg and I were lovers and I asked him to read this poem. One afternoon when we were totally stoned on grass, had fucked for hours, and had just woken up from a nap, I said, "Bob, you have to read this poem now!" and I dragged him to the tape recorder in the next room and he read the poem. He was totally stoned, so when you hear it, that luxurious quality of his voice is sort of like infinite sexuality fulfilled! That was 1966! So how dare anybody say that I'm selling out to pornography, when I've been one of the originators of it?

Does your present work offer a more somber approach to sex?

Yes. This new poem, "Hi Risque," that I'm writing is very erotic for a particular reason. I mean, sexuality, and everything that became liberated in the last twenty-five years, came to an end eight years ago. So when I perform, I'm talking about things that people used to do, and don't do anymore, and want to do, and long for it, and maybe do with the people they're living with—but that's different from the wonderful promiscuity there used to be, a decade ago. I think it's heroic in many ways, given the funding problems and given that most publishers won't want to publish you.

The secret of my work is that I do what I want to do, and I put in my work what I love to do. It's always been a liability, because pornography has never gone down well with the art and literary establishments in America, and they have always hated my work. I have never cared what they think.

New York—January 14, 1991

Perhaps we could begin by talking about the video versions of your poems. Was it your idea to juxtapose the words and performance footage in the video version of "Scum and Slime"?

Yes. That was made at a very unusual moment in that I had a lot of free time in the studio. When we converted the film *Burroughs: The Movie* to one-inch video we had to go into a really big, expensive uptown studio, and this kid—who just happened to see Burroughs on the screen—came in and said, "If you ever want to do anything, I'd love to work with you." Finally we got together and we started working. Every other Saturday evening I'd sneak in and work for twelve hours. Every night. If we'd had to pay for it, it would have been between twelve and twenty thousand dollars, using all the technology available and imaginable, and doing it really slowly. Anyway, what we did became this great collaboration.

In England, After Image Video Productions did *Life Is a Killer*, back in '82, I think. They got a whole bunch of money when Channel Four first began. It won all these awards—in the Vancouver Film and Video Festival it won the Best Performance Video. Anyway, each time, it's always some unusual moment or circumstance.

What else have you been working on?

My latest poem prints are a set of six silk screen prints published by George Mulder, and I'm also starting a new series of nine smaller *Recession Prints* with J. P. Russell, who did the printing for Andy Warhol. These are small, fourteen inches square, billed as *Recession Prints 1990*. Then there are all the large ones I did with Francesco Conz in Milan. We've done eight of them now—printed on black, green, yellow, and red vinyl. They are so beautiful.

Another thing that happened was that George Mulder took out a full-page ad in the January 1991 *Art in America*, announcing the release of the series and illustrating the print *Everyone Is a Complete Disappointment*. To make it fit on the page it had to be cropped and bled to the edge of the page. I was thrilled when I saw it!

How did you prepare these prints?

Well, I design them on a computer with Mark Michaelson—a very brilliant designer, who started in Seattle as one of the *RAW* artists—the cutting edge of comics—and the *Rocker,* this great rock and roll magazine. Then he moved to New York, working for the *Village Voice, House and Garden,* and *Newsweek,* and now he's head designer of *Entertainment Weekly.* Anyway, he designs my poem prints and album covers on the Time-Warner computer—I give him the copy, tell him what I want, how I want the line breaks. The way he does them is almost impossible on a home computer.

Do you have you any other plans or projects?

Well, the other thing that really takes up a lot of my time is the AIDS Treatment Project, which I started in 1984. We've given almost three hundred thousand dollars, helping people who have AIDS. I started going from hospital to hospital, just giving ten or twenty dollars in an envelope, anonymously, so that they can buy a magazine, cigarettes, or candy. Then the

last two or three years we've been giving to people directly who are in particular trouble. We give them five hundred or a thousand dollars instantly—the day they call.

The other thing about the AIDS Treatment Project is that I give the money by hand to everyone. I spend a half hour with this person—who's so happy to see someone he starts weeping, or so frightened he starts weeping—it's always a really, really strong moment. And that's the least I can do. I'm gay, and I was infinitely promiscuous, and I'm HIV negative. The doctors say I got home free, by some miracle. The fact that I don't have it, and all these other people do, is sort of miraculous.

Have you always followed this kind of interventionist impulse?

I think so, because one of my first concepts in 1965, when I began it all, was the idea that there was a poet and an audience, and the point of connection was many places, and many things and many possibilities. Previously the connection between the poet and the audience was through publication in some book or magazine. What I've been doing—Giorno Poetry Systems—is realizing a myriad of possibilities.

Dial-A-Poem is one way that a poet can connect to millions of people. Or video. Or CDs. The albums are played in the living room, but are heard also on the radio. Then what's on the album gets made into a video that's then on television or home video. The point of communication is the many possibilities. During all of this, the poet gets involved in the production and the process. If it's on a record, the poet is performing it. Or the poet is making a video and is developing video skills.

The AIDS Treatment Project has the same rationale of helping everyone indiscriminately. Some of the money comes from Giorno Poetry Systems royalties, but most of it is just gifts from people who also want to help. We give every penny of it away—we don't take any administrative fee. We've always had enough for every single person who's asked for money. It's almost like it's blessed!

Doesn't the optimism of this project conflict with the seemingly cynical rhetoric of texts like Life Is a Killer *and* Everyone Is a Complete Disappointment*?*

Those poems are not cynical—they are wisdom and truth—they transcend all phenomena. *Everyone Is a Complete Disappointment* is universal to the entire world from the beginning of time! People see that thing, *Everyone Is a Complete Disappointment,* and their first reaction is laughter.

Their first reaction is putting their hands to their heads and saying, "Oh no! I knew it all the time!" Their first reaction is joy, because it's recognition of something they've always known. Everyone is indeed a complete disappointment! But that doesn't mean that in everyone's heart the complete opposite isn't also true.

You can only write words like "Life Is a Killer" when you have great joy in your heart! It's just an awareness of the basic ground! It's the same thing in performance when the hearts of the collective audience get connected to yours in some moment of absolute recognition of wisdom that they hadn't recognized before, but already knew. That's when you're successful as a poet. You're only a poet when something actually happens, miraculously.

Your AIDS Treatment Project slogan, "Help a complete stranger as you would your closest friend," seems a little more affirmative.

That's a different intention. One goal is to encourage others to do exactly what I do—to treat complete strangers as if they were your closest friend. The intention is to tell people that they can do something else to help.

All this seems a welcome alternative to the general sense of apathy and neutrality usually associated with the so-called postmodern condition.

Well, I've always tried—everything I've always done is based on compassion. Helping political prisoners in 1970—that's no different than helping people with AIDS now. The AIDS Treatment Project and the posters are a way of saying, "This is what we are doing about it." It's helping people who are going to die—helping the quality of their last moments, however I can serve them.

Could one define the '80s and '90s as an era of renewed responsibility compared with the hedonism and indulgence of pop art and the '60s?

Well, you have an interesting point. All the pop artists, from Andy Warhol to Jasper Johns and Bob Rauschenberg—I knew them all really well, when I was young—had one main interest, their career. By some mistake, these artists did these great things at the very beginning, and they had something to develop. All great art is a mistake—it's like falling down the stairs and seeing stars—and then you realize what the mistake is, and you continue doing it. You realize what you've done well.

But their basic concern was with their career and money, and that discriminated against what went into their art. No gay image ever entered any of those artists' work—and they were all gay—Bob Rauschenberg, Jasper Johns, and Andy Warhol. Or anything political, because they knew that collectors don't want to hear about politics or anything that's in bad taste. Indeed, all those artists always made decisions against anything controversial. It always appalled me, and I finally withdrew from all of them.

One of the things that I've done through my entire life is work on anything that arises in my mind if I think it's true and important—homoerotic content, political content, as well as the Tibetan Buddhist content—if it seemed appropriate. I don't think of my career. I've been really lucky to survive for thirty years, to have just enough money to pay my bills, and the privilege and the leisure to work on whatever I want—and I work on ten different projects every day.

That's very unusual! For a poet it's really hard to survive in this world of ours. I've not done what my contemporaries have done—poets as well as artists—playing all my political cards correctly and playing all my socially acceptable cards correctly. I'm really lucky to have been able to do what I want, and I encourage everyone to do the same.

New York—August 2, 1996

How did you come to perform in the La MaMa Experimental Theatre's recent live production of Beckett's television play, Eh Joe?

Well, two very old friends of mine, Peter Ungerleider and Erica Bilder, who are both directors at La MaMa Theatre, were casting Beckett's *Eh Joe* and they hadn't found anybody they

liked for Joe, and Peter said, "Why don't we try John?" I was completely shocked, because I've spent twenty-five years performing my own work all the time! So when somebody asked me to do somebody else—this Beckett thing—I thought, What a weird idea—and what a totally great idea! So I said yes. Looking back on it now, it seems a brilliant idea, because although a lot of poets develop skills in performance, they're often not appreciated that much—people don't really consider poets as performers. So they asked me to do it and I did it.

Were you surprised by the production's combination of monologue broadcast by radio headsets, and the image track of your silent gestures, broadcast on a giant video screen from a set offstage?

No—they were trying to do this television play exactly the way Beckett intended it to be, following each of the stage directions. Being a television play, it's meant to be seen only on a screen. So what they did was have a vast screen—fifty feet by fifty feet square. I was in a room offstage, so that the audience at the end of it saw me doing it live and realized it wasn't a videotape. It was incredibly well conceived.

Again, were you surprised by the success of this relatively detached form of performance communicated by audio and video broadcast?

No. Performing is performing, and the one ingredient that makes a performance successful is the amount of energy that a person gives from their heart to the audience. It can be done any way. Diana Ross does it in her way, or a poet and an actor do it in their way. When you understand those things, it's understanding a concept experientially in a visceral way. It's easy to say "a performer gives all their energy to the audience," but how you do it is an incredibly complicated thing, and each performer has to invent their own way of doing it. So I had to invent a way to do this, because I've never acted before, and I remembered how this friend of mine, Harry Joe Brown Junior, who produced the first American production of *Krapp's Last Tape,* had this girlfriend, Marcia Stillman—who had been a girlfriend of mine—who he later married, who committed suicide at twenty-two or twenty-one. This was two and a half years before Beckett wrote *Eh Joe.*

A young girl suicides—it's the major thrust of this play—and it's sort of a composite of every young girl who commits suicide, so it's not Marcia. But I thought that she was one of the inspirations because Harry Joe used to bring Marcia to Paris. When he went to see Beckett with this gorgeous young woman, Beckett obviously fell in love with her! So her suicide at age twenty-one probably affected him and was one of the inspirations in the composite suicide of the young girl. Marcia's suicide was one of the things that came back to me every night to bring the depths of despair to my mind. And when that began to wear thin, I would just think of who died that day of AIDS and bring them up—not to wrench my heart with nostalgia or melodrama, but just to bring the nature of suffering clearly to my mind, when I was in front of the audience.

Did it seem strange to be performing virtually, from offstage?

I was offstage, but the audience was only twenty-five feet away from me, and it was packed—it sold out every night. And the thing is, I'm always on camera, starting with me walking around the room and then sitting on the bed, and then the camera gradually tightens on me—first with my whole body sitting on the bed, then my torso, then my head, and then my

lips to my eyes, and then just my eyes. My head by this time is the size of an office building! I mean, between one eye and the other is fifty feet!

A lot of the audience didn't realize it was live until they left, and when they saw me there it was an incredible shock for them. But when I was doing it, I was aware that my eyes were fifty feet wide up on the screen, that everyone was looking at it, and that it was very forceful. Some people who had AIDS would stay on weeping, and people would say, "Do you realize that there are three guys out there weeping? They haven't left the theater!" And I would not be allowed to leave my setup until the last person had left the theater.

And I discovered tricks—because I was inventing this great sadness in my heart. I was on camera, so the lights were very bright—the white bright lights of television. And because I'm a Zen Buddhist, among other things, I've developed a degree of concentration, as a by-product of meditation. When you watch your mind you don't blink your eyes all the time, and you rest your mind in a way—so I wasn't blinking my eyes even with this extreme light. And then I figured out a way, at about fifteen minutes before the end of the play, of lowering my eyes for a second and then opening them, and this lowering of the eyes released my eye muscles, relaxing the tear ducts, so that the tears started running down.

To the audience, these tears were three feet wide, going down the screen! The way I was using these tears wasn't maudlin at all. It wasn't about me crying, but the kind of tears that come from the center of your heart—tears that are symbols of suffering. I was trying to make it something Beckett would have liked—to produce tears as a symbol of a lonely man's heart.

How was the production received in Rome? Were there language difficulties?

No, there was a tape-over in Italian of the monologue. And it's quite a sad play—a tragic play—and there were these tears coming ten or fifteen minutes before the end of the play, and you know—Italians and tears! It was a huge, huge success in Rome! There were full-page reviews in national dailies, reviews on national television—it was really successful!

Some would argue that mediated imaging, such as Warhol's blown-up portraits, tends to neu-tralize content. Is this your impression, too?

No. I think they're both equally strong. Apparently, they've rediscovered Andy Warhol's screen tests from the early 1950s, including mine, and someone who saw it was saying how powerful it was. Take anybody's head and show it from chin to forehead and it's probably powerful. But I didn't see it this way when we did a video for the rehearsal, and to me it was just like this big giant rotting mango! Somebody was telling me: "John! It's so beautiful! I can't believe how beautiful it is!," and all I'd see was a rotting mango, as I thought: My God! What has happened to my face! But it was really interesting to perform as an actor, and I think I'm going to continue doing that.

Philip Glass. Photograph copyright Annie Leibovitz \ Contact Press Images.

PHILIP
GLASS

WHEN I MET PHILIP GLASS FOR THE FIRST TIME IN BRISBANE, during his ensemble's 1986 Australian tour, I wanted to ask him about his work with Mabou Mines' multimedia adaptations of Beckett's plays, which I'd taken to be a quintessentially postmodern mode of performance.

To my surprise, Glass ended our interview by virtually reversing this distinction, observing: "Maybe so, except the arts are such a conservative place, and you mentioned Joyce—and Duchamp—and I don't know anyone who's done work more contemporary than that. And it's 1986. So it's curious, isn't it?"

Two years later, Glass's opera *1000 Airplanes on the Roof* came to Brisbane, and this time we discussed the more inimitably late-'80s qualities of a multimedia production, which—as Glass observed—couldn't have been staged "five years ago," before the availability of the new "technical means which allow us to synchronize and reconcile these forms."

When we met again in New York in 1991, and in Melbourne in 1992, Glass discussed his continuing "relentless collaborations" with Allen Ginsberg, Doris Lessing, Ravi Shankar, Foday Musa Suso, and David Bowie. "I don't know exactly where that's leading and I don't really have an agenda for it. I learn a lot from doing it, and that's mainly why I do it."

For me, Glass's most striking observation was his sense that the 1992 revival of *Einstein on the Beach* left audiences "even more shocked" than those witnessing its first appearance in 1976. As Glass concludes, commercial culture's ongoing "corruption of values" increasingly threatens the "aesthetic idealism" inspiring this mid-'70s collaboration with Robert Wilson, inspiring Burroughs's filmic collaborations with Brion Gysin and Antony Balch, and generally fueling the "beacon of integrity" offered by Cage's research.

Brisbane—March 14, 1986

Could I begin by asking you about your early work, particularly with Mabou Mines, on productions of Beckett's plays?

I began in 1965 with *Play,* the first Beckett work we did. David Warrilow, for whom Beckett wrote a number of pieces, Fred Neumann, who also directed a number of Beckett's works, Lee Breur, Ruth Maleczech, JoAnne Akalaitis, and myself were Mabou Mines at that time, and I was the composer—as works entered our repertoire I did the music. In the work with Beckett material, I contributed incidental music for the most part.

For example, *Company,* a large prose piece, was made into a long monologue which lasts about an hour and forty minutes. When Neumann asked me to work on it, I suggested a string quartet because the musical equivalent of that kind of reflective piece is normally a string quartet. So Neumann asked Beckett where its parts should fit in—obviously a very crucial question—and Beckett replied that they should go in the interstices of the work, which we then had to discover. And we did—we found four places in the work that seemed to us appropriate to break the work. First of all, the actor needed a break. So the quartet became a technical way of breaking up the piece so that the actor could actually perform the piece at all. In that way, my work has been incidental in helping to solve a technical or structural problem in the work—sometimes the music is done that way.

In the case of *The Lost Ones,* the music is continuous through the piece. There the music occupies the role that perhaps you might say the costumes do, or the lighting does. It creates part of the atmosphere in a work, and is not used in a structural way.

In the notorious Boston production of *Endgame,* done last year by JoAnne Akalaitis in an abandoned subway station, I wrote a prelude to the piece. Rather than put music in the piece, I wanted a twenty-minute piece that would create a particular emotional ambience as the audience walked in. So that as you walked in, if you came five or ten minutes early, you heard a piece for a double bass and timpani, which was a very odd piece. It's a very odd piece of theater, *Endgame.* It's a very humorous piece too, in many ways, and I thought that the music set up a kind of visual equivalent of music as you watched an empty stage. Once the drama began the music stopped.

What happened in Play*?*

Play was one of the most interesting ones. As you know, it's a work where three monologues are cut up and put back together, and at the time, there was a literary movement, very unrelated to Beckett at all, of course, though he may have known about it, where Brion Gysin and William Burroughs were doing cut-up words. With the music I did a similar structural thing. I took four or five pieces of music that consisted of one instrument playing against itself, and forming a simple but catchy rhythmic and melodic kernel.

The work went like this: I took a piece of music of, say, twenty seconds and then I had a ten-second pause and then another twenty seconds would be the next scenario, and then another ten-second pause, and then another twenty seconds, and then another ten-second pause. This piece of music in the end was as long as the play. There was music and silence, music and silence, music and silence. And this was simply thrown right against the play in very much the way that a John Cage music score would be used with Merce Cunningham, very much in that way. It was that kind of thinking.

And did the two cohere?

Well, it produced a very, very interesting effect, and one that I've been very interested in. I've watched this many, many times, this particular production—and we must have performed it fifty times, all over, in Paris and then later in New York. And I noticed that every night I saw it, the exact coincidence of music and words was different. Every evening I watched the piece, the epiphany of the piece, if I can use that word, was in a different place.

And I pondered this for a while, because this was something I thought was extremely interesting. In a play by Sophocles, Shakespeare, or Chekhov, the words are designed to produce an emotional catharsis. In fact, the poetics of Aristotle are exactly about that, about where exactly is that catharsis produced, and what it is and so forth—it's a psychological mechanism which is built into the nature of the work. And looking at Beckett in this light, I discovered that the catharsis didn't work in that way. It works in a very different way. I finally came to the conclusion that it had to do not so much with the internal structure of the work as with the relationship of the listener to the work itself.

And there, I was really at home with the thinking of Cage and Duchamp and any modernist thinking. It points to something very interesting about the way we as a contemporary audience approach the theater, which is that the theater is really a relationship between the play and the audience. Whereas formerly I don't think people ever thought about plays that way. You thought of a play as something complete in itself. The performance of the play, and the play, were the same thing. You never thought of the performance, and the relationship of the performance with the audience, as affecting the content of the play.

This was a very important discernment for me. Later on I did a work with Robert Wilson called *Einstein on the Beach,* which is very much based on the principle that an opera—this opera—did not need a libretto, since everyone brought their own libretto. In other words, we depended on the audience to complete the work—an idea which is very much in keeping with the ideas of Cage and Cunningham and Duchamp. And this is what I consider a particularly modernist idea, and one which I've discovered quite a lot in music, in a nonliterary theater tradition, but the first and only place that I found it in a literary tradition was in Beckett. It's what really separates our approach in contemporary theater, I think, from a prior period—the fact that the audience helps to complete the work in a work like *Play,* and most of his works.

My personal theory, on which I base a lot of my own theater work, is that the psychological mechanism doesn't have to do with an identification of the viewer with the character, which is the classical way. That's how we experience *Hamlet,* and the poetics of Aristotle depend on that. The mechanism is through identification with the character. I don't believe these contemporary works work that way. I think that in the contemporary theater what you have is a separation between the play as an object, and the viewer or listener. We don't depend upon the confusion between the two, but what you begin to perceive is a relationship between the two. I think what happens is that the emotional content arises spontaneously between the two—that's where the emotional content is.

Might the audience be empathizing with a general situation?

I think it is even more different than that. I think the point of a Beckett work is that you don't empathize with the character, but that you see it as an object, you see the play as an object and yourself as a viewer. It really comes down to quantum mechanics, doesn't it?

Can you explain that a little more?

Well, the Heisenberg principle is that you can't just observe something—in physics we discovered that you couldn't just locate an electron and measure its velocity. You could do one or the other. The introduction of the observer into the experiment became part of the contact. And from that point of view, contemporary physics and contemporary philosophy are again consistent with contemporary aesthetics. It's the same thing. Simply, that when the audience looks at Beckett's work, the work is no longer an independent thing. It's the relationship between the work and the audience that we're talking about.

I think the important thing I learned was that I began—through Beckett—to understand another kind of relationship an audience can have with the literary event. Then later, in my own work with Bob Wilson, and in my own work after Bob Wilson, and again with him later on, I found that it became a comfortable aesthetic attitude to carry through in other works.

How did you develop this aesthetic?

Well, in *Einstein on the Beach* we created a musical theater piece based on Einstein in which there is a libretto of fragments, of things people wrote, but there is no narrative, there's no normal narrative in which a story is told. And it's a four-and-a-half-hour piece, in which the text can be numbers, in which it can be the do-re-mis of music, or speeches written by some of the characters. Unfailingly, people saw this as a libretto about Einstein. Unfailingly. In a certain way the work of the Living Theatre is very much like that, a work like *Frankenstein*, from the '60s, in which the meaningfulness of the work is an attribution of the audience and not necessarily of the authors.

Does that come from Cage?

I think it's from Duchamp actually, but I think Cage articulated that very well in books like *Silence* and in the late works that came after 1948. I think he was able to articulate the ideas more than someone like Duchamp. So if you look at Duchamp's work, you see it there too. I think Brecht was another person who was very involved in finding a new kind of relationship of content to audience.

How important to you is high technology?

Well, in my work it's very important, I use it all the time—though not particularly in the Beckett pieces, where I've sometimes done acoustic instruments playing through the pieces, and sometimes done pieces on tape. It's not been crucial in that, but in my other work I've used a lot of technology.

You've described your aesthetic as "modern." I'm probably splitting rather fine hairs, but it seems to me that perhaps what you and other artists using high tech are doing is distinctively postmodern, in the sense that Joyce and Duchamp are part of a pretechnological era.

Maybe so. Except that the arts are basically such a conservative place, and you mentioned Joyce—and Duchamp—and I don't know anyone who's done work more contemporary than that. And it's 1986. So it's curious, isn't it?

Brisbane—September 10, 1988

Do you think of 1000 Airplanes on the Roof *as an opera?*

No, I don't. My own use of the word has to do with two things. First of all, that it uses people trained in the tradition of repertory opera. If I'm using singers that are trained in that tradition, or orchestras, singers, and choruses, that's one criterion. Another one is where they take place. *Einstein on the Beach* doesn't really fall into that normal category of opera, because I use two or three singers but the orchestra is my own ensemble. However, it requires space for the drops to go up and down, wing space for buildings to go on and off, and an orchestra pit for the ensemble to be in, more or less out of sight of the audience. So I've come to call it an opera because the only place you can do it is in an opera house.

1000 Airplanes on the Roof is a multimedia piece in the sense that it uses my ensemble, it uses one actress, and it uses slide projections for visuals. We have done it in a kind of ersatz theater that was built in an ice-skating rink in Berlin, we've done it in an airplane hangar in Vienna—I daresay you could do it in a basketball court! We need a certain amount of height in order to build up the scenery. But it doesn't need to be in an opera house. For me opera really has come to mean those pieces that I intend to have produced by opera companies. Anything the Stuttgart Opera House can do, I'm willing to call an opera. That includes *Einstein on the Beach,* which they're doing this year, *Akhnaten,* and *Satyagraha,* which they've already done. I can't do *Akhnaten* by myself. But I can do *1000 Airplanes*—I have the material and the physical talents to do it within a small company. I guess it's really what I'd call music theater.

Would you distinguish that from old-fashioned performance art?

Yes, I would. It's nice that you call it old-fashioned, because I can remember when it began in the museums and galleries in New York as an expression by visual artists of live performance values, and most performance artists were, to begin with, visual artists.

Laurie Anderson, for example, was a sculptor when I first met her. Her credentials were as a visual artist. I remember seeing Bruce Nauman doing performance pieces, Allan Kaprow, people like that.

Then you've got writers like William Burroughs and Brion Gysin doing literary performances with cut-ups and permutations.

That's right, I've been on a number of programs in which Brion performed his work. It's very common in New York to do benefit performances such as the Nova Convention that we did as an homage to William Burroughs at the Entermedia Theatre on Second Avenue in 1978. We had Frank Zappa, I performed a solo piece, of course Laurie Anderson did, Patti Smith performed, John Giorno read poetry. You could have dancers, poets, performance artists, visual artists.

Do you find your work progressively integrating these different arts?

Yes, I do—I describe myself as a tireless collaborator. In this year alone I've been involved with *1000 Airplanes on the Roof* with Jerome Sirlin and David Hwang, the Doris Lessing

This production is a once-in-a-lifetime opportunity, a renewal of faith, a must.

"This is for dance people, music people, art people and especially theatre people. It is also for audiences. It's one of those rare pieces that truly open the way for something new." Los Angeles Times

When the most influential composer of our time and the most influential theatre-creator of our time met to discuss a collaboration, the work which resulted from that meeting was to re-define for all time the parameters of theatrical and operatic art.

This seminal production of EINSTEIN ON THE BEACH premiered at the Avignon Festival in 1976. It has been revived by the original creative team only twice – in 1984 in New York, and now this year in five world presentations only – the 1992 Melbourne Festival, Tokyo, Frankfurt, Barcelona and Madrid.

"A masterpiece. Constantly involving and almost religiously moving. An experience to cherish for a lifetime." The New York Times

The composer is Philip Glass. The theatre-creator is Robert Wilson. With brilliant choreographer Lucinda Childs they created EINSTEIN ON THE BEACH.

EINSTEIN ON THE BEACH is the first of Philip Glass' operas about men who changed the world in which they lived through the power of their ideas.

EINSTEIN ON THE BEACH defies all traditional definitions of opera and theatre, forging nothing less than a new operatic and performance language. It is unquestionably an epic masterpiece which bridges this century and the next with the boldness and beauty of its vision.

"When talk runs to the truly pivotal artworks of our time, EINSTEIN ON THE BEACH ranks near the top. A massive allegory of the atomic age, it is built around the central figure of Einstein. It is welded to, and irresistably propelled by, Philip Glass' eclectic, electrifying score. A masterpiece. EINSTEIN will endure." Newsweek

"The most beautiful experience you can have is the mysterious." Albert Einstein

RUNNING TIME: An uninterrupted 4 hours 30 minutes. Audiences are invited to take a break at their discretion.

Flyer for *Nova Convention* cassettes, Giorno Poetry Systems, 1979. Photograph by Giorno Poetry Systems.

opera—*The Making of the Representative for Planet 8,* and *The Fall of the House of Usher* with Richard Foreman.

I'm very interested in what happens when these talents interface with each other in this way. This is an avenue which led me to an inclusive attitude toward theater, rather than a reductive one—an inclusive one where I see how much stuff I can put together.

And yet you might well be typecast as a minimalist composer doing something relatively narrow.

It's exactly the opposite. You know, minimalism was always about "less is more." But in collaborative theater, "a lot more is more." It's rather a crude way of putting it. But what was interesting for me in this collaboration on *1000 Airplanes* was bringing together the

very strong visual projections of Jerry Sirlin, an extremely talented theater writer like David Hwang, my own ensemble, and the actress Jodi Long. I guess that pretty much excludes the possibility of talk about a "minimalist collaboration." I don't think there could be a "minimalist collaboration"—it's an oxymoron.

As director of 1000 Airplanes, *what were your responsibilities?*

My functions as director were twofold. We were experimenting with a rediscovered art form—the melodrama—which is where spoken words are set to music, so I had to set the words to music. That was my first responsibility. Second, I had to stage the work within the visual limitations and the visual possibilities that Jerry Sirlin provided, so that the text, the visuals, the music, and the acting complemented and served each other. And at times, I must say, it was difficult, because I was dealing with four very strong artists.

One of the problems of the piece was to find a balance so that if I put all the elements together it was still viewable. I had to balance the music to the words, balance the visuals to the other things, and this took a certain amount of just plain fiddling.

David, Jerry, and I made up the story, and then I made a graph of the piece in which I showed the relationship of music to words in general. For example, I decided there would be a six-minute musical prelude followed by about a minute and a half of monologue, followed by about two minutes of music alone, followed by another three minutes of monologue, followed by another two minutes of music. I went through the whole piece with David, working out the relationship of words to music, without any words actually being written. Then David wrote the piece, and using his text and the scheme that I'd mapped out, I then wrote music and placed the words in that musical landscape.

About this time I made a synthesizer tape of the music and I read the words myself, and placed them in the musical montage, and Jerry began to make the visual score, dropping in the slides into the music. That process went on right until past the first performances in Vienna. We are just at the point now where the visual score seems to be set, and we are in a position now to computerize it.

How did you stage the movements of the actress, Jodi Long?

We had to consider a number of limitations. I went through the text, and decided where I wanted Jodi as close to the audience and as far from the audience as possible. I first began to think of it in terms of proximity to the audience—when is she downstage, and when is she upstage? Then I began to look at it in terms of when is she onstage, and when is she offstage? And then again, I began to think of when and from where her entrances were to take place. By the time I had gone through this I had a kind of general idea of how I was going to block the movement, before we began rehearsals. Then we began working with her movement within that blocking.

Now this way of working could be said to be "working externally." It's a formal way of working, in terms of the external qualities rather than, let's say, the internal expression of the actress. When you work internally you have no idea where you're going. It's great fun too, and if you have the luxury of time to do it, it's a great way of working. But I decided in this case—because I was relating to fixed media like projected visuals and sidelighting—to work in a more formal way with external blocking. And then we began to talk about the

characterization. Generally speaking, the music provides tremendous clues and always tells you how you are feeling about what you see.

And helped Jodi Long remember what she's saying at a particular moment?

Yes. She tells me now that the music and the words are so linked in her mind that when she hears a certain line of music she hears the words that go with it. It also works with the movement. She tells me that besides the music cues and the word cues, there are movement cues, too. She is working with the placement of the light, the placement of her body on the ramp or on the proscenium, and the placement of the words and the music. It's a big job! Each time you see it, it probably reveals different things to you. It's a very dense piece. On the other hand, of course, to be truthful, I'm aware that many people will see it only once. You know, the theater is a place where art and entertainment come together.

Does this convergence worry you? According to the Marxist critic Fredric Jameson, MTV video clips and multimedia theater share the same superficiality and generally typify the impoverishment of postmodern culture.

Multimedia theater? Does that mean me?

He's thinking of one of Laurie Anderson's performances in particular. Have you encountered this kind of criticism?

That hadn't occurred to me. If anything, the model for *1000 Airplanes* would be the cinema. For example, we're using a sound effects track, which you don't normally get in the theater. The images also work with a montage effect, going from one scene to another, blending, halting, fading. Basically, it's really a movie with a live actor. Now let's get back to your Marxist friend. Let's first say that critics who go into criticism with whatever ideologies are heavily handicapped. I would say that to approach one art form weighed down with the ideologies of another is like tying sandbags to your feet and trying to go dancing—I mean, why bother? I haven't read the man's work, but just generally, why encumber yourself with all this baggage that you don't need?

In other words, it's more interesting to examine the positive potential of new kinds of multi-mediated performance?

Well, we couldn't have produced this piece in this way five years ago. What's new are the technical means which allow us to synchronize and reconcile these forms. Just simply to be able to mix the voice of an actress with that ensemble, to move the ensemble from foreground to background in the course of the evening, or to pull out one instrument to accompany her voice and coordinate that at the same time with visual effects, requires extremely complicated technology.

You may have noticed a number of changes that occur sonically and visually at the same time. Quite a few effects in *1000 Airplanes* are visual, aural, and musical. To synchronize that, you have to have a stage manager calling a very complicated show, talking to two or three other technicians. What you're talking about is a man with a headset talking to four other stations—to lighting people on the back, to a spot man up in the ceiling, to a slide man in the back, and to a sound effects man up in the front. Basically, our stage manager

coordinates the show live, every night. It's quite amazing to have one central nervous system with a command center going out to, activating, and coordinating these other media.

Do you have a preference for working with past or present texts?

It could be anything—I don't stick to any role for very long. With *1000 Airplanes*, I worked with a writer, writing a new text. With Doris Lessing, she adapted her own texts. I'm now interested in working with some texts by Cocteau, and at the same time I'm evolving a new text for another piece with David. So I don't have a set way of working.

New York—January 12, 1991

I believe you've been working with Allen Ginsberg on an opera entitled Hydrogen Jukebox.

Yes, it's a chamber opera for six voices and a small ensemble. It opened in Spoleto in May last year, and it's going to be traveling in North America this coming fall. The staging of them is done by a young woman called Ann Carlson. Jerome Sirlin also did some of the visual material.

How did you put this opera together?

Well, we combed through his *Collected Works*—covering a period of forty years—and picked out about twenty poems, and those became the libretto. With "Howl" we used the middle section, but many of the other poems, like "Aunt Rose" or "Father Death Blues," were used intact. *Hydrogen Jukebox* is really a collaboration, in the sense that the music and the words are at this point inseparable for me. You couldn't do the music without the words.

Did you find your musical settings of the poems constrained by the patterns of Ginsberg's intonations?

No, I didn't. Allen recorded all the poems for me, and I made a point of not listening to them. What Allen had always done in previous collaborations with other composers was to retain the spoken meter, so that the music was a kind of a window dressing for the words. And I had no intention of doing that. So when Allen gave me the tapes I simply did not listen to them. I could imagine how Allen would read it, but I did not follow his way of reading it.

Sometimes the music was very different from the poems, and sometimes the music fitted the poem. I would take one aspect or image of the poem, turn that image into a musical image, and that became the setting. But it could sometimes be only one phrase of the poem. And you might have to wait through the whole poem to come across the phrase that matches you to the music. A simple example would be the poem "Aunt Rose." He describes her as an elderly woman—she has one leg shorter than the other, and she limps. So the music was set in a five-eight rhythm, which is a kind of limping rhythm. You might not know why I picked that rhythm until at one point in the poem he mentions that she limps down the hall. And the match is there. But there's no attempt to describe anything.

There's another poem called "The Green Automobile," which Allen wrote when he was only twenty-five. The refrain is, "If I had a green automobile," and then he goes on to

describe what he would do with the green automobile. What I did for that poem was write a piece of music in which a very rapid modulation that ends up in a new key becomes the image of starting the car. You may not know that's what the intention is, but after a while this rapid series of chords finally arriving in a new key, and stabilizing there, becomes a kind of musical image of the car. But the music doesn't have horn honking or anything like that. So it's a musicalization of one feature of a poem.

How did you first come to collaborate with Ginsberg?

I had been asked to perform in a benefit to raise money for VIETCO, which is a Vietnam veterans theater group. And I said, "Well, maybe I'll have my friend Allen do this with me—I've known Allen for some time—we live in the same neighborhood, and we run into each other all the time." They liked the idea very much and suggested I do something from *Iron Horse*, because it's about Vietnam. A week or so later I ran into Allen in St. Mark's Bookstore, and he said, "Oh, what a nice idea." He sent me a tape of *Wichita Vortex Sutra* and I worked with the tape—I wrote music for his reading and we performed that together, as a duet as it were. And that turned out so well, I said, "Let's try to do another work." About that time I was doing *1000 Airplanes,* and I wanted to do a second chamber work that could be taken around the country and I got the idea to do this piece with Allen.

Ann Carlson and Jerry Sirlin both made beautiful contributions to the work, and it became a kind of four-way collaboration in the end—you have the words and the music and the staging and the visualization—the four things together. It's one of these extremely happy collaborations where each part is a kind of unique contribution that the other contributors were not able to do—or even to imagine. I mean, I didn't have any idea what Ann Carlson would do or how Jerome Sirlin would approach this work.

Are you primarily interested in this kind of four-part collaboration?

Well, basically that's what I've been doing for years—it's usually three or four. The style of the collaboration changes a lot depending on my role as a composer. *Henry IV* parts one and two really is a director's play, and I supply music where JoAnne Akalaitis wants it, and have very little other contribution to the whole thing. With *1000 Airplanes* I was really the director and the composer, so I had a lot of input into that.

When I saw Robert Wilson rehearsing Quartet, *in 1988, I noticed how he repeatedly modified performers' positions, gestures, and lighting. Does your music also become modified in your collaborations with Wilson?*

No, it doesn't. With *Einstein* the music was done first, and I didn't change it very much throughout the staging. But with *the CIVIL warS* he had done the staging first, and then I wrote the music, so it wasn't necessary. In our new piece—*White Raven*—we're doing it that way again. We conducted a workshop together in Lisbon with about twenty actors playing the parts in the opera, and we more or less made a dry opera—an opera without music. We'll do the opera "dry" first, and then when it's staged we'll do a videotape of all the staging. And then we'll do all the timings from the videotape. And so, there, it's not necessary to rewrite the music, because I'm fitting it to the action that's already conceived.

Do you find that operas you've directed—like 1000 Airplanes—*differ from Wilson's approach?*

Oh yes, certainly. If Bob had done *1000 Airplanes* it would have looked nothing like what I do. My own way of working as a director—though I haven't done that much—is in a certain way much more traditional than what Bob does. And one of the reasons I like working with people like Bob or Richard Foreman is that they bring something very fresh to the work. In my own field, which is composition, I can be innovative, but in the field of directing—when I do direct—I'm not inventing theater language.

With *1000 Airplanes* I more or less had to direct it because that was the only way to put the words and the music in the right place. With *Hydrogen Jukebox* I was interested in finding another director—someone to bring a very fresh and different way to think about the staging. And that's what Ann Carlson did. It did not occur to me to be the director of that piece—though I'd like to direct *Akhnaten* sometime. There have been three productions of it, but I haven't seen one that is true to the music in the way that I conceive it.

What is the particular problem here?

Well, it's getting a director that will do what you want to do. And they don't. In order to get the interesting directors who'll bring something new to the work, very often there'll be certain aspects of the work, which you've cared for, which won't appear. That ideal director that'll be both completely innovative and obedient to the author—I don't think he or she exists. So, in the end, I've always chosen to go with the director who simply doesn't pay any attention to my ideas, and does something quite original. In the end, I think it's been more interesting to work that way.

But on a few occasions—for example, for *Akhnaten*—I would like to see the opera once done the way it was written, just in terms of following the libretto! If you look at the libretto of *Akhnaten,* act one ends with the funeral of his father, act two ends with an image of that funeral, but seen at a greater distance. And act three ends with the funeral procession entering the kingdom of Ra, the god of Egypt. So the theme of the funeral was a very fundamental concept for *Akhnaten.* In fact, I saw the whole opera as being contained in the funeral of his father. It's never been done that way. That idea was simply dropped.

I had come across the subject of *Akhnaten* through the Russian American writer Velikovsky, who had the idea that the Greek myth of Oedipus was really based on the historical fact of *Akhnaten.* Coming to the material through the eyes of Velikovsky, and seeing Akhnaten as a precursor of the legend of Oedipus, the interpretation of the funeral becomes central to this vision. But it's never been done.

Presumably you'd distance yourself from those who equate the postmodern sensibility with the neutralization of all historical content and all originality?

Well, I don't consider myself a postmodernist, as I understand that term. I have an antihistorical approach, but it's not a postmodern approach. There's a kind of postmodernism that simply equates history and style as though the two were the same thing—isn't that so? Historical materials are mixed very freely—that's one way of doing it. And I don't believe my work is a part of that. Because I think that if you look at what I've done, I think my work—if I can be candid about it—has a real individuality to it. It's not a borrowed language—it's not

the postmodernist idea where musical styles can be somehow intermingled meaninglessly, and where a composer doesn't have an individual language.

I think if you listen to *Einstein* or *Satyagraha* or *Akhnaten*, there's very clearly a musical language involved. And if you compare that with *The Making of the Representative for Planet 8* or *The Voyage*, you'll see an evolution of that language. I'm still of that generation of composers who begin with the language, and then evolve the language, rather than giving up the idea of individual language altogether.

Do you find that television lends itself to this kind of language?

No, I don't like it very much for music. It seems to me that opera is not good on close-ups, and that's what television is. Television is all about close-ups. And opera is not about close-ups—it's about big-scale things. And for me, when I look at opera on television, it doesn't work very well. So I don't do it. I mean, there are plenty of opera productions on television. I don't think the lack of mine will be missed very much.

Melbourne—September 18, 1992

How does it feel to be reviving Einstein on the Beach *in the '90s?*

There are two ways of looking at that. First of all, at the piece itself, and then second of all, at how it seems to fit in with what's going on. The lighting has been somewhat refined, the staging is the same, and the music is virtually unchanged, but in each successive revival of *Einstein* I've been able to get better singers. So what we're seeing is the original version—but perhaps better than we did it originally. If we could go back in time to 1974 and hear what it sounded like on the first night at Avignon, it probably was a mess. We were just learning the music and the singers could barely do it, and it would not sound anything as together as it does now. The other thing that interests me—and this is a complete surprise to me!—is that the piece seems more radical in 1992 than it did in 1976.

Why do you think this is so?

It's partly because the world has become so conservative. Not only the political world and the world of economics, but the world of theater has become more conservative, which I attribute mainly to the pervasive and unrelenting influence of television. The sustained mediocrity of television production in terms of its effect on theater has been devastating. Sixteen years later, when an audience sees *Einstein* now, they are actually less prepared for it than they were in 1976. They've had sixteen more years of second-rate drama served up, either on television or in Hollywood movies.

So the idea of a piece that is motivated entirely by aesthetic idealism—which *Einstein* was—is completely outlandish! We simply don't see it. Most pieces are done with an eye to the box office one way or the other, or to critics' review or to historical judgment of some kind, and I can truly say that when Bob and I did *Einstein* we simply never thought about that. It was a piece that was untouched by commercialism of any kind at all.

And now, there's a kind of commercialism in video, in television, and in movies that has

affected a lot of the younger generation. People think they're supposed to get rich when they become artists. You know, when we were kids, it was practically a vow of poverty when you became a composer of contemporary music—it was something like that. No one would accept that idea today. And the corollary is that there are financial interests involved in a lot of things that are done. And not just in the arts but in the presenters—they have to show that so many thousand people saw this or that, and can be criticized if a piece in their festival doesn't have a good reception.

All of these things conspire to undermine what I'd call aesthetic idealism—the idealism of the artist. So looking at *Einstein* now, in 1992, in only its second revival since 1976, what you're seeing is a work that has fewer companions, so to speak, in the world of music theater, than it did then. People who see it now, they're even more shocked now than they were then. Isn't this surprising?

My jaw is just dropping, because I was wondering if Einstein *hadn't become* The Sound of Music *of the avant-garde, given that it's sixteen years old, and might well have lost its original impact.*

No, it hasn't become that, and I'm a bit surprised. First of all, it's a comment really on the arts community today, more than on the inherent values of the piece, whatever they may be. It's amazing how the influence of commercialism has insidiously insinuated itself into what used to be the avant-garde. Wouldn't you say that's true?

Yes, but couldn't one also argue that MTV clips at times assimilate a more adventurous kind of imaging in a partially positive way?

Well, of course that was true—certainly for *Koyaanisqatsi* and *Powaqqatsi*, the films I did with Godfrey Reggio—those were films that were entirely image. I haven't seen that on MTV. The other thing about the MTV things I have seen is that their pace, their rate of change, their rate of movement hasn't changed. You don't find pieces that are willing to take on time in terms that Bob and I did. The thing about MTV is that things happen very fast.

It's all done in three minutes.

That's right. And *Einstein* is the opposite of TV. It happens very slowly, and it takes five hours. If you want to count it from when I begin—I begin before the audience comes in—the entire event takes five hours, and there's simply no rush. Again, today's theater is not so willing to do that. We very often deal with union rules of three-hour performance times and things like that.

All these things conspire against a piece where the extension of time is fundamental to the concept of the piece. You'll see for yourself—I think you'll be amazed. It's not that it's aged well, it hasn't aged at all! Rather, everything else has aged. My impression is that it has stayed somehow young. Now I can't say that I expected that—I'm surprised!

We've done it in Germany and we've done it in Princeton, New Jersey, in the United States. In Germany, people thought we had just written it—they thought that it was a new piece. Don't underestimate the ignorance of the music theater public—especially a European public that has more or less been taught that if you're German, music theater comes from Germany, and if you're Italian it comes from Italy. The Italians barely acknowledge the existence of any music theater outside of Italy—when *Usher* was done in Florence this spring they thought it

was absolutely scandalous. So it's hard for the Europeans to swallow this piece—it's a tough one—because it doesn't fit into that tradition at all.

*Maybe it's also a problem because people have only seen watered-down versions of the avant-garde on things like MTV. For example, the original prints of some of the early Burroughs films—*The Cut-Ups *and* Towers Open Fire—*were recently screened here in Australia when the French sound poet Henri Chopin brought them over, and audiences seemed astonished by their unexpected freshness and integrity.*

Well, *integrity*'s an interesting word. Integrity produces authenticity—it's about the whole-ness of a piece, about a piece that exists on its own terms of value without having to accom-modate a foreign aesthetic. I guess that's the meaning of the word—it invariably produces a feeling of the authentic and the real. Whereas the commercial world works from the outside, not from the inside. So that to talk about integrity and commercial work is an oxymoron—it simply can't happen and it doesn't happen. That doesn't mean there can't be commercial works that one likes, but they don't have the kind of integrity that you referred to in the Burroughs work, or the kind of integrity in the work of Merce Cunningham and John Cage.

One of the things one remarked when John died was that he was a kind of beacon of integrity. He simply went his own way, and with such resoluteness and such originality of spirit, that basically he got away with it. I think that, in fact, people who do that do actually "get away with it," because in fact we don't see enough of that. The kind of stagings Bob does or the way he works with lights—you don't get tired of them because they have a wholeness, which is what we respond to.

But you sense an increasing insensitivity to such integrity?

I think we're not in a good period right now. I think it's of a piece with the demoralized po-litical and economical situation that's worldwide. It seemed in the '80s that we were moving into a spirit of internationalism, and that turns out not to be the case. The Europeans are making their common market, the Americans are making theirs, and now here I read in the paper that there's to be an Asian common market, too. So that instead of internationalism, you're having a kind of supernationalism going on, to the point where you have even the kinds of things that are going on in Yugoslavia and Russia. These are extremely negative forces, because it moves away from the spirit of expansion and inclusion, to one of exclusion and prejudice. And in the end the artists get affected by it, too.

At one point, I think, in the '70s and '80s, you got a better idea of the function of the artist in society, and now it's become very cloudy again. Is the artist the entertainer? Is he the court jester? Is he the philosopher? Is he part of the society? Or is he somewhere on the sidelines and not participating in a way?

I think that in a certain way the radicalism of the '60s and '70s provided a very firm iden-tity for artistic expression. With the loss of that, or maybe the degeneration of that, the role of the artist isn't so clear anymore, and that's another problem. I hate to give you all this depressing news, but you know it all yourself.

Where does that leave you? The last time we spoke you said you were doing a number of inter-national collaborative projects.

I've continued doing that. I did *Music from "The Screens"* with Foday Musa Suso, and I just did a record with Ravi Shankar called *Passages,* and I just did a new record using the music of David Bowie. So I continue in my kind of relentless collaborations. I don't know exactly where that's leading and I don't really have an agenda for it. I learn a lot from doing it, and that's mainly why I do it.

I've also three new operas coming out in the next two years. One is *The Voyage,* which will be at the Met. Another is a new work with Robert Wilson called *White Raven,* which is a celebration of the Portuguese discoveries. And I've got a new opera that is going to come out in Boston in the spring, based on the film *Orphée,* by Jean Cocteau. I got the rights to the screenplay from the Cocteau estate, and I made the adaptation myself. It's written for a chamber orchestra, and there are four main singers. It follows the film very, very closely. My idea was to draw from classic film as a source for opera.

I'm also touring, again relentlessly. I have a tour of *Koyaanisqatsi* and *Powaqqatsi* in America in the spring. This *Einstein* tour goes on until December. I'm doing a very brief tour in India in February just for a couple of weeks with the dancer Molissa Fenley. Then *Einstein* will go out again in the fall, probably back to Europe, and then to America in spring 1994.

Does this leave much time for sustained aesthetic idealism?

Oh! It does actually, because what I do is I take off—I'll take off a month at a time, and then I really sequester myself for that time. I have a house in the country in Canada, and I still go there. In the last five years I've been spending more time in Brazil—I just rent an apartment in Rio, and I work there.

I find that I go on these very extended music retreats, and I'm invariably alone. I don't have any companions or friends with me, and I usually have minimal phone contact—when I'm in South America I speak to someone at my office about three times a week, and that's it. So basically it's in those situations that I seem to do my best work these days.

Brion Gysin, Polyphonix IV, American Center, Paris, June 1982. Photograph by Françoise Janicot.

BRION
GYSIN

I FIRST HEARD FROM SOUND POET, CUT-UP POET, AND PAINTER BRION GYSIN IN 1970, when a request for contributions to my magazine, *Stereo Headphones,* prompted a card from Tangier saying, "Thanks for your great little magazine but I'm sorry I'm not in the poetry bag at the moment spending all my time on the beach."

Four years later Gysin wrote, "If you come to Paris we might do something," and following written responses to a questionnaire concerning "advances" in avant-garde poetry that I'd sent out from my new office in Brisbane in 1979, we finally met in September 1982 during the Final Academy performances in Brixton.

I transcribed our interview, and Gysin "Gysined" it, ironing out such gems as the following marvelous overview of the groupings, regroupings, and degroupings of the cut-up, Lettristes, sound poetry, Le Domaine Poétique, and Fluxus avant-gardes in early 1960s Paris—a chronicle far too good to miss:

I was working with Ian Somerville at that time with dream machines and had the idea that one could work with projections, which we'd done already with William at La Bohème, which was a nightclub in Montparnasse, or something like that. It was our first public performance I guess, it must have been 1959.

So then I heard some things of Heidsieck's which he must have recorded in the wine cellar in the house that belonged to his family at that time, which gave stereo effects because of the echoes, and then I integrated him into the Domaine Poétique group. He came along and became part of it.

Then that group had actually fallen apart by the time that one met Chopin, who had been doing his own thing with the tape recorder that he'd been fucking around with, and then he brought out the records in the magazine *OU,* and things fell apart and people went off, and each went his own way—we brought in Dufrêne, who really came from the Lettristes, but who had his own sort of theatrical thing.

My whole idea was to make it theatrical, to be live presentation in a theatrical sense, as I had worked in the theater in America, and then we met Fluxus through that—they came along for a week or something which we shared. That must have been 1963, I suppose—1964 even—and then everything sort of split apart. I went back to Morocco, and then from Morocco to New York, and then we went on to other things, but through the years there were more chances of doing poetic performances particularly in Italy, and in Belgium, and Holland, Amsterdam . . .

As Henri Chopin observes, Gysin's innovations and insights were those of "a master" offering "fabulous ideas."

Paris—August 1979

Has poetry advanced since Dada? How? In what ways do you think experiments with poetry and art have advanced in the last ten years?

Advanced in the last ten years . . . *ten years*? Your questions are loaded with nineteenth-century optimism at a time when the whole idea of progress is up for reconsideration—above all, such accelerated "advance." Of what? To where? Since when? "Since Dada"?

Tristan Tzara and I used to bump into one another sometimes in the late '50s around about midnight, for a standup steak and a beer at the circular zinc counter of the old Royal Saint Germain, now transmogrified into the monstrous Le Drugstore, where no poets meet who can help it. Every time we met, Tzara would whine, "Would you be kind enough to tell me just *why* your young friends insist on going back over the ground we covered in 1920?" What could I say, except, "Perhaps they feel you did not cover it thoroughly enough." Tzara snorted: "We did it all! Nothing has advanced since Dada—how could it!" When I suggested that poetry was getting up off the page to become oral again, he cried: "It always was! I created poems in the air when I tore up a dictionary to pull the words out of a hat and scatter them like confetti—and all that was way back in 1920." When I talked about the use of tape recorders to make sound poetry, which I preferred to call machine poetry, Tzara snarled, "Music?"

Dada, French surrealists, and later existentialists, situationists, New Philosophers, et al., have always abominated music. Music is not rational. They prefer ratiocination, to which the French language lends itself only too easily *and* utterly unmusically owing to the uniform terminal stress on all French words. Dada adopted the French language and got lost in a revolving door at the dawn of the Jazz Age, when Tzara and Breton were rivals fighting for the papal crown of the avant-garde. I always refrained from ever even reminding Tzara of this painful incident in the Closerie des Lilas, where a traditional versifier named Saint-Pol-Roux was being feted as the Prince of Poets. The loosely amalgamated avant-garde of the time organized a commando night raid on the celebrated café and was routed by the riot squad. Breton loudly proclaimed that Tzara was a fink: he called the cops. When the lights went out, Breton heard the voice of Tzara calling the commissariat on the telephone, distinctly. The commandos chose to believe him. They went in together: they came out apart. Dada was dead. Surrealism, dubbed by Apollinaire, was in the ascendant. There was nothing left for Tzara to do but slink off and become a Communist Party bureaucrat under Aragon, who wrote best-selling novels.

Art is political . . . (from the Greek *politikos*: the art of governing a city, a society, a state).

Poetry is political but confined to the language it chooses. Painting is political and not bound within the same limits. The message can be read at least superficially by even the illiterate.

Music is political and crosses all frontiers, reaches all ears, especially those of the young. Pushy poets get into the act with pop lyrics and sound poetry, both filtering through the language barrier. Prominent political poets like Ginsberg and Yevtushenko speak to the young in much the same idiom but foreign languages, yet the message really gets across. Ginsberg has added a guitar and a banjo to the Wesleyan drone of his old Indian harmonium. Since catching his act on the beach at Ostia this summer, Yevtushenko may soon be making the rounds of the upper-bracket poetry festivals with a balalaika.

Some of us have been multiplying the effects of our own vocal cords ever since we first got our hands on tape recorders back in the 1950s. Henri Chopin began issuing our records in France in the early 1960s, followed by others in Germany, Italy, Sweden, and the States, of course, where John Giorno hooked our many voices into the Bell telephone system, Dial-A-Poem, and a whole shoal of LPs. Bits and pieces of our inventions soon began turning up in both pop and repetitive music, where it is occasionally acknowledged, as well as in radio and television, where it is not. Sound poets are infiltrating the festivals, crossbreeding with improvised and free jazz, singing "Come to Free the Words," a potent phrase I permutated years ago into "Too Free Come the Words . . . The Words Come Too Free," et cetera.

So, if the words go free, where do they go? Perhaps a word of warning: things could get out of hand around here. Look at what is happening to poor painting, done to death by Deceptual Art. The Me Generation has pushed both painting and sculpture to the brink, and there is every likelihood they will be pushed right on over into the graveyard of history. And why not? They have had their heyday in the five hundred years since they gave up being anonymous and got star billing in the marketplace. Why not give some other art a chance? Since the moonwalk, we know we got to go, even though Burroughs may suggest that there is no place in space. There may well be no place for those arts. Body art fades away with the decaying body, leaving nothing but a bad smell. Garbage art and junk sculpture return to the dump where no further archaeologist could possibly identify the product. Images have been taken over by electronics and blown up accordingly.

When painting was for princes and priests, the average pilgrim might get to see only one sacred image in a lifetime. Today we are swamped by them. When museums of modern art were opened only about fifty years ago, art had to be modern every week, like the display windows of department stores. Art became a household word, and every housewife became an artist. Styles of painting were in and out like women's fashions, to which they have always been somewhat related in any case. Art dealing is the uptown branch of the rag trade.

So what are we going to wear in space? We are here to go and what to pack for the trip? Take along our precious paintings? Our moldy old cracked and peeling masterpieces? Not likely. Our tons of bulky marbles and bronzes? There would never be room for them, and why should we when our spaceship is the most beautiful supersonic sculpture of them all? We love it. We really get off on it. Maybe we might take along just a few pretty things to interior-decorate it for the long voyage out? No, the pilot would never allow it. Regulations, you know. In his own way the pilot is a sort of poet, but the litany of the logbook he recites and knows off by heart is likely to be in only one language for all of space. Space will not be

for everyone, after all, but music will remain his lifeline into his own interior space and will mingle with the music of the spheres when he gets there.

Who cares what "advances" were or were not made in the last ten years? It's always the next ten that count.

London—1982

What started you off working with tape recorders?

You mean "working with" or "playing around with"? "I don't work, you dig," as I said in my permutated poem: "Work, I don't dig you!" It is work to record somebody else's sounds. I first wanted a tape recorder to tape long-ago medieval sounds in Morocco circa 1950 but I never did it systematically when I realized you don't really hear what you are recording until you get the secondhand playback of it. Playing around with the machines is different, fiddling with speeds and overlays, for example. Life begins with two tape recorders because you can make copies. Art begins with three tape recorders when you can create new sounds, invent them, make them invent themselves.

I first heard of tape recorders right after World War Two when I was swept away by the idea of immediate playback, but I didn't lay hands on machines of my own until about 1956 in Tangier. I had been listening to the Master Musicians of Jajouka since 1950 and opened the Thousand and One Nights restaurant in Tangier to have them under my roof, but I did not record them until we took Brian Jones of the Rolling Stones up to their village. And that was a bit of a disaster because the musicians have still never got paid. From 1965 until 1973 I recorded some of the last of the medieval Muslim magic music that was being played year-long in the streets for weddings and funerals and festivals or in the mosques, the brothels, and the greenleaf country cafés. I still have a few score hours of that.

I really began playing around with the tape recorders when I got back to Paris in the old Beat Hotel about 1958, 1959. I had stumbled upon the cut-ups and then permutations, so I began recording them to show Burroughs how one could use tape recorders to cut in and out of already recorded material. He went right out and bought a cheap Japanese machine and then Ian Somerville came along with better machines. We hooked up our three machines between our three rooms because we had only forty watts apiece to play with by candlelight or we blew out our fuses down in Madame Rachou's bistro from which she ran the hotel.

That sounds like the beginning of The Third Mind.

Yes, you could say that. Ian was our third mind. We shared him. We showed *Cut-ups* to Gregory Corso and Sinclair Beiles, who contributed to the little booklet we put out early in 1960, *Minutes to Go.* Then William and I put together *The Exterminator,* published in San Francisco. It had cut-up texts from William's word hoard out of which he had already conjured *Naked Lunch.* There were permutated poems of mine accompanied by my repetitive calligraphies to match, attempting to show that these techniques could be decanted back and forth through different media.

We had used found material from newspapers, so I decided to write a *Poem of Poems* directly onto tape by reading only the most potent literary material, the very best cut back in

on itself at random. The Song of Solomon, Shakespeare's honeyed sonnets, the *Anabase* of Saint-John Perse in the T. S. Eliot translation, if only because Perse had lived in our narrow little Parisian street and written about it: "Rue Gît le Coeur, Rue Gît le Coeur." Then a smattering of "special knowledge" from Aldous Huxley writing about his mescaline experience. William immediately began applying these techniques to his monster manuscript, which was sliding out of an old suitcase by itself, demanding to be published.

Some of this noise came to the ears of George MacBeth in charge of poetry at the BBC Radio, and he invited me over to London to do a reading on the air. In the studios I met Douglas Cleverdon, who had produced *Under Milk Wood* by Dylan, the real Dylan, Dylan Thomas. Cleverdon had me invited back a few months later to put together a half-hour program called *The Permutated Poems of Brion Gysin*, which was broadcast in August 1961 to a zero rating but brought some very young repetitive musicians right to my door back at the Beat Hotel. Daevid Allen, who formed Soft Machine and Gong, actually moved into the

Brion Gysin, "By Silence to Say Good." Private collection.

room next door recently vacated by Gregory Corso, who wanted to have nothing to do with cut-ups because he figured they threatened his "Poesy." He had a unique voice of his own and he wanted to keep it. He was right. I very much admire his work.

Then a French group picked up on what was happening in the old hotel and invited me to join a group they were forming, to be called Le Domaine Poétique. They were floundering around a bit between French careerism and a vague Fluxus influence from Berlin. As I had worked on Broadway in the early 1940s, I jumped in with a theatrical approach aided by Ian Somerville with the projected visuals. We were so successful that George Maciunas tabled the light show aspects of our efforts as "Expanded Cinema," on his chart of what happened in the '60s.

What we had going were tapes of my permutated poems like "I Yam That I Yam," the Divine Tautology, "Junk Is No Good Baby," "Kick That Habit Man," and "Calling All Re-active Agents." In a white jumpsuit, I played live into the color projections of my slides on me, or I could be invisible dressed in black and pull up a sheet with a slide of me naked showing on it to make a little gentle point about the Beats who had dropped their drawers to shock the U.S. public while they howled for attention and got it. I wanted to do something else, despite my admiration for them.

There was a whole muggy area of doubt as to what to call this monstrosity I helped bring about. Because of the machines involved, the electronics, I would have called it "machine poetry," but everyone shied away from that. I felt good about creating through the machines, and they did not. I wanted to make language work in a new way, to surprise its secrets by using it as the material one passed through the available electronics to amplify the voices of poetry. "Poets are made to make words sing," I wrote. I wanted to get as far away as possible from "inspiration." I wanted expiration instead, to breathe out rather than in. A lot of us wanted to get poor poetry off the page where it was laid out like a corpse. "Concrete poetry," as some of my stuff was called, simply brought attention to the patterns poetry made on the page, a decorative thing. "Text-sound texts" left me perplexed because there were too many exes in the title. "Poésie sonore," as Ira Cohen said, sounds too much like *snoring*.

I wrote a sound poem with a single pistol shot recorded at one, two, three, four, and five yards away and permutated the number. "Pistol Poem" makes a beat you can dance to. It makes you perform. I guess that's what got me on the stage and behind a mike. I can be so short of breath I'm coming in short pants or so wheezy with asthma I can hardly whisper, but put a mike in front of me and I clear up instanter. I'm a ham. I yam, I yam!

How did you get into jazz, writing songs with Steve Lacy?

Like that. A happy encounter. I was back in Paris in 1973 after giving up Morocco, where I spent what is still more than a third of my life. Having stayed on so long to listen to the Master Musicians of Jajouka since 1950, I had missed out on a whole lot of the jazz scene as it had developed in Europe and the U.S. I ran into Steve Lacy in the very same American Center in Paris where the Domaine Poétique had performed ten years earlier. He said: "I'm writing music to texts by painters. Do you have any?" We have been working our way through them for nearly ten years now. Most of them are on the album put out by Hat Hut in Switzerland, *Steve Lacy, Brion Gysin, Songs* with the Lacy Septet and Irene Aebi singing. I'm on the album, too.

Hasn't something else been happening since then?

Yeah, quite a few things. Steve has gone on to produce a ballet cycle on the songs I made for the screen script of *Naked Lunch* by Burroughs. Then I have a solo record out, a maxi 45 called *Orgy Boys,* with poems dedicated to friends who are poets and pop stars. William, Allen, Giorno, then, Keith, Mick, Patti, Bowie, Iggy the Blue Baboon. I just got a playlist from WRUV, the FM jazz station in Vermont that all New York musical ears listen to. They play it and someone like Pat Irwin of the Raybeats writes me they really hear it.

How did you come to sing with a rock group at the Final Academy in London last September?

That is entirely owing to young Ramuntcho Matta. Early in 1982 or even earlier he began persuading me to try and sing my own songs with his music. He got the group together from among his friends, and we started rehearsing more and more seriously before we went into a sixteen-track studio to make a demo. One of those songs, "Junk Is No Good Baby," is on the new Giorno Poetry Systems record, *Life Is a Killer.*

Then, for the Final Academy, Ramuntcho put together an English group with Tessa from the Slits on bass, the drummer from Rip, Rig and Panic, and another boy. The ages of all of them added up together would not be much more than my age. Like Mae West, who made a great rock and roll record not too long before she left us, I would like to make a maxi 45 with Ramuntcho and then retire a lot earlier than she did, don't you think so?

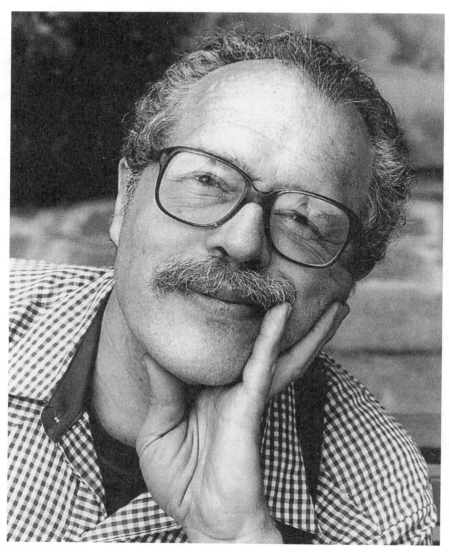

Dick Higgins. Photograph courtesy of Jessica Higgins.

DICK
HIGGINS

I FIRST WROTE TO DICK HIGGINS AROUND LATE 1968, and he sent three poems for the initial issue of my experimental poetry magazine, *Stereo Headphones,* in 1969. We exchanged letters and publications, and met briefly at a New York book fair in the 1980s, but never really talked until 1993, when I finally caught a train up the Hudson to his converted church in Barrytown.

Jumping in at the deep end, we immediately began discussing the term *postmodern,* the questionable cult of absolute originality, and the general "failure of nerve" of those critics unwilling to come to grips with innovative creativity.

Questioning the merits of mere "technical demonstration," and disparaging the lavish scale of Biennale art exhibits, Higgins generally championed the more modest and more mysterious gestural intensity that he attributes to the French poet Henri Chopin's performative presence when likening it to "this golem—this demon that's generated by the piece."

As Higgins suggests—when citing his friendships and correspondence with Dadaists like Raoul Hausmann, Richard Huelsenbeck, and Hannah Höch and enthusing about younger artists such as Meredith Monk and Larry Wendt—the most positive momentum of the multimedia avant-garde is surely its creative continuity with those "brothers and sisters who happened to live a long time before us."

Regretting radio's reluctance to broadcast such hybrids as his *Storm Riders,* and academia's departmental exclusion of multimedia creativity, Higgins suggested a drive around nearby patrician mansions, a gesture of solidarity with the local past befitting an explorer of the present too enthusiastic ever to be "just a composer, or just a poet, or just a visual artist."

Dick Higgins died on October 26, 1998, while participating at the Art Action, 1958–1998 colloquium in Quebec City, just days before he was scheduled to fly on to meet old and new friends at the Re-Thinking the Avant-Garde Festival in Leicester.

Barrytown—July 5, 1993

Perhaps I could begin by asking you how you respond to debates about modernism and postmodernism?

Well, I see modernism as an ongoing tendency to focus on innovation and on a constant need for renewal, and therefore on new forms as well as on new visions and, ultimately, new messages interrelating with these things.

I see postmodernism as a tendency that began some time in the '60s, with a hunger for a kind of Thermidor—"Please slow down, little world!"—and the sense that one should try to get outside of the modernist tendency. They felt that the economics of the arts could not go on indefinitely in the expansive mode that they saw as characteristic of modernism. And so they turned in on themselves, and to some extent the focus shifted towards critiquing rather than doing.

Why do you think academics embraced this sense of postevolutionary or postrevolutionary postmodernism?

Because it put the spotlight on them. They didn't have to keep themselves informed about what mere artists were doing because criticism was the art. This was just what was wanted by those academics who tried to replace traditional artistic discourse with something which they found analogous to science. Now there's a very good reason why you simply cannot have a science of criticism, and it's that innovation in art does not work the same way as innovation in science.

In science, if I invent, say, a new medical procedure which is better than your old medical procedure we all switch to the new medical procedure and have no particular commitment to the old form. Therefore, we innovate by replacing outmoded forms. But what happens in the arts is really quite different, because rather than replacing, we augment. Twenty years ago Richard Kostelanetz pronounced the collage principle in the arts dead. And yet I see a great deal of interesting new work being done—and it is undeniably new—following collage principles. So we have an ever-expanding repertoire of technical possibilities, as opposed to a replacement of one by another.

There's usually an emphatic sense of positive continuity in the art world, where visionaries like the concrete poet Ian Hamilton Finlay emphasize their reverence for the past, as opposed to the theory world's claims that this or that aspect of the past is "dead."

I've called that the "neoteric fallacy"—the assumption that artistic and cultural development follow the same way as they do in science. And that assumption, I think, is simply false. Therefore, it doesn't surprise me at all that Ian should say that he reveres the past. I revere the past. John Cage revered the past, certainly. Jackson Mac Low reveres the past. Most of the artists I know do in fact revere the past.

Sometimes one goes through a stage, when one is in one's twenties, wanting to claim for oneself a degree of novelty that isn't really appropriate, and it's a natural thing in growing up to attack the past per se. As one gets older, though, one finds that those were simply brothers and sisters who happened to live a long time before us, and that we can learn a great deal by studying them and in fact almost anything that's worth doing has at least been hinted at by

somebody else. I get very skeptical about work that has no antecedents whatever. I don't find it real originality—I'm apt to find it a sort of artificial originality.

To what extent would you say that new technologies offer original creative possibilities?

Well, technology expands the vocabulary, just as new forms in other ways do. I really do not enjoy work which is done for technical reasons. I can show you computer work that is just so focused on the technical capabilities of those machines that it's as if the artist had abdicated the responsibility to think, and I think that it becomes increasingly hard for people to just plain think. They should use the machine, of course, to do what they can't do themselves, but when they let the machine go beyond its bounds and take up all their attention, then they can be in real trouble. I wait for the real work which technology makes possible—that's what I'm looking for. So I don't really tend to stress the purely technical in my work—not for its own sake.

Ditto with Nam June Paik's various electronic innovations, which he made back in the '60s and which he still draws on for his video art. Video art, per se, is not particularly interesting. But in Paik's case, what one finds is that it's used for a constant evocation of the new as part of its own mythology—a sort of self-reference to video techniques as well as to a world in which video plays an active role.

Which other artists give you the same sort of buzz as Paik?

Pauline Oliveros, the composer—her work never seems to stop with the technical; it always goes on to other dimensions. But not very many, not very many. I don't think this is a very happy time for the arts. In times like this, there are really rather few people who have kept the faith, kept the vision, and kept their nerve—as Gilbert Murray described it in his marvelous book, *Five Stages of Greek Religion*. Do you know that book? He ascribes the collapse of the classical world to above all a sort of failure of nerve. I do feel a sort of failure of nerve now, among many artists and critics, although of course I hope it's not permanent.

But there are some individuals who have kept their nerve, kept the vision, and kept the energy together. So, although this is not a world in which everybody seems to be doing all kinds of incredibly stimulating things, as they did, say, in the '60s, and is basically somewhat of a down world, it's probably therefore a nexus point or transition point towards whatever is going to come next—hopefully, a positive one.

It seems to me that a lot of critics have lost their nerve because they're not doing their research. Politically correct cultural studies and cultural theory all too often simply decode advertising and popular mass media, neglecting more challenging creativity.

Yes—it's a cop-out. Mass media is not as powerful as people think, particularly advertising, because advertising is ultimately always the slave of success. Its very success causes it to self-destruct at a certain point because people get tired of it. I for one have a great dislike of advertisements because they strike me as such dull art because they're overdirected towards a particular purpose.

What do you think of some of the more polemical forms of verbal-visual art that have occurred in the past decades? It seems to me that artists like Jenny Holzer and Barbara Kruger are addressing the mass media with the tools of mass media.

Oh yes, indeed they are. And their work belongs to the world of mass media. It's the mass media in bohemian drag. It's very unsatisfying to me as art, but it's kind of amusing to see it happen. I was in Venice at the Biennale in 1989 when Jenny Holzer's slogans were all through the city in little advertisements on the little boats on the canal and so on. I found that they didn't work for me at all, because they were preaching to the converted and didn't seem to have any appropriate new sense of conviction. I saw them as an attempt to *seem* new. This is the way advertisements work, isn't it? They always want you to think that this form of ice cream is new, this form of cigarette is new, where in fact it's really not very new, and, in some cases, it's a sort of degeneration of the one that came before.

In defense of Jenny Holzer, she has some interesting things to say about her installation at Venice. She describes the room on the right-hand side as a kind of "hell room."

Sure, but if you work on these things long enough, you're bound to develop metaphors for them. But that doesn't mean that it *was* a hell room. I found myself asking how much everything cost. It just seemed so lavish that I couldn't help being struck by that. The message that I read in that pavilion was "Look at me—I got all this money together," and I could not find that a form of protest or of moral conviction. Instead, I was separated from any sincere moral conviction, which maybe she has, by the costliness of the whole matter. There were, after all, marble pieces with metal inlays—precious materials throughout the thing. I think I would have been more interested if these works had been on paper and left on the floor of the pavilion and then simply replaced every morning as they got scuffed up. That would have impressed me far more if a moral issue were really the installation's subject, rather than wealth or fashionability.

But hadn't Jenny Holzer already done that in New York when she stuck polemical labels in phone boxes and things like that? Perhaps this highlights the problems of socially committed artists entering the arena of big-bucks, big-prizes competitions like the Biennale, with sponsorship from very wealthy organizations? Optimistically one would hope that good art would still materialize.

Optimistically one would, but why flaunt the wealth of it all? I don't begrudge these artists their money, but I think flaunting their wealth is not the way to make the message stick. The best thing to do with the wealth is to increase the scale or increase the magnetic outreach of the thing, so that you can reach more people with your message.

Perhaps this is partially what Jenny Holzer does with her more public electronic signboards? Don't you think there's something quite exciting in the fact that she's actually presented language texts in New York as large-scale textual installations? I remember how a number of concrete poets writing in the '60s—such as the English poet John Sharkey—wrote of their dream of having poems as big as advertising in the city. Haven't language artists like Holzer at least partially realized this ideal?

I like Sharkey's proposal, but I think that's a different issue from the way that Holzer uses language. John Sharkey's proposal was that he should do pieces on a large scale, and I would like to see those, as poems. However, there's no way that Holzer's texts can be taken as poems. They aren't. They're technical demonstrations, they're media poems at best—more likely, simply advertisements or slogans.

They just do not have an adequate poetic basis. They don't create a world of metaphor or of an imaginative view of life, or any of the applications of the principles of music to language. They simply do not match these forms, they don't feel like poetry, and ultimately, taken as poetry, I would find them extremely unsatisfying. So Sharkey's proposal, or other pieces by Alain Arias-Misson—people like that, who have also tried to work in the form of public poetry—those I find much more stimulating and satisfying as intermedial compositions and concepts, as well as for what they are, taken in a simple form.

But isn't Holzer's early work consciously written as prose?

I suppose so. After all, like Monsieur Jourdain, we've been speaking prose all our lives. If I tell you that I need to have the salt passed at the table, and you do it, indeed, I ask the question in prose and you reply in prose. That doesn't mean that it's going to be an interesting text, taken as a text. So indeed, Jenny Holzer's doing prose, but that's because it's prosaic as much as it is prose. Mark Twain can be a poet in prose in his *Huckleberry Finn*. She ain't no Mark Twain.

My sense is that her more recent confessional texts are in fact more poetic than her earlier, rather blunt statements. The scale and the complexity of her work across the media function quite convincingly as a synthesis of some of the different energies of language art, installation art, and electronic art. Maybe one also finds the same kind of accessible synthesis in the most lavish performance works of Robert Wilson and Laurie Anderson?

I don't know Robert Wilson's work very well. Laurie Anderson's work can lose me on occasion when she tropes the image of the poor little country girl just fresh to the city—she's been around for thirty years, and she ain't that young anymore. I feel that her voice gets altered negatively when she tropes this persona of the ingenue. It simply doesn't fit. On the other hand, apart from that, the simplicity of her means, the well-digested nature of her technical element, and the ability she has of remaining somehow simple are quite the opposite—that's convincing and very beautiful. What she does, she does so extraordinarily well, and I find Laurie Anderson really one of the most satisfying artists who do this kind of thing.

Elsewhere, you've discussed "well-digested" technologies in terms of "intermedia" art. How did you come to use this term?

I revived it from Coleridge. He used it in a lecture that he wrote in 1814 and which he published in 1816, and used it only once as far as I know. I must have come across it when I was a language student in Yale or Columbia in the late '50s, and more or less forgot about it until I needed it in 1963. To me, the difference between intermedia and multimedia is that with intermedia there is a conceptual fusion, and you can't really separate out the different media in an integral way. Now, if, for example, I play a recording of an opera, what I'm hearing is the music of the opera, and perhaps the text as well—but I'm not seeing the mise-en-scène. That means that an opera is a mixed medium.

If, on the other hand, I go to a Happening or I look at some of Dick Higgins's theater pieces, there the musical element is really inseparable from the textual or the visual. They all have to go together, or you simply do not get the aggregate experience. Those are therefore intermedia, whether they fit into the form of intermedia which have recognized names or not.

For example, if I speak of concrete poetry, I'm dealing with an intermedium which is partly poetry and partly visual art. It's an intermedium between those two relevant areas. And if I use the Italian term *poesia visiva* for the kind of visual poetry which developed after concrete poetry, it's a valuable thing to be able to think of it as a new and rather clearly defined intermedium.

But I find that when I do artistic work, I follow my nose, and it has a tendency to lead me out—always out—of established intermedia, which have therefore simply become new media of one sort or another, towards trying the frontiers of this and trying the frontiers of that. People are often dismayed, because what I'm working on simply does not fit the priorities they've set for themselves.

For example, one of my *Hörspiel* compositions of 1990, entitled *Storm Riders,* collages the first *Moral Essay* by Alexander Pope and my own poems from a set in which all the nouns and all the verbs begin with *St*, spoken by characters whose names begin with St. These St people are then referred to where all the nouns appear in Pope's original text, so that I have Alexander Pope talking about Harriet Beecher Stowe or Alfred Stieglitz or Igor Stravinsky and people whom obviously Pope could not have known.

This substitution and interplay become a perfectly valid form of new *Hörspiel,* and yet it's absolutely maddening when I play these kinds of things to a composer, because the composer finds the musical implications are more or less minimal. The piece functions conceptually on a completely different plane from the one that composers are used to. They find it old-fashioned because they hear iambic pentameters, and they don't see that I'm doing something entirely different with a body of material that I've drawn from the past, mixing it with highly contemporary stuff, like my alliterative texts with St, and with other historical references. Belle Starr, the famous bandit, is another of my characters there. The characters—incidentally—are chosen by the performers, so therefore every production has a different set of characters.

How was this piece received?

Well, it's never been broadcast, because not a single composers' group or radio group has been able to sort it in their own minds as fitting into their programs. I produced *Storm Riders* when I was at the Banff Centre in Alberta and have been trying for three years to get somebody to broadcast. I simply cannot do so, because it just does not fit into anybody's program. Maybe in five years I'll find the right place, but by then there'll surely be some other piece that simply can't be used by anybody because it does not fit into their assumptions.

Another problem with intermedia is the funding problem. The people who assign the funds make their priorities according to their own particular interests, so that the people who are orientated towards music tend to fund the musicians and the people oriented towards visual art tend to fund visual artists. But the intermedial artist who is both visual and musical, for example, is nobody's priority and is therefore apt to be left out, even if a program exists in the name of intermedia. That's one reason why you don't see new intermedia works performed very much.

New York video artist David Blair similarly tells how his cyberpunk film Wax *was initially cold-shouldered by purist video festivals, before finding success at film festivals, where such slightly sci-fi video was more acceptable. Do you find this kind of resistance to hybrid aesthetics typical of American culture?*

Storm Riders

a drama to be heard

by Dick Higgins

This piece is intended as an audio work, either for radio or to accompany an otherwise unrelated visual work, or for public reading. One to nine actors or actresses participate, and one of these is always the NARRATOR. If there is only one actor or actress, he or she performs the NARRATOR's part plus up to twelve PERSONÆ, using samplers and electronic means to change his or her voice so as to resemble the voice of the PERSONA. Or if, for example, there are

The last names or most familiar names of the PERSONAE begin with an ST. A list of possible PERSONÆ might include (but is not limited to) the following:

Joseph Djugashvili "Stalin" (1879-1953), Henry M. Stanley (1841-1904), Belle Starr (=Myra Belle Shirley, 1848-1889), Sir Richard Steele (1672-1729), Lincoln Steffens (1866-1936), Gertrude Stein (1874-1946), Joseph Stella (1877-1946), Henri Beyle "Stendahl" (1783-1842), Laurence Sterne (1713-1768), Wallace Stevens (1879-1955), Adlai Stevenson (1900-1965), Alfred Stieglitz (1864-1946), Harriet Beacher Stowe (1811-1896), George Stjernhjelm (1598-1672), Alessandro Stradella (1644-1682), August Stramm (1874-1915), Johann Strauss, Jr. (1825-1899), Igor Stravinsky (1882-1971), August Strindberg (1849-1912), Erich von Stroheim (1885-1957), Charles Edward Stuart (= "Bonnie Prince Charlie, the Young Pretender," 1720-1788), Gilbert Stuart (1755-1828) or Peter Stuyvesant (1592-1672).

Dick Higgins, first page of *Storm Riders*, 1990. Courtesy of Hannah B. Higgins.

Oh yes. Here, our art life is largely controlled by people in the university, and until we have departments of the arts in which the visual artist or professor is seated side by side with the poetry professor, it's not very likely that people will get beyond their areas of professional specialization. Academics tend to choose to teach whatever it is they can teach, and to ignore those things which they can't. And that usually means any new work that doesn't readily fall into classifiability. That's the problem with intermedial work working its way into academia. Since I know I'm an intermedial person, I would not have felt comfortable had I followed my scholarly inclinations into academia.

Well, there always seem to be tensions between the coherence of curricula and dynamics of new creativity. You probably know the San Jose sound poet Larry Wendt?

Sure—he's wonderful! He's a person who uses technology in a very appropriate and exciting way!

Well, I was talking with Larry and the electronic composer Allen Strange about the problems of devising courses on sound poetry, and Allen argued that such courses would probably become too hierarchical and inflexible, rather than really reflecting the diversity of sound poetry.

I wonder if you couldn't teach the history of sound poetry, cutting off at some arbitrary date such as 1985, and not worrying about exactly what was current, but dealing with the history of these materials, starting with the croaking chorus from *The Frogs* by Aristophanes, going through some folkloric materials—Navajo horse songs and things like that, and then hitting the twentieth century, when there's a great deal more of it, starting, say, with the Russians and the Dadaists and Christian Morgenstern, and working up to whatever cutoff year you chose.

 If you did a purely historical survey, then people would be able to say, "Yes, I'm in this tradition, I'm in that tradition," "I want to develop this, I want to base something on that," "This has been done, so it doesn't have to be done again." You'd have people careening off in all kinds of different creative directions, simply from their access to material. What we need is a popular book on sound poetry to make the field available as one of the possibilities that's open to any poet.

Given such observations, it seems obvious that there's still a contemporary avant-garde. Certain artists are still producing works—like your Storm Riders—*which are not yet accepted by the mass media, and others are still elaborating traditions—such as the sound poetry experiments you've just outlined—that are still widely unknown.*

How can there *not* be an avant-garde in that case? I certainly don't work in the intermedia in order to be obscure. It's my intention that the works should eventually be widely known and much enjoyed by everybody—that means one man today, more people in the future.

How do you respond to the counterargument that there can't be an avant-garde given that New York advertising will assimilate or appropriate anything new within five weeks or so?

Oh, they take the shell of things, but they really don't take the meat. I'm not too worried about the New York commercial types appropriating things. Let me give you an example. About fifteen years ago I was at a concert at the New York Philharmonic where a piece by John Cage was practically broken up by the the mink coat set who consistently got up during

the performance, went to the back of the hall, returned to their seats, cackling and talking. Now, co-opted? John Cage? If that's the way the audience is? Not really.

And I think it continues to be the same situation generally. It's easy for advertising to co-opt pop art, because pop art had started out to co-opt advertising. But it's much harder for the advertising people to co-opt anything which has its assumption on different areas than advertising and advertising communication.

For example, I can't imagine the world of advertising picking up on Larry Wendt's sound poetry performances, because the two simply have no basis of communication—they simply don't work together. Larry's pieces usually have a quality of being bemused about the world. You can't sell figs if you're going to seem bemused about figs, so that the initial pose, say, of the artist is unsuitable for commercialization. Far from the avant-garde itself being co-opted, it's only the image of the avant-garde that gets co-opted.

Your distinction between the artwork's "shell" and "meat" reminds me of your discussion of the "golem" in Henri Chopin's performances. That, I think, is precisely the magical creative dimension that structuralist analysis refused to contemplate.

They've missed that. But that's the level it exists on, apart from the surface level. Usually an artwork has a surface level and a depth level. In sound poetry the depth level is apt not to be on the symbolic level or in some hidden semantic element, the way it would be in a sonnet by Shelley. Instead, it's on the level of the characters that are generated by the piece, where the vitality is a concealed one.

And yet, anyone sitting in the audience seeing Chopin perform can't help but be struck by how huge he seems, although physically he's not a tall man—by his possession, by a sort of spirit of Dracula, that's what it looks like to me, a sort of erotic Dracula—and yet that's utterly different from Henri Chopin, the human being whom I happen to know. When he's dead, of course, nobody is going to be able to experience Chopin's physical presence. Yet I feel that in those pieces, even done by someone else, something of this golem—this demon that's generated by the piece—is going to continue.

Might video documentation solve this problem? Have you video-recorded much of your work?

Very little. I simply can't, because a good deal of my energy, because of my interest in publication and so on, has gone into trying to get my works into print, rather than into video documentation. It may be a mistake, but I think it's an inevitable one, given my focus on typographic design and my interest in graphic arts generally.

My first introduction to your work was a photograph in The Beat Scene *anthology.*

That was my first major appearance outside of essentially student-oriented, college publications and so on. I came to New York in 1958, after two years at Yale University in New Haven, Connecticut, which is a fairly provincial town. I liked New Haven, but I really needed to find out what was going on in New York. So I transferred to Columbia, studied with John Cage, did my writing, and performed in the evening at the E-pít-orme Coffee Shop and other coffee shops in the West Village, where the Beat scene, per se, was taking place. I was too young to be a Beat poet—but I did relate to those people, and I did enjoy them in varying degrees. So that's how I happened to be in that book.

Time went by. I studied at the New School with Cage and at Columbia with Henry Cowell. Cowell, of course, had been a teacher of Cage, so I picked up what Cage had got from Cowell, by studying at the same time with the student and the master. In this case, when Henry would talk about events, and Cage would talk about events, I realized how profound Cage's debt was to Cowell, in the event concept of performance pieces. What this meant was that by 1959 I was producing a large body of material with no idea what in the world to do with it. I was doing graphic notation, I was doing sound poems, I was doing visual poems, and there were no magazines for things of this sort, so I realized that it would behoove me to try to move into a profession where I would be able to cause some of these things to appear.

So when I finished my bachelor's degree, instead of going to graduate school, I went to printing school—to a small printing school in Lower Manhattan, near the Chambers Street loft of Yoko Ono. I got my certificate and worked for a printer for several years, doing such things as Elvis Presley's paychecks when I was working in a check manufacturing place. Then I went to a book manufacturer after I came back to America from the first Fluxus Festival in 1963, and I worked there on and off until the middle of 1965.

In the meantime I had started Something Else Press—my focus was definitely on publishing and on the things that I wanted to print, rather than purely on making a living where I worked—and I was in publishing until 1973, when I left Something Else Press. Then I started another small press which I made into a co-op called Unpublished Editions, and then, Printed Editions, which lasted until 1986. Since then, I haven't officially been a publisher, although I've been helping Brian McHugh with his Left Hand Books series.

What did you feel most compelled to publish when you started Something Else Press?

I wanted to publish whatever had not been done that I felt really needed to be done. I also felt like limiting myself in competition with any other existing organizations—those things went hand in hand. So that's why I wrote *A Something Else Manifesto*—"Whatever the other people are doing, I'll do something else." Since virtually none of the original Happenings and Fluxus texts and scenarios had been brought out in book form suitable for reaching a largish audience, I focused on that initially, and then on different forms of narrative, re-creating our own past by reissuing texts by Gertrude Stein. At the time, very few of her books were actually available, so we had a program of reissuing Gertrude Stein's books, the *Dada Almanach*, and Henry Cowell's *New Musical Resources*—great avant-garde classics of the past.

We brought out concrete poetry, musical scores, and graphics of various sorts and tried to push the limits of publishing and of the nature of the book. We did books in boxes, and we were technically the publisher of Alison Knowles's *The Big Book*, the almost nine-foot-high book that she did in the late '60s, and all kinds of odd formats. The main idea was to try to get these avant-garde materials into a form where people could simply buy them, have them, live with them, and get them beyond the charmed circle that was the limit of distribution, say, that George Maciunas's Fluxus boxes could reach.

Did Something Else Press succeed in terms of your expectations?

Oh yes—oh yes. There were eighteen thousand copies done of Emmett Williams's *Anthology of Concrete Poetry*—that's quite a lot for a small press. Also, there were about twelve or thirteen thousand copies of Claes Oldenburg's *Store Days*. The numbers go down from there.

You were working both with contemporaries and precursors, such as the Dadaists?

Oh, indeed. That's partly because my stepmother was a friend of Dr. Hulbeck—Richard Huelsenbeck—when I was a child. I first recontacted Richard Huelsenbeck when I asked him who had done the book design for the *Dada Almanach*. It turned out that the typography for that was done by John Heartfield, which was what I had suspected, but nowhere in print that I know of will you ever see that John Heartfield did the layout for that book! Raoul Hausmann had attacked Fluxus as being too oriented towards "renaissances," and so I contacted him and pointed out that in no way was it a renaissance, but that it was an attempt to draw upon roots, but moving in a totally different direction. And he wrote back and said I may indeed be right!

Hannah Höch was in Berlin when I went to meet Vostell, and he said we should go and see her, so I did, taking my little daughter Hannah Higgins with me. I got talking with Hannah Höch, and Hannah Higgins wandered into the old lady's studio room, discovered some crayons and a piece of paper. It was clear that Hannah Höch's eyesight was failing, and I thought this was likely to be terrible if she put things where the old lady didn't expect. Instead of which, while we were in the middle of a conversation, little Hannah Higgins came running into the room with a drawing that she had made for the old lady, and handed it to her, and the old lady was so touched that a tear formed in her eye, and she said, "Oh bless you, my dear, bless you!"

I've tried to define the difference between our attitudes and the Dadaists' attitudes in my essay "Fluxus Theory and Reception" in the Fluxus issue of *Lund Art Press*. Fluxus is neither the descendant of Dada nor the illegitimate descendant of Dada—it's sort of like the Dadaists were our uncles and aunts, but the whole teleology and purpose of these things are very different.

What directions did your interests take after the Something Else Press period?

Well, in the aftermath of the end of Something Else Press I became quite ill, and part of my solution came to be to try to look at English-language literature and find my place in it. So I went and enrolled in graduate school at New York University. That meant that I was really thinking about literature of the past and how it related to the present. I did a lot of work on the past of intermedia and a lot of work on pattern poetry and sound poetry.

Then in the early '80s I did a large amount of musical work—my musical years were about '77 to '82. It was a good time for me to do music, because in academia I was studying literature, and therefore at home I wanted to do something different.

But I was not satisfied with the visual side of things. My visual impulses are perhaps even stronger than my musical impulses, and I realized that the best thing for me to do was to try to work through a dialectic of my relationship with works, images, and the past in general. That's the reason for *The Dialectic of Centuries* being the title of my theory book of 1978. It's the subject of *Scenes Forgotten and Otherwise Remembered*—a *Hörspiel* that I did in Cologne. And it is the theme that eventually elected itself for me to do in various forms in a series of acrylic-on-canvas paintings which I began in 1982 and which I'm in the process of finishing this year.

The first group of paintings is based on arrows and is a direct outgrowth of my musical notations. The second group has maps in it—always maps which reflect different political boundaries than those of today. The next group was *The Brown Paintings*—different forms

of browns and off-whites and yellows and earth colors and red, with images drawn from the history of magic—entertainment magic—as a strategy for making my peace with popular culture, which I did not altogether succeed in doing. Then the next group of pieces was *The Blue Cosmologies,* intended for showing in Germany, which traced the history of how people looked at the universe. And the next series, called *The Natural Histories,* was about how people looked at nature over the centuries, working through the various classes of fauna. That's the one I'm in the process of finishing now. Very soon now, I will stop dealing with history or the past—I've done as much as I can with it, and I'll have to deal with other issues.

Were you surprised to find yourself painting?

No, no—I've always painted. I've always done all the arts. My mother did some painting, my father composed music, my grandmother composed music. When I was a little boy, my mother's best friend was an artist who had a little art school and I learned all about grinding down the pigments and mixing them together with linseed oil! I would find myself going up to the old ladies struggling to do this or that, and I would just reach up and make a little nick with my hand, and—"Oh! He's corrected it!" I was terrible—I was like a little teacher. I wasn't at all a prodigy by any means, but I did have certain techniques that just came my way, because that's what happens if you're a curious ten- or eleven-year-old hanging out in an art school.

Well, Cage said that curiosity was one of the greatest of virtues. He said that he'd like to be like a tourist for whom everything is new.

John had that quality, always did. He seemed like a perennial tourist, and that was part of the source of his freshness.

Were there other artists of Cage's generation who had that spirit of inquiry?

Of Cage's generation? This will sound strange, but Franz Kline. He had more curiosity, just about, than any other individual I've ever known. Even when he was drunk, he had curiosity—and I don't think I ever saw him except when he was drunk. He used to go to the Cedar Bar in New York City and sit there and talk with whoever chose to talk to him. He was very curious what the young artists were doing, and he would get them to do little sketches on napkins of what they were up to. Either that, or he'd be in one of his moods where he wasn't interested in art at all, all he was interested in was playing the horses, which was also possible. But most of the time he was really very curious about what other people were doing, and he would comment on things and it was almost as if he were teaching, although he was not at all an academic person.

Were you friendly with other artists at the Cedar Bar?

Well, I knew de Kooning casually, and a few others, because I had an aunt who was very much in that scene in the '50s. Her name was Ilse Getz—she died fairly recently—and she was sort of a gofer for Leo Castelli when he first opened up in '57 or '58, and she introduced me to Castelli, and God only knows who all else. When I was a teenager and used to come to New York on holiday, I would always telephone Ilse practically the first thing I did when I came to the city, and she would tell me what was going on. She'd say, for example, "Oh,

Bob Rauschenberg has a perfectly mad show—everything in it is white!" So I went to see Rauschenberg's White on White show as a teenager—surely the only unaccompanied teenager to go into that show!

I didn't feel any necessity to duplicate the experience of her generation—I couldn't relate to it that way—but I'm still more sympathetic to it than many of my contemporaries are, because I remember it before it was so famous and established. There was no need to duplicate what they had done—that would violate my own manifesto!

I suppose this brings us back to the problem of identifying the quality of the '80s and '90s.

Well, as I said, I think there's a nexus that's taking place—because it always seems that when nothing is happening, in fact a great deal is happening that has not surfaced. I'm sure this is bound to be taking place now. But what it will be, we really don't know.

I suppose my own enthusiasms are for multimedia theater such as the work of Meredith Monk and Robert Wilson, which are often wholly seductive and enthralling, but which can also veer towards Cats *and sophisticated pop performance.*

Meredith Monk performed in some of my earlier pieces—we go back a long way together. My sister knew her in college—in those days she was known to us as "Merrie Monk," but nobody calls her anything but Meredith anymore! She danced at the Judson Church and that turned me on; she performed in my piece at Sunnyside Gardens in Queens and that turned me on; and I performed in some of her pieces in the late '60s and *that* turned me on! I have a very high opinion of Meredith Monk—I find her theater pieces absolutely satisfying, and usually rather profound on some level.

Pauline Oliveros I've mentioned already—she's worked on a large piece by the name of *Njinga* with a friend of hers named Ione, which is certainly a multimedia piece—a highly ambitious piece. A fragment of it was performed across the river in the town of Kingston last August. I have some reservations about its essential pageantlike quality—it seems somehow curiously old-fashioned, and I don't quite understand what it adds up to. Perhaps it's a little bit too much like a musical—perhaps there's too much of *Cats* in it. But on the other hand, it may be important for the black community to do that, because *Njinga* is an African figure and Ione is a woman of color, and so it may work out as something that I can support unqualifiedly.

What do you think of the work of artists like Karen Finley?

I don't.

I mean those artists testing the edges of pornography and so on.

I don't care. I mean, there have always been people doing that. We did it ourselves with Paik's *Young Penis Symphony*—we tested the limits of pornography. So it seems like whipping a dead horse, in that aspect.

What, then, would you say were the most intriguing limits to be explored in the '90s? Are there any particular areas which seem most likely to repay attention or merit attention?

I think one of the areas that has been understated since the immediate postwar era has been ethics. And I think exploring the nature of kindness or of cruelty, or of the various implications of Bosnia or of militarism or things like that—that ethical exploration is an area of subject matter that has to be dealt with. Putting it all on economic grounds, blaming it all on economic grounds, on the various minorities that exist, won't do it. It's incomplete. Putting things on racial grounds, no matter what you do, is going to ultimately be self-defeating if the objective is to present a comprehensive view and raise one's consciousness.

On the other hand, dealing with all these things as ethical principles, and working them out as ethical problems, is an area of subject matter that I really think has got to be dealt with more. Otherwise the art of our time is going to be terribly superficial because we won't have addressed the real problems which underlie these matters. The issues and problems for women, gays, blacks—whatever—can be explained in terms of ethics as well as they can in any other subject, and therefore that's a kind of inquiry that I think has to be followed through.

Finally, what directions are your present projects taking?

These include a piece called *Buster Keaton Enters into Paradise,* which is my own sort of pageant piece, or if you will, multimedia piece. The texts are written by chance operations working off a Scrabble vocabulary.

Second, there's a critical biography of a book designer named Merle Armitage, who's fascinated me for many, many years. He did a very innovative type of book design in the U.S. in the '30s, '40s, and '50s, and lived on till 1973. The books he produced don't use rules the way the Bauhaus people do, and don't have exotic formats the way some of the Something Else Press books do, but they do have extraordinary combinations of typefaces and layouts, and they're perfectly beautiful, strange books.

Then there's a book of poems with illustrations, which is being produced by Paul Woodbine, of Woodbine Press in Providence, Rhode Island—he's an interesting independent artist. And then, there's a long sound poem by myself called *Bodies Electric: Arches,* which uses the words of Walt Whitman's "I Sing the Body Electric," strung out into alphabetical order, section by section, and as a whole, and interplaying the two so that they coincide at certain points and suggest arches in that way. It's to be performed live by two people whose voices are relatively similar.

At the moment there's no musical work going on in my head, except that I want to write a third piano sonata in the sense of a sustained musical composition for piano, which would be chance-structured. I've only used chance in my own way. Cage did it so much in the '50s that I wouldn't have wanted to do it in his way. But now that Cage is gone, I think I'm free to write a chance piece for piano. So that's what I'm working on now!

Given this range of activities, how do you best like to be regarded?

As a whole! Actually, I became ill over the matter when I was very young—it was part of the crisis that led me to move to New York from New Haven. I kept asking myself, Dick, you can't possibly be serious? When are you going to be just a composer, or just a poet, or just a visual artist? And as I realized that I couldn't specialize, because every time I tried, I got depressed, I realized that it just was not my way. I cannot stop working in all these different media and so on, so I can't say I want to be just a composer.

I would say that I am indeed a composer, which is actually where I began, but that I compose with visual and with textual means. That's a fairly accurate way of describing my approach. A composer is apt to work with more design in his approach than a prose writer, or a poet, or a visual artist is apt to do. That is, the composer maps out the architectonics of a musical work. And that basic approach is the one I've carried on over all the areas that I've investigated.

I'm a person who sets out his form, usually in advance, and then follows it. It's not that I don't appreciate the spontaneous departure from that. But I'm usually happiest, and keep my best sense of proportion, when I allow the spontaneous to work on the details of things, but where the overall structure is one that has been preconceived and that I continue to use as a matrix. So I would say I was a composer, but not necessarily of music. Something like that is a good way to describe me. And if people think of me as that, I'll be quite happy.

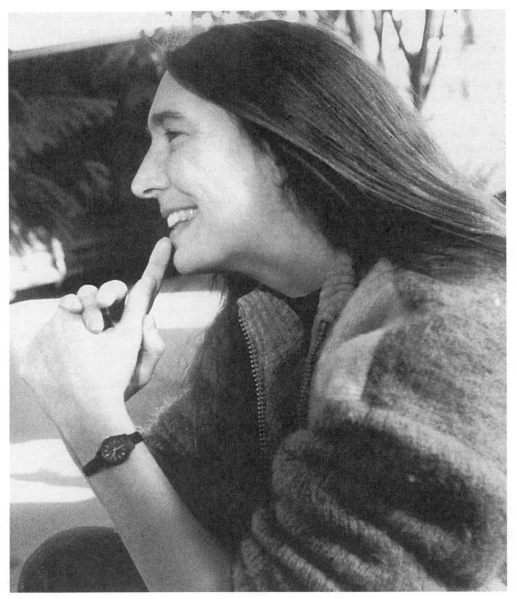

Jenny Holzer. Photograph by John Deane. Copyright 2003 Jenny Holzer. Courtesy of Artists Rights Society (ARS), New York.

JENNY
HOLZER

HAVING BEEN PARTIALLY BOMBARDED AND PARTIALLY ENTRANCED by the "information overload" in Jenny Holzer's remarkable text-based installations at the 1990 Venice Biennale, I was keen to ask her more about her thematic priorities.

I took the train up to Albany the following year and advanced by local taxi to Hoosick Falls, where I listened to stories about delinquent bears as the driver explained that he'd been to New York "only once, thankfully!"

Holzer's house, spacious, uncluttered, and brightly lit by morning sunshine, had a clear, almost Shaker feel about it. Entering her study I was intrigued to see a copy of Beckett's *Watt*.

Did she share this novel's reservations about language? No—Beckett wasn't an influence. Was she a "language artist"? No—a "public artist."

What became most evident was Holzer's commitment to different kinds of "calls to action," and to works that were not so much ironic as "effective." If they used "dazzle," then this was "dazzle in the service of content," allowing the artist "to communicate something and run."

Yet at the same time, Holzer's dazzling installations clearly sharpen a didactic edge in order to offer a "reasonable representation of some parts of modern life."

What parts of modern life? "The hellish parts of modern life!"

Identifying and responding to "threats that have always been there," which "have become new again and unbearable," Holzer's work typifies the pragmatic ethical impulse animating postconceptual feminist multimedia art in the 1980s.

Resisting both utopian technomania and dystopian technophobia, Holzer cogently concludes, "If high tech gets the message across, it would be stupid to turn your back on it."

Is this an "avant-garde" impulse? Perhaps not, if one predefines the avant-garde as being axiomatically "beside the point." But perhaps so, if one identifies the avant-garde as those innovative practices dazzlingly deploying new media to serve new purposes.

Hoosick Falls—January 15, 1991

Perhaps I could begin by asking you how you began to work with language. Do you happily accept the idea of being called a "language artist"?

It's a good partial description. Usually if I have to come up with a short title, I say "public artist" to be a little more encompassing.

What do you understand by public artist?

It reflects what I like to do, which is to put sentences in public places, where people take them at face value.

What led you to work with language rather than with painting?

When I was a painter, I was an abstract painter, because that's what I loved. But then, I found that I wanted to be outspoken, and I didn't want to be a social realist painter, so I turned to language as a way of being—when I needed to—quite explicit.

What was the first content of your language?

The first series I wrote was the *Truisms*. They were one-liners, meant to sound like real clichés, on almost every topic. I wanted to do a survey of the issues that people were concerned about, in a form that would be short enough to be displayed in public places where people can absorb only a small amount of information. Before I started writing the *Truisms*, I had tried to do public pieces—abstract pieces—that I wasn't satisfied with because people only were puzzled by them. Which is something! It's not a bad thing to puzzle people, but it wasn't all that I wanted because I wanted to talk about large topics.

Did these abstract pieces include the paintings you left for people to find on the beach?

Yes, I tried that. I was able to stop people. People noticed the work. But what I wasn't able to do was to tell those people what I wanted to say, or have them think about what I wanted them to consider. That's what those pieces didn't do, and that's one reason I turned to language. I had the desire to do public pieces, but I hadn't found a way to be effective.

You found language an effective medium?

It sure is a reasonable way to communicate.

I asked that question because I just noticed Beckett's Watt *on your bookshelves. This novel's claim that everything is "unutterable" and "doomed, doomed to fail" didn't deter you?*

Well, no—luckily I hadn't read him then. I was at that stage of climbing on a soapbox and making pronouncements about what you held dear, or what frightens you. I guess I could have been paralyzed by literature if I'd thought about it.

Perhaps European writers are overly influenced by literary tradition. Does your thinking come from a more public tradition like advertising?

No, more the soapbox model. If you have something you want to say about how things are or aren't, you simply make a pronouncement or the equivalent to that—write down a short statement about how things should be. I do use the form and the media of some ads, though.

How pleased were you with your readers' general response?

I think it went reasonably well. I could tell people read them, because they would write things back to me on the posters. I could see that people would go down an entire list of sentences, and check things off that they liked or that they loathed. So I knew that people were reading and thinking about them. That was something—to get somebody to freeze in a public place and consider these matters.

The one criticism I took to heart about the *Truisms* was that because they were about every possible subject, and because they were written from every point of view—be that left, right, middle, common sense, or extremist—they were disappointing for people looking for solutions to pressing problems. I put before people all the ways of thinking about questions, and I outlined every problem, but I didn't necessarily show a way out. I thought that was a legitimate critique of the work, because there are pressing problems that need immediate solutions.

What redeemed the *Truisms,* though, and what I was doing deliberately by presenting all the different points of view, was that for once, it was not a didactic presentation, or even a dialectical one. It's not just A and it's not just A versus B, and it's not the sum of A and B, it's a universe of equally weighted opinions. And so one trusts the reader to come up with the correct answer, once he or she has considered and tolerated all these viewpoints.

So it's an attempt to promote tolerance, in the sense that you're presenting the coexistence of these things?

Yes, and to present thought. At the very least, thought!

Is that still your attitude today?

It's still my attitude, but sometimes I think you have to go straight to certain questions, and sometimes the more effective strategy is backing into answers, or going around them. I try different approaches, and I'm not certain which is the right one. So I think I cover it by trying all these ways.

What happened next, after the Truisms *street posters?*

I did another series of posters entitled *Inflammatory Essays,* where in attempting to answer some of the criticism about the *Truisms*—that each sentence canceled out the other—I upped the ante by making the *Essays* hotter. Again, they represented many points of view, but each one was either an urgent call for action or was such a despicable thing that it demanded that you do something after reading it and recoiling.

What sort of statements were these?

Oh, everything from personal manifestos that start out, "Don't talk down to me" . . . *"I'll cut the smile off your face,"* which I thought was a good all-purpose "get off my back" one—it

could be used by women or the "underclass," to ones by sex-crazed maniacs, to texts that were written very much like political manifestos.

What format were these?

They were paper posters—basic offset, cheap posters. The *Truisms* were black and white and maybe two feet high and one foot across. The *Essays* posters were eleven inches square. They were little colored blocks that I would stick in the middle of music posters or political posters or advertising posters on the street. I wanted them to be in public places where anybody could see them—where a real mix of people would read them. People do look at posters, so I tried to take advantage of that fact. I used the other posters as a frame for mine.

What came next?

I decided to write more matter-of-fact texts and write to specific issues. I'd tried the across-the-board theory with the *Truisms* and *Inflammatory Essays*. And so I wrote the *Living Series,* and next the *Survival Series.* The language was quieter here—it was stripped of any hyperbole. It was about issues that you encounter in your daily life, but then you can escalate to death, war, peace. So in the *Living* and *Survival Series,* I wrote all the stuff down and then tried to find appropriate forms. That wound up being either bronze or aluminum plaques—cast plaques, like commemorative markers—or hand-painted signs.

Were these plaques intended to be juxtaposed against other commercial plaques?

Yes, they were to be on the facades of buildings or in interiors, anyplace a plaque might be—over an elevator button or over a water fountain.

When did you first use electronic signs?

I had a chance to do the sign at Times Square. That's now dead—may it rest in peace! After using the underground medium of the poster, I thought it would be interesting to put unusual content in an official medium—the official medium being the electronic sign that normally has advertising or the occasional public service announcement. My piece in Times Square had a number of texts—"Private Property Created Crime" maybe was the best one. It was up for two weeks every twenty minutes or so.

So this again was a deliberately subversive piece?

I was hoping so, who knows? Rather than getting the expected content—an ad for a Broadway show or spaghetti or whatever, you would have something about private property. I had some daffy ones, too—"Expiring for Love Is Beautiful but Stupid"—but then some serious ones, such as "Torture Is Barbaric," all mixed in with the ad copy.

When did you start doing installations in a commercial gallery or museum situation?

Probably a year or two after moving to New York, I did some pieces in alternative spaces that consisted of the *Truisms* blown up on large photostats and placed in windows facing the street. I did installations at Franklin Furnace, at Printed Matter Bookstore, and at Fashion

Moda, the storefront museum in the Bronx. These were accompanied by audiotapes. The *Truisms* were blasted on the street so that you could hear them and read them.

Were the audiotapes done with your voice?

No, I had a number of voices. I tried to find clichéd voices to match the material—very normal men and women—more men than women, because sadly, it's still more typical to hear male voices telling you what's what.

Does this use of male voices add an ironic tone to the piece?

No, actually, it was to make it sound real. It's ridiculous that the male voice is considered the normal one, but I wasn't using men to snigger. I was doing it so that people would take the work seriously, because you're supposed to believe what men say.

There wasn't an implicit subliminal humorous intent?

Well, somewhat, sure. I only am reacting against what you said about irony, because I don't like that to be the dominant thing in the work. It's fine if there's a dose of irony, but things that are tongue in cheek remain only that. I want the work to be effective. But I thought it was funny, having the man droning on, saying, "Romantic Love Was Invented to Manipulate Women."

Have you done any other pieces using audiotape or voices?

I had audio in an elevator once. Another time, I used a voice in pieces I did for television— spots that have computer-animated sentences flying by, or doing something else extravagant. They are accompanied by a voice-over. Someone says the text as it flips around the screen.

Did you find that a successful or a satisfying combination?

It's hard to do. I don't know as much about television as I should. I need to practice. But I think the presentation I chose was close enough to what normally appears on television to be credible. Both the way I did it and the fact that it's on television make it convincing. But again, the content supplies the shock.

Presumably the content also provides a certain hedonistic register, in terms of just the look of TV?

I think that's always a part of it. It's necessary that things are attractive enough so people watch. I want people to stare at them, and I want people to consider them. It's the law of the jungle that people look at things that are dazzling.

But the dazzle isn't your prime concern?

No. I like some dazzle, but I don't want to rely on that. Dazzle in the service of content!

Would it be fair to think of your television pieces as a kind of parodic advertising?

Well, my pieces are in advertising slots, but they're also another version of public service announcements—that's as much the model as the ad. You hear pronouncements on television

all the time. I wanted to make some alternative pronouncements. Maybe the model for the posters as well as the television is not advertising but political posters and broadcasts. Who cares about advertising? There are more interesting fields.

Do the same sorts of precedents inform your gallery installations? With the Truisms *and the* Inflammatory Essays *it seems quite clear that you're working within a familiar genre and subverting or expanding its conventions. What happens in the gallery installations? Looking at some of your installations in Kassel and Venice, I had quite a lot of trouble working out what the piece was trying to do, and how the piece combined its elements. The gallery installations with electric signs and texts carved on pieces of granite seem to be exploring something that doesn't have an obvious model.*

With gallery installations you have more of a chance to concentrate on the visual. In a gallery situation the visual can enhance the presentation rather than distract. In public, your work has to be juicy enough to stop somebody, but obviously you don't want too many embellishments and flourishes. You're not trying so much to intoxicate or to set a mood, as you're trying to communicate something and run.

I am interested in purely visual stuff, and I like the effect that it has on the viewer—the kind of tone you can set, the frame of mind you can put people in, be it somber, euphoric, sick. When you do have the time in a controlled environment, a museum or a gallery, it's interesting to add all the special effects.

You've described your Venice Biennale installation as an attempt to use interacting colors in such a way that the viewer loses all sense of space and solidity, and I read that you previously painted everything in your Rhode Island studio white with an overlaid blue wash in order to suggest a similar spatial ambiguity. Are your gallery pieces using electronic signboards consciously continuing to explore such atmospheric effects?

That's probably fair. I like to turn people upside down two or three times to get their attention and to make them look at things with fresh eyes. The blue room that you mention, from graduate school, was an attempt to make people reorient themselves. In the room in Venice I was trying to do a version of hell.

I took the floor away from people—the floor seemed to be a sheet of glass, there was infinite depth, and you couldn't be sure where your feet were. I wanted it to be visual hell, where your sense of space was destroyed. It also was information-overload hell, with aggressive sense and nonsense on the multilanguage signs. I thought it was a reasonable representation of some parts of modern life.

What parts of modern life?

The hellish parts of modern life!

Which parts of the Venice installation did you like best?

The galleries were completely different. It you compare the two electronic rooms that the stone antechambers set up, the mother room was absolutely sincere, sad, and sober. As electronics go, it was quite subdued, because the pace was slow and words were rising from the ground and moving quietly in sync. The tone and the content of this piece were very different from the hell room. There were a dozen elongated vertical signs on the end wall of the

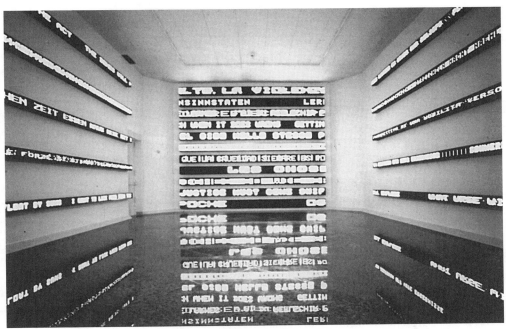

Jenny Holzer, "Hell Room," *The Venice Installation*, United States Pavilion, Forty-fourth Venice Biennale, 1990. Photograph by Salvatore Licitra. Copyright 2003 Jenny Holzer. Courtesy of Artists Rights Society (ARS), New York.

mother room, showing a longer version of the floor text. The text on the floor gave people a chance to read something that held still. The first paragraph was a thesis paragraph, and then the signs showed the longer text. The mother room probably was my favorite.

So both textual environments required or invited the reader to spend more time with them?

Yes. I was hoping that people would linger to read the text in the mother room, and I was hoping people would get bent in the hell room. Get bent, somehow or other—read enough to break. It was the kind of room to fry a rat.

What was the text about in the mother room?

It is a text about what happens to you when you have a child, when all of a sudden the threats that have always been there—to which you've become inured because you're older or more decayed or more blasé or less hopeful or whatever it is that lets you tolerate horrible things—become new again and unbearable because you are spending every second of the day trying to protect the child. All the troubles that are around you suddenly seem real. This probably was the only reason I was brave enough to write on a subject like motherhood. I thought it did tie into the work I've done all along, which is, "God, what are we going to do about A, B, C, D, and how will we survive?"

So it's a powerful individual response to these things?

Yes. I felt them more acutely than I had since I was about nineteen, when I woke up to the fact that there were grisly things around, and that maybe I should do something. I think

the mother text was effective. I was waylaid by crying people. They'd lost a child, or their daughter had lost a child, or they had had these same fears.

So once again, this affirms what apocalyptic postmodern theory denies—that one can forcefully communicate personal experiences, even when living in an age of mass media?

I hope you can communicate grief, and I did make a few people sick in the hell room.

While you wanted the elaborate electronic signboards in the hell room to leave people feeling sick, I assume you wanted the mother room to produce a more modest sense of vertigo?

Yes. I wanted it to seem a little difficult, but I needed people to stay and to be able to read. I wanted it to be somewhat tough because the subject was, and also I just plain like the way it feels when the text rises from the floor and takes you with it.

Are you planning to explore new technologies such as virtual reality?

I'm interested in virtual reality, but I don't know enough. I want to try to talk to some of the companies that are researching this, to see if there's anything I can use. There's a long history of illusionism in art, and so this would seem to fit in. If I find anything I can use, I suspect I will present the usual themes, the survival themes.

I can't quite imagine what it will look like, since I haven't seen enough of virtual reality, except the bad movie versions! I would hope that by using virtual reality, you would get a look at everyone's either occasional or perpetual desire to be someplace else when things are terrible—that's what motivates our space program, I think. And I want to use virtual reality to highlight some issues, to try to make the problems that actually are here seem real to people, all over again. I'd also like to build a virtual reality utopia.

Finally then, how does this leave you in terms of the questions or notions of avant-garde practices? Do you consider yourself to be an avant-garde or experimental artist? Or would it be fairer to say that you feel yourself to be simply working with what's there?

I don't worry about the term avant-garde. I guess there's an honorable tradition, when people really did make breakthroughs, stopped painting academic nudes, and went on to something better. But I think the term has fallen into disrepute recently. Don't you feel that *avant-garde* usually means "completely beside the point" to most people? So I wouldn't want to be avant-garde by that definition.

But for my practice, I think it's important, since we live in an age where there are so many technological marvels and horrors, to use technology when appropriate. If high tech gets the message across, it would be stupid to turn your back on it.

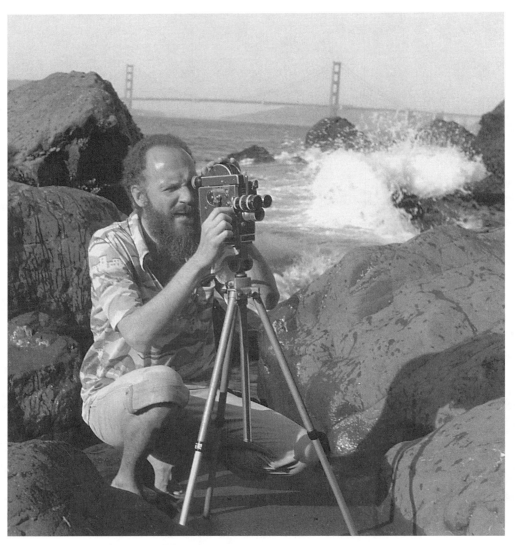

Mike Kuchar. Photograph courtesy of the artist.

MIKE
KUCHAR

HAVING READ ABOUT GEORGE AND MIKE KUCHAR'S FILMS as precursors to the "transgressive" cinema documented in Jack Sargeant's book *Deathtripping* (1995), and having already met New York filmmakers Nick Zedd and Beth B in London in late 1995 and early 1996, I leaped at the chance to interview Mike Kuchar when he came to London in April 1996 to introduce a selection of these films at the Brixton Roxy—the site of the 1982 Final Academy performances by Burroughs, Giorno, and Gysin.

A colleague at De Montfort University had lent me a video of George Kuchar's films. Creation Books' recently published *Camp America* (1996) offered additional insights into the Kuchars' low-budget, high-camp parodies of Hollywood blockbusters, and Mike Kuchar's opening remarks at the Roxy further clarified his strategies of making do with minimal funding, inventing roles for backers' statuesque wives, and exploiting the kind of inspired bricolage that Larry Wendt calls "handy tech."

Chatting with one of Creation Books' publishers at the Roxy's bar while Kuchar was interviewed by *Flesh and Blood* magazine, I discovered that Kuchar had just been to see the Tate Gallery's collection of Blake's watercolors, and immediately wanted to ask him how this enthusiasm related to his seemingly antithetical B movie imaging.

Kuchar's comments were everything I'd hoped they'd be, offering the perfect definition of the avant-garde as a process of independent and innovative "exchange," opening "possible channels to be further explored," and at its best culminating in "graceful" and "spiritually contagious" creativity.

Discussing his work with and for the younger performance artist Kembra Pfahler—lead singer of the New York group the Voluptuous Horror of Karen Black, and one of the stars of Nick Zedd's film *War Is Menstrual Envy*—Kuchar fascinatingly described his transmutation of Pfahler's "raunchy punk attitude" into her more classical, mythological, or "timeless" register that he associates with the equally heavily eyelashed Gina Zuckerman and Donna Kerness in *Sins of the Fleshapoids* (1965).

223

Revering artists such as Blake for the way in which their vision "gives one the energy to want to continue making works," Kuchar—like Cage, before the paintings of Robert Ryman—offers a timely reminder of the ways in which curiosity before the "unknown" may be intensified by both the most distant and the most recent "visionary arts."

London—April 23, 1996

Could you tell me how you first began making films?

In the beginning I was brought up in the era of the great movie theaters being like palaces and temples—the era of Hollywood movies and big studios like Twentieth Century–Fox and Warner Brothers. I would constantly be going to the movie theater, and I was aware of these realms up there on the screen in two dimensions. Maybe too, in some ways I was memorizing them and noticing how they were made—like when the music would come in. I'd notice the lighting, the lushness, and the certain quality in the way those people were on the screen and what they wore, and this glamour exuded. The pictures they formed and this sense of adventure were very stimulating to me.

I was fed on those big studio productions, and they fascinated me—it was like peering into the world up there on Mount Olympus. It was like a world that was coexisting with that other big world of going to school and coming home and talking to your mom and dad. I guess that was the impetus for wanting to emulate that and to make my own movies—to continue that kind of enjoyment. I knew that they were filmed products, and I began by getting my friends to play roles and wanted to do epic pictures with volcanoes blowing up and things like that. Some of those pictures were reinterpretations of what I was being fed. In some ways they were similar, but in some ways they weren't. There was something else—there was this other element coming out from them. In the book by Jack Stevenson, *Camp America,* it's discussed in terms of the word *camp.*

The way I interpret it is that I'm setting up my tent on an established recreation ground— in this case, the Hollywood movie. And I'm beginning to have fun with this, using the elements that are used in it, but somehow it's getting twisted or I'm littering it or I'm kind of defacing it. I'm using it for my own enjoyment. But somehow it's turning out different. I'm using all these artifacts and artificiality, and they become even more evident.

In *Sins of the Fleshapoids* the actress's eyelashes are too big—something's going wrong. But the thing is I always was aware that many of these actresses were wearing false eyelashes and makeup. And somehow, I don't know—it probably originally started out subconsciously— I'm sabotaging it in a way. In my pictures the eyelashes have got to be three times bigger!

Or sometimes when an actor would do something in the movies I saw, the music score would come in. They'd have a lush music score, whether it's ominous or very sweeping or romantic. Watching Hollywood pictures I would notice this great orchestra coming in, and then I'd put it in my movies, only it would be louder! In other words, I'm starting to have fun, I'm using these methods but they're sort of going wrong. Or maybe they're going right, because there is this consciousness that these are manufactured products. This is my interpretation of what that word *camp* means. I'm noticing that their entertaining value is in seeing the mechanisms of standard pictures going wrong now, but that are going wrong in the right direction!

Gina Zuckerman in *Sins of the Fleshapoids* (1965). Photograph courtesy of the artist.

Perhaps Warhol's use of blurred, overprinted eyelashes in his silkscreen portraits might be seen as a way of deliberately blowing up those particular distortions and giving a certain autonomy to their energy.

Right. Because no matter what, although movies are made with the assumption that you suspend disbelief, they're people playing other people, and whether they're playing peasants or whatever, they're getting a paycheck. There's a camera filming them—there's a whole cast and crew there! It's people up in front of a camera trying to be somebody else. When they're

not polished, when they're not professional, they begin to falter—you sense the artificiality of it—like this is what movies really are. I mean, they're manufactured, they're re-creations of what we call life. They try to be life—but they're not.

But here's the thing—when you see actors falter and yet try to maintain their dignity, that's very heroic. Now a drama is happening other than the movie you're actually watching. You're seeing human nature under the scrutiny of cameras trying to be somebody else. A whole new thing is happening. There's another kind of enjoyment, another kind of glamour. There's another entertainment value, another drama going on, another kind of beauty that's coming out of these pictures, which are not failures. They just reveal something else, something more beyond themselves, whether intentional or unintentional. And there's a whole audience of young people today who love these films that were considered junk in the '50s and '60s. There's a whole new generation searching them out and in a way patterning their own lives and their visions on their role model.

But your aesthetic isn't just a simplistic "junk" vision, is it? I heard you just went to see Blake's work at the Tate Gallery—which suggests that you're interested in a wide range of creativity. In other words, while some artists may just be producing subversions of elementary pop culture like I Love Lucy, *it seems to me that you're reassessing popular media in terms of their relatively unexplored distinctive energies. You're not just mechanically recycling trash culture?*

No, no—no. When I make a picture it depends on the chemistry around me, it depends what the inspiration is, and I can never tell what my next picture's going to be. I just follow it—if I get a certain vision or a certain feel. Or if I meet certain kinds of people who bring out in me something I've always wanted to do, and that I can do now, because they have this quality about them. I've also done abstract movies where I'm interested in forms and design. I've done films that have no narrative, in which I try to work with a mood and with photography. I might then do something that might be considered camp.

Lately when I've gone back to camp, I use it only as a means to make the work less painful. I use an attitude, or there is this veneer or approach to the subject matter, which makes the work more digestible and less painful. No matter how horrible life is or how miserable, we've got to look at it with fatalistic humor—it makes it a little more digestible, looking hopefully with a little wit at situations which really aren't nice or fun or that pleasant.

I've done pictures where I might be interested in the human form, and instead of painting it—and I like to draw and paint—I want to see if I can do it justice photographically and hopefully convey a certain mood or capture a certain beauty. My films vary—I'm not trying to sell a sense of identity, that's not where I'm coming from. So I can't tell what my next picture's going to be, but whatever it does it comes from my own heart and my own feelings and what I know about and what I feel or what I watch. I could be around in some landscape that kind of haunts me, that has some quality to it, and feel I must go back there with my camera—to some place that I can work with, some essence about the place. I'm aware of things around me and people around me, and they bring out things in me—or else it's something about them—that I can work with. It depends on who you meet and where you are—that's what gives me the impetus to go ahead and say: "Get out the camera, let's get a few bucks out, let's buy the film. I want to do it!"

What other impulses have driven your work since the '60s? If your early films responded to B movies by elaborating or exaggerating their conventions, are they very different now?

No—sometimes I have to sort things out within myself, so I do it by way of a film. It's really all me, but I'm giving it characters and having conversations with myself. I see different sides to a particular situation or story—I remember things that happened to me, and I include that in there. I give it characters, they act it out for me, but they're really me. If you analyze my work you'll know all that I'm about.

They're meditations?

They're meditations, but it's also like a psychiatrist's couch. In my pictures you'll see all my obsessions. It's all there, but it's in the form of the people who are acting it out. They are playing my drives, my obsessions, or whatever. I can only do things that I know about or feel. In a way these pictures are very autobiographical. If they exploit anything, they're exploiting me—they come from inside me, they're my subconscious. Many of these pictures are not scripted out beforehand—I have to make characters react to each other and do something.

But every action has a subconscious meaning to it—you're opening the doors and you're getting access to your subconscious. All you've got to do is have a start. Then I see where they're going and begin to see if I can give them a solution. Or begin to structure it and send it in a certain direction, and come to some sort of solution or resolution or something. When you're working with this kind of style of filmmaking you can make these films any way you want to. Nobody can dictate, because you're the producer and the director and you finance it yourself.

In other words, you have been able to do what you want to do with film?

Yes, provided you know what your limitations are and work within them, you're able to do it. It can get very expensive making films with various kinds of equipment, many of which you don't need. First, know what you have to work with and then push it around, make it work for you. Because nobody's going to help us—I've never got any money to make these pictures. But you go ahead and do it—that's the challenge!

Well, in Sins of the Fleshapoids, *for example, you certainly didn't have* Star Wars *special effects, but a painted background, although that didn't weaken its fabulistic quality.*

Yes—it fulfilled what needed to be done. In fact, I did another really hard-core science fiction picture when I only had a hundred dollars. Somebody had asked me to apply for a grant—a ridiculous four-hundred-dollar grant—and I waited around, and did they give it to me? No! So I'm sitting around, I'd waited all these months, and when I get the rejection slip, I could have made this picture already! So what have I got? I've got a hundred dollars. This was a challenge now—it got me thinking: How can I devise the sun exploding? How can I devise going at the speed of light?—which this script called for. I realized what I had to work with, that I had a hundred dollars and that the special effects all had to be done in the camera. This gave me the thrill of seeing if I could get this off the ground and made me want to tackle it!

This seems the most exciting aspect of the last decades—the sense of creativity going forward. Despite claims that technology neutralizes art, it seems clear that high-tech, low-tech, and what Larry Wendt calls "handy tech" practices allow low budgets to create big effects.

The thing is, this picture worked. I got out the rushes and I was amazed—these things just jelled together. At times I had twelve exposures on one strip of film—it took a lot of discipline. And the message of the picture and the feel of the picture came across and it worked. The fact that I had to do certain weird things only made the picture that much more memorable and that much more unusual. It can often fall together if you're really passionate!

Would you call yourself an experimental artist?

Yes—all films are experiments, it's all an experiment. I like to paint, I like to draw, I like to write, and I like to make movies—they're the media I like to work with a certain vision to see if I can solidify it in some way.

What are your biggest challenges?

I always feel that what's really important is the soul or the imagination or what it is that you're saying or doing, whatever medium it is! I feel that whatever we do, what's really important is the feeling one gets from viewing the information it contains, and how gracefully it was done or what kind of soul it has.

Do you feel continuities between your work and earlier artists?

Yes, yes—I looked at those paintings by William Blake, and I said, "God bless you!" It was so beautiful, it was so positive, and made me feel so good—it was a beautiful experience and I thank him for that. It was so affirmative, it was beautiful to behold. And then Blake also works with symbols. There were Christian elements, pagan elements, and nature—and I see these things myself—and it was beautiful how he expressed it! It was so positive, it made me feel so good.

It's odd that so many intellectuals don't recognize such positive energy.

Yes, you feel that something just wings upwards.

Do you feel there's a contradiction about working with popular or science fiction imagery in order to explore such perennial profundities? For example, in your brother George's film, Hold Me While I'm Naked, *the voice-over comments upon the clash between the vulgarity and the purity of its imaging. Do you sense a similar clash between purity and profanity in your own films?*

Well, there's this running theme of symbols and classical stuff in all my pictures—I'm constantly referring back to Greek mythology and stuff like that. Maybe that's why those paintings by Blake struck me: because I see him working with these symbols and essences and these feelings, and in some of my work I do that myself. Sometimes characters in my films look timeless—subconsciously I'd make them timeless, and you don't know what age you're looking at. They look biblical, they look like martyrs, or they look like punk cupids.

I did something for the actress and punk rock singer Kembra Pfahler, who acted in a couple of my movies—she's very striking and she's a wonderful exhibitionist. She wanted me to do this promo for her band, the Voluptuous Horror of Karen Black, and it wound up like something from a Roman vase or from Dionysus. It was the funniest thing—what started as this kind of raunchy punk attitude thing turned into my ode to these kinds of

people. They reminded me of timeless characters, timeless people, and I thought of that as something immediate and temporary, but also as essences, essences of man and woman, of youth—of beauty and hedonistic qualities.

Are there other artists you think of as fellow spirits?

All I can say is that when I do see something inspiring, it gives one hope—it gives one the energy to want to continue making works! It's very affirmative, it energizes—it energizes me.

And presumably you'd like your work to have the same impact?

Yes—it's the best compliment. Many years ago, at a party, John Waters came up to me and said, "You know, Mike, your *Sins of the Fleshapoids* really inspired me and gave me the energy to finish *Pink Flamingos*." I was so flattered. I said, "Thank you, thank you, I love your picture, I saw it two months ago!" I was so pleased—it was the best kind of flattery you could give me.

John Cage similarly remarked how Robert Ryman's white paintings completely surprised him and gave him a sense of the unknown that didn't so much overwhelm him as remind him that there was more to discover. I think that kind of affirmative shock is the most exciting thing.

Yes, I think what we do is we open these doors to each other, and we show a possible path that could be traveled further. And maybe somebody else will see that and take it further or add themselves to it. It's like an exchange we have between ourselves, and whether it's in speaking to each other, or whether it's in the work we need to do or have to do, it's like a continuity—it opens possible channels to be further explored. And this goes on and on from there, so it's very much like an exchange and a sharing—it's opening gates and channels for further explorations.

How have your critics responded to your work?

Some people tell me, "Oh, it's the worst stuff I've ever seen," and other people say, "It's the greatest!" After a while what really matters is just what you do or what you must do. Once the work is done it goes into the outside world, which puts labels on it, like "art" or "junk." But I myself, I cannot say, "Oh, I'm an artist." I can't say that, that's assuming an awful lot. All I can say is, "Hey, I'm working on something, do you want to see what I'm doing?" This is something I have to do, it's something that's in me, this drive, I can't help it—sometimes it's an obsession.

Are you working for a particular audience?

No. These are things I have to work out for myself. All I can do is be myself.

That reminds me of the poet Robert Lax, who likens his work to a process of talking to himself, arguing that artists should first learn to talk to themselves before communicating with others. Would you say your work shares this contemplative quality?

I'm certainly talking or working these things out myself. However, I am also conscious I am doing this in a particular medium. If I was writing I would try to organize my words so that

it would be understandable. Since I'm working in film, this has to speak without me being there, and the way it's going to speak is with the succession of images up on the screen and their culminating effect. Therefore, in a way, yes, I am conscious of an audience, because I have to manipulate the film in such a way that it speaks without having to be interpreted afterwards.

Does it worry you that your work might not be widely marketed?

No, it's not my main aim. I know that marketing field. You've got committees to say what you can do and what you can't do. You've got taste to cater to, there's conformity. Here's the thing: I'm making movies. They're not costing sixty million dollars and I don't have the big stars. But it's up to me—I'm going to find my own stars, and that's kind of exciting. I needed to make them and I make them, and so I'm not stifled. I'm making pictures.

Even if a person or a couple of people see it, something happens—a channel might be opened or a gateway, and it may affect them and what they do. That means a lot. When an individual responds—in this case, John Waters—I feel warm inside. No matter what we do we are influential in some ways. Hopefully what we do is graceful, and also maybe in some ways is positive. In its own way it might be very, very strange, or might open a new perspective or a new way of seeing things.

That's the funny thing, you never know who you influence. But you'd be surprised—it could be in a theater that has six people sitting on ripped sofas, but something happens that night! It doesn't matter if it's not seen by millions and millions of people or distributed all over. The main thing with me is that it was a personal odyssey or a personal voyage that had to go on, and it was done! Then, when it's done, I feel in some ways complete, because it was part of what had to be done.

Robert Lax, Patmos, January 1998. Photograph by Jack Kelly. Courtesy of the estate of Robert Lax.

ROBERT
LAX

I FIRST WROTE TO ROBERT LAX IN 1968 OR 1969 to ask permission to republish his poem "for ad Reinhardt" in the first issue of my magazine, *Stereo Headphones*. We corresponded off and on after that, and in January 1985 I visited him on the Greek island of Patmos, seeing him again in London when he read at the Nigel Greenwood Gallery in October 1987, and in Lucerne, where we recorded a second interview in April 1989.

Like all great artists, Lax fits into no particular categories save those of his own making. A "visual" poet writing "abstract" poems partially reminiscent of Ad Reinhardt's mono-chromes, a "concrete" poet published in the 1960s in Ian Hamilton Finlay's magazine *Poor Old Tired Horse,* and a "sound" poet whose work Vincent Barras (director of the Poésie Sonore program at Geneva's Festival de la Bâtie) describes as "an absolutely original voice devoid of all rhetorical or metaphorical pretension," Lax leaves one persuaded—as Emmett Williams puts it—that one doesn't know "another poet quite like him" or another poetry so moving in its "profound simplicity" and its capacity to suggest "things that have always existed—the sea, the sky, light, darkness, meeting, parting" in "a new form."

Almost inevitably, it seems, Lax's peers include Burroughs, Gysin, Finlay, Merton, Kerouac, Reinhardt, and such fellow contributors to Editions Francesco Conz, Verona, as Ashley, Chopin, Giorno, Higgins, Mac Low, Paik, and Williams. All these artists, Conz suggests, are the new "saints" of the contemporary avant-garde.

More modestly qualifying his poems as the inner songs of "an artist who lives inside you who wants to do a lot of things" and has "something he really wants to say," who has searched for "usable language" and whose terms have become "both more limited, but slowly, richer too," Lax suggests that such investigations may help poets to get back to "the sort of scale or color wheel that musicians can work with, and painters can work with, and which we have a harder time working with as writers."

Lax's poems find further elaboration in his collaborations with jazz musician Steve Lacy (who has also worked with Gysin), and with the artist, filmmaker, and publisher Emil

Antonucci. But as Emmett Williams observes, "To illustrate Bob's later poems you need a Robert Lax. It's that simple. The poems illustrate themselves."

Patmos—January 13, 1985

I wonder if we could begin by discussing the origins of your vertical poems and abstract, color poems? How did you come to develop these poetic forms?

I think I've had a tendency to write these vertical lines and to use some repetitions from quite early on. But it developed, and it got to be much stronger and much more conscious, near the end of the '50s, when I was living in New York. I'd written *The Circus of the Sun* in the early '50s, and Emil Antonucci's Journeyman Press had published it in 1959. I'd been writing a number of short poems, and I found they moved more and more toward a new style of repetition, and more and more toward abstraction, than things I'd done before. When I had a collection of those short poems in 1962, I wanted to call it *New Poems,* because it was a new style for me. I had a feeling that I'd taken a decision in that direction.

What did you like best about writing in this vertical way?

I wonder if Cummings's typographical arrangements didn't have something to do with it. I liked him, I liked what he was doing with the page, and I felt that isolating a word would give it a chance to be absorbed for what it was. It brought some attention to the word itself. Writing down in a vertical way, I felt, gave you one word at a time—or one syllable at a time, instead of seeing words lined up horizontally, where it was natural for the eye to just bound ahead and see what was at the end of the line.

I'm not sure that if words were all written vertically, the way I've been writing them, you wouldn't just start bounding down the page, the way you bound across the page to read the horizontal line. But up to now, doing them down, vertically, I think slows your reading, and keeps you to one word at a time, or one syllable at a time. And that for me is an advantage, particularly when you're also working very often with one image. I think that was the part I liked about it.

Did you find yourself repeating words or phrases for a maximum number of times in New Poems*? Is there a basic unit of repetition?*

I think you have to talk about these units in terms of organic functions, like breathing and cerebral functions. I think there are units and rhythms that come naturally to you, and those are the things that determine the language. I found in writing things like the poems in *New Poems,* for example, that there was a regular stopping place for certain words or certain combinations of syllables. I've asked other people to say some of these words as fast as they could, until they come to a natural pause, and they usually come to the same natural pause that I've used. If you like, I could ask you to say *never*—"never, never, never"—as fast as you can. Say it until you come to your natural pause.

Never, never, never, never, never, never, never, never, never, never, never, never, never.

I'm not sure, but I really believe that that was probably thirteen nevers. You stopped right where you wanted to, and in writing that poem—"never"—I stopped right where I wanted to. Also at the thirteenth never.

You mentioned the inspiration of Cummings. Were you also influenced by Ad Reinhardt?

Yes, I think conversations with Reinhardt, and his directions in painting, certainly had an influence on my writing. Sometimes not specifically, but the general direction he was working in certainly did—towards reducing the number of colors, reducing the form, and repeating the theme—I could understand that. I liked the sort of things he said.

Were you aware of other painters?

Yes. With Reinhardt, we had been friends in high school and then again in college, and after college we saw each other often and went to meetings of the New York Artists' Club to which all the painters went. So we'd see them all, and we'd see their shows.

And you also met Kerouac?

Yes, I saw him often when he was around New York, and we'd exchanged letters and postcards even before we met. I liked him, and like his writing.

Didn't the abstract expressionist painters' and the Beat writers' approaches seem rather different from your poetry? Isn't the prevailing organic or formal register of New Poems *quite distinct from the off-the-top-of-the-head aspect of Beat writing and action painting?*

I think I see my own work as having a kind of pendulum movement. Things like the prose text *Tractatus* are really my version of off-the-top-of-the-head Beat writing. The first influence on me for fast writing probably was Henry Miller. I've always really liked the two poles of that swing.

How was New Poems *received?*

My friends liked it, and some friends really liked it a lot, and it was reviewed in little magazines. I didn't hear any other reaction.

When did you first find out that people interested in concrete poetry were beginning to associate your work with this movement?

I think Mary Ellen Solt's anthology, *Concrete Poetry: A World View,* was one of the first publications to make this link. I suppose many people started seeing the poems after James Fitzsimmons published "Sea and Sky" in the *Lugano Review,* in 1965. Then people like Ian Hamilton Finlay probably would have seen it. David Kilburn saw it then and began publishing things of mine in England, in *Green Island.* And Finlay published some of my poems in *Poor Old Tired Horse.* Then Julian Mitchell, whom I'd first met on Patmos, did a BBC radio broadcast which included "Black and White" and things like that. And Robert Kenedy, hearing the broadcast, decided to write on my work in *Art International.*

Did you read your poems for the Julian Mitchell program?

No, they had professional readers. I've only heard a pirate tape of the broadcast, but it sounded good.

Brion Gysin, Ernst Jandl, and Bob Cobbing also had BBC radio programs made featuring their work around that time. Did you hear these broadcasts?

No, I didn't hear any of those things. The only way I knew about other writers' work was if they showed up in anthologies or in magazines.

I think I first saw your work in 1968 in the special Robert Lax issue of Voyages—*another publication that made your work more evident.*

Yes, it did. That was a heroic effort of William Claire's. He had read *The Circus of the Sun,* and when he started *Voyages* he planned this issue.

How did you subsequently bump into other experimental poets?

I tend to bump into them pretty much by chance, or because we've all showed up in response to the same invitation. I think Anthony Bannon, who had heard a reading at Art Park in America, wrote to Maurizio Nannucci, and he invited me to Florence. It's only that way that I've got to meet people. I met Burroughs and Gysin through a friend, David Budd, an abstract expressionist painter who had married into the Cristiani family, and I knew him through circus experience first.

And you've also attended concrete poetry symposiums in Germany?

Yes. A curious thing happened there. Jeanne Lee, who is a jazz singer and a dancer, who had known my work, came to Athens at one time, to perform at the Goethe Institute. So I came up to see her there and she introduced me to the cultural director, Hartmut Geerken, and he then invited me to a concrete poetry colloquium at Bielefeld.

How did you get on with the concrete poets?

Well, I was getting along with them at a human level very well, even though I don't speak German. I certainly didn't feel far from them, but I don't call my work concrete poetry. Somebody described some of my work as abstract. I feel at ease with that. If I'm grouped with concrete poets, I don't feel uneasy with that, but it doesn't seem to describe what I'm doing.

Could you say a bit more about your sense of being abstract?

Well, I don't know. I think my poetry has some relationship to abstract painting. Maybe you could tell me what the difference is between representational painting and something you might call semiabstract, to abstract expressionism, to abstract so that I can see how you think of it?

Well, I might think of paintings like Constable's landscapes as representational; then something like Turner's paintings of clouds or late Monet water lilies as semiabstract. Then a Matisse might

be titled Escargot, *but you might not see a snail, so that's even more abstract. Then Arp's organic shapes seem still much abstract, and with somebody like Albers you get geometrical abstraction.*

Good. I agree with you about the way the gradations go. Still, why does the word *abstract* seem to work? Why would you call it abstract?

Maybe it's just a useful word for nonrepresentational?

Well, I guess abstract is *drawn from*—off the detailed surface—and into something which is more general, working towards a principle or something like that. I have a feeling that what I'm looking for, or working towards, or working with, has something to do with that. Representational would be to say "red roses," and more abstract would be to say "red flowers," and more abstract would be to say "red." That would be one direction towards abstraction. Why you'd do that, I don't know. I think you'd have to go back to painting or music to find out why there is this tendency that we have to abstract from the familiar, and to find what is the operative part of what first attracts us.

So, in a sense, what you're doing is trying to find, define—or refer to—that operative part?

Yes, I think it has something to do with that effort. Also it has something to do with—if you have at a prose level or at a factual level, the fact that Sam is here, and at the next moment, the fact that Sam is gone, that truth's got a lot to do with Sam. But also, the fact just of something being here, and something being gone, has an interest of its own.

You mean the process of transition?

Yes, that's right. I do think that process is important. I think it's an important part of what I'm trying to get in touch with.

So in "Sea and Sky" the reiterated reference to a bird aspiring to "fly to the ends of the sea" seems to be not just a motif but an intermittent process or a kind of time factor?

A time factor, and also an image of space—wide space—and also of movement, and eventually, in that poem, of a movement towards something. I think something else is going on in poetry in general, in human life in general, and in nature, that I'd really be trying to get in touch with, no matter when I was living or where it was, or anything else.

I suppose someone like Teilhard de Chardin has got more to do with what interests me in this sort of poetry and in art in general, than many others of the people one might talk about. And what interests me in him is somehow the thought of evolution—universal evolution towards something, and evolution that is enacting itself through processes in nature, and processes in nature moving along through something that you might call, for example, genetic intervention, the way chromosomes carry genetic information, and tell each other—very briefly—what to do and where to go next. And I think that if I've got an interest in simplifying language, and saying as much as possible in a few syllables, it is more in terms of some such biological process—not only reflecting it, but actually participating in it.

Could you explain how one of your recent poems—"The Dark Earth: The Night Sky"—reflects these things?

Perhaps I could toss this back to you first. At one point you found you liked it. Why do you suppose you said that?

I think I liked it for a number of reasons. I like it for its structural harmony. I like the way a number of statements are composed or interwoven in a succession, and yet into a succession which seems to lead to some sort of finality. I like the balance of it. And I suppose I also liked it for somewhat anecdotal reasons.

Coming in on the boat to Patmos, I was aware of the night sky and water—two sorts of dark—and then the intervention of something else, the land in the middle, and then a light. And as the boat moved along from left to right, there was a sort of repetition of these elements which one could look at and think about, to and fro. So just at that level, it seemed quite natural to be reading the poem's relatively concise, reiterated, and varied observations. In that respect, I'm imposing a little bit of my own travelogue onto it, and I'd imagine that you're doing rather more here, perhaps, than simply tracing the shades of darkness seen from the deck of a ship.

So I suppose I find the poem both structurally successful or pleasing, and also a work whose elements—the elements that you chose—fit evocatively together. It would be rather different if you'd used more detailed or complex terms like "the red wheelbarrow," "the yellow leaf," "the blue shirt." That would have been a different set of units with a different evocation, even if the structure had remained the same.

I think that's right, I think that's good. One thing I could ask you would be, does it remind you of any other art or any other arts?

Perhaps woodcuts or graphic diagrams. You could imagine a cut in one direction for the sky, and another for the earth or the sea—I'm thinking of something like Emil Antonucci's abstract illustrations for—or abstract graphic translations of—your poems. I suppose one could also imagine it as a film, or that one might relate it to music.

That's right. And I think that the fact that you can think of it in terms of three arts, or three or four arts, has something to do with its abstraction—the fact that it doesn't have a lot of detail to drag with it. There are three general elements—earth, sky, and star, with some description of each: two are dark and one is bright.

And those are fairly easy to indicate in simple words, and they would be fairly easy to indicate, as you say, by simple woodcut technique, and probably equally easy to evoke musically, if you got a word or two into the title. And even if you didn't want to evoke earth or sky or star in that much of a literal way, you could still evoke those values musically and not say a word about the sky.

What do you mean by "those values"?

I don't know. But I do think that if you were understanding, say, the mood of the poem, and you wanted to write a musical piece that somehow had the same effect as that poem, you could call it *Opus Number Three,* and start it out with a cello going at the right tone, and communicate those values without saying a word about the star or the earth.

Has this been done at all? Have you collaborated with any musicians and replicated the sort of things you had in mind?

the
dark
earth

the
dark
earth

the
night
sky

the
night
sky

the
dark
earth

the
dark
earth

the
night
sky

the
bright
star

the
bright
star

the
dark
earth

the
dark
earth

the
bright
star

the
bright
star

the
night
sky

Robert Lax, "The Dark Earth," 1985.

Yes. Gerald Levinson did some music to go with a night poem of mine—his whole piece is called *In Dark*.

To what extent do you think the quality of abstraction which makes your poems so accessible to other media might also make them problematic to the average reader? Do you ever regret not adding more details?

I think I'd be more likely to question words like *dark* and *night* and *bright*, than to think of adding another word. It would simply open a question of why it was there. If these words don't raise any questions, if everyone is willing to consent that "dark" should be there and that "dark night" is the easiest way to describe it—if everyone agrees to that proposition, then I can move on to the next. Does it really need "bright star"? I didn't feel that "bright" was excessive, so I included it.

Some of the words that you use here appear quite evocative in their own right. The "bright star" might seem to have religious overtones—"little star of Bethlehem"—or something like that.

Working this way, I'd want to avoid any very evident promotion of religious overtones—which wouldn't mean that it would be a deliberately secular poem. You try to avoid the obvious reverberation into that or any other field—I mean, it's not a red star over China, either! I certainly don't think you can tell people how they should take your poems, but I think you should feel responsible for any reverberation that a word you've chosen may have. I think if you say "red," you have to realize that some people will see red! But you also have to hope the context of the poem itself will establish and clarify what you're saying.

Perhaps that feeds back into what you were saying about trying to write something which would have a slightly more timeless context, rather than something specifically contemporaneous?

Yes! I think timelessness is a real value to art, and timelessness is also always accessible to a serious artist, just as it's fairly accessible to a serious mathematician or a serious scientist. Timelessness is something you can hope to work with. Though how you can talk about timelessness and progress at the same time, I'm not sure.

The superficial paradox might be that the form of your work might strike some people as being relatively new and unorthodox—so that it would seem more newfangled than timeless.

That's right. If your work is serious, you're probably going to arrive at some things that will look new to some people. And they will look less new to people who have worked along with you, seriously, in the same art.

Do you think it's actually the case that people in the same art—in other words, poets—are more sympathetic to each other's work? Or have you sometimes found more sympathy from painters, musicians, or even scientists, for example? Henri Chopin commented that when he sent out subscription forms for his sound poetry review, OU, very few poets subscribed, but scientists, mathematicians, and people outside literature itself seemed to have a fairly open mind.

I think that's pretty true, too. I've been lucky in that I haven't really been much attacked by fellow writers, and I have found some fellow writers who like my work. But it has been

easier to show some of these poems to painters and musicians who seem to understand them right away.

The forthcoming exhibition of Ad Reinhardt's paintings and your poems at the Neue Staatsgalerie in Stuttgart seems to be an example of their positive reception in an artistic milieu. What sort of works will you be showing there?

The exhibits will include books, manuscripts, and drawings. There will also be a reading, and possibly they will want to show some films that Emil Antonucci made from my work, and some video readings.

Could you tell me a little more about Emil's films?

Well, he's done several films. One was based on *New Poems*. These were visual equivalents—he photographed images from around New York. Those poems were written in New York, and Emil took one of these poems at a time—he'd drive around the city until he found the appropriate image to go with the sound track of the poem.

Were these films a collaboration, or did Emil work on them more or less independently?

He did all the work—I didn't see them until they were shown. It worked out very well—I was very pleased.

Do you think you prefer having your poems illustrated?

I think it's a mixture of feelings. When you're working with someone and it's a good combination, then I think the illustrations should be shown along with the poems. I have a feeling that sometimes things like that are like jam sessions.

I don't recall seeing a lot of poets who have systematically presented their work with illustrations to the extent that you have.

Well, actually, I suppose one of the ways it worked was that it was illustrators and painters, artists and musicians, who saw my poems and who wanted to do things with them. And so they really were the publishers of my work.

That's very interesting. It's as though the poems themselves have inconspicuously invited collaborations from various artists in the various media.

Yes—I think that is literally true. That's just the way they've come to public notice at all.

And more recently you've met Steve Lacy, the jazz musician?

Yes. He was at a festival in Salonica, and somebody introduced me to him. I also met him later in the street, with his wife, the singer Irene Aebi, and we talked. And he said something like, "I'd like to see some of your stuff, because words are important." He really wanted to see some poetry, and I said, "I think you might like these." And he said yes, as though he was quite sure he would! I look forward to sending him some poems. I like the music he does, and I like the way he uses words.

He would set them to music?

He'd set them to very lively jazz, I think!

Are there any other intermedia projects that you have in mind?

I would like to do more films. Let's see—Costas Giannopoulos who broadcasts a jazz and music program in Athens talks about doing a reading with some dancers. I have seen some of the things he's done with dancers. Most of these intermedia things have worked out pretty well.

Yes—it's a curious thing, I think. Bob Cobbing says that he's taken some of his sound poems to drama schools and art schools in England—and students have happily started dancing. And Henri Chopin wrote some pieces for ballet dancers, and Bernard Heidsieck had gymnasts in one of his early pieces. I suppose one aspect of the new arts is that they're supportive of each other's possibilities.

Yes. When Jeanne Lee came here, I showed her a poem—a "red and blue" poem—and she looked at it and gave it back to me. Then, during her performance, she announced that I was there, and she said that she'd like to perform one of my works. She had memorized the poem in that glance, and she performed it—she sang and danced to it—and very well, too! So those things do happen.

This seems to fit in with your notion that working with illustrators can be something of a jam session. Do you find this a useful notion for collaborative work across the media?

Yes. If something like a theme is set, and it's a theme that takes on—to which a couple of people respond by lending various other arts—then something can come of it.

Presumably your collaborations with the images and films of Emil Antonucci work very well because you know his visual style and he knows your poetry, and you've both got a good sense of what each other might do. Do you have any reservations regarding other more recent projects, such as the Steve Lacy collaboration?

Well, the only reason I feel quite sure that I'd like to collaborate with him is that I heard two full evenings of his work with the band, and I was very well pleased with what they did, and could at least imagine some works.

Is there any conflict between the idea of a kind of spontaneous, jam session creativity and collaboration, and your usual compositional practice? Do you find that the first impromptu version works well, or do you find that it's a gradual process? Do you work on a poem for quite a while and rewrite the text?

I guess you'd call them spontaneous—except that they've been growing up for a long time. But when they're ready to pop, they're there! And without even realizing it, I find that I rewrite the same poem a number of times over the years. It's not exactly the same poem, but if I write one poem spontaneously in '65, then perhaps in '72, I would come upon the same poem. I'd see a brand-new thing, and write a brand-new version of it. That would be the closest I'd come to rewriting a poem—probably almost having forgotten the first. Someone looking through the poems would realize that this is that same poem!

Does it worry you at all to think you might be writing the same poem several times?

Not any more than it would worry me to be having the same dream or dreams on the same theme a number of times. If it was too many times, then it might worry me.

The concrete poet Ernst Jandl rather differently posits that every new poem has a certain sort of structure, which only needs to be used once—and then the poet goes on to write another poem. Would you agree with that?

Well, I don't know—I think there are a lot of things at play here. If you think of poems as a product, or as something you make, that's one thing. If you really think of them as sort of a fruit of your spirit, it's another. I think if you think of them as sort of organically appearing, as part of the life of your soul, if you like, then the fact that the same themes recur shouldn't surprise you. It really should be seen as a good thing—as a development.

This might lead us, perhaps, to the differences between your various writings. For example, there are the semiabstract poems that we've been talking about, like "The Dark Earth." Then there are your fables, which seem much lighter in tone.

I don't know. I guess some of them are funny—and they should be. But I think whatever it is that I or someone who lives inside me would be trying to say in any one of these things, would be tried to be said in all of them, in some different way—in drawings—and in whatever else you do.

We'll just invent—we'll say there's an artist who lives inside you who wants to do a lot of things. He wants to do a lot of things because he has something that he really wants to say, and thinks he should say. And so he finds any means he can to say it. I don't think that means so much having a message to deliver, as that the fact of his being, as part of his being, speaks. A star shines. As part of being a star, a star shines. And so the self—or the self that is an artist—produces works of art.

I think this myth about an inner self who is trying to talk, and trying to find a language to talk in, could be used to explain various forms that one's work could take. Sometimes it flows, sometimes it comes slowly, sometimes it comes in vertical forms, and so on. But I think all of it is working towards a language—towards a usable language—usable by this one person who's trying to talk. I don't think it's anything like trying to develop an Esperanto or a kind of national language, or anything of that sort. It's a language for self-expression—as I said, we're just positing a person who wants to talk.

If that person has looked over the world and decided that most things can be divided into light and dark images, then he's going to be talking in all of these poems in light and dark images—or he's likely to be. He feels that such images are ways of expressing a number of meanings at once, and a number of meanings that are actual and of some importance to the speaker. Then the vocabulary, over the years, becomes both more limited, but slowly, richer too, because it is finding the words that it can work with.

So it's not so much purifying the language of the tribe, as purifying the language of the tribesman?

Right—yes—I could agree with that.

I suppose the next problem is one of finding a way to communicate these values to the general reader?

Well, I don't think there's anything very asocial or antisocial about writing for yourself. I think it's a good thing to do. I think that if you can't make contact with yourself, you're going to have a hard time making real contact with anyone else.

So that the first thing to do is to develop a vocabulary in which—and with which—you can talk to yourself. And if that's working well enough for you that you've got some texts to show for it—then in terms of the tribesman and the tribe, if a tribesman has gotten articulate enough with himself so that some of his devices are usable by the tribe, that's fine. And if it turns out that none of them are, at least he's left able to talk to himself.

In what directions do you see your work progressing? Do you see it progressing in all the directions that it's gone before—and some new ones?

I guess I'd expect the pendulum to keep swinging. I'm glad when it does flow the way it did in *21 Pages*—that would be good. But I like the long vertical poems too, and they can go on for a distance. I used to think that very short poems would be very good things to write, and I still do—I like to write short poems. But I also find I get a growing interest in the idea of continuity. I'd like to do something, even if it's only a continuous series of short poems. I'd like to have more continuity, and fewer breaks.

And would use of literal movie films—rather than the metaphorical option of vertical "movie" poems—offer a more continuous medium?

Yes, I'd like to do things with films too, and with either drawings or something like drawing. I think that in all cases, you're working with images. Even the words you use are very likely to be image words—words which evoke images. And I think all images also carry a symbolic value—but I think the conventional symbolic values that a word may have may only be echoes that you're not particularly interested in exploiting.

Would you be more interested in something archetypal, rather than a more systematically explicit image?

Right—yes. I think that working in the way we're talking about, you don't want something that's too easy—that's too explicit. You need a symbol to which some mystery is still attached, or it isn't a symbol—it isn't a working symbol. So you're looking for elemental, archetypal things. But I think you have to discover them in live form. You don't just pick them out of an encyclopedia.

When you say "live form," does that mean writing—or do you mean something like inner life, or just where you happen to be?

Introspection—introspection is more what I mean by finding things in "live form." If they show up within your own stream of consciousness, then they may have symbolic value to begin with for you. And those are the things you might work with. Something like the psalms in which David says, "The Lord is my shepherd." When something like that comes from David, and from a pastoral background, then it is a living symbolism, and he can use it to speak to himself and to his fellow shepherds. And in that way, what he's saying is clear—and clarified—by his choice of symbols.

Lucern—April 2, 1989

Robert, your work seems to be exploring a whole new field of poetry—a poetry using quite sculptural structures, certain forms of repetition, and the abstract imagery of different colors. One might be tempted to relate it to a number of different things, such as the way in which Lawrence Weiner uses permutated colors in his "language art," or the way in which an artist like Maurizio Nannucci uses repeated colors. Could you say a little more about the things your poetry is attempting to say or to discover?

From the beginning, I had a feeling that what I liked about a line of poetry was its ability to bring you a clear image of some sort. So that when I was still in high school and college and the years after college, I was very interested in images and metaphors. I began to feel that the origin of the most lively metaphors, the most lively images, was quite likely to be interior—that the images that come to you in your stream of consciousness are more likely to be eloquent than those that come from just the outside—from a walk in the fields or in the woods.

And the more I looked at the images in my stream of consciousness, the more I become aware that as well as there being a limited range to their kind and quality, most of them, for example, are light and dark images; that those that are colored are likely to be in primary colors; that the shapes of the objects in an image are fairly classical shapes—they're circles and squares and such things; and that in order to understand and to convey those images to a line of poetry, you needed a kind of language that I thought was a simple language—one that really covered the territory.

So, in a sense you're mining that stream, to find what the images are. Why you would be doing this later became a question to me. What's your interest in this? Is it so that you can publish many poems, or write many poems? I realized after a while that my interest in it is an interest actually in my life, and in communications with myself. Just as I'm interested in dreams, and just as dreams seem to produce themselves and to be interested in themselves, it's just a part of my existence—even my biological existence—to be in touch with my own stream of consciousness. I realized that it would be a help for me to find a language—some verbal equivalent to the things I was seeing inside.

If you wish to call it poetry, then it's poetry. But it's a matter of finding words for these light and dark images, and these round and square images, and the red and blue ones—things that simply are constants in the inner stream. I think there's a rhythm too, as far as the rhythm goes. I think it's part of us to wish to talk with a certain rhythm, to move with a certain rhythm. And even our dreams have a certain rhythm. And so it's not an artificial imposition to put these words and images into a rhythm.

Given that you're using relatively limited references—light and dark images, and color images—and a particular set of rhythms, do you find that your work has nevertheless tended to emphasize a particular subject matter?

I think part of what happens in these poems is that I like to think of them as wholes. And I like to think that most of them—the ones we may be talking about now—light and dark, and red and blue kinds of poems—have a beginning, a middle, and an end. I usually know—I recognize—the end, when it comes, and that I've been working towards it. What you hope is that it's a little like rubbing two sticks together to make a spark. You have these

two central elements, and you play with them in their permutational ways, in a way that gets to be more and more familiar to you. And you're hoping for a spark at the end. The spark at the end is what makes it constitute a poem.

And so you're not just exercising with colors, or just parading colors or demonstrating them. But you're hoping that by working them together, and by working the contrast towards a resolution, you're also working towards a living spark at the end which does communicate the meaning of the whole, in the way that a musical composition would work towards its beginning, middle, and end, or a dance would work towards its beginning, middle, and end.

Perhaps we could look at some examples from your early collection, New Poems, *of 1962? The first poem—"one stone"—seems to be a meditation upon lifting a stone—thinking very carefully about what one is doing, and seems a little more accessible than your more abstract, color poems.*

Yes, I think that's true. I think this whole series of poems—and poems like this—really did begin with the "one stone" poem. So it is sort of archetypal for all of these. I remember when I thought of it, walking down the street in New York—and suddenly I must have written it right in the street at that moment, too. What I liked about it is that the image of the stone is very concrete. It's also monosyllabic. If you combine lifting a stone and thinking about it, it's a kind of incarnation—you've done as much towards bringing the world of thought and action together as you can, at a very primitive level. And if it hadn't been primitive, I probably wouldn't have recognized it! I thought that was the kind of concreteness I needed and could respond to, at a time when many things seemed—and still seem—nebulous, ethereal, and not incarnate and not real.

What about the poem "is"? Why does it reiterate the word is *some twenty-seven times? What did you mean by "is/is"?*

It's a bit hard to say, now, because I now write poems that say "is/was," "was/is"—things like that! But at the time I was just saying "is"! I think I was bringing up the word *is* to my consciousness, and repeating it—not in a way that was so monotonous that it would repel me, but rather, repeating it in a way that was rhythmic enough to make me wish to keep it before me in my consciousness. Also, the particular word is related to the present, for one thing, and it's related also to the whole idea of being. So that what you can always say about the universe, the cosmos, existence, and all the rest, is that it is. It's a very basic word. Whatever you may wish to say about all the rest, it either is or it isn't. But the most positive thing that you can say is that it is.

Interestingly, you don't use the word it.

You don't use the word *it* because that's already making it more concrete than you perhaps have a right to do. It's a meditation on *is,* or on being.

So to say "it is," "it is," "it is" would be too obvious?

It would seem to limp, to me. It would go dead and then come alive. "It" doesn't sing for me, the "it" doesn't sing for me.

Your remark that people usually warm to your poems when you read them aloud similarly suggests their songlike quality.

That's right—but I'd want to say again that what I'm singing to is either my self, or my capital S Self. It's an interior singing, first of all. If it can also be enjoyed beyond the interior circle, that's fine. But it isn't singing in public as a first thing. I feel that way about circus performers, incidentally—I think most of them really like to walk tightrope, and like to do things on trapeze, and would be doing them if they were alone in the jungle! The fact that the crowds gather is secondary. It's not to be despised for that reason, but it's not the primary interest.

What about a poem like "goodbye," which advances from "the first goodbye" to "the twelfth goodbye," and then leaps to "the hundred & twenty-first goodbye"?

Well, I thought that by the time it got to the twelfth it was time for a leap—there was no question of that! Again, the best way to understand it for me is as thought. That if I am thinking about how goodbyes go, and how it's the first "goodbye" and the second, and the twelfth, and on and on to the "hundred & twenty-first" and so on, then I can understand the rhythm of the poem, and the structure of the poem and everything else. And where it gets to "goodbye / goodbye / goodbye," that's where the thought—the whole thought—goes, for me. But it's my own reaction to the idea of "goodbye." Again, it's not a show, it's not a vaudeville act.

What about the number poem that goes "123 / 123 / 12234 / 123" or the letter poem that goes "AAA / AAA / AAAA / AAA"?

I think some of this comes from wanting to write—wanting to write a poem—seeing what abstract painters can do with their works, seeing what musicians can do with their work—and trying to find what the essence for me of a traditional poem is, and getting it down to that. It was again a personal exercise, not a public performance. But I wanted to see what it would be. And it's something like this. I wanted to do it with the simplest elements. So I did it with "123," or with "AAA," and things like that.

The imagery in the next poem—which begins "fire / water / earth / & air"—seems to anticipate your longer permutational poems.

Well, again—and this is probably a long-term interest since the time I was five years old—I've always been interested in those elementary combinations. I mean, the idea of primary colors—red, yellow, and blue—sounded fine to me, right from the beginning. When it got into more elements than that I got dizzy. But I liked four. Or if you hear the Chinese talk about five, they don't sound really as elemental as these four. But that sort of thing has a real appeal for me, just as the four seasons do. I keep feeling that if you have a hold on things like this, you have some chance of having a picture of the universe—or something. You have some chance of knowing what the conditions of your life are. The biological conditions of life have a lot to do with all the conditions of life, I think. So that if the four elements have something to do with it, the four seasons have something to do with it—the idea of all those things like respiration and nutrition and growth—growth and decline!—all those things are known to have something to do with it. Or those are thought to be sort of essential parameters.

I think the other thing that goes on here—and here comes the cosmos again!—the other thing I feel is that nature talks to us. It talks to each of us in its own way. But nature

talks to us in these permutations and in these changes. One day it rains, one day it's sunny, and so on. Clouds come, and clouds go. And if we get used to looking at permutations in our poetry, we have a chance of beginning to, not understand, but to get a way of watching the permutations that take place in nature, and in the more microscopic life—in all those permutations that take place in the DNA scale, and all things like that. All through nature there are these permutations that take place, and there is all this play of elements. And I think in a way, music gets close to the way those things in nature work. But poetry—up to now—has been riding on the fringes of it, rather than getting to anything that is as essential as the DNA scale.

Getting back to that business of rubbing two stones or two sticks together, if an early man does that, he's not creating fire, he's only working with elements that are available to him, and trying to repeat an effect that he had come upon by chance the other day. And he gets to know more and more about the stones, and more and more about the fire, as he proceeds. But he discovers quite early that he's more likely to get fire with two dry sticks than with two wet ones. So he knows he is dealing with elemental concepts here, and he's playing them against each other, and he knows good things may come of it—that something even needed may come of it. But he's not always playing very consciously with the effect this poem will have.

So it's not like Magritte painting a deliberate enigma?

No. In all of it, I feel that I'm dealing with elemental concepts or forces, and trying also to use them in a positive way. But in a sense, I'm waiting for things—this is more like it!—waiting for things to fall into place, and watching them fall out of place and then back into place. And I'm quite willing to let them fall into place and out of place.

Does this mean that you revise your work a lot?

No—I seldom revise, actually. The most manipulation it might involve is something like building a waterwheel. If you know there's a stream, and you build a waterwheel, then you're pretty sure the stream will turn the wheel. But there may be a thousand things about wheels and circles and spokes and streams—and their contents—that you can't have learned before you built the waterwheel. But you know enough to build it.

But all the same, there's some element of selection?

That's right. I think there is an element of selection, and a lot of it is aesthetic. But it isn't aesthetic in the sense of being in an aesthetic tradition. It's aesthetic in a personal way. This is as much as I want to hear of this poem—or this is where it ends. All of those things you know for yourself, just the way you select any other thing.

This restrained tone of "love & / death" also seems quite different from the confessional register of much '60s writing on these themes.

Yes—I think in that sense it's going towards abstraction. It may have something to do with feeling that for the moment at least, we've had enough emotional statements about sheer emotion.

For some critics, the abstract impulse in poetry represents a retreat from social commitment. Does this reproach worry you particularly?

It doesn't worry me because I think my real social commitment, and the only one I can take seriously in anybody else, has something to do with a commitment to, not just mankind, but life, living forms in general, the survival of mankind and of living forms in general on the planet. I don't know whether you call that "social commitment." It's what I think any conscious living form might well be committed to. And I would admit to being committed to that. What may be called social commitment in someone else's vocabulary seems inadequate to me as a serious social commitment. The people I think of as the good guys on the planet now are those that are interested in the survival of all living forms on the planet, and the survival of the planet. The ones I think of as not so good are the violent types, no matter what their ideals may be, and who aren't committed to the survival of the planet and so on.

The register of the next poem—"in the dark / in the dark / my love / is lying / in the / park"— seems much more lyrical and personal—almost perhaps like a poem by Verlaine?

Yes, that's right. I guess the other thing that is a fairly constant interest of mine is the world of dreams, and finding a language for the world of dreams. And maybe this is like an evocation of a dream, and trying to get that into the fewest words. But again, words with rhythm and with some evocation.

Presumably your prose writings represent your most extended narratives.

Yes. I think *21 Pages* is as close as I've come to anything extended. The *Tractatus* texts were another move in that direction, and I think there's one called *A homage to Wittgenstein* that goes on for quite a way, and there's one I haven't seen in years, *A homage to Kandinsky*. I remember that I wrote the Kandinsky one first, and the title came later, because I realized that it was full of Kandinsky images.

This seems to typify your idea of writing something and then discovering other things in the process, rather than having an initial set formula?

Yes, I think that is it. This business of a stream, or watching a stream, or letting a stream run, and coming slowly to understand the stream through watching it, is what I like. Whether it's a real stream, or whether it's your stream of consciousness, I think there's a way of watching it that doesn't have to be too chaotic or too experimental, or anything else. It can be a quiet way of watching it, but you do learn things in what turns out to be—after all—a fairly systematic way. But it isn't imposing a system on it, it's learning from the flow of the things themselves.

Presumably this sort of flow animates "in me / is the / watcher," where two "in me" and "is the / watcher" statements lead to the repeated synthesis of "in me / is the / watcher" and to a final presentation of the original statement, and also seem to invite a kind of visual reading of its textual blocks.

Yes, I think that's right, they do at least admit of it, in the way they're laid out. But I think, essentially, the rhythm still is that of a person talking to himself. And I think the discovery

for me was just what it says there—that below all the things that happen, or below all the things even that I am doing, there is a watcher, and so I say, "in me / in me / in me / is the / watcher." In all of this we're talking about finding a language. It is bringing words up, out of an area where you really only have flashes. And my feeling is that if you're going to bring them up, you have to do it with simple words of not very ambiguous meaning. Words like *red* and *blue,* I suppose, are ambiguous enough, too! But *red* and *blue,* and *light* and *dark*— we have fairly good agreement on what those words mean—much better even than words like *luminosity* or *roseate,* for example.

Further on you have mediations based simply on groupings of the words life *and* death.

Yes. And I think the way that works again is that if you do repeat it, various meanings jump off the word. As you go along, at the right number of times there becomes—I don't say a resolution, but a feeling that you've put it through its paces, at least.

The death poem begins with two sequences of three repetitions of the word—"death / death / death" and "death / death / death"—which I suppose could be frightening. But then it leads to a more gentle final sequence of "death death" and "death / death / death."

Yes, I think it turns it into a waltz of some kind! It's like lifting "one stone." You lift a word like *death,* that's always been a stone, or has always been a stone to you, and you look at it, slowly, a number of times, and you're able at that point to put it down.

So it's like making friends with words?

Making friends with words—something like that. If we're talking to the city, for example, it isn't that the city will really evaporate, but that this image, the oppressive image of the city, will dissolve. And you don't even watch it as it dissolves. But you come to terms with it, not by confronting it, not by attacking it, but by letting it go back to its own elements. I think what you're trying to do is to invite all the words into the universe of your mind—to have no unacceptable words, no untouchable words. To accept them as words and as elements, and have them all part of the family of your words. It's admitting that they're there, and inviting them in.

Providing spaces for prodigal sons?

Yes! I think it's more like that. Inviting the words in—inviting *black* in as well as *white,* and *death* as well as *life,* and *no* as well as *yes,* and showing that they're all parts of one—a symphonic whole. Showing yourself that they're all parts of one symphonic whole, first of all, or testing to see if they are not. And in that sense it is getting rid of a number of bogeymen. But why get rid of them? Not only so that you can get to sleep, but so that you can live more freely—something like that—when, on the piano, there are no forbidden notes. But, in our vocabulary—in almost all our vocabularies—there are forbidden words, frightening words, things like that.

And perhaps this is some way of getting back to—aspiring to the condition of—music and getting back to the sort of scale or color wheel that musicians can work with, and painters can work with, and which we have a harder time working with as writers. I think that has something to do with what I'm interested in.

Jackson Mac Low, Internationales Festival Phonetische Poesie, Szene Wien, Vienna, February 1983. Photograph by Françoise Janicot.

JACKSON
MAC LOW

ENTERING JACKSON MAC LOW'S NEW YORK LOFT IN JANUARY 1991, I found myself facing several pathways through piles of books and papers—a series of options, perhaps, not unlike the choices offered by his variable performance scores.

Mac Low's is a sharp intelligence, wary of generalizations about the "death" of poetry and of injudicious textual comparison. The suggestion that the lines of one of his early poems sounded "a little like Stein," for example, prompted the rejoinder, "It's not the least like Stein"—along with the qualification, "Maybe . . . yes . . . I *had* read a little of Stein's writing."

I'd wanted to find out more about Mac Low's "nonintentional" performances, but while I was aware he'd attended Cage's New School classes with Dick Higgins, George Brecht, and Allan Kaprow, I had not realized how his first work for theater—*The Marrying Maiden: A Play of Changes* (1960)—had been produced by the Living Theatre, along with interscene taped scores by Cage, modified by "'hands-on' manipulations such as manually stopping, slowing, or accelerating the tape reels."

Resisting "normative syntax" and "fixed *accumulative* or total meaning," Mac Low's strategies for allowing his performers to "find (or 'enact') for themselves many different meanings for each segment" typify his subsequent work's attempts to "*expand* art to include a good deal of ordinary life, but not to destroy art in any way."

If Mac Low calls himself "a latter-day modernist," this is doubtless because he feels closer to the affirmative experimentation of early-twentieth-century visionaries such as Kurt Schwitters, than to those "numbed" by the alleged postmodern crisis. Advocating simple remedies, Mac Low advises, "Well, whoever the media numb—let them wake themselves up!"

As he also observes, the last decades have witnessed the L=A=N=G=U=A=G=E poets' increasing popularization of disjunctive composition, a development typifying the way in which the "contagious" momentum that Mike Kuchar attributes to the multimedia avant-garde's creativity gradually infiltrates more mainstream practices and, in Mac Low's terms, "furthers freedom in the world."

Mac Low's comprehensively revised transcript of this interview gives precise references to his *Representative Works: 1938–1985* (New York: Roof Books, 1986), abbreviated *RW*, and to his other books.

New York—January 16, 1991

Transcript revised by Jackson Mac Low, July 16–August 18, 1991, New York

How did your career as a poet begin?

I began writing poetry in 1937, soon after I started discovering modern poetry. I hadn't liked poetry before I read Walt Whitman in about 1936, but soon after that I discovered some of the twentieth-century American poets such as Carl Sandburg. Then, one day in 1938—when I was still going to high school in Winnetka, Illinois, north of Chicago—I went out to the University of Chicago to talk to Bertrand Russell, who was teaching there at the time. He was my intellectual hero in 1937–38, and I'd read everything I could find by him in the libraries for which I held cards. Of course, he didn't have the time to talk to some high school kid who'd just shown up without any warning.

So since I was out at the university with nothing to do, I went to the university bookstore. There I discovered Ezra Pound's book *Culture* (its American title when first published by New Directions in 1938—its British title had been *Guide to Kulchur*, its present American title). I read most of it in the bookstore, and on my way home I stopped downtown at the main Chicago library and took out all the Pound books I could. They (together with the editors, then, of *Poetry* magazine, George Dillon and Peter DeVries) led me to the rest of modern poetry.

By my last year in high school (1938–39), I was giving lectures on modern poetry to my English class. So—in October 1937, not long after starting to read modern American poets—I began writing poetry. I also began writing music seriously then, though I'd been studying music since I was four years old. Since 1937 I've continued to write poetry and music, as well as plays, multimedia performance work, essays, radio works, and so on.

Besides Pound, Eliot, Williams, and other American poets, I also began reading sixteenth- and seventeenth-century English poets—Donne, Herbert, Herrick, and Shakespeare's sonnets—as well as Gerard Manley Hopkins and other nineteenth-century poets. They all affected my writing, and in some ways still do (I was just reading George Herbert last night). My first poems were written in various kinds of so-called free verse. An extreme example is the only high school poem I include in *RW*: "HUNGER STrikE whAT doeS life mean" [written in November 1938; *RW*, 3–8]. Read the first few pages and see how you would characterize it. Most of my work then wasn't that radical.

This sounds a little like Stein.

It's not the least bit like Stein—it was written under high emotional pressure, and very little of Stein's work was that explosively emotional (though it is certainly emotional).

I was thinking of the work with sound and the similar words, such as the first two lines: "Water and water and water and water / Whater you thinking about."

Maybe . . . yes . . . I *had* read a little of Stein's writing, mainly in bookstores, but didn't come to know her work well till later. By the middle '40s I already considered her a great poet. Now I think she's the greatest American poet of the twentieth century. Towards the end of high school I taught myself to write metrical verse, and I alternated between vers libre and metrical verse throughout the '40s and most of the '50s. My music was first influenced by romanticism and then by medieval and Renaissance music, and in the later '40s and early '50s I was mostly writing "twelve-tone" music.

In the middle '50s, John Cage and his friends began to give concerts here. I'd first heard his music in 1948, when he played the *Sonatas and Interludes* for prepared piano at Columbia University. In the early '50s, works written by nonintentional methods, such as chance operations and random selection, and/or indeterminate of performance—by Cage, Earle Brown, Christian Wolff, and Morton Feldman—began being played in concerts. Many were brilliantly realized by the pianist David Tudor, now a composer of works for live electronics. They sounded interesting to me, but I had misgivings about "chance" as an artistic principle.

In 1954 Cage moved to a cooperative community in Rockland County, New York, which had been started by some anarchist-pacifist friends of mine and mainly included people who had just come north from Black Mountain College, in North Carolina. Some of them had been students there; others, like Cage, teachers. When I visited the co-op, after having become acquainted with Cage in 1953, he and I became friendly and talked quite a bit about chance operations, indeterminacy, and related matters.

When did you actually begin working with nonintentional methods?

During 1954 I wrote some piano music by chance operations and random selection. (Unfortunately, the notebook in which I wrote them was stolen from a dressing room at the Living Theatre in New York in 1960, so that music has been lost.) Then at the end of 1954 I decided to see what could be done by utilizing nonintentional methods of composition with *language.*

Nothing quite like this, and very little vaguely resembling it, had previously been written, especially in English. Using the Hebrew Scriptures as a source, I wrote the "5 biblical poems" [*RW,* 16–34] at the end of December 1954 and the beginning of '55, by a random-selection system utilizing a single die. It determined both the structure and the contents of the poems: the number of lines in each stanza (which was also the number of stanzas in each whole poem), the number of "events" in corresponding lines of each stanza, and the nature of each event in each line, that is, whether each event should be a word (or name) from the Hebrew Scriptures or a silence (each silence is represented in the text by a "box").

The "5 biblical poems" were the first in which I wrote what I later came to call "eventative verse," in which the lines include specific numbers of "events"—rather than feet, syllables, or stresses—in that case, of single words and/or silences. For each event I first threw the die to determine whether it would be a word or a silence. If it was to be a word, I used the die to determine whether to count lines from the top or the bottom of a column. (I moved from column to column, obtaining one word from each successive column of the Scriptures.) Die throws then determined which word in which line was to be taken into the poem.

The duration of each silence is "indeterminate": each box stands for *any word the reader wishes to say to herself.* The last of these poems, "21.21.29., the 5th biblical poem (for 3

simultaneous voices) the 1st biblical play" [*RW*, 32–34], was my first "simultaneity" (poem, musical piece, or multimedia work performed by two or more people at the same time). In its title I call it a "play," but it's really a simultaneity for three voices.

While I was writing the "5 biblical poems," I also invented another nonintentional method: "translating" musical notations into words. I first used a modern edition of Guillaume [de] Machault's multivoice ballade *Quant Theseus* (When Theseus) to draw words from a nineteenth-century children's natural history book to write the poem "Machault" [*RW*, 35–40], of which the following are the first and last stanzas:

> it wits it it by the lasso)
> tired animal." tired lasso) it
> wits it that it
>
> • • • • •
>
> his in as Of
> off proverb, confessed
> as confessed as as

Then I wrote another poem by "translating" the notation of a Bach sinfonia (three-part invention) into words from several different sources. In later years I "translated" other music, notably a Dufay *Gloria* and a Beethoven bagatelle.

Much of what I've written and composed since 1954 has involved nonintentional methods (ones in which a relatively "impersonal" system determines features of an artwork), such as chance and random-selection operations, and from 1960, reading-through methods, simultaneity in performance work and indeterminacy (which means that each performance of a work will be significantly different from each other one).

When did you begin writing such work for the theater?

In 1958–59 I wrote my first play of that kind: *The Marrying Maiden: A Play of Chances*, a scene from which appears in *RW* [44–51]. It was produced in New York in 1960 by the Living Theatre, directed by Judith Malina and with decor by Julian Beck. It was given forty-seven performances from June 15, 1960, through April 25, 1961.

During summer 1958 I drew the words for the play's speeches, the names of all but three characters, and the titles of the scenes from *The I Ching or Book of Changes* [Bollingen Series 19 (New York: Pantheon Books, 1950), Cary F. Baynes's well-known English translation of Richard Wilhelm's German version] by means of a combination of I Ching chance operations involving the coin-oracle method and random-selection operations using random digits [from the Rand Corporation's table *A Million Random Digits with 100,000 Normal Deviates* (Glencoe, Ill.: Free Press, 1955)].

During the summer of 1959, a year after I wrote the text, I added three layers of delivery regulations—which eventually added to the difficulties that the Living Theatre's actors experienced in working with an asyntactical text. Word strings of various lengths acquired notations regulating tempo, dynamics, and "manner" (denoted by adverbs and adverbial phrases).

The word groups corresponding to the different kinds of regulation do not coincide, but overlap and often continue into one or more successive speeches of different characters. The tempos range from very slow through slow, moderate, and fast to very fast; the range of

dynamics runs from very soft through soft, moderate, and loud to very loud. There were five hundred possibilities of manner, but not all of them appear in the final text, since random-selection operations determined which "manner" appeared where and how many words it applied to.

Was that combined with music?

Cage composed music for the play by tape-recording a rehearsal, cutting the audiotape at breath pauses, and using a special score to rearrange the segments and insert between them chance-determined lengths of tape on which were recorded various durations of room silence. [The score—including plastic transparencies—used in making this tape was published by Cage's publisher, Henmar Press. Its Henmar number is 6737.] This tape was played *during* the scenes, producing an intermittent simultaneity with the live voices. It was turned on and off by a silent dice-player (added to the original nine characters by Judith Malina) whenever he threw a seven.

The voices on this tape (which has been lost) were unmodified, but Cage also used the rehearsal recording and score to make six short interscene tapes in which the voices were modified by him and the late Richard Maxfield by "hands-on" manipulations such as manually stopping, slowing, or accelerating the tape reels. [Copies of the nine-minute series of interscene tapes—Henmar 6737a—may be rented from Henmar/C. F. Peters, 373 Park Avenue S., New York, NY, 10016.]

Were you thinking of The Marrying Maiden *as predominantly musical or as poetry?*

Both—as well as theater, of course. (This is true of much of my work written and composed since 1954.) The musical organization is quite obvious, but the meanings of the words are also very important. Many people call work like this "sound poetry," by which they mean work composed only of vocal *sounds,* without meaning, even when they include words.

But I've never been only interested in the *sounds* of words. I always think of the *meanings* of whatever linguistic units I include as being at least as important as their sounds, whether they be separated speech sounds, syllables, words, word fragments, phrases, sentence fragments, or sentences—even when they are not ordered by normative syntax and have no fixed *accumulative* or total meaning. Whenever a human voice produces a sound, it carries meaning—emotive and/or semantic, simple or complex. And I think this is true also of letters and other graphic symbols.

In fact, I believe (despite Saussure and his followers) that there's an intrinsic connection between sound and meaning. In this I agree with Hopkins, who held, according to a biographer, that "sound and meaning are yoked by a psychological association considerably deeper than mere onomatopoeia or alliteration, and that perhaps they are also linked by the visual appearance of the words" [R. B. Martin, *Gerard Manley Hopkins: A Very Private Life* (New York: Putnam, 1991), 66].

However, each word has a number of different meanings connected with it, and these multiple meanings may be combined in an infinitely large number of ways, so that perceivers of work such as mine may find (or "enact") for themselves many different meanings for each segment as well as for each performance piece or text as a whole.

After writing The Marrying Maiden, *did you continue to write the same way—with chance operations and so on?*

Yes, for a while then, as well as later. But in May 1960 I began writing acrostic "reading-through" poems. The first group of them was later published as the book *Stanzas for Iris Lezak* [*SfIL*; Barton, Vt.: Something Else Press, 1972; see also *RW,* 71–105]. That was quite a departure. At the time I thought the method was a kind of chance operation, but strictly speaking, it isn't, even though, like them, it is *nonintentional.* It's a way to obtain linguistic units by reading through a source text.

One uses a word or name or phrase as a "seed or index string" (in *SfIL* the seed is usually the poem's title, which is often the source's title) and then successively takes into the poem words or word strings that have the seed string's successive letters as their initial letters. (For instance, the first line of "Poe and Psychoanalysis" [*SfIL,* 54; *RW,* 94]—"Point, out effect"—spells out the name "Poe" acrostically.) Although it's a *nonintentional* method, it's not really a matter of *chance:* the words, and so forth, taken into the poem are *already there,* waiting in the source text in the order in which they'll appear in the poem, though separated by other words.

Did you follow these rules in a very strict way?

Yes, of course. When I use strict methods, I follow them out strictly. The *Stanzas* poems, written from May to late October 1960, were written by means of a group of very strict acrostic reading-through methods. Later, in January 1963, I developed what I call "diastic" reading-through methods. In using them one reads through a source text and finds linguistic units (word fragments, words, phrases—different units, or mixtures of them, in different works) that have the successive letters of a seed string in *corresponding places:* one "spells *through*" the seed, hence "diastic" (from the Greek *dia,* through, and *stichos,* line), a neologism analogous with "acrostic."

For instance, the first eight lines of "'Ridiculous in Piccadilly'1" [*The Virginia Woolf Poems* (*VWP*; Providence: Burning Deck, 1985), first poem]

ridiculous
P**i**ccadilly.

en**d** stain
book**c**ase,
reass**u**ring brutal**l**y
eating-h**o**use.

eating-ho**u**se.
waitresse**s**,

"spell through" the seed word "ridiculous" *diastically* (the seed letters are underlined above and in boldface). In addition to *VWP,* other books of mine, including *The Pronouns—A Collection of 40 Dances—For the Dancers* (New York: Mac Low, 1964; 2d ed., London: Tetrad, 1971; 3d ed., Barrytown, N.Y.: Station Hill, 1979; see also *RW,* 180–86), *Words nd Ends from Ez* (Bolinas, Calif.: Avenue B, 1989; see also *RW,* 320–25), and *Words nd Ends from Goethe/Wörter nd Enden aus Goethe* (produced and broadcast as a four-voice *Hörspiel,* or radio work, by Westdeutscher Rundfunk, Cologne, in 1986), were written by various diastic reading-through methods.

Would another poet—or an assistant—have written the same poems as the ones you've written by acrostic or diastic reading-through methods if you'd have said, "This is the method, this is the seed string, and this is the source text. Go ahead, please"?

I don't see why not, except for works written by variant methods that require certain decisions (for example, in writing *The Pronouns* I had to decide, for each dance-instruction poem, what pronoun or pronoun-like noun would be the subject of all the sentences in it and where to insert time expressions such as "then" and "finally"). Otherwise, other people *would* write the same poem—*if they paid such close attention that they made no mistakes.* I make mistakes from time to time, so they probably would, too. It's the mistakes that would make the poems different.

In writing *SfIL* I used forty different types of stanzas. In many of them, if a letter is repeated in the seed string, I repeated in the stanza the first word (or other linguistic unit) having that initial letter that I found *while writing that stanza.* Each line spells out one word in the seed string, and each stanza spells out the whole seed.

In others I don't repeat words or other linguistic units, but find different words, and so on, for the same letter within each stanza. I had a large array of possible linguistic units: syllables, single words, phrases, sentence fragments from the acrostic word to the end of a sentence, and even whole sentences. Different linguistic units, or mixtures of them, appear in different stanza types.

How did you determine which of these possibilities you were going to use?

Sometimes I would *choose* a stanza type or use one convenient to my circumstances (it was hard to use auxiliary means when writing on the subway). But often I'd use random-selection operations involving random digits or even dice. While the general pattern depended on the seed string (usually the poem's and the source's title), the formats varied: some have a verse format, others a proselike format, and some have a mixture of the two.

Were those your only acrostic poems?

Not at all. In October 1960 I began a new series of acrostic reading-through poems called "Asymmetries," since they are not symmetrically stanzaic. [See *Asymmetries 1–260* (New York: Printed Editions, 1980) and *RW,* 106–27.] In writing them I would start with any word or phrase in a source text and spell that word or phrase out by initial acrostic with words placed vertically at the left margin, and by spelling each of those words out horizontally—by words or phrases that followed the initiating word or phrase in the source text. For instance, the word "all" is spelled out in "Asymmetry 72" [*Asymmetries 1–260,* 72]:

all language language
longer one nescience gained exist room
look only obligations.

knowledge.

The poems were often ended by contingencies, such as my finding no more words with a particular initial letter or coming to the bottom of a notebook page.

I wrote about 500 Asymmetries. While only the first 260 have been published as a book, many others have appeared in magazines, anthologies, and *RW.* Like the *Stanzas* they were drawn from whatever I was reading: scientific texts, Buddhist and other religious texts,

newspapers, poems, political pamphlets, and so on. Though they can be read as "solos," any number of them may be performed simultaneously. Their earliest group performances (at Yoko Ono's studio), as well as many later ones, included both speaking voices and musical instruments.

There are ten ways to perform Asymmetries. The Basic Method is to read the words and to interpret the blank spaces on the page (right and left indentations, large spaces between words and empty lines) as silences, each as long as it would take the reader to speak whatever words are printed above or below the space. Other ways are to read through the poem silently by the Basic Method while playing a letter that is a pitch name, for example, *e*, as a continuous tone; to speak the words but play such a tone in place of some or all silences; to read the words *without* observing silences for blank spaces; and to whisper the words printed above or below the blank spaces rather than reading them silently to measure silences.

Could they be read or performed either by you or by a group of people?

That's right.

Have all the performances of such poems been live?

No. I've participated in both live, recorded, and broadcast performances of Asymmetries, *Stanzas* poems, and many other works, often with other people. Some works have been realized in studios, sometimes by superimposing several tape recordings of live performances. Among these have been groups of my later, *diastic* Asymmetries, notably "The Bluebird Asymmetries" and "The Young Turtle Asymmetries" [both published in *21 Matched Asymmetries* (London: Aloes Books, 1978); the "bluebirds," in *RW*, 196–208].

What other compositional methods did you devise?

Well, in spring 1961 I developed what I came to call the "nucleic method." It involves obtaining "nucleus words" or phrases by chance operations, random selection, "translation," reading-through, or other nonintentional methods and then connecting them with more or less freely chosen structural (and sometimes lexical) words to form normatively syntactical sentences.

The nucleus words in my earliest "nucleic" poems and performance scores were drawn by random selection (using random-digit triplets) from Charles K. Ogden and I. A. Richards's 850-word Basic English list (developed in the 1920s). In "From Nuclei 1,2,a." (*RW*, 128–30), which begins:

Politically we take our breath

wherever breath may be

I used the same series of Basic English words in each of the six strophes. Each nucleus word could be used as a noun, verb, adjective, or adverb (often by adding affixes or changing inner vowels)—a matter of choice, like the selection of connecting words and kinds of syntax and sentence forms. (The nucleus words in the example are "political," "take," "breath," "breath," and "may"; they appear in this order at the beginning of each strophe.) So in works like these there's a play between "chance" and choice—nonintention and intention.

I composed many poems and performance works by nucleic methods, notably my *Light*

Poems [see *August Light Poems* (New York: Caterpillar Books, 1967); *22 Light Poems* (Los Angeles: Black Sparrow, 1968); *23rd Light Poem for Larry Eigner* (London: Tetrad, 1969); *36th Light Poem in Memoriam Buster Keaton* (London: Permanent Press, 1975); *54th Light Poem for Ian Tyson* (Milwaukee: Membrane, 1978) and *RW,* 136–51 and 221–33], "The Presidents of the United States of America" [*RW,* 152–69], "A Vocabulary for Annie Brigitte Gilles Tardos" [*RW,* 293–303], and "Antic Quatrains" [*RW,* 304–5].

A notable nucleic performance piece is the card pack "Nuclei for Simone Forti" [composed January 1961; SF is an important innovative dancer]. Each card includes one to ten single words and one to five action phrases: a group of "nuclei" around which a dancer or

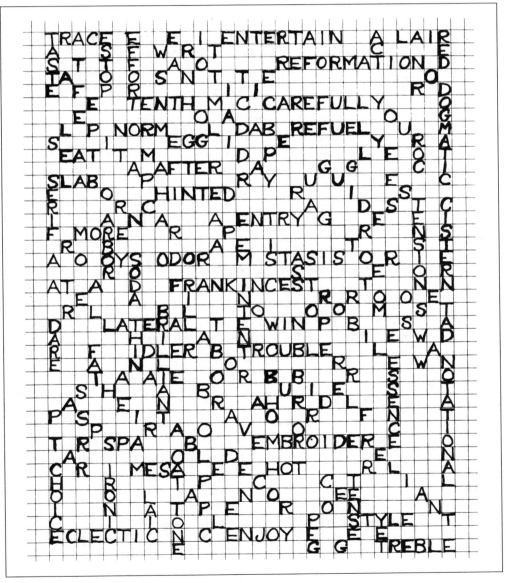

Jackson Mac Low, *Free Gatha 1.* Copyright 1986 by Jackson Mac Low.

performer may construct an improvisation. The words were drawn directly from the Basic English list; the action phrases came from a separate pack, derived from the same source, from which I later made *The Pronouns* dances by a diastic reading-through method.

What were your motivations in exploring these things? Did you want to move poetic language into a freer sort of domain?

Aren't nonintentional methods more *constraining* than conventional ones, rather than freer?

I mean "freer" in the sense that the performer can roam around within different textual and musical options.

Oh, you mean in *performances!* Allowing performers to make a lot of choices is something that didn't come into my performance works until December 1960, when I wrote *Thanks: A Simultaneity for People* [see *An Anthology,* ed. La Monte Young (1st ed., New York: Young and Mac Low, 1963; 2d ed., New York: Heiner Friedrich, 1970)]. The instructions for *Thanks* gives each participant the freedom to produce any vocal sound, to repeat it or not, and then be silent awhile, after which the person may produce a new sound, and so on.

Soon after that, in January 1961, I wrote my first *Gathas* [see *RW,* 234–47]—scores consisting of words lettered in various directions in the squares of quadrille ("graph") paper on which the performers are free to "follow their own paths," saying and/or singing the letters' sounds or names, syllables, words, and word groups, and/or to "translate" the letters into instrumental tones. I continued to write various types of *Gathas* well into the '80s and continue to perform them to this day.

And in 1960–61 I also wrote many other works allowing performers plenty of choices: *A Piece for Sari Dienes,* whose score consists of vague rows of repeated marks made by rubbing a pencil over a "computer card" placed over a rectangle of paper, and which can be realized with any kinds of sounds the performers choose; *Thanks II,* a piece similar to *Thanks,* but mainly for nonvocal sounds; *Letters for Iris Numbers for Silence:* fifty-one three-by-four-inch filing cards on each of which I'd handprinted one to ten letters that performers may sound in any way and order, and a number indicating a duration of silence; and *A Word Event for George Brecht,* which is realized by one or more performers' choosing one word, name, or phrase, and then speaking its separated sounds (phonemes) and/or syllables, rearranging them into other words, grouping them in phrases or sentences, et cetera [see *RW,* 134–35, where it is followed by its 1971 variant, *Word Event(s) for Bici Forbes,* which explicitly allows singing as well as speaking].

Many of these were performed in Fluxus Festivals and appeared in various Fluxus publications (more about that later), and I have continued during three decades to perform *Word Events* as well as the piece for Sari, both by myself and with others, especially (since 1979) with Anne Tardos.

Then, in 1968 and in the '70s and early '80s, I composed *Vocabularies:* scores that are drawings or paintings on each of which many words that are partial anagrams of a dedicatee's name are lettered. Performers are free to speak any number of words in any order and/or "translate" them on instruments—with freely intervening silences [see *RW,* 279–83 and 293–305 for some *Vocabularies* and poems derived from *Vocabularies*]. These, as well as the *Gathas, Word Events,* and so on, have been performed by myself and others all over the world.

But all these pieces where the performers have so much freedom were, it seems, composed after you wrote and first performed the Stanzas *and wrote most of the* Asymmetries. *Am I right?*

Yes—beginning in December 1960. (I'm afraid I'm weaving back and forth in time!) Till then, performances of my simultaneities were constrained by strict chance operations. For instance, in performances of *SfIL,* the separated stanzas and paragraphs of all the works that later appeared in the book—typed on filing cards (shuffled before each performance)—were read in random order. Each reader had a pile of the filing cards, a pile of playing cards, and a pack of small cards with numbers on them, and some sound makers. The playing cards determined how you should say the words on each card: loudly or softly, rapidly or slowly. The number pack determined how long the reader was to be silent at the ends of lines and between text cards and when to produce nonvocal sounds.

So there'd be several packs of cards?

Yes—but only for performances of *SfIL.* The shift to performers'-choice pieces was gradual: during rehearsals of *The Marrying Maiden,* Judith Malina had provided an arbitrary scenario of actions for each scene. (I hadn't specified actions—only speeches and how they were to be delivered.) I found Judith's action scenario too limiting and rigid, so I wrote a large number of action directions, which the painter Iris Lezak lettered on about fourteen hundred playing cards. They include both such simple actions as "Walk forward ten paces" or "Bow to nearest actor" and more indeterminate ones such as "Do something romantic" or "Do something fierce." The dice player Judith had added to the cast not only turned Cage's tape on and off when he threw sevens, but, when he'd throw an eleven, he'd hand an action card to the actor who was to speak next, who was supposed to perform the action during her or his next speech. However, some actors "saved up" a group of cards and used the actions to improvise little scenes with each other. Some got very adept at making such improvisations.

What did you think of that?

At first I was taken aback at this breach of the "rules," but I came to like it very much. It made me realize that I could allow performers ordinary freedom of choice within a non-intentionally determined situation (one constrained by such means as chance operations and systematically random selection and/or by a score composed by such means). This led directly to my writing the pieces I've described that allow so much choice to performers. So I may owe that whole side of my work to Judith's scenarios and my reactions to them! (However—eventually—I think I'd've gotten there anyway—but maybe not so soon.)

By that time you seem to have been working—or participating—quite widely, with composers like Cage and with a drama group like the Living Theatre.

Outside of Cage's writing the music for *The Marrying Maiden,* my only direct participation with him (until recent years, when I figured in several Cage "festivals" and conferences) was when, after he invited me, I attended intermittently his course in experimental music at the New School for Social Research [New York, c. 1957–60]. As to the Living Theatre, I worked on and off with Julian and Judith from 1953 to 1961 and helped them build their theater on Fourteenth Street in New York. (I first showed them the speeches from *The Marrying Maiden* on the subway one night in 1959 after we'd been working there together.)

Were you associated with other groups? Had Fluxus begun?

No, no. Fluxus wasn't yet even a gleam in George Maciunas's brain! Fluxus first appeared later—after September 1961, when Maciunas left New York. I think it was his response to a series of concerts that the composer La Monte Young had organized at Yoko Ono's loft studio on Chambers Street [New York, October 1960 to May 1961]. Each composer, choreographer, or other artist was given an evening and an afternoon in which to present his or her works. Mine was my first "one-person show." It involved a lot of performers, since it included a play, simultaneities, piano pieces, and so on, the earliest being some of the "5 biblical poems."

Then in June 1961 the poet Frank Kuenstler asked me to participate in a "variety program" at George Maciunas's AG Gallery on Madison Avenue near Seventy-fourth Street (not far from the present site of the Whitney [Museum of American Art]). I presented my play *Verdurous Sanguinaria,* which had premiered in my programs at Yoko's in April. (The performers at Yoko's had been La Monte Young, the poet Diane Wakoski, Simone Forti, and myself; at the AG, Iris Lezak performed the role Simone had taken at Yoko's.)

For many years I thought that—because of this performance at the AG—I was the link between George and the 1960 New York "avant-garde." Before that, except for some works of his own, he'd shown derivative abstract expressionist work at the AG and presented good ancient music programs on Sundays, played on authentic instruments he'd imported from East and West Germany.

Now I think I *wasn't* the only link. La Monte Young had come from California to New York in summer 1960—to study with Richard Maxfield, who introduced me to La Monte that summer during a performance of *The Marrying Maiden.* Richard (who died in 1969) was a very original electronic composer to whom Cage bequeathed his New School course in experimental music in 1960, when he left New York to teach at Wesleyan University in Connecticut. Richard turned it into a course in electronic music that he taught at his home/ studio. Not long ago La Monte told me that George showed up at Richard's class sometime *before* we gave the play at the AG. So that was probably Maciunas's first contact with the New York "avant-garde" of that time.

In any case, right after we'd performed my play at the AG, Maciunas projected four series of programs there of avant-garde instrumental, verbal, performance, and audiotape works. I had two programs of my own works, one mostly instrumental, the other mostly verbal and performance (including Simone's first performances from my nuclei cards), and some of my early audiotapes were played in a tape program.

Sometime in June '61 Maciunas asked La Monte and me to come up to the gallery so he could take our pictures for advertising flyers. Before that—in late '60 and early '61—La Monte had collected a wonderful group of works from innovative artists all over the world for an issue of the magazine *Beatitude East.* Its editor, Chester Anderson (who later performed in my April '61 programs at Yoko's studio), had invited La Monte to edit an issue and include anything he wanted—music, poetry, performance works, concept art, essays. La Monte collected many works (including twenty pages of my own work), but eventually Chester was unable to publish the issue and, after a short disappearance, returned the manuscripts. We mentioned this collection to Maciunas while he was taking our pictures. His response was, *"I'll* publish it—I've got lots of paper!" And he *did*—he had all *kinds* of paper in a back room of the AG.

But gradually the AG Gallery decayed and died. George and his partner owed money to everybody—including the Internal Revenue Service. We gave the last programs there by candlelight. Eventually George had to fly off to Wiesbaden just ahead of the IRS and his other creditors. But just before he left, he designed—sitting for three days solid at a drawing table in a friend's loft—what was later published as *An Anthology [AA]*. Then George gave a small deposit to a downtown printer and flew off, leaving La Monte and me to produce the book ourselves. (I did a lot of the production work because La Monte couldn't stand the printer, who periodically had to be stimulated by new infusions of money.) We finally got *AA* out in May 1963, nearly three years after La Monte began collecting materials for *Beatitude East*.

While Maciunas was designing *AA*, he asked its contributors (many of whom were help-ing to type it) for pieces not in it that he might be able to use some way in Europe. Later, in December 1961, several of us received directives from Wiesbaden informing us that we were editors of something called "Fluxus." George conceived it first as a series of antholo-gies. Later he projected concerts—the so-called Fluxus Festivals presented eventually in Wiesbaden, Cologne, Paris, Copenhagen, and elsewhere.

While some whose works were played in them participated in the Fluxus Festivals, I didn't. (I had no money for traveling.) But several of my 1960–61 pieces were performed in them—my first European performances—and were included later in Maciunas's Fluxus newspaper *(V TRE)*, in his first Fluxus anthology, and on Fluxus "scrolls." *AA*, however, is definitely *pre*-Fluxus. La Monte edited it, and George designed it before he ever thought of Fluxus—or at least before he ever spoke of it.

What later became known as "Fluxus pieces" had two main models: La Monte's *Composi-tions 1960*: musical and performance works whose scores—many of which were written in California before he came to New York—were short descriptive paragraphs (eventually pub-lished in *AA*); and George Brecht's card pieces, composed from 1959 to '62 and—beginning sometime in '61—mailed to friends [and eventually collected in the Fluxus box *Water Yam* ([New York]: Fluxus, n.d.), arranged by Brecht and including signed cards by him and anon-ymous ones by Robert Watts]. Brecht's most characteristic card pieces are extremely laconic, and "demonstrative" rather than descriptive, for example, "WORD EVENT / • exit" and "SIX EXHIBITS / • ceiling / • first wall / • second wall / • third wall / • fourth wall / • floor." (All of La Monte's 1960 compositions and most of Brecht's card pieces were written long before Fluxus was "founded" by Maciunas.)

Brecht's earlier work included elaborate chance operations. He'd attended Cage's New School course, one of several artists—such as myself—that John invited to take part in it. Cage had learned about my early nonintentional work from our talks together and from having seen much of it, and Brecht, who'd written an essay on painting by chance opera-tions [later published as a pamphlet by Something Else Press], had corresponded with him. I got to the class as often as I could; I think Brecht attended it more regularly. Other people, such as Dick Higgins, were registered students, and the class also included composers of Happenings—Allan Kaprow and Al Hanson.

Maciunas thought works such as La Monte's and Brecht's and also Dick Higgins's *Constel-lations*, as well as the later Fluxus pieces derived from them, furthered a transition to *no* art by teaching people they could take an "art attitude" toward *anything*. He still thought this way as late as '64.

For instance, by producing works like La Monte's *Composition 1960 #5*:

Turn a butterfly (or any number of butterflies) loose in the performance area. When the composition is over, be sure to allow the butterfly to fly away outside. The composition may be any length but if an unlimited amount of time is available, the doors and windows may be opened before the butterfly is turned loose and the composition may be considered finished when the butterfly flies away.

6 • 8 • 60

or George Brecht's *PIANO PIECE, 1962:*

• a vase of flowers on (to) a piano
G. Brecht
1962

Maciunas hoped to teach people that they could take an "art attitude" toward any ordinary thing or happening, after which artists wouldn't be needed. They could then take their places in a future "socialist" society as productive workers.

Did you feel sympathetic toward this attitude?

No. Not at all. I didn't share this idea of George's. I've never had any anti-art attitude whatsoever. I wanted (and still want) to *expand* art to include a good deal of ordinary life, but not to destroy art in any way. Whereas Maciunas felt all these smart people were wasting their time making art, and that pieces like these could show such people they could do something useful and productive instead. I don't think many of the people in the group George encouraged—by producing performances and publishing—shared his anti-art attitude. Henry Flynt opposed art for a while—but his ideas were quite different from George's.

It sounds a little like the Dada movement. Their more extreme manifestos sound anti-art, but when you look at what they actually did, you realize they were usually very positive creators.

I think what's different is that several of the Dadaists were consciously "doing anti-art." But hardly anybody in the Fluxus group (except Maciunas and maybe Flynt) felt they were "doing anti-art."

Did they think they were doing neo-Dada or rediscovering Dada?

No. I don't think so. No one was interested in repeating Dada. I doubt that La Monte knew much about Dada, though Brecht probably did. Marcel Duchamp profoundly influenced Cage, who became a close friend of his (and brought him to Henry Flynt's lecture in La Monte's series at Yoko's), and both through Cage and directly his ideas significantly affected the work of Bob Rauschenberg and Jasper Johns as well as many so-called Fluxus artists. But the input of other Dadaists was minimal.

I myself have been influenced since the early '40s by Kurt Schwitters, who called himself and his work *Merz* rather than "Dada." He explained the term as follows:

I called my new manner of working from the principle of using any materials *MERZ.* That is the second syllable of *Kommerz* [commerce]. It originated from the *Merzbild* [Merzpicture], a picture in which the word *MERZ,* cut out and glued on from an advertisement for the *KOMMERZ-UND PRIVATBANK* [Commercial and Private Bank] . . . [later] I expanded the title *Merz,* first to include my poetry . . . and finally to all my relevant activities. Now I call my-

self *MERZ*. (Excerpted and restyled from translation by John Elderfield in his *Kurt Schwitters* [London: Thames & Hudson, 1985] from *Merz 20. Katalog*, Hannover, 1927, 99–100)

Schwitters was never anti-art. He was always consciously making art. I came across his work soon after arriving in New York in 1943. The poems in my recent book *42 Merzgedichte in Memoriam Kurt Schwitters* [Barrytown, N.Y.: Station Hill, 1992] were derived from various writings by and about Schwitters—the first impulsively, the next twenty-nine by systematically random selection (via computer), the last twelve from earlier ones by special computer programs and rule-guided editing of their outputs.

My attitude has long been much more like Schwitters's than like Maciunas's. I'm strongly convinced that you can use anything to make art, and I think I believed this even before I discovered Schwitters. He merely reinforced this attitude, which has led me to use everything from newspapers to great books—anything I happen to be reading—as sources for writings, as well as all kinds of detritus and found objects and words in visual works.

What have you been writing lately?

For about ten years I've been writing many so-called intuitive poems (I'll explain in a minute what I mean by that) parallel with writing by nonintentional methods. And during the last few years I've also been using computer programs to help me write other poems with the words of my own intuitive poems.

In 1989–90 I wrote a hundred twenty-line poems (called *Twenties*, because each poem had that number of lines), which I began in February '89 while commuting between New York City and Binghamton, where I was teaching at the State University of New York. They were written in buses, airplanes, cars, taxicabs, and Venetian *vaporetti*, as well as in hotel rooms and private homes (including my own) in this country and Europe. They are made up of asyntactical strings of single words, and occasionally phrases, separated not only by line and stanza endings but by caesural spaces of different lengths within the lines (i.e., various durations of silence).

I wrote them "directly" and spontaneously—without using chance operations or other nonintentional methods. Most of the words and phrases came to me immediately from my own mind—but some I saw or heard while writing—and I wrote them down immediately. I did very little verbal revision, mostly to eliminate repetitions of a word within a poem, but I often revised, inserted, or deleted spaces signifying caesural silences. The series was finished in Italy in June 1990 and will be published by Roof Books, New York, in fall 1991.

How did you use computer programs with these poems?

I typed the two thousand lines of *Twenties* into the computer and ran them through one or more programs: Diastext and Diastex4 are automations of my diastic reading-through selection method. They were written by Charles O. Hartman, a poet and critic and professor at Connecticut College in New London. Travesty was written by the critic Hugh Kenner and the computer scientist Joseph O'Rourke and utilizes letter-combination frequencies in English. Besides the *Twenties* and other poems of my own, I've also used other sources, such as, Elizabeth Anscombe's translation of Wittgenstein's *Philosophical Investigations* and poems by Emily Dickinson, Walter Savage Landor, Ezra Pound, and Rosemarie and Keith Waldrop.

I might mention that I often modify the outputs of computer programs, especially lately. I change formats, punctuation, and sometimes even syntax. As in writing "from nuclei," I

enjoy *interacting* with the products of nonintentional systems, and when so much is done *for* me by computer programs, I'm inclined to do more myself.

Have you used computers to modify the sounds of poems as against generating their texts?

Yes. I'm presently working on a three-minute piece for "The Museum within the Telephone Network" of the Nippon Telegraph and Telephone Company [NTT]. When the project is completed, anyone in Japan—or elsewhere—can call in and hear my piece, whose words I drew from a nine-page list of definitions and synonyms of "communication" and "communications" I'd compiled from several dictionaries. I'm working at the Brooklyn College Computer Music Studio (which is directed by the composer Charles Dodge) with the composer and computer programmer Curtis Bahn, who has developed a number of voice-modification programs and also systems by which he may enter digitally recorded speech and other sounds directly into a computer and superimpose "layers" of them within the computer.

For the NTT piece, my wife, Anne Tardos, and I each recorded solo readings of parts of my list, with silences between the items. Then we recorded one "layer" in which we read together softly, and one in which we whispered. Finally Curtis composed two "layers," from what we'd already recorded, by modifying our voices in various ways by means of his unique software. (He knows my work, so he used nonintentional methods to sample and modify segments from what we'd already recorded.) So the final work will comprise ten superimposed "layers." Curtis is presently preparing several different mixes, from which we'll choose one for the NTT "museum."

I've also substituted periods for paragraph breaks in my "communication(s)" list and then I've run it through Travesty and rewritten its output thoroughly, making different sentences out of it, some that "make sense" and others that are more or less absurd. Thus I've used the same material in two quite different ways: in a complex "sound" work derived from live readings of parts of the list by means of specialized voice-modification and mixing software developed by Curtis, and in computer-aided transformations of the list into sentences.

Are you happy with the "sound piece" produced by this collaboration?

Yes. Very much so. Anne and I have often collaborated in performances and recordings, and I'd been wanting to work at the computer music studio for a long time. Dodge is a composer who often works with verbal materials and has developed voice-modification software over many years. He's been wanting to work with me since 1970, when we both participated in a radio program directed by Richard Kostelanetz and recorded for the Voice of America, though it was never broadcast. Then in 1989 Anne and I met Curtis in Graz, Austria, at an art and science conference and festival organized around chaos theory. It included poets, composers such as Warren Burt, an American-born composer who lives and works in Australia, visual artists, and scientists working in mathematics, physics, biology, and other fields.

What were the main things the collaboration added?

The modified-voice sounds—myriad audible-range variations on all the parameters of speech—and the mix itself, in which the amplitudes of the unmodified speech sounds are adjusted to each other in various ways. The result is a "sound piece" with a continually changing texture.

Would you call this kind of collaboration avant-garde or experimental work? Is "avant-garde" a term you find useful?

No. I don't use either term.

Do you see this, then, as just working with available facilities?

Yes. I don't care for the term *avant-garde*. I dislike it most because of its military connotations. But also, so many present-day works have characteristics formerly classed as avant-garde—new materials and procedures, new uses of older ones, new approaches to art—that the term has lost whatever meaning it originally had. It's not useful. I often say I buried "avant-garde" around 1970, when I wrote it on a piece of paper that I buried in Dick Higgins's garden behind the house he lived in then, on West Twenty-second Street in New York, a block south of the Chelsea Hotel. I've never liked the term much. I sympathize with the way John Cage uses it, for works and artists that do things that hadn't been done before—new ideas, new genres, new materials, new ways of using materials *that don't duplicate what other people have done.* But I no longer find it useful to call my own work or that of other artists avant-garde. And I don't consider my work experimental—it's just composition.

I know people write very serious books defining avant-garde (and/or experimental) as against modernist—I know the discussion. But I reject those terms as well as "postmodern"—a term that's "ungrammatical," as Wittgenstein would have said. How could something contemporary be "after the modern"? Of course, I know this is a matter of periodization—that "modernist" refers to certain kinds of work produced between 1900 and sometime in the '30s or '40s, and that what's called "postmodern" is another kind of work, produced *after* the modern period—mainly after World War Two. Nevertheless, I find the term very irritating. Insofar as I go in for any "isms" or "ists"—and I really don't—I call myself a "latter-day modernist."

What's your response to the general claim that the "postmodern" or contemporary period is one of stagnation and neutralization—a period without depth and meaning?

I don't understand that. Do you mean that it's purposefully without depth?

No. It's simply claimed that it's impossible to do anything meaningful anymore.

That's bullshit. Critics who say that are just talking about themselves. I'm sure Barthes, for instance, has never said anything like that.

Well, Barthes said that the author and originality were dead, and then changed his mind. But Baudrillard is a great one for apocalyptic statements.

Baudrillard. Yes. But who cares? You know, Adorno wrote [near the end of his essay "Cultural Criticism and Society," in *Prisms,* trans. S. and S. Weber (Cambridge, Mass.: MIT Press, 1983), 34]: "To write poetry after Auschwitz is barbaric." We can share his anguish, but why should we believe him? Many nonbarbarians have written poetry since Auschwitz, and some of it is very good. The scale and cold-blooded cruelty of the deliberate extermination of Jews and others at Auschwitz are unique.

But similar horrors have taken place throughout history. Roman legions fighting

Mithridates VI, the king of Pontus, are said to have put 360,000 people in one city to the sword in one day. And even if ancient accounts are exaggerated, we know that between twenty and thirty million people, by the best estimates, were killed during the T'ai-p'ing rebellion in China (1853–64). In two days alone, July 19–21, 1864, 100,000 were murdered by government forces in the sack of Nanking. Yet a great deal of Chinese poetry was written after that, by many different poets, most of them surely not barbarians. Adorno felt that no one *should* write poetry after Auschwitz. But, you know, we do.

It's also argued that the media are so numbing that we can't do anything with them.

Yes. Well, whoever the media numb—let them wake themselves up! (Some of us think our artworks may help them do so.) I know the Baudrillard rant—that we're only producing simulations of simulations of simulations—but I don't find it interesting or cogent or relevant. I'm convinced that meaning abounds. As I've said, any sound produced by a human voice is meaningful—words or nonwords, normatively syntactical or not. All words in poems are meaningful, whether they intentionally convey messages or not and whether they're brought into the poems intentionally or through nonintentional methods. The perceivers of poems *enact* meanings, at the end of the day, whether the poets *intend* to *convey* meanings or not. (And this is also true of other types of art.)

Wouldn't you rather get a postcard with a message, even if it's only "wish you were here," than something abstract?

I'm not sure what you mean by "abstract." Those poems of my own that are not meant to convey specific messages are "concrete" rather than "abstract": they allow the reader/hearer to perceive language elements—their meanings together with their sounds—*concretely,* unburdened by my own messages or emotions. Most postcards are meant to convey messages—not to function as artworks. However, I've received some very interesting postcards that were, in your sense, "abstract"—in mine, "concrete." They were artworks. An artwork may either convey a message or not. Whether it does so or not and whether it has a connected overall meaning or not are neutral matters. A perceiver may wish to reconstitute an artist's *intended* meaning or to *enact* meanings for themselves—especially from works comprising disjunct elements.

As you know, I often find it very interesting to produce work—by intentional or nonintentional methods or a combination of the two—in which there's a high degree of disjunction between elements or parts. This turns a good deal of the meaning production over to the perceiver. But I also make works having clear connections and messages. One kind isn't superior to the other. Sometimes I want to turn attention to language itself; at other times, I want to say something specific.

Many poets here, during the last twenty years or so, have been making disjunctive poetry, sometimes with the help of nonintentional methods, but usually not. I find much of their work interesting. A number of them are called L=A=N=G=U=A=G=E poets, mainly because two of them published a critical magazine called *L=A=N=G=U=A=G=E,* which highlighted such work. Whether by poets in that group or others, I think some of the most interesting work written lately has been written that way—I mean, so that linguistic units below the sentence level, and/or whole sentences, are syntactically and/or logically disjoined. And such work—even when composed largely by nonintentional methods—can

convey a message, and often does so. Long before such work abounded, I wrote many poems by reading-through and other nonintentional methods that convey political messages.

I think contact with so-called language writing rearoused my interest in intentional, or at least "quasi-intentional," writing. While I'd often produced poetry by nonintentional methods that is syntactically and even logically connected, for example, *The Pronouns* and "The Presidents . . . ," I now began writing disjunctive poetry "nonsystematically"—or as I often put it, "intuitively"—without the intervention of nonintentional operations. [See *From Pearl Harbor Day to FDR's Birthday* (Los Angeles: Sun and Moon, 1982), *Bloomsday* (Barrytown, N.Y.: Station Hill, 1984), and the forthcoming *Twenties* (New York: Roof, 1991) and *Pieces o' Six* (Los Angeles: Sun and Moon, 1991).] While some of my works written this way comprise disjoined but normatively syntactical sentences, others comprise disjoined single words and/or phrases. So that, paradoxically enough, some of my most recent "intuitive" or "quasi-intentional" poems resemble my earliest nonintentionally written works more than my later, more syntactically connected, nonintentional writings.

Do you think audiences or readers confronted with disjunctive work eventually put things together—not necessarily as logically connected semantic meaning, but as something that coheres in unexpected ways?

Yes. Each person who hears or reads this kind of work produces something new—whether one wishes to call it "meaning" or something else. This is, of course, true to some extent of every kind of artwork. But it's especially true of works in which the elements don't cohere through some conventional verbal, musical, or visual syntax or through logical argument or narrative devices such as plots or comparable structural devices in the nonverbal arts.

Meanings produced by their disjoined elements' coming along one after the other, or simultaneously, are different for different perceivers—in performances, for different people in the same room. This happens in the latter case not only because of the variety of disjoined and/or simultaneous elements (and the multiplicity of each element's "intrinsic" meanings) but also through the distribution of speakers and/or instrumentalists throughout the performance space. Every person's experience will be different, not only because of the different meanings enacted, but also because of the physical situation itself.

This gives people a great deal of freedom. I'm very much interested in the various kinds of freedom possible. As I've said, my performance works (for speakers and/or instrumentalists) offer performers many opportunities for choice. I like the kind of free situation where people make choices in relation to everything that goes on, constrained only by what's "in the piece" and what isn't, and by such old-fashioned virtues as tact and courtesy and goodwill manifested in concentrated listening and other perception and carefully discriminating choice. Freedom within such an ethical context is very interesting to me, and for more than thirty years I've been endeavoring to develop artistic forms that advance and encourage freedom—as well as the ethical attitudes and ability to pay attention to other people and one's surroundings that make it meaningful.

But the "audiences," as well as the performers, are also exercising many kinds of choice—both perceptive and meaning-productive. And this is equally true of the readers and hearers of my so-called solo poetry. Most of my work in the arts provides for many types and areas of freedom. And I hope it furthers freedom in the world.

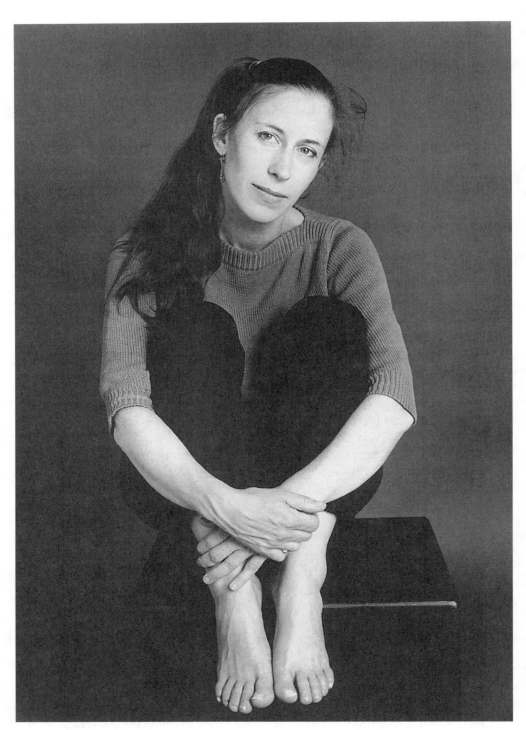

Meredith Monk. Photograph by Bob Shamis.

MEREDITH
MONK

SOMETIMES ONE READS A STATEMENT BY AN ARTIST whose ideas seem so inspiring that one can't wait to learn more about them. Meredith Monk's essay "Sharpening the Senses"—in Connie Kreemer's *Further Steps: Fifteen Choreographers on Modern Dance* (1987)—had precisely this effect on me. Advocating the "breaking down" of categories and the search for "new hybrid forms," it defined her ideal as work which "cleanses the senses" and which "has a freedom to it that is like a prototype of possibilities."

Finally meeting Monk in 1992, and recording this interview over lunch in a small bistro in Tribeca, I was surprised to find that she traced the origins of her multimedia performances to her folk background, "singing ballads to my guitar," as opposed to minimal music's more academic explorations of compositional "pattern and gradual processes of change."

Likewise, rather than single-mindedly advocating the kind of high-tech aesthetic that I'd associated with multimedia performance, Monk observes how "the voice can do anything that electronics can do," and while orchestrating elaborate productions such as her opera *Atlas*, concludes that she would also be "very comfortable singing with one candle—and that's it!"

Generally speaking, Monk's aesthetic advocates highly "flexible" collaborative explorations of available resources, insisting that "one of the reasons for doing art now" is to repair the "numbing" effect of popular mass media, and to inspire people to "fight for change in their own lives" and refuse anything less.

Again, rather than claiming that her work is substantially different from that of the early-twentieth-century avant-garde, Monk suggests that it is both continuous with and sustained by the example of the eclectic independence of modernists like Jean Cocteau—a European role model creating poetry "in a lot of different ways" whom both Kathy Acker and Richard Foreman also cite to lesser and greater degrees.

Several days later, sitting in St. Mark's Church, I watched John Cage and Merce Cunningham carefully weaving their ways to their places to see Monk's wonderful *Facing North*. Five

years later, weaving my way through the Lincoln Center's outside auditorium to see Cage and Cunningham's *Ocean*, I found myself sitting almost directly behind Meredith Monk.

New York—February 5, 1992

Perhaps I could begin by asking you how you would define your practice in the arts? Do you think of yourself as predominantly working with music or with dance?

I guess I would say that the heart of my work is the voice. And because of my background, I don't really separate that from the body. I actually think of it as one thing. Basically I started as a child with a lot of singing and movement as well, and the two of them influenced each other a lot. So I always feel like my voice is dancing and my body is singing. But in terms of my daily practice, the vocal work is the real heart of what I do. Even if I'm working with very large musical theater forms or with film, the musicality of the form is what I'm very concerned with.

How did things begin?

Well, my mother was a professional singer, and her mother was a concert pianist, and I studied piano at a very young age—at four or five years old. I also had some coordination problems, so my mother took me to Dalcroze eurhythmics, which is a movement discipline, dealing with music through the body, thinking of sound as space, a notion that remains a basic premise of my work. That was a wonderful way of learning music, and a wonderful way of learning moving. So through my whole childhood I was basically working in both disciplines.

In high school I took theory and harmony, sang in the large and small chorus, and was beginning to do my own choreography (I had studied dance up to that time). And after that, at Sarah Lawrence College, I was doing what was called a combined performing arts program (which the college allowed me to design myself). My program included classical singing, opera workshop, and some music theory. I was also writing compositions for voice and piano, studying dance technique and composition and theater—so I was following my interests. My years at Sarah Lawrence were very stimulating and liberating. Thinking back, I definitely had glimpses of how I wanted to combine those forms even at school, because I was doing my own pieces there, trying to weave the elements together, one way or another.

Was that an entirely personal ambition, or were you aware of the experiments of the early twentieth century?

I wasn't at that time. It was a very personal thing I was trying to do—to integrate those interests and by extension myself, you could say. But I always think the microcosmic impulse seems to match with the outside world. For example, at the same time I was in college, the Judson Church movement was going on in New York, and in the later years that I was at school I started seeing some of the concerts. There was a big impulse at that time to break down barriers and to find new ways of putting things together, and there was a wonderful, very inspirational exchange between artists from different media.

Which artists were you most aware of?

Well, I got to New York in 1964, and the Judson Dance Theater formally had been abandoned. But it was still a performing space, and there were still people who had been in the Judson Group who were doing concerts. So I was certainly aware of Yvonne Rainer's work, Lucinda Childs's work, Robert Morris's dance pieces—which I thought were wonderful and fresh since he came from a visual arts background. I also remember Carolee Schneemann's early work, Elaine Summers, Sally Gross—lots of people who worked in the Judson Dance Theater. And then I was aware of Philip Corner—what he was doing in music—and Jackson Mac Low, the poet.

When I first came to New York, I realized some of Jackson's Poems for Dancers, and I performed in Dick Higgins's work. They were welcoming to me as a performer, and I became very much part of the end of the Happenings movement. For me that was very interesting, because in a very improvisational way, I could fulfill my different interests. I would sing in some pieces, move, change persona, create visual images. I was also very committed to creating and presenting my own work (that was really my priority), and was able to do both of those things at the same time, the first year that I was in New York.

Did you find your work comparable to the Fluxus aesthetic?

At the very deepest level, I was always more interested in magic and in a certain kind of theatricality. What was wonderful and refreshing about the Fluxus work was that it was delineating the particular magic in concrete and ordinary reality. I always found that inspiring, but looking back my work always had a kind of metaphysical aspect to it as well. I loved the immediacy and freshness of what they did, and I felt very close to their idea that you could use anything as material in your work. But the more mythical or mystical aspect of my work was something that had a different feel from what they were doing.

Presumably it's also at odds with minimalist aesthetics?

Definitely. There were things about the minimalists that I admired very much. But for me it was very difficult to fit the way I thought about things into that aesthetic, as much as I appreciated it. It was like trying to squeeze a circle into a square, because I think there was always a sense of multiplicity in what I did, and I was much more interested in the primal, emotional qualities of the voice.

Whereas the minimal aesthetic usually seems more cerebral?

Yes—but I also think it came from what that group of composers was reacting against, so it's a generational thing. For example, in dance, a lot of the work that people at Judson were doing was in direct reaction to, say, someone like Martha Graham, or that kind of 1950s modern dance that was very attenuated and so laden with symbols, images, objects, psychology. It was loaded with so much that there was an impulse to just break through that and get to something that was very clean and very real and in a sense, very honest and raw.

A lot of the people who were at Judson were also working with Merce Cunningham in one way or another, and it was clear that he had made that kind of leap. He had made the liberating move of eliminating the literary content from dance. But in the next generation there was also a reaction to the trained-bodies aspect of what Merce did, because he was still

working within that very technical kind of dance form—that very formal movement which required certain types of bodies and skills.

What was going on in Judson was the process of seeing the beauty of something that you would think was very ordinary, but had so much integrity and authenticity in it. I think that was what was happening for that generation. I felt very strongly about it too—I really liked seeing the humanity come out first. So what would be called clumsy, I thought was interesting!

Were you influenced by minimal tendencies in music?

No, I really don't feel I was particularly influenced by minimalism. At the time I began working with my voice (that would be in 1965), I was aware of the minimalist movement in the visual arts. I saw exhibits by Donald Judd, Robert Morris, and Carl Andre, but I had never heard music which is now referred to as "minimalist." You know, I always have a problem with these labels anyway. My musical influences at that time were Bartók, Stravinsky, Satie, Perotinus (and medieval music generally), and rock and roll and pop music. My process began with digging into the physicality of my own voice, exploring and expanding its possibilities. What would be called repetition in my music—and actually, there isn't really a lot of out-and-out repetition (if you listen carefully each phrase is slightly different)—is more what I would call an instrumental carpet for what I'm doing vocally.

I always think of the voice as flying or jumping over a very stable kind of base, and that comes from my background in folk music and rock and roll. I was a folk singer in high school and in college—I was singing ballads with my guitar and I was in a rock band called the Inner Ear. So when I first started my own vocal work, I did think of it more as song structure. At that time I was working with electric organs, and that repetitive underpinning of the instrumental aspect came much more from the need for accompaniment to the vocal material that had more freedom. That's basically where it came from.

Whereas I think that in their own different ways, Philip Glass and Steve Reich—who are two artists I respect very much—were dealing with pattern and gradual process of change, as a reaction to coming from a conservatory background, where developmental structure was a given. Since I was working as a vocal composer, I thought more of song forms, and then the music branched out from there. Basically, I think of myself as a composer of vocal music.

Does this imply a warmer rather than a cooler aesthetic?

The human voice is a very direct connection to emotion—it comes from the center of the body and it goes out. In that way it is very organic, which by nature implies human warmth. Yet I never think of someone like Steve Reich's music as being cold—I always was very moved by it. I would say that for both Steve and Philip, it seems like the core and the beginning of their thinking are more instrumental, although one can never speak for someone else. Many of the things I do for the voice are very instrumental—the voice as an instrument is one of my basic principles—but I never forget that it is the first human instrument. So I always want it to have that quality of very primal and essential utterance.

Where does that leave you in relation to electronic sampling devices and the use of live and recorded voice?

I think the voice can do anything electronics can do, so I'll tend to try to get whatever I can from the human voice itself—from the live voice. But I'm not closed to electronics. My opera *Atlas* is scored for an ensemble of ten instruments, which is the most I've ever used. But the two keyboards are samplers, because otherwise we would have had to have pianos and electric organs in the pit, and so the sampler made it a lot easier for us to get different sound textures from a keyboard instrument.

But I don't think I would ever use a sampler as a substitute, say, for a live instrument. And I think in terms of distorting the voice, it's more interesting to actually do that live. I'd like to try to continue just going as far as I can with that, before I have to resort to electronic manipulation. And I do like the interaction that happens working with other people.

Do you mean with other performers or with the audience?

Both, both. At a young age, in my twenties, I realized that my personal quest of trying to integrate these different elements in live performance—not only for my own reasons but as a philosophical belief—was a way of conveying or embodying a form which affirmed the richness and complexity of the whole human organism—not only the performers but also the audience members as well.

And I felt that a multiplicity of perceptual modes woven into one form was very indicative of the world we live in now. Whereas the European tradition was very much about separating elements and devoting one's life to being a specialist, I think you could say that our contemporary world requires a nonlinear, simultaneous, mosaiclike way of perceiving. It seems very important to create an art form which reflects that—and then also, in a sense, to give the opportunity to the members of the audience to sense the fullness of their experience and all aspects of themselves.

This seems a rather more positive notion than the claim that postmodern art consists of predominantly cynical or playful mosaics of references in which nothing is really affirmed or clarified.

I think there's something very important about work like that, because it's a real mirror image of a particular time. But I would say that I'm much more interested in recurrence—in a more cyclical consciousness of time. So basically, what I'm interested in are things that have always been in the world and always will be. And that implies a kind of spiralic layer to that mosaic—it's still mosaic, but there's also a spiral within it.

Are you primarily interested in rediscovering things from the past, or are you also utopian as well?

I would say both—I would say it's past, future, and present. In a way, it's like affirming roots in the past, in order to be able to live fully in the present. And in the same way, to be utopian, to live fully in the present. It's basically just trying to find a way to be in the moment, and to be as now as possible—and to make a performance form that offers an audience that sense of immediacy.

But I actually don't think you can do that fully if there's no sense of roots. I mean, everyone always says how antitradition I am, and in some ways I am. But human tradition also needs a sense of acknowledgment and appreciation. I don't necessarily mean traditional marriage or traditional rules, but I mean the tradition of passing wisdom on from one generation to the next.

What are the most important aspects of this process in your work?

One aspect is always trying to get down to very essential expression, a sense of going back to the beginning—the beginnings of utterance, the beginnings of movement, the beginnings of theater, the beginnings of storytelling. In every piece I do, I start with the unknown; I try to wipe the slate clean every time. And that in a way—that thing of trying to get down to basic goodness, you could say, does have to do with the most general sense of human tradition. And I don't mean basic goodness meaning only angels—I mean basic goodness including all aspects of life.

Is that easier inside or outside New York?

Well, I sometimes long to not live here. And it's interesting because there was a certain period of time in the early '80s when *Turtle Dreams (Cabaret)* and *Turtle Dreams (Waltz)* tried to address the fact of living in an urban environment. I felt it was very important for me to explore this strand, which has continued throughout my work. But the process of nature seems to be more of an ongoing source of inspiration.

Was Quarry *similarly empirical in quality?*

Quarry dealt with history—with an event that really happened in the world, and trying to make some sort of sense of it aesthetically. It was almost like working on a documentary and yet transforming those events into poetry. And *Ellis Island* was also like that, and so was *Book of Days.* All three pieces were dealing with history as a kind of springboard to other perceptions.

How do they compare with more recent work like Facing North?

Facing North was much more inspired by environment, like *Songs from the Hill,* which I wrote in New Mexico. I was up in an artist colony at Banff, Canada, working on *Atlas,* surrounded by days and nights of silence, snow, and cold. I hadn't really experienced that bracing weather and stillness since I was a child. I ended up making *Facing North* there because it was so inspiring. A very essential landscape experience, the most direct kind of inspiration—environment!

Discussing Atlas *you've suggested that both opera's audience and very substance seem likely to change over the next twenty years.*

I hope so, because the potential of the form still fascinates me, though what's been done with it disappoints me. But the idea of it is still for me the closest that you can get in this Western world to an integration of music, movement, visual image, and storytelling in one way or another.

Are you more enthusiastic about non-Western opera?

Yes, I am. In Kabuki theater I think there's a fluidity of performance—the form itself is very fluid. I love the way it changes mode very quickly and very gracefully. In Kabuki theater you might have a narrative—a story—and then in the middle of that suddenly go into a section with nothing happening at all except that the instruments are played and the stagehands

Meredith Monk and Robert Een, *Facing North,* 1991. Photograph by Joyce George.

bring in three trees, and then it goes back into narrative again. It's so refreshing—it's like a slip from one reality to another, a shifting foreground/background relationship. Another thing I like very much is that the performer is required at one moment to sing something, and at the next moment to do movement, and the next moment be an actor, the next moment be an object—there's a total fluidity of modes.

Is that easy to achieve? You've described how Atlas *required virtuoso singers who could relax onstage and sing in a nonoperatic manner.*

Some of the music was composed before I saw the performers, but then I did some more music based on working with them for a month and hearing their voices and getting to know them. The movement was also very integrated with the music, and so I would have to make adjustments. It was very challenging because in a way I was composing all the elements at the same time. But I think that's what gives me pleasure.

In the old days I wanted to have total and utter control over every last thing. But at a certain point you just have to trust people you're working with, let them have some freedom as a way of showing respect for them as artists in their own right. And so, although I always have a clear conceptual basis for what I do, I feel I've loosened up a lot. If you hold too tightly you're missing out on many possibilities that might not have occurred to you.

On the other hand, there is something refreshing about not knowing so much about a particular medium. I think the way I've worked in films, I've done things that somebody who had gone to film school would never do, because I really don't know that you're not supposed to do this or that. When you come to another medium, you look at it freshly, and you don't have the same kind of boundaries or limitations as people who are working in that

medium. But it's also very satisfying to know how my cameraman, Jerry Pantzer, looks at something, because he may see some possibilities that I would not naturally think of.

It's very much a kind of give-and-take, especially in something like film and theater, where to make a large piece or a large film you have to collaborate. If I'm working on a solo then I can make my own costumes or whatever it is. But if you're doing a film, you're—just by nature—working with a lot of people. You're trying to get your vision up onto that screen, and it's a collaborative medium—there's no way around it.

Have you been pleased with audience responses?

We've been very lucky these last ten years. I think there's something about the music not having a text basis that allows audiences all over the world to respond. I think we're dealing more directly with the emotions—and an audience member doesn't have to literally walk through text to get to what we're doing. So in that way, I feel we've had very strong responses to the work over the years—particularly the music—because it's so direct.

What about mainstream theater and opera audiences?

Well, when we opened *Atlas* in Houston, which I guess is about as mainstream as I've ever gotten, the tuxedo crowd definitely left after maybe ten minutes of the piece. The people who stayed were very enthusiastic. But there were some people who were not willing to be curious.

Do you think television and video represent an eventual means of making such work more available?

I think so. I mean, there's a lot that gets lost in video. I feel that video does not convey energy very well—it just really conveys shape and surface. But any way that we can educate our potential audience is very useful. I'm very worried about the next generation—the children's generation—because I think the emphasis upon television in this culture is depriving them of imagination, and it's limiting their patience and the desire to seek the commitment of deep involvement.

I don't watch television that often, but if I'm on tour I go right to the television set in the motel room to find out what children are watching. And the level of bombardment and speed is so overwhelming that you realize they're being taught to not be involved—they're being taught to have things hitting at them, very fast and very aggressively.

Or they're being taught to read very quickly?

Yes, but then every image is equal to every other image. There's nothing wrong with that as a modus operandi, but I think that discriminating intelligence gets somewhat atrophied. And yet, this generation is fluent in the language of images and in the concept of time as nonlinear, two aspects that have been important to me and a number of other artists.

In other words, your work advocates less speed and demands—or invites—a certain degree of patience?

Yes. I would like to think that my work offers a time and place to break habitual thought patterns if only for a short while, to experience reality in a fresh way.

Many critics argue that the mass media bombard us with fragments of culture and that we're left incapable of responding.

Well, I think this thing of being bombarded by shards of culture is very interesting. Basically what happens to me when I'm bombarded by something too long is that I just start numbing—I just get completely numb. And in a sense you could say that one of the reasons for doing art now is to provide the antidote to numbing.

It really is time to see if there's a way of getting back to not living in a sleeping state. It's like waking up the senses and waking up the perceptions and waking up insights. I think part of it is being able to get breath back in, because when you are bombarded, with no air, you just don't feel anything—and that situation is part of the hold the dominant culture has on so many people.

But both live and technological performance can sometimes help restore the senses?

Live performance offers a figure eight of energy between the performer and the audience. The vulnerability of the performer becomes part of the power of the experience. Technology offers other dimensions and resonances. The senses can be stimulated in myriad ways. We all use technology for what it can do. I certainly sing in front of a microphone and I use lights, although I also feel that I'd be very comfortable singing with one candle—and that's it!

But basically I think what we need to do now, all of us—as human beings and as artists—is just to learn how to be incredibly flexible. I think that's why the hard times in a sense are kind of interesting—because what they're calling upon us to do is to be very fluid and very flexible with what comes up.

And your work tries to activate this kind of flexibility?

Yes. I would say I do have a very strong belief in the art process as a healing process, and it's very necessary in the world we live in now that there's some place where people can actually experience alternative ways of behavior—in terms of the people who are performing and what's being performed and the basic situation, which I'd hope would be as openhearted as possible. Maybe experiencing that would make people want to fight for change in their own lives—so that they would want to have that quality of life and wouldn't stand for less. I guess that's what I think art can do.

I would hope also to try to do artwork that's life-affirming. I don't mean that it doesn't include darkness, but I'm saying that it does have an affirmation of life energy one way or another, and a certain kind of vitality. That's what I would hope to be able to pass on to society.

When I read your statements in Connie Kreemer's book Further Steps, *I thought it was one of the most lucid meditations upon multimedia culture that I'd read since John Cage's* Silence. *Could I ask how you respond to Cage?*

I am very privileged to be a friend of his. To spend a few minutes with John is probably more inspiring—certainly on a spiritual plane—than almost anything I can think of. If I have that kind of vitality, mental acuity, and alertness at even ten years younger than John I'll be happy. I feel I have learned so much about *being,* just by being around him.

It doesn't mean my aesthetic has to be the same, but I just have tremendous respect.

I guess the thing I admire so much about John is that he still is very, very curious. He's kept his curiosity and a freshness and wonder about every moment—and so he always is growing and changing. That's a big inspiration.

Do you share Cage's sense of the increasing overlap between Western and Eastern cultures?

Well, when I did my first full music concert in 1970 at the Whitney—it was called *A Raw Recital*—a lot of people came up to me and said things like, "You know, the things that you're doing sound like Balkan music. Have you ever heard Balkan music? Go and get such and such a record." So I heard the record and liked it very much. This would happen from time to time when I'd do my concerts—people would suggest another ethnic record to listen to.

What I realized at that time was that by my explorations of my own vocal instrument I'd come upon the fact that in the human voice there are certain transcultural qualities. Just by my own explorations I had found things that existed in a lot of different cultures—and that indeed are a part of a world vocal family! On top of that, intuitively I had been working with what I would now call archetypal song forms—lullabies, marches, love songs, laments—and those things also exist in every culture, and yet I was finding my own personal versions of those impulses.

So that's been one whole branch of my work over the years that has given me a great deal of comfort—knowing that when you work with your vocal instrument you are part of the whole world. And then the other side of that—and the paradox—is that each of our throats is totally unique. There is a universe to explore in each of our voices.

Presumably, too, even your more abstract songs have a partially New York quality and would take Balkan audiences by surprise?

Yes. When we performed in Yugoslavia two years ago they were absolutely stunned, as though it were something completely and utterly new for them! I remember when I did my first album, *Key,* in 1970, Edwin Denby said, "This is Manhattan folk music." But I guess that now I travel so much, I feel so much a part of the world that I just don't put so much energy into thinking I live in New York and I don't feel that I need to be there to work. In a way, I guess as I've gotten older I just feel more independent from where I live.

Do you feel equally independent from time frames? Would you say your art represents a shift from the '60s, '40s, or '30s?

I always think of time as a circle. So when I think of the '30s I think of someone like Cocteau, who I feel always gave me a lot of courage—not because his sensibility was the same as mine, but because he was a person who was dealing with a lot of different elements, yet everything he made was poetry. I felt very close to that. His spirit has sustained me in times of depression.

So in that way I feel that what I'm doing is not so different from what he did, and what artists in the '20s or '30s or '40s were doing. But I'm just doing it in my own way. I think that's what we're all doing. There's really nothing new under the sun—it might be just seeing it in a different way.

Nam June Paik. Courtesy of Electronic Arts Intermix (EAI), New York.

NAM JUNE
PAIK

ON LEARNING THAT THE NEW YORK VIDEO ARTIST NAM JUNE PAIK was in Sydney for the 1990 Biennale, I managed to ring him at his hotel, recording the first of our interviews by telephone from Brisbane, before recording the second interview in Sydney.

What, I wondered, were Paik's intentions when assembling the monumental installation—*Beuys' Voice*—that I'd seen three years earlier at the 1987 Kassel Documenta, and then in a rather more modest version in his 1988 Hayward Gallery retrospective in London?

To my surprise, Paik initially discussed this work primarily in terms of its financial logistics, claiming that artists "don't really set out to do any concrete objectives . . . we start from a few given conditions." Consolidating this suggestion of aesthetic indifference, Paik added that he didn't care which version of *Beuys' Voice* was presented, apart from the fact that "the computerized version was more expensive—that's all I care!"

Quite clearly, this was not the whole story. Relating how he had first studied and then abandoned semantic theory, in order to use his time more "productively"; remarking how delayed commercial success had allowed his work to develop several stylistic phases, since he had "no reason to hang up into one style"; and generally arguing that intellectuals should "give up certain parts of intellectual vanity, and look at the good parts of so-called high-tech research," Paik increasingly indicated the distinctive independence and integrity of his aesthetic.

When we met in Sydney three days later, Paik further emphasized the way in which the Fluxus group successfully downplayed notions of "national hegemony or personal hegemony"; explained how he wanted to "handicap myself and do low-tech video" to compensate for relatively easy access to "high-grade" computers; and suggested his equal interest in both "very rapid" and "very slow" imaging in works like *Living with the Living Theater*—a tape he was still struggling to broadcast in America. Living in a world propelled by vanity and commercial interests, Paik concludes, the multimedia artist needs to be "very vigilant."

Keeping a partially vigilant eye myself, I've twice chanced to find myself at adjacent tables to Paik—at a pavement café in Venice and at a Greene Street restaurant in New York.

285

Brisbane–Sydney—April 10, 1990

Perhaps I could begin by asking you about your installation at Documenta 8 entitled Beuys' Voice. *What sort of things were you trying to do with that footage of Beuys's performance? Were you interested in registering it as a performance?*

That's a good question. But artists—generally speaking, you know—we don't really set out to do any concrete objective. So, in my case, when I make an artwork, we start from a few given conditions. One condition was that I was invited to do a big work by Documenta. And then, we had just finished a performance with Joseph Beuys in Tokyo, where I played a piano and he kind of screamed.

It was quite an interesting performance—he liked it very much. Also, Beuys is popular in Germany—he's popular everywhere—but this piece was for Germany! So I thought, I'm going to do something with Beuys on that performance. So first I tried to use multiple projectors, but it didn't work out so well. Then there was a new technology available—multivision, or the so-called TV Wall. It's quite expensive—they were renting it for ten thousand marks for three days. So I gave up for a long time.

But after all, Documenta is a big opportunity to excel and you don't get too many offers, and then, by that time, Beuys had died, so the information had become more dramatic. So, through our friends, we inquired how much a couple of companies would charge for three months in the summer. And because in summer there are no trade fairs, they gave it to us for one hundred thousand dollars. So it became more or less feasible. Documenta gave me forty thousand dollars or marks—I forget—and I raised maybe sixty thousand dollars—I forget! So we did it. Artists, generally, have no profound theories, you know—we have instincts, and then practical methods afterwards.

The main channel was normal Beuys, undecorated. And then there were two channels, left and right, where I and Paul Garrin did some computer processing. So it was really successful like that. It went very well. So that was the inside story.

I also saw another version of that piece at your retrospective in London, at the Hayward Gallery, where it seemed a more complicated piece because there were not only monitors which showed your work with Beuys but other screens which seemed to show a lot of unrelated images at tremendous speed. Was there any reason for this difference between the installations?

In both shows we used identical tapes, because we didn't have any money to reedit them—we just copied them. However, in the Hayward show we didn't have any money to rent that TV Wall system. So we used this Documenta main channel which went into the TV Wall undecorated—you know, natural Beuys—as one channel. The other two channels were decorated, computerized video. So, without the TV Wall, the proportion of decorated, computerized tape became bigger. Whereas at Documenta, most likely, most people just watched the undecorated tape, at the center. They didn't pay attention to the left or right, which is computerized tape. So everything most likely looked more complicated to you.

Which version did you prefer yourself?

I don't care! But the computerized version was more expensive—that's all I care!

All the same, you seem very much committed to the significance of the new media arts. This se-rious motivation seems to be overlooked by critics such as Fredric Jameson, whose catalog essay for the Boston Institute of Contemporary Art's Utopia show in 1988 claims there's no point in expecting your installations to offer coherent art. Elsewhere he argues that video is essentially a highly volatile medium which only generates superficial, ever-changing effects, and taking this argument one step further, he concludes that postmodern culture as a whole consists almost exclusively of superficial effects without any substantial meaning.

Where did he write that?

In his essay "Reading without Interpretation" in the anthology The Linguistics of Writing. *A* Flash Art *interview is equally dismissive of video.*

Yes—the so-called semiotic people, you know, they don't like video.

Why do you think this is?

I don't know really. I don't understand semiotics. Most likely semiotics is quite highly regarded in non-French-speaking countries, like England, like America, and also Japan, because it's difficult to understand. Academic people know they have to deal with compli-cations. They think McLuhan is too much talked about, and is not academic enough. It's very hard to make a science out of communications because it is changing very fast, and in a way, it's too large.

So French—and also kind of Labour-left British people—made these kinds of post-Marxist theories. For some reason semiotic people like to be very manneristic—they hang on to very little things. They're basically sort of French-based people who kind of missed the bus of revolution, and who want to make a rear-guard critique about it.

I respect theory when it is bold and something new. Cybernetics I respect, because you can learn something from it. I think I read one book by Foucault and then one book by Barthes, and one by one more guy. But when I study how much time I spent, I didn't get too much out of it. So I thought I would keep a kind of respectful distance from it, and then I will use my time more productively, that is, making videotapes and computer tapes, and computer programming.

My work is rather popular in France, so I asked my French friends whether they thought I should spend X number of hours to study semiotics or not, and everybody laughed, and told me, "You are much more advanced than they are—why should you spend your time studying semiotics?" So that is my relation to semiotics. If somebody has a Ph.D. and gets a teaching job in semiotics, that's fine! However, I have no time for that.

Going back to the notion of content in video, would you say that you're interested in communi-cating some general sort of message or content? Or are you most interested in exploring new sorts of process? Or would you say that it's a combination of the two, or perhaps something else?

You know, we are, as I told you, an artist—and work with intuition—so we have, maybe, a higher rate of metabolism, so we get tired of it very quickly. So when in 1960 I did some sort of performance art, it was very nice at first. You know, I got kind of known in Fluxus circles in Germany. And then I met Beuys, who was not yet known. Then I was approaching thirty-one and I got tired of performance art. At the same time also I needed to make some money

and then I started to make some *objets sonores*—you know, sound objects. Then, slowly, slowly, I got attracted to television. So I thought, Well, you know it's kind of nice to do the first video art. I said "electronic television art" at that time, since I was doing electronic music art, which was not doing too well.

So then the first show was a hit and then the second show was a hit and the third show was a hit, so I stayed with this medium. And when I came to this American country, it was rather easier to raise money in television, because official television was so bad. You said, "Oh, I'm working with television," and everyone was throwing money at you, you know! Also, we have to be written up in the newspapers and stuff in gallery shows and museums. So you speculate, Oh well, I did this, next I did this, next I'll do this.

In the case of so-called important visual artists, painters, they in a way got their style fixed up by their midthirties—numbers, silk screens on canvas, dots and enlarged comics, and so on. I don't say that they make compromises. But other artists get fixed with styles which became successful. Some artists change and have two or three styles. At most you can have three styles in your lifetime. Of course, everything in video is in one style, but in my case, I think I changed that a little more. Because number one, my work has not been profitable here, until three years ago. So I have no reason to hang up into one style. And second, all the electronic industry here has progressed very much.

Think—at the time when I was doing video, you know, it was 1963, before Sony had even introduced their video recorder. The only home video available was Grundwig's camera. So for the last thirty years video technology has changed. So when new hardware combinations came up, either in home video, or more important, in computer programming in industry, I have more opportunities to try out new combinations of new hardware and new software. Hardware-software combinations are very, very rich, almost inexhaustible. And then, obviously, I was not that bad in that application—there are other guys that are worse. So, for two reasons, because I did not make much money until three years ago, and because hardware keeps changing, I keep changing. So your question is almost irrelevant. Art making is for anybody like breathing—luckily we don't have to go to the post office and use stamps. We are a kind of privileged class—we don't have to work very hard. So we don't have to set up any objectives.

I suppose your explorations of new media are like swimming in an endless ocean.

A tabula rasa, you know, a white paper. Video is a white paper, a tabula rasa.

Are there some pieces that you think have worked particularly well, not only as a new process, but as a new way of saying something about something beyond video?

I get bad reviews still—*Art in America* recently wrote one. But I survive. If we think deductively, then certainly *Beuys' Voice* was successful. And another which was a very successful piece is *TV Garden,* where you see lots of TVs among the leaves. That was very successful, I think, for two reasons, three reasons.

One is that people look down at TV here, so it was kind of a new position. And in a way, you are fixed into one TV, generally, but you look around. And I deliberately made it to look around, but when you watched TV your eye got fixed. And most likely, the human instinct, the human nerve which is controlling the eyes' nervous system, is very happy that they are liberated from the one TV position, so that you can look around. And obviously, of course,

the optic nerve likes that electronic impulse too, but also likes the natural habitat of looking around. So these two combinations made the people happier watching *TV Garden*.

And then, of course, many people had thought that television is against ecology, but in this case, television is part of ecology. Then it had nice color, and nice rock and roll music, and it was dark, with light flowing from leaves in various greens and various rhythms. And then people were leaning on railings in kind of comfortable positions, and could talk to their neighbors, whereas when you're watching TV or going to a movie, you don't talk to your neighbor. But in this case, all those disciplines are out, and you can go in and out at your leisure, like at a John Cage concert. I think that basically speaking, the use of natural leaves and television—that paradox—was important for people.

Well, I think you've said that you're interested in humanizing television and video.

That came from *The Human Use of Human Beings,* a book by Norbert Wiener. Norbert Wiener is a '50s scientist—I think he's a genius. Although it was corny, I used the phrase "How to humanize technology" in the press release of the Howard Wise Gallery, in '69. I thought it was very corny. But, for some reason, everybody quoted it and even now keeps quoting it, you know, twenty years after! It was exactly in 1969 that I wrote that press release, anonymously. So, obviously, that rings a bell for many people.

It's probably the reverse of Andy Warhol's claim that he wanted to be a machine, whereas you want machines to be human.

Yes. For some reason this kind of quotation becomes famous, so obviously people need that.

What do you think of contemporary culture as a whole? Would you say that we're living in a corny culture?

Contemporary culture? As a whole?

Well, that's a very big question, and probably a silly question.

Yes. As you know, we are not Henry Kissinger—we are just a little player. I am generally optimistic about the human future, because of the Soviet crumble. For instance, Milan Knizak, the Czech artist, was arrested three hundred and sixty times. He was in New York when the tanks rolled in '68, but he chose to go over to Czechoslovakia. So he had a hard time. But he is now the president of the Royal Academy there. He was a real vagabond, a Fluxus artist. And then, the president of Lithuania, Vytautas Landsbergis, he was the best friend of George Macunias—they were classmates in grade school. His father and Landsbergis's father were best friends.

And so, obviously, although our liberal left bet on Karl Marx too long, and found they bet on the wrong horse, the horse of liberalism also won, so that's very nice. Of course all intellectuals are against technology, and all for ecology, which is very important. But in a way, we are inventing more pollution-free technology. We intellectuals don't like cars and television, but we have to admit that compared to Charles Dickens's time, we are living better, no?

So we must give up certain parts of intellectual vanity, and look at the good parts of so-called high-tech research. For instance, hydrogen power, which nobody's talking about. It seems that people are getting smarter, and also that in the Western world people are getting

less aggressive. When I look at the art world, they are playing games very harshly, but still they're not as bad as corporate games. Australian, Japanese, or Korean artists—or whoever—who are not playing games in New York shouldn't pay so much attention to the New York art world. If you make your own art work and can make a living, then that's good—if you're happy and don't have to dig ditches!

When we started out becoming an artist, we didn't aim or even think about becoming a famous artist. To take fame out of art, well, that's the most important thing. Let's make that the closing statement for today. To take fame out of the art world. That was the spirit of Fluxus.

Sydney—April 13, 1990

At the end of our interview the other day, you said that the Fluxus movement attempted to take the idea of fame away from the idea of the artist.

Yes—we hope so! Whether Fluxus has any common aesthetic or not, one thing which is remarkable about Fluxus is that for thirty years many different egos—twenty, thirty different artists—stayed quite good friends and collaborated, which is remarkable. We must be very proud of it, because it is one of the very few anarchistic groups which has succeeded in surviving. Because with anarchists, by definition, the strongest guy becomes the dictator. In our case it didn't happen, basically speaking.

Would you say that there are any special differences between Fluxus in America and Fluxus in Europe?

Hardly any. For instance, George Macunias, George Brecht, La Monte Young, Dick Higgins, and Alison Knowles were kind of cool people—they wouldn't go and shout, "I am not typical of Fluxus." Fluxus is a kind of minimal aesthetic, and a minimal aesthetic, by definition, is not easy to succeed in.

However, in Europe, we did have a fairly good political base. When George Macunias came, the European neo-Dadaist aesthetic already occupied a major forum. So we could incorporate very quickly. American and European Fluxus both needed each other. Of course, Europe had its own idea, and its more aggressive attitude. It was more arty—or more wet, and not quite dry—more dirty, and not quite clean. And if we include Joseph Beuys, whom we should include because he worked with Fluxus many times, then we have excellent artistic talent. So we don't owe everything to America either!

Then, also, George Macunias, being an internationalist Marxist, he always paid attention to Eastern Europe. He was also a Japan worshiper. He discovered Takeshisa Kosugi, and some unknown Japanese at that time, who became known, and also had a very strong Dutch component. He had the idea of a united artists' front, like Karl Marx's idea that all the workers should unite. So he was very international from the beginning. There was really no elbowing for national hegemony or personal hegemony. I think that's the record we're most proud of.

Your work has also crossed many frontiers and artistic boundaries. You started out as a composer, didn't you?

I think I made three performance pieces that can survive. And then I do notation work and video. And then I wrote two piano pieces which will survive absolutely my death. I'm fifty-eight, so you have to think—even healthy Ben Vautier had a heart attack a few days ago. Fluxus is still a kind of stepchild in the art world, so if we don't care about our legacy, we will be very quickly wiped out by commercial interests. So we have to be vigilant about what we did.

Are you trying to document this work?

Not document. My music was not recorded. I refused to record it because you need a certain kind of excited consciousness, and if you record them it looks very empty. I rather thought when I was young that it was better not to leave any records, rather than leaving false records. But now I know how to record those things!

Was Cage one of the people you enjoyed working with?

Of course, needless to say! His ascetic, egoless way of life influenced lots of people. Also his kind of West Coast, semi–American Indian aesthetic—his undense, not dense aesthetic—that influenced many people. I admire these West Coast people very much—they are still very underrated. People think they were influenced by Oriental Zen. That's true, too, but also, I think they're influenced by electromagnetism coming from the earth. You know, geographical magnetism, which defines American Indians as a kind of egoless, nature-bound lifestyle. I think that comes from an electromagnetic sphere that we haven't discovered yet.

How do you find living in New York? Would you prefer to live in California?

I'm in New York two-thirds and three-quarters of a year. The very practical reason is that computer time is very, very cheap in New York—almost one-quarter of California, or one-tenth of Germany. A certain kind of computer I use for video is not only cheaper—it's a fraction of the cost elsewhere. The Media Alliance program finds the empty hours of computers for artists, and uses them as a training ground for the new computer operators of that company. It's a very good mixed economy—capitalism and socialism.

So I have to be in New York for that reason. There's no other place. Also there's a certain density of communication in New York, so that you meet people in the street and talk. Also, we're all regular human beings and so you work harder if there's an incentive. So you say, "Ah! This guy's not really as talented as I am, but he's now getting bigger space in the *New York Times*," and you tend to work harder for that week! You have to admit that happens!

I'm lucky to have access to this high-grade computer very cheaply, which Germans or, you know, Japanese and French don't have. So I need to handicap myself and do low-tech video. Or I make best use of my resources. Because computers change very quickly, so things that we can do this year, we may not do next year, because that computer may be junked! Many of my early technological pieces are unplayable now. So I will continue with what I have access to. Because I've got assistants who are much better than me. For example, I work with Paul Garrin—he's about thirty-one—he's a genius! His computer-programming operation is about twenty times better than mine. He may quickly get rich and never have time for me, so I want to make good use of this opportunity! I also have another assistant my own age, in Japan.

So this means that you enjoy collaborative work?

Yes—with high tech you have to collaborate! There's no other way! I work not only with these two guys, but when I go to the computer studio, it's the chance of that day that such a person is there. But that doesn't mean that only high-tech art survives. For example, last year I made a Living Theatre video tape, *Living with the Living Theater,* which is not high-tech video, but a documentary. As you may know, the highest rated TV show in America is an anthology of home video—a thing called *America's Funniest Home Videos.* It's the ultimate documentary. The most popular show is *60 Minutes,* but one week they topped *60 Minutes.* It's the very show that I've been preaching about—everybody makes video!

Are you still doing performances yourself?

I'm getting old, so I conserve energy, you know. I don't want to imitate young people when I'm old, because I didn't imitate old people when I was young.

What do you think of the recent developments in multimedia theater? Have you seen any of the productions of Philip Glass and Robert Wilson?

Oh yes—*Einstein on the Beach* was so good, I was really jealous! It's one of the most unforgettable experiences of my lifetime.

I suppose that's not really the sort of work that you'd be tempted to do?

No. It needs a lot of labor, a lot of energy and organization. I did television shows, but I'm not really that sort of a perfectionist.

What about installations? Are you interested in this direction?

Yes, because number one, they're easier to make. That means there's more net contribution to humanity there. Because most likely the combination of changing space and time on that rather big scale, computing that much information, is like a combination of grand opera and big exhibits. At the Whitney Museum I had a piece called *Image Wall,* twenty-eight feet wide and twenty feet high. And I think that I was able to create in that limited space the sound and the power of a space five times bigger than that, if you didn't use electronic media.

So it's a sort of condensed art?

Yes—inch by square inch, it has more power, I must say. *Art in America* said it was like the Palladium disco in New York—but the designer of the Palladium said he was influenced by my other work. The Palladium has fifty monitors going up and down. It looks like a space-ship landing and going up—you know, it's great.

What do you think of MTV?

I think MTV is great. The first two or three years of MTV were very good—it was a big cultural phenomenon. And we video artists must take credit for that, because two key persons of MTV came from our lab. You know, their vice president in technology was practically my engineer. We had what was called the Television Laboratory. And the first program director and the first vice president in technology came from our organization.

Some of your pieces—such as TV Buddha—*seem quite contemplative, whereas MTV usually offers more frantic imaging. Do you have any preference for rapid images or slow images?*

Generally, I might make it either very rapid or very slow. For example, *Living with the Living Theater* juxtaposes a very rapid style and normal tempo. It's my newest video piece. We're trying to get airtime for it in New York this summer, but it's not easy. So we're still fighting.

Yvonne Rainer. Photograph by Haruko.

YVONNE
RAINER

WHEN I PHONED THE NEW YORK DANCER AND FILMMAKER YVONNE RAINER in February 1992 to request an interview, I mentioned this book's concerns and rapidly discovered that the term *postmodern* was not one that she had much time for.

Having read Rainer's essays on dance in *Work 1961–73* (1974), and having heard her speak about her films at the Performance Space's Re-evaluations conference in Sydney in 1990, I'd wanted to discuss the way in which her work—like that of a number of key chronologically postmodern artists—seems to have advanced from the postauthorial minimalist and structuralist mentality of the 1960s, towards the increasingly subjective and politicized ethos of the '80s and '90s, generally resisting what Félix Guattari condemned as the "ethical abdication" of French poststructuralist theory.

Had she read Robbe-Grillet, who subsequently claimed that his superficially objective work was in fact alive with subjective "phantoms"?

Yes, he was her favorite writer. And yes, even her "tasklike stuff" had a certain "surrealist cast," just as her films have a frequently overlooked "sly cast of humor."

So far, so good. We began to differ, however, when discussing Jameson's assertion that there can be "no masterpieces" in an age—allegedly—where "the autonomous work of art . . . along with the old autonomous subject or ego—seems to have vanished."

From my viewpoint, Jameson simply hadn't done his homework. From Rainer's viewpoint, the very concept of the "so-called great book" smacked of an elitism fueling—and fueled by—"particular racial, ethnic, and sexual interests," favoring privileged intellectuals who "didn't have to buy the groceries or wash clothes," and ignoring such present "economic realities" as the collapse of state subsidies to the arts.

Rather than trying to "second-guess the future" and "make films for posterity," Rainer characterized her priorities as the attempt to "challenge and clear the air and provoke," by addressing "specific, topical issues" and making art for "where you stand right now."

Nevertheless, as Patricia Mellencamp observes in *Indiscretions* (1990), posterity seems

unlikely to neglect the skill with which Rainer's films offer a "fascinating and knowledgeable kaleidoscope of women's voices . . . troubling the negative account of postmodernism."

New York—February 7, 1992

When I phoned to ask if I could interview you for a book with the word postmodern *in its title, you said this wasn't a term you were particularly fond of. Could we begin by talking about your response to the notion of the postmodern?*

Yes, I could try to talk about that. The word *postmodernism* to me is the same kind of mine-field as *deconstruction*. It suggests an experimentation and investigation strictly at the level of the signifier, which seems formalism basically. And I think much of postmodernism is about rearranging formal elements. It doesn't suggest any kind of social agenda. My work, and the changes in my work, have been as much about an evolving political conscious-ness, as about looking for innovative formal procedures. So the term is just not inclusive enough.

Would you call your early work with dance postmodern, and your later work with cinema something else?

Well, I did call my early work postmodern for reasons other than the way the word devel-oped in the art world. "Modern" dance was something that had been around since before the turn of the century—Loie Fuller, Isadora Duncan. So when my colleagues and I, who had studied with Cage and Cunningham, began to show our work, it seemed logical to call it postmodern because "modern dance" referred to the generation of Martha Graham, Doris Humphrey, and others. The origin of *modern* in the dance concept had to do with a dialogue with and rebellion against ballet, which of course goes back two hundred years. So that when we used it in the '60s, the term *postmodern* didn't have the connotations that it subsequently had a decade later.

What connotations did it have for you in the '60s?

Well, a refusal of the grand storytelling gesture, a refusal of emotion-laden pantomimic ges-ture, a refusal of the Louis Horst theme-and-variation approach to constructing a dance, and a turning to John Cage's principles, which came out of Duchamp, and to the use of chance procedures. I guess a lot of it was a preference for surrealism over expressionism. But because of the way the designation *modern* had bearing on the history of ballet, we needed something else to distinguish ourselves.

I'm surprised you mention surrealism in a way, given your emphasis upon the rather restrained and austere register of minimalist tendencies in mid-'60s dance and sculpture. One wouldn't necessarily think of this kind of minimalism as being something surreal.

Yes, this is strictly a retrospective view. But I think a lot of the work that went on then seems to have had a surrealist cast, even the strictly tasklike stuff. There was a great variety of work done at Judson Church, some very flamboyant and expressionistic, some very

Gabriella Farrar in Yvonne Rainer's *Privilege,* 16mm, 103 minutes, 1990. Photograph courtesy of the artist and Zeitgeist Films.

minimal. Steve Paxton and I always used to joke that he invented walking and I invented running—because we made dances that consisted almost only of those two kinds of loco-motion. Then there were dances where people carried things. But there was a lot of wildly expressionistic dancing, and there were collaborations with artists around sculpturelike environments and objects. So there's no one label that is really accurate—that accurately sums up that period.

But certainly, we were interested in other kinds of small experiments, rather than the epic masterpieces that were the aspiration of a lot of previous choreography that was in-spired by the matriarchs of modern dance.

Robbe-Grillet also retrospectively notes that his writing and films weren't as neutral or objective as Barthes claimed them to be, but were always full of "phantoms," and always using objective materials in a subjective way.

Well, I know that one always thinks one's doing something other than what twenty years later you realize you actually were doing. We can talk of Rauschenberg's idea of "combines"—with combining forms. Somehow what comes to my mind is Steve Paxton turning someone around in a tub of ball bearings, which was a play on the partnered ballerina pointe. So this industrialized source of movement produced a kind of parody of classical partnering, and also the idea of the ballerina in the washtub—the banality of that. We were always invoking the everyday, but when you invoke the quotidian in a theatrical setting you're playing with a kind of surrealism.

So perhaps your better-known texts give an overly austere impression of your ambitions?

Oh, absolutely. Because I used music a lot—I was always playing in an ironic way off bombastic music.

Was it important to be working with artists from other media?

In some ways it was very fruitful; in other ways it generated social schisms within the group. We met every Monday night at Judson Church and the concerts came out of what was produced and shown in the workshops. I guess that in its heyday, which was from 1962 to 1964, there must have been between two dozen and fifty people who participated. The idea of career crept in in the mid-'60s, and then things kind of splintered. Up to that time it was a very social, energized, coexisting investigation.

Were you also aware of things going on in Europe?

Fluxus was an influence, certainly, on a number of people. There were Fluxus concerts concurrently around town, and also Yoko Ono's loft was a place where you went to see different kinds of things. At George Segal's farm there was an event with Fluxus people such as Wolf Vostell. Dick Higgins produced some events.

What was your response to Fluxus events?

I thought they were kind of silly, but I always went and even participated. I performed wherever there was an opportunity. I didn't take Fluxus that seriously. I was much more ambitious—the two-minute piece was not something that I could be satisfied with. It was a very heady time because Happenings were going on, and there were all kinds of music, dance, gallery, and storefront activity, and you went to everything. Whether you liked something or not it was not really important, because it was all stimulating and cross-fertilizing.

Sally Banes makes certain comparisons between your work and that of Robbe-Grillet. Were you aware of his writings?

I had read one of my favorite books—*For a New Novel*—by 1964, and those kinds of proclamations and prescriptions about the old and the new were very challenging. I'm sure I had read that book before I wrote the essay about my dance for ten people and twelve mattresses—*Parts of Some Sextets*. At the end I made this manifesto which said no to this, no to that, "No to spectacle, no to virtuosity, no to transformations and magic" and so on.

Do you now feel that you were a little overenthusiastic?

Oh, absolutely! It was totally overstated! And I'm still dogged by this manifesto. But I don't know—manifestos are meant to challenge and clear the air and provoke. That certainly is what it did and continues to do. Dancers still get upset by it! I've had to eat my words many times over.

What sort of things led you to revise this series of noes?

I never revised them. I kept doing what I was doing. I never went in for spectacle. What were some of the others? "No to moving or being moved." Well, I did plenty of that, and I was

already doing plenty of that. "No to magic or make-believe." I went into film, which is certainly a kind of magic and illusion. But I went into film because there was the opportunity for that extreme of illusion, but also the opportunity to probe it and to undermine it.

So I've always had an ambivalence about these very things, like narrative. I mean, I have a totally ambivalent relationship to narrative and traditional storytelling. In my last film, *Privilege,* I engage the conventions of cinematic narrative, but in almost every scene there's some strategy that makes you aware that you're watching an illusion or being taken in. So I still have that same ambivalence.

You've described your surprise to find you've gone back to using character and narrative, and make the point that you use these filmic conventions both in order to undercut them so as to address a wider perspective of ideas, and in order to engage the sympathies of the audience, as a kind of lure.

Somehow, when we start dealing with the specifics of social life, it seems to require strategies of verisimilitude, and you have to make recognizable interactions in order to engage the empathy and identification of an audience. But I've always maintained that at the same time, simultaneously, you can engage their critical capacity. So I'm always playing on those two, as other people have done in film, such as Godard.

Considered chronologically, then, there seems to be a general broadening of focus in your work, towards your films' emphasis upon the personal existential dynamics of identity, age, race, and gender, as opposed to your earlier exploration of untrained dancers' potential physical dynamics. In a letter to Nan Peine of the early '70s you discuss this in terms of a shift from the relatively subjective focus of dance to the more collective and more specific language of film. Do you feel you've moved quite a way from your mid-'60s project of working as "a postmodern dance evangelist bringing movement to the masses"?

Yes, but I think you can sometimes only engage these ideas at a certain historic moment. In terms of dance history, the expectation of a godlike superhuman body led to the wish to see untrained people move and attempt technical feats.

Trio A was the dance I referred to when I said I was a postmodern dance evangelist. It was quite difficult—it had a great deal of nuance and technical demands—and I wanted to teach it to the world. The first untrained person I ever taught it to was very stocky and athletic, and to see her struggle with that movement, which required a stretched-out body and standing on one leg, you felt a kind of heroism in that person. It totally went against that tradition of ease and camouflage of effort and training and difficulty. Here, all of that is on the surface. It seemed a highly social moment. Not a transcendent moment, but a material moment—you saw the material of a struggle in front of your eyes.

Years later, in 1979, the producer of *Dance in America*—the weekly dance program on public TV—had this idea to show *Trio A,* and that I should teach it to Bart Cook of the New York City Ballet, to Sarah Rudner of the Twyla Tharp Company, and to Frank Conversano, who didn't have formal training but who worked with a mixed group of people. I did teach *Trio A* to all of them, and when I saw the finished product, the performance no longer had that edge of struggle. I think it was because that moment to watch untrained people dance had passed. It was no longer interesting.

I mean, today it would just look like bad dancing. I saw a group last night, and the choreography was interesting, but it was clear that the dancers weren't up to it. Yet it was not

intentional. So the challenge is, how do you make a dance that is too difficult for your dancer, and make that act of negotiation the point of the dance? It's a very hard thing to do, and it seemed at that moment it was possible. Just as Steve Paxton was very interested in invisible performances—in integrating his performers into an everyday situation, and having maybe small groups observe this performance. At that point, everything became a performance. Performative actions were everywhere—the whole world became this stage. That also had to do with that particular moment.

Maybe another kind of art in everyday life would be the work of artists like Jenny Holzer's or Barbara Kruger's ideological statements on large-scale signboard?

Yes, that's interesting, that kind of intervention, and important. Whereas in the '60s, the idea of theater and art in everyday life was that things done in public were to be more invisible, and not to proclaim themselves, so that the everyday life was more an intervention than the art, rather than the other way round.

How did you move towards cinema, from dance and multimedia performance? Were you already making films in the '70s?

Yes, I made short films that for the most part became part of performances. I was interested in a contrast in scale—the human scale and hugely magnified projections of parts of the body, such as legs and hands. These films were from five to ten minutes long. There was one with Steve Paxton and Becky Arnold where they were nude in a white living room—white walls and white furniture and a big white balloon, and minimal choreography with them passing this huge balloon back and forth. The film was part of a performance in a series of concerts at the Billy Rose Theater—my only Broadway appearance—in a section that contained various kinds of references to obscenity.

I told a story about snot, by Lenny Bruce, and on one side of the proscenium was a projection of this Becky-Steve nude film, which was very chaste, and on the other side was an actual piece of pornography—I had to sneak a pornographic film into the theater. It was kind of a scandal, but by the time the projectionist realized what was happening and turned off the projector, it had happened. I was telling the snot story on one side, and then there was a whole line of performers looking straight ahead, moving their ribcages very slightly—that was the minimal part of it, and especially funny because it was so chaste in that "obscene" ambience.

Did you actually read a Lenny Bruce script?

I recited one of his stories about how you can't get snot off suede. It begins with, "I'm going to say the filthiest word in the language—it starts with an 's' and ends with a 't.'"

This suggests—at the very least, on this occasion—a humorous undercurrent in your work!

Oh yes!

Again, your manifestos don't really indicate that.

They don't indicate that—right. And a lot of the serious writing on my movies, too, doesn't indicate that they're funny, that they're very funny movies. I don't know why. Usually, I guess it's a sly kind of humor, or very often it's an editor's humor like having the first part

of a printed sentence in one shot that leads you to assume the ending, and in the next shot it's something else.

In your films you use a lot of quotations. Is the Lenny Bruce story a sort of precursor of that sort of appropriation and collage and editing of other people's statements?

Yes—though there are even earlier precursors. In my first long dance, *Terrain*, of 1963, one whole section was about moving and telling stories at the same time. There were stories by poets, storytellers, Spencer Holst—I don't know if he's still around, but he wrote these rather quixotic stories about his early life, his grandfather, and his grandmother.

Was that in the tradition of some of Cage's performances, where there are little stories?

Yes, but in my case juxtaposing two totally different kinds of continuity. I made the dance totally separate from the stories, and then learned the stories and put them together.

Isn't that still quite close to the indeterminacy characterizing Cage's juxtaposition of his stories and David Tudor's scores? Would you distinguish your aesthetic from that of Cage?

I was certainly influenced by Cage, but I wrote an essay critical of what I'd now call his religiosity, his deferring—despite the indeterminacy—to some higher organizing principle, so that this seeming abandonment of choice and personal taste was not as radical as one might suppose. It was a very convoluted argument—it was my coming to terms with my own "Cagian" past. Certainly, I was very immersed in that aesthetic. My very first solo was organized by means of one of Cage's scores, using his strategies for indeterminate relationships of sound and image.

Would this mean that your use of text and textual material is perhaps more strategic?

Well, certainly, now. Then, it was a way of sequencing things I liked, it was somewhat arbitrary. There was an overall design, but where the particular moments were concerned, there was no design. In *Parts of Some Sextets* there were excerpts from an eighteenth-century English minister's journal. The excerpts I chose all had to do with natural disasters and circuses coming to town, or disease—it was all on audiotape, voice-over readings from this journal. And for forty-five minutes there were a variety of actions, from carting these mattresses around, to dance phrases, to grouping in unison, so it was totally by chance where the discrete words corresponded to a given image. Yet it had a kind of sense—everything that went on onstage became an analogue for this daily life and this community.

And now you can see traces of that in my work where, for instance, I'll have found footage from an old movie run backwards—a kind of crude device for questioning narrativity itself, demonstrating the arbitrariness of one person's point of view, which may not be the truth and which may be a fiction.

Isn't it possible that people become "immune" to various forms of hypothetically subversive narrative or antinarrative as they gradually become just another familiar convention?

Well, I think everything has its time. As I've said, the moment comes and goes. My work has never appealed to a very wide audience—although it has a wider audience now than it had then, because there wasn't this present apparatus in operation for drawing the audience into

dance. The Brooklyn Academy of Music, the Joyce Theater, and all these companies now can raise huge amounts of money and make big productions, and there's an audience. None of that apparatus was in place when I was doing my dance work.

Film, because it hangs around in a material form, does end up reaching quite a broad audience. My films have an afterlife in universities and other places. As far as the aesthetic techniques are concerned, what were called the "New Talkies" in the '70s—these films which had a lot of spoken, theoretical material, rather than naturalistic dialogue—are now being derided by some of their former champions.

Where does that leave your present practice and concerns? What sorts of problems seem to be primary for you in the last decade? Presumably feminism has become more central?

Well, what is interesting in the last decade is another word that has a lot of minefields attached to it—*multiculturalism,* which is generating all this activism and activity in the funding agencies. But it has enabled many people who had previously been excluded from this arena to make themselves heard—ethnic groups, black, Asian, and gay voices. So that is what has changed, and I hope it stays. But with the deplorable state of arts funding in this country, it's hard to say what's going to happen.

Has this meant that your own subject matter has broadened and become more explicit? In your last film you were talking very explicitly about aging, gender identity, and national identity. This seems a far more focused social agenda—to state the absolutely obvious—than the earlier "No to everything." It seems more "yes to explicit definition."

Well, my agenda has certainly changed and, as you say, become more focused. I suppose I have been moving towards examining the conditions that enabled me to be an artist—conditions that had to do with being white, with being heterosexual, as I was until recently and was in the early days of my development. And that focus came out of just thinking about social inequities in general. So this is a continuing area of concern for me.

And the way I handled it in *Privilege* is, of course, very controversial—for whites to deal with white racism. Which is why I appropriate so much—I find writing that is suitable for my black and Puerto Rican characters. I don't attempt to write for them myself, which partly says something about my feeling that I'm not a writer. I'm not a fiction writer—I must always go to other sources. You might call it plagiarism, but it's also collage and quotation.

You might also call it collaboration as well, if you think of Robert Wilson and Heiner Müller's productions. Wilson says that Müller's texts have a toughness that he can't attain, and Müller says that Wilson's imagery has an intensity that he can't attain.

But that is a collaboration, and I don't collaborate with writers.

So you haven't actually said to writers, "Would you like to write a text about X or Y for me?"

No, I haven't. That may come next, but I haven't done that.

So in a way it's been retrospective, or I'd imagine, referring to your notebooks or to your favorite underlined pages?

Yes—and, of course, I always give attributions.

Another facile approach to quotation is to say that appropriation equals neutralization, and to equate postmodern culture with a playful mentality mixing disparate materials to no particular purpose. Your work seems to demonstrate quite the reverse—which shouldn't take anybody by surprise—namely, that one can appropriate things with respect.

It's much more purposeful. It's about points of view, and not only pleasure, although some of the material I use is very pleasurable. A writer named Gloria Anzaldúa made the distinction between appropriation and proliferation.

Appropriation is a kind of acquisition or use, but to some other purpose than its original intent, and proliferation is about getting the word out with an eye to its original purpose. I think the way I put these texts in the mouths of my characters is more about proliferating points of view that belong to the original authors.

Are you also trying to suggest that certain minority groups might not have that sort of verbal or rhetorical power?

Good heavens, I hope I'm not making a condescending generalization like that. The issue is access, not some kind of innate lack. Putting Frantz Fanon's words in the mouth of the Puerto Rican male character was not meant to make a pejorative value judgment or comparison, or to underscore his lack of education. On the contrary, I would hope the strategy can be seen as symbolic empowerment. Similarly, the Puerto Rican female character, Digna, although sometimes speaking as a madwoman or Carmen Miranda, is enabled to override these degraded positions through her language of analysis and critique.

The criticism of one reviewer—that all of the female characters of color speak from an inferior social position—while not entirely true, ignores the fact of what these characters say. Given the fact that in many spheres of everyday life women are not listened to or heard, regardless of their relative authority or social stature, it is important not simply to replicate that situation in representation. The ploy of contrasting a disparity in social position and language within one persona—following the by-now classical Brechtian mode—disrupts a seamless reproduction of social reality.

Getting back to your question about immunity, I still believe in these strategies, although it is becoming increasingly clear to me that people seem less inclined these days to read them as critical disruptions, but rather fasten on one aspect or another, and not the totality, in order to find evidence of racism or sexism. We live in parlous times, one result of which may be social and aesthetic amnesia. I'm finding that my students have little or no interest in history. Their competition with the past is of a different order than mine was. My quarrel was with the canon, theirs is with everything, canonized or not.

Are you fairly happy with your films, or do you sense that there are now things in them that you'd like to change?

No, there's no point in going back. They are what they are. I mean, I looked at *Lives of Performers* recently—I hadn't looked at it for years—and was bemused by it. Who was the person who made that film? You know, that's all you can do. People may not be interested in that now, and I can perfectly well understand. I don't make films for posterity. One can't do that. You have to make them for where you stand right now, and not second-guess the future, or second-guess an audience even.

It seems to me that it might depend on the literal or symbolic quality of one's vocabulary. For example, Beckett's Film *works primarily with symbolic, atemporal iconography. Meredith Monk also seems to use this sort of atemporal symbolism, and when I asked her if she felt her work broke with modernism, she suggested she was exploring the old themes and the old problems, rather than anything radically or extraordinarily new.*

But Meredith is working with what she sees as essences, and I'm always focused on specific, topical issues.

I think they're both brave ventures, and if you say you're focused on topical things, that again emphasizes that art—or at least the concerns of art—changes, and effects change. All of these things seem forgotten by those critics like Jameson, who argue that we inhabit a schizoid culture incompatible with meaningful or great creativity—a claim I find very questionable.

Yes, I can't go along with that either. But there are certain conditions that mitigate against the so-called great book. If you think about how Freud worked in the midst of a whole household—he didn't have to buy the groceries or wash his clothes. People live very differently today, even privileged artists. I mean, you have to be a very privileged writer indeed to get an advance that enables you to write every day. So things are made differently. The revolution that Cage set in motion is the whole questioning of who can make and what constitutes a masterpiece, and the concern you describe—the loss of masterpieces—may still be clinging to that idea of greatness, don't you think?

Well, I suppose I still cling to that idea myself, and still think more or less great art is as possible now as it ever was. By contrast, Jameson and company seem to claim that given present crises, nothing good will happen anymore, and there can't be any revolution. But, I'd argue that despite cultural crises—or transitions—and despite one's democratic instincts, one always finds some contemporaries outstanding, whereas others seem less monumental.

I say you're both wrong. The recognition of great art is as much in the hands of the historians and conservators of it as in its creators. And we know how art history is, or has been, up till very recently, written—by those with particular racial, ethnic, and sexual interests. And I have to keep pointing to economic realities. For instance, with the demise of the communist system the whole apparatus for film production has totally collapsed in Eastern Europe and Russia. There are no films being produced because there are no more state subsidies. The "greatness" of art is irrelevant in these circumstances.

I'd imagine this places you in a rather ambiguous position. On the one hand, you're probably sympathetic to those critics who claim that the mass media can be a soporific force and who question the romantic myth of great art. And yet while such critics often also diagnose the alleged death of art, you're busy making films and distributing them independently.

So are a lot of people. The mainstream media, let's face it, are noxious, but there's cable television with all these weird excesses, including pornography, and Paper Tiger Television and Deep Dish TV. Dee Dee Halleck initiated this weekly show on cable ten years ago, and it's gone into more ambitious kinds of programming—it's a media-critical half hour taking everything to task from the *New York Times* to *Vogue* magazine. When the Gulf War started they were able to get tapes from all over the country—newsreels and critical stuff—and

make these composites. It's very fly by night, and they do some very progressive stuff. So when I see things like that happening I think all is not totally lost.

Kathy Acker suggested that there's almost a sort of underground revival insofar as all sorts of minority groups are publishing "forbidden" writings in anthologies such as High Risk.

I buy this magazine—*Bomb*—every now and then. It has criticism and fiction and mixed-ethnic authors. So in this country there's still some kind of underground. Things really look bleak with this shift to censorship, and the way the former commie menace has now been transformed by the right into an internal arts menace. Evangelists and moral majorities have changed their enemy, and the purported enemy is closer to home now. This is sinister stuff of a different kind.

With that in mind, do you have any particular projects for the next three or four years, given economic difficulties and given the present censorship and funding crises?

Well, I'm not thinking about money. I got a very prestigious grant last year and I won't worry about money until I have a script in hand. So I'm just working on a script about two sixty-year-old lesbians—two areas that are very unrepresented—aging women and lesbian sex. I have my hands full for a while.

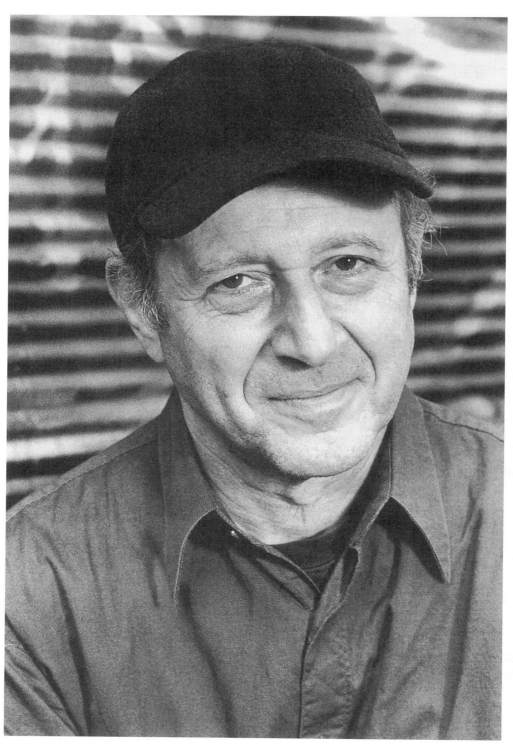

Steve Reich. Photograph copyright Alice Arnold.

STEVE
REICH

READING STEVE REICH'S ESSAY "MUSIC AS A GRADUAL PROCESS" (1968) in his book *Writings about Music* (1974), I'd underlined his call for composers to redirect attention from the personal rituals of "*he* and *she* and *you* and *me*" to the more impersonal register of "*it*," in order to make musical experience more like "watching a minute hand on a watch."

Reversing these archetypal minimalist and structuralist priorities, Reich's more recent opera *Different Trains* (1988) carefully integrates the personal sounds of various hes and shes in order to evoke the poignant contrasts between the destinations of "different trains" in Europe and the United States during the Holocaust. If the early minimalism of Reich's *It's Gonna Rain* gradually transforms audible sound bites into abstract reverberation, instrumentation in *Different Trains* plays second fiddle, and at most, unobtrusively "doubles" plaintively personal narration.

Such postminimalist strategies typify the multimedia avant-garde's general transition from the initial structural austerity of the 1960s and '70s, to the more "maximal" articulations of existential commitment of the '80s and '90s. As video artist Bill Viola's essay "Interpreting a Wineglass" (1988) suggests, late postmodern culture increasingly effects "the reestablishment of the broken link between art and the public" and "the restoration of art to a functional place in people's lives."

When I spoke with Reich by telephone during his 1990 visit to Australia, he fascinatingly explained how his then work in progress—the multimedia opera *The Cave*—was taking such maximal formats several steps further by integrating different Jewish, Arabic, American, and European answers to questions like "Who to you is Abraham?" and "Who to you is Isaac?" within "a kind of family paradigm" for present conflicts in the Middle East.

Like other recent multimedia work, such as Kenneth Gaburo's *Testimony* project, Beth B's installations, and Yvonne Rainer's films, Reich's *The Cave* incorporates personal utterance in order to highlight the discontents of a society in which, as Rainer has observed, many feel they "are not listened to or heard."

But for all its good intentions, Reich concludes, such work must "live or die on the strength of its musical or artistic value," or else prove to be "so much irrelevance."

Adelaide–Brisbane—March 12, 1990

Perhaps I could begin by asking you about the works you're presenting at the Adelaide Festival, before discussing your use of sound, language, and video imaging in performance?

The main piece will be *Sextet,* which we'll end the program with. It's about half an hour long—it's a piece from 1985 that is scored for four percussion and two keyboards, which for me is perhaps what the string quartet was for Beethoven—it's a means I can really express myself with.

It's a piece that also reflects taking harmonic thoughts that were used in a piece called *The Desert Music* for chorus and orchestra a year before, taking that kind of harmonic elaboration and variety of timbre, and trying to transfer it to some extent to the forces at hand—namely, four percussion and two keyboards.

So you have a very wide orchestral range of sound—very low bass drums, low piano, low synthesizers, and a very, very high sound at the top of the piano keyboard, and so on. You also have some usual sounds—the bowed vibraphone is used as a predominant voice, so you have a kind of ghostly string section happening as well. It's a piece with a large sound for a chamber work and a great amount of variety, all for six musicians.

The program will also include *New York Counterpoint,* a fairly recent piece for clarinet and tape which was written for Richard Stolzman, the American clarinetist, and it's part of a series of pieces where soloists are playing against prerecorded tapes that they themselves have made. So in this case it will be clarinet against clarinets. The piece also may very well suggest early jazz, I mean the jazz of the '20s and '30s, and in some way, perhaps poetically, suggests an earlier form of New York City.

The first part of the program will be earlier pieces of mine, from the early '70s. *Drumming,* part one, is the first twenty minutes of the piece *Drumming,* which is scored just for tuned bongo drums. Another early piece is *Clapping Music,* which is just what it says, two people clapping for about five minutes. And the last piece in the first part of the program is *Six Pianos,* which we like to do on six grands, but which we rarely get a chance to do on six grands—and in this case will be done on six digital pianos.

How important to you are tape, sampling, and other technological ways of supplementing live performance?

Well, I'm someone who has no use for oscillators or synthesizers. I do use them in *Sextet* as a kind of marriage of convenience, but basically I'm not interested in electronically generated sound. As you correctly implied, I am interested in using amplification to create balances, and tape to supply multiples of instruments, so that soloists can play against themselves, as in the *Counterpoint* pieces and in *Different Trains*—and most interestingly, the use of sampling keyboards, which I sometimes feel were invented for my very own personal use.

I love samplers so much because they can incorporate really meaningful sound words—train whistles in one piece. Anything in this world that makes a sound that means some-

Steve Reich and Beryl Korot, *The Cave,* 1993. Photograph by Andrew Pothecary.

thing to people can be incorporated into musical composition, not just à la John Cage, any old time, in some sort of collage manner, but very precisely, coming in on the end of three of the fifteenth measure, because the sampling keyboards are keyboards and they can play just like any other instrument.

So I'm very interested in their possibilities, and I am very much involved in using them, first in *Different Trains* and now in *The Cave*—a collaboration with the video artist Beryl Korot, who is one of the finest multichannel video artists in the world and who also happens to be my wife. This is the largest work I've ever done in my life by a long shot—it will apply sampling to video as well as audio, and will begin a new genre of music theater.

Will you be using video images as precisely as you're using audio material?

Well, I'm not doing the video—Beryl is—but yes, they will be as precisely focused. It will not be a multimedia piece in the sense of John Cage or any kind of rock and roll light shows or any of this kind of random collage. It will be exceedingly focused, exceedingly worked out, and fine-tuned as any musician fine-tunes eighth notes or sixteenth notes.

Your reference to the use of sounds with specific connotations interestingly challenges one's more simplistic sense of minimal music as an attempt to neutralize referential meaning by emphasizing formal process rather than existential reference.

Well, I think it depends what pieces you're talking about. If you're talking about some very early pieces of mine, like *It's Gonna Rain* or *Come Out*, well, sure enough, you find words and they do mean something, and then the abstract sound that they begin to generate is still tied to what you know were the meanings. Later pieces were not vocal pieces, and therefore they have no "meanings" in this sense.

I don't think Beethoven's Fifth is fate knocking at the door. I think it's about motivic development, and I don't think there's any "meaning" in the *Brandenberg Concertos*. I think there's meaning in music when there are words used with meaning. And when people say music has meaning besides words, they're on very sticky, embarrassingly sentimental mud, intellectually speaking. So obviously, when I did music that was instrumental music, the meaning of it was what it was about musically—that was the meaning of it.

But the meaning of *Different Trains* is about America before the war and Europe during the war and after the war. And the meaning of *The Desert Music* is the meaning of the poems of William Carlos Williams. And the meaning of *Tehillim* is the meaning of some of the selections of the Book of Psalms in the original Hebrew.

So when you're dealing with text, then certainly you can have very, very specific meanings. And music gives those meanings a resonance they wouldn't otherwise have, and can perhaps suggest things by the singing of words that the saying of words alone would not have, as we know from the history of vocal music.

Would I be right in thinking that there's a transition, perhaps, between some of your works where you're using the voice almost as an instrument to counterpoint or to "double" the musical instrument, and works like Different Trains, *where you select verbal material as a sort of starting point to be "doubled" by instrumental music?*

Well, actually, in a sense what *Different Trains* does is almost to reverse the process. In *Drumming* you have voices imitating marimbas, while in *Different Trains* you have a viola and a cello imitating the human voice—but obviously, you can feel the same musical mind at work. Yes, you're right: one is the reverse of the other.

How does your work relate to the music theater of Philip Glass and Robert Wilson, or to that of Robert Ashley?

Well, I really don't know Robert Ashley's work, and so I can't say much about him. As far as Glass's work goes, he did a very adventurous work with Bob Wilson—*Einstein on the Beach*—and I would give them great credit for that.

I prefer to talk about Kurt Weill, whose *Threepenny Opera* completely changed the idea of what the vocal style of a musical theater piece could be, and indeed what the orchestral forces could be.

And I think one can learn from Kurt Weill. *The Cave* will be another form of music theater appropriate to our time and our place, and which has nothing to do with Verdi or Wagner, which were very well suited to their own time and place. I'm trying to do something that fits my own life and doesn't feel like I'm wearing some kind of costume from another era.

How does The Cave *use multimedia to address contemporary conditions?*

Well, *The Cave* is about the Cave of Machpelah, in the town of Hebron on the West Bank, where Abraham from the Bible is buried, and it is very much the root of the situation in

the Middle East today. The patriarch Abraham had two sons. One of them is Isaac, who is the father of the Jewish people, and the other one is Ishmael through Hagar, Sarah's servant, who is the acknowledged progenitor of the Arabs. So in essence, you have here a kind of family paradigm for the roots of a conflict which didn't begin with the partition of Palestine, and didn't begin with the Balfour Declaration, and didn't begin with British involvement in the Middle East at the turn of the century. It is foreshadowed in the biblical period and really begins with the rise of Islam in the seventh century. And unless one understands those historical realities, one has a very superficial view of contemporary political life in that part of the world.

So the opportunity that video and sampling offer is the opportunity of dealing with real human beings living in that part of the world, who get a chance to comment on simple questions, like "Who for you is Abraham?," "Who for you is Isaac?," "Who for you is Sarah?," "Who for you is Hagar?," "Who for you is Ishmael?," in a way that doesn't involve an actor pretending to be Abraham or pretending to be some character who's in the political light in the Middle East today, but rather, bits of reaction from people who are living this reality right at this time, taken into a musical context by the melodies of their voices doubled by musicians and singers.

Of course, there will be many other aspects of this piece. It will be in three acts. The first act will deal with these questions asked of Jews. The second act will deal with these questions asked of Arabs. And the third act will deal with these very same questions asked of Americans. And of course, answers by *those* people to these questions may very well be, "Do you mean Lincoln?" or "Are you joking?" or "Are you serious?" because over here, in the West, those questions have lost resonance and relevance. Basically, we'll be dealing in the first two parts with an informed and concerned group of people dealing with a certain biblical-Koranic reality, and in the third part, with an ill-informed and unconcerned group of people. And indeed, that is perhaps the political thrust of the piece.

So The Cave *is a critique of European and American cultural ignorance or complacency?*

Well, it's obviously a piece of music theater, but it's also documentary in that we're dealing with, not our concoctions directly, but rather, our editing of a subject matter which is in essence documentary. And certainly, when it's all over, rather than try to solve the problems of the Middle East—which, of course, we would be ill-equipped to do—it might perhaps shine a bit of a light on what happened since the Enlightenment in the West, and will show some of the results of that Enlightenment as we find it today.

But as you've remarked elsewhere, you don't expect music to change the world?

I'm afraid that it will have virtually no effect whatsoever. All it can do is remain an evening of music theater that hopefully people will enjoy and perhaps think a bit about. But it will have, I think, virtually no political effect. Kurt Weill had no effect on Hitler. What we do know is that while his work is known and loved, the political situation that engendered it went to the worst possible conclusion, in which his only political participation was to run like hell!

Maybe The Cave *might have a more general intellectual impact, in the sense that it challenges the complacent claim that we're living in a culture where historical meaning no longer really exists. Thematically, it seems committed to historical and cultural values.*

It may be, but it will live or die on the strength of its musical and artistic value. If it lives on the strength of that artistic value, then those thoughts will continue to live with it. If it fails on the strength of its musical and artistic merits, then those arguments will be so much irrelevance.

How seriously do you take accounts of postmodern cultural decline?

Well, I think we're living at a very different time than, let's say, the time I tried to portray in the opening of *Different Trains,* when America was a much more innocent and a much more morally unambiguous situation. Since 1945 that's been in rapid change. *The Cave* will also deal with what's going on here, but it will also posit certain things as well. So, again, I'm not a politician, I'm not a philosopher, and I'm not someone who is trying to change the world by political means. But since I am a human being I have to do a piece of music theater about subject matter which gets my juices flowing—and this material gets my juices flowing rather strongly.

Which other artists or composers get your juices flowing?

I admire the work of Arvo Pärt enormously. He heard my music in the Soviet Union before he left there to go to Berlin. And yet he's been able to come away writing something which is very, very clearly his own, in a totally personal voice. His *St. John's Passion* is a marvelous—a very important—piece of music, and I'm interested in anything that Arvo Pärt writes. There are younger people—people like Michael Gordon, who's extremely interesting, and David Lang and Julia Wolfe, who are all part of the Bang on a Can group.

How seriously do you take concepts of minimalism? Would you describe yourself as a minimalist?

Well, you know, Debussy is still an impressionist though he's dead and gone, and Arnold Schoenberg's an expressionist though he's dead and gone. But none of those composers really gave a damn about that kind of thinking—they were very busy trying to write the next piece. And that's the situation I'm in. I understand that I'm labeled that way, and that it's a convenient way to mention me and a number of other composers with one word. But whether I like it or not really has nothing to do with it. My problem is quite different. My problem is to write the next piece, which will be perhaps a surprise to me as well as to you, and I've got to keep my eye and ear firmly fixed on that goal.

Do you already have a "next piece" in mind?

The Cave is such a huge project, and it involves so many innovative techniques and ways to write music and make theater, that I doubt that I'll have a thought about anything in this world until after 1992, when this piece premieres at the Stuttgart Opera.

What have been the rewarding consequences of working collaboratively on The Cave*?*

So far, the collaborative problems have turned out to be collaborative pleasures. I feared for my personal life when my wife and I decided to work together, but it's actually brought us closer than we were before and it seems to be a very, very healthy collaboration. I'm also working with other people in the theatrical end of it. The lighting director is Richard Nelson,

who did the lighting for Stephen Sondheim's *Sunday in the Park,* and has also worked with Merce Cunningham and Laurie Anderson, and he's been a joy to work with. Our stage director, Carey Perloff, has also been very good to work with. And our set designer is John Arnone, who's worked with the Guthrie Theater in Minneapolis and who has worked in New York recently with Eric Bogosian, and has been great to work with as well. So, so far, it has been a very positive experience.

Rachel Rosenthal in *filename: FUTURFAX*. Photograph by Pam Demuth.

RACHEL
ROSENTHAL

I FIRST CAME ACROSS RACHEL ROSENTHAL'S NAME in the winter 1981–82 issue of *High Performance* in a feature about three "Taboo" artists published alongside a review of Laurie Anderson's, William Burroughs's, and John Giorno's performances at the L.A. Roxy, and a section on food and art with a performance text titled "Fear of Dining and Dining Conversation" by Ellen Zweig, who almost certainly showed me this magazine during my first trip to California. Ellen also kept mentioning Rachel Rosenthal's name in our subsequent conversations about American performance art, but it was not until 1992 or 1993 that I phoned from Brisbane to try to arrange a meeting during my next visit to the States.

Embarking from one of L.A.'s truly terrible motels—brochure a wonderland of models lounging round the pool, room service menu covered with scrawled complaints—I paid the taxi driver to the ominous sound of barking activated by my approach to Rosenthal's South Robertson Boulevard HQ. The door opened. "Hello, are they dangerous?" "No, they're friendly rescued strays!" Well, I hoped so. Exchanging introductions, we sat down, I reached for my tape recorder, and Rosenthal started things off with the wonderfully interrogative imperative, "So—questions?"

An epic narrative began with childhood memories of her father's collection of works by Chagall, Monet, and Pissarro—"like living in a museum!"; of family visits from Eisenstein; of art studies with Hans Hofmann; dance studies with Merce Cunningham; theater studies with Roger Blin and Erwin Piscator; and New York days with Cage, Johns, and Rauschenberg. Rosenthal's adventures across the arts tell the story of the one who got away to L.A. and successfully explored post-Artaudian, post-Beckettian, post-Brechtian, and post-Cagian "instant theater"; feminist autobiographical performance; and partially solo, partially ensemble performances addressing the "appalling" '90s. "It's about forcing people to pay attention to certain things. But the form it takes, I hope, is art."

Self-consciously steering clear of more "quotidian issues" arising from—and returning to—only "a small range of the spectrum," Rosenthal summarizes her work as the attempt

"to open up those issues to a much larger context, and see them in a way that goes beyond the immediate personal hurt, within a much bigger sense of time and space and evolution."

Like her enthusiasm for all those artworks that "just sit there over the eons and look gorgeous," Rosenthal's humor, generosity, and energy are an inspiration. "I'm pumping iron now," she told me, when we met again in 1996. I'm still agog with admiration!

Los Angeles—July 7, 1993

So—questions?

Perhaps I could begin by asking you about your early influences?

Well, it starts a really long time ago. Interestingly, my father was a big influence in my life because, although he was a businessman in Paris, he was sort of a frustrated artist, and my mother was also a frustrated artist—she wanted to be onstage and never did a stitch of work in her life. My father was a very sensual man. His business was importing precious stones and Oriental pearls, and he adored Renaissance painting and painting in general. From the age of three, I think, he was taking me to the Louvre every Sunday, when he had a day off. I was exposed to art all the time. We had a lot of art and beautiful things in our home, very valuable things, a Monet, a Chagall, a Pissarro, and the whole house was decorated by Jean Dunand—you know it was really like living in a museum!

Very early on I wanted to be an artist, and they decided that this was a great idea. A Russian émigré called Robert Falk gave me some painting lessons, and then a student of his, a woman called Madame Chabchai, continued giving me lessons—when I was six or seven. I was also studying ballet with Olga Preobrajenskaya, a famous dancer from the Moscow Ballet who was teaching all the big ballet stars.

Then, during the war, I went to the High School of Music and Art in New York, and that was an extraordinarily strong influence in my life. The art students studied music appreciation, and the music students studied art appreciation. All the artists who were refugees from Europe came to talk and meet the students, so there was this tremendous input of interesting people—plus the fact that my parents knew a lot of people like Chagall and Vladimir Horowitz. At Music and Art a sculpture teacher called Mrs. Rosen exposed me for the first time to modern art, and I became an absolutely rabid Picasso fan very early on.

After Music and Art, I studied with Morris Davidson, a minor painter in New York who was very much of a French modernist. His work was not very arresting, but he was an excellent teacher, and he made me understand how to look at painting and how to look at art. He really taught what it was that made a work of art beyond the subject matter, beyond the surface seductiveness, and so on. Then I studied with Karl Knaths, who was a more famous painter at the time—he was an American also coming from Europe, also a modernist and a very interesting painter actually—and then I went to study with Hans Hofmann. And so I had a modernist and abstract base and structure on which to build.

My father (bearded under the flag) [Rosenthal refers to a photograph] was born in the Caucasus (Russia) in 1874. He left his home at age fourteen and came to Paris in 1888 "to seek his fortune," penniless and not knowing the language. By age twenty-five he was an

importer of precious stones and a multimillionaire, and had brought over his entire "tribe" to live in Paris also. These are his brothers and sisters and their spouses around 1910, I'd say.

My father married a French Catholic woman and had three children. He met my mother, a Russian Jewish refugee from the Russian Revolution, in 1921 and they instantly fell in love. His wife wouldn't give the divorce, and so he lived openly with my mother until I was seven (I was born in 1926), at which time his wife accepted a huge settlement and my father and mother were married on my birthday. My mother is front center in the fur collar, and my father is at her left, bearded.

My mother is in the gray Persian lamb coat. To her left is her sister Hanka, in the glasses, who was one of many in the family later killed by the Nazis. To Hanka's left is Eisenstein, and behind and between them is my mother's first cousin, Leonid Azar, an award-winning film editor. The first man at the left of the photo is his brother, Boris Ingster, who came to Hollywood in the late '30s and became a director, writer, producer of films at first, then television.

After the war I went back to Paris, and at the time I was really torn between wanting to be a visual artist, and yet knowing that deep in my heart I was really a performer and clown, and absolutely not at all gifted for staying alone in the studio, painting. I was very much influenced by Jean-Louis Barrault and by Antonin Artaud. When I came back from Paris, after having met Merce Cunningham and John Cage there, I continued studying with Merce and became acquainted not only with him but with his whole entourage, including the sculptor Richard Lippold, the composer Lou Harrison, the writer M. C. Richards, the pianist David Tudor, and the poet Jackson Mac Low.

I also got very close to Bob Rauschenberg and Jasper Johns, who were later brought into Merce and John's circle. In the early '50s we shared a little building—I had the upstairs loft, Jasper had the loft below me, and Bob Rauschenberg had a loft around the corner. Cy Twombly was also part of that group. So that whole postmodern thing was also part of my life. I had a lot of ideas, but they were all very embryonic. John and Merce, of course, were already fully formed in their philosophies and aesthetics. John was a very strong influence because he was very loquacious and talked about his ideas to all and sundry—we were all, of course, into Zen Buddhism, because he was. Bob Rauschenberg was very young but he was also fully formed, and then when Jap—Jasper Johns—came into the fold he was on the verge of being fully formed. It was while I knew him that he burned all his old works, and then began to do targets and flags.

So I felt at the time that I couldn't compete with that kind of solidity—that I was still too ill-formed and too fragile. And yet I brought a lot of ideas from Paris about absurdist theater and the theories of Antonin Artaud, and through conversation with all these people, I was an influence in a certain way, even though I myself had not yet found my authenticity. In 1955 I decided to move to L.A. because my father had died in Beverly Hills, my mother was moving here, and I felt she needed the company. I also felt I needed to be away from these people whom I'd adored and admired so much, but around whom I felt I could not find my own voice. And so I came here. I got a job at the Pasadena Playhouse, teaching there, and within a few months I started my own workshop.

Out of that workshop came my first Instant Theater—the company that I had for ten years, which was in effect a parallel on the West Coast to what was happening on the East Coast. There, it was an adjunct of visual art and created by visual artists. For my part, I immediately associated with theater here, for lack of another context, with no audiences

except for the artists who exhibited at the Ferus Gallery—Ed Kienholz, John Altoon, Billy Al Bengston, Ed Moses, Wally Berman, and their friends who were poets and musicians. Those were the only people who came to see what I was doing, because it was totally abstract and experimental. There was nothing here—it was a desert, except for the film industry.

This move reminds me of the way a second generation of younger female surrealist artists, such as Leonora Carrington, seems to have needed to distance themselves from first-generation male surrealists in order to distill their more feminist and mythological visions. Was your decision to leave New York similarly motivated?

I was not aware of the male aspect, because I was so male-identified that I never thought of myself as a woman. I was afraid that if I identified with being a woman I would not be an artist. I had totally swallowed that line that either you're a woman or an artist, and if you're an artist you have to be male, and if you're not male then you're not an artist. It was a very unconscious thing—it wasn't thought out but was always there below the surface. For decades I suffered from that mind-set immensely, without realizing what the malaise was.

Also, you see, when I was in New York after the war with those men, they were all gay, and so there was a lot of confusion in my life and in my emergent sexuality. You know, today, I say that I'm "a gay man in a woman's body," because that's true—I behaved with them the way they behaved with each other. There was no way that I could behave as a woman and be acknowledged as a woman, because these men were not interested in women sexually. And so I believed I had to become a gay man—not consciously, but the effect was there. That whole art movement was a gay movement—the one that came after abstract expressionism, which was definitely a macho-man movement. It was all a very interesting offshoot of camp and the whole camp sensibility. My emergence as a woman and as an artist came when I got involved with the women's movement here in Los Angeles.

Whereas Cage suggested that indeterminacy should make art more like life, so that art's meaning coincides with a general sort of life process, your use of chance seems to promote more pragmatic thematics, in the sense that you affirm that "life is a skill." Did you ever find Cage's approach to chance insufficient in terms of your sense of art's purpose?

That came later. Because you see, my Instant Theater was an improvisational theater, and in a sense it was very much influenced by John. We developed a skill for doing collective improvisations and creating works in the moment. All of us participated not only onstage but offstage, with the lights, the sound, the set—everything was completely spontaneous, in the now, happening once and never repeated. The skill that enabled us to do that for a paying audience was honed in workshop. We workshopped five nights a week, for about six or eight hours, from seven until two in the morning or whatever, in order to learn all kinds of forms and approaches to enable us to create works of art spontaneously and collectively. At the time it was very much influenced by Zen and Zen arts like *sumi-e*—the art of ink painting. With *sumi-e*, you make a stroke, and you can never change it or erase it. It has to be, and it has to be followed up in such a way as to be perfect—and this is very much how we worked.

The understanding was that anything that was offered onstage—either a sound or a gesture or a word or any of those things—had to then be followed and built upon in order to create the work of art as a whole. Sometimes there were short pieces, sometimes the pieces were an hour long. I never went Cage's route of negating or ignoring the rhythms of an

audience, the ebb and flow of breathing, attention span, or emotional curve. Our work was sometimes abstract and surreal, but never Dada or nihilistic.

In a way, I was already groping for an art vocabulary that would enable me to create risky theater but with a communication of ideas that was accessible—ideas that could be articulated—something John didn't like. It's only in the mid-'70s that I really felt the need for more control, to get away from this kind of improvisation, to have a text, and to go in-depth, do research, and stay with one thing long enough to be able to repeat it.

How many people were there in the Instant Theater?

There were five core people, and a lot of my students would come and go. Sometimes we had up to ten or twelve people, sometimes only the five of us.

Were you aware of other groups doing this kind of close collaborative workshopping? The composer Kenneth Gaburo seems to have had a similar ensemble—did you know of his work?

No. I was more aware of the cabaret-style improvisationalists. They were people who were extremely clever and who had a good gift of the gab, who created little scenes and vignettes that were close to the belt, and more or less realistic, but in a comedic style. Whereas we had a much larger range, because we sometimes did very funny things, but the comedy emerged less as a clever verbal thing than as the shock of collisions of totally unexpected elements.

The kind of style that we had was very surreal and based on visual images and poetry and dreamscapes. So in that sense I think we were quite unique. I don't think other people had the guts to do that, because it was very difficult—it was really like tightrope walking in front of an audience without a net!

You've mentioned surrealism and the absurd—was this work predominantly European in register?

Well, I brought a lot of European stuff with me, but everybody else was American and the mix of styles brought on some very interesting results. We managed to create these pieces that held together very well in terms of their composition, but that were shocking in the sense that we came from totally different traditions. After a while, I became more absorbed by an American style—because I didn't go back to Paris for twenty-three years.

Were you also aware of Beckett's work?

Yes, yes, of course. As a matter of fact, I had seen the premiere of *Waiting for Godot* in Paris, because Roger Blin, who was the director and who played Pozzo, was my teacher.

And Brecht?

He's another influence I forgot to mention. I went to the then-called Dramatic Workshop where Erwin Piscator—a devoted Brechtian—started teaching, and I became his assistant director and was very much influenced by that style of acting.

Your career seems a fascinating series of encounters with different creative impulses from Europe and America.

Yes—I'm a real collage! I've always been, I think, a person who synthesized things. I was always a sponge—I really sponged up all these influences—but I was able to synthesize them, so a lot of my work has that collage quality. What I do is work with all these different styles and approaches within one piece, and create a kind of cubistic structure. So in a sense, I was able to find a cohesion, in all this multiplicity, within myself.

When did you first feel that you were really your own person? Was that after the Instant Theater?

No. I think a lot of my work during Instant Theater was going in that direction. We experimented in so many ways that today I'm totally spoiled when I go to the theater, because we did it all! We never repeated things and were totally unsung and unnoticed, but within the walls of our theater, we tried out all the things that came afterwards—or even that had come before, unbeknown to us. When I go to the theater it really has to be something pretty special for me not to fall asleep!

Has technology modified your performance options? Productions like Robert Wilson's Einstein on the Beach *surely explore lighting and staging effects that a modest five-person ensemble couldn't hope to emulate.*

Yes, technology has become a very important player in the game. When we worked in Instant Theater, it was like a cottage industry, because we were so underindustrialized, and worked with totally shoestring and low-tech materials. For instance, we used to carry lights and move onstage with them to create all kinds of fluid effects which were quite wonderful! And they were done with nothing! We used saturated gels and in a way predated psychedelic lighting. So perhaps five people actually could push things to the limit!

That's an interesting point, because as the San Jose sound poet Larry Wendt remarks, whereas lavish university music studios often produce relatively unexciting stuff, artists building their own computers from bits and pieces often produce maximum effects.

Absolutely. You know, Richard Foreman did in New York the same thing that I did here. He used very simple lights, but he was, I think, the first who worked with the effect of having lights in the audience's eyes. Suddenly all the lights would shift and go into the depths of the stage, away from our eyes, and it would be an absolute switch in spatial quality which was wonderful—and done with nothing!

On the other hand Philip Glass's production of 1000 Airplanes on the Roof *used computerized lighting and scene changes in order to synchronize effects which he said he could never have attained five years earlier.*

But I love technology! If I had enough money, I would work with some very high-tech stuff myself. It's just that I've never had the kind of money support that I would need to do that. First of all, I love science. I hate science when it's life-invasive, but I'm very excited that technology has made possible the new sciences of chaos, complexity, and systems, because they have opened up a whole new way of looking at the universe and at reality, which will counteract the reductionism we've been suffering under for so many centuries. But you have to have control—you can't let technology become your boss.

How did your performances develop after the Instant Theater years?

I ended Instant Theater in 1966. We had a brief revival in 1976 and 1977 with a beautiful company—we did gorgeous work, and lost our shirt. In between, I went briefly back to visual art and did a lot of sculpture—and that was the time when I got involved with the women's movement here. That was a very big transformation in my life. In 1975 my mother died, and it was no coincidence that it was the same year that I began to do performance. Actually I did Instant Theater after my father died.

My parents were extraordinary—extremely charismatic. It seems that I was not able to be who I was until they died. When I began to do my own pieces they were always solos, even if I had other people in the piece, so I consider myself a solo artist even with a lot of people onstage with me. Because of the influence of the women's movement I began to do my performances as autobiography. When the feminists began to do performance, the slogan was "The personal is the political."

My first performance took place when a couple of men who had a gallery in the Valley, and who had been Instant Theater aficionados, came to me and said, "Why don't you do a performance for the gallery?" I thought, What am I going to do? Because at the time I had tremendous problems with my knees, I did a piece about my knees, with a lot of material from my childhood. It was about how physical disabilities or physical problems grow from internal psychological or spiritual problems. It had a lot of fun and irony in it, but at the same time, all of it was true and concrete, down to the X rays and a tape of my doctor's voice.

From then on, I continued for a few years doing pieces about my life but always as a metaphor for larger issues. It was a way for me to somehow redeem myself. I felt that I needed to redeem my life, because it hadn't been lived the way I thought it should have been. But in reality, you know, it didn't change my life one iota. I just acquired a body of work.

Perhaps there's a parallel with Beuys's emphasis upon personal and national regeneration?

I think there's a parallel, because he brought the personal into his art, but I think the work I did was much more revealing. So much of the males' work was very hidden and couched.

You mean feminist art was more probing than the semiautobiographical register of works like Cage's Indeterminacy?

Yes—and if people like Cage and Jasper Johns were so veiled it may have something to do with the fact that they were all in the closet, at that time. Everybody knew that they were gay, but they were closeted. The times necessitated that, and I think it became a way of being, a way of presenting themselves, even beyond their sexuality. There was a very hidden and impenetrable quality about all of them.

And I think that when the feminists let it all hang out, including their lesbianism—and the gay movement came out at the beginning of the '70s, just at about the same time—there was a great deal of churning of the personal and hanging out of dirty linen and all that stuff. So in that way, I think those works differed greatly. That generation of male artists never changed, you see—they never became more candid about their personal stuff.

Subsequent artists like John Giorno seem more openly confessional.

Yes, and Spalding Gray and Bogosian—and many others. Many of the men were influenced by the feminists, not only in performance but also in their visual work. What the feminists

brought to art—the quotidian, the decorative, the materials that were not noble, and so on and so forth—became part of the vocabulary of both genders after a while. Women had a tremendous influence on all that.

How long did your work explore this confessional impulse?

For a long time, until 1981, it was autobiographical—and if it was all put in one book, in a continuous text, according to the chronology of the subject matter, it would be like an autobiography. But it was never purely confessional—it always incorporated conceptualism and nonlinear forms and structures. In 1981 I seemed to have finished with that phase. Although they still evoked the personal very strongly, my pieces became much more involved with global issues, and all the work I've done since 1981 has been of that nature.

Every time I work on a piece I try to bring to it a completely different approach, and so each is different, one from the other. Although the general subject matter of my pieces is the same, the specifics are different, and so I have to do a lot of research—I usually tackle things I know nothing about, so I have to learn about them. But even in the structures, there's probably a general family resemblance.

Most of the time I work from fragments that collage together, although I have done a couple of pieces that are pretty linear. Most of my work has a central subject matter—it's a little bit like spokes in the wheel, so that each spoke approaches the subject from a different point of view but meets up in the center. It comes to the central issue each time, and the completeness of the piece will then bring forth the image of my work—whereas if you look at each piece separately, you see just one aspect or one fragment. A lot of my performances have that kind of structure.

The last one I worked on—*filename: FUTURFAX*—is more like a piece of theater in the sense that it is a linear narrative, and has the classic unities of time, space, and action in a weird way! It involves me in the present and me in 2012, and then it brings in a fax from the future, from 2092. But the actual action all takes place in my room, in the present—which happens to be the future—and the unity of action is that it's just me, going through my daily life, after the "Great Calamity"—the ecological crash—receiving this fax and eventually being killed. I liked the idea of taking a very contemporary piece of technology, and just sticking it onstage and seeing it in action. It's got a nice spot on itself, so that it becomes the star of the show.

Do you start with the text, with movement, with the setting, or with some other aspect of the piece?

I start with the text. The reason for that is because all the years that I did Instant Theater, it was visual, movement oriented, and imagery oriented. Text was there, but it was very much like Artaud's theories, where the words are objects and the text is no more important than the other components.

What happened is that when I began to do my own pieces, my knees, as I said, were in such bad shape that I could hardly move. I had been a tremendous mover when I was young. I was a very good dancer—I had an incredible style of throwing myself off-balance and catching myself, and it was very painful for me to think that I couldn't do that anymore. It was a loss of expression. So I crammed everything into language, just to counterbalance the fact that I couldn't move. For quite a few of those years, that was my only recourse, because every time I performed, I would damage myself some more.

And then in 1990, I had a terrible, terrible year—a lot of my bones broke, and I had an inordinate amount of pain. I mean, I had lived with pain for two decades—with the legs, it was like twenty-four-hour-a-day pain, in bed, out of bed, all the time—but when I had fractures in my vertebrae, the agony was twenty times worse! That was the year I created *Pangaean Dreams,* which is about the breaking up of Pangaea—the super continent that existed two hundred and sixty-five million years ago, and that eventually broke into the continents that drifted into the places they're in today. The earth's breaking up was a fabulous metaphor for my body breaking up.

At the end of 1990, in December, I had a knee replacement operation which changed my life—it was just amazing! I have no more pain—I can move! Unfortunately, now, I'm a little old and creaky and not in very good shape, but at least I can think in terms of moving again. It's sort of late in the day—but so what?

My work is still very textual, and it's based on words and what words have to say, but in spite of that, it's been extremely visual, because with the words I've worked with projections, with video, with live musicians, and the actions that go with the words are very visual. They're also very surreal, most of them, very strange. But I don't do things arbitrarily, just for the hell of it.

I bring in visual metaphors, and I think the objects I use—and this I got from Instant Theater work—are extremely eloquent, and bring in a new dimension and another way of looking at whatever it is I'm talking about. I need to get the ideas across, because that's the whole purpose of my art. They have to be clear enough—they can be pretty surreal, but people have to get them.

You seem to make the same distinction when you observe how the amateur videotape of the L.A. police beating Rodney King constitutes an elementary kind of documentation and communication, whereas you're also aiming at another level which is less easy to quantify.

I think there'll probably be a lot of things written about the history of that tape. You know, somebody heard a noise and looked out of their window and saw the beating of King, and happened to have a camcorder and started to film. And then it's taken off with a life of its own, in ways that were totally unexpected.

In what ways?

Well, the availability of filming technology makes artists and/or reporters of us all. It's a very grainy, very amateurish-looking piece of work that has, in a way, made such a noise in our history—it's a very interesting interface between art and amateur works, as well as everything else. When it's inserted into a news report, for instance, you see the difference in texture and in quality—the slickness of those news reports, most of which now are created for camera, some of which are doctored and relived for camera, and then this piece of work which is so raw and very real.

And yet, interestingly enough, when it was presented at the first trial particularly, it was so pulled apart and stretched—all its dimensions were electronically altered in so many ways by pausing, going in slow motion, and by zeroing in on certain details—that it completely lost its impact and allowed the first jury to let those guys off free! So it's interesting that even something which is so real and so raw and actual, taken from so-called reality, also can be subverted and co-opted to that extent.

Presumably your work more successfully resists co-optation by the media?

Well, you know, I have a kind of weird career, because I never really pushed it. I could prob-
ably have been much more "famous" because I'm an interesting person and my work is
good, and so on—but I didn't look for it. So the little attention that the media has paid to me
has been quite by chance. KCET, which is our publicly supported channel here, is supposed
to reflect what goes on in this town—and I don't go on in this town.

As a matter of fact, this town hardly supports me at all. I have to go out of town and tour
everywhere else in order to make a living. I make a living right here from teaching—my
students are here, and they're plentiful. But for my performance work, it's very, very hard for
me to get one on here. I've had pieces at both L.A. Festivals, but otherwise, they're very few
and far between. Most of the venues are dead, the big venues haven't wanted to touch me,
and the small venues can't afford me.

Are you pricing yourself out of the market?

No, I haven't priced myself out of the market in general, because I do get my fees—which
I think I deserve after all those years—anywhere else. But I have trouble getting them here
and in New York. I'm better off in the provinces, in big universities and places like that.
Also, I think that being white, and being older and no longer "emerging," is getting to be a
handicap—being a woman doesn't help, being Jewish doesn't help, apparently. Most of the
effort now is to bring in people who have been excluded up to now and a lot of the money
goes there. It's a needed transitional phase.

Flyer for performance workshops with Rachel Rosenthal.

Has censorship also been a problem?

No. I was never a target for censorship. My ideas, I think, are very subversive, but they don't deal with sex, so they pass. The conservatives and the radical and religious right are obsessed with sex and I don't deal with sex really, and so they've left me alone.

What do you think of those contemporary performance works that deal more explicitly with sex?

Well, it really depends on how it's done. I think, for instance, that Karen Finley's works are very important, because she deals with feminism and the female body in ways that are very political, and I think very valuable. A lot of pieces that are just done with nudity for nudity's sake, or with sex just to titillate or to scandalize or whatever it is, I think are stupid.

It seems a bit repetitive if that's all it is.

It's very repetitive and it's very unnecessary. I find it a bore frankly, because other issues are so much more important. But you see, it's reflective of this society, particularly here in America. I mean, we're going through such sexual upheaval, coming from a very puritanical base, then the permissiveness of the '60s, then the drugs stuff, and then finally AIDS, and now the feminist movement having totally panicked the men—the men can't get it up, they're so upset. It's really a problem here in America. And so I can understand that artists would want to address sex, because it's such a biggie! It's not a biggie for me, but it's a biggie for everybody else, it seems! "The body is the political!"

For all its reservations, your work usually seems very assertive in terms of its emphasis upon positive values such as responsibility, curiosity, and the need for some kind of healing balance.

Yes. My work is predominantly about our species' relationship to the planet. But, you know, I'm going through a lot of change right now. It's funny, because I started out very misanthropic. I never liked humans very much—I liked nonhuman animals much better. Over the years, I grew to like individual people, and in the last few years, I've become much more understanding and compassionate—probably through all my teaching and dealing with people as much as I do.

But I am *not* humanistic or anthropocentric. The human race exasperates me. I have no patience with it. We refuse to learn, we refuse to change, we refuse to evolve, and either we're going through a completely chaotic upheaval which will result in a sudden transformation and evolutionary change in the species, or else we are regressing and will obviously end up extinct and taking everything else with us. We're going through such a frightening and appalling period of time. There is so much more information, there is so much more knowledge available, more enlightenment in the human species, and there are so many individuals and groups that are doing things in the direction that I've been screaming about for so many years. People are beginning to understand, and really listen, and do something about these things.

At the same time, it seems to me that every time there's a step forward, there are two steps backward, mainly from the fact that we are totally unable and unwilling to do anything about controlling our breeding. All of the problems that we have today, with immigration, with famine, violence, with the deterioration of the environment, with all the cracks in the fabric of politics and government everywhere, all come from the fact that there are just too many people. Unless this issue is addressed, nothing is going to work. This is a monstrous

problem, and most of us don't want to touch it with a ten-foot pole! So I don't know. On the one hand, I am exhilarated every time I read about some of the profoundly intelligent actions that are taken. But on the other hand, I'm thinking, Drop in the bucket! Drop in the ocean! It has to change radically, and on a *huge* scale, in order to make a difference. So I get very, very depressed about that, you see.

At this point, I'm trying more and more to do pieces about what I call "the big picture"— in other words, not only global, but even cosmic. Where are we? Is it possible that an intelligent species has only so much evolution before it has to self-destruct? Is it something that's built into that kind of system? Because it seems so absurd that after the amount of intelligence we've achieved, after the amount of knowledge we've amassed, we've come to the point today where we're really on the brink and in total denial.

I have tried up to now to be somewhat upbeat in my talks and my performances, in the sense that I want to leave people with the impetus to go out and do something and change their thinking. But I myself am getting more depressed and more and more pessimistic. I'm wondering, Is it possible to change? Is it possible? On the other hand, I have no choice—I can't do anything but what I'm doing. Whether it results in anything or not, time will tell. I secretly would like to speed up our extinction to allow the earth to recoup, yet I do works that attempt to transform our way of thinking and being in order to avert that catastrophe. It's a paradox!

In a sense you're simply advocating values that any human being would advocate. But it's certainly surprising in this day and age that—

That it's still radical! It's so weird!

When I asked Dick Higgins the other day which issues he found most pressing, he similarly argued that the one thing art isn't talking about is ethics. It's shockingly surprising, perhaps.

Hear! Hear! I believe ethics is the lifeblood of our species, and we've become totally anemic in this respect. Every time I talk to Jap I get a shock, because his position is that art shouldn't be about anything but art. And he doesn't like my work—I mean, he likes me, and he's a dear and all of that—but he doesn't like my work because for him it's not art. And I think that John also didn't like my work because for him it wasn't art either. What can I say? It's true that my primary impetus is to communicate ideas. It's about forcing people to pay attention to certain things. But the form it takes, I hope, is art.

Has television attracted you, in this respect?

I would love to have my things televised! But the problem is that you have to create for the medium, and I create for live audiences. When I have enough money to do videos of my work, I take them to the studio and I re-create them for the camera. Those are the best videos I've done, of course. The others, which are just done as documentation, doctored a little bit, just don't make it. I would love to put my ideas on television, because that's the way you can reach millions of people. Often, I feel I'm preaching to the converted, or that I'm saying things everybody knows. But it's just not true. Even the people who are liable to come to see me, and who I'd assume are the converted, still need to hear these things, as reinforcement. People need to be reminded of our individual power.

And art reminds one of this and offers a sort of safety net which helps us to keep going?

Oh, absolutely. It's so tragic to think that art is the first to go when there's no money, and that this society so undervalues it and so misunderstands its function. When you think about history, if you are not a historian you really don't remember anything but the art. And that's why I'm just so appalled, when today, for instance, you see people actually going out of their way to destroy mosques or the Uffizi—to destroy those things which are the only important things that remain, and which are so nonpartisan and can't really hurt anybody. They just sit there over the eons and look gorgeous!

What about the argument that art is a privileged series of objects made by one class at the expense of another class?

But that's only in the Western world. If you look at traditional cultures, you will find that everybody makes art, and there's not even a word for it—it's just, whatever you make, you make it beautiful. I think one of the big problems we have is that we see so much through the eyes of Western civilization and Western society, and we've completely lost all perspective of other ways of being.

Has your work ever been criticized for being insufficiently historically or socially contextualized, in the sense that you're dealing with mythologies and a rather global vision?

No, not really, because I think it's pretty well researched. I think people are sort of relieved that I steer clear of some of the more contemporary and quotidian issues—because a lot of work that is responsible to issues is a bit shortsighted and tunnel-visioned, and has to do with the kind of separatism that you see today among the ethnic groups and the classes, and which really deals with antagonisms and problems which occur in a small range of the spectrum. I can well understand why people want to do performances about this, if they are political. But what I try to do is maybe open up those issues to a much larger context, and see them in a way that goes beyond the immediate personal hurt, within a much bigger sense of time and space and evolution. I think the personal antagonisms have to be defused—and it's very hard to do, because they're so hot right now, and people are really aching to fight on every level.

There's also the fact that fashion is such a huge influence and such a mammoth creative force in both good and bad senses right now. So many people are sensitive to fashion and wish to belong in it to the extent of losing all perspective on who they are and what they're doing. And by fashion, I mean everything from the clothes of the gangs to everything else. It's almost like, if you're not in fashion, you're vulnerable to great violence and possibly even death. Kids have killed for the "right" sneakers. There is no safety in our society, and fashion delineates safe boundaries within groups. So I try to go beyond that in my pieces, to skirt that completely.

What will be the main concerns of your next work?

I was sort of hoping that *Zone*, the piece I have to do in February—which is going to be about chaos and about the millennium—would be the piece that I would be able to mount with enough money to do what I really want. It hasn't come out that way, so I have to do it on a shoestring, like everything else I've done. It's not going to be a solo this time—I will

have a company of five people plus myself, and I'm going to get a hundred extras, if I'm allowed by the fire department! So the piece will be like a sea of bodies onstage, and all of the things that happen, will happen over, through, and between—and derive from—this crowd of bodies.

I want to show first of all the proliferation of our species, also all the laws of chaos working through these masses of people, and the relationship between the white race and the races which are nonwhites. The hundred people will all be of color, and my company is all white and in whiteface! It's just six people in this sea of nonwhite people. So I think it should be very interesting as a statement. Of course I'll be sticking my neck out, but so what's new?

After that I'm thinking of phasing out some of my touring, so that I can actually sit down somewhere away from the telephone and write my books. I want to write about my teaching methods, which are very specific and different from most, and I've never put them down. So that's what I want to do next.

To ask one final, rather redundant question, are you fairly optimistic regarding the prospects of art in general?

Oh, yes! I think art is the only thing that will remain as long as there's one person alive!

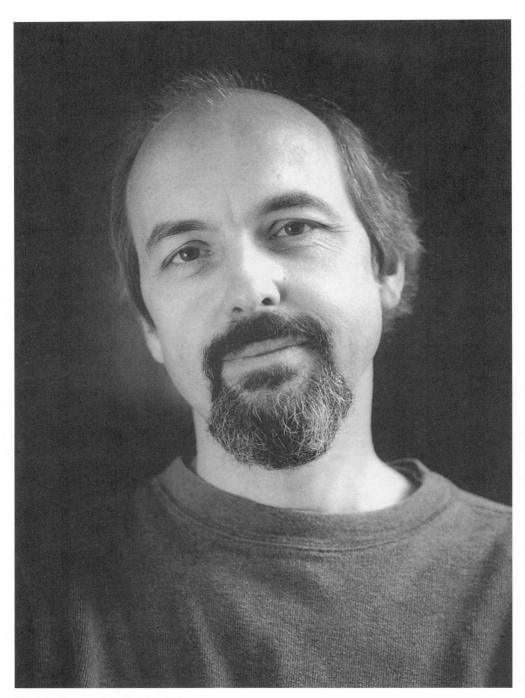

Bill Viola. Photograph by Beth Herzhaft.

BILL
VIOLA

I BECAME AWARE OF BILL VIOLA'S WORK when I saw his retrospective at London's Whitechapel Gallery, where the highlight for me was his stupendous *Nantes Triptych*. Subsequently seeing *The Greeting* at the 1995 Venice Biennale and reading his visionary essays in *Reasons for Knocking at an Empty House* (1995), I became all the more convinced that Viola was an artist offering exemplary attention to the positive potential of new electronic media.

Prior to our interview, I had also spent some time reading French theorist Paul Virilio's predominately negative accounts of the accelerating impact of mass-mediated culture. But in the light of Virilio's countersuggestion that explorations of cyberspace may well approximate "a quest for God," and following discussions with him in Paris in which he conceded his at least partial enthusiasm for technological art, I was eager to ask Viola about his use of decelerated technological imaging to address "the deeper questions and mysteries of the human condition."

Arriving at Viola's studio near Long Beach, I successively mentioned my interest in the parallels between his ideas and Virilio's most positive conclusions, Robert Wilson's sense that new technologies return us to the classics, and Jean Baudrillard's recent accounts of photography's capacity to capture "the silence of the image." One observation led to another, and before I knew it we only had forty minutes left for the interview itself.

I need not have worried. Viola immediately defined his work's central priority as the attempt to give other people "the possibility to experience things that I have experienced—revelations—in one way or another"—a process of "possibly revealing something a little deeper, broader, or wider," by employing video technologies to discover "new points of view and new insights in a very simple way, a very direct way."

Situating himself as one of the late '60s, early '70s generation who first attempted to employ the "new alphabet . . . new words . . . new grammar" generated by the '50s–'60s avant-garde, recounting his commitment to content during "the whole content versus form issue," and describing his explorations of video-mediated "microacting," Viola inspiringly insists

331

upon technological art's capacity to restore art's "connection with the community" in "exciting times" when "the commerce of images is a global phenomenon."

Indeed, reversing the hypothesis that the "poststructuralist" sensibility implies the theoretically correct cynical relativism of the '70s and '80s, Viola equates the most positive poststructuralist art with those content-driven contemporaries looking beyond the purely structural concerns of the '50s and '60s in order to explore the "real privilege" of new imaging technologies.

Long Beach—August 6, 1996

Could I begin by asking you how you would define your particular priorities as an artist?

Well, I think it's giving other people the possibility to experience things that I have experienced—revelations—in one way or another. I'm not speaking necessarily in religious terms, but just in terms of moments when one is confronted with a physical situation which causes one to see things in a different way, to think about something in a different way, to have some turning over of the familiar and the commonplace, and in the process possibly revealing something a little bit deeper, broader, or wider.

And I found that this thing called the camera—the video camera—and the screen, the monitor, are tools that can do that by their nature, because they give you the world back, but in the process of doing that—because it's not your own experience, but yet it's not mediated to another person, it's this kind of mechanical art—it can give you new points of view and new insights in a very simple way, a very direct way.

The clearest example I can think of is a piece that I did in 1976 called *He Weeps for You*, which is a drop of water that's magnified by a camera with a special close-up lens on it, and what's going on is something I had realized quite by accident one day—that within a drop of water is an image of the whole space that drop of water is in—and the camera and the video screen in that piece are simply used in a very direct way to give people the possibility to recognize that a drop of water contains an image of the world. And that's a very simple, direct kind of process.

What interests me particularly is the way in which you've used the video installation as a means of evoking heightened experience—with your use of several screens in the Nantes Triptych *or with your juxtaposition of similar gestures in* The Greeting. *What kinds of challenges were you addressing in these works?*

Well, with the *Nantes Triptych* and an earlier work that I did called *City of Man* I'm less interested in those images as an appropriation of classical form than I am in the triptych as a form of consciousness. When one sees a triptych, one—in Western culture—is participating in a structure of consciousness which has to do with the cosmological significance of heaven, earth, and hell, which is part of our modes of thinking now.

The wonderful thing about culture and art is that it goes on a journey that begins on the retina, but it actually ends up in very deep, unconscious behavior, and deep psychological, subconscious structures. You don't have to look for the history of art in museums, it's in our behavior, in our blood and gestures, as Rilke says. So that interests me a lot, that kind of

Nantes Triptych, video-sound installation, 1992. Photograph by Kira Perov.

classical form—how that affects who we are, and how we think about the world, and then, by a sort of resonance, it also very literally evokes a certain period in art history and makes a direct connection which I really feel we are experiencing again.

You mentioned Bob Wilson's remark that the avant-garde is helping us rediscover the classics, and I feel a sense that there is a stronger relevance to what we call the classics to today's world than in the heyday of the avant-garde period. The avant-garde period—the one-hundred-fifty-year tradition, or however long it is—is being bracketed now, and what's relevant is no longer a perpetual quest for the new, of being at the tip of the wave as it breaks. I think part of that is going back to what was rejected, to the academy, the classical, the neo-classical, to reconnect with it, because the great themes are really very much about who we are—they're not just concerned with isolated extremes. I feel a real connection with that.

What was the motivation for The Greeting*?*

That was really curious. I'd never really ever consciously taken a direct reference to another artwork and used it in my work. I've been influenced by lots of things and I'm very happy to talk about those things in my writings. But Pontormo's painting *The Visitation* just resonated with me. I did not in a conscious way set out to imitate that painting. I just found the image in a book and stuck a reproduction of it on my wall, something I've only begun to do in the last couple of years. I don't live with images per se, but I photocopied it, and I put it up on that wall over there and lived with it for a while. I didn't put it up there thinking, Oh, I'm going to make something about this. It just was there.

And then I began thinking about people meeting each other, and I began to observe— just in my daily life—people on street corners. And I became fascinated with this silent dialogue that one witnesses from a distance. I'm sitting in my car, and I'm looking out, and

there are these people who are just meeting, and you can't hear the dialogue, so it becomes this wonderful visual choreography of gesture and interaction, and you can read into that projected interest what's going on there. So that, I think, became really the driving force behind wanting to make *The Greeting*. And then the connection back to the Pontormo painting was really easy, because that's what's going on in that painting too. And before the figures in that painting you become a kind of silent witness—they're not moving and there's no sound. Then as I began to look at the painting a little bit more carefully, I became fascinated with the background and the architectural buildings, and started thinking of making something that kind of took off from that painting on a visual basis, rather than as either a classical or a contemporary re-creation of a historical period.

It's a little like a Robert Wilson set perhaps?

Yes, it has that feeling.

Or maybe there's something of de Chirico?

Yes, for sure, but more unconsciously, in the way that we designed the buildings. It was the first work where I created everything from scratch, which is a lot like painting—like the blank canvas.

The other issue in the piece that was interesting to me was the social interaction. In a lot of my work, when there are figures in it they're either part of this background or there's an individual figure that you're concentrating on, but rarely is there anything to do with what in normal, everyday life, would be how those people interact in the world—which is socially.

I found it a very powerful analysis of interaction, inasmuch as there seemed to be a mixture of both the ecstasy and the agony. People seemed very pleased to see one another, but the slow presentation of the meeting also showed a certain sense of horror, as one of the two people talking saw a third person arriving and expressed intense dismay before this oncoming interruption.

Yes, there was an awkwardness there—that was the main focus for me. The main focus for me in that piece was the dynamics of what happens when two people who know each other are happily engaged in conversation, and a third arrives, upsetting the intimacy of the first two and causing what I call the "third woman"—who doesn't know this new person—to become very unsure of her role, because she's with her friend who knows the other one who's just arrived, but there's no connection between the two. Structurally, and almost sculpturally, that was to me the interest. That triad—that triangulation—was the essence of the work in terms of its dynamic structure.

It seemed to me to be an interesting decelerated drama, slightly reminiscent of Beckett's play Come and Go, *in which three women sit together and then successively go offstage while the other two talk about their absent friend's apparent decline.*

Oh, that's lovely—no one's ever mentioned that in relationship to that piece.

That slow intensity was also extremely interesting, and I'd imagine that's something that one could only do with that medium. That's to say, in bad soap opera, characters tend to gaze at the

screen in amazement, fear, or confusion at the end of episodes, but this sort of dumb show seems very ponderous by comparison with the careful quality of movement in The Greeting.

Yes, I call that microacting. If they paused for longer than a second, that second would have been ten seconds in screen time. If they miscue by two seconds or if they don't do something right, in a very short amount of time it becomes extended and a big, big problem at the end. It wasn't as critical in *The Greeting* as it was in this other piece called *Déserts,* which was based upon the music of Varèse, but it was a similar kind of problem. At certain times you had to be very careful about the timing—the whole theme unfolded in about forty-five seconds.

And yet it lasted how long?

Ten minutes. So it's like transposing music, changing keys.

Do you also see your work as being related to performance or to a certain sort of drama, as opposed to static imagery?

Yes, I always have. Although I'd have to say it relates to both. Obviously I've been influenced by painting and art history, and quite a number of people who have commented on my work have talked about it as painting. And I am interested in the visual image—I have not lost faith in the visual image. I haven't become cynical about the image, and so there is a visual craft there. But on the other hand, when I was younger, performance art was really in its heyday—early performance art, "body art" of the early '70s—and I found that very influential. The idea of just simply, as a solitary practice, turning the camera on oneself in the privacy of your own space was really quite strong, and quite impressive.

Are you thinking of somebody like Vito Acconci?

Yes, sure, Vito Acconci, even someone as goofy as William Wegman or Bruce Nauman. A number of artists did that, and I think that was the great contribution of video—as opposed to film—in that period. It was something unprecedented, and that influenced me a lot. So in a lot of my early works I'm the performer. In my later works, when there is a figure, such as the male in *Déserts,* there's a guy there that I use, an actor I've come to know who really looks like me—he's got a goatee, and I think he's sort of my alter ego—and I use him the way I would have used myself, earlier on, in my work. But I need more control now, behind the camera. So I was very influenced by the performing side of things, and considered the work that I was doing as performance pieces.

It is hard for me to look at myself in any kind of objective way, but I think one of the things I was trying to work through, particularly in the '70s pieces and in the tapes, was how to link and how to synthesize the performance tradition with cinema, with montage, and with editing structures. In a piece like *The Space between the Teeth,* which I did in 1976 when I was twenty-five, those things really came together. I mean, it's as much about editing, it's as much about Ernie Gehr's experimental films as it is about Acconci's performances.

You were differentiating your work from the tradition of the avant-garde in terms of your sense that your work was interfacing with the potential of various mythologies or classical art forms. If initial experiments demonstrate basic possibilities such as staring into a camera, then perhaps in its later phases, experimental art moves into what the French critic Michel Chion calls a

phase of final "hybrid" creativity in which all options become interfused. And so it's no longer simply a case of being polemical and saying, "I can if I want to," but of pushing that into a more meaningful domain.

Yes. That's a very good thing—you're talking about something that I haven't seen much in criticism, and that I wish some people would delve into and write about. I don't want to sound presumptuous, and I haven't said this in public too often for that reason, but I really felt in a way very privileged going to university in the late '60s and early '70s. The avant-garde film movement was at its peak in America—in its second wave or whatever—and modern art was being pushed to its limits by people like Cage, and the painters by that point had gone through abstraction and were really out there!

And I felt that all of that served to give me a language with which to start writing short stories, you know. They were literally forming new letters, creating a new alphabet, creating new words, new semantics, a new grammar, and I felt my privileged position was to be able to take that grammar and start to talk with it. At that point, too, I remember very clearly in university the whole content versus form issue, where content was a really bad word. If you were dealing with content, that was like, "Forget it!" And I think the power in any language is in its structure—it's the underlying structure that allows you to think in a certain way, and what these guys were doing was redefining the structure for new forms that they saw as existing. It's very, very—it's really admirable, important work.

I grew up with that structure that they had intellectually turned over in their brains—and then a new generation of kids came along who began just thinking like that from the beginning, because we didn't have forty years of our lives to sort of overturn. For me content became very important—I was criticized for that when I was younger. It became really important to me that I was applying this editing/montage technique—going back to Eisenstein and Ernie Gehr and Hollis Frampton—to this particular image of a guy who was obviously dealing with a really cathartic moment, as opposed to just an empty hallway or a shot of a table or whatever. For many artists at that time it almost didn't matter what the content was, it was the structure that was more important. And I really felt that the content was important.

Well, the difference between a memorable and a less memorable installation surely reflects the content within such structures. And while many postmodern cultural theorists suggest that all the old structures have broken down and that new media are incompatible with authentic content, aren't you arguing that new postmodern technologies are in fact capable of revealing to us how we think—maybe particularly how we think in the twentieth century—and how we've always thought?

Yes, because we're connecting the body with the mind—that's the real issue, right now, that's the historical practice right now. It's like we've come out of nineteenth- and eighteenth-century scientific materialism, this intense, rational structuring of the world, this fact-gathering, organization, and categorization according to which the body becomes secondary, and I think we're being forced now to use new tools to go back to the body.

It's very clear where that rational discourse lives. You see it in the experience people have of art museums, when someone goes, say, to a show by Picasso, and they come out and they're able to say when he was born, when he died, where he was born, and they're able to name three or four works and a couple of periods of his life. That, one might argue, is the

least significant level of art appreciation and art experience that one can have in a museum. It happens to be the actual goal of most museums to give that to people, hence wall texts, framing, and all of this sort of funny stuff that they do.

Alternatively, the deepest, most successful art experience one could have is when someone comes out of a Picasso exhibition and all of a sudden is totally in the mind of the artist, and they come out and this is a different world now, and they see things in a way that they've never seen before, and they're living in an associative, sort of very deep world that Picasso would have been in, or any artist goes through at some point when they're doing their work. And that's the highest level—which is nowhere near even being achieved.

Now the interesting thing, once we all started with these video tools, is that all of a sudden, you come to a situation where you cannot deny the physical, the physiological, and palpable visceral experience of these ideas. I mean, when Nauman made *Public Space, Private Space*—one of the great works in the history of video art—and you're standing there in this empty room, and on the monitor you can see another room with a monitor just like the room you're in, but you're on that monitor in the empty room, that is an incredibly profound statement of the human condition. It's a philosophical statement, and it's not made through language—language doesn't enter into it at all! It's made through being, through presence, through perception.

And I think seeing this work when I was younger, and realizing that one could make deep philosophical statements simply by restructuring perception, was really important. And that connects us to the ways in which Eastern culture's rituals in many cases allow primarily illiterate masses of people to go through these physical experiences and come out on the other end with deep philosophical knowledge—but not through opening a book and reading it. That's a really important process that we're engaged in, as a world society.

How does that project relate to mass culture—to Dallas, *soap opera, TV jewelry sales, and so on?*

Well, it does relate in the sense that I've always felt that the power of the mass media—by vicarious lies—is the dream machine. People go and they do their daily jobs, and then they come home at night and it's dark and they turn on the TV and they sit and watch—and what do they see on the TV? They see people who look sort of like them engaged in situations they may have experienced—something vaguely related to that. Of course, the extreme of aliens coming from outer space is not what someone experiences, but on a metaphoric level—yes—I kind of have respect for that as well.

I don't discard the mass media because they're not up to the status of art. I think art is a special practice that is about reaching very high standards of visual perception, achieved with craft and vision. But I still have respect for the mass media, and I see its need in society. It's not unlike the countless Hindu myths that are told in the villages of India, and those have a very important function. But I wish the people making these things, however, would be more aware that they have a mythological, allegorical relevance in society.

Do you feel frustrated or annoyed that your own work isn't widely distributed by the mass media?

Well, all my tapes have been shown on television. But they've been marginalized because they've been shown in the experimental hour on public television—they've certainly not been shown in prime time on commercial television—so I'd have to say that I'm satisfied with what I've been able to do.

When I show at the Museum of Modern Art in New York, I'm reaching more of a mass audience than I'd ever reach showing in some alternative space—you get school kids and tourists, for example. When I did the *Nantes Triptych* in France, it was shown in a seventeenth-century chapel on the list of tourist stops in Nantes, and so the vast majority of people who saw that piece were coming in to see the building, and they were confronted by the *Nantes Triptych*! That's been great! Certainly, if I could reach more people publicly, I would, but on the other hand I am not willing to change my work.

Do you sense that there's a certain clash between the contemplative pace of your work and the general speed of mass culture? You've indicated that you're particularly interested in decelerated rhythms and narrative speeds.

Yes, and I think to some extent that gives the work a kind of strength. I don't see that as a problem—I see that as a very important aspect of the work. It's not easy, but it provides another alternative, another time—and I think that's extremely important. One of the general historical roles of artists, particularly the avant-garde artist, has been to provide the vision. Poets have a way with words, where other people don't have any, and crystallize some aspects of ourselves, in a different way, and people connect with that. Artists have a gift of visualizing that many other people don't have, so part of what they're doing is providing not just a vision that is coherent with and connected to the rest of the society, but visions that are underrepresented and not represented.

And I think being able to stretch time and slow it down, as I've done, in this age of hyper-time, is important. I think it's important for people to be aware that throughout history the idea of meditation, the idea of slow time, is very integral to certain cultures on the earth. To think the awareness of that possibility could die out is just very, very disturbing, because it's part of what human beings are—a meditative consciousness of life, of the space between things, when things open up with what Baudrillard calls "the silence of the image."

Those are the moments of eternity that we're given, and which need to be there just for our simple functioning as whole, complete human beings. We have to be aware of another kind of time. People are—that's why they go to the mountains, that's why they go to nature, that's why they go to the desert.

Virilio has suggested that those sorts of moments of time are incompatible with such different forms of mediation as text, painting, or sculpture. But for you, one of the attractions of working with video and film is that it does allow one to chart or document or reveal precisely this kind of experience?

Yes. When I started working with extended time, from the very first works I did, I was interested in compressing time and expanding it—I was least interested in it as itself, or what we call "real time." And so that to me became the awareness of a very deliberate practice—when I was younger—of creating a palette. You have red to blue, and everything in between, and I realized that we are chromatically working in a very narrow palette of time for the most part. And I was interested in the full palette—I wanted to have a shot that's held on the screen for six minutes without an edit, and to have a shot that appears as a frame—and phew! – is gone! That's my range. Or to put it more accurately, the camera without a recorder on it, the surveillance eye—from that to the single frame, and in computer terms, even to the pixel, perhaps. That's your palette—the creative palette that this tool gives you.

And anytime you go out of real time you're in the domain of the subjective in terms of human experience, because we can do all these things in our mind. But now, given these artificial tools we can also do these things—things that we could previously only do mentally and emotionally and spiritually—and that's a real privilege.

What do you see as the artist's most central responsibilities in the next decades?

To show people the way towards self-awareness and self-empowerment—I think that's the most important thing. It's not only important in visual terms, in perceptual terms, in social terms, but also in political and spiritual terms.

We're coming after thousands of years of tradition taking power away from the individual, and the reason why the average person cannot go into an art museum and encounter a work of art—from no matter what period, what time, what place, what style—and have a genuine, personal encounter with that work, without worrying, Oh, what does this mean? or What does the artist want me to think? is the result of a political, historical process that goes right back to the origins of Christianity.

The first couple of hundred years were very open, and all of sudden Paul came up with all this fire and brimstone—"You're going to burn in hell unless you believe"—which had nothing to do with what Christ was saying at all. It was all about changing true religious visions into dogma by undermining the confidence of the individual to have a direct experience of God, and that's why the mystics have always said, "You don't need that. You just go out there and God will come right in!"

All of that history has led to this point now where we're surrounded with this incredible media system that is about point-to-point individual communication, and finally the Internet is here, and the kind of guideposts that have guided us as a society, the rules—these rules which religion provided, which the church provided, which political leaders have provided—all of a sudden they're blown wide open. It's a very confusing time just for me as an individual to know what to do. Where are the moral, ethical guideposts that have existed in things like mythology and the stories of a culture? They're all embedded in these things called Hollywood movies and media, and we don't know how to decode them.

So it's a process of literacy which starts with self-awareness, with being aware of how these things come in, and where they are. Hence the large practice in art about deconstructing media, helping us to understand. That's very important as a literacy effort. But beyond that there's an effort of empowerment that has to come back to people, to recognize that you have within yourself the power and the awareness and the ability to chart your own course. To understand these structures and see what they're doing, and perhaps to make a judgment about them that's compatible with the entire good of the society—that's for the good of society and not against it.

These are really unique times now. This is happening on a global scale—it's just staggering, the scale at which this inner confusion is spreading. And so people cling to nationalism or to whatever they can. It's an age of extremes we're moving into right now—"English is the official language of America!" "Let's get the foreigners out of the country!"

Does this leave you feeling optimistic or pessimistic?

I'm feeling very optimistic. I think things do get better. We're in troubled times now, but think of the events of the last ten years—isn't that phenomenal? The major, epochal changes

that have happened, in some cases without a lot of bloodshed and horrible scenarios—it's extraordinary! And then you realize the power of people—that the human being's power is collective energy. That's the essence of who we are—the way people react when an earthquake happens or a flood where everybody joins together in ways they normally wouldn't do in their daily lives. That kind of idea of collective energy is the heart and soul of the power of what human beings are—their strength.

At the same time, where does that put the artist? The artist has the individual vision. And this is what the artist has always done. Before people criticize the position of the artist today, they have to look at history. I've been in villages in Melanesia where I've met the guys who are the best mask makers, and they're just better than other people. They have a talent and an ability that other people in the village don't have. That's recognized, that's acknowledged—it doesn't create a huge problem. And there will always be people who are better at doing things than others, and artists are better in certain ways.

But the difference—the key crisis today in contemporary art—is the disconnectedness from the community. That's why I love the fact that I can show my work on TV—painters can't do that. That's really important as part of the connection back to the community, because art's being distanced as a separate practice. And I think this is one thing that hasn't necessarily been the case throughout history—that people who have the vision are able to give it back to the community through a common language. So I think that's my hope. It's exciting times—television is a global phenomenon, the Internet is a global system, the commerce of images is a global phenomenon.

So hopefully it's a positive commerce?

Well, there have always been negative forces there. But yes, I have great hope and faith that these are really, really exciting times.

Larry Wendt. Photograph by Françoise Janicot. Courtesy of the artist.

LARRY
WENDT

WHEN I MAILED OUT MY EXPERIMENTAL POETRY MAGAZINE, *Stereo Headphones*, to its few international subscribers in the early '70s, I first addressed two of my most valued friends of the '80s and the '90s—the San Jose sound poet Larry Wendt and the Melbourne sound poet Chris Mann. But it was not until 1979, soon after joining Griffith University in Brisbane, that I received a phone call from Chris Mann, and not until 1981 that I visited Larry Wendt in San Jose.

Thereafter, whenever I flew back to Europe via the States, I made my way to the San Jose airport, struggling to lift book-filled cases into the unfortunate cars of Larry and his friends, before driving off to eat in local Vietnamese or Mexican dives. "How you doing, man?" Yes, this was San Jose again.

This ritual was reversed when Larry—along with fellow Californians Charles Amirkhanian, Carol Law, and Ellen Zweig—came to Australia to perform at the Soundworks Festival that I'd coorganized with Performance Space directors Allan Vizents and Nicholas Tsoutas, as part of the 1986 Sydney Biennale. Arriving at my house in Brisbane prior to this extravaganza, Larry instantly blew all the fuses by plugging in his homemade computer. So this was "handy tech"!

As Barbara Kruger has suggested, such small events often clarify the complexity of the larger events of late-twentieth-century culture. Generally speaking, the international and multigenerational tracks on Wendt's guest-edited *Vocal Neighborhoods* CD for *Leonardo Music Journal* (1993) typify his solidarity with the most recent directions in high-tech text-sound culture. But at the same time, the ironic multimediated narratives making up his *Remembrance of a Technological Past* (1986) suggest parodic parallels between the aftermath of the "overnight" rise and fall of Silicon Valley, and the "bizarre" responses of earlier West Coast generations confronting "experiences of extreme boredom or difficulty, or mental and physical pain."

Resisting commercially driven technoculture, Wendt typifies the integrity of those "rare

individuals" innovatively orchestrating "low-tech" experimental electronics in order to explore what he calls "really new frontiers in vocal speech and syntax manipulation." And while only too aware that emerging virtual or nanotechnological cultures will probably once again obscure the "real geniuses of the form" beneath "a lot of really bad, bad stuff," Wendt engagingly concludes, "It should be very interesting, and we'll probably see just the beginnings of that before we go out."

San Jose—May 15, 1981

Perhaps I could begin by asking you how you first started working with tape-recorded compositions?

Well, I had read some of Burroughs's things on using tape manipulation, and so I was interested in trying those experiments myself, with splicing different voices and so on, but I never owned a tape recorder until the late '60s and I didn't really seriously start doing pieces until after hearing Charles Amirkhanian's programs on KPFA. One in particular was about text-sound composition at Fylkingen in Sweden, and that's when I really got interested in it, in the early '70s.

At the time, I was doing a comparative literature thesis on *Ulysses* at San Jose State. Steve Ruppenthal was involved in his master's thesis on sound poetry in the music department, and I also was taking a course on electroacoustic music from Allen Strange. Allen told me that I should meet this guy, and we finally met in a course on *Finnegans Wake* and started collaborating on things. Steve played some of my works to Allen, who was publishing a cassette series in the mid-'70s, and he published my work, and that's how I got started!

Along with Dominic Alleluia, Carl Loeffler, and Bill Gaglione, we put on a festival of sound poetry in 1977. It was totally free—we didn't have any money at all! We had the Four Horsemen from Canada, who'd managed to get over here for nothing, Pauline Oliveros, who did some chanting kinds of things, Jerome Rothenberg, Laurie Anderson showed up for a roundtable discussion, and Charles Amirkhanian and the heavies from the Bay Area, and we also played tapes. By that time I had picked up a lot of Steve's correspondence and had managed to get tapes from everybody in the world, and about that time we put together this cassette anthology of sound poetry, *Variety Theater*.

What were the main characteristics of the West Coast participants?

I think the tendency towards music. There's also a tendency towards using tape, tape manipulation techniques, and real-time electronics, live electronics as well as studio electronics. The Bay Area has long been an active center for electronic music since at least the days of the San Francisco Tape Center in the early '60s. Several very important American composers were involved with it—people like Morton Subotnick, Pauline Oliveros, Steve Reich, Terry Riley. Don Buchla was involved in making the first modular synthesizer system, and that came out of the San Francisco Tape Center, though Robert Moog is often credited with making the first one. A lot of those people were very influenced by John Cage, and some of them studied with Cage.

Pauline Oliveros did a lot of kinds of performance art, which were very influential in bringing performance into electronic music. Before, you know, you sat in front of a bunch of

tape recorders and a speaker. They did that, too, but they also did very bizarre performance events such as *Double Basses at Twenty Paces*—one performer plays a riff on a bass and another answers it, and they had this dueling bass kind of thing! On another piece, the performer walks out onstage and shoots the piano with a gun, a .45! In other words, they were sort of like the *sintesi* of the Italian futurists in the early part of this century, very small play kinds of things with music. Another aspect of this kind of outlaw tendency in electronic music was its move towards intermedia performance. It's very similar to the kind of things that the Fluxus people were doing on the East Coast at that time.

Were poets involved as well as musicians?

Well, I think so. I know Clark Coolidge was at Mills for a while. His early experiments in writing were with tape loops much like Charles Amirkhanian pursued later. So that was, I think, important.

Charles was also involved in broadcasting sound poetry and new music?

Yes. He got involved with the radio station in 1969, with KPFA, and started producing where he presented these weekly three-hour programs—*Ode to Gravity*. He went to Europe a lot, interviewed a lot of people, had gotten all the records, and had these very in-depth interviews and discussions of this type of poetry and music. So we had a pipeline to Europe through Charles, and we'd get all this great stuff. It was an education listening to these programs.

What about Anthony Gnazzo? Do you know how he started?

Well, I don't know what his formal background is, but he had become involved with the San Francisco Tape Center at the same time when they moved to Mills. The first year, he was the director of the Tape Center, I believe this was in '69 or '70, or even earlier perhaps. He had been involved in Bay Area electronic music from its inception, in the '60s, and was also involved in doing language kinds of things as well as electronic music. He and Charles collaborated, and he helped Charles a lot with the technical aspects, because Charles doesn't have the technical thing as well as Tony does. Tony also did these long compilations of several of his pieces, presented in a cohesive kind of radio play and performed a series—*The Unfortunate Diving Duck Trilogy*—at 1750 Arch Street in Berkeley, which were broadcast live over KPFA.

That's another thing that KPFA did, too—they broadcast a lot of new music performances live, as they occurred. 1750 Arch Street was a house in the Berkeley hills with a very small performance space and a professional recording studio in its basement. They also produced records. Most European composers who come through would do a performance at this space, people like Lars-Gunnar Bodin—one of the founders of text-sound composition—and several of the other text-sound and electronic composers from Sweden and France. Allen Strange did a few performances there, Charles and Tony did a whole lot of performances there, and Steve Ruppenthal and I also did a performance there.

What approaches or concepts do you find most productive?

What I'm interested in is technology—the availability of microprocessors to process vocal material or speech material or sound material, and new ways of dealing with raw sound

material with more flexibility. I hear certain sounds in my head, or I've got some concept of a sound in my head, and to be able to realize that concept with existing technology is for me a very important thing. The availability of microprocessors right now explodes certain things wide open in terms of being able to reach some really new frontiers in vocal speech and syntax manipulation.

What sort of effects do you have in mind?

Well, in terms of poetic effects, being able to change one sound into another. Like you have maybe an animal sound that's changed into a human voice sound in a very smooth and natural sort of way. And also, with the use of computers, you have the possibility to do something that's very difficult to do on a tape recorder even in terms of splicing. With a computer, you can splice a lot finer than you can with a tape recorder, and so you are able to produce new words, new-sounding words, and things like that, probably synthetic kinds of words, out of the fragments of old words. So there's like things locked into a word, the sound of a word, elements locked into the sound of a word, that you can extract with a greater facility than you can with standard manipulations, or with analogue, with filtering, things like that. You have the potential of doing that. The technology is not quite there yet, but the potential is there.

It's a whole new bag of tricks one can play on language. The easy things that one could do with a tape recorder have been used as much as one could use them—though someone can always come along the line to produce something with these tried-and-true methods that's quite unique, and a beautiful piece of art. Still, you know, one wants to be able to produce these things without the technology getting in the way. Because doing things like tape manipulation, you have little bits of tape all over the floor. You're removed from the actual physicality of producing that sound.

Certainly, the technology isn't quite there yet, so you still have a problem of saying something and then coming back the next day and hearing what you did. But with the microprocessor, you can say something and have it come back in a whole unique way, which is a lot nicer to do. Because you get a more immediate control of that. The problem is that to get to that point you have to go through all that brain damage in programming computers and building equipment and making it work! But after you get through that whole hardware-technological stage, you can use this thing as a creative device, as a wand or a paintbrush to paint these strokes.

There is a real problem with people who are into high-tech art. They get into the paintbrush more than what they are painting. Designing this thing, they never produce much. That's the problem with the larger computer music centers: they have this real high-level technology, lots of money, and they're into cataloging sounds and synthesis techniques that are going to be extremely useful for the composer. But in terms of producing substantial works in this thing, they haven't done it really. There are a couple of pieces that are really good, but for the most part their results are exercises in running the technology through the hoops they have.

Who do you think of as being significant in these new areas?

Well, I think of people who have been associated with Mills College at one time or another. I'm particularly fond, right at the moment, of Paul DeMarinis's work. His is more electronic

music orientated, and, of course he might not fit in the text-sound composer category or anything like that, but he's done some very interesting things with a low-cost speech synthesis "toy," Texas Instruments' Speak and Spell. That avenue of using low-budget technology to do all these elaborate kinds of manipulations and shifts—I think that's the way to go. And building your own instruments and trying to use what technology can be accessible on a low budget are important.

What I think happens with the high-budget things is that they get wrapped up so much in the technology that they don't produce the art. They have to justify their expense by doing something technological rather than artful. A lot of the art is lost in the technology. And though that may change, when they finally master this, it seems like they're on the cutting edge of research, and so they're going to continue in this area of really developing the research. Maybe this stuff will filter down to the low-budget groups, but in terms of what they're doing, it's far too academic, I think, and away from real music.

Then there are these guys who get a bunch of really lousy-sounding electronics together, jam together, and seem to me more interesting than the really pure, ultrapure, finest-quality sound people. Because it becomes so sterile and lacks something for me. Pure sound reminds me of white bread. Others may disagree with that, but it seems that it's not music for the common person.

What things coming out of Europe impressed you most?

Well, text-sound composition in Sweden. The technology wasn't as advanced as now, but they used whatever they had available. They produced pieces that for me were very moving, and used all these kinds of techniques for changing language and finding new resources. Bernard Heidsieck in France did the same thing. He had more limited access to technology: he just used tape echo and tape superimposition. But he uses those techniques very artistically. He's mastered his media, same as Henri Chopin. And Chopin's way of using a tape recorder is horrendous! I would hate to work on a tape recorder after he got through with it, you know, sticking matches into it! And I've seen him perform, and he sticks his finger in the thing, and it must damage the heads and motors—it's just horrifying to see.

But he's mastered his instrument. He's like a person with a saxophone, you know, the way he uses the tape recorder. He's mastered that instrument. He's mastered the early types of tape recorders, not those big, multitrack, two-inch, twenty-four-track jobs, but the ones that first came out—the stereo, two-channel tape recorder. To see people use technology artistically, in an artistic fashion, is what impressed me about Europeans. We do that too here in America. Still, the Europeans seemed to be able to use language more, which I was interested in. It was growing out of a literary thing—their whole thing grew out of a literary thing, whereas it doesn't really occur here, at least on the West Coast. Now on the East Coast, you have people like Jackson Mac Low. And Jerry Rothenberg was out there for a long time. It's a whole different impulse. But what they do is completely different. They're exploring phonetic aspects and things like that.

To what extent are Rothenberg and Mac Low comparable?

In terms of their art, it's quite a bit different. But in terms of their reliance on acoustical ways of dealing with language they're comparable. Even though both of them have used multi-track tape-recording techniques, it's not their primary interest. They're more into semantics

and literary values, and in terms of recent work, acoustical poetry. And so it's quite a bit different. Whereas Charles Amirkhanian is more and more interested in the technology, Jerry and Jackson are going back to nature, towards primordial kinds of systems.

Where would you situate John Giorno's performances?

I guess that if you use a strict classical analysis of sound poetry, it's not quite sound poetry—it's more like a declamation in terms of Marinetti reading his manifestos. But in terms of using tape recorders in his more recent works, though, I think it is sound poetry. He uses a lot of multitracking, and these superimposed tracks change positions, to accent certain parts of what he's saying in a sonic sort of way. And so that aspect of it is sound poetry—or text-sound composition.

I think what's really important is his temporal sense. He's got a time sense like Bernard Heidsieck's—Bernard has immaculate rhythm, and so does John. Because, like I saw him do this performance, the tape is going on with his multiple voices, and he's reading along with it, and at certain points in the performance he would not say anything, and this tape would go on, and like there'd be a whole time thing, and then he'd start again, right in sync, you know, and like his timing sense is incredible, it was just wow!

Presumably tape has given all kinds of technological artists a renewed sense of timing.

I think this is an aspect of live performance, too, because you don't get it in tape. Because you can do it, you can fake it with tape—the timing. But in live performance you can't fake it, you have to be on time and have that sense of rhythm. Those differences in timing are what give live performance its excitement. I think it carries you through, rather than just sitting in front of a speaker.

But the tape thing is important too, in that you can send it through the mail, and it's sort of like an electronic novel sort of thing, or an electronic poem, in that you're sending it through the mail, and you come home after work, and you slap it on your tape recorder and you listen to this thing. And that's important in terms of distribution. But you also run into the problem, though, that most radio stations won't play this stuff. Though some others have done it—KPFA is a real exception in this country. In Germany they do radio plays all the time, but it's rare here. We're really fortunate on the West Coast to have something like KPFA and Charles's programs.

San Jose–Brisbane—December 18, 1988

How have things changed most significantly since we spoke in 1981?

Well, my views about the nature of electroacoustic music and sound poetry have not changed that much since the 1980s, but these fields have changed somewhat, though. Sound poetry has perhaps died out as a specific area of working, or perhaps it's not called that anymore by new people working in that area. One doesn't hear the words "sound poet" as much or even less "text-sound composer" anymore—only diehards still speak in those terms. Yet, there are festivals occurring all over the world where this sort of thing is being done. I have performed at sound sculpture festivals, performance arts festivals, and electroacoustic

concerts over the past few years doing more or less the same kind of language art that I have always done.

Last year, I formed a "band" with another technician at San Jose State, Eric Gatzert, and we did a concert of "postindustrial" music, with Allen Strange and some other friends. The campus radio station went nuts over it and will play anything now that we give them on the radio. I always thought one had to die to gain that kind of recognition. All I needed to do was call it by a different name as some kind of experimental rock and roll! I find that I can now pass off my earlier text-sound compositions to a completely different kind of audience. These are strange times!

In electroacoustic music, there is still a "high-road" way of working, exemplified by IRCAM in Paris and the CCRMA at Stanford University, but the "low-road" way of working has been more or less taken over by the hoards using commercially made instruments based on the Musical Instrument Digital Interface—or MIDI—standard. But there is still a small collection of cranks, crackpots, and rare individuals who continue to insist on using home-built and "low-tech" experimental electronics. They are usually shunned by the electroacoustic aristocrats and MIDI freaks and have been exiled to haunt an electroacoustic third or fourth world of small dank galleries and "festivals" in places like San Luis Obispo. Of course, that's the classification that I can be identified with.

In the last eight years we have had this situation where manufacturers and commercial music concerns have totally warped what electroacoustic music is about. When synthesized drums came out, all one heard on the radio was these bad-sounding synthetic space drums. The same thing happens with samplers. Everything is homogenized to a kind of soupy, gray pabulum—there are no sharp corners to provoke an original thought, everything is very safe and assured. Everyone wears the same kind of designer jeans. And that's the way they make these new electronic music instruments.

Our electroacoustic students at San Jose State are only interested in developing those skills which can have some kind of commercial applicability—they might do one or two "experimental" pieces as a lark, but as a whole they are very serious at finding a job. The world is a much meaner place now than when I went to college—there seemed to be a lot more people willing to take chances then. Intermedia arts have never caught on academically either, even though there continue to be many attempts at promoting this way of working. I find most of our students unaware of the whole history of electroacoustic music and experimental art—all they seem to know about is the classical music stuff that they have to learn for the music department or the really commercial stuff they listen to on the radio.

In a way I suppose electroacoustic music has become a bankrupt art form as a result of this commercial intrusion—the "low-road" stuff, though more accessible, has become increasingly moronic, while the "high-road" stuff remains difficult to obtain on recordings and often too interested in justifying its existence through excessively sterile academic posturings, and there seems to be very little in terms of exploring new wildernesses or wild experimentalism in the field. But I still have hopes. There also have been a lot of advancements in digital signal processor chips lately—integrated circuits designed to process audio and other kinds of signals. These kinds of things are relatively inexpensive, and though they are somewhat difficult to program, it is not impossible to get some fairly sophisticated sounds from them. All this sort of thing is becoming cheaper now, and certain manufacturers have also started to produce boards and software tools to make these kinds of things easier to use.

The advantage of using this kind of technology over the present commercially available

synthesizer is that one is not locked into a specific synthesis technique and always having to buy next year's model. These digital signal-processing chips allow one to have a much more open kind of system as well as a taste of what the "high-road" guys are doing, in the comfort of one's own garage and on a shoestring budget. If a new synthesis technique comes out, all one has to do is program it in, which may or may not be a simple matter, but is certainly a lot easier than buying a new instrument and taking six months to figure out how to use it.

In terms of my own work, I have made extensive use of microprocessor-based devices which I have built for my performances. These things have gone through a variety of generations and are mainly used to modify my voice during a performance, in order to etch out and "make strange" aspects of my speaking as a contrast to a background tape I usually play during the piece. As such, my text-sound work has evolved into these extended narrative sorts of things which "reminds one of someone trying to tell a story in a noisy bar," to more or less quote something you once said. I also do this sort of electroacoustic work or studies that eventually help me develop the "sound grounds" used on the background tapes to my performance work.

Generally, I have always strived to build something which I couldn't buy, to perform some kind of unique electronic effect. Often, the quality of effects was hampered by what I could afford to build, which has always been very little. Also, these things which I built tended to be fragile and somewhat dangerous to use. You probably remember the hole I burned into your kitchen table in Brisbane a few years ago, when I got a quick course in Australian electricity. Those kinds of dangers are also a feature of the experimental nature of art—one's always trying to find out what one can get away with.

For the past few years, I have been working here with Daniel Kelley, who designed a digital signal-processing system using those integrated circuit chips which I mentioned earlier. From his designs, I have built a system which is portable enough to take around to performances. Unlike my previous systems, this device has a sound quality which is in some cases better than a lot of commercial devices on the market, and it also gives me a flexibility at processing sounds which I have never had access to before. It's not the easiest thing to use, and I still have a lot of work to do before I can really take it out on the road. Dan is presently working on an even bigger and better design, and where all of this will go for me I can't speculate. I truly think, though, that perhaps home-built and low-tech kinds of expression will become popular again.

A few months ago Dan and I visited an electroacoustics class Tony Gnazzo was teaching at the University of California and did a show-and-tell of our new instrument. We almost set fire to his table there, too! His students were amazed that smoke could come out of electronic music instruments—sort of like city kids finding out for the first time that milk came out of cows instead of bottles. Perhaps things haven't changed all that much over the years.

San Jose—February 8, 1991

Is it still the case that things haven't changed much over the years?

Well, I think you still have this dichotomy between what's commercially viable and people who are working in their garages. But it seems like there is a lot more activity in independent distributions as more and more independent distributors branch into CD publication

as production costs drop. There's this guy, A. M. King, in Fremont of all places—in a little place like Fremont, California—doing some very interesting stuff, who's connected with people all around the world. He's the one who's going to be publishing this Henri Chopin anthology—he's published a lot of postindustrial groups, as well as other experimental work. It's interesting that the younger generation made this connection. It's the same kind of support structure the pioneer sound poets had twenty or thirty years ago in terms of independent, low-budget publishing and distributing.

The fact that William Burroughs and Laurie Anderson are now on commercial labels seems another development.

Yes—the commercial thing sure didn't exist twenty or thirty years ago. Now you have this Kerouac LP collection being distributed by Tower Records, as mainstream as you can get. To have that kind of exposure for that kind of art thirty or twenty or ten years ago would be unheard of.

Has your own work also changed?

Well, I think so, in that I had gotten into these storytelling pieces, and then I got interested in actualizing some of these story pieces in terms of group performance pieces and building specialized pieces of equipment. Putting on these wacky kinds of performances, and essentially actualizing some of the stories in terms of a three-dimensional performance, has been an interest that I've pursued for five or six performances now. I'm kind of coming to the end of that.

What did those involve?

Well, I did my last performance with Sadness without Brains—a collection of people associated with the music department at San Jose State University, one being Ed, the guy who repaired the acoustical equipment. He became our mascot and the cultural icon for the group. The group actually consisted of only me and Eric Gatzert, another music department technician at the time. We would involve several other people, but Eric and I were the cofounders and group leaders. We'd have Ed sitting in a chair, sleeping, things like that. Once we had him giving a lecture while we tore apart stuff. It was like a school for technicians, and he was showing us how to do it. Then we had him barbecue a chicken with an acetylene torch. That got his name in the local newspaper. He was getting too popular—everybody would just applaud him, and they acted like it was his group.

So this last time, the rest of the band members decided to kill him. Eric and I made an effigy of him with papier-mâché and plaster and filled it with musical instruments, old liquor bottles, and things like that, and dissected him onstage with contact microphones. We also made a series of slides using computer-generated images, showing him meeting Saddam Hussein and George Bush, and in other ridiculous situations with him finally disappearing into the woodwork. With our last performance, he ended up getting bigger applause still! So a very local history—a kind of personal history—grew up and overshadowed all of us.

We also put on a show in an empty field in Bakersfield, California, where I had a group of art students collect junk for a week—we had a car, a large gas stove, old furniture, and a television—and then the water polo team came over and they trashed it all. They had a lot of beer, and it was like a big fraternity party wired for sound. It was all wired up with

contact microphones, and we supplied ancillary sounds in terms of tape as well as signal-processing electronics.

Did you find it successful?

Well, the *San Jose Runner* responded with a half-page feature titled "Cyber-Punks Wreak Havoc at Performance"! It was the kind of one-time performance thing which I had always been interested in. That kind of spontaneity—and the way in which the thing was talked about afterwards—appealed to me. A certain number of people would come to our various performances and they would tell all their friends, "You should have seen this thing!" And then we'd do something different the next year.

Do you think these performances will feed into your storytelling?

Certainly—they were trying to actualize some of the earlier stories, and then they led to new stories. I did this really long almost radio play story-piece, and a lot of it was taken from these performances. You get involved in very bizarre activity, like, how do you build a copy of someone? I hadn't had any experience with this kind of thing since grade school in terms of modeling clay and plaster and stuff. So you begin exploring other aspects of what you can do. It's a challenge—and that was the whole point of these performances.

Was that more of a workshop than a professional situation?

Well, the performance starts when you start thinking of the piece. It isn't when you're in front of the audience. That's the culmination perhaps, but the performance is like six months long, getting the stuff together, because you're always on, in terms of actualizing this bizarre piece. I mean, there'd be no reason to build this kind of stuff, or do this kind of stuff—or learn how to do this kind of stuff—for anything except for this specific performance.

So you have to learn a whole technology or a whole technique. How do you make a microphone that will fit into a chicken that you can burn, without burning up the microphone? So—asbestos microphones! And what is a chicken supposed to sound like when you burn it? What's going to happen? With a lot of stuff we weren't able to know what was going to happen until we actually did it. Dealing with a larger group of people than just Eric and me—like we had to do in Bakersfield—the whole process became this strange sort of anarchistic military operation in trying to decide who will go out and find what, and then how do you get rid of it afterwards. I think there is still an old car down there which we abandoned in a parking lot.

Burning chickens and trashing televisions seem rather obvious forms of avant-garde provocation, don't they?

Well, we weren't so much interested in the shock and the physical violence as in the question, What does this really sound like? The problem is, though, that when you attract other people to your event, you attract them because of the violence, weirdness, and the shock. Like the water polo team—they just wanted to raise hell. We were more curious to know, What does it sound like when you drop a television ten feet? In one of the early pieces we had a car onstage that we had hooked up with microphones, and we ground stuff on the car with a disc sander, which made these beautiful sparks and this incredible noise.

Eric was listening to a lot of the postindustrial groups like Einstürzende Neubauten, and

I was listening a lot to Nurse with Wound, who's actually one person—a graphic artist who did these incredible sound collages with things like sweeping up metal from the floor. His stuff was very innovative, I think, in terms of rediscovering a lot of things that they were doing in the '60s, and earlier, but doing it with the new technologies and new aspects of the recording industry. There are some very interesting ideas, moving beyond the boundaries of this media. A group called the Haters came out with this LP that was blank vinyl—just a black LP—and a bag of dirt. You have to rub this dirt on the LP for the sound. That was rather a famous postindustrial piece. But it's interesting because it's a repeat of some of the things that were done in the '50s and '60s—some of the things that the Fluxus people were doing.

Couldn't you say that it's rather boring—seeing them reinvent the wheel, albeit with this technology?

Well, yes—in some ways it is boring. It's like, "What? I've heard this before!" But maybe they've discovered some new aspect about it. Like a lot of anything, a lot of it is no good. But some of it bears examination, I think. I liked that stuff in the '50s and '60s, and I wanted to hear more of it!

Would you describe this work as avant-garde? And do you still find "avant-garde" a viable term?

Well, I really don't think it is, because it's lost any kind of impact or meaning. It's been around since 1890 or something like that. Though when you explain to people who aren't artists what you are—"Oh, I'm an avant-garde artist"—they know what you are. You do that weird stuff, or you're "experimental." I use the term *experimental* more, because I feel that I am doing research. I'm using things for purposes they weren't designed for, or discovering things. Even though somebody else might have done it, or ten, twenty, or a hundred other people have done similar kinds of things, I'm discovering it for the first time. So to say that I'm really going to be experimental or really avant-garde with this piece—or that I'm going to do a pop piece—is really hard for me.

All I can do is what I do—I don't have much leeway in terms of being able to do anything other. And I don't always consider my work to be all that experimental. Because when I go to a concert or a performance, or get a CD and hear something that knocks me out, I'm always thinking, Gee, I'm twenty years behind, I've got to learn to do this, this is incredible!

Burroughs similarly observes that he could never write a successful best-seller, and suggests that the most interesting artists are more concerned with experimentation—or with redefining an area—than pleasing a mass market.

Well, when I start a piece it sort of takes over. And so I don't have any control making it appeal commercially. It sure would be nice sometimes! But it's just not going to happen. It just sort of takes over and does its own thing, whatever that might be. Besides certain aesthetic reasons, it would be totally impossible for me to do anything that was a commercial or popular success.

Your stories about San Jose seem very audience-friendly.

Well, I get good audience response. And it's the same thing with these group performances—good audience response. I got the first review in the local paper that I'd ever got here with one of these.

And so, "Well! Let's do some more of this!" So there are certain—maybe—compromises that you make with your integrity in that you do some more, especially if you feel there's more there that you need to explore. "If I could push this a little bit more, maybe I could get on National Public Radio or something, or maybe make a lot of money on MTV?"

You think about that for maybe a second or two, and then you go back to the drudgery of getting a real piece together. With the story pieces I want to continue essentially about California. I'm very interested in the local history and the local guy in the street and the alternative realities of California living—and this undoubtedly has limited mass appeal to a wide audience.

But that's one of the things I like best in your work—that element of distinctive content. Although you can explore new sounds in spectacular ways with chickens and cars, wouldn't you say that there's something more substantial in the narrative content of works like Remembrance of a Technological Past*?*

Well, a lot of the performances evolved out of the background sounds of my story pieces—I use a lot of found sound, and so it was just a logical exploration of that. But at one point I was getting a little tired of the story pieces and of being alone out there on the stage. Group sound poetry pieces don't work very well for me, and I wanted to get involved with more nonsemantic things, get more people involved, and have the whole piece connect together as a story. And though there are these improvisatory aspects about it, they fit into a rather rigid context because I usually do them with a taped background that defines the piece in terms of a frame. Ultimately my only control over these pieces is this kind of framework. And so there is a relationship, in that the enrichment of exploring these other sound sources is coming back into the ways in which I'm doing stories and collecting sounds for the story pieces.

If I have just the pure voice on the stage, I find it not so appealing, in that we are experiencing voices all the time with all of this noise that's happening in the background, to the point of not being able to distinguish what is more interesting—the refrigerator that just turned on and started humming, or the talking! Sometimes it gets to be a toss-up.

And so for me as an artist I find just reading the text as a performer not so interesting as trying to read through this mishmash of noise from our environment, especially with the live electronic processing of the voice, so you have this multilayered effect where the sound and the voice are part of the environment and you get this solid sort of thing. In terms of my stories, that's what I've always been interested in and continue to pursue.

And increasingly sophisticated technologies offer ever richer opportunities?

Yes. Ever since I started, I've been interested in electronics, of course, in terms of etching out certain aspects of the spoken voice, and both blending it with one's environment as well as contrasting it with one's environment. This is home-built electronics, of course. And as these gadgets become less expensive to build, they have also become more flexible with their effects.

Now, the kind of sounds that one can collect with the new digital tape recorders is incredible. This kind of commercial equipment would have cost a hundred times as much a few years ago. And the quality is amazing—a whole new reality is brought about by listening to digital sounds. Dealing with these concerns in terms of stories, I think they elicit certain

responses in terms of seeing your world with even more detail and accuracy. My writing is getting more complicated, even though the stories are getting more stupid, so there's this weird thing going in both directions!

I've been collecting local history books of San Jose in the 1890s—they explain some of the things about this town in terms of its history, growing up from a kind of very agrarian society and becoming a high-technology center overnight. Some really wacko people lived here! And after reading about people I never knew, I found the same wackos in my family, in some family archives my grandmother loaned me.

That kind of stuff is interesting to me—the local history. It's not the big events—the Civil War and all that sort of stuff. It's the little things: the guy starting the apple orchard and the widow lady going to church every Sunday. That appeals to me. All of these local histories have these interesting peculiarities. We seem to have forgotten it now and ground off all these eccentricities, and you get this amorphous, shopping center kind of mentality here now. But there were all kinds of bizarre things that people would do—out of extreme boredom or difficulty, or mental and physical pain.

Given that you've probably written your San Jose Dubliners *in taped pieces like the* Remembrance of a Technological Past, *are you now envisaging a still-grander* Ulysses?

Well, I should probably pursue it that way, but I'm interested even more now in the stories of the little places, in the little out-of-the-way places in which people had these heroic lives in some ways—but also very miserable kinds of lives. Warren Burt has also suggested I should make these things two or three hours long. But when I recently finished two longer, forty-five-minute story pieces they seemed less pleasing to me in some respects—the shorter pieces were certainly more effective in terms of an audience response.

The problem with the ten-minute pieces, however, is that you can't really develop them too much. But the forty-five-minute pieces are very exhausting for me to do in terms of taking three or four years to write, as well as trying to perform them adequately, and having all kinds of technical difficulties. What I'm working on presently is simply a cycle of stories with recurring characters and places. That will let me expand on concepts and things, as well as keeping the stories to ten to fifteen minutes, although if I'm making a piece for a compact disc or for radio, it can be a lot longer.

I try to get double the fun out of my pieces in that I go in for performances where you want something punchy, but you also have something—in case by remote chance it is put on a record or played on the radio—that they can listen to it maybe two or three times, without saying, "Turn this off, this is really boring because I've heard the joke." I tend to use humor a lot, and a lot of my humor gets really tired really fast. Satire and parody have been very appealing to me all along. That's the appeal of Joyce and Burroughs—it's grand satire and parody, and it's very well constructed and complicated and intimate. They appeal to me more than drama and high comedy.

Finally, what do you see as the most interesting potentials of the next few decades?

Well, I think a lot of the stuff from the last thirty years has taken the stuff from the turn of the century and actually realized it in a way that they couldn't do it—as with the Futurists and the Dadaists. Now we have finally succeeded—in terms of aesthetics as well as technology—in realizing these kinds of dreams. And I assume that fifty or sixty years down

Larry Wendt, *Narrative of the World Wide Web.* Photograph courtesy of the artist.

the road, they'll be realizing our dreams about nanotechnology and virtual reality. It's the new alchemy—the transmutation of reality—and I think all art is trying to deal with that now. And there'll be the same kinds of problems that we have now, along with commercial overuse of this stuff. I mean the potential for dreck in the whole thing is quite enormous. So you'll have a lot of just really bad, bad stuff, and then you'll have a few who are the real geniuses of the form. I think the majority will be really awful. It should be very interesting, and we'll probably see just the beginnings of that before we go out.

Emmett Williams (right) talking with Robert Lax, at Editions Francesco Conz, Verona, 1991. Photograph by Francesco Conz.

EMMETT
WILLIAMS

I CAME ACROSS EMMETT WILLIAMS'S NAME IN 1967 OR 1968, as a student in Neuchâtel, when Hansjörg Mayer sent me his silver-covered copublished edition of the Something Else Press *Anthology of Concrete Poetry,* but it was not until almost thirty years later that we finally met up in Berlin, where I'd flown for the weekend, taking time off from teaching in Leicester. Enjoying a bottle of Rioja he'd brought back from Hansjörg Mayer's cellars in Spain, we spoke about his most recent project, a biography of George Maciunas—*Mr. Fluxus*—and of his various encounters with the avant-garde's "saints" in the overlapping phases of his transatlantic career.

I remain fascinated by the ways in which Williams's reminiscences invoke meetings with almost every visionary I could think of—Ay-O, Claus Bremer, William Burroughs, Francesco Conz, François Dufrêne, Robert Filliou, Ian Hamilton Finlay, John Giorno, Brion Gysin, Dick Higgins, to sketch only the beginnings of an alphabetical listing. The more questions Williams answered, the more strikingly he illustrated the complex creative crosscurrents interlinking the different arts, such as the parallels between "what makes my early poems work and the things that make the early compositions of Stockhausen or Boulez work." "Artists and composers," Williams memorably recalls—rather than "literary tea parties"—provided his "motivation."

At the same time, Williams movingly suggests the effort required to adequately map the achievements of any one such artist, pointing out how the "mosaicked" anecdotal documentation in a project like *Mr. Fluxus* at best offers an introduction inspiring scholars to "dig deeper," rather than a definitive "source book for scholars."

These pages have similar limitations. To really understand the avant-garde we need to begin by collecting the writings, interviews, and reminiscences of each major figure, and as Williams remarks, it's already becoming difficult "to dredge up memories and reflections so long after the facts." *Mr. Fluxus* suggests how this initial research might be accomplished.

As Williams also emphasizes throughout his interview, his enthusiasms are not so much

for "plugged-in" technopoetics, as for the immediate performative impact of the Fluxus "classics," for the "American grain" in Burroughs's recordings, and for the "real thing"—"All that profound simplicity, echoes of classicism in a new form"—in Robert Lax's readings.

Williams's leads offer cultural theory the ideal means of modifying its counterproductive accounts of the alleged "deaths" of authenticity and avant-garde creativity.

Berlin—March 16, 1996

Perhaps we might begin by talking about the book you are presently putting together on George Maciunas.

It's called *Mr. Fluxus,* and it's a pretty exhaustive portrait of George Maciunas mosaicked together by Ann Noël and myself from the anecdotes and recollections of about seventy people who knew him well. That's an overstatement: nobody, repeat nobody, knew him *that* well. Anyway, his aristocratic Russian mother, his sister, the Fluxus people, friends, enemies. It wasn't easy to get people to dredge up their memories and reflections so long after the fact. He's been dead for going on twenty years. So I hounded them through the years, I begged them, and finally we've got a book. From his birth in Lithuania, growing up in Nazi Germany, coming to the United States as an immigrant after the war, the invention of Fluxus, his return to Europe to organize the first Fluxus festivals, then going back to America to subvert the art world there through Fluxus.

In the finale, this chronically ill joker, this joker cast in a tragic role, who did so much for so many, dies in utter poverty of various cancers and physical breakdown. You might even say he died laughing. It's a tragic story, but it's a happy story. You laugh and you cry. It's something Dostoevsky might have dreamed up. In any case, it reads like a novel. It was never our intention to produce a source book for scholars. On the other hand, it will prob-ably inspire them to dig deeper.

What was it about Maciunas's life that you found so compelling?

George was a genius, and he *did* change the world of art. After his death it became the fash-ion to put George down, claiming that he wasn't really so important. Without George there would not be the word, there would have not been the cohesion, there would not have been a forum for our kind of work. George was Mr. Fluxus. He was our father figure in the art world while he lived. And I thought it worthwhile to explore the life of this man whose ideas had turned on so many people all over the world.

What kind of discoveries did you make as you put the different contributions together?

Well, I knew George quite well while he was living, but now I know him much better. I can compare my knowledge of George with that of seventy other people who also knew him. The details of living and working with him, of reacting to his dictates. People were quite frightened of George, you know. He demanded so much of them. He simply gave his life to Fluxus.

He made the money that paid for the festivals, the objects, the publications. He designed the work of the other Fluxus artists. He was, as John Cage says, certainly the most important

artist in Fluxus. Well, we have Fluxus people who say that George wasn't an artist, only a designer, the way it became fashionable to write off Breton and Tzara as mere organizers.

Would you see Maciunas as a postwar equivalent of someone like Breton or Tzara?

I think he will certainly emerge as someone with the stature of Breton and Tzara, and I would also say of Duchamp and John Cage. But of course I'm prejudiced, with a European bias. His ideas had consequences for so many artists, as I think the many Fluxus exhibitions we've seen in the past few years make clear. Also there's the fact that Fluxus is the art movement or direction in art that has outlived all of the others. Fluxus has been around longer in terms of years than Dada was—or surrealism—as a movement. It was the longest-lived thing, in terms of an art movement, in the twentieth century, from 1962 onwards, and it's still making waves. Just listen to all the noise Fluxus is making in Poland, in Hungary, in Russia. It's just beginning!

What would you say were the principal differences between Fluxus and Dada?

I think George made a great mistake in 1962 when he referred to Fluxus as "Neo-Dada in der Musik." The then still living Dadaists took offense, and so did I, but for other reasons. I never had the desire to be a "neo" anything. Anyway, I recently got hold of a letter from Raoul Hausmann to George, written in 1962, informing him that Tzara, Huelsenbeck, and Hans Richter agreed with him that "neo-Dadaism" does not exist. "Why not simply Fluxus?" he asked George. "It seems to me much better, because Fluxus is new and Dada is historic." Whatever the case may be, something scared George away from calling Fluxus neo-Dadaism. A lot of critics, unfortunately, still call it just that.

There was something very happy, you could say jokerism, in Fluxus, but coherent jokerism, instead of the almost spiteful hiding of what they were trying to do by the Dadaists. The Fluxus artists had more fun, I'd say, and had much of this fun during the Fluxus festivals, which may have been one of the most important aspects of Fluxus—you know, friends getting together or even enemies getting together as friends. It's a difficult question, because so many people still consider Fluxus to be neo-Dada, and because Maciunas himself was politically committed.

What was it like as an American working in Europe?

Well, I'd been in Europe since the end of the '40s, and my circle of friends was largely European. George, of course, was European himself, you know—Lithuanian. And I met Americans like Dick Higgins and Alison Knowles for the first time in '62, when George brought them over from the United States. I didn't know anything about those people before then. They were exotic!

Did you gradually feel part of a transatlantic phenomenon?

It began to feel like that after George started the Fluxus Festivals here, and we corresponded with one another. We performed one another's pieces, and then I got to know all of these Americans! La Monte Young became a household word! It was La Monte who started publishing my work in America, sometime before Fluxus even, but I finally found out what these people were really doing all because of George Maciunas. It was George Maciunas

who said you were Fluxus or you weren't. And we all of us did such different things! In effect, he wanted to copyright us all and bind us together so that we had to work with him or with no one. When you performed somewhere without using the word *Fluxus,* he would be furious—you'd be reprimanded for it, and some of us were called prima donnas or independents and kicked out, then let back in, and then kicked out again. He held the power of excommunication against us!

When did you first meet Spoerri and Bremer?

The first meeting with Spoerri was in the middle '50s, when Daniel was publishing *material* magazine, a review that went for four or five issues. The first one was a little anthology of concrete poetry, the next number was Diter Rot, and the next one mine. We met in the club under the *Schloss* in Darmstadt, our favorite bar. We've remained close friends through the years.

In other words, your contacts as a poet were artists, sculptors, and people working for the theater, rather than literary influences?

Well, this is very important. There were also the Darmstadt summer courses in new music which were dominated by Pierre Boulez, Karlheinz Stockhausen, and others, and these people influenced me markedly because of their musical notations and the things they talked about. I had a very big dose of that in Darmstadt in the '50s, and it certainly affected my work for many years to come, knowing that there were other people in other disciplines who were doing things that would seem to fit in with my schemes, too.

 I was centering on language, and they were centering on musical notation, yet I would say that there's very little difference between what makes my early poems work and the things that make the early compositions of Stockhausen or Boulez work. I did not go to literary tea parties and things. I identified more with artists and composers, and this is where a lot of my motivation came from. I'd had a nice classical education, but it wasn't enough for my place and time.

Is it possible to say which direction you were all moving towards in your different ways?

If anything, it would be that phrase of Ezra Pound, "Make it new." Not the mere fascination of novelty, but finding new ways to work with materials that fascinated us. We wanted to do things that we had never seen before, to make the kind of books that simply didn't exist—books like *sweethearts,* an epic built entirely with the eleven letters of the title.

Could one say, then, that on the one hand you were doing work with a sort of concrete aesthetic, which seems very orderly and geometrical, and adjacent to that is the Fluxus work, which is perhaps more spontaneous or open-ended?

Well, you can do very orderly work, and it can look outrageous—or open-ended, if you prefer. For example, when the anthology *Movens* was published in 1960 by Limes Verlag it caused a lot of waves in Germany because it was what you might call a very far-out book in those early postwar years. It had a lot of concrete people, essays by Stockhausen, a lot of "funny people"—Diter Rot, Claus Bremer, me. Some of my concrete work was really quite formalistic, but *Spiegel* magazine spoke about my work as "the equivalent of working like

emmett williams

SONG OF UNCERTAIN LENGTH
Performer balances bottle on own head and walks about singing or speaking until bottle falls. 1960

DUET FOR PERFORMER AND AUDIENCE, 1961
Performer waits for audible reaction from audience which he immitates.

FOR LA MONTE YOUNG, 1962
Performer asks if La Monte Young is in the audience. 1962

10 ARRANGEMENTS FOR 5 PERFORMERS
Leader rings bell, performers move, leader rings bell second time, all freeze saying a single word. 1962

B SONG FOR 5 PERFORMERS
Phonetic poem group performance. 1962, score.

Emmett Williams, Fluxus events scores, 1960–62. From *Film Culture* 43 (Winter 1966), "Expanded Arts Issue."

```
          e  ee  eee  eeee
         ee  eee  eeee  e
        eee  eeee  e  ee
       eeee  e  ee  eee
      e  ee  eeee  eee
     ee  eeee  eee  e
    eeee  eee  e  ee
   eee  e  ee  eeee
  e  eeee  ee  eee
 eeee  ee  eee  e
ee  eee  e  eeee
eee  e  eeee  ee
ee  eeee  e  eee
eeee  e  eee  ee
e  eee  ee  eeee
eee  ee  eeee  e
eeee  ee  e  eee
ee  e  eee  eeee
e  eee  eeee  ee
eee  eeee  ee  e
eee  ee  e  eeee
ee  e  eeee  eee
e  eeee  eee  ee
eeee  eee  ee  e
```

emmett williams

Emmett Williams, untitled, from "ideograms" issue of *konkrete poesie*, 1962. Courtesy of the artist and Eugen Gomringer Press.

Jackson Pollock with letters." And of course you couldn't have said anything less true than that, because the methodology and the way of working were entirely different. But that's the way they saw it then—they obviously didn't look at it very carefully.

I would have thought that the French sound poet François Dufrêne was closer to Jackson Pollock in terms of abstract improvisation.

I have a very high opinion of the work of Dufrêne. But I'd say his "abstract improvisation" is more like a carefully structured language game.

How did you get involved with Dufrêne and the other poets in the Paris-based group the Domaine Poétique?

Well, as soon as I went to Paris I was a part of it, through my friend Robert Filliou. I first appeared in '62 or '63 with Robert, François Dufrêne, Bernard Heidsieck, Brion Gysin, William Burroughs, and Ghérasim Luca. It was quite an eye-opener because I was not used to that kind of literary forum. It was quite different from the Fluxus thing, because it was directed into more classical channels. You can imagine the elegance of an evening of Dufrêne and Heidsieck, and to some extent Robert.

When I introduced some of my Fluxus notions into the Domaine Poétique, Dufrêne was enraged—he didn't like this kind of spontaneous thing, he didn't know what to call it. Whereas Gysin was all for it. By the way, Gysin taught me a few tricks of the trade. "If you're going to do this kind of thing, let me give some tips," and he taught me some basic lessons about breathing, elocution, and other things that made me a better performer almost immediately. In the Fluxus things, on the other hand, I was not using my voice as a musical instrument, the way that I eventually did, in the Domaine Poétique, and subsequently.

How did you meet Gysin?

Oh, long before Fluxus! In the late '50s. We met in the old Beat Hotel while I was visiting a girlfriend in Paris. At that time I was still involved with Spoerri and Bremer and *material*, and I gave him copies and we looked at it and talked about it.

Was Gysin doing his cut-ups and permutations then?

Well, yes, yes, there was that. That impressed me very much, although there was a sense of reworking Tristan Tzara's cut-up method, but I liked the way he was doing it with a great flair—he was a very talented person, an actor, a painter, and various other things. There was the Dream Machine that was quite beautiful, and the insights that one got through drugs too—that was always very interesting with Brion. Robert Filliou and I got into trouble when George Maciunas and Fluxus came along, because we were interested in the drug experience and George thought this was the most horrible thing on earth—he hated it enough if you smoked a plain cigarette or drank a glass of wine! Anyway, it was very interesting to be doing both Fluxus and the Domaine Poétique.

How did William Burroughs's work seem to fit into this cosmos?

I was quite fascinated by the work of Burroughs and did the jacket notes to his first record, *Call Me Burroughs*. I thought it was great stuff—I liked his style of delivery and I liked him. Very much in the American grain. A great humorist.

When did you first meet John Giorno?

I met John Giorno in 1966, when I went back to the United States after I translated Spoerri's *Anecdoted Typography of Chance* and became editor in chief of the Something Else Press. Shortly after I arrived I met this guy at a dinner party. He didn't say much, but we left together and went somewhere to have a beer and we got to know one another and talked for the next two years—it was another one of the good meetings! The last time I saw John was a couple of years ago in Berlin. A great reunion!

How did his approach seem to relate to your Fluxus aesthetic?

Well, remember, Fluxus wasn't the only thing I was involved in. Three of the most important books I've ever done—*sweethearts* and two books of poems in German—by no stretch of the imagination have anything to do with Fluxus. John's work fitted in immediately with visual poetry, concrete poetry, and with so-called found poetry, but with a vengeance! The way John organizes his work on the page is a rather complex proposition. It needs good performers. For years John didn't read his own work—he had professionals doing it for him. But one day he started reading his own work, and he was magnificent!

You've also corresponded with the Scottish concrete poet, Ian Hamilton Finlay. What do you think about the way in which he has collaborated with different kinds of artists across the media?

In the early '60s he invited me to go on a fishing trip with him on one of the islands off Scotland. I never did, because at that time I was living at the Château de Ravenel in France, absolutely penniless—I could hardly get to Paris, to say nothing about going fishing in Scotland. There came a time when I felt I might help him get his work better known, when I became editor in chief at the Something Else Press and I said, "Hurrah! Hurrah! Hurrah! We'd like to do a book of yours!" He sent me a text and asked me if I could get Claes Oldenburg and Roy Lichtenstein to draw pictures for them.

And I thought, Wait a minute! That's an easy way out, isn't it—you write a few words and then you have two of the most important living pop artists doing drawings for you, and you're doomed to success, aren't you? I've always thought that the words should be the beautiful things, and not illustrations—visual poetry for me produced its own beauty, without the intercession of a visual artist or a designer.

Wouldn't a concrete poem typeset by a typographer like Hansjörg Mayer—such as your sweethearts, perhaps—be more of a two-person collaboration?

I owe more to my friend and fellow poet Hansjörg Mayer than I can probably tell you. But, as for *sweethearts,* I'd like to show you the original typewritten manuscript. It's all there. The typewritten setting would have been effective and satisfactory, the way my book *konkretionen* was, typewritten by me on offset plates. Hansjörg's edition is a beauty, my favorite of all my books. But I wouldn't call it a two-person collaboration. On the subject of poets

working with illustrations, go to William Blake. It's all there, poems and pictures, and he did it all himself.

What about Robert Lax's collaborations with the artist and designer Emil Antonucci?

Beautiful books. But Antonucci's designs are to me somehow superfluous. Lax is so strong a poet that his words move along very well, thank you, without someone else's embellishments. Don't get me wrong: I liked the books, bought them, and treasured them, but primarily because of the poems, not the illustrations.

When did you first meet Lax?

In Florence, in 1982. A convenient place to meet a saint. Many people call him a saint, you know. The way they call Robert Filliou one, now that he's in heaven, or wherever hell-raising Tibetan Buddhists go. Maurizio Nannucci had arranged this Poesia Sonora Festival. Three of us from the old Domaine Poétique were invited, Bernard Heidsieck, Brion Gysin, and myself—it was the last time I saw Brion alive—and we met Robert Lax for the first time, happy that Nannucci had lured him away from his Greek island for a few days. Most of the poets had brought a lot of fancy equipment with them—you know, plugged-in poets—but this bearded patriarch just sat down and read his poems, and we just sat there and listened, knowing it was the real thing.

Florence was our first face-to-face meeting, although we had corresponded since the late '60s! It was Bob's great friend Thomas Merton—hurrah! another saint!—who suggested that I write him. So finally we met, and I felt like I was seeing an old friend again, it was that kind of meeting! A few years ago we spent several days together with our mutual friend and publisher Francesco Conz in Verona. He had hurt his leg, or strained a muscle, and couldn't get about too well, and we had lots of time to just sit and talk. Bob's got a Rabelaisian streak, you know, and it comes out in his conversation and letters. His correspondence with Thomas Merton, published in *A Catch of Anti-Letters,* is something I pick up on those dreary gray days when I need cheering up. It's a sort of vaudeville act for two saints, the mystic and the monk, and it brings the house down every time. My house, at least.

And presumably you find the similar qualities in Lax's poetry?

Yes—I don't know another poet quite like him. All that profound simplicity, echoes of classicism in a new form. A piety that rings true and provokes laughter. What my Japanese friend Ay-O and I call cosmological humor. Reading a work like *21 Pages* is a wild religious turn-on. Someone, I forget who or where, talks about Lax's "rediscovery" of things that have always existed—the sea, the sky, light, darkness, meeting, parting. Love. His words are *things.* Do you remember those lines from Archibald MacLeish that we all learned when we were young—"A poem should not mean / But be"? Well, Robert Lax's poems *are.* Which returns us to the subject of collaborations between poets and artists. To illustrate Bob's later poems you need a Robert Lax. It's that simple. The poems illustrate themselves.

You're wary of collaborations?

Well, recently I did a large print with a computer scientist, who took a very simple text of mine and made it so complex I didn't know whether to sign it or not. I'm afraid of technology

that I can't quite control—and I have this deep-seated fear of having somebody else do my work. That's one of the reasons why Ann Noël and I don't collaborate, because she knows how to do all of these things that frighten me.

Well, it's certainly a sensitive area. I remember how one or two of the English concrete poets responding to a questionnaire that I sent out in the late '60s regarding the success of collaborations between poets and typographers questioned the typographic versions of their typewriter poems in the pioneering Anthology of Concrete Poetry *that you edited for Something Else Press. All the same, it's an extraordinary introduction to the global scale of postwar verbal-visual poetics.*

Well, I was certainly proud to be associated with Dick Higgins's Something Else Press. On the other hand, the success of the Something Else Press was one of the great tragedies in the life of George Maciunas and Fluxus. There was George, slaving away as a designer trying to raise funds to publish this stuff called Fluxus, and Dick came along and started up his press that took so much of the impetus away from Fluxus. From this moment starts the rift between Dick and George. I was caught in the middle, because here I was, the new boy in town after seventeen years in Europe, serving as Dick's editor in chief. George thought I was King Shit, a traitor to the cause of his beloved Fluxus. Yes, life is full of misunderstandings! Still, George and I didn't make peace until he was on his deathbed. Literally! And maybe the *Mr. Fluxus* book I was telling you about earlier is my penance for having "betrayed" him in this fashion.

Or more affirmatively, it's one of the first major celebrations and documentations of Maciunas's achievements? And surely you're still flying the Fluxus flag, even if it's probably a little strange to be restaging all the historic Fluxus pieces at the recent Fluxus festivals in Seoul, Istanbul, Eastern Europe, and so on?

We often talk about that situation, you know, and when people say, "But this was heralded as such a great experimental troupe during the '60s, how can you justify doing what you did then thirty years later?" I can't see why on earth not. I mean, Mozart didn't stop after the second performance of a work, and is there any reason why Fluxus should? No one ever said of Fluxus, "These are spontaneous performances—you can only do them one time." Some of us still do the Fluxus classics because the pieces are strong and good, and audiences still like them and we like to perform them. Maybe we look funny up there onstage in our sixties and seventies, but that's no reason to stop. We're not doing striptease.

Finally, are there any other sorts of work you wish you'd done?

Don't make me cry, Nicholas. Of course there are. I'm sorry that as a child I didn't master the piano and things like that. I'd like to have had more time simply to paint. To carve. To sing. To act. To write more poems and stories. But unfortunately I have lived most of my life unwisely, generally in debt, raising two families over a long lifetime. I can't afford to be footloose and fancy-free.

Still, I've managed to accomplish a few extraordinary things. I did learn to paint, and I am about to enter my African sculpture period. I don't have to ask anyone to design my poems for me. Yes, I like to do things my way. And what am I going to do next? Come around in a couple of years and I'll show you. But it won't be on the Internet, most likely.

Robert Wilson. Photograph by Lesley Leslie-Spinks. Courtesy of the Byrd Hoffman Foundation.

ROBERT
WILSON

I DISCOVERED ROBERT WILSON'S WORK IN 1987, when I chanced to see his production of Heiner Müller's *Hamletmachine* in London. What an extraordinary production! I thought. What virtuosity! What a range of effects! But what exactly did they mean?

Thanks to the American Repertory Theatre's literary director Robert Scanlan, I subsequently sat in on rehearsals for Wilson's 1988 production of Müller's *Quartet*, and finally met Wilson in Boston in 1991, when the ART hosted his production of Ibsen's *When We Dead Awaken* and the Museum of Fine Arts hosted his retrospective, *Robert Wilson's Vision*.

How did he integrate technology in his productions? How precise was his theatrical vision? "One invents a language and then once this language becomes discernible, we can destroy it and start again. I think that's what Mozart did when he was composing—you know, the theme and the variation."

Once again—against all odds perhaps—one confronts further evidence of the continuities between past cultural practices and the contemporary avant-garde—what Emmett Williams calls the avant-garde's "'rediscovery' of things that have always existed" and its "echoes of classicism in a new form."

Rejecting the ways in which naturalistic drama places "too much garbage on the stage," Wilson isolates and then undercuts such echoes, refining them with almost painfully decelerated intensity, before plunging into raucous cabaret mode, as his cast loses the plot, falls into chorus line, and generally has "a gay old time." Not surprisingly, Wilson welcomes Müller's fusions of "very compressed, dark" rhetoric and "terrifying" humor.

As Wilson's international productions demonstrate, the finest techno-avant-garde creativity both "destroys our codes" and "rediscovers the classics," as it advances with the distinctive élan that the veteran surrealist Louis Aragon—writing about the Paris production of Wilson's *Deafman Glance*, in 1971—perfectly describes as "after us, beyond us."

Boston—February 5, 1991

Could I begin by asking you how you've used technology in your Boston production of When We Dead Awaken?

Well, I have an audio score—an electronic score—that will accompany the spoken text which is sometimes also electronic and acoustical. The speakers will be arranged around the room in a three-hundred-sixty-degree sphere, meeting at the back of the performers and at the back of the audience, some higher and some lower. And sounds will be played thinking about the space as three hundred sixty degrees. They will sometimes be traveling diagonally across the space and at other times around the space. I try as much as possible to separate what I hear from what I see.

So when I first started working on this piece we sat at a table, we read the text and talked about it for a couple of days. And then I put the text away, and I made all the movements for the piece as a dumb play—a mute work. All the gestures were choreographed, videotaped, and then studied. And already at that time, I began to make suggestions about light and drawings for the structure of the lights, and also I began to work with Hans Peter Kuhn on a sound environment that would accompany the work. This sound environment didn't necessarily follow the text directly, and also did not necessarily follow the movements.

When the movements were more or less choreographed, staged, and worked out, I ran it as a silent work to see how this visual book works in terms of the movements and the gestures, which can be something independent on its own. We could see it only at that level. Then I worked on the text, on different ways of reading the text, thinking about the visual book being a mask for the text.

I was in Greece some years ago, and I met an Eskimo woman who told me about a Greek drama she was doing for two or three people in which she would have these two or three people forming all the parts. They'd be the chorus, the protagonists, or the antagonists. And she used a traditional Eskimo format—to have a fire in the center of the performing area surrounded by a series of masks on stands. Sometimes there'd be groups of masks, or individual masks, or two masks together, so that these two or three people could play all the parts simply by positioning themselves behind the appropriate mask. They could switch parts, roles. And I found that very fascinating—that the visual book or the mask could be a cover for the text. And I think to some degree that's what happens in my theater. One problem I have with most theater is that the boundaries, the audio and visual frames, are confined.

I like a situation similar to the experience one has when one is listening to a radio, when one can imagine pictures, or when one sees a silent film, when one can imagine a text. So that there's a certain mental freedom or space for interior reflection, aurally and visually. So often, what we see in the theater and cinema follows too closely. If I say something, my gesture doesn't have to reinforce or illustrate it. The visual book usually is superfluous or decoration, or never equally considered—the text is the thing.

To me, there is always something missing in this kind of experience. Because the two basic ways in which we communicate with one another are through our aural and visual senses, and it seems to me that so often the visual sense in the theater is an afterthought. We do the gestures after we speak the text, we do the lighting at the end of the rehearsals. So in this theater I try to think about them all separately from the beginning, and then put them together.

I'm not so interested in the collage, like, say, Merce Cunningham and John Cage, although I greatly admire their work and have been influenced by them, especially by Cage early on, and later by Cunningham. But I'm not interested in the collage or chance factor. I'm more interested in structure and how things are thought about when they are seen together—how one thing helps you hear or see another. I'm not saying that I don't frequently use chance elements in determining what happens in performance. In fact, it's always there, to some extent, even when something is prepared or thought out.

I'm much more interested in the kind of production that one saw in my production of *Hamletmachine*. You know, if I say, "I want to *kill* you!" threateningly, or if I smile and gently say, "I want to kill you," there's something in the smile that makes it more terrifying. So I'm much more interested in how the audiobook can reinforce the visual book, and vice versa. Through this dualism, this parallelism, they can reinforce one another.

In a way, that necessitates a multiple focus, and presumably, the use of the different media helps one work across the borders?

Exactly.

You've said you're interested in structure. Does this imply that, without wishing to be didactic or overexplicit, you're interested in certain quite precise conjunctions of effects?

I am. I'm not someone who's interested in interpretation. Interpretation is not for me the responsibility of the artist or the actor or the director or the author of the piece. Interpretation is for the public. We make a work for the public, and we invite them to share this event with us, and then it's up to them to put together conclusions. Or philosophers, in time, can do it. Not critics. I think that's not the responsibility of critics. A philosopher, in time, can think about it and reflect.

But you're making certain, very deliberate choices when you select some of the ingredients, I suppose, because you seemed to be telling actors in rehearsal that one gesture was particularly appealing, or that a way of reading seemed particularly satisfactory.

Well, now we're beginning to put it all together. It's very difficult for these actors whose experience or training has been in psychology, whose motivations have been psychological ones. I gave them a series of movements and never explained them—I didn't talk about them and I didn't want to. In the beginning these seemed quite arbitrary movements. Then with this text we began to eliminate something and move it over here, adjust it.

So in a sense you're adjusting most of the ingredients until they seem to jell?

Exactly. The problem is that if I start with the text, and then think of a gesture or movement—invariably, even myself—it will just follow the text. So I say, "Forget about it, here are all these movements." Sometimes, as in this play, I just put numbers. I'd have 275 different movements. So I'd say, "movement 17, movement 24, movement 16, 15, 16, 15, 16, 15, 16, 17, 18, 19, 15, 16, 17, 18, 19, 1, 2, 3, 4, 17, 18, 19." So I made a rhythm of different movements. There's a man sitting in that big chair in rehearsals, making gestures for movements one, two, three, four, and so on.

So that gives it almost a sense of ballet or of gestural music?

Of formality. I'm not interested in naturalism. I hate naturalism. I think it's a lie. This effort to be natural is always so artificial to me. I think it's better just to be honest and say, "This is an artificial form I'm working with and it always seems more natural." If I see a Noh actor performing a very stylized form of movement, it's much more natural than if I go and see Tennessee Williams, and I see these actors trying to express and emote! It's so boring! I see this Noh actor, and it's like being in the country or with nature. Its very formal, very stylized, but it's much more natural to me than what they call naturalism.

And yet it is still expressive in its own register?

There's deeper emotion because it's more distant. There's more space.

Could you tell me a bit more about your use of video to prepare your productions?

Well, I record it, study it, look at it, and change it. I use many, many, many videotapes in the rehearsal process. Actors look at it, go back, and replay it. So a lot of the composing is done with the video monitor.

And this makes it easier to compare different effects and facilitates different productions?

Well, it helps, because assistants can study it, the second cast can study it, and I can go back and look at it in the future, to re-create it.

Have you ever made video versions of a piece?

I just did *The Black Rider,* with William Burroughs and Tom Waits, in Austria for Austrian TV. We didn't have an enormous budget, and I had five days to rehearse, and I shot three performances. I had originally asked for a much longer time, for a month to six weeks, and to be in a studio. Then I would have made all different kinds of decisions. But considering that we didn't have that much time I thought it was better to treat it like a live performance. So, what it is, essentially, is a kind of documentary of what I put onstage.

Do you find there's a different thought process, or logic, to video work as opposed to live work? Or do you find your video work feeds back into your theater?

Well, I think it's all the same thought, it's all the same process. The result's different, because the time and the space are different. The video is more about a close-up. What you see is getting closer, the time you see is quicker, the scale is different, the time and space are different.

Some artists, such as Jenny Holzer, remark how they work in terms of the average three-second attention span. Is this kind of consideration a factor in your video work?

Yes, I have that in mind, too. The first one I made in the '70s, *Video 50,* had a hundred thirty-second spots. They're all broken down into three, four, five, six, and seven—it's still slower than most TV—it has a different rhythm from commercial TV.

But onstage you work with a different time dimension?

Space is different. I can have someone cross the stage in an hour and a half and it can hold the audience. It would be difficult to do it with video.

Unless one was Michael Snow, with Wavelength*?*

Yes. I love his work.

What do you like best in Burroughs's work? What led you to invite him to collaborate on The Black Rider*?*

Well, I like his humor, his dryness. I like the sound of his voice. I like the fact that he's not afraid to destroy the codes in order to make a new language. The language becomes more plastic, more three-dimensional, like molecules that can bounce, combine, and are reformed. That interests me a lot. Because essentially that's what all artists do. One invents a language and then once this language becomes discernible, we can destroy it and start again. I think that's what Mozart did when he was composing—you know, the theme and the variation. I think that that's what we do essentially. With *When We Dead Awaken*, a series of movements becomes a language, and once that's discernible, then I began to change it, and destroy it and add something else.

How did you work with Burroughs?

Well, what I do best, I think, or one of the things I do anyway, in collaborations, is that I make a form, a structure. I can't write the lyrics. I don't have the talent, and I can't write the music, and I can't write the text. And then, once this form or structure is established, various people can fill it in and do whatever.

So I made a structure, a form. The work was in twelve parts, and I made a little scenario, a series of drawings, which became a storyboard or an outline. There's a black box in the center of the stage. We look at it for eleven seconds, and it takes nineteen seconds for it to stand up vertically. It takes seventeen seconds for it to go stage right. It takes three seconds for a leg to come out. We look at this leg for fifteen seconds, the leg goes back into the box, the door opens, and the devil comes out. The devil crosses the stage for a minute, and then the entire company comes out of the black box. This should take two and a half minutes, and there could be a song to introduce the company, like the circus, when you parade the circus at the beginning and at the end, to introduce the company and to let the audience know something about what the piece is going to be. It's going to be hopefully a gay old time! And it's going to be sung by the devil!

Then everybody disappears into the black box, and that should take eleven seconds. Then the black box should expand until it covers the center stage. And that should take one minute—there should be some strange music or something happening through that. The first number should be loud and quick. This can be slower with the expanding of the black box. The black box expands and now it becomes a room. And in the interior of this room we see two giant chairs and a table fill the entire space. And there's a portrait in the center of the stage, and this is an old man, an old family portrait who speaks to the father. Et cetera, et cetera, et cetera.

And I made a series of drawings. Scene two is a smaller space, it's a flashback, and it's in color. Scene one's in black and white. Scene two is smaller and occupies the same space as the table in the center of the stage. Scene eight is a flashback, and it's also in color. The two flashbacks are in color and the rest of the play is in black and white. So I make a visual book, and then I give it to Tom Waits and I give it to Burroughs and they write texts. In some cases I staged the work as a structure of silences, and then videotaped it, and then sent them the videotape, and they wrote the music.

I am making an opera with Philip Glass—*White Raven*—it's being done in 1992. I staged the whole opera with no text and no music. It's a three-and-a-half-hour work. So then an author—a Portuguese woman—and Philip look at this videotape, and they imagine what the text might be! Philip and I know each other and we trust each other. I can have a visual theme in the first act, first scene, that is slightly introduced, that becomes a major theme in the fourth act, third scene. And he may have a major theme in music in the first act, first scene, that becomes a minor theme in the last scene. So we don't always have to follow each other, but we have our structures, and they're like screens which are out of phase and out of line, and sometimes they line up. And they're exactly in sync, and then they go out. So that's sort of what happened with Burroughs and Waits.

When I first discussed the collaboration with William, I said I felt that I wasn't so interested in conventional dialogue or traditional writing for plays—what I call "ping-pong" dialogue:

"Hello, how are you?" / "Oh, fine."
"What did you do last night?" / "Well, I went to the movies."
"Did you like it?" / "Well, so-so."

I didn't want to have this question-and-answer situation. But I loved his dreamy, cloudlike texts. So I felt that I could tell the story visually, in scenery and in gestures, and that if he wrote these cloud texts, they could float over these stage pictures. And in some cases that's what he did, and in some cases he did other things. It's always good to have contradiction.

Burroughs told me that he was writing initially in couplets.

Yes, that's true.

Did that work well?

It was beautiful.

So he wrote sort of cloud couplets?

Yes, exactly.

Turning to another of your collaborators, Heiner Müller, could you say what it is you like best about his work?

What I liked most about my collaborations with Heiner Müller is the humor in his writings, as well as the density of his texts, and the freedom which his texts give a director. On the surface, Heiner's texts appear to be very compressed, dark, and at times, political and even violent. But with further investigation, one sees there is an underlying humor which makes the play strong, terrifying.

The density of his texts derives from their volume of contradictions, which makes interpretation impossible. There is no one way to read them; they can be read in many different ways, like all great literature. Heiner's work awaits collaboration from the director. In his texts, one frequently does not know who is to say what line, or where the text is to be placed in terms of setting. Text can be a long monologue, or be distributed among a group of actors—one actor, two actors, or forty actors could be assigned the same passage.

With his kind of writing, Heiner has eliminated the ping-pong dialogue that exists in most other forms of theater writing. His dialogue breaks away from the normal question-answer sequence. Ultimately, what one is left with is a lot of questions. For me, Heiner is not so much a political writer—as he is most known for being—but a philosophical one.

Have audiences gradually learned to see and hear your productions more effectively? I imagine you'd argue that it's still possible to communicate with an audience, rather than sharing the sense that we live in an era devoid of meaningful art and communication?

Well, I went to see a recent production of my *Death, Destruction and Detroit* in Berlin. It was full of people. In the beginning people were very confused—it was an older audience. It took five hours, with nine stages surrounding the audience, where you just had to freely associate. There were plenty of people who stayed. I mean, there was no story. People found connections and sat there, you know, in their mental space.

I think a few years ago it would have been difficult to have had an audience that would have stayed there, looking at a play that one had to freely associate. Dance you can, and music—I mean now we have a more sophisticated public for dance. But if you go back and read Edwin Denby or any of the critics who wrote about George Balanchine, you discover the problem he had in the '40s with his abstract ballets. I remember in the '70s, being in Paris, and reading these French critics writing about Balanchine and making all these stories out of it, or people making stories out of Merce Cunningham's work.

Even when Merce was in Paris working in the '70s, he said it was so difficult because of the dancers—you put two boys on the stage and immediately they'd think it was some complicated story! Whereas he was just looking at it abstractly, as lines, timing, and composition in time and space. It's still difficult to do it in the theater for the most part, because people are still thinking in narrative form. But it's changing for younger kids—for better or for worse, television does it.

What are you looking forward to in the next decade?

I want to continue traveling. I'm interested in working internationally. I've worked a lot in Germany in the last three years and I'm trying to work more in Latin America and South America. That interests me. I'm going to do a piece in Caracas—I'm going to do a piece in Mexico, Buenos Aires, and Brazil—a piece in Spain, and another piece in Portugal. I'm interested in Thailand, I'm very interested in going to Indonesia. I've worked in Japan, but I'd like to go more into the roots of that culture.

So in a sense, free association is going international?

I think so. By different cultures, different ways of thinking. I'm also looking forward to working more in America.

What are the biggest problems with American audiences at the moment?

Television! I think what we see on television is a series of one-liners. You know, you get the information in three seconds, and then that's it. So you see Dustin Hoffman in *Death of a Salesman,* and it's, "Do you get it, audience? Do you get it?" And you see him doing Shakespeare, and it's, "You've got that one? You've got that one?" And that's OK, too. But I don't want to draw any conclusions, and I'd rather process it in time, as something we think about, that's a continuum. When the curtain goes down, you don't stop thinking about it. You go home and still think about it. It's part of an ongoing thing, it's a continuum, it's something that never, never finishes. It's something that continues to intrigue or fascinate.

Why do we go back to *King Lear?* Because we can think about it in multiple ways. It has no one way of thinking about it. It could not be interpreted. It cannot be fully comprehended. So it's foolish for us to think that we can understand what it is that we're saying or doing. Because it's far too complex. We can reflect on it and think about it, have understandings. But to assume that we can understand what it is we're doing is a lie. And that's one thing that's so disturbing to me about most theater. I feel that the author, the director, the actor, is assuming too much that he understands the situation, instead of approaching it with more of an open mind. The questions, "What is it that I'm saying? What is it that I'm doing?" That's the reason to make theater. And if we have the answers, don't do it. There's no need to do it.

Would you say the new technologies have proposed any especially productive or new questions? Or do you think in a sense that you're just working in some sort of transhistorical continuum?

Well, I think they help us destroy our codes, find new languages, and rediscover the classics. Socrates said that the baby is born knowing everything. It's the uncovering of the knowledge that is the learning process.

Nick Zedd, 1985. Photograph by Casandra Stark.

NICK
ZEDD

JOHN GIORNO DREW MY ATTENTION TO NICK ZEDD IN 1991 when he described his plans to publish "this great young poet who did this totally great pornographic video called *Whoregasm*." I subsequently read a brief profile of Zedd's tormented career in a New York fanzine picked up in Kim's Video Store, but never imagined I'd meet this unlikely namesake in London until a colleague showed me a press release announcing his presence at a film screening to launch Jack Sargeant's book *Deathtripping*—the first critical overview of what Zedd calls the "cinema of transgression."

I phoned Creation Books, arranged an interview, and walked up to the party—three or more hours of screenings in an eerily dilapidated upstairs room on Charing Cross Road. The next day I made my way to his hotel. A sleepy voice asked if we could postpone things till noon and meet in the bar. When I arrived, Jack Sargeant was already there, so we ordered beers and chatted about the book until Zedd arrived, ordered tea, and the interview began.

Describing his initial wish to make films as "direct and loud" as punk rock numbers, and recalling such gems as the time "the smoke machine went out of control . . . and forced the audience to run out into the street," Zedd rapidly revealed his considerable gifts as a wry raconteur. But as he adds, if his films always try to "go further" this is not so much to produce gratuitous shock effects—although I sense that this is often at least partially the case—as to make his audiences "look at what's happening" beneath media hype.

Likening his vision to "what Goya did," suggesting that "maybe Hieronymus Bosch is closer to what I do," relentlessly exploring the most harrowing images, and generally cooking up a disturbing amalgam of intelligence, provocation, and compassion, Zedd's work pivots upon ethical ambiguity, revulsion, and—at its finest—a truly horrifying contemplative intensity.

Like Robert Wilson's productions, Zedd's films lure us into an alien mind-set, bemuse us with variously superficial or transgressive mind play, dazzle us with momentary insight, and then plunge us back into the very banality just transcended. For Baudrillard (whose

writings usually follow identical strategies), this interplay between the partially "ecstatic" and partially "insignificant" is best perfected by Warhol—apparently, "our new mystic, and the absolute anti-mystic." "Our" new absolute anti-mystic? I don't think so.

London—November 10, 1995

Could I begin by asking you how you began making films? Were there any particular artists who provoked your work in any way, or was it more of a reaction to a particular situation?

I started making films when I was twelve years old for fun and to tell stories. I wasn't influenced by anyone because nobody else was making movies that I knew. My father had a movie camera, so I'd shoot movies with my friends. When I was fourteen I did a couple of science fiction movies. Then I went to New York and did this movie called *They Eat Scum* in 1979. This was the same time that Beth and Scott B were shooting, and I remember when I was making *They Eat Scum* I was pleased that there were other filmmakers shooting films in Super 8. I was glad that they were showing these movies in an environment like Max's Kansas City, a rock and roll place with a bar, instead of a museum or a regular movie theater. It seemed like it had more validity because it was more threatening, it was more of a risk and was being seen by people who would not necessarily be art aficionados.

Then I showed *They Eat Scum* at Max's Kansas City. It was interesting because there was a critic at the *Village Voice* who did a big article on these other Super 8 filmmakers, which came out before *They Eat Scum* was completed, and basically this writer decided to lump all these filmmakers together and call them "para-punk cinema." I thought this was a very arbitrary label that he used to try and corral a bunch of filmmakers who didn't really have that much in common, except for the time period. I was completely excluded, and at that point I realized the arbitrary nature of the way media define movements and trends in general, and felt I did not want to be a victim of the censorship of omission that occurs when journalists arbitrarily decide they will make history.

I felt I could make history, so I formulated this concept of the "cinema of transgression," but I knew it was premature to use that term in 1979, because there were no other filmmakers who were making transgressive film. I felt *They Eat Scum* was transgressive, but I felt the films of the other filmmakers like Eric Mitchell and Beth and Scott B were derivative of the 1960s. I felt there was a generation gap between my state of mind and theirs, and I waited until 1984, when Richard Kern started making films and Tommy Traitor—I wanted to see if they would produce anything significant enough to warrant the announcement of the "cinema of transgression," which I then did in 1985 when I put out the *Underground Film Bulletin*.

Did you also find Warhol's films unsatisfactory?

No. I always enjoyed Andy Warhol's films, especially the ones with Paul Morrissey. But I felt that the elements could be integrated in a more powerful way and in a more confrontational manner, that they could be more succinct in a different style. I think the music of punk rock and No Wave had some kind of influence—the songs are really short and direct and loud, and that's the way the films, I thought, should be.

Were there any other artists—or performance artists—around with this kind of energy? Did you find other allies elsewhere, if not in filmmaking?

Yes, G. G. Allin, who else? Diamanda Galás I was impressed with.

What did you like about Diamanda Galás's work in particular?

The effect it had on my bowels!

A gut reaction?

Yes, I was impressed by that. She'd be starting the music, and I'd have to run to the bathroom and take a shit—I don't know why.

Presumably you're not just trying to create shit art? Do you want to affect the bowels of your audience, or worse?

It's always nice to get a surprising response. I mean, I make my movies for myself really, to astonish myself—I don't know why, I cry sometimes, when I see my own films, or laugh. I like to get an emotional response from the audience, laughter or crying or whatever. Sometimes it appears to be indifference, so maybe that's shock, silence, I don't know. I'm not that concerned with the audience really—I do it to please myself.

Do your films ever overlap with performance art?

I used to do expanded cinema performances. I did one called *Me Minus You* in which I used this movie that I did with Kern—*Thrust in Me*—as a dream sequence. At the time, in 1985, I was really broke and I couldn't afford to buy film and shoot anything, so I thought I'll write this thing and perform it live—it'll be like a live movie. So I did that—Tommy Traitor was one of the actors in it with me, and I performed in drag as the lead female role.

And in 1985 I did something called *She*, which was a performance thing I wrote with Lydia Lunch—well, I don't call them performances, I call them ordeals—it was an ordeal that I wrote with her. She originally performed it on TV in Holland, and I did it at the Downtown Film Festival with Richard Hell narrating it and me performing it onstage. I also did it one time in a place called the Limbo Theater, and the smoke machine went out of control and filled up the whole theater and forced the audience to run out into the street, and that was nice.

In what way was this an ordeal?

It was a really excessive kind of monologue praising this woman—it was based on my feelings of adoration for Lydia at the time, because I was in love with her. I guess I loved her more than any other woman, and put into words these feelings, and then she modified it. It was pretty much like a fifty-fifty collaboration—she had a very high opinion of herself, so it pleased her immensely to receive this thing. At the end of it the guy is so obsessed with this creature that he wants to eat her and stab her and devour her completely.

What did Lydia Lunch's protagonist say or do?

In the original performance, she's on a bed, writhing around and squealing while one guy's going on about how he'd like to nail her palms—like crucify her—to the bed, and then the guy comes with a knife and attacks her and then the lights go out and there's silence—that was it.

Did this kind of performance differ from your films?

Yes, it was different. I mean, I noticed that in live performances such as *Me Minus You,* especially the original one, which was done at the Pyramid with Rick Strange, who is now a TV evangelist but who back then was just like a maniac. He played the lead character. He showed up drunk and didn't remember any of his lines and I handed him the script onstage and he ripped it up, you know, onstage, and then it became an improvisation. I knew my lines pretty much, and Bunny Atlanta had the script right in front of her face, and she could recite her lines. Meanwhile, Rick was ripping up the set while the performance was going on, and I got so mad at him that I threw him off the stage.

He didn't get mad, though. He always admired me, and I admired him in a way because I felt he really epitomized transgression—he had no morals, he was like both good and evil at the same time. Everybody I knew hated him and wouldn't talk to him, except for his girlfriend, who was this spaced-out hippie. We then went backstage in the dressing room and then he went back upstairs during the screening of the dream sequence of *Thrust in Me,* looking for his knife—for this bone-handled knife that he had lost by the stage. He was going through the audience saying, "Who the fuck stole my knife? Which one of you motherfuckers stole my knife?," which was very intimidating to the audience. That wasn't scripted, but I was pleased that it occurred.

What did he want to do with this knife?

Maybe he wanted to kill me with it? Maybe he just thought he needed it to defend himself against the audience. I don't know. The audience wasn't really hostile—they were sort of bemused up to that point—but when he started looking for the knife I think they became alarmed and started to complain to the bouncers. So, you know, I'm backstage, and somehow he ended up backstage with me, and the bouncers came in and said, "You have to leave," and he said, "Fuck you, niggers"—he was just a maniac, he didn't respect anybody's feelings. So the bouncers physically carried him out and threw him out on the street. When I came out afterwards he was terrified that I was going to kill him for ruining *Me Minus You,* but I was very pleased. It was great—there was total chaos—the whole thing deconstructed before my very eyes, in a really amusing way, and nobody got hurt, so that was OK. Maybe some people's feelings were hurt, like the bouncers, but they're used to being called names and they're used to pushing people around.

Have you collaborated with Lydia Lunch in films as well as in performance?

Yes, I made one movie with her, *The Wild World of Lydia Lunch.* I had this taped narration of her telling me about her feelings when she went to England, which I only heard in New York after I had shot the film in England and Ireland. When I heard the tape, which was of letters that she'd dictated into a tape recorder expressing her feelings of confusion about the state of our relationship at that time, I felt it would be a really good narration for the movie.

I also used music—with the lyrics taken off—from an album she was working on which I think reflected both of our states of mind at the time.

So there are three levels—the backing track of the album, her correspondence on tape, and then your images.

Right—and the images are of her wandering around in London and in the countryside in Ireland by some burned-out castles with sheep. It's like a portrait you know—a moving portrait of someone I was in love with. I never did another movie like that. I've had different motives for each one of the films— *Police State* had a completely different motive.

What was the motive for Police State*?*

Revenge—against the police. The thing is, I found great humor in the interactions that would occur when the police would try to harass and intimidate me—there'd be real humor there.

Were you often intimidated by the police?

Well, I wasn't. I was supposed to be, I know I was supposed to be—they were trying to scare me—but it was so funny, the conversations we would have, it was give-and-take, but then at some point they made it really clear that if I keep joking like this I'm going to get the shit beat out of me. At that point I always was mad because I felt, Why does their sense of humor just suddenly disappear? Because their intelligence wasn't up to my level, and they couldn't win a verbal battle, they had to resort to twisting the handcuffs, and saying, "OK, your wrists are going to break now—is that funny?" and that really angered me. And I felt, Well, the humor is there, I remember the dialogue, I'll make a movie about that. And I'll just see what would happen if the guy wasn't even afraid of getting hurt, and he just kept insulting the cops right back, and how far would it go?

One time I was modeling in an art class on Staten Island and I thought that there were going to be such repressed kids, art in the suburbs, but the kids were OK, and I'm sitting there naked, and nobody was giggling or acting silly or stupid, they're doing the drawings, the teacher was OK, I got paid. I'm walking down the hall, I did my job, and some asshole fucking teacher comes out and says, "Where's your hall pass?"

So I said, "I don't need a hall pass, I'm not a student here," and I kept walking. "Wait just a minute you're breaking the rules." "I'm twenty-eight years old, so why do I need a hall pass?" She chased me down the hall and says, "You come right back here." "Fuck you, I'm going home." I'm walking out the door, and she gets a cop—they had a cop on duty in the high school—who comes and grabs me, chases me into the office, handcuffs me, takes everything out of my pockets in front of these secretaries who're looking the other way as if nothing's happening, and I'm being threatened with arrest and bodily injury, just because I didn't recognize this petty authority.

It was then that I realized that I was in a police state. He was threatening to break my wrist if I didn't stop joking around with him—which I did—I stopped joking around. At some point you have to stop smiling and pretend that you're intimidated, otherwise you get hurt; so they let me loose and that was one of the incidents that made me want to do this movie. Another was the time when twenty cops descended upon us after Rick Strange broke a window on a newsstand with a chainsaw.

Video cover for *The Wild World of Lydia Lunch* and *Police State*. Photograph courtesy of the artist.

I haven't heard of police intimidation from the other New York poets I've met, though I recall that in Burroughs: The Movie, *Burroughs describes the way in which he carries about eight different weapons.*

That's good.

Although he also unexpectedly adds that he hopes he doesn't have to use them, because "I don't like violence."

I hate violence.

You hate violence? Surely there are a lot of violent images in your films?

I hate violence in real life, but I enjoy fake violence—I really enjoy professional wrestling. But in real life I need to get some better weapons, I guess, because the last time I got into a fight in the subway, I pulled the Mace out and shot the guy with it, and it had no effect at all. This stranger was making an observation about the tightness of the dress of the girl I was with, and I felt it was insulting, so I slammed a car door on him and got into a big fight. It was interesting, though—the train's moving, and these passengers are sitting there, trying to dodge us as we bounce around the car, and the guy's trying to demonstrate these kung fu moves, but he doesn't know what he's doing—he's seen them in a movie—he's trying to do this kick and he's missing, and I was saying, "You missed that time!"

Neither one of us got hurt that much, maybe a bruise here or there, and meanwhile his scrawny crack-junkie girlfriend's standing there saying, "Leave him alone, motherfucker! We're calling the cops on you!" Plus my girlfriend's saying "Nick, stop, stop, it's not worth

it! It's not worth it!," and people in the car are saying, "Don't use the Mace! Use your fists, man!" It was scary and funny at the same time, but not that funny—I felt that I was too old to be doing these sorts of things. It was shortly after that that I got a car—I think it's maybe a better form of transportation for me.

The juxtaposition of industrial footage and scenes from an operating theater in Son of a Whore/Smiling Faces Tell Lies *seemed rather more disturbing.*

That film is also a union of opposites because it's two movies that have nothing to do with each other being run simultaneously. I first worked on the section on the right as a dance movie, for Emma Diamond, an English dancer. It's been called a structuralist film. I'm pleased with the way I showed the subway train cutting into itself—it's two shots of the subway train, but I cut it in such a way that you get this real conflict and visual assault. That particular sequence is beautiful. It's also very metallic, sharp, and urban. And then on the left I contrast this with homosexual pornography and open-chest surgery.

That reminds me a bit of some of John Giorno's poems, when he's got two columns of simultaneous or interweaving narrative rapidly collaging different registers and materials. Do you find it entirely satisfying working with such conflicting images? Or is it becoming increasingly difficult to find something even more chilling, even more pornographic, even more mechanical?

That's the challenge—to always go further. I mean, I want people to be less timid—I want people to look right at what's happening. I think the next step is to go beneath the surface of the bodies, beyond pornography, into internal organs. I met a forensic pathologist in a bar, and he gave me his number, and he said that he does autopsies on corpses and that I could shoot them. I'm hoping maybe I'll be able to shoot some real corpses—I think it's arbitrary that only the outside of the body is seen as erogenous. Maybe people will be turned on by internal organs.

Presumably you don't want to encourage casual disembowelment?

No, no. It's just that it's going on all over the world so much, and people don't really consider this. When there's war, you know, this is what happens—people's insides come out, and there's all this destruction of bodies. I think if people were more aware of that they would not support this government's policies. I think that if they'd had cameras at the Waco massacre showing those people—those children—burning to death, the American people would have been so shocked and horrified that Clinton would have been impeached. But, of course, the government is very good at covering up their atrocities.

Isn't there a danger that by uncovering atrocity you're perhaps encouraging others to do that in rather a prurient manner?

I'm a mirror, I'm reflecting life in the twentieth century. I'm just not shying away from it—it's what Goya did.

Do you want your work to have an explicit or an implicit critical edge? Goya's paintings of the horrors of war have been discussed as being far more forceful than those of Manet. Are issues of critical realism something that's on your mind?

Maybe Hieronymus Bosch is closer to what I do.

Well, I was thinking just that when I was watching your films last night—that maybe this guy is a kind of contemporary Bosch. But do you feel that you're sufficiently Boschish or Goyaish?

I'm sufficiently Zeddish.

Do you think your recent work has to some extent moved away from the more overtly critical vision of Police State, *which seems a fairly accessible piece of obvious satire? Does it worry you at all that some of the other films may not be as explicitly critical?*

No—I mean, ambiguity has strengths, too. There are different levels of interpretation that occur and it can be more thought-provoking for people to try to decipher the meaning. I don't want to have to lower myself to the lowest common denominator and pander to a general audience. I think it's more fascinating when there's mystery involved.

Yes. That's what Robert Wilson says about his work—he says he rehearses a production, and if it seems too clear he reorchestrates it in order to allow a sense of haunting mystery to remain with the audience. Does it worry you that your work might also be misinterpreted as simply offering a heady mixture of violence, sex, and shock effects?

There'll always be misinterpretation. And if there weren't any misinterpretation it would be propaganda, and I'm not going to make propaganda—I am against that.

What about distribution of the work—is that a problem or an annoyance? Has it ever been shown on TV or been given mainstream distribution?

I think in the future maybe my movies will be on regular television. Who knows? I mean, I did predict that this critical recognition would occur in ten years, but then I thought, It's not going to happen, after being ignored for so long. And then this book—Jack Sargeant's *Deathtripping: The Cinema of Transgression*—comes out! So I now see it as possible that my movies could end up on normal television, even though it seems strange that it would occur. What surprised me about this book was that I thought they would get it all wrong, but I think it is pretty close to what my original vision was. Maybe Jack's very good at paraphrasing my concepts!

Are you surprised that it's an English critic who's written this book?

I don't know—I think I am. I wasn't sure whether recognition would come from Europe or from America first. I'm still pretty much ignored in America.

Presumably this increases the difficulties of financing new work.

Right. I had an investor on my last big film, *War Is Menstrual Envy,* but that investor is now unable to give me more money.

Do you find that it is difficult to get into an editing suite, among other things?

Yes! Sometimes I'm lucky and I can get in there for free if I know somebody, like in Sweden when I did *Whoregasm* onto tape—that was for free. I was invited to show movies in

Gothenburg, and while I was there Radium wanted to put out a tape of *Whoregasm* and *Police State* and got me access to a studio.

You edited Whoregasm *there?*

Yes—the right and left sides into one screen, going in and out.

Is this two-screened editing feeding back into any kind of performance?

Yes, my last film did. The right side of *Son of a Whore/Smiling Faces Tell Lies* was originally presented under the title *Lock, Stock and Barrel,* in a performance by Emma Diamond, at St. Mark's Church. It was projected onto the rear of the church—onto the rounded shape of the wall. It was really big, with the girls dancing in front of it. I would like to do it with nude dancers, though. Actually, I was thinking I would really like to project my movies onto animals like an elephant or a warthog. I'd get a bunch of little animals and project my movies onto them, that would be really nice.

Do you have any new major projects?

Completing the novel I've been writing—I'm sure that'll be done by next year.

What's that novel?

Its tentative title is *No Guilt.* It's—I can't reveal what it's about.

It's interesting—you said that one of your collaborators, Rick Strange, had no morals, and there's the title No Guilt. *Would you say that your vision is that of a moralist or an amoralist?*

I think morality is a human invention. I think morality is not necessary—it's a value system imposed by another authority, but I have a sense of ethics: I don't believe the strong should hurt the weak. I think that the smart should take from the strong.

In a nutshell, perhaps, what do you think you want your art to do, ultimately?

That's not for me to say.

I'm just wondering whether you see yourself more as an agent provocateur or whether you share the kind of agenda evoked by Meredith Monk, who says she wants to create visions of harmony or some version of balance?

I resist putting it into words. I think putting it into words limits it. To know the answer, you have to watch my movies.

Ellen Zweig, Centre Pompidou, Paris, June 1984. Photograph by Françoise Janicot. Courtesy of the artist.

ELLEN
ZWEIG

I MET ELLEN ZWEIG IN 1981, when I traveled from Brisbane to Europe via California. We'd both researched similar fields—she'd just written one of the first doctorates on performance poetry and intermedia and had coedited *The Poetry Reading* (1981) with contributions from Charles Amirkhanian, Jackson Mac Low, and Larry Wendt among others—and we both enjoyed almost every cuisine in town, so not surprisingly we got on well and became firm friends. Zweig visited Australia as writer in residence at Griffith University the following year, and it was in Brisbane that we recorded both the first and the last of these interviews.

How had she been drawn to performance poetry and intermedia? Back in England we'd all wanted to be Beat poets, and it was only thanks to the timely discovery of the addresses listed in the two "Changing Guard" issues of the *Times Literary Supplement* (1966) waiting for me upon the dusty departmental library shelves of Neuchâtel University, that I'd first contacted various transatlantic concrete poets and associated innovators. How had she chanced upon them?

Zweig characterized her models as "people who do things that are very different from what I do"—artists such as Linda Montano and Philip Glass, whose examples variously inspired *Green Silk,* an early performance incorporating a live voice and a four-voice tape engineered by Larry Wendt, and the later multimedia piece *Running Errands in Africa,* which she brought to the Sydney Biennale's Soundworks Festival in 1986.

Further interviews in Geneva, New York, and then once again in Brisbane—during her 1995 Australian tour with Kathy Acker—introduce Zweig's subsequent work with mobile multimedia installations such as the "stagecoach converted into a camera obscura" in *She Travelled for the Landscape* (1986), and with site-specific installations such as her Forty-second Street window piece *Hubert's Lure* (1994). As Zweig concludes, the most rewarding contemporary multimedia works are surely those—like Gary Hill's *Tall Ships* and Chris Marker's *Silent Movie*—which unexpectedly offer a "quiet place" where one can still be "contemplative."

Over and over again, despite popular theory's alarmist predictions, it is precisely this sense of beauty and contemplative profundity that one finds in the finest works of the post-modern multimedia avant-garde.

Brisbane—August 15, 1982

Ellen, you're best known as a contemporary poetry scholar and as a performance poet. What first drew you to performance poetry?

I started out as a poet, and in the late '60s there was a feeling among the poets in New York, where I was then living, that poetry needed to become more oral. We went to poetry readings and were bored with them, because there was a monotone style of reading that was quite dull. We thought the poetry reading itself should become a more interesting event, and we began to talk about performance—what did that mean? So I went to the other arts to explore concepts of performance.

Which kind of poets presented this monotone delivery?

It was very much a style of the Black Mountain poets, with careful attention to the end of the line, to the breath. I was interested in those concepts but not their live manifestation, and in the late '60s I was also interested in poets who read with jazz bands and some black American poets like Don L. Lee and Sonia Sanchez whose poetry became jazz—who'd just do it with words.

But you've been more influenced by other art forms?

Yes. Since that time, I have been influenced by performance art coming out of the visual arts world and by minimal music—my influences tend to be people who do things that are very different from what I do. The performance artist Linda Montano has been important to me. The first work I ever saw of hers was called *Mitchell's Death*—at a performance festival in San Diego in 1978. It was both visual and like a piece of music.

There was a videotape of Linda inserting acupuncture needles into her face, somebody playing a gong and somebody playing a sruti, and Linda—acupuncture needles hanging from her face like silver lines of pain and transcendence—was reading from her journal, chanting the details of finding out that her ex-husband, Mitchell, was dead, going to Kansas City to see his body, and all the feelings she was having, seeing this person she had loved dead. It was a mourning ritual, and in fact in the audience there were people who had known Mitchell, people who burst into tears at the end of it. The text as a piece of music was something that I'd been exploring myself, influenced by Harold Budd, Steve Reich, early Phil Glass, Terry Riley. I wanted to do minimal music with spoken words, but work with texts more complex than Reich had used.

When did you first seriously present performance art?

I didn't become aware of performance art until the late '70s, and by that time I had done a lot of poetry with jazz and I'd tried a number of different things. I wore masks, a crow cos-

tume, painted my face with abstract designs, played percussion instruments, mostly rattles. I was getting my models from Robert Bly, who performs with masks and sometimes with musical instruments and from my interest in alchemy—the crow as symbol of the dark night of the soul.

Where did that lead?

At that time in the late '70s I was writing my dissertation, on performance poetry, considering Allen Ginsberg's improvised poems, Jerry Rothenberg's total translations from the American Indian, and sound poetry. So when I discovered performance art, that brought about a profound change in my work. *Green Silk* was the first thing I did that moved away from the simple ways in which I was trying to move into performance.

In *Green Silk,* I started out by recording a tape with a friend, improvising a conversation about a green dress, and then I wrote a text in a kind of automatic writing. When I first performed it, I hung up the green dress, played the tape of the conversation, and passed a piece of green silk around the audience. After the conversation part of the tape, I read the text, out of sync with the same text on tape—but in such a way that I could start reading and improvising behind my taped voice, and wind up in front of it. I now do *Green Silk* with a four-voice tape that Larry Wendt engineered, so there are now five out-of-sync voices, rather than just two.

What happened next?

I continued my simple technical experiments with a mono tape recorder for a while. I found I could get an enormous amount of echo and feedback, so I made pieces like *Eros, C'est la Vie* for that function of that tape recorder. Then, because of my collaboration with Larry Wendt—and later with Greg Jones, who composed the music for *Sensitive Bones*—I began to work with much more complicated tapes that I could make in Larry's studio or with a synthesizer Greg would compose music for.

The visual aspects got more involved with technology, too. I began using slides, Super 8 film, video. Since then I feel I'm going in two directions. One way is to present my work on tape or as sound track for film, because it's difficult to travel around, to take yourself and your equipment and all that, and if you have a tape or a film, then it gets to more people. The other is *Impressions of Africa*—an evening-long theater piece. So in a way I'm going less live and more live at the same time.

Do you see such multimedia activity as a particularly American trend, or have you come across parallels elsewhere?

I've seen it elsewhere. Sten Hanson, the Swedish text-sound composer, does a couple of pieces with slides and a computer dissolve system. There's an Italian, Maurizio Nannucci, who also does things with slides and tapes. It's hard to know whether American art influenced this or whether European performance art developed out of its own traditions—probably a bit of both.

Perhaps American performance art is more dramatic than European sound poetry? The 1972 Fluxshoe Festival touring England featured American Fluxus artists whose emphasis upon

enigmatic action seemed to contrast with the way English and French sound poets used rather fewer gestures.

We're talking about a number of different worlds here! When you talk about sound poetry in Europe, you're really talking about people who consider themselves poets and come out of the poetry world. But in the States, the poets didn't do sound poetry. Sound poetry really comes from people like Charles Amirkhanian or Beth Anderson who are composers. I'm not exactly sure why this is, but the people who do what we would more strictly define as sound poetry—text-sound, let's say—in the States, in general, started out as composers.

Which American poets and composers are you thinking of?

Well, Charles Amirkhanian, Beth Anderson, and Larry Wendt. Charles Amirkhanian basically started doing text-sound because he worked in a radio station and had access to tape recorders. He was a percussionist originally. I don't really know how Beth Anderson got into it. Larry Wendt, I would guess, because of his interest in Futurism and Dada, and also just because he loves to tinker with tape recorders and computers and whatever.

What about those around Cage?

Cage's influence is so far reaching at this point that it is almost taken for granted. Cage taught classes at the New School for Social Research between 1948 and 1960, and in those classes were Jackson Mac Low, Allan Kaprow, Dick Higgins, Al Hanson, George Brecht, and other people. What came out of those classes was Fluxus, Happenings, and in an indirect way, performance poetry of a certain type. The chance poetry of Jackson Mac Low and Cage's concept that everything is music merged in that class.

New York is really unique in the States in that all of the arts intermingle. If you read accounts of the audiences at the Judson Church performances, there were writers, dancers, musicians. Everyone came to see what was going on, and everyone got involved. I've interviewed Jackson Mac Low and Armand Schwerner about what times were like and what influenced them, and they say that they in general did not hang around with poets. Armand hung around with musicians, mostly, because he played clarinet, and Jackson hung around with musicians and visual artists and the Happenings people. Jackson, in particular, feels that he's the person who brought some of those influences into the poetry world from musicians and visual artists.

When Jackson first read this weird stuff in the '60s at the Tenth Street Café he was booed off the stage. He makes his poems by doing chance operations on the books he's been reading—so it doesn't have normal syntax or intended meaning, and he might read it in various ways, vary volume or pitch because he thinks of it as music. So it must have been disturbing to people who were used to poems that made sense. However, they invited him back quite soon after that and were very intrigued by the work.

Is there the same intermingling of poets and composers in California?

No. People in the different arts rarely mingle. Charles Amirkhanian works with Carol Law, who's a visual artist, but there isn't a free mingling, the way there is in New York.

How would you say things have most changed since the late '60s?

Well, I find that most performance now has a profound lack of content, and I am beginning to be as bored with it as I was with those monotone poetry readings—and I want artists to be responsible to their content. Many performance artists fear words because they're afraid to be tied to limited meaning. They don't understand that words can convey immensely complex meaning and can convey irony and other complex content more accurately than visual images, which are often tainted by our visual media culture. Especially when a performance is very technically sophisticated, I think, My God, there's so much stuff that this person can do—I wish this person were also saying something!

I like things where I feel people have challenged themselves in a personal way. Subject matter like Linda Montano's *Mitchell's Death,* which was an incredibly personal and moving performance. Sometimes, but not too often, it's interesting when someone is saying something about the technology that they're using. In my own work, I've been involved with analyzing ideas of the "exotic," of the Other that we have invented as we traveled and colonized lands such as Africa.

Where do you think verbal and sonic performance are heading next?

At the moment, the trend is to be funny—to be liked, to do little skits. And it's usually not terribly funny. You know, I'm going to all these performances, and I'm saying that "what I want is content." What a lot of people are saying is, "I'm bored! I want to be entertained." I don't think that is a bad thing—certainly art has been serious for a very long time—but most of it's fairly trivial work.

A person whose work I find more interesting, because it's deeper, is Meredith Monk. I recently saw a film of a "dance opera" piece of hers called *Quarry*—and it's just incredible! It's basically about a sick child who is feverish, and the beginning of World War Two is happening around her. She repeats the words "I don't feel well" and they become a metaphor for the sickness of the world. With practically no words at all, she gets so much intellectual and emotive content into this piece! She uses dance, singing—the special sort of singing that she does, film, props—it's total theater.

Are you inspired by this kind of scale?

Yes, that's my ideal for *Impressions of Africa*—that it be something like Monk's operas, but, of course, I use lots of words, and I'm not a dancer. So, it'll be quite different. But I'm hoping to use a number of people, so it won't be my usual solo performance.

San Francisco–Brisbane—1989

What have been the most recent developments in your work?

Impressions of Africa has been on hold for several years now—I still want to do it, but am less interested in the large-scale spectacle I spoke of in 1982. I developed a shorter piece, *Running Errands in Africa,* which I toured for many years. I designed it for easy travel. But in 1986, I began to build camera obscura installations in a new series of pieces called *Ex(Centric) Lady Travellers.*

This series came out of the concerns of *Impressions of Africa,* out of my interest in the exotic Other, but I turned my attention toward a certain type of traveler, the Victorian lady, because of the ambiguous position she held both in her own society and in the societies she invaded. She was both the conventional imperialist invader of the Other, and she was the Other traveling out to escape her domestic confinement.

For the first piece in this series, *She Travelled for the Landscape,* I converted a stagecoach into a camera obscura. I rode in the coach, dressed in Victorian clothes, with a small audience. We listened to a text-sound composition, and saw the outside world projected through a lens system onto a screen inside the coach.

The round image was magical, conveying a feeling of nostalgia, a longing for the past. Since then, I have choreographed a performance at the Giant Camera behind the Cliff House in San Francisco (1986), built a camera in a gazebo in Minneapolis (1987) and in a barrel-shaped silo at Artpark (1988).

I am currently working on a permanent installation for the Exploratorium, the science museum in San Francisco, which will commemorate the one hundred and fiftieth anniversary of the birth of photography and the seventy-fifth anniversary of the Panama–Pacific Exposition for which the Palace of Fine Arts—which houses the Exploratorium—was built. These days when asked what I call myself I don't worry as I once did whether I'm a poet, a composer, a visual artist, a performance artist.

As my dear friend, Jim Pomeroy, says, "I'm a general practitioner." And I wonder what the next seven years will bring.

Geneva—September 15, 1990

Here as part of the Festival de la Bâtie's Sound Poetry program, you've just presented a collaborative performance with Armand Schwerner. How does this relate to your other work?

I'm doing less and less performance actually, and more installations—and my performance is going in two directions. One direction is these collaborations with Armand. I'm less and less just reading a piece of paper. I still use audiotape, videotape, sometimes slides and projections, so there's still a multimedia aspect—but it begins to be much more like experimental theater than either performance art, or *poésie sonore.* The other direction is that I'm very interested, instead of doing live performance, in doing video. I want to get myself out of the exhaustion of live performance in order to get myself out into a directing role. I've been working with juvenile theaters—you know, paper theaters that kids put together—and I'd like to do a video with this little theater on it, with these little paper things, because this theater is like a video screen. So again, it's sort of putting together old things with a new technology.

Generally speaking, whose work do you find most inspiring at the moment?

The Wooster Group is the theater that I find the most exciting. What I like is its complex content—and interest in content—but still with this kind of strange, deep, body, emotion, gut thing. And the combination I find very interesting, because I work with content, but I don't really work with that gut thing. And that's the kind of thing that for me as a performer,

I don't think I'll ever be able to do. And it would be interesting for me to work with performers who could understand and deal with the complex content, but who also could do that kind of gut thing that takes the emotional part of a piece to a different level.

New York—January 14, 1991

Last time we spoke, you discussed the way in which your poetic work moved in the direction of theatrical and video performance. But you've also written that you've been working with interactive camera obscura installations.

Yes—but most of my installation work actually comes out of performance. The first camera obscura piece was in Houston, Texas, for New Music America in 1986. It was a stagecoach converted into a camera obscura, with a text-sound composition inside titled *She Travelled for the Landscape*. It's partly about a Victorian lady traveler named Marianne North, who traveled around the world painting landscapes and wildflowers, and it's partly about camera obscuras—the way "The prettiest picture I ever saw was one drawn on the wall of a dark room."

In the performance of this piece I dressed in Victorian clothes, and rode with four riders inside a very nice typical American stagecoach, pulled by four white mules. When the people got in the stagecoach I closed the door, gave a signal to the driver that we should start moving, and turned on the audiotape. The people could hear the tape and see an image of whatever was happening outside, and of course it was moving because the stagecoach was moving. So the performance element came about both from the moving images and my persona as the Victorian lady traveler.

Now what was interesting to me here was that I had never done a piece performing *in* the public before in that kind of way, instead of performing *to* the public. I was worrying for a long time about whether I should say something, whether I should write myself some lines, or maybe I shouldn't speak, or maybe I should just be myself and be natural. But there was no way that I couldn't interact with the people riding in the coach, because they would ask me questions while the audiotape was on. I wanted them to listen but they were going, "Oh, look at that!"—or, "How is that doing that?"—and I had to answer their questions.

Another interesting thing that happened was that I was sitting with the coach before we started, and a couple of kids wanted to sit in it. So I said, "Come in, you can see what's going on." And they looked at the image, looked at me, and looked back and forth at the image a few times, and then this one kid said, "Lady, you've got a time machine." I loved that, because somehow my costume made it a performance, it made it this nineteenth-century thing. Just the costume—I really wasn't acting—I was just being myself in the costume.

The second piece, which was also called *She Travelled for the Landscape*, took place at the Giant Camera in San Francisco. Ten performers in Victorian clothes walked outside the camera, passing objects to each other, doing things—a choreographed walk, and people could see them outside, could talk to them or mingle with them, and could also go in the camera. The same audiotape that had been in the stagecoach was playing inside, and I was also there in my Victorian clothes.

This camera has a lens system that rotates three hundred and sixty degrees, and I was moving the lens system, following the performers, so I was the photographer, in a sense,

following and framing the performers. They were performing outside and I was performing inside. I was very interested in the distortions that the lens makes, and in the power relationships that you have as the viewer in this private space—almost like a spying machine—or as the photographer who can control exactly how the images are framed. The audience stood in line to get in, and when they entered I gave a little introduction. Then the piece started, and they listened to the tape and watched the performers on the screen. It was much more quiet and meditative, and much more of a pure performance situation.

I've made a number of camera obscuras since then, some of them without sound. Almost all of them have had a performance, but often the performance has only been at the opening of the piece. For example, at the Exploratorium, I've made a permanent installation of a camera obscura. It's audience interactive in that there are three different ways of getting an image—two lens systems and a slot—and the audience can press buttons to open shutters so they can choose which image they want to see. At the opening, there was a performance with three performers in costumes that I designed. It was in conjunction with the one hundred and fiftieth anniversary of the birth of photography, so it was a kind of history of photography in costume with sepia-toned photographs, Xerox photographs, and digitized photographs on the costumes.

What have you been working on most recently?

I'm actually working on a very large piece for the Broadway Windows in New York—five windows on the corner of Tenth Street and Broadway. It's a piece about people's ideas of the monstrous and is a kind of re-creation of seventeenth-century cabinets of curiosity. It's about scale—how things that are too large or too small are monstrous—and about Antonie van Leeuwenhoek, the inventor of the microscope, and the little monsters that he found in a drop of water. So there'll be a camera obscura that you peer into, because you'll look into one window and see the scene projected from another window. There'll also be things that look like little creatures in water that will be projected out into the street, and onto people walking by. There's no audio, but there is a lot of text, some of it printed fairly large and some of it made into stencils and projected as shadows and as various layers of text in the windows. I'll see what happens.

Brisbane—July 28, 1995

Ellen, sitting here in the Botanical Gardens in the very new world in Brisbane, I wonder if I could ask you what you think about present developments in multimedia art?

Well, I think we are in the middle of—or maybe we've already been through—a technological revolution. Artists of my age, of my generation, tend to take the ideas that have matured using other materials and transfer them to digital technology, and they struggle with things like interactivity because for my generation of artists you want the art to be your vision, and when it's interactive it's not necessarily your vision. Younger artists don't seem so tied to that idea, and their move between high culture and low culture is much more fluid. So to go and work for a company designing video games can just as easily be their art as to put some-

thing into a museum. Now I kind of wonder if it's always been this way? Maybe decorative mural painting in someone's house and the kind of painting that goes into a museum are a kind of analogy? It's kind of hard to tell what's really changed.

Have any developments really taken you by surprise?

The most surprising thing for me as I sit and compare what I thought I would be doing with what I now do is that I always believed I had an esoteric, elitist practice. At a certain point I said, "That's OK, that's what I do, I'm like a mathematician, I can only talk to other mathematicians," but interestingly enough that has not turned out to be true.

For example, *Hubert's Lure,* the piece I did on Forty-second Street, was very popular. *Hubert's Lure* is about all of the things that lure you into the freak show—the banners and the bally, the rap of the barker who talks you into the place. Instead of talk, I used an eighteenth-century magic trick called "Pepper's Ghost"—it's simply a reflection in glass that looks like a projection, and I performed a mime bally dressed as a bearded lady. This was shot on video and then projected onto glass into a miniature set of the outside of a Dime Museum, so that the lady is made of light but she walks and sits on solid objects.

It was surprising to me how seductive a miniature can be, and I'll tell you it's hard to compete with the visual confusion and stimulation of Forty-second Street! But you could see that little bearded lady moving in her window from across the street and it drew crowds who were fascinated by the magic of it. Since the old Hubert's Museum and Flea Circus had been there up until the 1960s, there were people walking by who remembered it and told me stories about it. That's the way I like to invoke the past and connect it with the community that experienced it.

I'm particularly inspired by an artist named Siah Armajani, an Iranian artist who has lived in the States for thirty or forty years, who makes architectural public sculptures or installations. It's not "community art" in the sense that Siah is asking people to tell him what to do. What he's asking them is what they need. He'll go into a community and say, "What would be good to have here? Do you need a quiet garden? Do you need a bridge so that it's easier to cross that street?"—those kinds of things. My practice is a little different from Siah's, because I haven't had that kind of community involvement. Essentially, I do magic tricks—the things I do with optics are like magic tricks. I always felt, especially as a poet, that I could never be entertaining and the thing about magic tricks is that they are entertaining and are a kind of a lure which allows you to insert other kinds of content such as the material about attitudes toward deviance in my Forty-second Street installation—and I'm surprised that I've been able to do that.

Would you say we're witnessing a retreat from a more hermetic or elitist art?

I guess there are two streams going on, and I kind of have a foot in each one. There are those who still do very esoteric, conceptual, language-based art, which frightens the general public because they don't understand it. Other kinds of artists or curators place more emphasis upon works and exhibitions that can be understood or explained more widely. For example, the Whitney's exhibition *The Black Male,* curated by Thelma Golden, presented different images of what a black man could be. They developed a whole education program where they would bring kids from junior high school, high school and talk about these exhibits

Ellen Zweig, *Hubert's Lure,* Forty-second Street, 1994. Photograph courtesy of the artist.

and different images—and usually you never see these kids in the Whitney Museum. I'm not going to say that I think this is world-changing, but I think a few minds get touched by these sorts of things—and that seems to me to be encouraging.

Why do you think there's this emphasis on social identity?

Well, first of all, the art world—although certainly not as much as one might hope—has taken into it all sorts of communities that were not there before. Although you still only see white people in most SoHo galleries, there are inroads of other groups of people, and those sorts of people have their own concerns and have been quite vocal about them, and that's been a great influence on the art world.

The other thing has been the attack on funding, because here we are making our art, and people are basically saying, "We don't want it, we don't want to pay for it, we don't want to look at it, we don't want to have anything to do with it." So then you begin to think, Well, what is my function in the society I live in? The thing about art is that everybody thinks it should be theirs, they think they should be able to understand it. But it always has one foot in the esoteric and one foot in the popular. So you begin to think, What are we doing it for? Who are we talking to?

Where do you think this is leading?

There's definitely another cycle of young artists who are doing things that are quite esoteric, except that they seem to still retain a kind of popular culture component. The high art thing

seems separated from the media of popular culture—it still exists, but it seems for the most part fairly lacking in real energy.

Although a few works, such as Bill Viola's video installations, surely succeed in imbuing the ordinary with a kind of mythological energy?

Yes. That reminds me of one of my favorite pieces of the past few years—a piece by Gary Hill called *Tall Ships* at the 1993 Whitney Biennial. On entering it you went into this very dark space, and it took quite awhile for your eyes to adjust, and then you saw these video figures on the wall—ordinary people, a little bit bigger than life-size—lining two walls of a long corridor. I was lucky enough to go in there by myself, so I got to explore its interactive impact. I would walk up to a figure who was perhaps sitting with his back to me, and as soon as I faced him, he would get up, turn around, and walk towards me until he was facing me. If I walked away he would also walk away, and all the figures did this—there were maybe ten or twelve figures.

I found this to be an incredibly moving piece, because it was a metaphor for community and yet it was the simplest thing. To me, it basically said, "If you face me, I will face you," and that face-to-face contact is important. In the context of this show it was incredible, because everybody there was speaking from their position and in some sense not facing each other. So that kind of simple work was very moving and very powerful.

Maybe this exemplifies a return to the subject? The Australian video artist Leigh Hobba recently made a portrait piece featuring the curator Noel Sheridan talking with an engaging irony about the difficulties of being an artist. Have you come across this sort of thing?

Well, I've heard about a video piece by an artist called Muntadas which has all these different artists, curators, museum directors, and critics talking about the art world—but as art I don't find that interesting. I still want art to be transformational perhaps, or surprising—I want that feeling of awe or wonderment. And although I don't discount work that goes into a community and empowers people in the community, that's not the work I'm interested in. I'm old-fashioned in a way—I'm still an artist who wants my own vision.

What recent works do you think best attain this sense of personal vision?

The thing that has impressed me the most recently was a video installation by Chris Marker at the Museum of Modern Art, called *Silent Movie*, about the one hundredth anniversary of the birth of cinema. *Silent Movie* is a five-monitor column. The images are computer controlled so that although there's a particular tape on a particular monitor, the conjunction of images is always different. There's one monitor that always has texts, poetic texts which are sort of like intertitles in a silent movie, only they're his writing so they're a little strange and poetic and surprising. Much of the footage is footage that he took from all sorts of places, but some of it he shot himself, and then there's a sound track of about an hour of music that might be the music that would be played for silent movies.

And this piece is incredibly beautiful—entrancing, in fact! I mean, I could have stood there for hours—it was beautifully made and it had really deep content. It was really saying something about what the movies give us, what kind of visions movies are in particular, the

kind of play with the past and the present and the future that movies can do so well. Marker took it apart and put it back together again. I found that piece very inspiring.

So despite the relevance of basic deconstructive art, we're agreed that art can still—and should still—evince this kind of "wonderment"!

Yes, there's still a place for beauty, and Marker's piece was incredibly beautiful. I have a yearning for that. I can take all sorts of other things seriously and deal with them—I find industrial things beautiful also—you don't have to have nature. But what Marker did there, I think, was make a quiet place, a place where you could be contemplative and where you could take in lots of information, both visual and verbal. It was simple but not simple—it was a simple thing that had so much complexity in it. And in a way, that's all we need.

BIOGRAPHIES

KATHY ACKER (1947–97) was one of the most influential writers of her generation. A performance artist and author, she published numerous novels, usually with underground presses, including *Blood and Guts in High School* (1984), *my mother: demonology, a novel* (1993), and *The Childlike Death of Black Tarantula by the Black Tarantula* (1998), as well as the opera *Requiem,* which premiered after her death.

CHARLES AMIRKHANIAN has produced text-sound compositions informed by his study of modernist poetry, his background as a percussionist, and his many years in front of a microphone as music director of KPFA-FM radio in Berkeley. He has performed internationally, often in collaboration with visual artist Carol Law, and he has produced electronic music incorporating ambient sounds sampled and reworked in digital synthesizers. In 1974 he produced the first anthology of American text-sound pieces for 1750 Arch Records, generating much interest throughout the United States for the medium. Since 1993 he has directed the Other Minds Festival of new music in San Francisco.

LAURIE ANDERSON is an artist whose work includes music, performances, installation, and film.

ROBERT ASHLEY has composed opera in formats suitable for television production since the opera *Perfect Lives* was written and produced for television in 1980. His most recent opera, *Celestial Excursions,* premiered at the MaerzMusik Festival in Berlin in 2003 and was also performed at the Kitchen Center in New York that same year.

BETH B is a producer and director in the genres of documentary and narrative filmmaking. In 2001 she produced and directed *An Unlikely Terrorist* for Court TV as well as segments for HBO's pilot program *Nerve.com* and *Egg: The Arts Show.* She is currently in production on another documentary for Court TV, *Badge of Dishonor.* She is also a visual artist and

has created photography exhibitions and large-scale multimedia installations in the United States and Europe.

DAVID BLAIR is a video/computer artist. His first feature was *Wax; or, The Discovery of Television among the Bees* (www.waxweb.org). His forthcoming project is *The Telepathic Motion Picture of the Lost Tribes* (www.telepathic-movie.org).

WILLIAM S. BURROUGHS (1914–97) was one of the twentieth century's most important artists. Writer, painter, performer, and collaborator, he was an integral member of the Beat Generation, and his novels, including *The Naked Lunch* (1959), *Junky* (1953), and *The Wild Boys* (1971), redefined the modern novel. Influenced by the cut-up techniques of friend and collaborator Brion Gysin, through which text order is rearranged to produce permutations and new meanings, he continued publishing until his death.

WARREN BURT is a composer, performer, multimedia artist, writer, radio producer, and educator. He was born in the United States in 1949 and moved to Australia in 1975, where he has been based in Melbourne. He has performed his music and multimedia pieces in the United States, Europe, Japan, and Oceania, and he continues to create, perform, and produce work in Australia and internationally.

JOHN CAGE (1912–92) was a singularly inventive American composer, writer, philosopher, and visual artist. His systematic establishment of the principle of indeterminacy brought both authentic spiritual ideas and a liberating attitude of play to the enterprise of Western art. To reduce the subjective element in composition, he developed methods of selecting the components of his pieces by chance, first through the tossing of coins or dice and later through the use of random number generators on the computer. His mature works did not originate in psychology, motive, or drama, but rather were just sounds, free of judgments about whether they are musical or not, free of fixed relations, free of memory and taste. His most enduring—indeed, notorious—composition is the radically tacet *4'33"* (1952), during any performance of which no sounds are intentionally produced.

RICHARD FOREMAN founded his Ontological-Hysteric Theatre (www.ontological.com) in 1968 and has since directed fifty-two of his own plays for this group, as well as directing and designing additional operas and plays at major theaters around the world. He has won a MacArthur fellowship, nine Village Voice OBIES, a literature prize from the American Academy of Arts, a lifetime achievement award from the National Endowment for the Arts, and the PEN Master American Dramatist prize. Six collections of his plays have been published, as well as book-length critical studies of his work.

KENNETH GABURO (1926–93) was a pioneering composer, teacher, performer, writer, and publisher. He studied music at the Eastman School of Music, the Conservatorio di Santa Cecilia in Rome, and the University of Illinois. He received numerous awards and grants, including ones from UNESCO, Guggenheim, Rockefeller, Thorne, Fromm, and Koussevitzky foundations. His teaching career led him to Kent State University, the University of Illinois, the University of California at San Diego, and the University of Iowa, where he directed the Experimental Music Studio. His professional archive is located at the University of Illinois, Urbana-Champaign.

DIAMANDA GALÁS is a composer, vocalist, pianist, and poet. She lives in New York City and is the director of Intravenal Sound Operations. Her Web sites are found at www.diamandagalas.com and www.brainwashed.com/diamandagalas. She is the composer of *Defixiones, Will and Testament; Schrei X; Vena Cava; Plague Mass; Cris d'Avuegle; Panoptikon; Eyes without Blood; Wild Women with Steak Knives; Tragouthia apo to aima exoun fonos,* as well as many vocal and piano pieces based on the work of Pier Paolo Pasolini, Charles Baudelaire, Gérard de Nerval, Miguel Huezo Mixco, and César Vallejo.

JOHN GIORNO is a significant figure of twentieth-century poetry. An innovator of performance poetry and spoken word, he is the founder of Giorno Poetry Systems, which has released more than fifty LPs and CDs of poets working with performance and music, along with numerous cassettes, videos, and books.

PHILIP GLASS has had an extensive career as an innovative composer. He moved to Paris at age twenty-three to study with Nadia Boulanger. In Paris, he was hired to transcribe Ravi Shankar's Indian music into Western notation; when he returned to New York he began applying Eastern techniques to his own music. By 1976, he had composed a large collection of new music, culminating in *Music in Twelve Parts,* followed by the landmark opera *Einstein on the Beach* that he created with Robert Wilson. His repertoire includes music for opera, dance, theater, chamber ensemble, orchestra, and film. His most recent film work for Stephen Daldry's *The Hours* received Golden Globe and Academy Award nominations and won the Anthony Asquith Award for Achievement in Film Music from the British Academy of Film and Television Arts. In 2002, Glass premiered *Symphony No. 6 (Plutonian Ode)* with text by Allen Ginsberg, commissioned by Carnegie Hall to commemorate Glass's sixty-fifth birthday, and the opera *Galileo Galilei,* directed by Mary Zimmerman.

BRION GYSIN (1916–86), a self-taught artist and poet, closely collaborated with William S. Burroughs and devised the "cut-up" technique, which rearranged text (first on paper, later as sound recordings) to produce different permutations of language. He invented the Dreammachine; its flickering lights stimulated brain activity and became a source of inspiration for other artists.

DICK HIGGINS (1938–98) was a member of the Fluxus art movement, author of numerous volumes of poetry and essays, and founder of Something Else Press. His publications include *Poems Plain & Fancy* and *A Book about Love & War & Death.*

JENNY HOLZER lives and works in upstate New York.

MIKE KUCHAR is a filmmaker. His recent works include *On a Shore beneath the Sky* (1996), *Kiss Napoleon Goodbye* (1991), and *Cupid's Infirmary* (1993).

ROBERT LAX (1915–2000) was born and raised in Olean, New York, and after 1962 lived in the natural surroundings of the Greek islands of Kalymnos and Patmos. The list of his published writings, and works based on those writings, runs to more than five hundred items, ranging from single poems to pamphlets to books, and including graphic art, film, video, photography, and performance art.

JACKSON MAC LOW is a poet, composer of music and performance and radio works, visual artist, and performance artist, as well as the author of twenty-eight books. His works have been exhibited, published, and performed, frequently with his wife and collaborator, Anne Tardos, in the United States and many other countries. He has received awards from the Guggenheim Foundation, National Endowment for the Arts, New York Foundation for the Arts, CAPS, and other fellowships, and he was the recipient of the 1999 Wallace Stevens Award of the Academy of American Poets.

MEREDITH MONK is a composer, singer, director, and choreographer, and creator of new opera, musical theater works, films, and installations. A pioneer in what is now called "extended vocal technique" and "interdisciplinary performance," she has created more than one hundred works. She has received numerous prestigious awards, including a MacArthur "Genius" Fellowship, two Guggenheim Fellowships, three OBIES, and a "Bessie" for sustained creative achievement. In 1968 she founded the House, a company dedicated to an interdisciplinary approach to performance, and she formed Meredith Monk & Vocal Ensemble in 1978 to perform her unique compositions. She has made more than a dozen recordings, and her music has been heard in numerous films.

NAM JUNE PAIK is a seminal figure in video art. His video sculptures, installations, performances, and tapes encompass one of the most influential bodies of work in the medium. Merging global communication theories with an irreverent Fluxus sensibility, his electronic collages explore the juncture of art, technology, and popular culture as he interweaves avant-garde figures, pop icons, and electronic processing.

YVONNE RAINER has made films, dances, and gallery installations. Her films deal with aging, U.S. imperialism, sexual identity, oil pollution, political violence, and love, disaffected and otherwise. Her most recent videotape is a rumination on the avant-garde and fin de siècle Vienna.

STEVE REICH was recently called "America's greatest living composer" by the *Village Voice*. He won a Grammy award for *Different Trains* in 1989 and a second one in 1999 for *Music for 18 Musicians*. In 1994 he was elected to the American Academy of Arts and Letters; he has also been elected to the Bavarian Academy of Fine Arts and was awarded Commandeur de l'ordre des Arts et Lettres.

RACHEL ROSENTHAL is an interdisciplinary performer and theater artist who has toured solo and company productions nationally and internationally since 1975. She is currently artistic director of the Rachel Rosenthal Company and teaches her signature brand of improvisational theater around the globe. She was awarded an honorary doctorate by the School of the Art Institute in Chicago in 1999 and was named a Los Angeles Cultural Treasure in 2000. She has also received OBIE, Rockefeller, Getty, NEA, and CAA awards. She stopped performing in 2000 and is now painting, teaching, and writing a book about her teaching methods.

BILL VIOLA is a pioneer in the medium of video art whose work explores the spiritual and perceptual side of human experience. Recipient of numerous awards and honors, including a MacArthur Foundation grant, he has created more than 125 videotapes and multimedia installations since 1973, which have been shown in art museums, in galleries, and on public

television worldwide. In 1997, the Whitney Museum organized a twenty-five-year survey of his work that traveled to major museums in the United States and Europe. He recently completed his most ambitious project, *Going Forth by Day,* a five-part projected digital "fresco" cycle in high-definition video.

LARRY WENDT has been, since the 1970s, an active writer and practitioner of text-sound composition with a particular interest in the interface between narrative and technology. He has organized sound poetry events and has collaborated both as an artist and technician for performance works with others. He presently works as an electronic technician for the School of Music and Dance at San Jose State University.

EMMETT WILLIAMS was born in South Carolina, grew up in Virginia, and studied poetry with John Crowe Ransom at Kenyon College. Poet, performer, painter, and printmaker, he is the author of many innovative volumes of concrete poetry in both English and German, including the book-length poem cycles *sweethearts* (1967), *the boy and the bird* (1969), and *the voy age* (1975). His *Anthology of Concrete Poetry* (1967) remains the best introduction to this international movement. In his autobiography, *My Life in Flux—and Vice Versa* (1991), he explores his active role as a performance artist in Fluxus, the radical international art movement he pioneered in Europe in the 1960s. He lives and works in Berlin.

ROBERT WILSON has been an active artist and composer since the late 1960s, when he was a founding member of the Byrd Hoffman School of Byrds. He received critical acclaim for his 1971 silent "opera" *Deafman Glance,* going on to produce such works as the seven-day play *KA MOUNTain and GUARDenia Terrace,* in Shiraz, Iran; *The Life and Times of Joseph Stalin,* a twelve-hour silent opera performed internationally; and, with Philip Glass, the landmark work *Einstein on the Beach.* In addition to his stage productions, his art has been featured internationally in hundreds of solo and group exhibitions.

NICK ZEDD has produced, directed, and edited such movies as *Police State, Lord of the Cockrings, Ecstasy in Entropy, War Is Menstrual Envy,* and *Thus Spoke Zarathustra.* He acted in the films *What about Me, Thrust in Me, Bubblegum,* and others, and he is the executive vice chairman of the Institute of Xenomorphosis in Brooklyn, New York, where he lives.

NICHOLAS ZURBRUGG (1947–2001) was an academic and poet. At the time of his death he was professor of English and cultural studies and director of the Centre for Contemporary Arts at De Montfort University in Leicester, England. Much of his career was devoted to the study and support of avant-garde artists. He is the author of *The Parameters of Postmodernism* (1993) and *Critical Voices: Myths of Postmodern Theory* (2000).

ELLEN ZWEIG is an artist who works with text, audio, video, performance, and installation. She uses optics in her installations to create camera obscuras, video projection devices, and miniature projected illusions. She has presented work in Europe, Australia, and the United States, and has received grants from the National Endowment for the Arts, Art Matters, and the Electronic Television Center. She has been an artist-in-residence at the Rockefeller Foundation's Bellagio Conference and Study Center, at New York University's Interactive Telecommunications Program, and at the Massachusetts Institute of Technology.